Fashion Retailing

Second Edition

Fashion Retailing

A Multi-Channel Approach

ELLEN DIAMOND

Pearson/Prentice Hall
Upper Saddle River, New Jersey 07458

Library of Congress Cataloging-in-Publication Data

Diamond, Ellen.
 Fashion retailing / Ellen Diamond—2nd ed.
 p. cm.
 Includes bibliographical references and index.
 ISBN 0-13-177682-7 (pbk.)
 1. Fashion merchandising—United States. I. Title.
HD9940.U4D53 2006
687'.068'8—dc22

 2004060079

Executive Editor: Vernon R. Anthony
Associate Editor: Ann Brunner
Editorial Assistant: Beth Dyke
Director of Manufacturing & Production: Bruce Johnson
Managing Editor: Mary Carnis
Production Liaison: Janice Stangel
Manufacturing Manager: Ilene Sanford
Manufacturing Buyer: Cathleen Petersen
Senior Marketing Manager: Ryan DeGrote
Senior Marketing Coordinator: Elizabeth Farrell
Marketing Assistant: Les Roberts
Creative Design Director: Cheryl Asherman
Cover Design Coordinator: Miguel Ortiz
Cover Designer: Amy Rosen
Cover Image: GSO Images, The Image Bank/Getty Images
Interior Design and Composition: Carlisle Communications, Ltd
Production Editor: Ann Mohan, WordCrafters Editorial Services, Inc.
Printer/Binder: Banta/Harrisonburg
Photo credits and credits and acknowledgments borrowed from other sources and reproduced, with permission, in this textbook appear on appropriate page within text.

Pearson Education LTD.
Pearson Education Singapore, Pte. Ltd.
Pearson Education, Canada, Ltd.
Pearson Education–Japan

Pearson Education Australia PTY, Limited
Pearson Education North Asia Ltd.
Pearson Educación de Mexico, S.A. de C.V.
Pearson Education Malaysia, Pte. Ltd.

10 9 8 7 6 5 4 3 2 1
ISBN 0-13-177682-7

To the fabulous five

Alex, Michael, Matthew, Amanda, and Abby

Brief Contents

Contents

Preface

By the close of the twentieth century, fashion retailing was going through dramatic upheavals. While the brick-and-mortar operations still accounted for the lion's share of consumer sales for fashion merchandise, they were continuously challenged by the increasing business realized by off-site ventures. Catalog sales continued to soar, home shopping venues regularly showed increases in sales, and E-tailing was becoming more popular with shoppers.

Traditional fashion retailers, such as department stores and specialty chains, also continued to face competition from value merchants at unparalleled levels that severely cut into their profits. Discounters and off-price retailers, each conducting their operations from both on-site and off-site operations, produced greater sales revenues than ever before. Many traditional retailers saw the handwriting on the wall and either closed their doors, severely limited their plans for expansion, or joined the value bandwagon.

As the first decade of the new millennium began to unfold, the different types of fashion retailers began to change so they could survive in this highly competitive environment. The brick-and-mortar companies began to enlarge their catalog and Web site operations, the discounters and off-pricers were in an expansion mode never before seen in retailing, and Internet-only businesses began to make a niche for themselves selling fashion merchandise to consumers.

This first decade of the twenty-first century promises to be very difficult for merchants, especially those in the field of fashion. Competition is so fierce that only the fittest will survive, and lackluster companies are apt to fall by the wayside. It is a time when tried-and-true practices that companies once used to be profitable may be insufficient, and merchandising innovation will separate the winners from the losers. For fashion retailers that have been in business for many years as well as for the newcomers about to make their debuts, today's playing field is a bumpy one. All companies will require every bit of imagination and expertise they can muster to be successful.

The second edition of *Fashion Retailing,* now subtitled, *A Multi-channel Approach,* presents a wealth of theoretical and practical information to prepare students for today's retail environment. Past practices that are still relevant today are fully explored, as are the innovative concepts that have become part of the fashion retailer's world. The format of the text is the same as in the first edition, with five separate sections. There are additional chapters that address new industry directions such as "*The Emergence of Off-Site Fashion Retailing,*" "*Purchasing in the Domestic and Off-Shore Markets,*" "*Ethics and Social Responsibility,*" and "*The Retailing and Development of Private Labels and Brands.*" The chapters carried over from the first edition have been updated to include new materials and current examples of today's retail practices. New artwork is also featured to visually underscore the written message of the text.

The textbook features a DVD that gives the reader a visual understanding of the different components that comprise fashion retailing.

End-of-chapter materials include Terms of the Trade, Chapter Highlights, Discussion Questions, Case Problems, and traditional and Internet-oriented activities. Ancillary materials such as an instructor's manual, computerized test bank, and PowerPoint presentation are also provided.

Ellen Diamond

Acknowledgments

The second edition of *Fashion Retailing: A Multi-Channel Approach* was written with the assistance and cooperation of many professionals in the field. They provided a wealth of the latest innovative ideas in retailing, such as the multi-channel approaches used today, illustrative examples, photographs and drawings to make the text up to date and visually exciting. I am grateful to the following individuals for their contributions: Jason Arbacheski, QVC; Toni W. Babineau, JGA; Vickie Bloom, Regent International; Bonnie D. Clark, QVC; Alan Flusser, Alan Flusser Custom; Jim Frain, Chico's Retail Services, Inc.; Leslie J. Ghize, The Doneger Group; Marci Goldstein, JGA; Rene Kramer, Susan Bristol, Inc.; Glenda Laudisio, Checkpoint Systems, Inc.; Sheri Litt, Florida Community College in Jacksonville; Shawn McNally, Facconable USA; Amy Meadows, Marshall Field's; Maryanne Moore, The Doneger Group; Lavelle Olexa, Lord & Taylor; Michael Quirk, Superbag; Mark Rykken, Alan Flusser Custom; Barbara Schneider, Oasis Staffing; Richard Shweky, Regent International; Michael Stewart, Rootstein; Caroline Westhaven, Chico's Retail Services, Inc.; and Lexi Winkles, Chico's Retail Services, Inc.

In addition, I want to acknowledge the reviewers of this text for their many helpful suggestions: Jason Carpenter, University of Missouri; Pat Fisher, Johnson & Wales University, Rhode Island; Naomi Gross, Fashion Institute of Technology; and Kevin Keele, The Fashion Institute of Design & Merchandising.

SECTION ONE
Introduction to Fashion Retailing

An Introductory Analysis of On-Site Fashion Retailing

After reading this chapter, you should be able to discuss:

- The way in which retailing has developed from its early days to the present time.

- The success of the specialty stores and why they have become a major force in fashion retailing.

- Department store retailing and the reasons why it appeals to so many shoppers.

- The spin-off store concept and why department stores are using this form of retailing in their expansion programs.

- The differences between the discount organizations and the off-pricers.

- Warehouse clubs and the major reason they are able to sell their goods for less money than traditional retailers.

- Which type of fashion operation has enabled entrepreneurs to open shops of their own.

- The concept of multichannel fashion retailing and why merchants are embracing this methodology for expanding their businesses.

- The reasons for overseas expansion by merchants across the globe.

- The different methods retailers have used in expanding their businesses to overseas venues.

- Some of the trends of fashion retailers that are expected to continue throughout the beginning of the twenty-first century.

Retailing especially fashion retailing, has changed dramatically over the past several centuries. In pre-colonial America, for example, settlers would go to a **trading post** where they bartered their meager products with others. This evolved into the **general store**, the next shopping venue available to the majority of the population; it stocked products ranging from food to fabrics. There was no ready-to-wear clothing. Customers purchased materials and then turned them into garments themselves, with no regard to fashion. The rich, who had designers, dressmakers, and tailors create apparel for them were the ones who set the styles and wore clothing that could be considered fashionable. The profusion of affordable factory-produced goods, made available as the result of the industrial revolution in the mid–1800s, led to the development of clothing and household goods that were more than merely functional. To appeal to consumers, these items were attractive and fashionable, providing to a broader range of the population merchandise once available only to the rich.

Toward the end of the 1800s, the general store was joined by stores that were first known as **limited-line stores**, because their merchandise was limited to a single classification, such as mens wear or shoes. Soon they became known as **specialty stores**, the name by which they are still known today. As more finished products were manufactured, there was more selection to choose from, and the popularity of speciality stores increased, as customers

were drawn to the variety they offered. Soon merchants opened additional locations of their stores, heralding the beginning of the **chain organization**. The specialty retailers achieved considerable success, but some merchants realized they could better serve the needs of the consumer if they offered more than one product classification under a single roof. This led to the beginning of the **department store** concept. Offering a wide assortment of merchandise, the vast majority of which was apparel for the family as well as shoes, jewelry, and other wearable accessories, this latest retail entry proved to be very popular.

By the turn of the twentieth century, in the United States and abroad, more and more of the department store and specialty merchants turned their attention to meeting their customers' demands for fashionable merchandise. Merchants introduced the latest styles to the masses, who readily accepted them; they no longer wished to have only functional clothing and accessories. People of lesser means were now able to buy off-the-rack merchandise that simulated custom-made fashions at prices that were significantly lower. Fashion emphasis became the driving force behind the success of the retail industry. Although retail environments offered a wealth of other goods it was fashion merchandise that dominated their product assortments and generated the sales that made their businesses prosper.

Throughout the twentieth century, fashion-oriented retail operations prospered. As people left the cities for suburbs, the stores followed, so that shoppers no longer had to visit a downtown, central shopping district. Traditional chains grew by opening numerous units, and department stores expanded with branches. Other retail venues, both on-site and off-site, increased in popularity. Stores that came to be known as **brick-and-mortar operations** now included other formats such as **boutiques**, **off-pricers**, **manufacturer's outlets**, **discounters**, and **warehouse clubs**. The off-site specialists were initially relegated to the catalog operations, some of which were extensions of the brick-and-mortar companies and others were purely direct-mail operations. These were joined by the home shopping merchants and E-tailers, which offered their goods on Internet Web sites.

Now, in the beginning of the twenty-first century, consumers are treated to more retail outlets where their fashion needs are satisfied. Whatever their pleasure or preferred time to shop, a whole new world of retailing is available.

Fashion is by no means limited to apparel and wearable accessories. Furniture and home furnishings play a significant part in the overall fashion-retailing empire. One need only read the pages of the trade papers, such as *Women's Wear Daily,* and consumer periodicals such as *House Beautiful* and *Elle Décor* to see the vast number of clothing designers who have expanded their talents to creating lines of furniture, other products for the home, and cosmetics and fragrances. Ralph Lauren, Versace, and Liz Claiborne are but a few who have made the leap from designing apparel to items such as dinnerware, glassware, and tableware. Print advertising is full of layouts that feature such products, and brick-and-mortar operations offer extensive displays of these home furnishings.

CLASSIFICATION OF ON-SITE FASHION RETAILERS

Throughout the United States, and abroad, there are many different types of on-site retail operations. Some, in operation for more than one hundred years, such as Macy's and Lord & Taylor in America, Harrods in London, and Au Printemps in Paris, still command the attention of the consuming public. Others, such as The Gap, Banana Republic, and Ann Taylor, are relative newcomers that have had a significant impact on fashion retailing. Year after year, the players in this competitive business arena change. Household names that reigned for many years, such as B. Altman & Company, Abraham & Strauss, and Bonwit Teller, have shuttered their doors because of their inability to compete, and newer fashion emporiums such as Sephora and H & M have arrived on the scene to make their marks in the fashion-retailing arena.

Others had to adjust their operations to remain profitable by entering into new types of operations. Eddie Bauer, for example, which primarily sold apparel and accessories, has entered the home-furnishings business; The Gap has created a maternity line that it sells in spe-

H & M, one of the newest fashion emporiums to arrive on the retail scene.
(Courtesy of Ellen Diamond)

cialty stores dedicated to this type of merchandise; and Bloomingdale's has begun separate brick-and-mortar operations that solely sell furniture and home-furnishing accessories.

Whether it is the competitive nature of the industry, a shift in consumer habits, or the need to expand into other types of retail venues to gain a larger share of the market, there are more classifications of on-site operations that merchandise fashion than ever before. The industrial giants that dominate the department store and chain organizations as well as the entrepreneurs that operate small boutiques and specialty stores are all part of the overall playing field.

Specialty Stores

Originally called limited-line stores, the merchants who restrict their offerings to one product classification are now called *specialty stores*. The range of fashion merchandise that they carry might be in a narrow offering, such as shoes, or more diverse, as in menswear. Stores such as Zales exclusively deal in jewelry, whereas Banana Republic offers a broader merchandising concept with clothing and accessories for men and women. The former concentrates on just one product classification, and the latter a broader range of items, but they are both part of the specialty-store classification.

The sizes of the operations vary considerably. They run the gamut from the one-unit businesses to the giants in the field that might have as many as 2,000 individual units. Whatever their size, the concept of this type of retail classification is the same for all. Specifically, their success is based upon such factors as:

- *A broad assortment of specialized items.* A shoe merchant, for example often features more than one hundred styles in a single setting.
- *The size of the units.* Unlike the department stores, which occupy vast amounts of space, making shopping time consuming, the specialty store is considerably smaller, enabling the shopper in a hurry to quickly examine the available items and complete the transaction in little time.
- *Service.* The forte of these stores is generally personalized service. Unlike many department stores, which have often reduced their selling staffs to the point where it is difficult to find sales assistance, the specialty stores generally pride themselves on service.

It is important to note that as the size of the specialty chains grows, their cost of doing business is often reduced. Because of their size, they are able to purchase in greater amounts, which often results in lower wholesale costs. Operating from a home office or central headquarters, as most of the specialty chains do, provides them with more sophisticated decision-making tools that in the long run can lead to lowering the costs of doing business. With management at the highest levels in the hands of relatively few, there is significant salary savings, also often resulting in overall cost reductions to the company. Other responsibilities that are generally accomplished centrally, such as merchandise planning and procurement, development of advertising and promotional ideas, devising visual presentation formats, and merchandise handling and distribution, save the specialty chains from higher operating expenses.

Many of the specialty operations have entered yet another form of specialization, with the introduction of **subspecialty stores**. Once they have reached their goals with their primary merchandise offerings, some companies enter into a more defined business arena. Talbots, a nationally known women's clothing specialty chain, for example, has expanded its

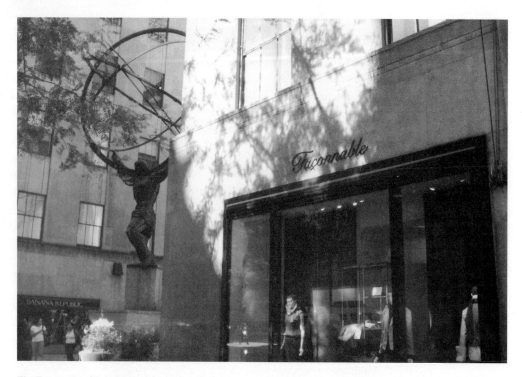

The Façonnable Flagship on New York's Fifth Avenue is an example of high-fashion specialty store retailing.
(Courtesy of Façonnable USA)

TABLE 1.1 The Top Twenty Specialty Retailers in the United States*

Rank	Company**	Format	Headquarters
1	Gap, Inc.	Traditional	San Francisco, CA
2	TJX	Off-price	Framingham, MA
3	Limited	Traditional	Columbus, OH
4	Intimate Brands	Traditional	Columbus, OH
5	Ross Stores	Off-price	Newark, CA
6	Footstar	Off-price	West Nyack, NJ
7	Burlington Coat Factory	Off-price	Burlington, NJ
8	Williams-Sonoma	Traditional	San Francisco, CA
9	Charming Shoppes	Traditional	Bensalem, PA
10	Talbots	Traditional	Hingham, MA
11	Tiffany	Traditional	New York, NY
12	American Eagle Outfitters	Traditional	Warrendale, PA
13	Abercrombie & Fitch	Traditional	New Albany, OH
14	Stein Mart	Off-price	Jacksonville, FL
15	Ann Taylor	Traditional	New York, NY
16	Men's Warehouse	Off-price	Fremont, CA
17	Goody's Family Clothing	Off-price	Knoxville, TN
18	Famous Footwear	Off-price	Madison, WI
19	Claire's Stores	Traditional	Pembroke Pines, FL
20	Casual Corner	Traditional	Enfield, CT

Note: Excerpted from *Stores Magazine,* June 2003.

*The companies in this list are primarily apparel, accessories, and home-furnishing oriented.

**Many of these companies have stores other than those that bear the corporate name.

operation by opening stores that feature petite versions of its product mix. In this way, the chain can concentrate on a small section of the market that wants products that are tailored to its needs. Gap, with the opening of Baby Gap, and Toys R Us, with Babies R Us, has led the way for others to explore this retailing subspecialization.

Although the vast majority of the specialty-store organizations in the United States are traditional in nature, many are off-price-oriented as demonstrated in Table 1.1. Some offer the services that are found in the traditional settings, but by and large, the off-pricers are not usually considered to be service-oriented merchandisers. Because of their importance to retailing today, off-price stores will be examined in detail in a separate section of this chapter.

Department Stores

Unlike the general store, which had no specific floor positioning for its variety of goods, the department store reordered the physical space and assigned similar types of merchandise to specific areas known as departments.

This department-style classification of retailing has become a fashion retailing mainstay that has remained popular with consumers since its inception at the turn of the twentieth century. In contrast to the specialty stores, which restrict their offerings, the department store offers a merchandise mix comprising a host of different product categories that run the gamut of **hard goods** and **soft goods**, including apparel and accessories for the family, furniture, accessories for the home, and appliances. Department stores that subscribe to this type of business are called **full-line department stores**, the best known, of which include Marshall Field's, Bloomingdale's, Macy's, and Burdines.

As their businesses evolved, many of the traditional full-line department stores began to minimize their selection of hard goods and to concentrate on their soft goods offerings. In fact, many of them completely eliminated major appliances from their product

Marshall Field's is typical of full-line department store retailing.
(Courtesy of Marshall Field's)

mix. This decision was prompted in part by the advent of discount retailers, which sold appliances at prices far below those of department stores. Consequently many of the department stores decided that stocking more soft goods such as clothing and wearable accessories, was more profitable. The exceptions are stores such as Sears and J.C. Penney. Sears, in fact, is still counting on the full-line concept that most have abandoned. In 2003 it embarked upon a new division called *Sears Grand*—open stores that are larger than traditional Sears units in locations that are far from the traditional, regional malls. The first store was the Jordan Landing Shopping Destination on the outskirts of Salt Lake City, followed by others in Las Vegas; Gurnee, IL; and Rancho Cucamonga, a suburb of Los Angeles. These stores are one-story configurations ranging in space from 165,000 square feet to 200,000 square feet. Sears expects this to be the type of operation that middle-income consumers will patronize.

Carrying the concept of offering a greater amount of fashion merchandise to an extreme, the **specialized department stores** restrict their mix exclusively to apparel and a host of accessories. Their premises are much larger than a typical specialty shop, often spanning many floors, and their inventories are significantly greater. They operate in the same manner as their full-line counterparts, except for their merchandise assortments. Widely known specialized department stores are Saks Fifth Avenue, Neiman Marcus, Nordstrom, and Lord & Taylor.

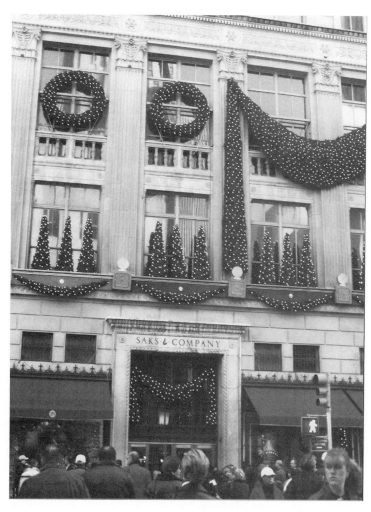

Saks is one of the major specialized department stores in the United States.
(Courtesy of Ellen Diamond)

Fashion Retailing Spotlights

NORDSTROM

In 1887, John W. Nordstrom, then sixteen years old, left his home in Sweden for New York City with only five dollars in his pocket. He soon ventured to California, Washington, and Alaska, where he thought the gold in Klondike would help him make his fortune. Although he found that it was not easy to earn a living in Alaska, within two years, he earned $13,000 and returned to Seattle. He entered into a partnership with his friend Carl Wallin and in 1901, they opened a shoe store together, Wallin & Nordstrom, in downtown Seattle. This eventually became Nordstrom, Inc. They opened a few more shoe stores, and in the late 1920s sold the business to the Nordstrom sons. By 1960, Nordstrom, still exclusively selling shoes, had eight stores in Washington and Oregon, but this was destined to change.

Looking for new ways to expand, Nordstrom ventured into the clothing business, first purchasing Best Apparel, a Seattle-based clothing store, and then purchasing a fashion-retail operation in Oregon. The company was renamed Nordstrom Best and became a line of specialized department stores in which shoppers could buy both shoes and fine apparel.

In 1971, now operating under the direction of the third generation of the Nordstrom family, the company went public. Sales at that time reached $100 million, and it became the largest-volume specialized department store on the West coast.

(continued)

Today, Nordstrom, Inc., is enjoying recognition across the United States. It has become a multichannel retailer, catering to upscale families in brick-and-mortar operations, in catalogs, and on the Internet. The company has 142 stores, composed of 88 full-line units and 47 Nordstrom Racks—outlets that feature end-of-season leftovers and manufacturer's closeouts. Included in this retailing empire are five Façonnable boutiques, which feature an exclusive collection of products that originate in France; twenty-four additional Façonnable boutiques in European countries; and a single remaining shoe emporium.

The company's philosophy has remained unchanged for more than one hundred years. Not only is its merchandise assortment considered to be one of the finest in its price-point classification but the service that sales staff offer to customers, including personalized attention in departments, is considered by many to be the industry benchmark. The company's sales associates are paid strictly on a commission basis. With no salary guarantee, this motivates the staff to gain as much customer confidence as possible when attending to the shoppers' merchandise needs, and consequently the sales people are rewarded with commissions that generally place them at the top of the retailing earnings ladder.

Nordstrom's plans for the future include expanding into other regions across the United States.

Department Store Groups

At one time, department stores were individual entries, with companies such as Sears typical of the giants in the retail scene. Over the past years, there have been significant changes, with giant retail organizations making an even greater impact through their acquisitions of other department store lines. For example, Federated now has under its wings two companies that were former competitors, Macy's and Bloomingdale's, giving Federated the distinction of being the second largest of the American department stores, right behind the leader, Sears. Not to be outdone, May Department Stores now includes Lord & Taylor and Marshall Field's on its roster, and Saks, which is currently headquartered in Birmingham, AL, includes Carson Pirie Scott and other formerly independently based stores, such as Younkers and Parisian, in its holdings.

The advantage to these giant groups is not only the chance to potentially increase profits by decreasing operating expenses but also the ability to purchase merchandise in larger

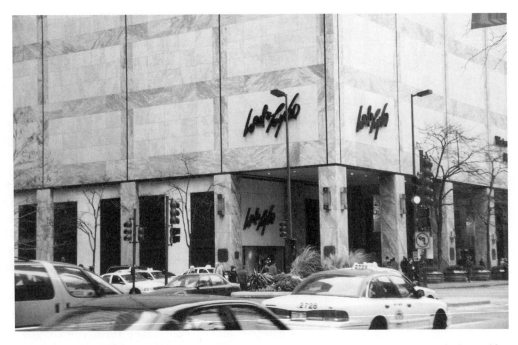

Lord & Taylor is a division of May Department Stores, one of the largest department store groups in the world. *(Courtesy of Ellen Diamond)*

quantities, resulting in lower costs. They also are able to feature the same private labels previously only available in one of their companies. Macy's, for example, exclusively merchandised lines such as Alfani and INC before it became part of Federated. After the acquisition, however, these two lines were available in Bloomingdale's as well as other units of the parent company, making the lines more visible to consumers. This trend of consolidating several stores into the hands of a few giant parent companies promises to continue in the future.

Table 1.2 lists the major American department stores in the United States and demonstrates how many of the leading organizations have several department store groups within their structure.

TABLE 1.2 The Top Ten Department Store Companies in the United States

Rank	Company*	Headquarters
1	Sears	Hoffman Estates, IL
2	Target**	Minneapolis, MN
3	Federated	Cincinnati, OH
	Bloomingdale's	
	The Bon Marche	
	Burdines	
	Goldsmith's	
	Lazarus	
	Macy's East	
	Macy's West	
	Rich's	
4	May Department Stores	St. Louis, MO
	Famous-Barr	
	Filene's	
	Foley's	
	Hecht's	
	Kaufmann's	
	Lord & Taylor	
	L.S. Ayres	
	Marshall Field's	
	Meier & Frank	
	Robinsons-May	
	Strawbridge's	
	The Jones Store	
5	Dillard's	Little Rock, AR
6	Kohl's	Menomonne Falls, WI
7	Saks	Birmingham, AL
	Saks Fifth Avenue	
	Proffit's	
	Younkers	
	Carson Pirie Scott	
	Boston Store	
	Parisian	
	McCrae's	
	Herberger's	
	Bergner's	
8	Nordstrom	Seattle, WA
9	Neiman Marcus	Dallas, TX
	Bergdorf Goodman	
10	Belk	Charlotte, NC

Note: Adapted from *Stores Magazine,* June 2003.

* Some companies have more than one department store in their organization, as shown in the indented lists of store names below the main store name.

** Target, a discount chain, is the parent of Marshall Field's and Mervyn's.

The **flagship**, or main store, traditionally was and continues to be generally the most important location in a department store chain. Such management decisions as merchandise procurement and advertising and promotion, are determined at these locations. Department store growth occurs with the addition of **branches** and **spin-off stores**.

BRANCHES

As department stores began to expand beyond their initial flagship unit, they opened smaller versions of the flagships, known as branch stores, in suburban areas all across the country. Each of these units carried a representation of the merchandise found in the main store as well as adjustments in their offerings to accommodate the needs of the communities they served. The branches were sales centers headed by store managers, who took their orders from the flagship's executive team. Their responsibilities were to oversee their branches and handle such matters as employee scheduling and hiring. In some department store operations today, such as J.C. Penney, branch managers have a role in determining the product mixes for their individual units so that each branch may better address its customers' needs.

SPIN-OFF STORES

Today, some department stores are beginning to counter the specialty store success with brick-and-mortar operations that feature only a segment of the flagship's inventory. This allows them to provide shoppers with a smaller, more specialized environment that offers a greater assortment of a single merchandise classification. Bloomingdale's has joined the bandwagon by opening stores that only feature furniture and home furnishings. Saks Fifth Avenue has also taken to this route with the introduction of small units that concentrate on just one segment of its fashion offerings.

The vast majority of the sales generated by the giant merchants continues to come from their flagships and branches. Their success, although challenged by the specialty chains, is still based upon their ability to provide services that give them considerable customer appeal:

- *One stop shopping.* Shoppers can satisfy their needs for a host of products under one roof, eliminating the need to go from store to store.
- *Personal shopping.* Fashion experts will accompany customers, free of charge, to help them with selections.
- *Registries.* Bridal and gift registries enable people to list the products they desire as gifts and make selecting gifts easier for the shopper.
- *Dining facilities.* Shoppers are able to complete their shopping needs and satisfy their appetites without having to leave the store.
- *Alterations.* On-site professional tailoring eliminates the need to go elsewhere to have garments altered. This is especially appealing to shoppers with limited time.

In spite of their longevity in retailing, department stores are dealing with a great deal of competition. Both the specialty chains and the off-site ventures, such as the catalog operations and E-tailers are making inroads into their customer bases. These types of outlets are discussed in chapter 2, "The Emergence of Off-Site Fashion Retailing."

Off-Price Merchants

What began as an operation in a woman's home in Brooklyn, NY, has mushroomed into a major force in retailing. Frieda Loehmann, the founder of the now well-known Loehmann's, started her business in a bedroom. Every day, she would scour New York's garment center for high-fashion closeouts and would bring them home to sell to an ever-growing clientele at a fraction of their intended retail prices. Her approach was to provide cash to the vendors, who were anxious to dispose of items to make room for the new season's offerings. Loehmann soon found that the overwhelming customer response to her "bargains", made her home too small, and she opened a store close to her home in Brooklyn. The rest is history. Loehmanns,

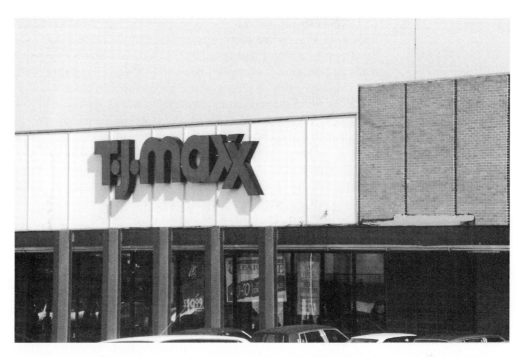

T.J. Maxx is a major off-price merchant that features such labels as Ralph Lauren, Calvin Klein, and Liz Claiborne at below traditional pricing.
(Courtesy of Ellen Diamond)

with a wealth of stores throughout the United States, is a leader in offering fashion apparel at prices that are significantly lower than those found in the traditional retailer premises in the United States. Little did Frieda Loehmann know that she was giving birth to what has become known as **off-price retailing**.

Today, brick-and-mortar operations, catalogs, and the Internet provide value-priced fashion merchandise for the consumer. Every price point is available, as are the products from such marque designers and manufacturers as Ralph Lauren, Calvin Klein, DKNY, Liz Claiborne, and Anne Klein. Companies such as T.J. Maxx, Marshall's, Burlington Coat Factory, and Stein Mart continue to grow their businesses all across America with units that are generally crowded with shoppers ready to buy.

Purchasing merchandise to stock these stores is still accomplished in the same manner that Frieda Loehmann practiced. Store buyers go from vendor to vendor seeking out the season's leftovers, closeouts, and odd lots, making deals to buy them at a fraction of their original cost. However, this is not the only means of their merchandise procurement.

Many use the Internet to learn about closeouts, checking out Web sites such as **www.wholesaleindex.com**, where a "closeouts" section is prominently displayed that lists different products and vendors and the merchandise and brands they have available for sale. Many are fashion-merchandise oriented. Buyers also can log on directly to Web sites held by vendors with whom they have established relationships.

Other buyers use the services of fashion-market specialists such as Doneger Associates, which have a division that specializes in off-price merchandise called Price Point Buying. These specialists, commonly referred to as **resident-buying offices**, are contacted by vendors to aid in the disposal of their unwanted merchandise, making them excellent resources for the needs of off-price merchants.

Although the traditional fashion merchants have the advantage of buying early in the season and reordering hot items when the need arises, the off-pricers are limited to **opportunistic purchasing** and cannot reorder items that sell out, meaning they do not have continuity in their purchases. Their goal is to purchase at rock-bottom prices and pass the savings on to their customers. Consequently, they forego the benefits afforded the conventionally organized department stores and chains.

To be able to purchase off-price from the better-known vendors, this group of retailers must also not interfere with the operations of their traditional fashion retailer counterparts, the department stores and specialty chains. They therefore open their units away from the malls and downtown shopping districts that house the leading fashion merchants. They locate in power centers, places where just a few discounters and off-pricers maintain large spaces to merchandise their assortments; small shopping centers that are anchored by such retailers as Loehmann's and Marshalls; major value arenas such as those built by the Mills organization that occupy as much as two miles of space under one roof; and other indoor and outdoor facilities such as the ones operated by Belz. With this arrangement the vendors are able to dispose of their slow sellers or season's leftovers to off-pricers and still maintain productive relationships with their regular department store and specialty clients.

Fashion Manufacturer's Outlets

Inspired by the success of off-price retailers, many fashion designers and manufacturers have opened outlet stores of their own in which they feature their collections. Since the early 1980s, Ralph Lauren, Calvin Klein, DKNY, Liz Claiborne, Coach, Anne Klein, and a host of other fashion names operated company outlet stores in centers that exclusively feature such outlets. The early entries in Reading, PA, and Secaucus, NJ, were later joined by North Conway, NH; Freeport, ME; Saint Augustine, FL; and other venues throughout the United States.

These designer outlets are significantly far from the major traditional malls so that they do not compete with the department stores and specialty chains that purchase the designers' full-price merchandise.

Discount Operations

Increasingly, the names of Target and Wal-Mart are recognized as places where a host of fashion products are available at the lower price points. These merchants, and others in their classification, offer goods that are discounted to sell for less than their conventionally oriented competition. The discounters buy in huge quantities that often allow them to receive price advantages that they pass on to their customers. Unlike their off-price counterparts, which primarily purchase closeouts and cannot offer continuity of merchandise, the discounters buy merchandise early in the season that can be reordered over and over again.

Warehouse Clubs

Costco and Sam's are generally associated with food and food-related products. Although the vast majority of their business is for these product classifications, they also realize an abundance of sales in apparel and accessories. In all of their units, a large section is devoted to pants, sweaters, jackets, golf apparel, sneakers, shirts, and the like. Brand names such as Dockers, Ralph Lauren, Ashford, Tommy Hilfiger, Addidas, and Perry Ellis are found in large supply, all at rock-bottom prices. Manufacturers make much of the goods specifically for these warehouse club retailers and are willing to sell to them for less because of the large orders they place; some of the name-brand items are closeouts.

Warehouse clubs require "membership fees," which enable them to sell for less. In fact, many of the items found in these stores can be priced with a minimal markup because of the enormous revenues these retailers derive from the fees they charge their customers for the privilege of shopping there.

Franchises and Licenses

Although most people think of companies such as McDonald's and Burger King when they think of franchising, this is not an accurate representation of this retail classification. **Franchises** and **licenses**, similar in nature, are forms of retail enterprises that enable those with little or no experience to capitalize on the reputations of established companies and realize

Costco is the largest warehouse club in the world.
(Courtesy of Ellen Diamond)

In addition to major brands, Costco also produces a private label collection under the Kirkland signature.
(Courtesy of Ellen Diamond)

the "American Dream" of business ownership. Instead of starting a business from scratch and dealing with such aspects as location analysis, pricing strategies, and employee training, they become part of recognized companies that have already developed tried-and-true concepts for running businesses. Franchisees and licensees, as these business owners are called, have

the immediate advantage of name recognition, company reputation, and consumer awareness. By entering into contractual arrangements with the franchisers and licensers, much of the risk of ownership is minimized.

One of the better known licensing groups is Benetton. The company, based in Italy, enjoyed one of the highest degrees of success when it first entered the United States market in the 1970s. Its premise was to provide a wealth of different apparel products, first for women and later for the rest of the family, in stores throughout the country. Licensers were able to choose their own merchandise mixes from the variety of products presented to them, making each location somewhat different from the others. For the right to become a participant in the Benetton family, the members had to provide a specific amount of capital for building structures, rentals, fixturing, and so forth; enter into a contractual arrangement that specified that their purchases would be exclusively from Benetton; and agree that they would follow the dictates of the company. They did not have to pay a start-up fee, as those involved in franchising must pay.

While Benetton's initial entry into licensing in America was considered highly successful, the company's importance in the United States was soon dashed. Stores began to close, and the name, although still popular in many European countries, faded into obscurity. Recently, Benetton has started a resurgence in the United States, beginning with a flagship in New York City on Fifth Avenue and the opening of many megastores in other venues. From all indications, the licensing of Benetton is again ready to become an important aspect of retailing.

Franchising is similar to licensing, except that in most cases, franchisees must pay a start-up fee.

Boutiques

In every part of the country where fashion-minded consumers are present, small businesses called *boutiques* have opened to serve their needs. They are primarily women's emporiums, but more men's and children's shops of this nature are coming onto the fashion-retailing scene.

Boutiques differientiate themselves from other types of retailers by offering an assortment of higher-priced items in small quantities, thereby providing a degree of exclusivity for

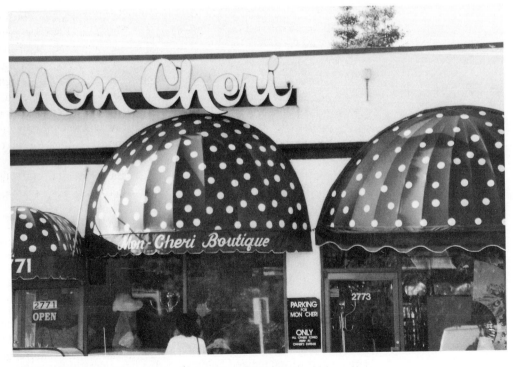

Boutiques carry limited assortments of upscale fashion merchandise.
(Courtesy of Ellen Diamond)

their clientele. The merchandise is also different from what the department stores and specialty chains offer. Many boutiques feature custom-designed clothing and unique accessories from fashion's famous global markets. Their forte is service. Generally one-unit entrepreneurships, boutiques are able to cater to the needs of a small but affluent market.

Flea Market Vendors

Once the rage of the fifties, sixties, and seventies, the presence of **flea markets** has declined. Also known as swap meets, they played a role in offering bargain merchandise to shoppers in makeshift environments such as drive-in movie parking lots. Most of the fashion merchandise were irregulars and copies of label merchandise, such as Calvin Klein jeans.

One of the major reasons interest in this form of shopping declined was the prominence of discount operations, off-price retailers, and wholesale clubs, each of which offered the same value merchandise found in the flea markets but in better surroundings and greater abundance.

There are still a sufficient number of these types of businesses in operation in Florida and California, and they continue to attract crowds.

MULTICHANNEL FASHION RETAILING

Given the wealth of different types of brick-and-mortar fashion operations now available, designers and manufactures are increasingly able to appeal to different consumer markets to sell their merchandise. At one point, companies such as Liz Claiborne, Ralph Lauren, and Calvin Klein primarily distributed their products through department stores and specialty organizations. Consumers shopping in these venues were willing to pay the full retail price if their requirements for early and complete inventories and excellent service were met.

These well-known companies now use other channels of distribution as means of reaching their targeted audiences, such as **designer shops** and **outlets** that bear the company's names.

Designer Shops

In malls across the country and in downtown central markets, a host of fashion merchandise producers have opened shops in which only their collections are sold. Donna Karan, for example, designs two distinct collections. One is aimed at the upper-income levels and is marketed under the Donna Karan label. The other is the DKNY offering, which fits into **bridge classification**, a designation that features price points between designer prices and moderate selling prices. Both of these collections are traditionally marketed to outside retailers. In an attempt to capitalize on her name, Karan has opened units that offer the Donna Karan and DKNY lines exclusively. Not only does this provide for designer clout but it also enables the entire collection to be shown under one roof, something that is unlikely to happen in the traditional brick-and-mortar operations, where space is often limited. Another advantage is that the designer's company has control over the management of the retail outlets and the decision making that is best suited to market the merchandise. Competition is also restricted by eliminating the presence of other lines.

Today, such renowned couturiers as Armani, Chanel, Saint Laurent, and Versace as well as more moderately priced offerings such as Claiborne are becoming commonplace in fashion retailing by operating their own merchandising units.

Outlets

In the fashion industry, where detailed planning goes into the creation of the product lines, even the most prominent collections often deliver styles that are not readily accepted by the consumer. Vendors dispose of much of this unwanted merchandise and product overruns by selling them to retailers such as the off-pricers. As was discussed earlier in this chapter many fashion design principals have added their own outlets in which they might sell their

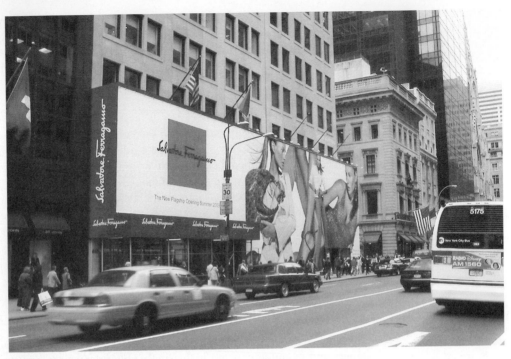

Salvatore Ferragamo has joined the bandwagon of internationally renowned designers who have opened shops that feature their own collections.
(Courtesy of Ellen Diamond)

leftovers, as is apparent during a walk through any outlet center. By practicing this form of retailing, the designers and manufacturers are able to realize better profits than they would achieve through the sale to other retailers.

Chapter 2, "The Emergence of Off-Site Fashion Retailing," discusses other means by which these creative talents are able to reach their markets.

THE GLOBAL SCENE

Today's retailing scene is changing radically. Not only are American and foreign retailers expanding their operations at home but many are going to overseas markets to reach consumers in other parts of the world. Although fashion retailers are not major players in this globalization, they do play a role in international retailing, as is evidenced by the growing participation of retailers around the world:

- Benetton's opening of its first megastore in China and three units in Japan.
- Ralph Lauren's expansion into the United Kingdom, which now includes his Home Collection. He is also entering the Italian market with his first entry in Milan.
- The Hermes stores are opening new units all across America and are enlarging and updating those already in existence.
- Kate Spade has entered the Asian market with fifteen units opening in Hong Kong, Korea, Taiwan, and Singapore.
- Moschino is targeting Germany for expansion with boutiques, the first of which is in Berlin.
- Burberry is opening bigger stores in the United States, beginning with a megastore on New York City's 57th Street.
- Cynthia Rowley is opening fifty in-store boutiques throughout Japan.
- Saks Fifth Avenue has signed a number of overseas licensing agreements that initially gives it a presence in United Arab Emirates, Qatar, Kuwait, and Bahrain, with others set to open in Japan.

Italy-based Benetton has expanded throughout the world to make it a major player in global retailing. *(Courtesy of Ellen Diamond)*

American Globalization

A look at the 200 top global retailers in the world immediately reveals that Wal-Mart is the largest. Aside from its enormous presence in every part of the United States, it maintains brick-and-mortar operations in Argentina, Brazil, Canada, China, Germany, Mexico, Puerto Rico, South Korea, and the United Kingdom.

The format of all these Wal-Mart stores is the same, with discount prices attracting the attention of the population of every country in which the company expands. Famous-label fashion merchandise as well as exclusive brands generate a large portion of the Wal-Mart sales in every part of the globe.

Sears is also a player in this overseas market, although the size of its stores is significantly larger than the typical chain's units, so its expansion potential is somewhat limited. At this point, Sears has operations in Puerto Rico and Canada.

Costco, which rounds out the top dozen retailers with global outlets, has a number of warehouses in Canada, Japan, Mexico, Puerto Rico, South Korea, Taiwan, and the United Kingdom. As is the case with its American entries, much of the merchandise mix centers on fashion merchandise and bears such labels as Ralph Lauren, Liz Claiborne, Ashford, Tommy Hilfiger, and Speedo.

In addition to the large discount and department store players, companies such as The Gap, with numerous units in Canada and several European nations, and TJX, with operations in Canada, Ireland, and the United Kingdom, are well represented globally.

European Globalization

The expansion of European fashion retailing is enormous. Companies that are based in a particular country often move into others. Metro, based in Germany, dominates the European retail market with stores in countries such as Austria, Belgium, the Czech Republic, France,

Germany, Italy, and Spain. Auchan, based in France, and Kingfisher and Marks and Spencer of the United Kingdom dot Europe with a multitude of fashion-oriented outlets.

Although the vast majority of these retailers are giants in their industry and market fashion merchandise to the masses, there is a significant growth in overseas expansion for many marque-label designs.

The success of these ventures is due in part to the extensive traveling many people do to just about every part of Europe, which allows them to continuously patronize the fashion emporiums. Because people of every country are familiar with the designs and labels of the French couturiers, for example, such overseas expansion is a viable approach to increasing sales. France, for example, leads the way with stores in places such as New York City's Fifth and Madison Avenues, Palm Beach's Worth Avenue, and Beverly Hill's Rodeo Drive; the world-famous boutiques of Chanel, Saint Laurent, Hermes, and others coexist with their American counterparts.

The overseas fashion couture explosion is not exclusively France's domain. The United Kingdom, Germany, and Italy also have their own creative geniuses that open worldwide retail operations and cater to the upper social classes in various countries.

One of the fastest expansions outside of the country of its origin is H & M; its operation now extends into a host of different global venues.

Fashion Retailing Spotlights

H & M

When H & M first entered the fashion retailing business in Vasteras, Sweden, in 1947, few would have anticipated the role it now plays as an international merchant. Established by Erling Persson, his intention was to provide fashion and quality at the best possible prices. He has since gone on to become known as the king of *cheap chic*. Now operating 844 stores in 14 countries, with plans to bring the number to about 1,000 by 2004, H & M has become a regular shopping venue for men, women, and children seeking to clothe themselves with the latest trends in fashion at affordable prices.

H & M's biggest market is Germany, followed by Norway and the United Kingdom. The United States is an overseas venue that constantly adds branches. H & M's initial success in America was its Fifth Avenue multilevel store, which attracts vast numbers of shoppers every day. A multitude of branches are now found in many other states. Today, H & M stores are opening in the Czech Republic, Poland, and Portugal.

Primarily a brick-and-mortar operation, the company markets its products by mail order in Scandinavia and utilizes the Internet in Sweden, Norway, Denmark, and Finland.

The merchandise sold by H & M is exclusive to the company. Ninety-five designers work with a team of up to fifty patternmakers, one hundred buyers, and a number of budget controllers to create the clothing collections for the entire family. Although H & M designs its own products, it does not have any factories of its own but instead works with around 900 suppliers primarily in Europe and Asia to produce the garments.

The collections are created in Stockholm. Some trends are predicted up to a year in advance in terms of color, material, and style but the very latest trends are developed on much shorter notice. Designers draw on influences from trips they take all over the world, street trends, exhibitions, films, newspapers, and trade fairs. To make certain that their product requirements are in keeping with their strict standards, one hundred quality controllers regularly visit the production facilities. Often, the visits are unannounced to ensure that the day-to-day operations are always in compliance with company demands.

H & M sells more than half a billion items a year, and new goods are delivered to the stores every day. To make certain that customers are able to satisfy their needs in a minimum amount of time, the stores are planned very carefully and designed down to every detail. Great importance is attached to the way the customers are given information via window displays, in-store presentations, and garment labeling.

With approximately 40,000 employees all working together to provide fashion and quality at the best price, H & M has become a leader in global fashion retailing.

TABLE 1.3 The Top Twenty Global Retailers*

Company***	Country of Origin	Classification	Countries**
Wal-Mart	United States	Discount	US, Canada, Brazil, Germany, Mexico
Metro	Germany	Department, specialty	Austria, Greece, India, Japan, Norway, UK, Vietnam
Target	United States	Discount, department	United States
Kmart	United States	Discount	United States
Sears	United States	Department, mail order, specialty	Canada, Puerto Rico, U.S.
Costco	United States	Warehouse	Canada, Japan, Mexico, UK, U.S.
JCPenney	United States	Department, mail order	Brazil, Mexico, Puerto Rico, U.S.
Auchan	France	Department, discount, specialty	Belgium, China, France, Italy, Russia, Spain
Ito-Yokada	Japan	Department, discount, specialty	Australia, Canada, Mexico, Thailand, Spain, UK, U.S.
Aeon	Japan	Department, discount, specialty	Canada, China, Taiwan, UK, U.S.
Kingfisher	United Kingdom	Department, specialty	Brazil, China, Germany, Italy, Turkey, UK
Federated	United States	Department, mail order	United States
Daiei	Japan	Department, discount, specialty	China, Japan, U.S.
May Department Stores	United States	Department, specialty	United States
Gap, Inc.	United States	Specialty	Canada, France, Germany, UK, U.S.
Marks and Spencer	United Kingdom	Department, specialty	Belgium, China, Greece, Malta, Netherlands, Portugal, UK, U.S.
KarstadtQuelle	Germany	Department, mail order, specialty	Austria, Germany, Italy, Luxembourg, Spain, UK
Coles Myer	Australia	Department, specialty	Australia, New Zealand
TJX Companies	United States	Discount, off-price	Canada, Republic of Ireland, UK, U.S.
Woolworths	Australia	Department, discount, specialty	Australia, New Zealand

Excerpted from *Stores Magazine,* June 2003.

* This list represents companies that have a fashion orientation in their stores.

** In some cases, these are only some of the countries in which these companies have retail operations.

*** Many of these companies are composed of stores with different names.

Asian Globalization

Leading the way in Asia is Japan, with a wealth of stores in many parts of the world. The most important of these international retailers is Ito-Yokado, which has outlets in Australia, Canada, China, Spain, Turkey, the United States, and other countries. It operates department and specialty stores as well as other types of retail outlets. Other international fashion retailers from Japan include Aeon, which has stores in Canada, the United Kingdom, the United States, and other places, and Daiai, which has branches in China and the United States.

One major Japanese department store that has maintained a presence in the United States is Takashimaya, which features a host of fashion products for the home. In its flagship on New York City's Fifth Avenue, the company occupies a multilevel store that is replete with a representation of merchandise from its Tokyo flagship.

Table 1.3 features the top global retailers with a fashion component.

OVERSEAS EXPANSION ARRANGEMENTS

Many retail organizations are opting to expand their operations outside the border of the countries in which they are headquartered. The reasons are numerous and include the following:

- *Overseas travel* has reached new heights and is attracting people to visit countries all over the globe. By doing so, the visitors become familiar with retailers and their products that are not generally available in their own countries and often wish to purchase from them once they return home. For example, The Gap has been a company that attracts attention from foreigners

visiting the United States. To maintain this offshore client base, The Gap has opened units in such countries as Canada, France, Germany, and the United Kingdom. By doing so, it has significantly increased its company-wide sales.

- *Competition* has caused some retailers to look outside of their traditional trading areas to overseas venues. By entering new markets, those with the right business formulas can expand their operations without the typical problems associated with competition. Marks and Spenser, for example, based in the United Kingdom, has ventured to Europe, Asia, and the United States, where their merchandising methodology is less likely be compromised by competitive retailers.

- *Product individuality* has always been the mainstay of the couturiers of France and Italy. The uniqueness of their designs is often the reason for their success. Designers such as Armani, Ferre, Saint Laurent, and La Croix have captured the fancies of Americans prompting them to open stores in the United States in record numbers.

- *Higher profits* are often the reason for offshore expansion. Because of the lack of competitive markups as well as the individuality of the products, these purveyors of fashion have found that higher prices often do not hamper sales. In fact, where the more affluent consumers are concerned, price is often not an object if the styles they want are available to them.

Despite the fact that these reasons often convince fashion retailers to move into worldwide arenas, there are often dangers associated with this type of expansion:

- *Economic volatility* sometimes causes unanticipated conditions all over the globe. For example, when a country devalues its currency, the prices charged for the items could change. Wholesale prices could therefore be more expensive than anticipated and affect the retail price of the imports.

- *Exchange rates* might also affect the price to be paid. For example, if the worth of the American dollar changes in the country to which the goods will be exported, the new rate might result in costs that are higher than when the initial relationship was established.

- *Local competition* must be carefully assessed before overseas expansion is considered. Care must be taken to make certain that the products marketed in stores overseas are sufficiently unique so that they will not be hampered by the domestic competition.

Once a company decides to expand to foreign markets, it must determine which type of expansion arrangement should be utilized. The following are the typical approaches used by businesses.

Wholly Owned Subsidiaries

A company that desires complete control of the overseas venture chooses to be a **wholly owned subsidiary**. By doing so, it assumes some risks, but at the same time, it has absolute control over the operation and need not divulge any secrets regarding its practices. It is also able to maximize profits by not having to share with other investors.

Of course, some nations frown upon sole ownership by foreign companies and require other means, such as joint ventures, discussed below, to be used in their offshore structuring.

Joint Ventures

When two businesses enter into a partnership to start a new company, they often form a **joint venture**. In international retailing, this is the most popular type of business arrangement.

One of the advantages of this approach is that the company wishing to expand overseas will gain the expertise from the foreign partner in terms of knowledge of consumer preferences, preferred business practices, and the requirements established by the government in such agreements. As investments of money and time can be substantial with overseas expansion, the expertise of the local retailer could help to reduce the risks of doing business.

Wal-Mart in Canada and China are examples of where a retailer with a fashion merchandise component has successfully used the joint venture route for expansion.

Franchises and Licenses

As noted earlier in this chapter, franchising and licensing are similar. In exchange for a fee and/or a percentage of sales, independent merchants are able to open retail operations using the franchiser's or licenser's name.

One of the better-known retailers that has expanded to other countries using the franchising arrangement is Benetton, headquarterd in Italy. It has entered into agreements with merchants in the United States, France, and many Asian countries.

TRENDS IN ON-SITE FASHION RETAILING

When brick-and-mortar fashion retailers entered the new millennium, they faced many challenges that necessitated changes in the ways they conducted their businesses. Significant among the reasons for these changes was the growth of off-site selling. Not only had the catalog offerings increased to levels never before seen but the advent of E-tailing substantially cut into their in-store sales potential. While Internet sales accounted for only 3.4 percent of overall sales in 2002, in terms of dollars, it was in the multimillions.

To combat the competition from their off-site counterparts, many stores that realized the vast majority of their revenues from store locations had to amend their business practices and address the competition head-on.

Some of the approaches taken at the beginning of the twenty-first century that continue to be utilized include the areas detailed in the following sections.

Development of Spin-offs

With the slowdown of sales in traditional department stores, many in this classification are starting to open specialty units. Saks Fifth Avenue is one of the early entries in this field, with small stores that will carry only a modest representation of its product offerings.

Bloomingdale's has also joined the bandwagon, with stores that will only feature products for the home.

Others are developing plans to follow suit. One of the major reasons for this trend is the competition from the specialty stores. Many consumers do not have the time to shop in department stores and have turned to the specialty retailers, where they can complete their purchases faster.

Expansion of Value-Oriented Chains

More shoppers are turning to off-pricers and discounters, known as **value-oriented retailers**. Record sales are recorded at discount companies such as Target and Wal-Mart, off-price emporiums such as Marshall's, and the warehouse outlets; all of these options offer fashion merchandise at rock-bottom prices.

As a result of the faltering economy in the first decade of the twenty-first century, consumers expressed the need to spend their money more cautiously. In response, outlets that offer value shopping have proliferated, and there is every indication that fashion retailers will continue in this direction.

Private Labels and Brands

A record number of fashion merchants, department stores, and specialty organizations continue to offer their own labels and brands, and they are expected to increase the proportion of their own **private labels** and brands that they stock in their stores over those that come from outside vendors. By doing so, they are able to offer a degree of merchandise exclusivity to their clientele and stem the problems associated with competition.

At the extreme end of the spectrum in exclusive merchandising practices is the concept known as "The Store Is the Brand." Fashion companies such as The Gap, Banana Republic,

Old Navy, and Ann Taylor have been successful using this merchandising route and other companies are expected to join them in this concept.

Shops Within Shops

Many major department stores have small shops—**shops within shops**—as part of their store's layout that bear the names of fashion designers and manufacturers. This allows them to attract customers who wish only to examine these lines without having to spend time searching the racks in regular departments.

This trend was begun by Ralph Lauren, who demanded that his merchandise be separated from the others in the department store, and it will likely continue to expand in the future.

Multichannel Expansion

While the brick-and-mortar operations continue to expand, the retail giants are also enlarging their empires with more catalogues and Internet Web sites to capture the segment of the market that prefers off-site shopping to the conventional ways of purchasing merchandise. The offerings from these venues will grow from what was once merely a smattering of goods that were representative of the stores' inventories.

Expansion Via New Concepts

Many of the giants in the industry that feel they have reached the point of oversaturation in their trading areas are turning to new concepts as a means of expanding their operations. Wal-Mart, for example, is adding new formats to its highly successful SuperCenters, Neighborhood Markets, and Sam's Clubs that include drive-thru supermarkets, a dollar store called Hey Buck!, and a reinvented convenience store prototype in which apparel would be as much a part of the merchandise mix as soft drinks and chewing gum. Also in the planning stage is a department store concept in which fashion merchandise would dominate the offerings.

Repositioning Merchandise Assortments Via Exclusive Commitments

Staying with the status quo has resulted in the demise of many retailers that were once household names. Companies such as B. Altman, A&S, and Bonwit Teller shuttered their doors because they were no longer as profitable as they once were. The problem with many of these companies was that their merchandise mix did not serve the needs of their consumers and the competition was too keen to make them viable players in their field.

Today, those merchants that are meeting the challenges confronting them are often repositioning their product mixes to revitalize their businesses. One such company is J.C. Penney. Its apparel was once considered mundane, and hard goods such as appliances were dominant in its merchandise assortment. New leadership is making changes in merchandising that is turning the company's picture from bleak to promising. Signing exclusive contracts with companies such as Bisou and Bisou, which previously was sold in stores such as Nordstrom and Bloomingdale's, Penney has started to show signs of turning the operation around and becoming more profitable.

Others embracing this approach are Target, which sells lines designed exclusively for it by Mossimo and Todd Oldham, and Kmart, which sells products exclusively designed for it by Martha Stewart and Joe Boxer.

Expansion Through Acquisition

As many retail companies successfully expanded their operations by aquiring other companies in the twentieth century, more retailers are expected to take this route in the near future. It reduces operating expenses and lowers merchandise costs because it deals with increased quantities.

SMALL STORE APPLICATIONS

Although it is obvious that fashion retailing is dominated by large department stores and chain organizations, that does not mean that entrepreneurs are no longer viable operators of fashion operations. Small boutiques as well as independent specialty stores can still successfully play a role in the business of fashion retailing.

Each chapter includes a special section called "Small Store Applications," that provides information and insights into the management and maintenance of small fashion companies. It will address the handling of advertising, visual merchandising, human resources management, merchandise procurement, store location, fixturing, and other areas vital to the success of small companies.

Chapter Highlights

1. Although the earliest retail entries, such as the trading post and general store, stocked a variety of products, it wasn't until the development of the limited-line store, or specialty store as it is now called, that fashion-oriented products were sold.
2. As the twentieth century gave way to the twenty-first, it was possible to purchase fashion merchandise in a variety of classifications other than traditional department and specialty stores, including off-pricers, manufacturer's outlets, discounters, and warehouse clubs.
3. The leading department stores today are generally part of parent companies and are not operated alone.
4. Department stores such as Bloomingdale's are now entering the spin-off market to compete with the specialty retailers.
5. Value shopping continues to increase its share of the marketplace with discounters, off-pricers, manufacturer's outlets, and warehouse clubs opening in venues all across the United States.
6. Fashion retailing is increasingly becoming a global phenomenon. American merchants are expanding to almost every part of the world, and foreign merchants are making inroads into new international settings.
7. Global expansion of fashion retailers are organized as wholly owned subsidiaries, joint ventures, franchises, and licenses.
8. Some of the trends in fashion retailing include the development of spin-offs, expansion of value-oriented chains, and shops within shops.
9. Increasing numbers of fashion retailers are now involved with multichannel ventures so that they can broaden their appeal to consumers who either haven't the time to shop in stores or merely like to purchase via catalogs and the Internet.

Terms of the Trade

trading post
general store
limited-line stores
specialty stores
chain organizations
department stores
brick-and-mortar operations
boutiques
off-pricers
manufacturer's outlets
discounters
warehouse clubs
subspecialty stores
hard goods
soft goods
full-line department stores
specialized department stores

department-store group
flagship
branches
spin-off stores
off-price retailing
resident-buying offices
opportunistic purchasing
franchises
licenses
flea markets
multichannel retailing
designer shops
outlets
bridge classification
wholly owned subsidiary
joint ventures
value-oriented retailers
private labels
shops within shops

For Discussion

1. In which retail operations did fashion first become available to the masses?
2. Why have specialty stores become one of the more important forces in fashion retailing?
3. What is the difference between a full-line department store and one that is classified as a specialized company?
4. Why have some major department store organizations expanded through the acquisitions route?
5. What is the difference between a department store branch and a spin-off operation?
6. Who is credited with the beginning of off-price fashion retailing? Give some of the history of this operation.
7. Why have many fashion designers and manufacturers opted to open their own outlets instead of exclusively utilizing outside retailers to dispose of their unwanted goods?
8. Why do some people wishing to open retail operations opt for the franchising or licensing route instead of embarking on their own formats?
9. How are fashion retailers addressing wider audiences without having to open new units all over the globe?
10. What are some of the major reasons that fashion retailers all over the world are going global to expand their businesses?
11. Which type of venture into foreign markets gives the merchant total control?
12. Why have increasing numbers of fashion retailers expanded their private label and brand offerings?
13. How does the shop within a shop concept benefit the world's leading fashion designers and manufacturers that already have exposure throughout the major brick-and-mortar operations?
14. Why might a joint venture be the better method for a company to expand into foreign shores?
15. What are some of the reasons that some retailers are repositioning their offerings?

CASE PROBLEM 1

Prescott's is a major full-line department store in the midwest. It began its operation in 1910, with its roots as a specialty women's retailer. In 1913, after three years of successful business in that classification, management decided the store would benefit from expanding its format to its present retail classification. Beginning in a multilevel structure, Prescott's new venture quickly became a leader in the many communities it served.

Opening branch after branch, Prescott's achieved significant sales volume and extremely high profits. Now with a large flagship and eighteen branches, there are signs of a slow down. In most of the departments, sales began to lag, most noticeably in appliances.

To correct the situation, Prescott's top management is discussing possible solutions. Three proposals have generated the most interest. Each is a different approach to improving sales.

Alexander Zachary, general merchandise manager, believes that the reason for the problem lies with the fact that many of Prescott's female customers are now working full time and have less opportunity to shop in department stores. He recommends that the company enter the spin-off market and open specialty units that feature merchandise from the company's most successful department, the Oak Room. As customers need less time to make selections in smaller environments, Zachary feels that this would attract the busiest customers.

Michael Joshua, director of store management, has another suggestion. He believes the establishment of a separate division for catalog sales is the answer. Instead of relying on the current methodology for its direct-mail business, which involves the same buyers and merchandisers that presently serve the stores, a new direct-marketing division would be more aggressive in terms of unique merchandise acquisition and could increase sales.

The third suggestion comes from Matthew Phillips, the company's fashion director. He believes that with the success of globalization in retailing, overseas expansion is the route to take. He uses examples of other companies that have successfully entered these markets and have substantially increased their sales volume.

At this point, the company has yet to decide upon the approach it should take to stem falling sales and less profitability.

Questions

1. Do you believe that a status quo approach is best for Prescott's? Why?
2. If you had to choose one of the suggestions offered by the management team, which one would you choose? Why?
3. Might there be other roads to pursue to bring the company back to the profitable position it once enjoyed?

CASE PROBLEM 2

Helen Avidon has worked for a fashion specialty retail chain for the past eight years. The company, Sophisticated Miss, initially hired her as an assistant store manger, and through the years, has promoted her to her present position, sweater buyer. Her first five years were spent at the store level in management, the latter three years in the home office, developing buying plans for her department.

Avidon's success was recognized through a series of raises with each promotion and ultimately a profit-sharing arrangement with the company. While by most standards her remuneration has been excellent in terms of the positions she held, she has always had the desire to fulfill "the American Dream," ownership of her own business.

Three months ago, Helen inherited $150,000. Her immediate reaction was to invest it in a business of her dreams. With eight years experience, she thought she had enough background to go along with the necessary financial investment needed to open a small fashion operation.

Through careful investigation, she learned that not only were there some opportunities to establish a store with its own unique concept but there were also established franchises and licenses that she could join. The initial investment of complete self-ownership and franchising and licensing was about the same, $150,000.

While her dream is still uppermost in her mind, she has yet to make the final decision.

Questions

1. What are the advantages and disadvantages of beginning a new business?
2. What are the advantages and disadvantages of becoming a franchisee or licensee?
3. Which of these avenues would you suggest she try? Why?
4. Should she forget about going into business and consider staying with Sophisticated Miss?

EXERCISES AND PROJECTS

1. Visit a full-line or specialized department store and an off-price fashion retailer and compare their operations. Using a form like the one below, complete the following categories to show their similarities or differences.

	Department Store	*Off-Pricer*
Merchandise assortment	_____	_____
	_____	_____
	_____	_____
Services	_____	_____
	_____	_____
Sales assistance	_____	_____
Visual presentations	_____	_____
Price points	_____	_____

2. Prepare a report on a franchised or licensed fashion-retail operation. The information may be obtained from such sources as the U.S. Department of Commerce, which has an Internet Web site, or from the Franchise Opportunities Handbook, which is generally available in libraries. The report should include:
 • Capital investment requirements
 • Product lines
 • Outlet locations (domestic and overseas)
 • Targeted market
 • Operation methods

The Emergence of Off-Site Fashion Retailing

After reading the chapter, you should be able to discuss:

- The status of E-tailing today, and the audiences that it regularly attracts.
- How designing a Web site can cost a relatively small amount.
- The different categories of fashion Web sites, and why each has become an important marketing tool.
- The meaning of *bricks and clicks,* and why companies use this methodology to reach consumers.
- Why interactivity has become an important component of many fashion Web sites.
- The manner in which Internet fraud is being addressed by the industry for the protection of shoppers.
- The way some catalogs have become more than just selling tools for their organizations.
- Why many shoppers opt to use catalogs more than any other purchasing channel.
- The reasons why some catalog companies have added Web sites as a means to sell their wares.
- The nature of *Internet catalogs* and how they help retailers that use them to reach potential customers.
- Some of the statistics that have made QVC a leader in home-shopping cable programming.
- Many of the trends in off-site fashion retailing.

Although brick-and-mortar retailing still accounts for the lion's share of fashion retail sales, there is a steady increase in the amount of business realized from off-site venues. Specifically, the Internet, catalogs, and home-shopping channels are producing more sales for merchants than ever before.

The greatest fanfare in the off-site arena has been attributed to E-tailing. Just about every major retailer has embraced the concept and has invested a considerable amount to create Web sites that will bring additional sales and, ultimately, profits to their organizations. Along with the brick-and-mortar and catalog operations that have Web sites, there are Web site—only companies that exclusively sell by these means. At first glance, eBay, one of the larger of these organizations, appears to be a site on which consumers make bids on such products as antiques, silverware, and home furnishings, but close inspection of the site shows that it features marque fashion labels such as Prada and Chanel. Not too long ago, consumers looking for such couture items would go to designer boutiques or upscale stores such as

Neiman Marcus. Now, purchasing them on eBay has become yet another means of procurement, and at prices that are often considerably less than in the stores.

Catalogs, in the earlier days of retailing, were the domain of companies such as Sears, which no longer has a catalog division, and Montgomery Ward, which is no longer in business. Today, a large percentage of households receive as many as a dozen or more catalogs a week ranging from those that feature department store offerings to others that are catalog-only companies. A wealth of fashion merchandise is displayed in these pages, and catalogs can serve as a means of doing business with consumers who have neither the time nor the interest to go into stores and make on-site purchases.

A look at many cable television stations immediately reveals a host of companies that sell elaborate precious jewelry and other fashion items to people who would rather sit in front of their television sets than shop in the brick-and-mortar operations. Led by HSN and QVC, the "programming" accounts for millions of dollars in sales every day.

By every indication, each of these off-site channels will continue to increase in popularity and make inroads into the sales volumes of the brick-and-mortar operations.

E-TAILING

The number of people around the world who own computers is ever increasing, and computer usage is at an all-time high. It is therefore not surprising that their use as a purchasing tool generates sales at record levels. Internet service providers, which allow computer users to access the Web, understand the importance of Web sites in terms of consumer purchasing, and they wage intensive multimedia advertising campaigns to attract computer users to sign up for their services.

On-line consumer spending reached $74 billion in 2002. An important figure in terms of Internet shopping is that men are responsible for 49 percent of the purchases, a significantly larger percentage than those who shop in the brick-and-mortar operations. This gives the off-site retailers reason to use the Internet as a means of attracting men who would not be likely to visit their stores. The consulting company, comScore, reported that the consumer who most often shopped on price-comparison sites was the 35-to-44 year-old male with minimum income of $60,000. There was also a reported increase in Internet use by minority shoppers, another segment fashion merchandisers want to reach.

Fashion apparel and accessories merchants also are beginning to emerge as one of the more important segments for *electronic retailing,* or **E-tailing**, as it is more commonly called. As reported by comScore, these product classifications are now the seventh fastest-growing nontravel E-commerce category.

The introduction of this purchasing channel has created a new language used by consumers and vendors alike. Internet users now readily speak in terms of *search engines, dot-coms, Web sites,* and *high-speed access.*

Creating a Web Site

When users connect to Web sites on the Internet, they are greeted by a wealth of different screens. Those sites that deal specifically with merchandise for sale run the gamut from travel to products for the home. Much as advertisements in print and broadcast media employ different styles and formats, the same is true for E-tailer Web sites.

The differences in the designs are based upon factors such as the costs associated with the site creation, the number of different screens needed to show the product line, and whether or not it will include an interactive component.

DESIGN DEVELOPMENT

The nature of the design depends upon the size of the company, its merchandise assortment, and the amount of money available for the site development. Companies with limited re-

sources can use standard **Web site templates** in which they merely insert their own products and prices. For a nominal fee, Web site design companies offer these models and help companies prepare them and launch them on the Internet. Costs associated with this type of site include monthly fees to the Internet service provider as well as the initial startup expense.

To distinguish themselves from their competitors the majority of E-tail Web sites are created by experts who tailor their designs to meet the merchant's exact requirements.

WEB SITE SPECIFICATIONS

When users log onto a search engine and enter in such keywords as E-tailers, on-line retailers, or retail Web sites, they are quickly offered a vast list of sites to chose from that reveal a host of different approaches. At one end of the spectrum are basic sites that are merely a page or two long and are no more than advertisements that feature a brick-and-mortar operation and the addresses of its outlets. Some sites are more complex and offer a number of pages that tell about the company, its products and services, locations of venues, and some items that may be bought on-line.

At the other end of the spectrum are sites that feature a multitude of pages. These are generally the Web sites of the major department stores that engage in multichannel retailing to reach as many prospective customers as possible, chain organizations that also merchandise their goods via multichannel marketing, and **Web site-only companies** that use the Internet as their only means of selling to the consumer.

Web site-only merchants, are constantly changing their sites in terms of size, scope, appearance, and product offerings, much as the brick-and-mortar merchants refine their instore premises. They offer a timeliness to their E-commerce outlets and give the impression to their targeted audiences that they are always seeking ways to better serve them.

They maximize their Web site effectiveness by either employing in-house designers who work exclusively for the company or using outside specialists who are on retainer to make the necessary changes and upgrades the merchants deem appropriate.

Classifications of E-Tailers

When it comes to apparel and accessories and fashions for the home, the largest types of E-tailer Web sites are divisions of brick-and-mortar operations; this category is followed by catalog companies with Web site outlets, and then Web site only merchants. The first two classifications follow the multichannel approach, using more than one type of outlet to interface with their markets. The latter exclusively uses the Internet as a means of shopper interaction.

BRICK-AND-MORTAR ORGANIZATIONS

Ranging from the fashion elite such as Nordstrom, Neiman Marcus, and Saks Fifth Avenue to the value-oriented retail giants such as Target and Wal-Mart, with a host of other stores falling somewhere in between, the Internet has become an adjunct to their businesses that were primarily on-site based. Recognizing that their trading areas are significantly larger than the geographical locales served by their stores, they have expanded through E-tailing. This methodology allows fashion merchants to reach consumers who were once served only when they opened a new store or through their catalog divisions. Although catalogs do reach consumers in trading areas not served by the stores, they are not considered as efficient as Web sites. For example, a catalog takes a significant amount of time to produce—often as much as three months—before it reaches the customer. In contrast, updating a Web site with new items for sale, price changes of current offerings, and the like can be accomplished in a matter of hours.

Those brick-and-mortar operations that reach their customers though their stores, catalogs and E-tail Web sites are known collectively as **multichannel retailers**. They believe that by using all three methods, they can reach a broader base of customers.

Fashion Retailing Spotlights

CHICO'S

When Chico's opened its first brick-and-mortar unit on Sanibel Island, FL, it was a very small operation in which Marvin and Helene Gralnick sold sweaters that they bought on a trip to Medico. The retailer's modest success soon gave way to a greater presence when the owners added other pieces of apparel and some unique furnishings for the home to their product offerings. Now, twenty-one years later, Chico's has grown into a major retail operation, with stores that number close to one hundred units.

Today, Chico's focus has changed to one of marketing its exclusive fashion collection to a sorely neglected segment of the American population—the mature woman who has money to spend but few places that cater exclusively to her. A focus on comfort has enabled the retailer to deliver unique sizing to its clientele. Instead of the traditional range of misses sizes, which usually begins at size 8 and often goes up to size 18, Chico's has adopted a system that features sizes 0 through 3, with 0 properly fitting those who wear 1 for "small", 2 for "medium", and 3 for those who wear "large." It is the versatility of the designs that make this approach to sizing possible.

In addition to the comfort level they offer, Chico's collections are exclusive to this retailer in its stores, catalogs, and on-line. In terms of multichannel distribution, Chico's continues to focus its expansion on both its on-site and off-site ventures. For women who have neither the time nor the desire to visit the stores, the catalogs and Web site offers the same products, but in the comfort of the home or office. While this type of merchandising is not unique to Chico's, the company's dedication to comfort and easy wear has made its offerings simple to buy without the need to shop in person. The ease of shopping off-site is further realized because the products do not require an exact fit. By offering a host of stretch materials, elastic-waist pants and skirts, and unconstructed jackets, Chico's is able to keep returns to a minimum.

Whether they are shopping on-site or off-site, shoppers are treated to special savings through the Chico's "Passport Club." Members receive such benefits as a 5 percent discount on all purchases, birthday bonuses, free shipping, discounts on gift certificates, incentives to introduce new members, easy check-writing privileges, and exclusive sales.

Chico's customers who frequent the stores are treated to personalized shopping, a phenomenon that generally does not exist in any but the most exclusive shops. Sales associates help customers not only with merchandise selection, but also with building and accessorizing their wardrobes. Customers tend to return again and again to take advantage of this unusual service, which otherwise just about disappeared from the retail scene.

With its own product development team headquartered in Fort Meyers, Florida, Chico's is able to design and develop new styles every week and keep its retail outlets stocked with the latest fashions. This, too, is an unusual occurrence in fashion design. Most other collections have been globally outsourced, making quick acquisition impossible.

With its attention to its clientele, whether they are on-site or off-site shoppers, Chico's is realizing unparallel success in this highly competitive business arena.

As an alternative to shopping in Chico's stores, customers can log on to its Web site. (*Courtesy of Chico's Retail Services, Inc.*)

TABLE 2.1 The Top Ten Retailers with Internet Websites*

Rank	Company	Selling Channels
1	Wal-Mart	Bricks and clicks
2	Sears	Multichannel
3	Target	Multichannel
4	Kmart	Bricks and clicks
5	JCPenney	Multichannel
6	Federated Department Stores**	Multichannel
7	May Department Stores**	Multichannel
8	Gap**	Bricks and clicks
9	TJX**	Bricks and clicks
10	Limited***	Multichannel

Note: Excerpted from *Stores Magazine,* July 2003.

*Those listed are either totally fashion merchants or have a portion of their mixes devoted to fashion products.
**These corporations have numerous divisions under different names.
*** Some of the companies within the chain are multichannel, while others are primarily bricks-and-clicks oriented.

Another road merchants can take to maximize their ability to reach shoppers is through dual channels: brick-and-mortar and E-tailing; these are known as **bricks-and-clicks retailers**. The *bricks* refer to the on-site stores they operate, and the *clicks* to the use of the computer mouse to log on, go to a Web site, and make merchandise selections. Many fashion-oriented chains such as The Gap and the TJX Corporation have embraced this means of customer interaction because they believe they can more effectively communicate by E-tailing than with catalogs.

CATALOGS WITH E-TAILING DIVISIONS

The route that some merchants with fashion orientations have successfully utilized is direct marketing via catalogs. Among them are Horchow, a division of Neiman Marcus; Spiegel; and Lillian Vernon. Selling a variety of products from the pages of their numerous catalogs, they continue to play an important role in off-site retailing.

In this age of E-commerce, many of these same merchants have opted to expand their businesses via Internet Web sites and choose to stay in touch with consumers exclusively via off-site ventures. A great number of these off-site operations are represented in a **virtual catalog.** When consumers access AOL, for example, they are offered entry to its Shop@AOL Web site, which features some of the merchandise on its partner Web sites such as Gap.com and Bluefly.Com. These offer a host of items from these and other vendors. Shoppers do not have to go to all of the specific catalog Web sites, so this convenience makes shopping easier. There are several of these virtual catalogs on AOL that offer consumers a look at the particular merchandise classification they want. For fashion merchandise shoppers, one such catalog is called "The Basics"; it offers a variety of apparel suggestions along with the accessories that will make the outfit complete.

Shoppers of all ages, ranging from young to old, use the off-site means of purchasing. The latter group, accustomed to catalogs but once fearful of the computer, like the convenience of buying without the need to go to the store, and they are purchasing on-line in ever-increasing numbers.

Most of the catalogers do operate outlet stores to dispose of their slow sellers, but their primary means of selling regular merchandise is off-site.

CABLE SHOPPING ORGANIZATIONS WITH INTERNET ACCESS

Yet another retailing classification that has taken to the Internet are the **cable shopping programs**. While their primary selling avenue is via "television shows," the major players in this field have expanded their businesses to include E-tailing. They eventually came to recognize that there was a large consumer market that was more apt to buy on the Internet than through television. HSN and QVC, for example, have entered this arena with offerings that

Fashion Retailing Spotlights

LILLIAN VERNON

Lillian was an escapee from the Nazis, emigrating to the United States with her family in 1937. As a housewife expecting her first child in 1952, she started her own small mail-order business in the kitchen of her apartment, using the $2,000 she had received as wedding gifts for her initial investment. Her idea was to sell purses that she would personalize free of charge. To attract attention to the product, she spent $495 on an ad in *Seventeen Magazine,* which resulted in $32,000 in sales. She quickly placed larger wholesale orders for the purses to meet the demand. This humble beginning launched what is one of today's major catalog businesses.

In 1954 she named the company Lillian Vernon after her own first name and the city in which she started the operation, Mount Vernon. She soon rented a small storefront to serve as her warehouse, a building next door into which she expanded her monogramming business, and another across the street to serve as her shipping center. In addition to manufacturing products for her own product line, she entered in contractual agreements with companies that included cosmetics giants. Max Factor, Elizabeth Arden, Avon, and Revlon.

Her first entry in the catalog business was a sixteen-page black-and-white publication that was mailed to 125,000 consumers. She expanded her line to include accessories such as personalized combs, blazer buttons, collar pins, and cuff links. As sales increased, the catalogs grew bigger and bigger, featuring new fashion items. To make her merchandise mix even more exciting, she opened a European buying office, and added merchandise from many countries.

To dispose of slow sellers, Lillian opened a series of outlets where merchandise could be sold quickly at rock-bottom prices. Over the years, she developed eight different entries for her catalog business: Lillian Vernon, Rue de France, Christmas Memories, Favorites, Lilly's Kids, Sales and Bargains, Lillian Vernon Gardening, and Personalized Gifts. The catalogs average over 96 pages with more than 700 products in every edition. The average product retails at $28.50; the average order is $56.50.

Going strong as a catalog retailer, the company decided there was opportunity for expansion with the addition of an Internet Web site. In 1995, Lillian Vernon added E-tailing to her successful venture. Not only can shoppers order from the vast merchandise offerings found on the Web site but they can also place orders from the pages of the catalogs that are mailed to their homes. A customer simply enters the nine-digit numbers of the catalog items, clicks to add each desired product to the "cart," indicates which should be personalized, and places the order.

By making both means of off-site ordering available, Lillian Vernon has made the perfect marriage between cataloging and E-tailing and has significantly increased overall sales.

QVC was initially planned as a home shopping program for consumers.
(Courtesy of QVC, Inc.)

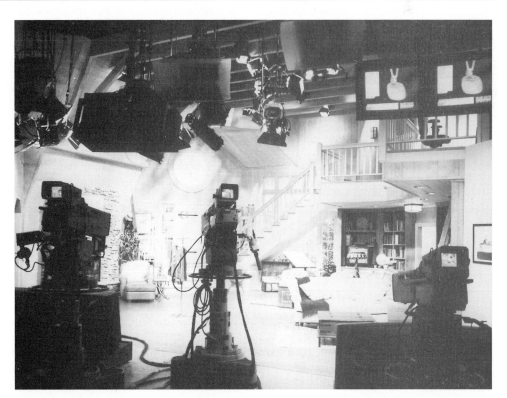

Shopping Cart | My Account | Order Status | Customer Service

QVC
QUALITY. VALUE. CONVENIENCE.

Accessories & Shoes | Apparel | Beauty | Clearance | Cooking & Dining | Electronics | Gifts & Flowers

Home Accents & Furnishings | Home Improvement | Jewelry | Sports & Fitness | Toys, Crafts & Leisure | All Categories

Search for [　　　] **Go** More Search Options

- 24-Hour Product Review
- Today's Special Value
- Item On-Air
- Watch QVCTV LIVE
- Program Guide

Accessories & Shoes
- Handbags
- View All

Apparel
- Intimates
- Maternity NEW!
- Outerwear
- View All

Beauty

Clearance

Cooking & Dining
- Food
- Kitchen Electrics
- View All

Electronics
- Cameras
- Computers
- Televisions
- View All

Gifts & Flowers

Home Accents & Furnishings
- Art Gallery
- Furniture
- View All

Home Improvement
- Lawn & Garden
- View All

Jewelry
- Gemstone
- Watches
- View All

Sports & Fitness

Toys, Crafts & Leisure
- Books NEW!
- Movies & Music NEW!
- Luggage
- View All

View All Categories

classic **cookware,** modern **convenience**

PRE-SEASONED!

Available For 2 Easy Pays.

Lodge Logic Cast-iron 3-quart Combo Cooker Set

Retail Value $58.75
$34.52 ONE-DAY-ONLY Price

holiday hosting

Shop now to get everything you need for holiday cooking and baking.

wearable art

Order more than one item from renowned designer Bob Mackie and save on standard S&H!

Lowest Prices Ever!
SAVE on select items for a limited time.

Denim & Co.® Jacket, Bob Mackie Jacket and Pants, and more.
Today's Offers.

star wars trilogy

Attention, Jedi Knights: The original trilogy is now on DVD – find cool collectibles, too!

halloween is coming

Fun Halloween accents and more turn your home into a "haunted" house...

new release tuesday

Today's CDs & DVDs: *Star Wars Trilogy, The Very Best of the O'Franken Factor*, and more.

what's new

- Just Added Clearance
- New Additions
- New This Week
- New This Month

Sign up for valuable QVC.com E-Mail Services

Receive order confirmations or E-Newsletters in your areas of interest. Just click below to sign up.

Sign Me Up!

QVC Information & More...

- AEIOU Pant Guide
- Bulletin Board
- Business Gifts
- Careers

- Corporate
- Customer Service
- Meet the Hosts
- Site Map

- Win a Trip to Monaco

Apply for a QCard® now!

Easy Returns Click for Details

Shop with Confidence

BizRate.com customer certified

Order Anytime Online or By Phone: 1-888-345-5788. (TDD: 1-800-544-3316)

QVC Privacy Statement • QVC General Terms and Conditions of Use • Product Recall Information
Manufacturer's Product Warranty Information

For those who prefer on-line purchasing, QVC has added a Web site.
(Courtesy of QVC, Inc.)

are as diverse as those seen on their cable shows. Of course, the three-dimensional aspect of merchandising is lost in this medium, but despite this, a sufficient number of sales are accomplished.

The cable shopping programs will be more fully examined later in this chapter.

WEB SITE-ONLY MERCHANTS

While the vast majority of Web site-only company sales are for books, CDs, computers, software, and office supplies, more fashion merchandise is starting to be sold by these companies.

For example, apparel and accessories are becoming more and more important in the merchandise assortment that Amazon.com offers. The second most important Internet retailer in terms of sales volume, the company reported that during the 2002 Christmas holiday season, these merchandise classifications were "the stars in cyberspace." Amazon attributed the increase in apparel sales to the growing share of women shopping on-line, about 60 percent, and the increases in minority users.

According to a report released by Forrester Research, "apparel will become the largest on-line category in retail sales by 2007, a $22.5 billion business."

Designoutlet.Com is another Web site—only company to enter the consumer market. With merchandise sporting such labels as Dolce & Gabana, Ralph Lauren, and Fendi, Designoutlet.com has made itself a very important resource for shoppers who prefer designer collections but can only buy them if the prices are attractive. This Web site offers just that: a wealth of different designer collections but at prices that are significantly lower than those at the traditional brick-and-mortar operations. As a result of Designoutlet.com's success, others have joined the high-fashion Internet bandwagon.

One of the more recent entries into fashion retailing has been eBay.com. Once only selling items by means of auction, eBay now has entered another phase of merchandising by selling at fixed prices.

E-tailing Interactivity

The nature of traditional retailing, specifically in the brick-and-mortar operations, offers shoppers such advantages as the chance to try on clothes and enjoy the attentions of knowledgeable sales staff. This is particularly important to many who are seeking fashion merchandise. Consumers may immediately see if the item fits and satisfies their needs. Personal shoppers are also generally available to assist in the selection of suitable merchandise.

Fashion Retailing Spotlights

EBAY

Founded by Pierre Omidyar in 1995, eBay has become the largest consumer site on the Internet. Originally an *auction-only Web site,* the company decided that the time was ripe in 2001 to launch apparel as a home-page category. In 2003, apparel became a $415 million business, with expected sales to reach more than $1 billion in 2004.

Originally, eBay's apparel listings were primarily used products that their owners no longer needed. They placed them on eBay to be auctioned to the highest bidder. Today, 52 percent of the products sold on eBay are new and include those that have become obsolete to their producers or are overstocks and returns, and they are not sold via action but at a fixed price. This method of merchandising apparel is so popular that the demand is greater than the supply, and eBay is constantly reaching out to retailers and liquidators, along with manufacturers, to bring greater amounts of high-quality fashion merchandise to its marketplace. eBay's appeal can best be appreciated by the fact that it operates in twenty-seven countries, serving as a worldwide seller. In fact, 26 percent of the company's revenues come from overseas. Its largest markets are in Germany, followed by Canada and South Korea.

With Nike shoes selling at the rate of a pair every two seconds, a Coach handbag every four minutes, and a pair of Levi's jeans every eleven and a half minutes, and 34,000 keyword searches made for Prada and 25,000 for Burberry every day it is obvious that consumers have embraced this distribution channel for value-priced branded fashion.

To provide similar services to the on-line shopper, more and more Internet Web sites feature shopping consultants and customer service representatives to answer any questions the customer might have. One of the leaders in this area is LandsEnd.com. Using LandsEnd's **on-line interactvity** service, a shopper may have any questions immediatly answered by merely typing them in. The other communication device enables the shopper to communicate directly with a company representative via a voice telephone connection.

Another new feature that Internet fashion retailers are using is known as the **virtual try-on**. As a leader in the latest Internet technology, Lands End was one of the first to provide this customer service. At its site, and others such as Macys.Com, the female shopper is able to create a "model" that features her specific measurements by inputting the requested information. After creating the model, the shopper may browse through the companies' offerings and "try on" whatever seems most appealing. If she is satisfied, she makes the purchase in the same manner as on other Web sites by being directed to a shopping cart or checking the page to finish the transaction. This considerably reduces the guesswork that is prevalent with traditional Web sites and catalogs, resulting in fewer merchandise returns.

Security Problems

One of the problems that continues to plague Internet merchants and shoppers alike is the potential for fraud. Many consumers who want to purchase on the Internet are reluctant to do so because of their concerns. There has been a great deal of publicity about *hackers* who have either broken into sites and stolen individual credit card numbers or who have gone as far as stealing the identities of people shopping on-line. According to the numerous statistical reports regarding these problems, the losses caused by fraud or the fear of fraud run to about 10 percent of on-line sales.

An organization that records Internet fraud information and produces reports concerning the problem is the National Fraud Information Center (NFIC), a nonprofit that can be reached at **www.fraud.org**. In a report based upon 2002 Internet sales, NFIC reported that the total overall loss for the first half of the year was $7,209,196—a significant increase over previous years. The primary culprits were on-line auction companies, with 87 percent of the overall frauds. The ages of the victims ranged from less than 20 years old to over 70, with the majority of victims in the 20-to-49 age group. This group, the major users of Internet shopping, accounted for 79 percent of the fraudulent transactions. The NFIC report also noted that California and New York were the leading locations for this type of fraud.

MINIMIZING THE RISKS

"Let the Buyer Beware," is a statement that is echoed around the world wherever consumers are purchasing from merchants. Buying on the Internet has made the warning even more important. When shoppers enter a store, they are somewhat able to assess the company and the products that are available for sale. On the Internet, this is more difficult. Web site screens are often replete with colorful graphics and tempting offerings, but the reliability of the seller is sometimes difficult to ascertain.

Numerous agencies are available on-line to help consumers educate themselves in terms of Internet purchasing. Many are nonprofits that offer their services free of charge to the consumer. One such informational site is made available by the American Bar Association at **www.safeshopping.org**. It helps cyber-shoppers to evaluate the sources from which they might purchase and tells them how to reduce the potential for fraud. On its Web site, it offers a shopping tip list that the organization suggests consumers refer to when shopping on-line. A summary of this list can be seen in Figure 2.1.

TECHNOLOGY TO REDUCE FRAUD

To counteract this concern, a variety of technologies have been introduced that reduce the fraudulent activity and make users more secure about Internet shopping. Many marketing research companies have expanded their areas of expertise to help consumers feel more comfortable and secure when shopping on-line.

SHOPPING TIP LIST*

Trust your instincts. If you don't feel comfortable buying or bidding for a particular product, you shouldn't do it.

Be knowledgeable about Web-based auctions. Take special care to become familiar not only with the rules and policies of the auction site itself but with such legal terminology concerning warranties, refund policies and so on, of the seller's items.

Double check pricing. Be suspicious of prices that seem to be too low. You might want to comparison shop.

Find and read privacy policy. Carefully review the information the seller is gathering from you and how the information will be used. If the site doesn't have a privacy policy, you may want to reconsider the purchase.

Review return, refund, shipping, and handling policies and other legal terms. If these policies are not readily available, you should be contacted via e-mail or telephone as to where you can find them on the site, or they should be provided in writing.

Check that the Internet connections are secure. Before placing the order and providing payment information, check the icons and software programs to make sure that security software is in place.

Use the safest way to pay on the Internet. A credit card is the best method.

Print the terms. Print out the terms and the date of the transaction and include conditions, warranties, item description, company information, and e-mail addresses that indicate confirmation. Save it until you receive your purchase and are satisfied with it.

Insure the safe delivery of the item. If no one will be at home to receive the shipment, ask for it to be delivered to an office or other place where you can receive it.

Inspect your purchase. Examine the merchandise immediately, and if you see any problems contact the seller at once. If a refund is warranted notify the seller in writing.

* Many aspects of this summary are spelled out in detail on separate areas of **www.safeshopping.org**.

Figure 2.1 How to shop safely when shopping on the Internet.

One of the leaders in this technology is CyberSource, a California-based company that helps merchants to screen out fraudulent transactions by calculating risk factors. Cyber source investigates 150 features of a potential sale to determine the relative risk involved. It is an extremely fast process that takes usually less than ten seconds and has resulted in losses of less than 1 per cent.

Biowebserver.com developed something unique in preventing fraud and securing network access, called **biometric detection**. Instead of using passwords and PIN codes, which users often forget, Biowebserver uses biometric databases to establish the real identity of the person at the other end of a Web browser. The concept of biometrics is based upon human characteristics such as fingerprints and voice patterns to identify potential users. The company's Web site. **www.biowebserver.com** offers a complete explanation to vendors and consumers.

Digital Envoy's NetActuity geo-intelligence identifies the location of Web site visitors down to the city level, worldwide, allowing providers of security and fraud-prevention solutions to harness this information and add another checkpoint. Interested parties can visit the company Web site at **www.digitalenvoy.net/security**, to learn more about the concept.

A wealth of fraud technology can be accessed by logging onto such servers as askjeeves. com, aol.com, and google.com.

CATALOGS

In the early 1900s, the second-most read book after the Bible was the Sears catalog! Consumers from every part of the country purchased everything from apparel and housewares to animal feed and tractors from this vast merchandise catalog. Although Sears stopped publishing the "big book" because of its decline in profitability, the company does continue to offer small specialty catalogs such as HomeCenter, ShowPlace, and Big & Tall, each of which brings a significant volume of sales to the company.

The demise of the Sear's-type **big book catalogs** has not dampened the potential for mail and telephone ordering. In fact today, catalog sales have reached heights that were once unimaginable by retailers.

Instead of the mammoth offerings of companies such as Sears and Montgomery Ward, whose editions were distributed semiannually, today's catalogs are considerably smaller and are sent to consumers as often as twelve times a year.

The companies that market them include the "pure" catalog companies—those that primarily sell via direct marketing publications—such as Spiegel, Horchow, and Fingerhut, that have some of their focus on E-tailing and a small amount via their outlet stores, in which they dispose of slow sellers. The others are the brick-and-mortar operations' catalog divisions; their offerings generally are representative of their stores' merchandise assortment, but they sometimes sell products that are found only in their catalogs.

The competition in catalog retailing necessitates careful attention to the physical format of the publications as well as to the merchandise mixes that are offered. Unlike most brick-and-mortar retailers, which are in clearly defined trading areas, the catalogs, by virtue of the fact that they reach out to many geographical areas, often market goods that have "boundless" appeal.

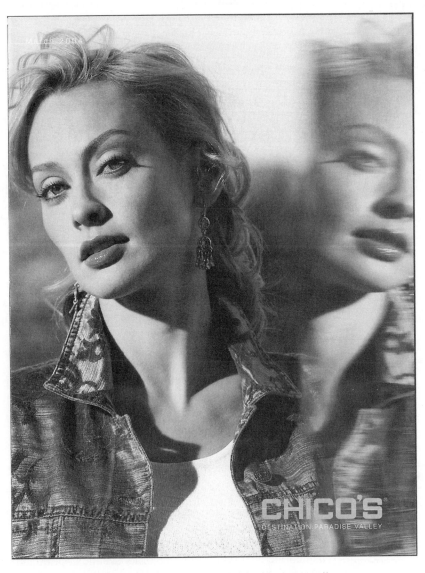

Catalog shopping has significantly increased sales for many brick-and-mortar retailers.
(Courtesy of Chico's Retail Services, Inc.)

<div style="border:1px solid">

Fashion Retailing Spotlights

PATAGONIA

It's hard to tell if a catalog from Patagonia is a magazine or a booklet selling merchandise. The quality of the photography and artwork is unlike that of most other catalogs. The photographs are taken by professionals, who receive photo credits, which is atypical of catalog photography, and makes them more exciting for the readers. The catalogs cover every outdoor venue, from the red rocks of Arizona to the deep waters of Alaska.

As purveyors of outdoor clothing, technical apparel, and gear, Patagonia is as committed to global environments as it is to the products it markets, as is apparent from a first glance. Since 1990, the company has undertaken field studies that have offered intense glimpses of nature's front lines through the eyes of athletes, travelers, and adventurers, and the catologs include essays about these adventures that feature the author's byline, another anomaly in catalog presentations.

The stories center upon mountain climbing, hiking through the world's rainforests, cycling through mountainous terrains, environmental concerns such as toxic dumps and acid rain, and nature. Surrounding each of these adventurous stories are carefully laid out offerings of the merchandise to which the articles relate. Next to an essay on mountain climbing might be the appropriate apparel for such an undertaking. Not only are the pictured items featured along with their colors, prices, and available sizes but they are accompanied by a complete explanation of the materials used to make them and their advantages to the potential purchaser. Other areas of interest in these quarterly catalogs include graphics that represent the proper attire for specific activities, and tips on such things as how to achieve maximum warmth in extreme cold.

The popularity of the products offered by Patagonia has crossed over into "fashion" dressing. Those who do not participate in the adventurous experiences featured in the catalog are often tempted to buy the clothing for everyday wear. In fact, this segment of the company's market has soared.

While the primary tool for reaching its targeted markets is the catalog, Patagonia has recognized that the Internet is another important channel for selling its merchandise. By logging onto its Web site, **www.patagonia. com**, shoppers are treated to the same product lines and stories that are featured in its print publication. Rounding out Patagonia's marketing strategy is making its merchandise available in its own stores, many of which are outlets, and in other retail operations with whom it is affiliated. Patagonia has made certain it is a full multichannel retailer.

Not leaving any method of merchandise purchasing to chance, the catalog features the Patagonia Web site along with a list of the addresses of all of the brick-and-mortar operations where Patagonia goods may be found.

</div>

Creating a Catalog

While the merchandise is the chief offering in any catalog, its design is of paramount importance to assure that it will tempt the shopper to look through its pages. With many households receiving as many as a dozen catalogs each week, many people often dispose of them before reading them. The key to catching the receiver's eye is often the excitement generated by the cover, which will hopefully motivate the reader to further inspect the merchandise offered for sale inside.

In addition to the uniqueness of the covers and the page layouts displaying the merchandise, some catalogs offer more than just the products they have available for sale. Some feature articles such as those found in consumer magazines. One such catalog is from Patagonia, a company that markets outdoor-related products.

Benefits of Catalog Shopping

The popularity of the catalog is based upon a number of advantages it affords the consumer. They include:

Convenience. With more and more consumers having less and less time to shop in stores, catalog's allow them to satisfy their merchandise needs at any time and to avoid the long lines typical in many stores and the time it takes to find the desired merchandise.

Merchandise Assortment. The number of offerings available in catalogs continue to increase, and some of the featured products are available only through the catalog. Victoria's Secret, for example, markets sportswear in its catalogs, whereas its stores generally restrict their offerings to innerwear. Home furnishing giants such as Crate & Barrel and Pottery Barn also use their catalogs to sell goods that are available only through these means.

Visual Presentation. Today's catalogs are no longer the lackluster productions they were in the past. The merchandise is accurately depicted through excellent photography that makes shoppers feel more confident about what they are purchasing.

Customer Returns. If buyers are not happy with the products, they can take advantage of generous return policies. Most companies will pay for the shipping of returned merchandise, so there is no expense for unwanted products.

Order Simplification. Order forms often accompanied by postage-free envelopes, make ordering extremely simple. For shoppers who prefer telephone ordering, order takers are often available around the clock and at toll-free numbers.

Classification of Catalog Companies

There are three types of retail organizations that use catalogs to sell merchandise: Catalog-only retailers, brick-and-mortar catalog divisions, and catalogers with on-site venues. Most in the first category have expanded their operations through Internet Web sites, but the bulk of their business comes from the catalogs. The second group, which uses the catalog as an adjunct sales tool to its in-store operations, reaps the greatest proportion of sales from store shoppers. The last group stocks merchandise in a limited number of stores.

CATALOG-ONLY RETAILERS

Companies such as Lillian Vernon, Spiegel, and Horchow primarily sell their products through sales books or catalogs. Although they each have ventured into electronic retailing, they are still considered to be **catalog-only retailers** because currently, sales from their mail order books far surpass those that come from the Internet. It is difficult to tell if this will continue to be the case.

Fashion Retailing Spotlights

HORCHOW

In 1971, Roger Horchow created a retailing empire without opening a single store. Unlike the numerous department store organizations that added catalogs to their existing brick-and-mortar operations, his venture was the first without stores. He launched the Horchow Collection, which featured an assortment of unique decorative items from around the world. His distinctive taste and eye for quality quickly caught the attention of those interested in upscale home furnishings and soon made him one of the more important catalogers in the United States.

His popularity was due in part to the customer service he provided for the off-site shopper. Satisfaction was guaranteed, with liberal return privileges always available. He is also credited with pioneering the use of toll-free telephone numbers for placing catalog orders. Year after year, the catalog increased in size as did the amount of sales it produced.

In 1988, Horchow became part of the Neiman Marcus Group. His distinctive quality merchandise perfectly dovetailed with the collections sold by Neiman Marcus stores, making it the ideal retailing marriage.

Today's Horchow offerings have been expanded into special catalogs, with each featuring a specialized range of products. In addition to the original Horchow Collection catalog, there are the highly successful Horchow Home, Horchow Fine Linen, and Horchow Garden publications. Each has been augmented by the Internet, by which customers can place orders for everything the catalogs have to offer.

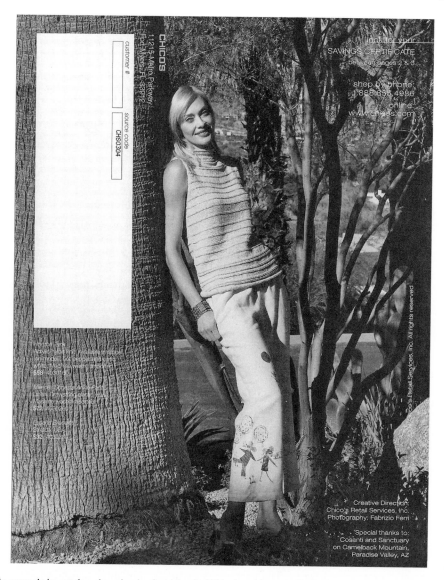

Chico's expands its catalog shopping by featuring its Web site address on the back cover of its sales booklets. *(Courtesy of Chico's Retail Services, Inc.)*

BRICK-AND-MORTAR CATALOG DIVISIONS

Just about every major store organization has a catalog division. Leading the way are the full-line and specialized department stores, with chains close behind. Typically the catalogs do not offer all the products available in the stores' on-site units, but more and more items are being included into these sales booklets as the stores realize more sales volumes with this method. Some catalogs such as those published by Victoria's Secret and Pottery Barn even feature merchandise that is not on the stores' selling floors.

Originally, the catalogs were specifically geared toward special selling periods, such as Christmas or Easter. Today, however, with catalog purchasing reaching all-time highs, retailers are sending out their sales booklets more often. Companies such as Bloomingdale's, Macy's, and Marshall Field's are constantly preparing new catalogs that reach consumers as often as twenty-five times a year.

The nature of shopping today has made it necessary for organizations that are primarily on-site operations to expand their catalog divisions. Although in-store shopping generally results in higher average sales, the time constraints that today's consumers face has made catalog selling inevitable. The goal of using catalogs for many of these brick-and-mortar companies is to gain a new customer market, and to tempt catalog shoppers to visit their stores.

CATALOGERS WITH ON-SITE VENUES

Some companies that are essentially catalog operations also have one or more retail outlets. Many are outlet stores in which slow catalog sellers and season leftovers are sold at greatly reduced prices. Others are traditional stores in which the catalog offerings are sold on-site. Still others are retailers, such as J. Crew, that began as catalog operations but have expanded their brick-and-mortar venues.

By entering the on-site arena, these companies are often able to feature a broader mix of merchandise than they show in their catalogs and are also able to reach consumers not interested in catalog shopping.

One of the more exciting catalog operations is American Girl. Its catalogs have appealed to little girls and their families since 1986. In 1998, the company decided to enter the brick-and-mortar arena by opening American Girl Place in Chicago. It quickly became a showplace where girls could bring their dolls and take part in teas, lunches, and special live presentations. Of course, the store is chock full of every type of doll and accessories produced by the company. The purpose of this on-site venture is two-fold: first, it provides a place where those familiar with the catalog may come and see the entire depth and breadth of the product line, and second, it helps to increase the size and scope of the mailing list for visitors who are not familiar with the catalog. American Girl Place has become a win-win situation for the company.

J. Jill, once exclusively a catalog organization specializing in women's apparel, has entered another phase of its business, The company has embarked upon an in-store expansion campaign that has produced sales that rival its mail-order operation.

Internet Catalogs

The effectiveness of catalog retailing is maximized when merchants dovetail their offerings through both publications and on-line Web sites. Recognizing that many consumers prefer shopping on the Internet to ordering from catalogs, many merchants have developed Web sites, called **Internet catalogs** that feature the same products as the sales books they send to customers.

Shoppers can either go directly to a retailer's Web site to see its catalog offerings or log on to such sites as **www.catalogs.google.com**, where they will find a wealth of publications from different retailers that sell merchandise directly to the consumer. The retailers are categorized according to product classifications such as apparel, accessories, and home furnishings. The user accesses the area of interest, and in a matter of seconds, an alphabetized list is displayed featuring retail catalogs for that merchandise. For example, there are 303 apparel Web sites; accessories has 39, and footwear has 48.

The Internet catalogs are available by nationally known names such as J. Crew and L.L. Bean as well as a host of lesser established companies such as 220 Hickory for women's wear, 14K-9 for jewelry, and A.P.C. for men's and women's clothing. Once shoppers examine a sampling of the catalog covers, they can access a merchant's Web site and see the entire collection on-screen. Many of these Web sites also offer noncurrent catalogs for shoppers wishing to locate something previously offered for sale.

One of the advantages of Internet cataloging for consumers is that they do not have to keep the publications. An advantage for the smaller company is the ability to reach countless consumers without incurring the expense of mailing. Once shoppers order via the Internet, they will automatically receive future on-line editions and become part of the company's mailing list.

HOME SHOPPING CABLE PROGRAMMING

Another means of selling goods to consumers off-site is by cable television programming available in every part of the country. Also known as **televending, electronic merchandising,** or **video shopping,** it is a multibillion dollar industry that is a comparative infant in the

Supermodel Carol Alt is featured on QVC discussing her line of beauty products with the program's host, Lisa Mason.
(Courtesy of QVC, Inc.)

retailing game, with sales that keep increasing at unparalleled rates each year. At virtually any hour of the day or night, viewers can sit back and shop in the convenience of their homes or wherever television receivers are available.

The product classifications include everything from apparel to home furnishings and are presented by hosts and visiting celebrities. The selling power of the celebrity is enormous. Actress Suzanne Somers, for example, drew 2,000 women on a Bahamas cruise in 2002 that was marketed on HSN, one of the larger shopping programs. It was billed as the world's largest floating pajama party and featured a live broadcast from sea. Since 1992, Somers has represented HSN with exercise equipment, diet products, jewelry, and pajamas. Her pitches have resulted in multimillion dollar sales.

The largest of the home shopping programs is QVC, the subject of the following spotlight.

Fashion Retailing Spotlights

QVC

QVC was founded in June, 1986, by Joseph Segal, and began operations in November of that year. Today, it broadcasts live, 24 hours a day, 364 days a year, and in the United States introduces approximately 250 new products every week to viewers in 85 million homes. It reaches 96 percent of homes with cable access and 21.4 million homes with satellite access. In addition to its American audience, it reaches many global markets such as the United Kingdom, with 13 million households; Germany, with 35 million; and Japan, with 12 million. Its employees number more than 15,000 throughout the world.

(continued)

Producing the QVC shopping program involves directors who plan the on-air offerings.
(Courtesy of QVC, Inc.)

The company is based in West Chester, PA, with additional U.S. telecommunications centers in San Antonio, TX; Port St. Lucie, FL; and Chesapeake, VA. The merchandise is shipped from distribution centers in Lancaster and West Chester, PA; Suffolk, VA; and Rocky Mount, NC.

The following facts demonstrate the enormity of the company:

- Sales in 2003 reached more than $4.8 billion.
- Worldwide, it received more than 179 million phone calls and shipped more than 120 million units in 2003.
- An average of 42,000 new customers are added to the client base each week.
- More than one hundred buyers search the globe for its merchandise mix.
- It is one of the world's largest purveyors of gold jewelry, sales of which currently account for approximately 29 percent of programming time.
- The distribution centers cover more than 4.6 million square feet, or approximately 102 football fields, goal line to goal line.

With the popularity of the Internet, the company established a Web site division on which virtually every item seen on television is available to the shopper. In addition, the on-line offerings are sometime greater than those found on the television broadcast.

The merchandise is selected on the basis of uniqueness, ease of demonstration, timeliness, and appeal. To make each item visually appealing, QVC employs a full-time staff of stage designers, technicians, and stylists. The numerous hosts of the show are the keys to selling the merchandise. They travel the world to research products, and they explain and demonstrate every item in an entertaining, informative, and friendly presentation, so that viewers feel that a friend is showing them the products, and helping them make informed purchases.

The success of these programs is due, in part, to their claims of selling items at lower prices than those charged by traditional retailers, and their ability to motivate shoppers to purchase items quickly. By using sidebars that tell how many of the displayed items remain shoppers are often inspired to buy them. Interactivity is also another feature that makes televending a viable selling tool. It enables callers to speak with the hosts to have their questions answered, many of which are shared by other viewers, who are able to listen to the conversation. Once the host answers the question satisfactorily, viewers are more likely to buy the item. Also typical of these formats are the use of trivia games and ticket drawings so that viewers can win featured items.

In spite of the success of television home shopping, the Better Business Bureau has concluded that the amount of savings advertised by these companies may not always be a true reflection of the marketplace and that claims are frequently exaggerated. The coupling of the television show with on-line availability, however, has helped make this industry reach new heights every year.

TRENDS IN OFF-SITE RETAILING

Because of growing consumer acceptance of off-site retailing, merchants are utilizing this method in greater numbers than ever before. Fashion merchandise, in particular, has been a growing product classification in this arena. The future of E-tailing, catalogs, and home shopping on television, is extremely positive. The trends described in the following sections are likely to occur during the next few years.

Increase in Small Retailer E-tailing

Although the giants in the retailing industry are the major participants in electronic retailing, increasing numbers of small operations will be embracing this channel of distribution for fashion merchandise. Expenses for developing, maintaining, and listing Web sites as part of search engines such as askjeeves.com and google.com are fairly low, making this a viable method for smaller retailers to reach the consumer market.

Sophistication of Web Sites

Initially, Web sites were simple and limited to just a few pages, but their size and sophistication has continued to grow. The next generation of the Internet Web sites will feature more products, a better range of coloration, and interactivity components that will make them a greater revenue-producing medium.

Fashion Merchandise Availability on Nontraditional Web Sites

With Web sites such as Amazon.com and eBay.com adding fashion merchandise to their offerings and achieving record sales for these classifications, others in the field will be adding fashion products to their mixes. For example, retailers that previously restricted their assortments to computer products or office supplies may enter this product arena on the theory that shoppers visiting a Web site, regardless of their original intent, will often access other parts of the Web site to learn about different products.

Catalog Expansion

The enormous increase in catalog shopping will result in more fashion merchants using this outlet in the future, and those who are already in the business expanding the number of pages in their publications. Better artwork and "news" features will begin to appear in the pages, making them similar to consumer magazines that feature stories and product advertisements.

Catalog Specialization

Although some catalogs feature a general line of products, such as those offered by the full-line department stores, and others feature more limited lines, as those offered in the specialized department store publications, more highly specialized catalogs will become part of the catalog landscape. Especially in fashion merchandise, subclassification cataloging will mean publishing catalogs that limit their offerings to such areas as "natural-fiber only products." This will diminish competition for these specialty merchants and give them a greater chance for success.

Internet Cross-Selling

The success of such companies as eBay.com has led other merchants to use these channels for selling their own products, which is known as **Internet cross selling**. Today, giants such as Sears are on eBay, as is Sharper Image, which offers unique merchandise, much of it fashion oriented; One Source Gems, purveyors of precious jewelry; and Madisonavemall.com, which features sable coats selling at $49,000.

The cross-selling phenomenon has been so successful that traditional retailers such as department stores and catalog companies will join popular general merchandise Web sites such as eBay and Amazon to sell their products.

SMALL STORE APPLICATIONS

Fashion merchants, such as those that own and operate small specialty stores and boutiques, may expand their businesses with off-site Internet Web sites at a minimal expense. For $1,500 or less, they can have a Web site designed to fit their needs and can easily interface with their clienteles or find new shoppers who will hopefully become customers.

A small retailer would be able to ask customers coming into their stores for their e-mail addresses so that it can inform customers about new offerings, sales promotions, and other special events that appear on the store's Web site or in its brick-and-mortar unit. In this way, the Web site can allow customers to buy direct, or it can be used to bring customers into the store.

Small retailers can also be part of a well-known Web site. For a small monthly fee, they could be listed on the site and have a link that directs shoppers to their own Web site.

Catalogs may be another option. Often, fashion-merchandise suppliers will provide promotional dollars to retailers to develop a catalog that will feature their products. If a sufficient number of fashion-merchandise vendors are willing to participate, the cost of producing the catalog will be greatly reduced. Merchants with mailing lists could easily distribute it. Those without them could purchase a list from a list house, which provides names and addresses of people who meet the retailer's specific requirements in categories such as income, employment, and so forth.

Chapter Highlights

1. On-line spending reached $74 billion in 2002, with men accounting for 49 percent of the purchases.
2. The fashion apparel and accessories classifications have become the seventh fastest—growing nontravel E-commerce category.
3. The creation of a Web site may be simply accomplished, at minimal expense, with the use of a standardized template.
4. The E-tailing vendors are divided into four categories: brick-and mortar operations, catalogs, and cable shopping organizations, all of which use this channel as adjuncts to their typical business outlets, and the Web site—only merchants, whose primary outlet is E-commerce.
5. Many fashion-oriented chains such as The Gap and TJX Corporation have become *bricks-and-clicks* merchants, meaning that they sell exclusively through their stores or on-line Web sites.
6. *Web site—only* companies such as Amazon and eBay have added fashion components to their product mixes and have achieved multimillion dollars in sales in these categories.

7. Interactivity between E-tailers and consumers is growing and helping to boost fashion merchandise sales.

8. One of the problems associated with purchasing on-line has been security. To alleviate shoppers' concerns, the American Bar Association has developed a shopping tip list that offers advice to would-be Internet users.

9. There is significant technological growth to help reduce Internet fraud. Companies such as CyberSource, Biowebserver.com, and Digital Envoy's Actuity geo-intelligence are just a few that have developed systems to protect on-line shoppers from fraud.

10. Instead of the big catalogs once used by Sears, smaller specialized editions are now used to reach mail-order markets.

11. Some catalogs, such as the one developed by Patagonia, are becoming more like consumer magazines, because they intersperse their offerings with articles of interest.

12. Catalog marketers are classified as catalog-only merchants, brick-and-mortar operations with catalog divisions, and catalogers with on-site venues.

13. Home shopping via cable channels is a multibillion dollar business, with HSN and QVC being the major outlets.

14. Being able to claim lower prices and the interactivity feature has helped to make cable home shopping the important distribution channel that it is.

Terms of the Trade

E-tailing
web site templates
web site-only companies
multichannel retailers
bricks-and-clicks retailers
virtual catalog
cable shopping programs
on-line interactivity
virtual try-on
biometric detection
big book catalogs
catalog-only retailers
Internet catalogs
home shopping cable programming
televending
electronic merchandising
video shopping
Internet cross selling

For Discussion

1. What dollar volume did on-line consumer spending achieve in 2002, and what percent of the total was purchased by men?

2. What are the two primary methods used in the design of a Web site?

3. How have today's Web sites changed in comparison to the earlier entries?

4. In what way does a multichannel's methodology for reaching shoppers differ from that of the bricks-and-clicks merchants?

5. Why have some of the major catalog companies, such as Spiegel and Lillian Vernon, opted to use E-tailing in their marketing plans?

6. What are the two major Web site-only companies, and how have they embraced fashion merchandise?

7. What is the purpose of interactivity in E-tailing?

8. How have security problems impacted on the use of the Internet as a sales channel?

9. What types of technology have been implemented so that Internet fraud can be reduced?

10. Who has been credited with the introduction of catalog shopping, and what uses does that company make of it today?

11. How have some catalogs gone from just featuring available merchandise to publications that merit further examination?
12. What are some of the benefits of catalog shopping?
13. Why have some catalogers started to use on-site venues?
14. What is an Internet catalog?
15. How have celebrities helped to motivate shoppers to buy merchandise featured on the home shopping cable programs?
16. What is the main reason for the success of the shopping programs?
17. Is it appropriate for small retailers with limited budgets to enter the E-tailing game?

CASE PROBLEM 1

The fanfare that has surrounded the use of Internet Web sites as tools to reach broad audiences has caused a wealth of merchants, from the industrial giants to the smaller companies, to enter E-tailing. The Shopping Bin, an off-price fashion merchant, has been in business for the past fifteen years and is considering the plunge into this type of retailing.

Initially, the company made its mark with the opening of its first brick-and mortar operation in a small shopping center on the outskirts of Baltimore, MD. With its significant success in that market, the Shopping Bin expanded its operation through the introduction of five additional stores, each of which is located in either Maryland or Virginia. These stores too have handsomely performed as profitable units for the company.

The nature of the off-price business is one that depends upon opportunistic purchasing at wholesale prices that are far below the traditional costs. By resorting to this buying concept, the company is able to resell the merchandise to consumers at extremely attractive prices. The only hitch in this type of retailing is that reorders are not possible, leaving the inventories to be replaced with different merchandise. Even if a product is a "hot item," it is unlikely to be replenished.

While this type of merchandising philosophy is extremely successful in brick-and-mortar venues, the introduction of a Web site to sell the shopping Bin's merchandise on the Internet has met with some resistance from the members of the management team. John Matthews, general merchandise manager for the company, believes that for an off-price operation to enter E-tailing, the disadvantages outweigh the advantage. Specifically, he feels that opportunistic buying will prevent merchandise continuity. Joy Green, divisional merchandise manager for women's clothing, feels that this should not be an obstacle and that the company should proceed with the opportunity to enter the E-commerce arena. She says that there is always merchandise available in the marketplace at closeout prices, and this should provide sufficient proof for the sense of starting an on-line division. She feels this should not be the deterrent for this potentially new endeavor.

At this point, the Shopping Bin has yet to make a final decision relating to the viability of Internet retailing.

Questions

1. Is John Matthews' point of view realistic? Why?
2. Is Joy Green's rationale overly optimistic, or is it an appropriate reason to pursue the new venture?
3. If the hot sellers can't be reordered, is there a way that they can be easily replaced on the Web site without causing prohibitive expenses for the company?

CASE PROBLEM 2

Ever since Amy Fain achieved some success with the opening of a boutique, Mon Cheri, three years ago in an upscale suburban town near Providence, RI, she has had E-tailing on her mind. Instead of opening an additional unit in another area that has the same type of customer base, she

believes that the Internet would be an excellent adjunct to the existing store. The key to successful boutique selling is owner-buyer presence in the store. It wouldn't be feasible for her to be in both locations, because they would be at least fifty miles from each other, and her valuable time would be spent in the car. She wouldn't have to shuttle between two locations if she launched at E-tailing Web site.

Her husband, David, who is very practical, believes that this type of expansion would be extremely costly. The development of a Web site alone would require a significant outlay of money, and its placement on the Web would add another expense. Although he is not an active participant in the boutique, he has served as a monetary resource and advisor in every matter that affects the running of the operation. He believes that there would be a need to maintain a much larger inventory to satisfy the increased sales potential and that they would have to open a shipping station to ship ordered merchandise. He also feels that Amy would lose the rapport that she has developed with her customers, because she would have to spend considerable time in the development of the new project.

In spite of David's negatives, Amy is still convinced that Internet exposure would be the right approach to increasing sales.

Questions

1. With whom do you agree? Evaluate each of their concerns regarding the new undertaking and use them in your decisionmaking.
2. Is there a way that even if the Web site isn't used for direct selling, it might be used as a marketing tool to increase business?

EXERCISES AND PROJECTS

1. Select a fashion-merchandise classification such as dresses, sportswear, shoes, and so on for the purpose of evaluating its appeal in catalogs and Internet Web sites. Using the outline that is provided below, record your findings for the same department or specialty store that utilized both selling channels.

COMPANY NAME

Product Classification _____

	Catalog Offering	Web Site Offering
Merchandise assortment	_____	_____
Price comparison	_____	_____
Visual appeal	_____	_____
Ordering techniques	_____	_____
Shopping interactivity	_____	_____

Present a summary statement based on which methodology was more likely to achieve the greater percentage of sales.

SUMMARY _____

2. Tune into QVC and HSN shopping programs on cable television and compare their operations. Complete the following form, with a summary of your opinion as to which one provides the better presentation and format to the viewing audience.

	QVC	HSN
Merchandise categories	_____	_____
Shopper assistance	_____	_____
Celebrity use	_____	_____
Interactivity	_____	_____
Hours of operation	_____	_____
Impression of hosts	_____	_____

SUMMARY _____

Organizational Structures

After reading this chapter, you should be able to discuss:

■ The differences between line and staff positions as shown on organization charts.

■ How an organization chart is structured showing the lines of authority.

■ The different types of organizational structures presently used by retailers.

■ The beginnings of organization structuring for large department stores and how they have changed to suit today's companies.

■ Reasons why chain organizations conduct their businesses as centralized operations.

■ Why some chains have decentralized some of their functions.

■ Reasons for separating the buying and selling functions.

Once the decision has been made to begin a retail venture, it is necessary to plan its **organizational structure** in a way that maximizes efficiency and profitability. All of the duties and responsibilities of those in the company must be identified, and lines of authority must be carefully delineated so that all members of the organization will understand what their job responsibilities are. By doing so, everyone knows who will report to whom, who the decisionmakers are, and which advisory personnel is on hand to assist in the decision-making process. No matter how large or small the operation, whether it is a major department store or single-unit boutique, each company must be structured in such a way that best serves its needs and makes the business a success.

To clarify their organization's structure so that all employees can understand it, most companies prepare a graphic presentation called an organization chart. The chart clearly spells out the various divisions of the company, the roles they play, lines of responsibility and authority, decision-making positions, advisory roles (if there are any in the organization), and areas of responsibility. Such charts allow employees at any level of the organization to immediately learn their place in the company, to whom they are responsible, and, in turn, their own paths of responsibility.

Each retail classification has certain traditional organizational structures. Department stores structures, for example, are somewhat dissimilar from those of the chain organizations, as are small retail operations from their giant counterparts. Each company tailors a chart that best suits its specific needs. Often, companies undergo structural changes that fit their needs to address any new directions they take. Most department stores, for example, at one time exclusively brick-and-mortar operations, are now engaged in multichannel retailing that necessitates placing their catalog and E-tail divisions on the organizational chart.

As small companies develop into larger ones, and as the giants expand their operations globally, their organizational structures must be adapted to fit their latest needs.

THE NEED FOR ORGANIZATIONAL STRUCTURES

Organizations need structuring so that lines of authority along with individual duties and responsibilities can be understood by every company member. There are, however, additional ways that these structures optimize the operation. Some of the more important ones, as offered by OrgPlus, a consulting firm that deals with the complexities of organizational structuring and chart creation, include:

- Turning groups of individuals into teams and getting everyone pointed in the same direction.
- Helping to orient new employees to the company and supplying them with career and succession plans.
- Understanding the complex nature of the structures and helping to simplify relationships.
- Empowering people to understand the strategic vision of the company by defining dependencies and relationships.

A wealth of additional information regarding organizational structuring is available on **www.orgplus.com.**

Once the different company leadership, divisions, departments, and other components needed to efficiently run the organization have been identified, they must be laid out in chart form.

ORGANIZATION CHART COMPONENTS

At first glance, an **organization chart** looks like a stack of different **boxes**. They are positioned by job titles to depict the various **company divisions** or **functions**, the relationships of these positions to each other, the decision-making positions as well as those that are advisory in nature (if they are present), **lines of authority**, and the overall size of the company.

To "read" organization charts and comprehend their meaning, it is necessary to understand the basic components and principles upon which they are based. Essentially, the charts are composed of only two major components: line positions and staff positions.

Line Positions

In every retail organization, no matter how large or small, decision making is a key to its success. Those who hold these positions are **company producers** in that they are directly involved in making money for the company. Whether they are the merchandisers who have the responsibility for the buying function, the sales associates who sell the products, or those involved in advertising and promotion, they all have a hand in "producing" revenue for the company. Collectively, they are the holders of **line positions**.

By examining Figure 3.1, excerpted from a typical merchandising division of a department store, it is easy to understand **line relationships**. The most senior person is at the top, in this case the divisional merchandise manager, followed directly below by the buyer, who is next in command, and ultimately by the assistant buyer who is least senior. Each line position is presented in a rectangular box that is attached to the others with vertical lines.

The nature of the placement of the positions and the use of the traditional lines makes it easy for the observer to understand who is responsible to whom, who plays the most important decision-making roles, and the direct lines of authority and communication. Employees are expected to follow the formal delineations of communication when discussing company problems. For example, in the chart in Figure 3.1, the assistant buyer communicates only with the buyer, the immediate supervisor, and not with the divisional merchandise manager (DMM). Only the buyer has the authority to deal directly with the DMM. It is only appropriate to deal with someone in higher authority if one's immediate supervisor permits it. Of course, in some organizations, an informal structure might exist that enables some people to communicate with others out of the formal order.

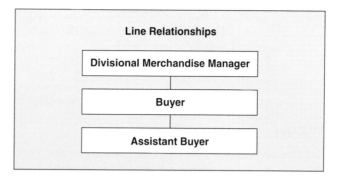

Figure 3.1 Line relationships.

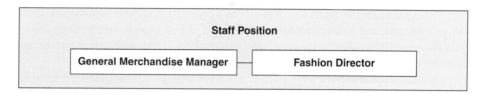

Figure 3.2 Staff position.

In smaller companies, the use of a **line structure** is typical since there might not be a need to have employees other than decisionmakers operate the business. Small companies also generally do not have the funds to employ people other than those who are the company producers.

Staff Positions

Stores that have either grown from smaller companies into larger ones or were initially conceived to be large-scale operations often have the need for advisory or support positions, technically classified as **staff positions**. They are specialists within the organization who work at the behest of the line people to whom they report. An example of this type of relationship is depicted in Figure 3.2.

In this example, the general merchandise manager (GMM), is a line executive who heads the merchandising division and has the ultimate power to determine guidelines and philosophies concerning product assortments for the entire company. Adjacent to the GMM box, connected by a horizontal line, is the fashion director. The fashion director is in a staff position and advises and makes suggestions to the GMM on areas such as fashion trends, silhouettes, fabric preferences, and color forecasts but does not have any decision-making powers. The GMM and the subordinates in the merchandising division make the actual merchandizing selections.

Staff members play an important role in retail operations. Their salaries are often higher than those of many in line positions, and they are not lower-level employees even though they do not make the actual decisions. It is their advice and counsel that often makes an organization operate more efficiently and productively.

Large retailers that use a combination of line positions with staff positions are called **line and staff organizations.**

CONSTRUCTING AN ORGANIZATION CHART

The creation of the chart used to be a complex undertaking that required not only an understanding of the different components that needed placement on the graphic presentation but also the ability to draw the boxes in a manner that was visually meaningful.

Today, computer programs such as SmartDraw assist those who have no artistic ability to quickly and efficiently construct the charts. "Connector lines" automatically format the chart, and built-in colors and shadows result in the perfectly created organization chart.

Fashion Retailing Spotlights

SMARTDRAW.COM

In 1994, CEO Paul Stannard founded SmartDraw to provide diagramming software over the Internet. Since then, the company has grown rapidly to become the major Internet source for constructing organization charts. SmartDraw has more than half of the Fortune 500 companies as its customers and has received accolades from. *Inc Magazine,* Deloitte & Touche, *Smart Computing Magazine,* Shareware Industry Awards, and others. Its Web site receives more than two million visitors a year, placing it in the top 0.1 percent of the most visited sites on the Internet.

The most attractive feature of SmartDraw's products is in their software designs. They are self-teaching, with built-in hints, tips, and examples that help the users obtain professional-looking results quickly and easily. SmartDraw Photo enables users to enhance their organization charts with digital photography, which makes them visually more exciting.

By accessing the company Web site at **www.smartdraw.com**, customers are able to examine a wealth of different organizational charts and choose one that fits their organization. Such needs as basic organization chart shapes, a company organization chart explanation, a human resource structure, an information technology organization chart, a management organizational structure, and others that are appropriate for retail enterprises are available on the site.

SmartDraw also provides businesses with additional resources and books about organizational charting that may even further educate companies in terms of their chart planning.

With SmartDraw's ability to provide French, German, and Japanese versions of their programs, the company is now able to satisfy the needs of the global market.

FASHION RETAILING ORGANIZATION CHARTS

Fashion retailers are divided into three main types: **on-site classifications**, which include the smallest operation, the single-unit small specialty store; the specialty store operation with several units; the small department store; large department stores; department store groups; and large chain operations; the **off-site operations**, which include catalog and Web site only retailers; and the multichannel operations, which include brick-and-mortar retailers with catalog and Internet divisions.

Each of their organizational structures is generally based upon a set of standardized practices, that are tailored to fit specific company needs.

On-Site Classifications

The brick-and-mortar operations, or on-site retailers, use a variety of organizational structures based on the size of the company and the activities in which it is engaged.

SINGLE-UNIT SPECIALTY STORES

These operations, which include boutiques, usually operate with a minimum number of people. Typically, the owner is the ultimate decisionmaker, with a few employees hired to perform more than one task, such as sort and ticket incoming merchandise, place the goods in the appropriate spots on the selling floor, make changes to existing visual presentations, and handle returns to vendors. The owner makes decisions that pertain to buying, store management, promotional endeavors, and the like. When stores are too big for their owners to handle all of the major decision-making responsibilities, they may hire managers to assist them.

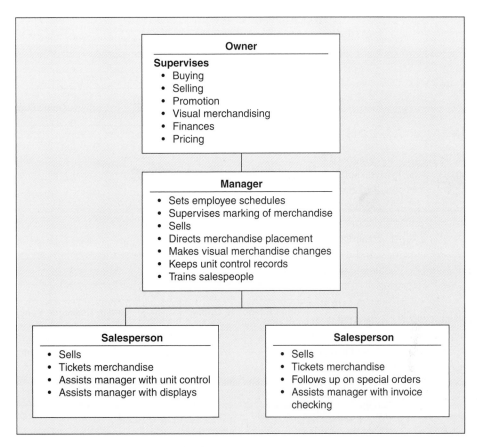

Figure 3.3 Single-unit specialty store organization chart.

The chart shown in Figure 3.3 is typical of single-unit specialty stores, and it follows the line organization concept in which each of the people in the company is either a decisionmaker or revenue producer. Figure 3.3 spells out the duties and responsibilities performed by each person.

In Figure 3.3, it is quite clear that the owner is in charge of the overall functioning of the operation, with the manager performing some specific tasks. The two sales associates on the chart, in addition to selling and merchandise sorting and ticketing, are required to assist in other areas.

When a company grows from a single-unit operation, not only does the number of employees increase but the different types of people are generally hired to perform more specialized tasks.

SMALL MULTIUNIT SPECIALTY CHAINS

Many small operations achieve success with their first stores and expand their operations with other units. Consequently, they must adjust their tables of organization to show the increased number of employees and their functions (see Figure 3.4).

When the chain grows to five or more individual units, such activities as merchandising, advertising and promotion, store management, human resources, and receiving are centralized in one facility. The company management, led by the **chief executive officer (CEO)** operates from this location and leaves the stores to attend to the selling of the merchandise.

SMALL DEPARTMENT STORES

The structure of many small department stores consists of two divisions. Headed by the company CEO, it often has a **chief financial officer (CFO)** to handle areas such as accounting and credit, and a **chief operating officer (COO)** to deal with matters of store protection, traffic and facilities management, and so forth.

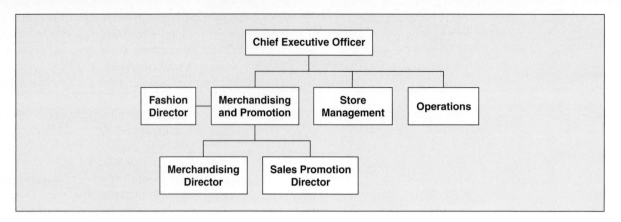

Figure 3.4 Small multiunit specialty chain organization chart.

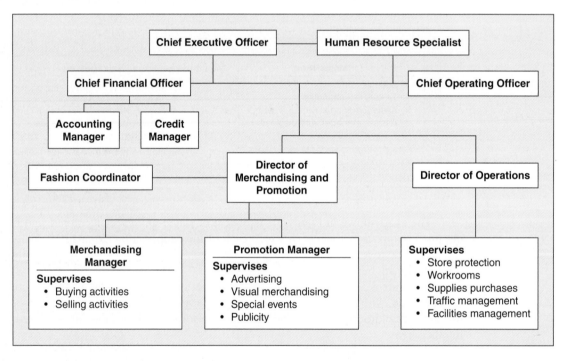

Figure 3.5 Small department store organization chart.

As shown in Figure 3.5, there are several departments within each of the two divisions, a fashion coordinator who operates in an advisory capacity and reports directly to the merchandising and promotions director, and a human resources specialist who works for both the CEO and the two division heads.

This organizational structure allows for a certain degree of specialization in the company but guarantees coordinated store effort.

LARGE DEPARTMENT STORES

At the turn of the twentieth century, department store expansion was at the forefront of retailing. Companies such as Macy's, Bloomingdale's, and Marshall Field's recognized that they needed expanded organizational structures to handle the growth. Some companies went from the two-function format that they used in their early days, to four, five, and even six divisional arrangements.

Early in the century, the National Dry Goods Association, later to be called the National Retail Merchants Association and now known as the National Retail Federation (NRF), was called upon to suggest the best manner in which department stores would successfully operate. Under the direction of Paul Mazur, the situation was studied and the four-function plan, or Mazur plan was introduced. For many years it was the basis of most major department store structures.

Today, leading department stores still use some of the Mazur Plan functions but have amended their structures to address the complexities of their organizations. Initially, the four-function plan had controller, merchandise, publicity, and store manager divisions. While these functions are still important to department store organizational structuring, some of the titles have changed—publicity is most often called promotion—and others have been added.

By and large, the present-day department store's **tables of organization** generally utilize anywhere from five to seven divisions. They are described in the following sections.

Merchandising. While each division is important to the overall success of the organization, the **merchandising division** is considered by most industry professionals to be the lifeblood of the retail operation. Most often, it has more upper-level and middle-management executives than any other division in a department store organization.

Merchandise planning and procurement takes a considerable amount of time and employs a variety of different line executives as well as staff positions such as fashion directors. The activities for which they are responsible are:

1. Purchasing merchandise from the four corners of the earth. With global acquisition so important to these companies, their buyers and merchandisers are in offshore markets year round.

2. Determining the product mixes not only for the brick-and-mortar operations but also for the off-site divisions such as the catalogs and Internet Web sites. Since the off-site operations generally have no geographical boundaries, the items sold through these outlets are often different from those found in the stores.

3. Developing private brands and labels for their company's exclusive use. With the enormous amount of competition between department stores and the widespread use of similar marque brands, the creative aspect has become commonplace for many buyers and merchandisers.

4. Determining the appropriate product mix in terms of price points that will best serve their clienteles' needs.

5. Pricing the merchandise in a manner that provides the profitability necessary for the company to remain a viable business enterprise, while staying competitive with the prices of other retailers.

6. Establishing the proper rapport with vendors that assures the best possible buying terms, such as getting discounts, prompt delivery, accepting returns, and so on, to maximize profitability.

7. Obtaining the highest vendor allowances for advertising and promotional purposes that will help deliver their company's message to the consumer at a minimum of company expense.

8. Interacting with industry experts such as resident buyers and market consultants who provide information on color, fabric, style, and other fashion trends.

Promotion. Today's retail atmosphere has reached such competitive proportions that the dollar amounts that department stores spend to make themselves visible to their regular and potential customers have skyrocketed. Coupling this increase with the realities of budget shortfalls has made it necessary for the **promotional division** to apportion the funds spent on these areas with great care. Included among the activities that it oversees are the following:

1. Dividing the allocations for advertising among the various media available to them. Since not every medium provides the same return on the dollars invested, care must be exercised in making certain that expenditures are in line with the sales they are expected to generate.

2. Selecting the appropriate media outlets within a classification that promise the highest awareness rate. If, for example, the trading area has more than one daily newspaper, the one with the greatest potential for consumer response should merit the largest percentage of the newspaper advertising budget.

3. Developing distinctive advertisements that are appropriate for the store's image.

4. Choosing an advertising agency that specializes in department store promotion and has the ability to create signature ads for the company.

5. Designing special events that will capture consumers' attention and motivate shoppers to buy.

6. Creating and installing interior and window visual displays that will produce sales for the store.

7. Producing press releases and kits that will attract the attention of the fashion world's editorial press.

Control. Behind the scenes in any department store operation are the people who make certain that the company's assets are protected and accurately spent. The **control division** serves in a multitude of capacities that include accounting, expense and control, and consumer credit. Specifically, its tasks are:

1. Developing the appropriate accounting procedures that address both account payables and receivables. In the establishment of these bookkeeping tasks, the best available computer programs must be procured or developed to fit the company's specific requirement.

2. Preparing reports for the merchandisers and buyers, human resources team, promotional executives, and other divisional managers as well as outside government agencies, as required by law.

3. Planning and supervising the taking of perpetual and physical inventories.

4. Establishing a credit card program that involves both in-house charge accounts and revolving credit, and third-party credit such as American Express, MasterCard, and Visa.

5. Developing a procedure that establishes customer credit card accounts in a timely manner.

Store Management. With department stores expanding through the opening of full-line branches and specialized units, the need for in-house managers continues to grow. The **store management division** is charged with overseeing the managerial positions and carrying out the practices that were established by the company's upper-level executives. Some of its responsibilities include:

1. Selecting the individual stores' managers, group managers, and department managers.

2. Determining the appropriate hours of operation for the flagship and branch stores.

3. Interfacing with the stores' managers to notify them of changes in corporate policies.

4. Communicating through means of personal contact, telephone, E-mail, and faxes to learn about potential problems in the stores.

5. Managing the customer service departments.

Store Operations. The management of the store's physical operations are under the jurisdiction of the **store operations division**, developed by the company's top management team. It then carries out the specific tasks and responsibilities to which it has been assigned. These include:

1. Maintaining the physical plant.

2. Managing the security of the facility and protecting the merchandise from being stolen by shoplifters and employees.

3. Purchasing supplies that are used to run the stores such as light bulbs, cleaning compounds, and office materials.

4. Managing the receipt of incoming merchandise and the functions used in marking and ticketing.

Human Resources. All of the activities that relate to the company's personnel, such as recruitment, training, and labor relations, are in the domain of the **human resources division.** Its decision making is extremely important to the proper functioning of the company, and its duties and responsibilities include:

1. Establishing the job specifications of the various positions in the company so that the right person will be hired to perform the specific job.

2. Developing recruitment programs that will attract the best-qualified candidates for employment.

3. Training new employees and retraining those already employed with the latest in-house systems.

4. Designing benefits packages that will be competitive with other companies in the industry.

5. Evaluating employee performance.

6. Establishing compensation programs that will attract the best employees.

7. Participating in labor relations between management and rank-and-file employees.

The organization chart shown in Figure 3.6 represents a six-division table of organization as described by the preceding material.

DEPARTMENT STORE GROUPS

As was discussed in Chapter 1, "An Introductory Analysis of On-Site Fashion Retailing," many department stores that were once independently operated are now divisions of major retailing giants. As these organizations grow, there is a constant need to redefine their operations and adjust their structures to reflect the changes. Also, some of these major department store groups sell off divisions to more profitably operate. The chart shown in Figure 3.7 depicts a typical table of organization for a **department store group.**

The May Department Stores Company typifies the department store group concept. The following spotlight describes its rise from a single company operation to a major force in retailing.

Fashion Retailing Spotlights

THE MAY DEPARTMENT STORES COMPANY

When David May opened his first store in 1877 in the mining town of Leadville, CO, it is doubtful that he or anyone else expected it to become the May Department Stores Company. Little by little, May and three partners began their climb by acquiring stores that were already established.

Their route toward the top began with the purchase of the Famous Clothing Store in St. Louis, MO, and a department store in Cleveland, OH; they renamed both stores May Company. Among the stores that became part of the company early on were Famous-Barr, Hecht's, Kaufman's, and G. Fox. By 1967, company sales reached the $1 billion mark.

The acquisition that made the May Company the fourth-largest department store company in the world occurred in 1986 when Associated Dry Goods Corporation became part of the group. The stores in that network included Sibley's, J.W. Robinson, Denver Dry Goods Corporation, Hahne's, L.S. Ayres, Strouss, and the jewel in the crown, Lord & Taylor.

Not satisfied to remain at that level, the May company purchased such well-known operations as Wanamaker's in Philadelphia, Woodward & Lothrop in Washington, D.C., Strawbridge & Clothier, and the Jones Store in Kansas City.

Rounding out the company's empire are three specialty stores: David's Bridal, the largest retailer of bridal gowns; Priscilla of Boston, a major upscale bridal chain; and After Hours Formal, the largest tuxedo rental and sales retailer in the nation.

The growth of the company necessitated the continuous reformatting of their organizational structure. Some of the acquired companies were renamed and merged into existing divisions that had greater consumer recognition. The present structure has seven quality regional department store divisions operating under fifteen different names. They are Lord & Taylor, Famous-Barr, Filene's, Foley's, Hecht's, Kaufmann's, L.S. Ayers, Meier & Frank, Robinson's May, Strawbridge's, the Jones Store, David's Bridal, After Hours, Priscilla of Boston, and Marshall Field's.

With sales of more than $14 billion in 2002, the May company is among the most successful retail groups in the world.

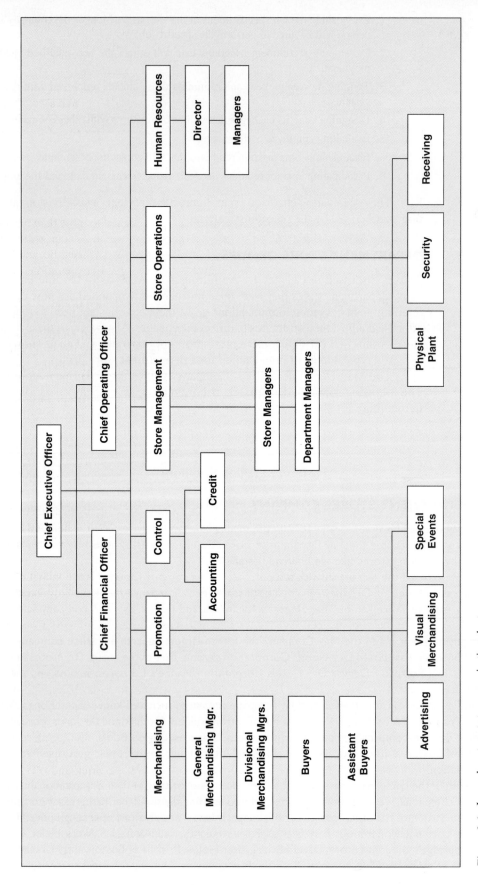

Figure 3.6 Large department store organization chart.

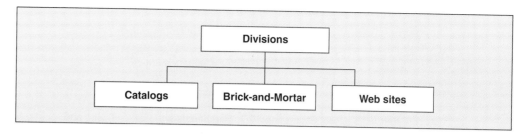

Figure 3.7 Department store group organization chart.

LARGE CHAIN ORGANIZATIONS

Large chain organizations have anywhere from one hundred to more than one thousand units. Among those with highly visible names are companies such as Gap, which operates many different retail concepts such as Gap Kids, Baby Gap, Banana Republic, and Old Navy. Some are traditional stores, and others are either discount or off-price operations such as Wal-Mart and SteinMart.

Their success is generally attributed to their centralized organizational structure that involves management from a home base or company headquarters. Typically, all of their decision making is accomplished there and includes buying and merchandising, advertising and promotion, warehousing, product development, human resources, accounting, purchasing of supplies, real estate development, and marketing research. In the giant chain organizations, there is often some form of **decentralization**, such as regional warehousing, which allows for shipments to stores to be accomplished in less time. In companies such as J.C. Penney, for example, some of the merchandising decisions are decentralized and left in the hands of the store managers and their in-store team. In this case, merchandise planning and procurement arrangements are left to the central buying team, which prepares "catalogs" of available products that store managers select from to develop their own merchandise mixes. In this way, each store in the chain can tailor the assortment to fit the needs of the individual trading areas.

In some chain operations, associate buyers purchase lines that are earmarked for specific locations. For example, if a limited number of units in the chain have markets that are atypical from the rest of the company's stores, their unique merchandise requirements can be better satisfied with this type of buying arrangement.

Although **centralization** is and will always be the manner in which chains can control their entire operation and curtail costs, there will often be the need to decentralize their operations in some ways, as described above.

Figure 3.8 is a typical example of the tables of organization of large chains.

Off-Site Classifications

Just as the brick-and-mortar operations find the need to make changes in their tables of organization to address their present-day businesses, so do the off-site companies. Many retail catalogers, for example, have opted to add Internet Web sites as a means of attracting a broader marketplace. Conversely, so have the companies that initially entered retailing as online merchants. Some have opened catalog divisions to serve shoppers accustomed to that form of purchasing and have even developed "tie-ins" with brick-and-mortar operations that will sell their goods. Even the home shopping channels have entered the catalog arena to make certain that they have covered all bases in terms of marketing their goods.

The following organizational structures are examples of some of the various divisions and functions within each of the off-site classifications.

CATALOGS

Unlike brick-and-mortar retailers, which utilize stores to generate the greatest proportion of their sales, the catalog companies sell merchandise primarily through the pages of their

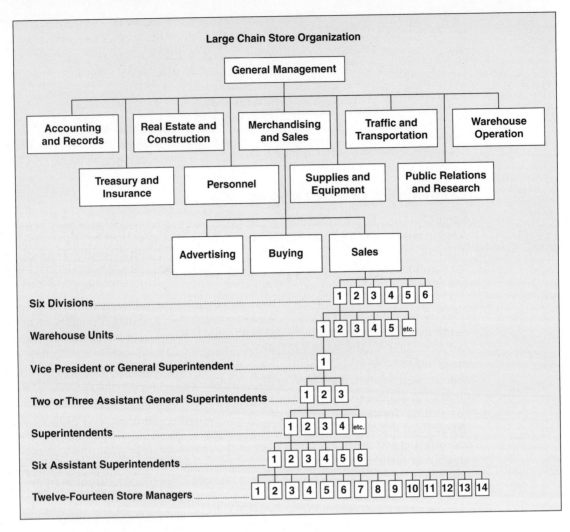

Figure 3.8 Large chain store organization chart.

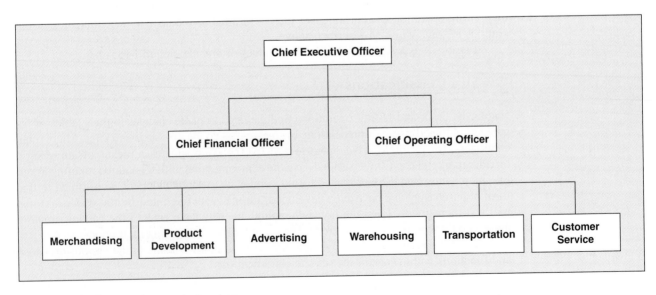

Figure 3.9 Catalog operation organization chart.

"books," though they are using on-line Web sites more and more. Thus, catalog retailer organization charts feature only those divisions and functions such as merchandising, product development, advertising, warehousing, transportation, and customer service. The chart shown in Figure 3.9 provides the general structuring of a catalog company.

INTERNET WEB SITE ORGANIZATIONS

By and large, the Web sites with fashion orientations limit themselves to the Internet to reach potential customers. Their organization charts, like their cataloger counterparts, deal primarily with product acquisition, visual presentation, warehousing, transportation, and customer services.

HOME SHOPPING ORGANIZATIONS

The main distribution channel for the home shopping shows is on cable television. Most, however, have expanded their operations to include direct marketing through the Internet. In this way, they are able to appeal to the vast array of potential customers who shy away from on-site purchasing and prefer to make their purchases either by ordering goods that they see on products-oriented television programs or the Internet.

Multichannel Operations

Retailers, large and small, have become proponents of multichannel retailing. Brick-and-mortar companies, in particular, have come to the conclusion that limiting themselves to in-store operations will prevent them from reaching wider trading areas.

In addressing these new opportunities, most have redirected their tables of organization to reflect all of the selling channels available to them. The organization chart depicted in Figure 3.10 is typical of large department stores, the largest of the multichannel merchants. In this example, in-store operations, catalogs, and on-line outlets are presented in three separate divisions. Although this is becoming the norm for these merchants, some merchants continue to maintain all of their selling channels under one division.

In retailing's rapidly changing playing field, the organizational structures that were "engraved in stone" are now flexible. To stay current and meet the challenges of the competition, retailers must restructure.

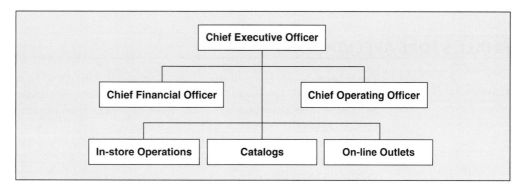

Figure 3.10 Multichannel organization chart.
This is for a department store but is easily adapted to a chain organization.

TRENDS IN ORGANIZATIONAL STRUCTURES

The growth in retailing, both on-site and off-site, has required merchants to readdress their tables of organization so that they will better serve the needs of their customers and make their companies more profitable.

Some of today's trends in organizational structuring for the fashion-retailing arena are described in the following sections.

Restructuring to Accommodate Multichannel Expansion

When department stores in particular expanded their catalog operations, many initially opted to make this division part of their brick-and-mortar operations. Similarly, when retailers saw that the Internet had the potential to increase revenues, they changed their organizational structure to reflect this and to make the overall operation function more efficiently. Today, the trend is for the major multichannel retailers to adjust and expand their tables of organization and separate the three functions into separate channels. Macy's, for example, is one of the giants in the industry that has changed to that format.

Consolidation of Divisions

The acquisition of department stores by major retail groups has become a dominant trend. May Department Stores and Federated Department Stores, for example, are two companies that have expanded their operations by purchasing other retail companies. In their pursuit of maximizing profits, these groups have, in many cases, decided to merge the new acquisitions into some of their own stores. May, for example, purchased sixteen Wanamaker's stores and three Woodward & Lothrop stores and merged some into their Hecht's division and some into the Lord & Taylor group.

Through this practice, fewer buyers and merchandisers were needed as were other executives who previously worked exclusively for one store. As this acquisition trend continues, this staff consolidation is likely to continue as well.

Decentralization

Much of the growth in large-scale retailing has come about by expansion into new trading areas. Although centralization was once the forte of the chain organization, this expansion has necessitated some decentralization of functions. Merchandise distribution, for example, has now been decentralized to include regional operations. When stores were so far from the single distribution center, the time it took for merchandise to reach many of the units was both inefficient and costly.

SMALL STORE APPLICATIONS

The manner in which small stores are organized is unlikely to change, because these operations require few employees to run them. The key roles are usually performed by the owner or partners with the remainder of the functions such as selling and stock keeping left to the sales associates.

When there isn't a store manager on site, as is often the case, a particular salesperson should be designated to take charge and assign tasks such as handling temporary changes in sales associates' hours.

When outside tasks, such as advertising and visual merchandising, are required, outside agencies should be hired to take care of them. The need for in-house specialists to perform these tasks is limited and is too costly for small businesses to afford.

Chapter Highlights

1. Both large and small companies should present their tables of organization on organization charts so that employees at all company levels may visualize the lines of authority.
2. Organization charts should not be left in place for long periods. They should be periodically reviewed and adjusted to fit the needs of the company as it changes.
3. An organization chart is a graphic presentation of the company and is presented in a series of boxes that are easy for everyone to understand.
4. Essentially, today's retailers utilize charts that feature line and staff positions, except in the cases where the companies are very small.
5. Line positions are used to indicate company producers and staff positions for the purpose of showing support personnel. The former group represents the company's decisionmakers; the latter, the advisory people.
6. Organization charts may be hand drawn or computer generated.
7. As retail organizations grow, the need to add staff specialists also grows. This enables the company to use advisory personnel who can make a favorable difference in the running of the company.
8. Large department store organizations use a variety of different charts to depict their organizational structures, with the number of different divisions typically ranging from five to seven.
9. Most professionals agree that the merchandising division is the lifeblood of the retailing structure.
10. The promotional division of a major retailer is responsible for advertising, special events, visual merchandising, and publicity.
11. Department store acquisitions of other companies have accounted for the restructuring of their tables of organization. In many cases, some of the newly acquired stores are merged into existing divisions.
12. Large chains primarily operate under centralized organizational structures, with the result being more efficiency in their everyday operations.
13. Some chains have decentralized certain functions as they have moved into numerous geographical markets.
14. As major companies move toward multichannel retailing, they have restructured their tables of organization.

Terms of the Trade

organizational structure
organization chart
organization chart boxes
company divisions
company functions
lines of authority
company producers
line positions
line relationships
line structure
staff positions
line and staff organizations
on-site classifications
off-site operations
chief executive officer (CEO)
chief financial officer (CFO)
chief operating officer (COO)
tables of organization
merchandising division
promotional division
control division
store management division

store operations division
human resources division
department store group
centralization
decentralization

For Discussion

1. Why is it important for all retail operations to graphically present their tables of organization?
2. What is meant by the term *lines of authority?*
3. In what way are the major components shown on an organization chart, and what are the traditional designations?
4. How do line positions differ from staff positions?
5. Why doesn't a small fashion retail operation, such as a boutique, use staff positions in its organizational structures?
6. What is the major function of a *company producer* in a retail operation?
7. What purpose do the *boxes* serve in an organization chart?
8. How does the structure of a small retail operation differ from a major company?
9. What are the major responsibilities of CEOs, CFOs, and COOs?
10. How many divisions are typically used in the structuring of large department stores, and what are they?
11. Why do many industry professionals consider the merchandising division to be the lifeblood of the company?
12. What are the areas of specialization that come under the jurisdiction of the promotional division?
13. How do the store operations and store management divisions differ from each other?
14. What is the key organizational principle on which large chain operations are based?
15. Why has it become necessary for many department stores that have become multichannel retailers to restructure their tables of organization?

CASE PROBLEM I

Tailored Woman began as a small retail operation with one unit in New Hampshire in 1988. After only two years, the partners, Pam and Eleanor, decided to open another unit about forty miles from the first store. There too the store was greeted with enthusiasm, and Pam and Eleanor were on their way to having a successful chain operation.

With their third store, this one in Vermont, the partners began to realize that their informal approach to organizational structure was no longer appropriate for their business but still neglected to develop a formal structure for the company. All of the major decision-making responsibilities were handled by the two. Pam was the buyer, and Eleanor handled store operations for the three units. The only employees other than the sales associates were store managers for each unit.

At this time, Tailored Woman is considering additional units in Maine and Massachusetts. Their profitability warrants the expansion but their informality in terms of organizational plans seems to be causing concerns for Pam. While she agrees that they have achieved more success in such a short time than either of them expected, she believes that a more formal approach would maximize profits. She envisions a small central warehouse for receiving, handling, and marking merchandise; an office for buying and merchandising; a computer installation for inventory control and other essential recordkeeping; and a shipping station for sending goods to the units. A small building that is central to the operation could be leased, and ultimately purchased, if the arrangements work well.

In contrast, Eleanor believes that the informal approach has been good to them and wants to continue that way. She still wants to use the first store's basement as their headquarters for recordkeeping. Merchandise would still be ordered separately for each unit, shipped directly to each by the vendors, and priced and marked by each. Each store would maintain its own computer for inventory purposes.

At this time, no decision has been made concerning any possible organization restructuring.

Questions

1. With which partner do you agree? Why?
2. Briefly describe a new organizational structure you would suggest for the company.

CASE PROBLEM 2

Beverly Hills is a small specialized fashion-oriented department store, with its flagship in southern Florida and four branches within one hundred miles of the flagship. The company has been structured as a four-divisional operation in the manner used by many department stores in the early 1900s. In this table of organization, the sales staff is managed by the company's buyers. With all of the merchandising duties and responsibilities required of the buying team, many buyers have complained that they simply do not have enough time to perform their sales management tasks.

Mr. Green, founder and CEO of the operation, feels that since its inception, Beverly Hills' buyers have always managed the sales areas and should continue to do so. The buyers' reaction has been that the fundamentals of buying have changed, and the markets that need to be covered are often times offshore. To allow them to perform their duties at the highest level possible, the buyers insist that an organizational restructuring is necessary.

John Thomas, Mr. Green's operations manager, agrees with the buyers and believes that the change is imperative so that the buyers may better carry out their daily tasks. Since buying is considered to be the lifeblood of a retailing company by many industry professionals, buyers would be wise to spend their time attending to purchasing responsibilities.

At this time, Mr. Green is ready to entertain some adjustments to the table of organization if he could be convinced of the necessity.

Questions

1. Prepare a list of reasons why the buyers are not able to manage the sales staff as they once did.
2. Suggest a table of organization that would make the company more manageable.

EXERCISES AND PROJECTS

1. Contact a member of a large retailer's management team to learn about its organizational structure. Make sure you identify yourself as a student who is preparing a research project for your class. Once you have the information, prepare an organization chart that features all of the divisions and departments of the company, making certain that the staff positions are included in the appropriate places on the chart.
2. Use any one of the many search engines such as **www.askjeeves.com**, to learn about organizational structures and computer companies that provide software for graphically presenting the company's structure. One such company is Smartdraw.com, but there are many others that provide this service. After you choose a software company's Web site, prepare a report telling about the specific services it provides to retailers for organizational planning and structuring.

CHAPTER 4

The Fashion Consumer: Identification and Analysis

After reading this chapter, you should be able to discuss:

- The various factors that influence consumers with their fashion purchases.
- The differences between rational and emotional motives.
- How demographic classifications affect fashion purchasing.
- Each of the social classes and their characteristics.
- Maslow's Hierarchy of Needs and the implications of each stage in terms of purchasing ability.
- The various stages of the family life cycle and each category's impact on the buying of fashion merchandise.

The success of any fashion retail business rests with the company's ability to understand consumer needs and offer merchandise that will satisfy those needs. Too often retailers are unaware of the fundamental principles of needs assessment and enter into businesses that are destined for failure. The practice of selecting merchandise without having addressed the potential customer's needs often results in an abundance of unsaleable merchandise and losses for the company. This is particularly commonplace with new small fashion operations, where inexperienced owners tend to "jump right in" without first learning about the complexities of the marketplace.

Although all merchants are faced with the task of selecting merchandise, none has more decision making than the fashion merchant. With manufacturers and designers constantly introducing new styles that soon move out of favor with a fickle public, it is difficult to choose merchandise that will sell and make a profit. Companies that specialize in staples such as appliances do not have the same merchandising problems of their fashion-retailer counterparts. Color preferences for appliances do not change as rapidly or as drastically as those for clothing and accessories, and the selling life for these products is comparatively long. A furniture operation generally relies on special-order merchandising and usually only carries samples in its showroom from which customers can choose. If some samples do not sell well, they are quickly replaced with others that might fare better.

In contrast fashion merchants must anticipate customer needs and place orders well in advance of the season, never knowing if the items will be popular. Since fashion consumers generally want their selections as soon as the new season approaches, stores must stock a complete inventory of the latest styles in a variety of colors, sizes, and price points to meet customer's expectations.

Because the dollar amounts expended for stocking such a fashion merchandise collection are often very large, the knowledgeable fashion retailer should examine all of the principles of consumer behavior, (a topic explored later in the chapter) before deciding what styles to purchase.

Fashion merchants can make their businesses profitable if they understand the services that their customers want, the types of surroundings in which they want to shop, the time it

takes for items that consumers have ordered through catalogs and on-line to get to them, the different price points of fashion merchandise available for purchasing, the different types of brick-and-mortar environments, and the alternatives to shopping in-store by way of catalogs and Internet Web sites. But in the face of increasing competition, fashion merchants also must understand what motivates people to buy fashion merchandise and how to appeal to those motivations to attract their target market and entice them to spend.

CONSUMER BEHAVIOR

The motives that make consumers act and react in a particular way are broken down into rational, emotional, and patronage motives.

Rational Motives

People who consider such factors as price, care, serviceability, practicality, warranties, and safety when making a purchase are rationally motivated. In times when the economy is poor and consumers are either out of work or are experiencing difficulty in paying their bills, **rational motives** play an important part in how they satisfy their everyday needs. This is especially important when people buy fashion merchandise, because such purchases are not as important as necessities. Shoppers who head to such value-oriented operations such as Target, Kmart, Wal-Mart, and Kohl's to make their fashion purchases as well as those who go to the off-price emporiums where marque labels such as Ralph Lauren and Liz Claiborne are offered for prices that are substantially lower than at the traditional retail operations, are most motivated by the rational factor of price. Some people who have good jobs and spend a great deal of their disposable income on fashion goods but do not have to pay attention to price are affected by rational motives and are opting to buy from companies such as Old Navy, where style is available at an affordable price.

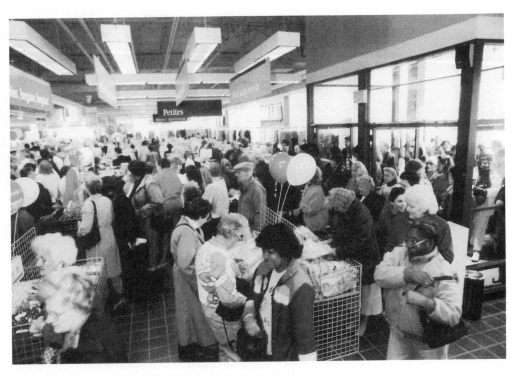

Price is a major factor for shoppers who patronize Filene's Basement.
(Courtesy of Ellen Diamond)

Emotional Motives

Striving to achieve prestige, status, romance, and social acceptance are emotionally driven motives. People often make fashion purchases to satisfy one or more of these needs. An important case in point is the "polo pony" that adorns much of the clothing in Ralph Lauren's collections. Does the insignia make the garment better than something comparable to it, or does it give the wearer a certain aura that implies prestige and status? Macy's Charter Club line features a polo shirt that rivals the Ralph Lauren design feature by feature. The only difference is the price. The Lauren shirt is significantly-costlier than the Charter Club version. How can merchants justify stocking their shelves with the higher-priced item? The answer is simple. A significantly large number of consumers are willing to pay higher prices for the "benefits" of status and prestige afforded them with such purchases.

A wealth of fashion merchandise is marketed solely on the basis of emotional appeal: couture creations from France and Italy that bear such names as Chanel, Armani, and Vuitton; cosmetics that bear names such as Estee Lauder and Bobbi Brown; footwear and handbag designs by Prada; and jewelry by David Yurman. There are many lower-priced versions of these items, but they cannot capture the attention of many fashion enthusiasts simply because the prestigious signatures are missing.

Patronage Motives

People have numerous places where they may purchase fashion merchandise, including brick-and-mortar outlets, catalogs, Internet Web sites, and cable television programming. The factors that motivate shoppers to buy from these vendors include service, price, sales associate attention, personal shopping availability, convenience, and merchandise assortment. The more of these features a retailer offers, the more likely it is that shoppers will continue to return for future needs. These are called **patronage motives**.

Nordstrom, considered to be the benchmark in customer service, offers a wealth of these factors and has thus emerged as a primary destination for the fashion consumer. Shoppers who

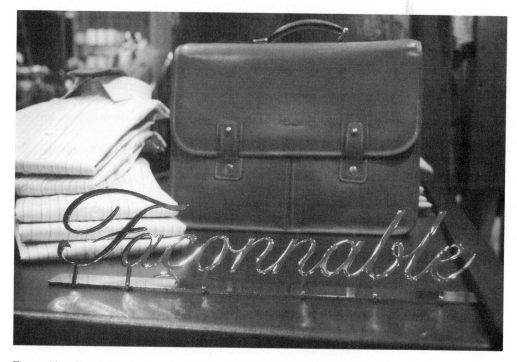

Façonnable, a French-based company, caters to many consumers who are emotionally motivated.
(Courtesy of Façonnable USA)

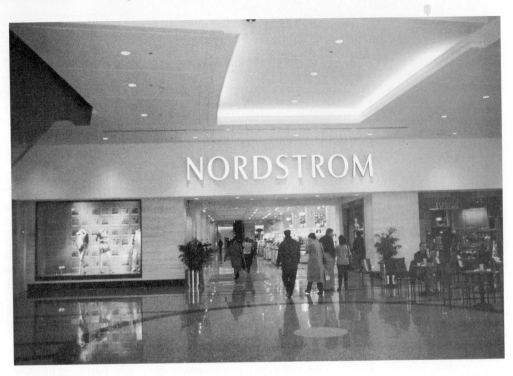

Nordstrom has led the way in shopper patronage.
(*Courtesy of Ellen Diamond*)

patronize Nordstrom have come to know exactly what to expect when paying a visit to their stores, buying from their catalogs, or purchasing through their Web site. Once customers begin to enjoy this comfort level, the store can expect repeat business.

With the wealth of competition that retailers face today, it is important to provide the right mix of merchandise and service that will appeal to a range of motivations and result in customer loyalty.

CONSUMER ASSESSMENT THEORIES

Several theories have been offered to retailers and other businesses to help them properly assess what prompts consumers in making decisions. These include Maslow's Hierarchy of Needs, the concept of decision making, the self-concept theory, and lifestyle profiling, also know as psychographic segmentation. Each is described in the following sections.

Maslow's Hierarchy of Needs

Maslow's Hierarchy of Needs is based upon the belief that people follow a strict order when fulfilling their needs. People must first satisfy the needs of the lowest classification before moving on to the next working their way up to the last level. The concept is represented in pyramid form, with the most basic needs at the bottom. The five levels are as follows:

1. *The basic needs of survival.* Cumulatively, these are considered physiological needs and consist of food, clothing, water, and shelter.
2. *The need for safety.* Once people have satisfied their physiological needs, they are concerned with the need for safety. They may make rational purchases such as sturdy athletic wear and sunscreen for bodily protection.
3. *Social needs—belonging and recognition.* Beginning with this level, people make purchases to gain acceptance by a group or to achieve recognition, and it is here that the fashion retailer plays an important role. Much of the purchasing people make is emotionally

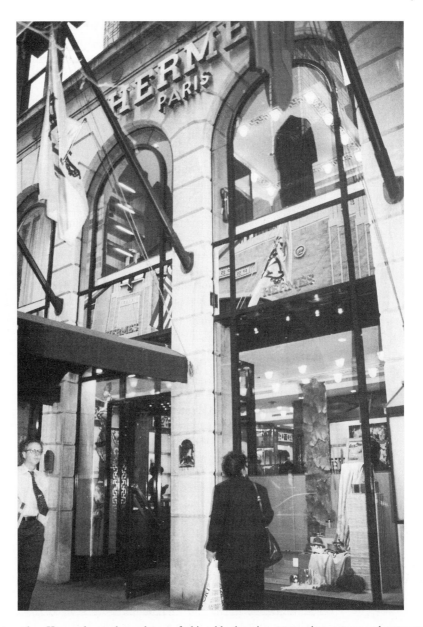

Merchants such as Hermes locate themselves on fashionable shopping streets where esteem and status are offered to the clients.
(Courtesy of Ellen Diamond)

oriented, with apparel, accessories, and cosmetics leading the way. Clothing purchases are not merely for protection and serviceability but for attracting attention and feeling a sense of belonging to a particular social stratum.

4. *The Need for Esteem and Status.* It is at this level that emotional purchasing plays the most important role. The need to be recognized as an achiever or member of an upper-class social segment prompts people to satisfy their emotional needs with such high-priced merchandise as designer or couture clothing, extravagant furs and accessories, and precious jewelry. Shops on America's fashionable shopping streets such as Madison and Fifth Avenues in New York City, Rodeo Drive in Beverly Hills, and Worth Avenue in Palm Beach all cater to the class that strives for self-esteem and status.

5. *The Need for Self-Actualization.* People who are the highest achievers reach this level. Their world involves self-fulfillment through acquiring artworks, traveling, and gaining knowledge. Their merchandise tastes very often turn to designers and couturiers who will assemble merchandise collections exclusively for them. Some people at this level, however, are so complete within themselves that they have no need for fashion.

It is apparent that the first two levels are of little importance to fashion merchants, since people's purchasing to meet these needs are totally rational and must provide for survival and security. The remaining levels have strong implications for fashion retailers, who must determine how they could best satisfy people's needs for recognition, acceptance, esteem, and status.

The Concept of Decision Making

The concept of **decision making** consists of five stages. By becoming familiar with how people make choices, the fashion merchants can gain still more insight into satisfying their customers' needs. The process involves the following:

1. *Awareness of Need.* Some stimulus such as advertising, a visual presentation, or a special event ignites need for a product. For example, a woman receives a wedding invitation.

2. *Gathering Information.* Once the woman determined that she wants to attend the wedding, she begins to gather the necessary information to satisfy the need. She may want to buy a dress to wear or buy a present for the newlyweds. She may know about places where she can buy these items from either print or broadcast advertisements; recollections of stores, catalogs; or Web sites that had satisfied such needs in the past; or a friend's suggestion.

3. *Evaluating Choices.* Oftentimes there are many dresses or gifts from which to choose. The woman must evaluate each before reaching a final decision.

4. *Making the Decision.* The woman carefully measures each item against established criteria that might include price, attractiveness of the product, alternate uses, and so forth. Once she has studied the items in question she makes a decision to purchase or not to purchase. If she has not reached a positive decision to buy a dress or gift, she continues the process until the need is satisfied. It is at this level that the retailer plays an important role. Through understanding the principles of decision making, the retailer can apply various approaches to assist the customer with the selection.

5. *Satisfaction with the Decision.* After the woman buys a dress to wear to the wedding, she may consider whether or not the decision was appropriate. Was the red dress she bought as practical as the black one left behind? Was the price reasonable or more than she should have spent? Will the selection satisfy her emotional needs, which is the underlying reason for most purchases of fashion merchandise? The answers the retailer can provide to these and other questions can either make the customer a "regular" or dissuade her from again patronizing the store. It is therefore important for the merchant to be as helpful as possible by assisting the customer, making suggestions that will be both beneficial to her, and assuring her that the red dress she chose is the best one for this wedding.

The Self-Concept Theory

The **self-concept theory** focuses on how the consumers perceive themselves. Fashion retailers can gain another perspective of their customers by applying this theory to how they stock their inventories. The four concepts are as follows:

1. *Real Self.* This describes what the person really is in terms of ability, appearance, interest, and so forth.

2. *Ideal Self.* This is what the person would like to be and is always trying to achieve. The fashion retailer attempts to satisfy this aspect by offering merchandise that would help them attain their desired image. The woman who saves and saves so that she can purchase a new fur coat or a smashing piece of jewelry to make herself feel successful and the man who uses the newest male-oriented line of cosmetics to achieve an impression of rugged, outdoors looks are two examples of this aspect.

3. *Other Self.* This is a combination of the real self and ideal self; what the person's self-image is.

4. *Ideal Other.* This is how others perceive the person and how the person would like to be perceived by others. It combines the first three aspects of real self, ideal self, and other self.

If the retailer can feature products that help people realize their ideal self, people will buy more of them. The cosmetics industry, in particular, offers products to make people ap-

pear as their ideal selves; fashion merchandizers selling luxury goods also help people achieve this image.

Lifestyle Profiling

By studying people's lifestyles and attitudes, fashion retailers are able to take even closer looks at their targeted markets. Where demographics reveal a wealth of information regarding the groups of consumers, **psychographic segmentation**, zeros in on individual lifestyles.

One of the earliest proponents of **lifestyle profiling** was Standard Research Institute (SRI), a consulting firm that studied consumers through a number of different research tools. Today, the company is an employee-owned spin-off called SRI Consulting Business Intelligence (SRIC-BI.)

Fashion Retailing Spotlights

SRIC-BI

When industry experts, including fashion retailers, want to use an outside resource to assess potential consumers, they invariably contact SRI Consulting Business Intelligence. The company's areas of expertise include strategy planning, management practices, technology management, innovation and commercialization, and external-environment intelligence.

SRI's experienced team of experts and research capabilities are enhanced by a unique tool set that develops new opportunities for its client base. Market assessment, scenario planning, and opportunity discovery are among the many areas that the company investigates, but none have been more meaningful than its VALS Segments. This concept applies psychology to understanding and predicting consumer behavior. It explains what motivates consumers to buy, how marketers and product designers use strategic and tactical planning to gain a fair share of the marketplace, and how consumer trends may be best understood.

The original VALS system was built by consumer futurist Arnold Mitchell, who created the concept to explain the changing values and lifestyles in the 1970s. At the time, *Advertising Age* cited it as "one of the ten top research breakthroughs." In 1989 the system was redefined to maximize its ability to predict consumer behavior. A team of experts from Stanford University and the University of California, Berkeley, determined that consumers should be segmented on the basis of enduring personality traits rather than social values that change over time.

By using psychology to analyze and predict consumer preferences and choices, the VALS system creates an explicit link between personality traits and purchase behavior.

The VALS Segments table (Table 4.1) identifies each segment, defines specific individual characteristics of each, lists what motives these types, and describes the nature of the purchases they are likely to make.

In analyzing the different VALS classifications, it is obvious that innovators, experiencers, achievers, and strivers are the best groups for fashion merchandisers to pursue. Each, to varying degrees, spends a considerable portion of its money on such purchases.

CONSUMER ANALYSIS

It is imperative that merchants have a complete understanding of the characteristics of the marketplace from which they hope to attract consumers. The major research studies deal with a host of different areas, one of the most important of which is **demographics,** the study of population traits and characteristics. By analyzing population shifts, market size, family status, nationalities, age groups, and so forth, it is possible to gain a significant insight into potential markets. Social classes, and the ways each level views its income, goals, education, and attitudes, and the family life cycle and how the needs of people at each stage affect their purchasing potential are two other areas that merit attention.

TABLE 4.1 The VALS Segments

Segments	Characteristics	Motivations	Purchases
Innovators	Successful, sophisticated, high-esteem	Image, new ideas, technologies	Upscale, niche products and services
Thinkers	Mature, satisfied, comfortable, conservative, reflective	Open to new ideas	Durable, functional, value products
Achievers	Goal-oriented lifestyles; focus around family, place of worship, and work; politically conservative	Image, stability, self-discovery	Established, prestige products and services that demonstrate success to their peers
Experiencers	Young, enthusiastic, and impulsive	Variety, excitement, risk	Fashion merchandise, entertainment, socializing
Believers	Conservative, conventional concrete traditions; established codes of religion, family	Ideals	Familiar products and established brands
Strivers	Trendy and fun loving, active consumers	Achievement, money, emulating purchases of people with greater material wealth	Stylish products
Makers	Practicality, self-sufficiency	Self-expression, tradition	Basic, practical, value products
Survivors	Few resources, cautious	Safety and security	Brands, discount prices

Source: **www.sric-bi.com/VALS**.

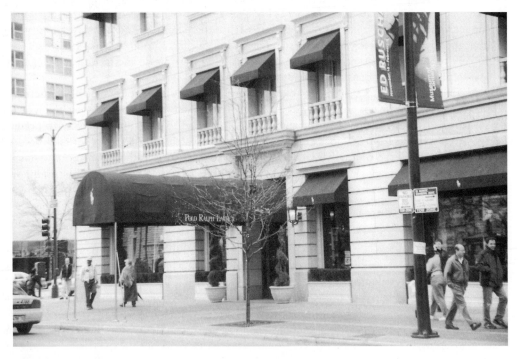

Achievers, according to VALS research, purchase established, prestige products from such fashion designer retailers as Ralph Lauren.
(Courtesy of Ellen Diamond)

Demographics

Demographic information is used differently by the various retail classifications. Brick-and-mortar organizations, for example, are more concerned with population density than are off-site operations such as catalogs and Internet Web sites, because their customers come from the geographic trading areas in which their stores are located. Off-site retailers, in contrast,

have no real boundaries, since consumers with computer access or a mailing address can examine their product assortment anywhere. Age classification, however, has implications for every type of retail classification. Therefore, retailers need to assess the population trends that most affect their consumer bases so they can determine the best use of their resources to attract them.

POPULATION CONCENTRATION

Brick-and-mortar fashion retailers in particular must evaluate the areas in which their potential customers reside, because if can affect the specifics of the merchandise mix that they stock. People living in the suburbs, for example, might have more casual lifestyles than their urban counterparts, so their fashion needs are in the lines of informal comfortable clothing. Those who live in the major urban cities, have a busier, faster-paced lifestyle, so their dress is often more high fashion or career oriented.

Studying these different regions will help fashion managers determine which of these groups will buy their products. If people from more than one geographic concentration will patronize their stores, merchants should carefully assess their needs and lifestyles to determine which products might appeal to both types of customers. Often, major retailers with stores in downtown, central trading districts and suburban shopping malls tailor their merchandise mix to fit these communities' specific needs. The downtown flagship might, for example, stock a greater mix of career dress and the suburban branches might have a greater concentration of sportswear.

CLIMATE DIFFERENCES

If a store has its units in just one geographical climate, then merchandise emphasis and assortment, are comparatively simple to determine. Those fashion retailers that exclusively operate southern outlets, for example, stock a mix that includes swimwear in each of their units. Larger companies, such as Banana Republic and Casual Corner, that have stores that cross into different climate zones must address the different merchandise needs dictated by their locations. Lightweight clothing fits the everyday needs of customers shopping in the stores in the year-round warmer climates, and heavier garments are in demand during the winter months in such areas as the northeast. Fashion retailers must carefully consider their merchandise differentiation to make certain that the right assortment is available at the right time and place; improper merchandise allocation could adversely affect overall company profits.

AGE GROUPS

Although age consideration is an important factor in the merchandising of most retailers' assortments, it is fashion merchandise that offers more variables than any other product classification. A look at consumers on the street immediately reveals that dress varies considerably among the different age groups. Within the same geographical location, a teenage girl wearing a micro-mini skirt in the latest style can be seen walking along with her grandmother, who is attired in a more conservativly fashionable outfit.

Given the different needs of the many age classifications, it is vital that the right styles are being marketed to the right groups. By segmenting the consumer market into age categories, retailers are able to determine the size of each group, its potential for growth or decline, and its distinguishing characteristics. In this way, they can assess which groups are better to target for fashion merchandise and what their specific buying preferences are.

Age groups may be segmented in a number of different ways. Recent designations used by marketers to describe particular segments, especially as they concern fashion merchandise, include **baby boomers**, people born between 1945 and 1959, and **generation X** and **generation Y**, people who were ages 18–34 at the beginning of the twenty-first century. More traditional age classifications have been established by the U. S. Department of Commerce, and they are described below with their implications for fashion retailers.

Children. Ranging in age from birth to under thirteen, this group has become increasingly more important to the fashion retailer. Although newborns don't count as purchasers, children from such early ages as three begin to be important as those who influence those who do buy the products. Because these young children watch television, they are regularly inundated with commercials for a wide range of products, and they often badger their parents until they get what they want. Older children are also influenced by their favorite television characters and often want to emulate their favorite personalities by dressing as they do. Companies such as Gap and Limited have taken their cues from the potential of this market and have expanded their operations. As the size of this age group grows Gap continues to open more units of Baby Gap and Gap Kids, as does the Limited with Limited Too.

Teenagers. When it comes to purchasing trendy fashion merchandise, this age classification has no rival. Teenagers tend to embrace everything that comes onto the fashion scene. If short skirts are the order of the day, they opt for the shortest; if it is ankle-length skirts that are being touted, then they will wear skirts that drag on the floor. No matter the shoes' color, the size, and the shape of its heel, teens will buy them if they're in style. Teens are often influenced by what is being worn on their favorite television shows. For example, the 2002 program *American Idol* significantly impacted the styles teenagers bought.

Young children have become increasingly more important to retailers, although they are not the direct purchasers. *(Andy Crawford © Dorling Kindersley)*

This group is a blessing for the merchant that primarily sells trendy fashions. Teenagers generally choose less-costly garments because they like to have a lot of clothes, but they stop wearing them once they are out of style. They make up their minds quickly because there are lots of styles in their sizes and they know what they want because their fashion appetites have been whetted by the fashion publications catering to them. Teens also buy in greater quantities than the other age groups. They patronize companies such as Old Navy, Abercrombie & Fitch, Wet Seal, and American Eagle.

Young Adults. This age group is actually composed of two classifications: Those still in college, and those in the early stages of a career. Both have significant needs for fashion merchandise; however, the former group is more focused on relaxed clothing and accessories for classes and special attire for social occasions. The latter group spends on both career dress and after hours wardrobes. As a whole, they spend more on fashion merchandise than their teenage counterparts since they are usually in better financial situations. They usually shop in specialty shops where they can find merchandise assortments tailored to their needs and can get in and out faster than they can in department stores. Companies such as Ann Taylor, Banana Republic, Limited, Express, Victoria's Secret, and The Gap pay close attention to the needs of this group. Young adults also do a lot of purchasing on-line.

Preteens are made aware of fashion from the television shows they watch.
(© Dorling Kindersley)

The teenage market is extremely important for trendy fashion merchandise.
(David Young-Wolff/PhotoEdit)

Young Middle-Aged. This group includes those with the highest incomes. Many are top-level corporate executives, businesses owners or professionals. Their incomes and lifestyles make them the prime target for the fashion retailers. They patronize prestigious specialty and department stores and make significant purchases from fashion catalogs and online because their time for in-store shopping is often limited. Well-tailored quality designer brands such as Calvin Klein, Ralph Lauren, and DKNY are directed at this audience, where price is a less important factor in their selections. Companies such as Saks Fifth Avenue, Bloomingdale's, Neiman Marcus, Bergdorf Goodman, and a host of upscale fashion boutiques cater to young middle-aged patrons and their fashion needs.

Older Middle-Aged. The people in this group are often of two types. One is still career oriented and requires fashions that are important to their everyday professional lives. They are often in the market for quality merchandise at upper-level price points. Since their careers often involve social obligations as well, they buy fashionable occasional clothing and accessories. The other segment of this group has retired and spends more time in leisure activities such as travel and recreation. These people still want fashion items but often prefer sportswear because they spend their time playing tennis or golf. Consequently, manufacturers of traditional sportswear offer collections tailored to these interests. Ralph Lauren, for example, features a line of golf clothing that is available at pro shops and department stores. The retired segment has more time to spend shopping, so they often prefer to make their purchases in department stores. They generally do not use the Internet.

Elderly. The elderly market is not typically as important for fashion retailers. The elderly are usually more concerned with health and other personal problems than they are about fashion. Their purchases are usually for functional merchandise, often lower priced and more conservative in nature. There are, however, a growing number of people in this classification who spend more time on vacations, and cruises are very popular. For those occasions they buy evening wear. Collectively, they are considered to be "difficult" shoppers because many live on fixed incomes and cannot be moved from their preconceived ideas about "proper" fashion.

Table 4.2 summarizes the six age classifications as studied by the U.S. Department of Commerce, with their age ranges, their fashion needs, and the typical retailers they patronize.

Except for a relatively small number, the elderly are not devotees of fashion merchandise.
(Ken Karp, Pearson Education/PH College)

TABLE 4.2 Age Group Segments

Classification	Age Range	Fashion Needs	Retail Patronage
Children	Under 13	Younger portion opts for "character" clothing; older group prefers dress of television stars	GapKids, Baby Gap, Limited Too
Teenagers	13–19	Trendy merchandise	Express, Wet Seal, Abercrombie & Fitch; on-line
Young adults	20–34	Sportswear, career dress, leisure apparel	Ann Taylor, Banana Republic, The Gap; on-line
Young middle-aged	35–49	Upscale fashion apparel and accessories, designer labels	Neiman Marcus, Saks Fifth Avenue, fashion designer boutiques; catalogs and on-line
Older middle-aged	50–64	Still working: career clothing, after-hours apparel. Retired: sportswear	Department stores such as Macy's and Bloomingdale's; catalogs
Elderly	65 and over	Functional clothing and accessories	Discounter such as Target and Wal-Mart; catalogs

OCCUPATIONS

Today's consumer marketplace is quite different from that of the past. Women, for instance, have made the transition from homemakers to business executives and professionals and have joined the ranks of the male members of society as viable players in the workplace. As a combined group, they are an extremely important segment of the population for fashion retailers. However, a major portion of those employed work in blue-collar jobs. While female office workers and nonoffice workers both have clothing needs, their requirements are quite different. The former segment is interested in a wide assortment of suits, accessories, and other fashion merchandise. The latter's needs are more basic and functional, and except for special occasions, they have little interest in fashion merchandise.

The apparel and accessories requirements of professionals and business executives also change. In the late 1990s two trends in the business world changed how office workers dressed. The first trend was **Casual Friday**, which became popular in the offices of attorneys, investment bankers, and other high-level places of employment. This phenomenon, which allowed men to wear open-collared shirts, sports coats, and contrasting slacks, caused a downturn in sales for merchants who stocked suits and more traditional workplace clothing. They had to change their merchandise assortments to deal with the new casual mode of dress. In fact, in many places, the Casual Friday approach to dress carried over into other days of the week, causing even more concern for those who sold suits, business shirts, oxfords, ties, and other more formal wear. The women's wear market was equally affected, since women wore pants suits in place of dresses.

At the start of the twenty-first century, many companies returned to the traditional formal mode of dress. This departure from the casual look brought with it a larger market for formal dress. Suits for men began to reclaim their share of the retailer's inventory, and more dresses were sold.

The second trend was the work-at-home phenomenon, which reduced the need for all kinds of career clothing. With approximately 40 million people telecommuting, jeans and T-shirts became the order of the day. Even sleepwear was being bought in greater quantities by those who didn't have to interact personally with coworkers and clients. Again, fashion retailers had to rethink their merchandise mixes to accommodate this ever-growing group of consumers. These recent trends show that retailers must continuously evaluate the business and professional marketplace to ascertain what the components of acceptable dress will be.

Today, there is no longer one standard of proper dress for people who are gainfully employed. Retailers must do regular needs assessment to determine that they maintain the proper breadth and depth of apparel and accessories that their targeted markets desire. They must adjust their inventories accordingly to ensure that they can profit from the trends rather than lose money on outdated merchandise.

INCOME

A person's income plays the most significant role in determining if a purchase can be made. Although shoppers might like to buy Armani creations, their ability to pay for them is the ultimate factor in determining if they will do so. Consumers must first pay for the necessities of life, (as outlined in the section on "Maslow's Hierarchy of Needs"). Other parts of their disposable income must be used for other important purchases; eventually, they determine what portion of their income is **discretionary income** that is available for more luxury items such as precious jewelry and designer apparel.

Fashion merchants must evaluate the various income levels of people residing in their trading area and make certain that they stock merchandise at price points that are commensurate with them.

EDUCATION

The manner in which people dress is often based upon their educational level. Those with advanced degrees in law and business administration, for example, will have a greater need for fashion apparel and accessories than those with less formal educational achievements. Attorneys, investment bankers, security traders, and those in similar professions are expected to dress in more traditional attire in their business environments and in the social engagements that are often extensions of the office place. The specialty retailer Brooks Brothers is a perfect example of a company that caters to this clientele; others include specialized department stores such as Saks Fifth Avenue and Neiman Marcus.

Social Class Groupings

One of the concepts most utilized by fashion retailers in the determination of appropriate merchandise mixes and price points is the one involving American **social class**, by which groups of people are segregated into homogeneous categories according to income, occupa-

tion, background, educational levels, and other factors. Studies show that the different groups have different shopping preferences and merchandise needs.

Traditionally, the most popular approach to social class groupings is to divide the population into three distinct classes with two subdivisions within each one.

UPPER CLASS

The most socially prominent group in the three classes is the upper class. This wealthiest segment accounts for approximately 3 percent of the population. It includes in its numbers both wealthy families that have inherited their wealth from past generations and the "nouveau riche," who have come into their own wealth as a result of their own successes.

Upper-Upper Class. This segment represents about 1 percent of the population. It has among its constituents such family dynasties as the Rockefellers and the Vanderbilts, who are considered to be the socially elite in the United States. Members of this segment make purchases that are often understated and without thought to cost. Their main requirement is quality. In terms of fashion, they prefer understated designs for casual wear and couturier designs for the many social functions that they attend. Some people in this class, in fact, have been known to be the catalysts in bringing new designers to the forefront of the fashion world.

This class patronizes such prestigious specialized department stores as Bergdorf Goodman, Neiman Marcus, and Saks Fifth Avenue and boutiques for both men and women that include labels by Calvin Klein, Ralph Lauren, Yves Saint Laurent, Gucci, Ferragamo, Dolce & Gabbana, and Fendi. They frequent such famous American fashion streets as Worth Avenue, in Palm Beach, FL; Madison and Fifth Avenues, in New York City; Rodeo Drive, in Beverly Hills, CA; and overseas venues that include Avenue Foch, Paris, and Rue Antibes, Cannes. Fabulous jewelry from such world-renowned companies as Harry Winston, Van Cleef & Arpels, and Tiffany's are also part of their fashion purchases.

Lower-Upper Class. The remainder of this upper class strata accounts for 2 percent of the population. These are the new rich Americans. Unlike their counterparts of the upper-upper class, these people are business executives in major corporations, owners of companies, professionals, and entertainers who have amassed their own fortunes without inheriting them. In terms of spending, price is not a major factor. They are conspicuous spenders and shop at the finest boutiques and specialty stores around the globe. Fashion purchases are often for products that will make them stand out in a crowd.

MIDDLE CLASS

Comprising approximately 42 percent of the population, the middle class is the second largest segment. Unlike the upper class, where the two subdivisions have spending similarities, the upper- and lower-middle class have distinctly different habits.

Upper-Middle Class. The smaller of the middle-class segments accounts for approximately 12 percent of the population. These people are concerned with prestige and status and seem to want to make the transition to the lower-upper class. They are professionals and owners of businesses and spend their leisure time trying to emulate those in the classes above them.

Although many in this class are high earners, their wealth is sometimes less than they need to enable them to purchase as freely as they would like. To satisfy their fashion needs with designer clothing and other prestigious merchandise, this group regularly visits well-known fashion department and specialty stores at times when markdowns enable them to purchase upscale, high-fashion goods at reduced prices. Off-price shops such as Loehmann's, closeout centers such as Last Call by Neiman Marcus, and designer outlets of companies such as Ralph Lauren and Anne Klein are regular haunts for this class. Shopping in these places allows them to buy the same fashion labels that are found in the traditional stores but to spend less money. Since recognition, by way of their fashionable wardrobes, is important to this class, they are the best customers for quality merchandise at bargain prices.

Lower-Middle Class. Significantly larger than the upper level of this class, this segment accounts for 30 percent of the population. Members of this class are primarily

conscientious workers with conservative values who have a strong desire for their children to earn college degrees

Unlike members of the upper-middle class, they place less importance on "showy" fashion merchandise and consider price to be a very important factor in making purchases. Where as the higher classes shop early in the season for fashionable clothes, this group makes its selections as the needs arise, and therefore shops frequently, though rarely spending large sums of money at one time.

People in the lower-middle class typically buy their fashion merchandise from department stores that specialize in popular-priced merchandise, from discounters such as Target and Wal-Mart, and from off-pricers such as Burlington Coat Factory and Marshall's. They are not terribly interested in quality or conservative styles but tend to be attracted by the latest styles and colors. Fashion designer labels are not necessarily important to this group except in cases where they are deeply discounted by off-price merchants.

LOWER CLASS

This is the largest class of Americans, at 55 percent of the population. At times when the economy falters, as was the case in 2002, this group has a rough time paying for the necessities of life, let alone fashion merchandise.

Upper-Lower Class. At 35 percent, this is the largest subsegment of the population. Members of this group are generally poorly educated and hold blue-collar jobs that give them insufficient amounts to spend on fashion merchandise. When they do have fashion needs, they generally buy very inexpensive apparel and accessories. Price is an extremely important factor, so they generally limit their purchases to discount operations, off-price shops, and specialty stores that merchandise the lowest priced lines.

Lower-Lower Class. With little or no formal education, the lower-lower class accounts for 20 percent of the population. Many in this group are welfare recipients and have barely enough to satisfy their needs for survival. Fashion merchandise is generally out of the question, except for the occasional celebration. When they do shop for this type of merchandise, they often head for the second-hand shops.

Since fashion merchandise is available at just about any price point, it is necessary for merchants to know the social classes of their markets. In this way, they can satisfy the needs of their customers and potential shoppers by providing them with the types of retail operations they find suitable to their social stations and the clothing and accessories they desire.

Family Life Cycle

People who are at a specific stage in their **family life cycle** generally have the same needs as others at the same stage of life. By studying these various segments or stages, fashion retailers can assess the needs of particular groups in their trading areas. For example if a geographic area is dominated by empty nesters, it is safe to assume that their needs and desires would be similar. However, there are also differences within each group in terms of income, occupations, educational levels, and lifestyles that affect their purchasing potential.

Classifications within the family life cycle have changed in recent years. At one point, retailers that assessed these groups for their planning strategies concentrated on more traditional classifications. Today, however, nonconventional segments have been added to the list and include such categories as multiple-member/shared households and single parents.

CHILDLESS SINGLES UNDER 45

This is a very diverse segment of the population. Those in their twenties, for example, are relative newcomers to their careers and generally have lower incomes than their older counterparts. Collectively, however, they represent an excellent market for many retailers. With little responsibility other than to themselves, many in the group have a great deal of discre-

tionary income. Once they have satisfied the needs of rent and utilities, the bulk of their salaries is often spent on fashion merchandise and cosmetics. Often intent on meeting others in similar situations, they have memberships in fitness centers, frequently dine in restaurants, and engage in travel to unique destinations. Each of these activities gives them reason to purchase active sportswear, apparel and accessories, and a host of cosmetics. Those at the upper end of the income scale in this classification are usually devotees of designer labels such as Prada, Dolce & Gabbana, Ralph Lauren, Calvin Klein, and Donna Karan. Those at the midpoint of this segment in terms of earning power opt for less costly merchandise and do their shopping at companies such as Banana Republic and Ann Taylor, where the latest fashions are readily available. At the lowest level of this group, The Gap is a familiar haunt where they can have their fashion needs satisfied.

CHILDLESS SINGLES 45 AND OVER

In today's society, more and more people are choosing to remain single. As is the case with their younger counterparts, they often enjoy significant incomes that afford them the opportunity to live exciting lifestyles that warrant a great deal of fashion apparel and accessories. Many are in their own businesses, have medical and dental practices, or are employed as attorneys, investment bankers, or technology managers. They too patronize the merchants that offer the latest in fashion.

Although many live alone, others participate in lifestyles that are akin to marriages but without the licenses. In these cases, because they share expenses, they often have greater discretionary spending power.

SINGLE PARENTS

With a divorce rate that seems to be steadily increasing and the number of unwed mothers also spiraling upward, this has become an important segment of the population for retailers to address when planning their merchandise assortments. Often short on cash, single parents typically do not have sufficient amounts of disposable income to purchase a great deal of fashion merchandise. They have to be able to support themselves and their offspring. Women are not alone in this category, although the majority of them have the children from their former marriages live with them. Men, although not typically the everyday rearers of these children, do have some financial responsibility in their upbringing.

Given their financial stress, when this group does buy fashion merchandise, it is more likely to buy from discounters such as Target, Wal-Mart, and Kmart and off-price merchants such as SteinMart and Marshall's.

MULTIPLE-MEMBER/SHARED HOUSEHOLDS

The costs associated with housing and other necessary expenses have contributed to the need for people without marital connections to live together. In major cities across America, rents keep rising to previously unseen levels. This phenomenon has given birth to this new family lifestyle category, **multiple-member/shared households**.

Those who are part of this group include, same-sex relationships, opposite-sex relationships with the possibility of marriage, opposite-sex relationships without the intention of marriage, and two or more sets of single parents with children who live with them.

The diversity of people involved in this group results in purchasing characteristics that differ widely. Singles who plan to marry each other, on the one hand, are among those who often share dual incomes that enable them to make more than just the basic purchases. Many of these couples have no intention of having children, making them excellent customers for fashion merchants. Companies such as Saks Fifth Avenue and Bloomingdale's and designer boutiques are their main purchasing outlets. On the other hand, single parents sharing a household with one or more children living with them often find it difficult to make ends meet. They often live from paycheck to paycheck and do not have the luxury of buying merchandise other than the basics. When they do purchase fashion items, it is often from discounters and off-price merchants.

Single-earner couples often have limited resources, especially when they have children.
(© Dorling Kindersley)

SINGLE-EARNER COUPLES WITH CHILDREN

Because of rising living expenses of raising children, this classification has seen a radical decline in the past twenty years. Of course, some in this category do retain the single-earner status and maintain a standard of life that allows them to satisfy their fashion needs. Attorneys, investment bankers, health professionals, and business owners, for example, are part of the upper-middle class and earn enough to make the luxury purchases they desire.

Those in this classification with limited funds buy their fashion merchandise from discounters such as Target and Wal-Mart; the more affluent members of the group head for the brick-and-mortar operations such as Bloomingdale's and Nordstrom, fashion boutiques, and catalog resources or on-line sites that specialize in fashion apparel and accessories.

DUAL-EARNER MARRIED COUPLES WITH CHILDREN

With two employed parents, members of this group are financially better off than their single-earner counterparts. Those in this group who have very young children generally require preschool programs or nannies to tend to their children while they are at work. This expense can be considerable and can affect the spending capabilities of these families. At the other end of the spectrum, those with children in college also find their expenses spiraling upward, requiring them to be cautious about spending.

Those who have substantial dual incomes are more likely to shop in the major department and specialty store organizations, while the less financially affluent are more likely to head to The Gap and Old Navy, where value fashion shopping is possible.

Once the children have moved out of the house and expenses for college have been satisfied, the sky is often the limit for these families. At this point, especially if both partners are still employed, cost is no longer a factor in terms of fashion purchases.

CHILDLESS MARRIED COUPLES

This classification is composed of couples at any age. They may be newlyweds who do not intend to raise a family, middle-aged people, or the elderly. In any case, collectively, they are

financially better off than their counterparts who have children. While the taste levels of those in this group vary considerably, they are generally able to buy whatever pleases them. Fashion purchases are generally made at the traditional full-line or specialized department stores and upscale specialty brick-and-mortar operations.

EMPTY NESTERS

Those who have raised families but now live alone, known as **empty nesters**, are in a position to buy what they want without the need to be cautious. With expenses greatly minimized, they often spend on fashion items that they once considered too extravagant to consider. Many are still working and are at higher levels of income than anytime in their lives. With the ability to travel and join country clubs, they are often in the market to purchase fashion apparel and accessories to suit their new lifestyles. Where they once maintained wardrobes that were business oriented, they now adopt a freer approach to shopping. Designer labels are often their choices, as are the stores that offer them in abundance such as boutiques and specialty shops.

While family life cycle classifications remain constant, the people within them generally move from one to the other, depending upon their times in life. Singles might marry, dual-earners might retire, married couples might divorce, and so forth, making their needs change. This is particularly true when it comes to fashion merchandise. The places in which they make their purchases might change from the traditional department stores to discount operations where value rather than selection might prevail. Fashion retailers must always address these different classifications and determine which family life cycles are most dominant in their trading areas.

While there are numerous theories and concepts that businesses have accepted in the study of consumer behavior and related topics, some companies opt to conduct their own research to determine customer reaction to their products. One such study was undertaken by Dupont to ascertain which groups of consumers had potential to buy products that used Dupont's fibers. The following "Spotlight" section on Dupont's study describes its findings.

Fashion Retailing Spotlights

DUPONT'S COHORT STUDY

By studying cohorts, or groups, marketers are able to determine which would be likely candidates for their products. Dupont, world leader in fiber manufacture, undertook research that would not only help the company in its attempt to market the right fibers but also would enable it to examine its potential customer segments.

The study separated, or segmented, ten age groups, ranging in age from eight to ninety, and investigated the values and consumption patterns of each. The findings are presented below, along with the implications for the fashion retailer.

World War I Babies. The hardships brought about by the Great Depression had lasting effects on members of this group. They remain overly cautious in their purchasing of anything but necessities. This age segment is extremely small and is not very important to the fashion retailer. The merchandise the members purchase is often practical and functional and must last for many seasons. The pay little attention to trendy or fashion merchandise. When they do opt for merchandise with a fashion orientation they usually buy it at chains or department stores that specialize in lower price points.

Roaring Twenties Babies. Members of this group are not preoccupied with possessions but prefer to spend on travel, entertainment, and similar things. They are more fashion conscious than their World War I counterparts, but they too are not considered prime targets of fashion retailers. Like the elderly in the preceding group, they are few in numbers. Those who are still interested in shopping for products other than the necessities generally have limited budgets. When they buy apparel and accessories, they do so at off-price stores and discount operations. If they shop at a department store, it is generally at markdown time.

(continued)

Depression Babies. Having spent a great deal of money on college education for their children, the time is ripe for members of this group to spend on entertainment, travel, and some luxury items. Those with considerable money are status spenders and are the prime targets for designer labels. They are likely to shop at upscale department and specialty stores, boutiques, and designer shops.

World War II Babies. While a large percentage of this class is still paying for their children's college education, members of this group are often devotees of fashion products. Many of the women are in the work force and require fashionable clothing and accessories. Since their careers provide them with less time to shop in department stores, those who still enjoy a hands-on approach to purchasing often head for the specialty chains and boutiques. Many in the group purchase through catalogs and Internet Web sites during their free time. This group accounts for a number of divorces, which means that they have less money to spend on fashion merchandise. Both divorced men and women shop at off-price outlets that feature designer labels at prices below those of the traditional department stores.

Mature Boomers. At ages forty-five to fifty-five, the **mature boomers** would like to spend on fashionable clothing, but many are often preoccupied with the costs of raising their families. They like nice things but cannot always buy in the amounts that they would like. Merchandise for members of this group is fashionable but functional, and they usually shop at chains, off-price centers, and specialty department stores.

Mid-Boomers. This age segment is from thirty-three to forty-four years of age. **Mid-boomers** spend more on fashion merchandise than any other group. Many are dual-income families, therefore significantly increasing their overall finances, and spend to reflect their increased income. Making fashion statements is a must for many of them. They shop at boutiques, specialty stores, upscale department stores, and other brick-and-mortar operations where their fashion appetites can be satisfied. Many of them also make significant use of catalogs and Internet Web sites to make their purchases.

Young Boomers. These twenty-six to thirty-two year-olds are often focused on making money and spending it as quickly as they earn it. **Young boomers'** fashion requirements are often trendy, and they shop at the specialty chains, from catalogs, and on-line resources.

Mature Busters. The twenty-to-twenty-five year-olds are generally influenced by their peers when it comes to purchasing fashion items. **Mature busters** are also greatly inspired by the fashion publications they regularly read and the personalities they see on their favorite television shows. They patronize lower-price point stores because their incomes are usually too low to afford better. Quantity is more important than quality in terms of their clothing and accessories purchases.

Young Busters. At ages fourteen to nineteen, these shoppers are not self-sufficient. **Young busters** have part-time earnings that go toward fashion purchases at chains such as Express.

Mature Boomlets. Although they are only eight to thirteen-years of age, **mature boomlets** are the ones whose members are highly indulged by their parents. Many are already aware of style and fashion and influence their parents to purchase such merchandise for them. They are more "sophisticated" in terms of fashion than any others in that age group that came before them, due in part to their fascination with television. Their needs are primarily satisfied by the chains such as GapKids and Limited II.

TRENDS IN FASHION CONSUMER BEHAVIOR AND STATUS

In the coming years, competition for consumers is expected to increase at significant rates. To make certain that they continue to get their fair share of the consumer's dollars, many fashion merchants will continue to study the trends that will affect consumer spending. Some of these trends are described in the following sections.

Assessment of On-line Buying Motivation

The enormous increase in the use of the Internet for fashion purchasing will prompt merchants to explore the motives of those who buy apparel and accessories on-line. More and

Two young girls at Christmas.
(Andy Crawford © Dorling Kindersley)

more studies will be undertaken to see if the shopping motives of the off-site purchasers are the same as those who shop in the brick-and-mortar operations.

Reexamination of Demographics

Many merchants who have extended their brick-and-mortar operations toward multichannel retailing will consider intensive investigation of demographics. With the expanded trading areas affording more business to these retailers, it will be necessary to research their new-found consumer markets such as Web sites and catalogs and to see if their merchandise mixes are sufficient to satisfy the needs of those purchasers.

SMALL STORE APPLICATIONS

Rarely do owners of small retail operations take the time to formally investigate the theories and concepts concerned with the analysis of consumers' wants and needs. Their approach to inventory procurement, for example, is generally based upon experience, intuition, the information disseminated by trade periodicals, and manufacturers' representatives. Personal interactions with their shoppers gives many store owners all of the information they think necessary to run a successful business. While past experience should play a vital role in small retailer decision making, these store owners should not rely solely on that.

Reading basic textbooks on consumer behavior and motivation is one way in which they can master a basic understanding of the concepts. Subscribing to trade periodicals such as *Stores Magazine, Visual Merchandising and Store Design, Women's Wear Daily,* and *DNR* can give them up-to-the-minute insights about trends that might affect their consumers' wants and needs.

The Internet, with its wealth of free information, is also an invaluable research tool that will help small merchants better understand their consumer markets. By accessing such search engines as **www.askjeeves.com**, and entering such phrases as "consumer behavior," they can access a host of Web sites that offer consumer studies and concepts.

Chapter Highlights

1. Very often, purchasing behavior is based upon different motives. They are either rational, where such factors as price, care, practicality, and so forth are important, or emotional, where factors such as prestige and status come into play.
2. The patronage motive helps a consumer make the decision about where to shop.
3. Maslow's Hierarchy of Needs is a theory that is based upon the order in which humans fulfill their needs.
4. The self-concept theory describes how the consumers perceive themselves.
5. Lifestyle profiling enables fashion retailers to take closer looks at their targeted markets. One of the major researchers in this field is SRIC-BI, a company that has been the pioneer in such studies with its widely used VALS system.
6. Demographics is the study of the population in terms of age groups, geographic concentration, occupations, and income.
7. The population of the United States is categorized into social classes. Each represents a portion of the population and suggests how those in the various groups are likely to spend their discretionary income.
8. The family life cycle offers retailers information regarding how people in the same group are likely to shop for fashion merchandise. The segments range from childless singles under age forty-five to the empty nesters, with a host of other classifications in between.
9. Many major companies undertake their own research to study how their potential customers are likely to react to their merchandise offerings.
10. Small fashion retailers, while unable to enter into their own research because of the often prohibitive costs involved, can turn to the Internet and avail themselves of a great deal of material on consumer behavior.

Terms of the Trade

rational motives
emotional motives
patronage motives
Maslow's Hierarchy of Needs
decision making
self-concept theory
real self
ideal self
other self
ideal other
psychographic segmentation
lifestyle profiling
demographics
baby boomers
generation X
generation Y
Casual Friday
discretionary income
social class
family life cycle
multiple-member/shared households

empty nesters

mature boomers

mid-boomers

young boomers

mature busters

young busters

mature boomlets

For Discussion

1. In what way do rational motives differ from emotional motives?
2. Why are patronage motives important for fashion retailers to consider?
3. In Maslow's Hierarchy of Needs, at what stage does the fashion retailer begin to surface as fulfilling a need?
4. According to the self-concept theory, at what step does the individual want to make a better impression.
5. What does the VALS system try to predict for retailers, and how does it go about doing it?
6. Define the term *demographics,* and tell how their study enables retailers to more carefully approach their potential consumer markets.
7. Which demographic age segment is most likely to be attracted to trendy, fashion merchandise?
8. For what situations might the elderly still require the purchase of fashion apparel and accessories?
9. How does the upper-upper class differ from the lower-upper class in terms of purchases?
10. Describe the upper-middle class in regard to its fashion purchases.
11. Why do *childless singles under 45* represent an excellent market for fashion merchandise?
12. How are some of the households composed in the *multiple-member/shared household* family life cycle?
13. Do the family life cycle segments remain constant? Explain.
14. Why do some companies, such as Dupont, conduct their own consumer research projects?
15. How do the youngsters in the *mature boomlet* stage influence fashion purchasing?

CASE PROBLEM I

Five years ago, Sue Gallop and Muriel Litt entered into a partnership agreement for the purpose of purchasing a small, established specialty boutique. The store, located in an affluent midwestern suburb, had been owned and operated for eight years by Margie Paxton. Its success was immediate, and Margie enjoyed the rewards of her business for all of the years that she owned it.

Her concept was to offer high-fashion, quality merchandise with an equal amount of designer clothing and custom-made models. Her clientele, initially drawn from friends and acquaintances, ultimately expanded to make hers one of the area's most distinguished boutiques.

When Sue and Muriel purchased the store from Margie, they put some of their own touches on the business, and the venture became more successful than when they bought it. Couturier designs from around the world were added to the merchandise mix, and these items became an important part of the store's collection.

As the sales volume began to grow, so did the two partners' desire for expansion. They thought of adding a wing to their existing location but scrapped the idea, feeling it would take away from the intimacy that helped make the store such a winner. The other choice was to open another unit.

After a great deal of searching, they came upon a location that seemed perfect. It was situated fifty miles from their first shop on a busy main street in a community that resembled their other location. The size of the vacant store was appropriate for their needs, as was the rent. A drive through the surrounding area drew their attention to the same types of houses that were in their first trading area. Their immediate response was that this was an ideal situation for a new venture.

Questions

1. Should the fact that the type of housing in the neighborhood near the new venture was the same as the housing near the first be sufficient for Sue and Muriel to go ahead with the additional store? Why?
2. What demographics should they consider before they expand their operation to the new location?
3. What other types of consumer information should they seek before they make an ultimate decision?

CASE PROBLEM 2

Pauline Edwards owns a store she named for herself. It is an established shop that sells high quality, tailored women's clothing. It has been in business at the same location for twenty-five years, serving the needs of the upper-upper class. Its reputation was founded on impeccable service and a merchandise assortment that was low key. Although the store's patrons could afford the glamour and style of the world's leading couturiers, they preferred a more conservative, elegant product.

When Pauline's son Alex joined the company last year, he was full of new ideas that included expansion into other affluent trading areas. After examining many potential sites, he set his mind on one. It had about the same square footage as the other store, was already equipped with fine fixtures, and would rent for a price that was in line with what they could afford for the operation.

One problem that seemed to disturb Pauline was the area that surrounded the location. By the vastness and styles of the homes, it was obvious that this was an environment that was filled with the upper-lower class, people who are often referred to as "nouveau riche." Alex believed that this would be a benefit, since these people often spent more on clothing than their upper-upper class counterparts.

At this time, they have still not decided if they will expand into the new location.

Questions

1. With whom do you agree on the assessment of the new area's class of people in terms of being the store's future customers? Why?
2. Aside from income, what other factors should Pauline and Alex consider before making their decision?

EXERCISES AND PROJECTS

1. Select five fashion advertisements of retailers in newspapers and magazines and evaluate each in terms of their motives. Remove each ad from the periodicals and use it in conjunction with the completed chart in an oral presentation to the class.

Retailer	Motive (Rational or Emotional)	Key-Word Motive Clues

2. Using the Internet as your research tool, log onto a particular search engine for the purpose of learning of five companies that study consumer behavior and how it relates to purchasing. Use **www.askjeeves.com**, or any other Web sites. Use the following chart to record your findings:

Company	Web Site	Consumer Research Study

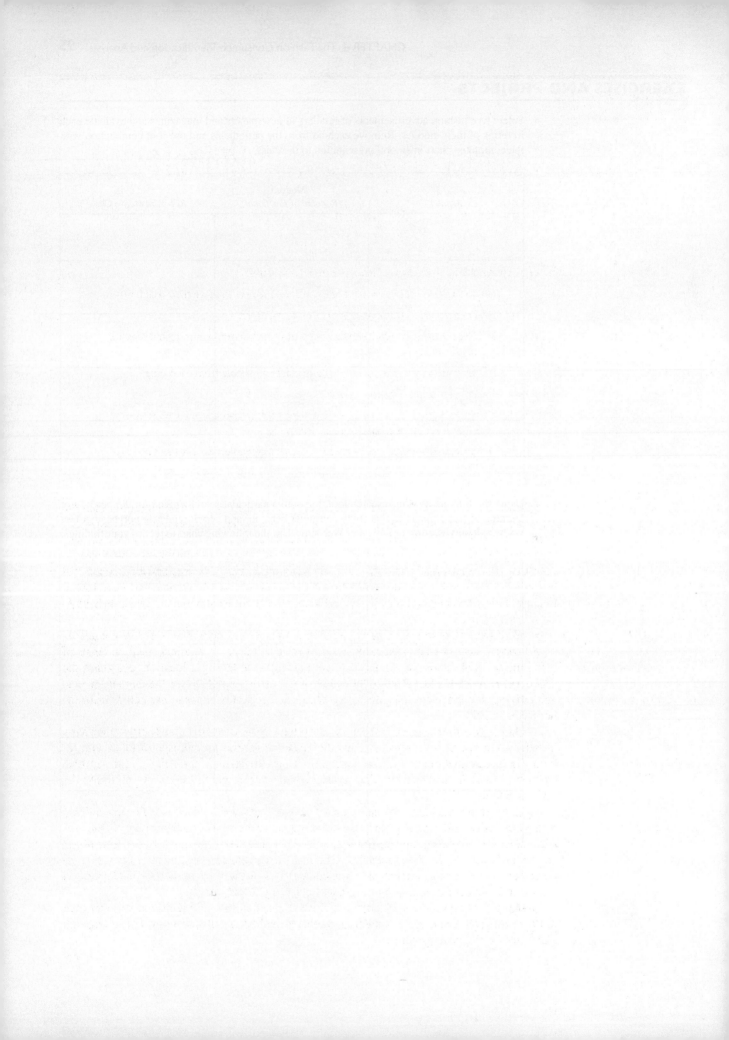

Classifications and Methodology of Retail Research

After reading this chapter, you should be able to discuss:

- Several areas of research used by fashion retailers to solve their problems.
- The various steps used in the research procedure.
- The differences between the observation and questionnaire techniques for gathering data.
- How primary and secondary data are distinguishable from each other.
- The role that the Internet plays in retail research.
- Why focus groups have become an important research tool for merchants to use in making merchandising decisions.
- How questionnaires are developed that help retailers assess their potential markets.

In the past, fashion merchants were more likely to base their decisions on intuition than the scientific approaches used today. They often purchased what they believed best suited the needs of their customers in terms of style, quality, function, and price. They offered the services they felt were appropriate to their companies and hoped that consumers would patronize them. For many merchants, these methods worked well. They established successful businesses and enjoyed the fruits of their labor. Others were less fortunate and were forced to close their doors because they were unable to attract enough shoppers to make their businesses profitable.

Were the successful merchants just luckier than the unsuccessful ones? While unseasoned people may talk about success in terms of luck, educated retailers speak in terms of being prepared to tackle problems, such as focusing in on the right location, designing the appropriate environment, selecting the merchandise assortment that suits the market's needs, and providing the services required by the clientele. They know that success comes from expertise, not luck!

Those who specialize in fashion retailing have more concerns than their counterparts in other retail operations. Not only must they face the various problems associated with retailing in general but they must also deal with the sudden changes in fashion, color, seasons, weather conditions, and so forth. The concept of "survival of the fittest" surely applies to the fashion retailer.

To meet the challenges of each day's problems, most of the major fashion operations, be they the brick-and-mortar giants, off-site ventures, or the multichannel organizations, prepare themselves by studying the marketplace. They must learn as much as possible about consumer behavior, the demographics of trading areas, potential customers' lifestyles (discussed in the preceding chapter), the types of services that will make their clientele want to return, and what consumers want in terms of price, style, and quality.

Many fashion retailers are able to address these and other problems and will continue to do so through a number of **retailing research** methods employed by in-house research teams and/or external agencies.

This chapter addresses research theories and techniques that bring the right information to the world of retailing.

THE NATURE OF RETAILING RESEARCH

Retailers must make a variety of decisions concerning store location, merchandising, advertising and promotion, customer services, human resources, sales methods, and competition. They must study each area so that they will be able to function in the most profitable manner. The following sections list the types of questions retailers should consider about these areas; some of them relate exclusively to brick-and-mortar establishments and others relate more to off-site or on-site ventures.

Store Location

1. What is the size of the **trading area**?
2. What are the **demographics** of the trading area? Specifically, what are the inhabitants' ages, occupations, education levels, and income?
3. What are the competing stores, and can the trading areas support another profitable store?
4. Is the particular type of retail environment appropriate for the intended business?
5. Do the available parking facilities provide a sufficient number of spaces?
6. Is there a public transportation network that will bring shoppers who do not have their own transportation?
7. Are there competing shopping centers that are more conducive to the consumers' needs?
8. Do compatible stores surround the specific site under consideration?

The Consumer

1. Will the consumers' needs be satisfied with the company's merchandise assortment?
2. Does the consumer in the proposed trading area have the finances to purchase at the retailer's price points?
3. Will the store's hours of operation fit in with the time the consumer wants to shop?
4. Is the target market psychographically segmented to fit the company's merchandising philosophy?
5. Are the consumer's shopping habits in line with the merchant's policies?
6. Are those within a particular sociological group matched to the store's image?
7. Will the **targeted market** order from the company's Web site?
8. Is the catalog's format appropriate for the intended consumer?

Merchandising

1. Does the merchandise mix feature the right brand assortment?
2. Does the store have an assortment of private-label merchandise that will help meet the challenges of competing discounters and off-price organizations?
3. Is the price structure appropriate for the targeted market?
4. At what time during the seasonal periods should new fashion merchandise be introduced to satisfy the shoppers' needs?
5. How many times in a year must the inventory turn over for the company to be profitable?
6. Should markdowns be handled as the need arises, or should they be taken at more traditional times such as after Christmas?

The consumers are key to the success of any retail operation, and their needs must be assessed.
(Courtesy of Façonnable USA)

The right merchandise mix must be determined to meet consumer needs.
(Courtesy of Façonnable USA)

7. Is an automatic markdown system an appropriate vehicle for the company?

8. Would more frequent markdowns help turn the inventory at a faster rate?

9. Should the number of merchandise resources be restricted to just a few or should numerous ones be utilized?

Advertising and Promotion

1. Which of the available media should be used to advertise the company's merchandise, image, and special events?
2. What proportion of the promotional budget should be spent on newspaper advertising?
3. Should advertising be purely promotional, or should a percentage be set aside for institutional purposes?
4. How often should catalogs be sent to the customers?
5. What format should be used for special promotions on the company's Web site?
6. What types of special events should the company utilize to attract customer attention?
7. Should visual merchandising be handled by a professional in-house team, store managers who follow the preplanned approaches designed by a visual team, or by freelance experts?

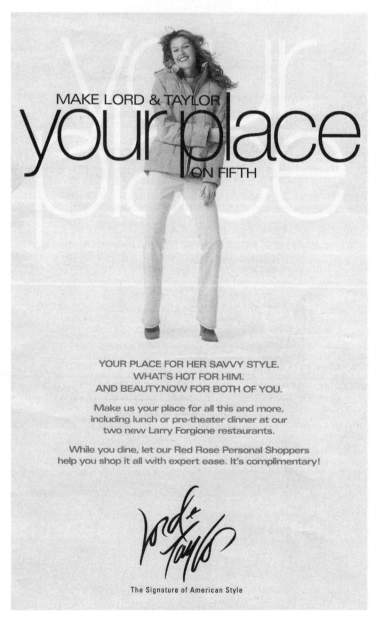

Advertising is essential to bringing the company's name to the shopper.
(Courtesy of Lord & Taylor)

8. Would the store be better served with the use of a traditional format that could be easily changed for the seasons, or would an "environmental" concept be better?

Advertising effectiveness is paramount to the success of most retail organizations. To ensure that they make the best use of their advertising budget, many fashion retailers use professional research organizations. One such company is Gallup & Robinson.

Fashion Retailing Spotlights

GALLUP & ROBINSON

Gallup & Robinson (G & R) is an advertising and research firm founded in 1948 by Dr. George Gallup and Dr. Claude Robinson to apply proven research methods to the study of advertising effectiveness. G & R has become a pioneering leader in providing advertisers and ad agencies with a broad range of research capabilities for assessing the effectiveness and efficiency of their advertising. This in turn helps businesses maximize the return on what they spend on advertising.

G & R innovated many of the techniques that are now standard in the industry. With an unmatched experience base of more than 200,000 tested ads and commercials the company has become one of the primary resources for communications research.

G & R specializes in copy research, tracking, concept testing, medium influences and media research, claims substantiation, spokesperson and icon testing, events and sponsorship research, and custom communications research. Its expertise covers every aspect of advertising, including the comparatively new interactivity that is now becoming popular on many retailers' Internet Web sites.

G & R uses specific tools that they have developed. These include the following:

InTeleTest: —Commercials are tested via VCR cassettes among widely dispersed samples in an at-home, in-program context.

In-View: —Invited viewing for obtaining on-air performance. Respondents can be invited to view the show in which the commercial is airing or has been placed into for testing.

Magazine Impact Research Service: —The industry standard for magazine ad testing. Ads are tested using an at-home, in-magazine context among widely dispersed samples. The system offers standardized measures with flexible design options. Test ads either naturally appear in the magazine or are inserted for testing.

FasTrac: —A pretesting service for television and print ads. It combines qualitative and quantitative analysis in a mall-intercept environment, providing a full range of multiple, in-depth measures.

G & R's leadership and expertise has enabled it to retain its position as one of the world's major resources for advertising and promotion research.

Customer Services

1. Would a staff of personal shoppers increase sales?
2. Should gift-wrapping be free, or should a fee be charged for each package?
3. Should there be a shipping charge for Internet purchases?
4. Would a child-care center be beneficial to overall sales?
5. Would the use of foreign language speaking sales associates help to increase sales?
6. What types of eating facilities would be appropriate?
7. Should there be a charge for alterations?
8. Should expanded shopping hours be instituted once a week to accommodate working men and women?

If alterations are important to a company's sales, their costs must be assessed.
(Bill Burlingham, Pearson Education/PH School Division)

Human Resources

1. Which sources of personnel provide the best employees?
2. What type of motivational techniques will reduce employee turnover?
3. What training methodologies are most appropriate to teach new employees about company policies?
4. What role should the human resources department play in the selection of employees?
5. Which benefits and services will motivate employees to stay with the company?

Sales Methods

1. Is self-service a viable alternative to personal selling?
2. Should employees be assigned to specific merchandise classifications, or should they be placed in the busiest areas as the needs arise?
3. Should computer stations be used in place of sales associates in some areas?

Competition

1. Should the company institute a system whereby it can assess competitor's inventories?
2. Should the number of competitors in a trading area be evaluated before any final location decisions are made?

While these are by no means the only questions that confront both on-site and off-site retailers, retailers should address them before making major decisions.

THE RESEARCH PROCESS

In cases where retailers need to make significant decisions concerning any of the aforementioned areas, they may engage in some type of formal research. Whether the research is conducted by in-house staff, as is the case of the industry's giants, by an independent organization, or by an outside consultant that works with the company's own research team, the methodology is the same.

The stages and tools that researchers use for retail problems are virtually the same as those used for other business situations.

Identifying the Problem

The first stage is to identify the problem or area of concern. It might be about determining the consumers' level of acceptance of private-label merchandise and whether or not the company should change its in-stock percentage of these items. Another area may center around restructuring price points and the potential problems associated with such change. Still another area could be the impact of separating the company's brick-and-mortar merchandising operations from those used for their off-site ventures such as catalogs and Internet Web sites.

Whatever the situation, the problems must be identified before further action may take place.

Defining the Problem

After the problem is identified generally, it must be defined specifically. For example, if the retailer wanted to concentrate on the price point problem stated in the preceding section, the researchers would need to know if the new restructuring is in the entire store or in a specific department. In the private-label dilemma, the researchers need to know if the retailer is focusing on every department or just menswear.

Narrowing the stated problems that have been identified is a necessity so that researchers will be better able to solve the problem. For example, the three problems identified in the previous section could be more specifically stated as follows:

1. Will private labeling be accepted in the shoe department?
2. Would the store benefit from **trading up** in the dress department, eliminating the lower price points and adding higher ones?
3. Should the merchandising for off-site divisions include children's wear?

Once the problem is narrowly defined, the research team can continue onto the next phase of the study.

Gathering Data

After specifying the problem, the process moves to the stage of collecting data. This is an extremely important area of the study, because the divisions are based on this information. The data comes from two sources, secondary and primary.

SECONDARY DATA

Data that is already available to the researcher is classified as **secondary data**. It may come from such sources as the company's own records, studies that were conducted by governmental agencies and trade associations, private research organizations, and periodicals.

Company Records. A great deal of information is continuously generated by the company's computer, which keeps track of records such as sales figures for every department and merchandise classification, customer returns, vendor analysis, employee turnover rates, and sales associates' commissions. Each of these are important when studying retail problems.

Governmental Agencies. Various government agencies provide general information that could help retailers researching a problem. At the federal level, for example, the Census Bureau, undertakes periodic studies of the general population, housing, and businesses, all of which provide valuable information for the merchant who is considering expanding the company. The Department of Commerce generates a great deal of timely information on business conditions that is appropriate for retailer use. The monthly Catalog of U.S. Governmental Publications produces a host of materials, free of charge, on topics including regular reports on new home construction, employment figures, and cost-of-living adjustments. By logging onto these governmental agencies' Web sites or by utilizing a search engine such as **www.askjeeves.com**, researchers can access a wealth of pertinent information.

State and local governments provide a great deal of secondary information that researchers can use to find out about business conditions in the retailer's more immediate trading area.

Trade Associations. There are many **trade associations** that deal with various specific aspects of retailing, such as the Institute of Store Planners, (**www.ispo.org**), and the International Mass Retail Association, (**www.imra.org**). However, the **National Retail Federation (NRF) www.nrf.com**, the retail world's largest association, provides a wealth of information on every conceivable area that affects retailers and their operational needs. In addition to offering a forum that retailers from around the globe attend to learn about the latest industry

Before making any buying decisions, the buyer is able to study company records by accessing merchandising data. *(Courtesy of Ellen Diamond)*

innovations, NRF regularly conducts studies that are important to the retail community. NRF members may obtain copies of its research that may help them with their own problems.

Private Research Organizations. There are numerous research organizations that engage in original studies, two of which, Gallup & Robinson and the Olinger Group, are discussed in separate *spotlights* in this chapter. Their Web sites, **www.gallup-robinson.com**, and **www.olingergroup.com**, offer a great deal of information on their research services. A.C. Nielsen, another major research firm, specializes in broadcast surveys. By examining its rankings of TV programs in terms of viewership, major fashion retailers are able to assess which programs they should advertise on.

Periodicals. Numerous trade papers and magazines regularly engage in research projects that retailers find useful. Fairchild Publications is a leader in fashion news with its *Women's Wear Daily* and *Daily News Record* publications. Almost every issue of these publications provides meaningful information regarding the state of the fashion industry.

Stores Magazine, published by NRF, presents studies that can assist retailers with their decision making; *Visual Merchandising and Store Design,* a monthly periodical published by ST Media Group, is especially important for fashion retailers, because its pages cover every detail of store design and display; and *Chain Store Age* offers the latest developments in that area of merchandising.

In addition to these periodicals that are expressly directed at the retail arena, others, such as the *Wall Street Journal* and the *New York Times,* often feature articles that may pertain to retailers and their problems.

PRIMARY DATA

It's possible that retailers can get enough information from secondary data to make their decisions. If they require more data specific to their particular situation, however, they need **primary data**. Primary data are the data that must be obtained firsthand through original research. The information is gathered from customers, potential customers, employees, vendors, market specialists such as resident buying offices, and the media through questionnaires, focus groups, and observations. Though valuable, primary research is often very costly to obtain.

Questionnaires. The **questionnaire** is the method most often used for information gathering. It is more costly than any of the other techniques, but by and large it provides the broadest range of data. Questionnaires may be distributed through the mail, filled out by surveyors as they talk to subjects on the phone, completed by online users, and used with intercept surveys (these different types are discussed in the following sections). The type used depends on such factors as the trading area to be examined, the size of the research team available for gathering the information, specific demographics, finances, and the time allocated for the collection of the data. Each does have advantages and disadvantages. When composing the questionnaire, retailers should consider the following:

1. The length of the questionnaire is important. It should be as brief as possible, rarely occupying more than one page. This is particularly true when mailing the questionnaire to respondents. Many potential respondents will discard the questionnaire if it seems to be too long.

2. The language in the questionnaire must be easy to understand. When reading questionnaires received in the mail or posted on the Internet, respondents might misunderstand ambiguous questions or just pass over them, so the questionnaire results are less than perfect. Even in the case of personal or telephone interviews, during which interviewers can clarify a question, interviewer bias might affect the respondent's answers.

3. Questions must be arranged sequentially for a smooth transition from one to another.

4. Every question must be specific. When words such as "generally" or "usually" are used, there is too much room for interpretation. The two words might have different meanings to the respondents and could alter the reliability of the research.

5. Wherever possible, the answers should be in a multiple-choice format. This makes the data easy to tabulate and does not necessitate researcher interpretation. Where using open-ended questions, provide sufficient space for the responses.

Mail Questionnaires. When retailers want to survey a very large market and they think that respondents will require more time to study the questions, they use the mail questionnaire. This format is sometimes favored by researchers because it eliminates interview bias. Only the respondent will answer the questions. Costs are generally lower than those of the telephone and personal interview formats, because they do not require paid surveyors. Another advantage is that respondents can complete questionnaires at their convenience.

The mail questionnaire has its disadvantages. The rate of response is very low, with a 10 percent response considered excellent. Some retailers offer incentives, such as a nominal amount paid for a completed form or a company discount on a future purchase; this can significantly improve the return rate. Another problem rests with the respondents' ability to comprehend the questions. If questions are difficult to understand, and there are no interviewers to explain them, this might result in an incomplete response. A way to avoid this pitfall is to first distribute the questionnaire to a small group and have observers determine if these respondents had any doubts about the questions' meaning.

Telephone Questionnaires. When researchers require an immediate response, the telephone survey is the quickest method. It is also fairly inexpensive, as calls can be made from a central location, thus eliminating the field staff needed to make personal interviews. Confusing questions can be explained, although this necessitates using professional, unbiased interviewers. Telephone surveys also allow for follow-up questions, an advantage not available with mail questionnaires.

The use of the telephone also has some shortcomings. Interviewees are often reluctant to divulge information of a personal nature over the phone, which can severely limit the number of respondents. Also, with many families composed of dual earners respondents are either not at home or have less time to participate. Many households employ caller ID, to screen their calls. Answering machines also screen calls, and people only return those calls they deem important.

Many researchers use computer-assisted calling systems in place of humans to conduct their surveys. A machine dials a number and a recorded voice describes the research and asks the questions. Some companies are finding that this reduces the cost of interviews, and if the call is unsuccessful, the machine can quickly dial the next number.

On-line Questionnaires. These are excellent means for conducting primary quantitative research, because today's computer-savvy consumer uses the Internet for a variety of reasons, ranging from business to personal use. On-line questionnaires are interactive and less intrusive than other methods. Their benefits include potentially lower costs, rapid information gathering, and respondent completion at their convenience. The rate of return has been found to be greater than that via the mail.

On the downside, the responders to on-line questionnaires tend to be from the younger generations. Those in the senior category, sometimes an age group that researchers want to study, are often computer illiterate.

Dr. Don A. Dillman, a major contributor to the development of modern mail, telephone, and Internet survey methods, wrote *Mail and Internet Surveys: The Tailored Design Method*, in which he addresses the profound changes that have taken place in recent years. It is possible to find other materials he has written by searching his name on the Internet.

Intercept Surveys. **Intercept surveys** employ, trained interviewers who are positioned at preselected public locations. One example of this marketing research method is the **mall intercept**, in which interviewers, positioned in a shopping mall, approach people and ask them to participate in an intercept survey. The interviewer administers the questionnaire to the participant face-to-face. This method is especially successful in researching problems for the fashion retailers that are the "anchors" in the malls.

The advantages of intercept surveys include the interviewers' ability to mediate the process, ensuring accurate questionnaire completion; control of the number of respondents; the ability of the interviewer to observe the respondents' facial expressions and body language; and the allowance of time for material sampling.

Dear Charge Account Customer:

In our attempt to bring you the timeliest, fashion-forward apparel and accessories, we have always scouted the domestic and international designer markets. Because we believe that many of you appreciate a fashion collection that includes merchandise exclusive to our company, we are developing a new, private label that is designed with you in mind. We will continue to feature all of your designer favorites and those on the cutting edge of fashion along with the new private-label brand. Since we value your judgment and opinions, we would like you to participate in a survey so that our new concept will reflect your fashion needs.

Please complete the following form and return it in the provided self-addressed envelope. If you prefer, you may complete the form on our Web site, *www.emery's.com*. In either case, if we receive your response within ten days from today, we will show our appreciation by sending you a 20-percent discount certificate that can be used on your next purchase.

We want to assure you that your answers will be kept anonymous.

1. What percentage of your fashion needs are purchased from our company? _____

2. In which department(s) do you buy most of your fashion items? _____

3. What prices, in the following merchandise classifications, are indicative of your fashion purchases?

 Dresses _____ , Sportswear _____ , Suits _____ , Coats _____ ,

 Shoes _____ , Accessories _____ .

4. Which designer names do you consider to be your favorites? _____

5. In which product classifications would you favor private labels? _____

6. Would you like the private-label items to be featured along with the regular designer items in the same

 department, catalog, or Web site page? _____ yes _____ no

7. Could you suggest a name or names for the private label(s)? _____

8. Are you employed outside of the home? _____ men _____ women

9. What is your approximate family income? Under $25,000 _____

 $25,000–$34,999_____

 $35,000–$44,999_____

 $45,000–$54,999_____

 $55,000–$64,999_____

 $65,000–$74,999_____

 Over $75,000_____

10. How would you describe your family status? _____ single

 _____ newly married

 _____ married with small children

 _____ married with grown children (home)

 _____ empty nester (still working)

 _____ empty nester (retired)

 _____ divorced

Figure 5.1 A typical fashion retailer questionnaire.

The main disadvantages to this type of survey is that sometimes shoppers are too busy to stop and answer the questions. It is also costly, as the interviewer must be paid. Figure 5.1 is typical of a questionnaire used by fashion retailers. In this case, the targeted group is composed of regular customers who have company charge accounts. The questionnaire is designed to determine the fashion needs of the retailer's existing clientele.

Observations. Although not used as frequently as the other research methodology for data-gathering, the **observation technique** is valuable in specific circumstances. For example those considering prospective locations for their companies must, in addition to studying the typical demographics of the area, determine if there is a sufficient amount of traffic in a

particular locale to warrant opening a brick-and-mortar operation there. A **traffic count**, is undertaken to study not only the amount of vehicular traffic passing the proposed site but also the types of vehicles and the number of passengers aboard each vehicle. Through these recorded observations, it is possible to draw conclusions about the numbers of passersby and their genders, approximate ages, appearance, and so forth, all of which may be meaningful to the location decision.

Another type of observation is the **fashion count**. Some fashion retailers use this method to record the specific styles worn by a particular group to help determine if their fashion projections are in line with customer preferences. This theory is based upon the premise that if people are wearing certain styles, they will buy more of them. Thus, if a large percentage of women in the study are observed wearing leather boots with high heels, this is a signal to the retailer to purchase more boots.

The fashion count is particularly important in times of radical fashion change. When evidence from the past five years, for example, indicates that women are happy with longer-length skirts but the industry promotes micro-minis, the buyers may be uncertain of how to replenish their inventories. While fashion-forward retailers must always embrace the latest styles, they must also be aware of the dangers inherent in overstocking what the industry is trying to promote. Too many times merchants have had to take enormous markdowns when they discover that their customers do not always follow the fashion market's dictates. By taking fashion counts in such situations, retailers can assess the pulse of the consumer market and follow a safer route.

Some of the advantages of both traffic and fashion counts are their low costs, the ease in which they are organized, and the little time it takes to gather the data. It is very important that the recorded information be accurate.

Traffic counters most often record such information as the types of vehicles that pass the location, the times they pass, and general descriptions of the occupants. The forms they use enable them to quickly note what they have seen.

Fashion counters usually record three or four different style elements worn by a preselected group. They are sent out in teams, with prepared forms in hand, to places where people they wish to count congregate. If high fashion eveningwear is being investigated, for example, they go to the opening night of the Metropolitan Opera at Lincoln Center in New York City. If swimwear is the style, the counters go to the resort beaches during the winter season so that buyers can make proper purchases for the summer season. Whatever the situation, they must target the right place if the results of the count are to be meaningful. Figure 5.2 is an example of a fashion count form for swimwear.

It is extremely important that all counters be completely familiar with the styles they are counting. They can be trained by showing them photographs or drawings of the styles so they can master these silhouettes before undertaking the research.

Focus Groups. **Focus group** research has become the most common form of all qualitative research methods, providing in-depth information regarding a particular problem or issue by using group dynamics. By using panels of eight or ten, the way the respondents interact with each other provides more robust information than individual responses. In focus group research, the group is guided by a moderator who openly discusses attitudes and ideas about a particular issue. A focus group assembled for a fashion merchant might discuss the fashion assortments carried by the company, the pros and cons of personal shoppers, types of customer service, and so forth. The selected panel may come from any number of sources, such as regular customers, charge customers, or those selected at random who know the company but do not shop there.

These groups are sometimes used on a regular basis such as once a month, or are gathered for only one session. The panel is generally given an incentive to participate such as cash payments or discounts for future purchases.

Extremely important to the success of focus group research is the selection of the moderator. Moderators should have a background in industrial psychology and the ability to communicate with the participants. Their role is essential to the process, because they guide the conversation and elicit interaction among the group to generate information that

```
┌─────────────────────────────────────────────────────────────────────────┐
│                            Fashion Count                                  │
│                             Swimwear                                      │
```

Style	Fabric Type	Color
1 piece "maillot"	latex	white
1 piece "front panel"	spandex	black
1 piece "high cut sides"	woven cotton	red
1 piece "boy leg"	knitted	yellow
2 piece "bikini"	jersey	orange
2 piece "string bikini"	mylar	light blue
2 piece "thong"		navy blue
2 piece "boy leg"		silver
other _____	other _____	stripe
_____	_____	print
_____	_____	other _____

Location of Survey: _____

Instructions to Recorder:

Place a circle around *one* appropriate item in each category. If the swimsuit does not fit a particular item, write a description of it in the spaces provided.

Figure 5.2 Fashion count form.

will be analyzed. Group dynamics are assessed as participants engage in a discussion with each other.

In some setups, the retailer can anonymously observe the focus groups from a viewing room, and forward any additional questions to the moderator during the sessions.

The benefits of focus group research include gaining insights into people's shared perceptions, observing the ways individuals are influenced by others in a group environment, providing direct involvement for the client, and observing participants' facial expressions and body language.

Fashion Retailing Spotlights

THE OLINGER GROUP

The Olinger Group is a marketing research consulting firm specializing in primary research studies for a host of clients in various industries. Its mission is to provide meaningful, understandable, and usable information.

The Olinger Group's Web site, **www.olingergroup.com,** provides a wealth of information that shows the firm's different research techniques and methodology so that potential clients can preview the company and see if it meets their needs.

The Olinger Group specializes in branding and positioning research. This is particularly important to many of today's fashion retailers that are either considering entering the private-label arena or are planning to amend their existing private-brand programs. To this end, the company researches image and awareness analysis, brand strengths and weaknesses, comparison to other products in the marketplace, and perceptions about the brand's attitudes.

Olinger uses the intercept survey method, mail surveys, telephone questionnaires, focus groups, and on-line surveys.

For retailers as well as other businesses Olinger offers its expertise in the areas of customer satisfaction, employee satisfaction and behavior, awareness and image research, branding and positioning, market segmentation, consumer behavior analysis, and advertising testing and effectiveness.

Selecting a Sample

When a market is being studied, it is neither necessary nor practical to survey everyone in the market. A **research sample**, or representative group of the body of people to be surveyed, must be selected. Research samples can be drawn from the customer base, such as the company's charge account clientele, or a potential group of shoppers. In either case a small number of them will be sufficient to help with decision making.

The same principle is used to predict the winners of elections. In a presidential election, for example, it is necessary to survey only about 1,000 people to accurately predict the outcome. If a retailer wishes to evaluate the size of a television audience for the purpose of selecting a program on which to place commercial spots, taking a sample of 1,200 families would have the same results as polling the entire population of the country. Careful sample selection is imperative if results are to be on target.

Collecting and Tabulating the Data

Once a retailer has made the decision to undertake the project and constructed all of the forms, the data must be collected. If the questionnaire is the instrument of choice, the methodology for data collection, such as the mail, telephone, Web sites, or interception, should be decided. In some instances, more than one technique might be used. In the cases of the telephone questionnaire or intercept survey methods, which use information gatherers, they must receive sufficient training so that bias will not enter into the questioning technique and everyone understands the nature of the project.

If the observation method is used, the locations where the counts are to be taken should be carefully selected. The observers must be chosen and trained in terms of what they are to record so that they will properly carry out the survey and record accurate results. Focus groups and their moderators must also be carefully chosen to guarantee that the derived information is exactly what the company is seeking.

When professional data gatherers are used, they do not require as much training. However, when novices such as college students are used, it is important that they are thoroughly trained in the manner in which to approach the consumer, either on the telephone or in-person; the handling of unwilling participants; the recording procedures; and so forth so that they will obtain accurate data.

After the data have been collected, they are compiled and processed. Computers can easily and quickly tabulate the data and make it ready for the marketing research experts to prepare their findings.

Data Analysis and Report Preparation

The researchers compile and summarize the data collected for the project in a variety of formats. They construct charts, graphs, and other instruments used in research to show their findings and recommendations. Each project requires a different amount of time and effort for data analysis and report preparation. The information gathered from a focus group is simple to analyze, compared with that from major surveys that require hundreds of responses from questionnaires.

Whatever the size of the study, the researchers always present the findings in a written report that summarizes all of the stages of the research process, the methodology used in the collection of the data, analysis of the data, recommendations, and an appendix that includes the data and their secondary and primary sources.

Making the Decision

The information generated from the study and the recommendations of the research team are prepared for company management to examine and evaluate. The researchers, whether they

are in-house or from outside agencies, do not have the authority to decide what direction the company should take regarding the problem. The management team has the ultimate decision-making power and must carefully examine everything that has been presented to it before taking any steps.

TRENDS IN RETAIL RESEARCH

With the enormous amount of competition experienced by today's fashion merchants, the need for research continues to increase. Every segment of the industry, whether it is the brick-and-mortar operations or their off-site counterparts, is being challenged by unprecedented new entries in the field. To better understand consumer markets and their potential as customers, more and more retailers are using research tools. Some of the trends in this area include the following:

Increased Use of Focus Groups

Because of its cost effectiveness and immediate gathering of information, the focus group will more than likely be the choice of merchants of every size. Many of the major retailers will continue to use their customers in regular sessions to study a wealth of problems.

Outside Agency Use

With the costs of maintaining an in-house research staff increasing, many merchants will choose outside resources to study their problems. This approach is more practical since research is not required every day and can be addressed by professional marketing research firms as the needs arise.

Organizational Studies

Many companies have entered the multichannel arena and have yet to determine how to most efficiently address their organizational needs in managing the different channels. A great deal of research, for example, will focus on the best way in which to merchandise the different channels. Would it be better to have a single buying team to handle all of the company's purchases, or would separate teams be better for each of the channels.

Human Resources Retention

Acknowledging that one of the keys to the success of a retail operation is employee continuity, most retailers regularly face the challenge of employee turnover. With the turnover rates at an all-time high, many merchants will address the ways in which they can motivate their staffs, ranging from upper management to sales associates, to remain with the company. Studies of employee wants and needs will continue to be addressed so that stability will be achieved.

Location Analysis

Good location is vital to the success of any brick-and-mortar operation. With a wealth of areas available, and the leasing costs spiraling upward, research will continue to determine which sites will be most profitable.

SMALL STORE APPLICATIONS

Although research is often reserved for the major retailers, occasionally it is the small merchant who can benefit from such studies. The use of an outside firm to study the problems inherent in running a small operation are generally out of the question, but there are some approaches that will be cost-effective and provide the necessary information for decision making.

One of the ways in which a study can be conducted with minimal expense is by using a college class in marketing research. Colleges and universities often serve the needs of their community with research projects that at the same time help their students to gain experience. Questionnaires as well as observation studies are generally within the abilities of students studying market research.

Focus groups are cost effective since they could use eight or ten of the retailer's customers who would be rewarded with a purchase discount. The only expense would come in paying the moderator. These costs could also be minimized if a graduate research or industrial psychology major could be utilized in the study.

Chapter Highlights

1. While many nonprofessionals believe that the success of a retail operation is just luck, those with experience understand it is consumer research that plays the most important role.
2. Fashion retailing offers more challenges to their operators than any other retail classification.
3. Retail research spans a wide number of areas including store location, consumer assessment, merchandising, advertising and promotion, customer services, human resources, sales methods, and competition.
4. The research process is a multistepped plan that ultimately brings potential solutions to retailer problems.
5. Initially in the research process, the problem must be identified; it must then be clearly defined so that the research team will be able to offer suggestions regarding solving the problem.
6. Secondary data includes data that is already available to the researcher via such sources as company records, governmental agencies, trade associations, private research organizations, and periodicals.
7. If there isn't a sufficient amount of information culled from secondary sources, primary research is necessary to solve the problem.
8. Primary research involves the use of such tools as questionnaires, observations, and focus groups.
9. Intercept surveys involve the use of interviewers who are positioned in strategic locations for the purpose of conducting interviews with consumers.
10. Questionnaires can be delivered via the mail, by telephone, on-line, or through personal interviews.
11. Fashion counts are used to record the styles that people are wearing so that the information may be used for future merchandising plans.
12. The focus group has become one of the more important tools for consumer research, because it is comparatively inexpensive to use and the information is immediately obtained.
13. A research sample is a representative group of the body of the people to be surveyed.
14. Once the data has been collected, tabulated, and analyzed, a final report is written by the research team in which suggestions to solve the problem are offered to management.

Terms of the Trade

retailing research
trading area
targeted market
InTeleTest
In-View
Magazine Impact Research Service

FasTrac
trading up
secondary data
trade associations
National Retail Federation (NRF)
primary data
questionnaire
intercept surveys
mall intercept
observation technique
traffic count
fashion count
focus group
research sample

For Discussion

1. Why is it necessary for retailers to conduct research studies for their companies?
2. What must the retailer learn about the consumer to maximize potential profitability?
3. What are some of the areas of concern for brick-and-mortar retailers to assess before choosing a location?
4. Can advertising and promotion research provide information to the retailer that will make its promotional investments more likely to result in greater sales volume? Explain.
5. How does the "InTeleTest," developed by Gallup & Robinson, work?
6. Describe some of the retailer's concerns regarding human resources that require research.
7. What is the first stage of the research process?
8. How do the first and second stages of the research procedure differ from each other?
9. Why is it necessary to conduct secondary research first?
10. From what sources are secondary data obtained?
11. How can trade associations help the retailer save money on a research project?
12. What does the term "primary data" mean?
13. List three techniques used to gather primary data and how they differ from each other.
14. What does the term "intercept survey" mean, and why does it sometimes offer more reliable information than mail questionnaires?
15. What are some of the benefits of using on-line questionnaires?
16. How does a fashion count help a retailer with merchandising problems?
17. Why do some merchants use traffic counts when researching prospective locations?
18. What is a focus group?
19. How can a retailer conduct primary research that is reliable without surveying every individual in the group?
20. Once the data is tabulated and analyzed, what is the final stage of the research project?

CASE PROBLEM 1

Cameo Fashions is a small retail organization. It has been in business for twelve years and has been able to expand its operation to five units. Each year, sales have increased, and the company has become extremely profitable.

The company's merchandising philosophy has been fashion forward, providing the latest styling for its customers at price points that would be considered moderate. Dresses, for example, range from approximately $90 to $225, sportswear from $35 to $150, and accessories from $25 to $125. Cameo offers a host of services and enjoys a very loyal customer base.

During the last year, the Cameo partners, John, Marc, and David, have become aware of a situation that might be meaningful to their organization. Real estate value has soared, and many

homes have started to sell for prices never before witnessed in their trading areas. Along with the higher-priced homes has come an influx of more affluent families. Another factor with implications for the company is the construction of three new luxury developments in locations close to three of Cameo's stores.

After a great deal of discussion, the partners remain divided on how to approach the area's wealthier population. John believes trading up to higher price points would be the best approach. Marc suggests that they have been successful for all these years and should not look for trouble. David believes that a broad price range would be most practical and would accommodate the old and new customers.

Questions

1. Should the partners follow any of their own beliefs?
2. How should they approach the situation in a more scientific manner?

CASE PROBLEM 2

Fashionable Feet is a women's shoe store that features a variety of footwear for casual, business, and evening dress. It carries many of the popular designer lines with a selection of imports from Spain and Italy.

Although it is still a profitable business, the store's owner, Joy Green, has noticed that sales are not increasing at the rate to which she was once accustomed. In fact, this past year's financial statement indicated a slight decline in sales.

Joy is concerned, since no changes have been made in the operation to warrant the downturn. The store carries the same lines it always has, at prices that have increased only because of inflation, and it has retained virtually the same staff to serve the customers.

After careful inventory analysis, Joy, noticed a drop in sales in the casual shoe classification. The customers still enthusiastically responded to the business and dressy shoes but have lately shown a declining interest in the casual collection. Joy was puzzled, since she carries the same casual lines as in the past and in the same styles that were always customer favorites.

In two months, she will be faced with making her purchases for the next season and does not know how or if she should adjust her inventory.

Questions

1. Should she drop the casual classification totally?
2. How could she, with minimum expense, research the problem?
3. What do you think are the reasons for the decline in casual shoes?

EXERCISES AND PROJECTS

1. As a class, decide upon a topic that would best be researched through the use of the observation technique. It might be a fashion or traffic count. Once the subject has been selected, develop a form similar to the one in Figure 5.2. After selecting the appropriate place for the research to be conducted divide into teams and go into the field to collect the data. Sort the data into categories, and prepare a report to show the findings of the study.
2. Contact a fashion retailer in the area to discuss the possibility of doing a research project for the company. It might focus on the company's merchandise assortment, customer services, or anything of interest to the retailer. After gaining the retailer's approval to conduct the study on the store's premises, follow the stages of the research process as outlined in this chapter. Once secondary sources have been studied, develop a questionnaire that should be used at the store's entrance. After collecting and analyzing the data complete a written report and present it to the company.

Ethics and Social Responsibility

After reading this chapter, you should be able to discuss:

- Business ethics and how it affects a company's operation.
- The need to understand the complexity of business ethics and the stages that must be established for the proper handling of ethical problems.
- The research that underscores the complexity of business ethics.
- Numerous areas of ethical concern for business organizations.
- Why questionable pricing strategies might adversely affect the running of a retail operation.
- The typical ethical dilemmas that businesses face.
- Codes of ethics and how they are written to meet the needs of business organizations.
- The need to include social responsibility in the retailer's overall marketing plan.
- Many ways in which fashion retailers do their share to aid charitable and other causes.
- The ways in which fashion retailers are becoming more socially responsible.

Is it ethical to conduct personal business while on the job, call in and claim you're sick when it is just an excuse to take a day off, habitually arrive late for work and leave before the work-day ends, lie to customers about the advantages of the merchandise you are trying to sell, or to surf the Internet during company time. Those in management as well as the rank and file employees are tempted by these types of ethical dilemmas.

The case of Martha Stewart, the fashion guru, is a public example that the problems regarding ethical misdeeds in the business world are more than just passing phases. Her indictment has severely impacted many different businesses, including Kmart, where she has been a shining light with her line of home products; the licensees that manufacture her goods, such as Shaw Industries, the producers of her Signature flooring collection; and the syndicated TV shows that feature her products, to name a few.

Although ethics debacles such as the cases involving top executives at Adelphia Communications, Arthur Anderson, Enron, ImClone, and WorldCom are not directly related to the fashion-retailing industry, the implications from their misdeeds are numerous and could someday surface in the retailing arena and affect those who work in it. For example, will employees who are prepared to become part of a company be concerned that their new employer will be charged with unethical practices and that such charges will personally affect their own futures?

There seems to be a feeling in the business community that the stories behind the scandalous headlines are only the tip of the iceberg and that other companies will be called upon to defend some of their questionable practices. Fashion retailers in addition to making certain that their in-house activities are ethically based, need to ensure that their business relationships with outside companies do not compromise their own standards. It is a common yet inappropriate, phenomenon that some vendors offer personal gifts and monetary rewards, tickets to out-of-area sporting events and rock concerts, and fully paid vacations to their most valued buyers.

It is crucial to the retailer's success that it conducts its business in a manner that is above reproach, and that it establishes codes of ethics for employees to follow that take any guesswork out of the decision-making processes. Once in place, these codes must be understood by everyone in the company—from those in the uppermost levels of management to those who perform more menial jobs as well as those outside organizations that the company does business with. For retailers specifically, vendors who supply their merchandise must understand their governing ethical rules and regulations; and the market specialists, such as resident buying offices who act as advisory consultants, must also be aware of their clients' ethical do's and don'ts.

Whether it is in the advertising campaigns that are targeted to the consumer, the methods used in recruitment, the veracity of the sales associates in their interactions with shoppers, or the actions of members of management as they interface with their subordinates every action must reflect an awareness of right from wrong.

Retailers also participate in their community's social programs; this not only helps numerous causes, but also plays a significant role in helping the retailer to build positive images with their consumers.

When companies practice ethics in a manner that upgrades their standards, and take part in programs that foster social responsibility it is likely that they will be better-run organizations.

BUSINESS ETHICS

The realm of ethics in the retail environment has many facets. There are ethical concerns that are different for companies of different sizes, dilemmas that retailers must confront almost every day, developing a code of ethics, and so forth. Before a retailer can write an effective company code of ethics it must first understand what the word *ethics* means, become familiar with research that concentrates on ethics, focus in on pertinent ethical concerns and dilemmas, and examine existing codes of ethics used by similar companies. The following sections discuss these different areas.

Defining Business Ethics

It is essential to understand what the word **ethics** means. As defined in *Webster's Dictionary,* ethics are, "moral principles, rules of conduct." It requires that people learn right from wrong. Of course, people do not always agree on what is right or wrong and use their own interpretations of a situation. For example, if Johnny is asked to tell a lie to cover for his boss, is he merely following orders from his superior, or is he engaging in an unethical practice? Some ethicists believe that ethical decision making is duty based and that it should be universally applied. Others, however, theorize that ethical decision making is **situational** and depends upon what is happening at that time.

Using these concepts as a starting point, the term **business ethics**, according to some theorists, refers to learning to know what is right or wrong in the workplace, and doing what's right in terms of how the decisions affect a company, its products, services, clients, and stakeholders. Of course, this is only one understanding of the term; there is no universal agreement on the subject, as is obvious by the arguments offered by those in the media's headline stories regarding the multitude of questionable practices in today's world of business.

To understand the complexity of business ethics and solve the problems inherent within it, companies should address the following areas:

- Ethical issues must be recognized.
- Analytical skills must be developed to address the problems.
- A sense of moral obligation and personal responsibility must be elicited before a solution to the problem can be rendered.
- Disagreement among the parties must be tolerated.
- There must be an opportunity to apply ethical decision-making skills to solving the problem.

Research Findings Regarding Ethics

Many studies have been conducted recently to evaluate the effect of the scandals plaguing just about every business arena. By paying close attention to these findings, companies of every size and stature can understand the adverse images that have been cast upon the business community and why they may either need to establish a code of ethics in their organizations or rethink those codes that are already in place.

Key findings in a recent study by Walker Information show the following trends:

* Only 49 percent of U.S. employees believe that their senior leaders are people of high personal integrity.
* Regarding ethical/compliance issues, 55 percent of U.S. employees say there is little pressure to cut corners.
* Nearly half of U.S. workers (48 percent) are comfortable reporting ethical violations. Yet a widening majority (65 percent) who know about a violation do not report it for reasons that include lacking enough facts and lacking faith in their employers' response and reporting systems.
* From a checklist of ethical violations, 54 percent of U.S. employees cite at least one occurring in the past two years at work, with lying to supervisors and poor treatment of employees at the top of the list.
* Industries with the worst ethics ratings are transportation, retail, government, and manufacturing.
* Industries with the best ethics rating are financial services, technology systems, and insurance.
* Integrity at work relates to employee loyalty. Nationally, 40 percent of employees who say their senior leaders have high personal integrity are also truly loyal to their organization. That number drops to only 6 percent when employees do not believe their senior leaders have integrity.

The implications of the study are quite clear for retailing, in that it is among the industries with the worst ethics ratings. Because manufacturing is also on the worst ethics list, and many retailers are involved in manufacturing through their private-label collections, it is imperative for retailers to take a clear look at their practices and make certain that they are ethical.

Areas of Ethical Concern

Retailers are involved in a wide range of activities to achieve their goals. These include purchasing merchandise, developing advertising campaigns, recruiting and evaluating employees, preventing losses, dealing with conflicts of interest, and choosing vendors. Inherent in each of these activities are practices that govern the people who carry out these responsibilities. The following sections explore these and other individual specialties that comprise the retail operation in terms of their potential for compromised ethics.

BUYER CONFLICTS OF INTEREST

In pursuit of the best merchandise to fit their company's product mix, buyers regularly visit many vendors to screen their lines.

While the majority of buyers approach their purchasing needs in a scientific manner, using computer-generated past sales records, meeting with market representatives such as resident buyers, and examining the appropriate trade publications for editorial direction, some buyers write their orders based on personal rewards.

The vast majority of merchants have developed company positions regarding potential **conflicts of interest** and how those in their employ must handle them. SteinMart, an off-price fashion retail chain, for example, makes it quite clear to its staff that those conducting business on behalf of the company shall do so in an honest and ethical manner. Those in positions of authority who interface with vendors and suppliers "may not accept cash payments, loans, gifts greater than nominal value ($50), services or non-local entertainment." Not only are employees made aware of this edict but also the vendors with whom they have business relationships are told of it. To make certain that everyone with the potential for unethical conflicts of interest can be aware of this policy, SteinMart makes it available in written form at its premises and on-line at **http://services.steinmart.net/services.nsf/Vendor**.

Buyers must assess vendor merchandise to make certain that it fits their customers' needs.
(Courtesy of Ellen Diamond)

Conflicts of interest are not only in the realm of buying. The potential for concern crosses into every part of the retail operation. The following spotlight examines the May Company's Conflict of Interest policy.

Fashion Retailing Spotlights

THE MAY COMPANY

Back in 1877, David May opened what was to become one of the premier fashion retailing operations, the May Department Stores Company. Through a multitude of expansion programs that included acquisition of already existing department stores and specialty chains, it has gained national renown in the industry and the markets it serves. Lord & Taylor, Kaufmann's, Hecht's, Filenes and Marshall Field's are part of the May family.

Recognizing that conflicts of interest may seriously affect its profitability, the company has developed a conflict of interest policy that governs all employees. The policy addresses relationships with suppliers, customers, and competitors. Prominently stressed is that "any direct or indirect conflict of interest between an associate and the company is prohibited unless consented to by the company." The policy stresses that an associate should not have any substantial stock or other financial investment in a competitor or participate in the business of or serve as a director, employee or consultant to a competitor.

Also clearly spelled out is the May Company's stance on the business activities of close relatives. It determines that an associate has a potential conflict of interest whenever a close relative has a significant interest in a transaction or a significant relationship with any competitor or resource. Such associates, the policy states, may not make or influence any decision that could directly or indirectly benefit his or her close relative. For example, buying merchandise for resale from a relative's company could be considered a conflict of interest because these transactions may not receive the usual careful scrutiny that goes into purchasing. Even if that is not the case, the appearance of an impropriety could have far-reaching implications.

To protect the appearance of a conflict of interest, May Company associates may not accept gifts including merchandise, trips, cash, or other valuable items from anyone seeking to do business with the company.

Other areas covered by conflict of interest policy include outside business activities, nonbusiness activities, personal use of corporate property and corporate information, disclosure of material inside information to outsiders, and insider trading.

The policy advises employees with questions concerning whether a potential conflict of interest exists to contact one of the people charged with the responsibility to make these judgments.

May's conflict of interest policy is one of the most extensively written documents on the subject in the retailing arena. More detailed information regarding the policy is available on the company's Web site, **www.mayco. com.**

VENDOR STANDARDS

When glaring headlines a few years ago blasted such unethical manufacturing practices as those of Kathie Lee Gifford's company, with its employment of minors to make its products sold in Wal-Mart, many major retailers rushed to develop initiatives that would prevent such adverse press coverage. By participating in questionable practices, retailers run the risk of losing business and causing shoppers to be wary of purchasing from them.

In today's fashion-retailing sector, more merchants are developing their own brands and labels. Since the cost of production is considerably lower in many global markets, most production takes places overseas. Unlike the strict legislation in the United States that clearly states the rules and regulations governing manufacturing in this country, many offshore production companies do not have such guidelines to follow. Since many American retailers have working relationships with these producers through joint ventures, they have direct responsibility to make certain that overseas producers follow the standards required by American law as well as the company's standards. Even where the production is accomplished domestically, these standards are not always met.

The Target Corporation has established a corporate compliance program that focuses on enforcement of its **vendor standards**. Some of the important features of the program involve an inspection program, during which random visits are made to vendor and subcontractor manufacturing facilities. Since many of Target's vendors are based offshore, a full-time overseas based staff regularly checks for compliance to the company's program. If and when violations are discovered, the penalties range from administrative probation to severance of the relationship. Assisting in this endeavor to maintain the highest ethical standards are the company's buyers and other personnel who visit vendor factories. They undertake a vendor compliance evaluation that is used as a screening tool to determine if a full inspection of a facility is warranted.

More retailers are requiring domestic vendors to sign contracts that mandate them to guarantee that all goods are produced in compliance with such laws as the Fair Labor Standards Act of 1938, legislation that governs how employers pay and treat their employees. Even though non-U.S. markets generally do not have such stringent standards, most American retailers have established basic minimum requirements to cover their off shore vendor relationships.

In the absence of any vendor standards, companies run the risk of having their images tarnished when substandard working conditions are made public.

QUESTIONABLE PRICING STRATEGIES

Most everyone loves a bargain, and retailers are often ready to legitimately offer them to shoppers. In both on-site and off-site operations, there are times when promotional pricing is used to motivate consumers to buy. In some of these situations, retailers resort to practices that are not only unethical but illegal. In the case of home-shopping networks, for example the thrust is always on the bargain that is available to viewers if they act in a timely fashion.

Often, merchants who engage in promotional pricing do so with practices that are questionable. Typically, the offerings speak of the "regular" prices, but the information regarding when they were offered at these regular prices—and in the case of the cable home-shopping shows,—where these products were offered at the higher listed prices—is not mentioned.

Such pricing strategies might be conceived as misrepresentations and can cause distrust among potential shoppers. While the temptation to use this strategy is great, it can invariably discourage consumers from patronizing that retail operation.

ADVERTISING MISREPRESENTATION

The larger fashion retailers use regular advertising as a means of attracting shoppers to their stores. Occasionally, these merchants tempt shoppers to their stores by advertising well-known products at prices that are well below their usual selling prices. These ads sometimes feature merchandise that is in short supply, and when shoppers come to the store to buy it, they are told that the item is out of stock, and efforts are made to sell them another product that will bring a better markup to the company. The technique is known as **bait and switch**, and it is not only unethical but illegal in many states.

Another questionable practice concerns placing conditions in **fine print** at the bottom of an advertisement. For example, if an ad features a storewide sale the fine print lists the exceptions to the sale. The unaware shoppers are motivated by the price reductions to come to the store only to discover the fine print has excluded their favorite brands from the sale. This poor communication practice, while legal, does compromise company ethics.

RECRUITMENT AND ADVANCEMENT IRREGULARITY

Charges of discrimination in the workplace are frequently the topics of newspaper articles. Minority groups continue to level charges against businesses that practice discrimination in hiring and promotion. Not only is this illegal but it also presents the perpetrators in an extremely poor light that can seriously affect their images. Bad press causes irreparable harm, and cannot easily be fixed by even the best public relations firm. Retailers should emphasize hiring the best-qualified candidates for positions, and offer promotions to those who qualify, regardless of their race or religious beliefs. With the use of sensitivity training sessions and focus groups, discriminatory hiring and advancement practices can be eliminated.

The National Association for the Advancement of Colored People (NAACP) has played a vital role in uncovering such egregious actions and has called for boycotts of these companies that practice discrimination. This poor publicity is detrimental to the profitability of retailers and other businesses that engage in such practices.

INTERNAL THEFT JUSTIFICATION

As discussed Chapter 10, "Merchandising Distribution and Loss Prevention," employees are stealing from their employers at record rates. These culprits are employed in every level of the organization, ranging from the upper levels of management to those who work in the stockrooms. While lower-level employees are often looked upon as the group that steals the most, it is often members of management, with their easy access to merchandise controls and an understanding of the company systems, who are the perpetrators.

Some, when caught, offer the excuse that they are underpaid and steal only as a means of getting what they believe they deserve. This is an unacceptable answer, and criminals must be punished for their crimes or the situation will become even more severe.

Through seminars at the time they are hired, employees should be told the company's position on internal theft and how those who steal from the company will be prosecuted.

Ethical Dilemmas

The fact that a code or system of ethics exists (a subject that will be fully explored later in the chapter) does not guarantee that potential and current employees will understand and follow it the same way. People are influenced by their religious upbringing, moral attitudes, responses to peer pressure, and other things to have different reactions to the same situations.

Internal theft poses threats to the success of retail operations.
(Courtesy Checkpoint Systems Inc.)

Typically, the following **ethical dilemmas** are faced on a daily basis by those engaged in retailing as well as other professional endeavors.

* *Exaggerating credentials on resumes.* To increase their chances for getting job interviews or to get an edge over others applying for the same positions, many job seekers exaggerate their skills and talents. This practice is the first indication that the candidate may also cheat on the job. Pure and simple, it is unethical to lie, and the potential for getting caught is significant.

* *Using the Internet during working hours.* Employee salaries are based upon the hours they spend performing professional duties. Buyers, for example, among other responsibilities, are paid to plan their purchasing needs for each season. In doing so, they are constantly working on their computers to check past sales records, analyze the performance of specific items, verify markdowns, and so forth. Their computers also give them access to the Internet, where more than just business information is available. Is it ethical for them to log onto particular Web sites or surf the 'net for their own pleasure during work time? Some buyers maintain that if they finish their professional obligations it is all right to use the computer for their own needs. Personal use of the computer to access the Internet unless clearly spelled out by employment manuals or supervisory personnel, isn't ethical. Buyers can always find work-related ways to occupy their time, such as going onto the selling floor and making visual observations of the shoppers, meeting with sales associates to learn what is in stock, and so forth. Employees who use every minute of the day to help the company reach its goals will more than likely benefit as well.

* *Bypassing the immediate supervisor.* In most large retail operations, there are tables of organization that indicate **lines of authority** (see Chapter 3, "Organizational Structures"). These routes spell out the appropriate staff members to address for a variety of reasons. In cases requiring dispute resolution, it is standard practice for subordinates to speak to their immediate supervisor. If there is a dispute between the supervisor and the subordinate, the person at the lower level may be tempted to bypass the superior employee and go to the next in line to solve the problem. This is generally not permissible. Disputes must be settled according to the dictates of the table of organization; and not abiding by the rule can adversely affect the lower-level employee. While the lower-level employees may feel frustrated, any "end-runs" are considered to be unethical.

EMPLOYEE GUIDELINES

S01 Employee Guidelines rev 01/03

In order to eliminate the potential for improper performance on the job, some preemployment companies provide new employees with on-the-job guidelines.
(Courtesy Oasis Staffing)

• *Becoming romantically involved with the manager.* Many business environments bring two people together on such a regular basis that it is possible for romantic entanglements to occur. Is it ethical for these relationships to continue? Will questions be raised among the other employees, especially if the involvement is between a manager and subordinate? The question of ethics in this case is a difficult one. On the one hand, two people, if properly performing their duties and responsibilities on the job, are certainly entitled to engage in personal relationships after the workday has ended. On the other hand, people in the same department might notice the manager conveying a degree of favoritism on the subordinate, which could lower morale for the other workers at the same level. Even if the manager is careful not to offer special treatment, the perception that it is there often exacerbates the sit-

EMPLOYEE CONDUCT AND WORK RULES

The following actions will result in your dismissal and/or disciplinary action:

- Theft or inappropriate removal or possession of property
- Falsification of timekeeping records, violators will be prosecuted
- Violation of company policies
- Violation of safety or health rules
- Reporting to work under the influence of alcohol or illegal drugs or using alcohol or illegal drugs on the job
- Unauthorized use or disclosure of information or records belonging to OASIS Staffing and/or the client
- Rudeness/insubordination/use of foul or abusive language/fighting
- Excessive absenteeism or any absence without notice
- Unsatisfactory performance or conduct
- Any conduct not in the best interest of OASIS Staffing or client

This is not a complete listing of all possible conduct for which you may be dismissed or disciplined. Disciplinary action up to and including dismissal will depend on the circumstances and severity of each case.

Remember however, we maintain an employment-at-will relationship with our employees. This means both you and the company retain the right to terminate this relationship at any time, with or without cause, and without prior notice.

Employees guidelines (Continued).
(Courtesy Oasis Staffing)

uation. Romantic involvement is not unethical unless the company forbids it or it interferes with the functioning of the workplace.

- *Feigning illness to take a day off.* Although this is regularly practiced by people in every type of business and at every level of employment without question, this is unethical. Employees needing some personal time should contact those in charge and explain the circumstances surrounding the need. In this way, they will most likely gain the confidence of those in charge and will probably be considered more valuable, ethical employees.

- *Becoming a party to another's lie.* On some occasions, situations arise that cause one employee to lie for another. For example, a manager might ask a salesperson to lie to upper management and say that he was on the selling floor when in fact, he was away doing personal business. This type of situation puts the salesperson in a precarious position. Becoming a party to such actions might result in the manager making regular demands for lying. On the one hand, if he doesn't acquiesce to the wishes of the manager, the manager could give him unfair evaluations. On the other hand, lying is not only unethical but also immoral. The salesperson asked to back the falsehood must make such decisions about whether or not to tell the truth.

- *Unfairly evaluating employee performance.* Supervisory personnel must objectively evaluate employee performance. Standards and procedures are usually established to provide guidelines for employee evaluations. Sometimes, however, personal biases are reflected in these ratings. There is no room for such wavering from the truth, and anything less than the truth is unacceptable. Too often, disgruntled employees who feel they have been unfairly treated in these reports file discrimination charges. The ramifications of such behavior are many and include the potential for costly lawsuits, adverse publicity for the company, and other negative results. There is no place in business for ethical misdeeds of this nature.

- *Misrepresenting product information.* Sales associates are often called upon to help customers evaluate the merchandise before they decide to buy. Misrepresenting the facts, or coloring responses that are not exactly truthful is unethical. For example, telling a customer that a garment is washable when it isn't will surely result in the shopper returning the merchandise, and losing confidence in the store. Such actions also require that the merchandise be returned to the vendor, who might be wary of accepting the return, and the store will have to incur the expenses for the delivery charges.

• *Falsifying expense accounts.* In fashion retailing, buyers and merchandisers spend considerable time in domestic and international markets trying to find excellent merchandise. In these travels, expense accounts are used to cover the costs of the trips. **Expense account falsification** has become a significant problem for retail organizations. Taking a spouse on such a trip and charging his or her expenses to the business is an example of an infringement. Not only are such practices unethical but they also tend to cost the company. It is never acceptable to be a party to padding of expense accounts or to using them for purposes other than those directly related to the business.

• *Blaming others for personal mistakes.* People rarely want to accept the blame for misdeeds and tend to pass it on to others. For example, a buyer who mismarks the merchandise and prices it below the intended price, passes the blame to her assistant when discovered. Blaming others for one's own mistakes is unethical and can cause severe downturns in employee morale. Few of the accused will readily accept that they are the ones responsible for the errors, and this could result in ugly confrontations. Those who err should be ready to take the blame and suffer the consequences.

• *Betraying the confidence of others.* Sometimes employees share their personal problems with others and ask that they hold the details in strict confidence. Since there is no guarantee that the secret will be kept, those who confide in others run the risk of exposure. Although it is unethical to do this, it is not illegal. However, employees who betray their coworkers' trust could cause the working environment to become less pleasant, diminish morale, and create fights, all of which could affect the running of the operation.

People view these types of dilemmas as ethical or unethical based upon their own experiences and beliefs. Management should carefully discuss the potential for ethical problems with new employees and hold seminars to refresh the memories of current employees. This will take many problems out of the work environment.

Codes of Ethics

Companies of all sizes are developing **codes of ethics** and codes of conduct that address their expectations of employees and other companies that interface with them. It is commonplace to state basic ground rules and acceptable practices to prevent poor judgment. When employees adhere to specific ethical practices, as outlined in these codes, they can carry out their jobs without having their decisions second-guessed. One of the major fashion retailers in the world is Gap Inc.; its code is discussed in the following spotlight.

Fashion Retailing Spotlights

GAP INC.

Gap Inc. was founded in 1969 by Donald and Doris Fisher in San Francisco, CA. Its beginnings were quite modest with only one store and a few employees. The resulting retailing empire that sprang from that inauspicious start is quite phenomenal. Today, the company is one of the world's largest fashion specialty retailers, and is composed of three divisions, The Gap, Banana Republic, and Old Navy. With more than 165,000 employees supporting and working in more than 4,200 units in approximately 3,100 locations in Canada, France, Germany, Japan, United Kingdom, and the United States, its international recognition is unparalleled in specialty store retailing.

In its desire to promote and ensure a responsible ethical work environment for all of its employees, the company created a code of ethics titled "Code of Business Conduct" in 1998 and regularly updates it to make certain it continues to meet the company's high standards. Not only does the code address a host of different ethical considerations but it also encourages company employees to act on anything that they consider violations of the code. If employees significantly violate the company's policies, employees face termination of employment as well as filing of criminal charges where applicable.

In the area of discrimination and harassment, a problem that seems to be increasingly plaguing businesses, Gap stresses its "Zero Means Zero" policy. The code clearly states that it has "zero tolerance for discrimination and harassment. All employment decisions are to be made without regard to race, color, age, gender, sexual orientation, religion, marital status, pregnancy, national origin/ancestry, citizenship, physical/mental disability, military status or any other basis prohibited by law."

Attempting to avoid any potential for a wide variety of problems, the code specifically addresses a host of issues such as complaint procedures, accommodations for disabilities, workplace violence, labor laws, alcohol and drug use, international trade regulations, bribes and improper payments, fair dealing, health and safety, confidentiality, **inside trading**, conflicts of interest, and gifts and entertainment.

In addition to presenting these different areas of concern in the code, Gap also attempts to clarify some potential problems with a question-and-answer segment to help the employees understand what is appropriate and what is unacceptable. For example, "A furniture vendor offered to build a cabinet for me for free at my home. Is this okay?" The answer, "No. The company's policy on vendor gifts applies at home as well as in the workplace".

The complete code of conduct, along with the questions and answers are available on-line at **http:phx. corporateir.net/phoenix.zhtml**.

Many professionals have expressed their opinions on the need for codes of ethics. Stuart Altmann, the chair of the ethics committee for the Animal Behavior Society, states, "The need for special ethical principles in a scientific society is the same as the need for ethical principles in society as a whole. They are mutually beneficial. They help make our relationships mutually pleasant and productive. A professional society is a voluntary, cooperative organization, and those who must conform to its rules are also those who benefit from the conformity of others. Each has a stake in maintaining general compliance."

WRITING A CODE OF ETHICS

The need for establishing codes of ethics involves many factors. The most important reasons have been presented by the Life Skills Coaches Association of British Columbia. They are as follows:

* To define accepted/acceptable behaviors.
* To promote high standards of practice.
* To provide a benchmark for members to use for self-evaluation.
* To establish a framework for professional behavior and responsibilities.
* To be a vehicle for occupational identity.
* To be a mark of occupational maturity.

Understanding the need for a code of ethics only begins to address the problem. Individual companies, whether they are retail organizations or other types must first assess their own needs. Once companies have established their codes, they must be written down and made available to all employees.

Typically the development of a code should consider the following elements:

1. Stating the purposes of the code. They may be to provide an acceptable behavior policy, how employees properly interface with those above or below them in their tables of organization, or other reasons.
2. Creating a set of documents that serves the purposes of the company.
3. Developing a code that is specifically tailored to the needs and values of the organization.
4. Preparing a list of the organization's rules and regulations so that there will be no doubt in the employees minds of what is expected of them.
5. Clearly stating the penalties of violating the principles set forth in the code.
6. Detailing the manner in which violations of the code of ethics will be punished.
7. Organizing a company committee that will develop the code of ethics. It is best to involve both upper management and people at all levels of employment so that their thoughts could

be considered. Limiting this development stage to only the upper-level decisionmakers will often cause a problem in morale.

8. Describing the manner in which the code of ethics will be implemented. Making certain that employees inside of the business as well as employees of companies that interface with the company are aware of the code is extremely important if it is to work. In the case of fashion retailers, who work closely with vendor's, and market consultants, who often coordinate purchase plans, it is imperative that they know the company's code so that no unethical problems arise.

9. Preparing a formal document that will encompass every aspect of the code.

10. Providing for a periodic review system that will allow for revisions and updates so that the individual aspects of the document will always be current.

SOCIAL RESPONSIBILITY

The print and broadcast media have made most people aware of the different types of social programs that retailers, as well as other business institutions, are underwriting.

Showing **social responsibility** rewards merchants in a number of ways. Not only do retailers provide funding for those in need but retailers improve their images as members of the business community. Each year, more fashion retailers are joining the bandwagon and setting aside funds earmarked for such purposes. However, retailers must be careful not to give the impression that they are only contributing funds to improve their image in the public eye. This will make them seem self-serving and might adversely affect their commitments. The public must be made to believe that the company's involvement is sincere. Professional public relations people can help bring the attention to a company's endeavors in a manner that will not cause suspicion.

Major fashion department store groups such as Saks Inc., which has in its family such leaders as Saks Fifth Avenue, Carson Pirie Scott, Boston Store, and Proffitt's, and Federated Department Store's with Macy's, Bloomingdale's, and Burdine's under its umbrella, continue to participate in numerous community activities that benefit a host of different organizations, as do such specialty fashion chains as Eddie Bauer, The Gap, and Limited Brands. Each of them has ongoing sponsorships with major charitable and community organizations as well as special commitments that address the needs that arise from circumstances in specific locations. Saks, for example, reacting to the tragedy of September 11, 2001, created a $1 million assistance program for the victims of the terrorist attacks.

Some of the programs that the fashion retailing community are involved in include AIDS research, cerebral palsy, the United Way, the Susan G. Komen Foundation, the Pediatric AIDS Foundation, Make-A-Wish, Habitat for Humanity, and the Juvenile Diabetes Foundation.

These and other fashion retailers do more than make financial contributions. Company employees also engage in volunteerism donating their time to a variety of causes such as mentoring programs, playgrounds maintenance, food and clothing drives, environmental projects, tutoring innercity youth, nurturing children, donating blood, and painting projects.

Les Wexner, chairman and CEO of Limited Brands, describes his company's commitment to social responsibility in the following statement: "I believe companies like ours should be a source for good. For us. For our communities. For the World." This is the essence of the beliefs of most other companies who are socially committed to charitable causes and the improvement of their surroundings.

TRENDS IN ETHICS AND SOCIAL RESPONSIBILITY

The unethical business practices that were exposed early in the twenty-first century has made many companies more carefully examine their practices and correct those that needed attention. Some of the trends that have come about as a result of these introspections include those discussed in the following sections.

Reconsideration of Management Salary Packages

Many executives who were found to be less than forthcoming in their dealings with companies and were relieved of their duties were nonetheless "rewarded" with **"golden parachutes"** that sometimes amounted to multimillion dollar bonuses. With the **severance packages** scrutinized by the media, companies were pressed to discontinue the lavish treatment of their departing upper echelon.

Today, more retail giants, as well as other businesses, have rewritten their monetary codes. Gone, for the most part, are the inflated salaries and benefits that had been bestowed by their boards on those in positions of power. The fallout from these scandalous headlines has made companies take a better look at how they are paying those who sit in the ivory towers.

Reconstruction of Codes of Ethics

In place of the codes that were once wrought with ambiguity, today's codes of ethics are more completely spelled out to eliminate the potential for misunderstanding. Ranging from areas that deal with hiring practices to the handling of employee complaints, these rewritten codes are more likely to address almost any situation. The codes not only deal with employees and how they perform their duties but also the vendors with whom they have business relationships.

Establishment of Recruitment and Promotion Standards

In an attempt to make certain that charges of discrimination in terms of hiring and advancement are eliminated in the workplace, more companies are using outside groups such as the NAACP to act as consultants in the development of their codes of ethics.

Reexamination of Advertising Claims

Many problems have arisen because of misleading claims regarding prices in advertisements. The use of terms such as "regularly," "originally," and "comparable value," has led to a rash of consumer complaints. In their codes of ethics, many retailers now clearly state when and if such potentially misleading pricing terminology may be used in their ads.

Development of Codes with Employee Input

Instead of leaving the development of codes of ethics only to those in upper-level management positions, many retailers are organizing focus groups composed of those at every level of the organization's structure. With input from the lowest levels, there is less potential for problems regarding ethics to arise.

Social responsibility has also become a more important area for retailers to consider. Some of the trends in this arena include those discussed in the following sections.

Caring for the Environment

With a greater percentage of consumers than ever before showing concern for the environment, many companies are instituting programs that fund environmental causes and are involving their employees in hands-on projects. Caring for trees and maintaining trails are just two of the ways in which retailers are showing concern for the environment.

Employee Volunteerism

Tutoring of disadvantaged youth, mentoring programs, helping in fundraising with special events, participating in blood drives, collecting supplies for families in need, adopting families during the holidays, and collecting food for families in need are just some of the ways in which retail employees are showing social responsibility through **volunteerism.**

SMALL STORE APPLICATIONS

Although codes of ethics are less likely to be formalized by small merchants, the application of ethical standards parallels those found in their larger counterparts. For example, employees in small retail operations were once hired on the basis of their "similarity" to the owner. Today, there is much more diversity in hiring practices.

Employees who were once required to work additional hours without extra pay are being paid for their overtime work. Although the practice of requiring employees to work past the standard forty-hour week without extra compensation was once the norm, today's small entrepreneurs pay their employees time and one-half for the extra hours worked.

In terms of social responsibility, small retailers do not generally have the funds to give for charitable causes. They do, however, run fashion shows and give the proceeds to charity, give a portion of a day's sales transactions to charitable causes, and help in various fundraisers that benefit the needy.

Chapter Highlights

1. The rash of unethical occurrences in business have caused retailers to make certain that their codes of ethics address a variety of issues to prevent improper actions by their employees.
2. In understanding the complexity of ethics, it is essential that the issues be recognized and that skills be developed to address the problems.
3. Research indicates that retailing is among the industries with the worst ethics ratings.
4. There are often buyer conflicts of interest in regard to their relationships with vendors.
5. In the absence of any vendor standards, companies run the risk of having their images tarnished when substandard working conditions are made public.
6. Advertising misrepresentation causes a great deal of trouble for retailers in terms of their public images.
7. Ethical dilemmas run the gamut from exaggerating credentials on resumes to feigning illness to take a day off from work.
8. Falsifying expense accounts is a major problem for retailers. Often times, management personnel such as buyers and merchandisers "pad" their expense accounts when away on business trips. The end result is a decrease in profits.
9. Codes of ethics are essential for companies of all sizes so that employees will be able to carry out their duties and responsibilities without being second-guessed.
10. A written code of ethics should define acceptable behaviors and promote high standards of practice.
11. Retailers of all sizes participate in social causes as a means of helping those in need and at the same time, raise their images.
12. Social responsibility comes in the form of dollar expenditures for charitable and worthy causes as well as from volunteerism on the part of company employees.

Terms of the Trade

ethics
situational ethics
business ethics
conflict of interest
vendor standards
bait and switch
fine print
ethical dilemmas
lines of authority
expense account falsification
codes of ethics
inside trading

golden parachutes
severance packages
social responsibility
volunteerism

For Discussion

1. Which fashion guru, by her actions, has caused significant potential harm for her retailing affiliate? Name the affiliate and the lines affected by this unethical practice.
2. Why should retailers develop codes of ethics for their employees and the industry partners with whom they interface?
3. How would you define the term "business ethics"?
4. What is meant by the term "situational decision making" as it applies to ethics?
5. What percent of U.S. employees believe that their senior leaders are people of high personal integrity? What percent of U.S. workers are comfortable reporting ethical violations?
6. Which four industries are reported to have the worst ethics ratings?
7. Why do many fashion retailers disallow vendors to give buyers gifts worth more than $50?
8. Describe one questionable pricing strategy used in retail advertising that often causes ethical concerns for consumers.
9. What are some of the unethical and illegal practices that some employees use when caught stealing?
10. Why is the exaggeration of credentials a telltale factor for a person applying for a position with a retailer?
11. Is it ethical for workers to use the Internet for personal reasons during the workday at the office?
12. Is it ethical for employees to take sick days when they aren't really ill?
13. Might workers lie for their supervisor if they are asked to do so? Why?
14. How can falsifying expense accounts harm the company?
15. What is the basic premise that any code of ethics begin with?
16. Why should retailers become socially responsible?
17. What types of organizations do major retail organizations support in their social responsibility programs?
18. In addition to providing monetary contributions to charities and other needy causes, what other actions do retailers take in their endeavors to become socially responsible?

CASE PROBLEM 1

Joy Green has been employed as a buyer for the Male Ego, a specialty chain of fifty units, for more than five years. Starting as an executive trainee ten years ago, she was promoted to her present position because of excellent performance. She has always conducted herself in a manner that is both professionally and ethically principled. Her buying expertise has made her department one of the most profitable ones in the company.

Joy's performance has been exemplary in that she bases her purchases on last year's sales figures, adjusting the vendor base according to the sales of each one. She carefully researches the wholesale market and chooses vendors that she believes will deliver the most appropriate merchandise for her department. She is not prone to take gifts of any nature, except perhaps the business lunch offered by the vendors with whom she is working at the time of purchase planning. She is, in fact, considered by her supervisor, the divisional menswear manager, the most ethical person in the company's roster of buyers.

Bearing all of these positives in mind, a question of ethics has surfaced regarding one of her actions during the workday. The unidentifiable complainant accuses her of using the Internet for personal reasons during the workday. The complaint states that her time spent on the job is not being exclusively used to perform job-related activities such as purchase planning, model stock development, and so forth. She has been reprimanded for her actions and told if the practice continues, she is likely to be terminated.

Questions

1. Do you think her use of the Internet for personal reasons is appropriate? Why?
2. How should the company make it clear that such practices are unacceptable?
3. Is there any time when such personal use could be considered proper?

CASE PROBLEM 2

The Damon Company, a fashion-oriented upscale department store, has been in business since 1985. Its success has been better than anticipated. Since the company opened its flagship store, it added five branches and a catalog division as well. To make it a multichannel operation, it recently added a Web site that has also been a success.

Each year the company has shown an increase in sales and profits. Even in times when other companies have been less profitable, Damon's has fared favorably. One of the reasons it attributes to its success is the strength of its work force. From upper management on down the company has had the good fortune of achieving solid performances. The human resources director, who had been with the company since its inception, recently retired and was replaced by John Franks, who was recruited from another department store organization. As is often the case with newly hired executives, he implemented changes to fit his own personal methods of conducting business.

John, after studying the company's recruitment practices, decided that the selection process used in the past wasn't as carefully controlled as it should have been. He learned from his employment manager that resumes weren't carefully scrutinized and instead reliance on whether a candidate was suitable was placed on the interview. Although this practice seemed to help select excellent candidates for the various management positions, he firmly believed careful resume checking would be beneficial.

John decided to review the resumes of those managers who joined the company during the past two years to make certain that the information they provided was true. He had his assistant make inquiries regarding twelve members of middle management that primarily consisted of company buyers. All of them had accurately stated their credentials on their resumes except for one. Anne Jenkins, buyer of better collection sportswear, who had been with the company for eleven months and performed admirably, had some questionable entries on her resume. Her dates of employment listed for her employment prior to Damon's were inflated, as was the list of previous employers. Two of them, in fact, didn't recall her being part of their companies. When confronted with the discrepancies, Anne continued the charade by saying the last company was wrong and the two that didn't have her listed probably kept poor records.

In spite of the questionable entries, Anne has been an outstanding employee significantly contributing to the profitability of Damon's. The situation now involves the problem of ethical practices.

Questions

1. Should Damon's terminate Anne's service with the company? Defend your answer with sound reasoning.
2. Would her continuance as a buyer pose a potential threat to the company?

EXERCISES AND PROJECTS

1. The concept of ethical practices is widely discussed on numerous Web sites. Each provides a wealth of information on the subject. Select five Web sites that have specific references to business ethics, and use the information to complete the following chart.

Web Site	Ethical Considerations

2. Contact a major retail operation either by telephone, fax, or e-mail and request an interview with a member of the human resources department to learn about the company's code of ethics. Write a two-page, typewritten paper outlining its code.

SECTION TWO

The Fashion Retailer's On-Site Environments

CHAPTER **7**

Store Location

After reading this chapter, you should be able to discuss:

■ How a retailer analyzes a potential location before determining its viability for a successful operation.

■ The importance of population, area characteristics, and competition to brick-and-mortar locations.

■ The various types of shopping districts for fashion retailer use.

■ Site selection in terms of competition, neighboring stores, and travel convenience for the potential customers.

■ Several trends in store location.

When seasoned retailers are asked which three factors they consider most important to the success of a new retail venture, they answer, "location, location, location!" This does not undermine the importance of the many other factors to be considered before embarking upon a new venture but underscores the vast significance played by location in terms of retail success. All too often, inexperienced merchants elect to forego a choice location in favor of a lesser one simply because they consider the costs of leasing a prime site to be too high, but they are willing to spend considerable sums on store design, fixturing, visual merchandising props, and so forth. There is nothing as disheartening as a store that is elegantly designed located in a place where consumers rarely venture. While it is occasionally true that a merchant finds good fortune in an **off the beaten path** location, this tends to be the exception rather than the rule,

The choices for store location are more varied than ever before. While once the downtown central districts, or the huge regional malls were considered to be the most viable retail locations, today merchants are discovering a host of new environments in which to begin or expand their businesses. Fashion merchants are choosing places previously considered to be inappropriate for their needs and are achieving unparalleled success in them, such as abandoned factories and warehouses, reclaimed historical landmarks, superhighway arteries, and "power centers." It is a combination of location analysis and creative thought that has given the retailers such new homes for their businesses.

This chapter discusses only the brick-and-mortar locations. Although offsite merchants need to consider such location-oriented questions as access to shipping terminals, they do not face the same issues as their brick-and-mortar counterparts.

CHOOSING THE LOCATION

Selecting the most suitable location involves a three-pronged approach. First is the choice of a trading area that best serves the needs of the particular company, second is the exploration of the available shopping districts within the desired trading area, and third is the choice of the exact site on which the store will stand. The following sections explore each prong and show its importance to the process.

Analysis of the Trading Area

How far a customer will travel to a particular store depends upon that store's drawing power and the customer's need for the specific merchandise it offers. When people are looking to buy a pack of cigarettes or a container of milk, they will go to the closest possible place. If the shopper wants to buy an expensive dress, she will often travel great distances. The places from which retailers can expect their customers are called **trading areas.** Some companies enjoy unusually large trading areas because of the nature of the products they offer and their exclusivity. L.L. Bean, for example, the world's largest purveyor of outdoor clothing and equipment, is in Freeport, ME, where it occupies more than a full square block. The destination is so popular that shoppers come from many surrounding states and Canada, making Bean's trading area unusually large. As a result of its unusual success as a **destination location,** the surrounding area has developed into a thriving off-price designer center that features such marque labels as Ralph Lauren, Cole Haan, and Burberry. Mall of America, in Bloomington, MN, is America's largest shopping venue; it also has an unusually large trading area. Shoppers travel hundreds of miles to visit the unique center to shop and to enjoy the multitude of unique attractions. Most regional malls have much narrower trading areas. Throughout the United States, there is a major mall approximately every ten miles. Since the malls are virtually all the same, it is unlikely that a shopper will travel past one to go to another that is farther away. Occasionally, some cities have malls that are even closer to each other than the standard ten miles. In Chicago, on Michigan Avenue, for example, there are three major vertical malls in less than one mile. With the limited amount of space in these high-rise ventures, there is little room to house all of the merchants who want a presence in them. Thus, there is a need for several of these entries.

To determine the extent of the trading area and if it is appropriate to support a potential business, retailers need to consider factors such as population, area characteristics, and competition.

POPULATION

The size of the population alone is not sufficiently indicative of the type of people who inhabit a trading area. Income levels, ages, occupations, living conditions, and so forth should be considered in the overall assessment. This information is available from sources such as the Census Bureau. Since the general population census is taken every ten years, major retailers undertake their own studies that are more timely and also better tailored to their specific needs.

The demographics important to fashion merchants include the following:

• Income level of the population plays a significant role in the evaluation of an area. For fashion retailers, this is probably the most important of the considerations. While fashion merchandise is available at numerous price points, it would be unwise to begin an operation in a socially and economically deprived area. Although retailers of food and other necessities are found in disadvantaged communities, those who sell fashion would not consider those lucrative areas. However, people with modest incomes do buy fashionable items. Since the fashion industry makes goods available at a variety of price points, the retailer must determine if the income level in a specific geographic area is appropriate for its particular brick-and-mortar operation.

• Different age groups have different fashion needs. Young professionals generally choose merchandise that offers status without considering price. Senior citizens, however, are generally very careful shoppers, primarily considering price and value. Similarly, each age group has specific needs and buying preferences. Since the wants and needs of all the groups are different, the merchant must study the population to determine if the predominant age group in the trading area is the one the retailer can accommodate.

• Occupation is an important consideration in the fashion needs of consumers. Career women, a population segment that is increasing, are major purchasers of fashion goods. They need clothing and accessories for their professional lives and their social lives. A shop that serves the needs of this population would be best located in a major city where these women

The size of the population alone is insufficient in determining a retailer's appropriate trading areas. Assessments must be made in terms of income levels, age groups, occupations, and so forth.
(Demetrio Carrasco © Dorling Kindersley)

Occupations play a major role in determining the right location choice.
(Courtesy Ellen Diamond)

work—and often live. Such a venture in a suburban location that is predominantly inhabited by families with infants and toddlers would likely fail.

• Marital status and gender of the trading area are worth considering. In some places, unmarried people dominate. This is particularly true in the Upper East Side and West Side of New York City, where a significant number of singles live. Since unmarried people have different spending patterns from married people, retailers should be aware of the marital status of potential customers. Singles, for example, are big spenders on clothing that appeals to the opposite sex and thus would be a natural market for retailers of this type of fashion. In some locales, there is a definite majority of older women, signaling a greater need for fashion retailers who specialize in clothing and accessories for the more mature female population.

• Household permanency can be a determining factor. For example, resort areas provide shopkeepers with people who are in the trading area for a short time. This can be a plus for the retailer, since people on vacation tend to spend more freely than when they are at home. In some vacation destinations such as ski areas, however, the retailer must determine if the business seen in a few months is sufficiently profitable to make it worth locating there. Seasonal ventures are often profitable, but retailers must carefully consider the pros and cons when embarking upon such an endeavor.

• Religious affiliation should be considered to make certain that there is nothing in the retailer's method of operation that would be offensive to the majority of the trading area in the form of the style of fashions sold or hours of store operation. For example, Orthodox Jews do not shop on the Sabbath, which could mean a considerable loss of business to merchants who view this as their most important day of operation. Although this problem might be a minor one, it should be carefully addressed before any investment is made.

• **Population shifts** are common and should be explored. While an area might presently house an appropriate number of potential customers, the figure alone will not reveal whether the population is increasing or declining or if the characteristics of the population are stable. If there is a population explosion in a trading area, there might be a different type of consumer group moving in. In the Lincoln Park area of Chicago, for example, upper-middle class young marrieds have replaced the lower-middle class population. Upscale shops now dot the landscape that was once reserved for merchants who offered low price points. And downtown metropolitan areas in other cities, once havens for the poor, have become places where the upper-middle class now resides. These people once lived in the suburbs but are now moving back to the cities and bringing with them the need for upscale merchandise. Of course, the reverse could be true, with lower socioeconomic groups replacing the more affluent ones.

If merchants do not pay close attention to these and other population characteristics, their businesses might not succeed.

AREA CHARACTERISTICS

Fashion brick-and-mortar operations need to study the particular area under consideration to determine if it offers certain advantages or disadvantages. Characteristics worth studying include the following:

• New York City, London, and Paris are considered to be prime trading areas for fashion merchants not only for their regular inhabitants but for the multitude of tourists attracted to these cities throughout the year. They offer excitement, entertainment, and culture. People visit New York City for its theater and museums, Paris for its art and beauty, and London for its historical richness. Although people don't go to these cities just to shop, tourists tend to buy more when traveling than they ever would at home.

• The accessibility of the trading area is of vital importance to the retailer. In places where public transportation is insufficient, the area should have adequate parking and an excellent network of roads to bring in the shoppers. In downtown Chicago, where street parking is almost impossible to find, the vertical malls such as the Water Tower have multilevel, underground parking facilities.

Paris, where the Samartine is located, is a prime trading area because of the multitude of attractions the city offers. *(Courtesy Ellen Diamond)*

• Local legislation must be investigated to determine if the retailer will face prescribed obstacles that would prevent business from operating freely. For example, some communities forbid Sunday openings, a day considered by many retailers necessary for conducting their business. Some areas have local sales taxes that deter people from patronizing the area when they can go to tax-free shopping venues close by. This is the case in New York City, which often loses sales to cities in New Jersey, where clothing is exempt from sales taxes.

• The number of competitors in the area should be assessed to make certain that there is room for similar businesses. Competition is a positive factor, since it indicates that the trading area is appropriate for a similar type of company. However oversaturation of a location with too many similar stores can be a problem, spelling trouble in terms of price wars and the ability to enter the market. Lack of competition, though, could indicate that other companies did not have much faith in the area and chose not to open there.

• Promotion for most fashion retailers is a must. Relying upon word of mouth to gain a share of the market is not sufficient for most retailers. Fashion retailers therefore generally use the advertising media, so they should determine whether the trading area has a sufficient number of newspapers and other media with which to promote their business.

• The availability of human resources is of paramount importance to the success of the fashion retailer. Companies such as Nordstrom and Neiman Marcus, merchants of the highest level of fashion retailing, carefully explore areas not only for good customer bases but for qualified personnel to carry out their businesses. With the enormous amount of competition in the fashion retail industry, merchants are recognizing the importance of customer service in attracting shoppers, and they need good employees to supply it.

CLASSIFICATION OF SHOPPING DISTRICTS

If the proposed trading area meets the prospective retailer's criteria, the next decision it needs to make involves selecting the specific type of district in which to open the store. At one time, merchants were limited as to the types of available districts, and downtown central shopping districts and the regional malls were the most dominant in the field. Today, retailers of fashion merchandise can choose from power centers, mixed-use centers, outlet and off-price centers, downtown vertical malls, festival marketplaces, and theme centers. Old suburban malls, such as Roosevelt Field on Long Island, NY, are being refurbished and expanded to meet the competition of new shopping centers; neglected historical sites have been restored and repositioned as exciting shopping districts; and downtown areas once blighted by hard times have been resurrected as vital shopping centers. Not every shopping district is appropriate for every fashion retailer. Careful analysis of each should be undertaken before the choice is finally made.

Downtown Central Districts

The **downtown central districts** in cities all across the United States have been home to major retailers ever since large-scale retailing began. Just about every giant department store organization has been headquartered in a downtown area. These districts not only provided a customer base from the area residents but they also hosted a daily influx of workers and in some cases throngs of tourists.

Although the downtown areas are currently alive and well in most parts of the United States, there was a period when the inner cities were being abandoned by many middle-class

Chicago's Michigan Avenue is an example of a thriving downtown central district that is continuously being refurbished to attract shoppers.
(Courtesy Ellen Diamond)

families that headed toward the suburbs. They were replaced by families with lower socioeconomic backgrounds that had different buying power. This in turn transformed the downtown areas from viable business districts to unappealing places. Today, however, the revitalization of downtown shopping districts is at its peak, returning these city areas to the glory days. Cities are spending enormous sums to redevelop the areas and make them more attractive. Following their lead, fashion retailers by the score are remodeling their **flagship stores**, such as Marshall Field's in Chicago's Loop, and other types of stores, such as those by the couturiers, are opening enormous flagships like never before. The benefit of such revitalization has caused many suburbanites to make the cities their homes. In places such as New York City and Chicago, the downtown central districts are thriving and fashion retailers are finding great success there. In addition to the individual stores that line the streets in these major central districts, urban renewal projects have incorporated structures that house vertical malls.

Even the small-city counterparts, which were once severely damaged when major regional malls opened less than a mile from their downtown centers, are enjoying a renewed interest from consumers. Many chains are lining these streets, as are fashionable entrepreneurs to cater to the crowd that prefers this type of shopping to the overcrowded mall scene. Downtowns are no longer the ghost towns of the 1980s but are in many cases viable shopping alternatives.

Inner Cities

There is a trend toward reevaluating inner-city locations by retail developers. The International Council of Shopping Centers has cited several areas in New York City, for example, that have reemerged from being fashion-deprived retail centers to vibrant higher-grade fashion-merchandise venues. The Shops at Atlas Park in the Glendale section of Brooklyn, a 400,000 square-foot project that houses Jos. A. Bank, Elizabeth Arden Red Door Salon, and Coldwater Creek, is just one example of these revitalization programs. Another is the project on Harlem's 125th Street, once a shopping street void of anything fashionable that now features such companies as H & M, a leading global fashion retailer catering to teenagers and young adults who seek trendy merchandise.

Regional Malls

When the population movement to the suburbs reached major proportions in the 1950s, the stores that dotted the main streets of these now-booming towns were inadequate to serve the needs of the inhabitants. Some department stores had branches in these areas that brought significant business to their organizations, but there were no major centers such as those in the important downtown central districts. Two of the earliest malls flanked New York City. Green Acres, on the New York City line, and Roosevelt Field, a little further east on Long Island, opened their doors in the mid 1950s as prototypes of what was on the horizon in retailing. With these two successes, the **regional mall** was off and running. Roosevelt Field would eventually expand into the fifth-largest mall in the United States, with companies such as Macy's, Bloomingdale's, and Nordstrom as anchors. Initially, Roosevelt Field was an outdoor mall, eventually enclosing its environs to compete with the first enclosed mall to be built that way, Walt Whitman in Huntington, Long Island, which was only a few miles away. Featuring climate control, these malls became the norm for regional malls. Later on, many regional centers would again adopt an outdoor design.

The **controlled shopping centers** were the first type of regional mall. That is, competition within the mall was controlled to enhance the probability that each store would realize a profit. Without the control concept, stores might be rented on a first-come, first-served basis, resulting in too many shoe stores, for example, and an insufficient number of dress shops. The draw of the mall then were the anchor stores, as they are today. Early on, there were usually two, one at either end of the facility. The **mall anchors** were the well-known department store branches with immediate name recognition. Since the department stores were, and still

The Fashion Show Mall in Las Vegas is typical of the major malls in the United States.
(Alan Keohane © Dorling Kindersley)

are, retailing's major advertisers, they attracted large numbers of consumers to the shopping area. Not only were the anchors successful, but the other stores in the mall were successful too because of the crowds in the malls to visit the anchors.

Today, regional malls bear little resemblance to their predecessors. They are often built as multilevel environments with as many as six anchors, movie theaters, and food courts to attract large crowds. People who patronize these centers may spend a full day there, enjoying themselves with shopping, eating, and entertainment.

Aside from the sufficient parking and easy access through highway arteries, the mall's success is due to a number of factors. It has become a place to spend time in addition to shopping. Many of these facilities are used by **mall walkers** who enjoy the controlled climate for their workouts, since the vast majority of these malls are enclosed. Some of these shopping arenas are outdoor ventures such as Old Orchard in suburban Chicago, the Falls in Miami, the Esplanade in Palm Beach, and Bal Harbor Shops, in Florida. Retailers also enjoy many organized promotional activities undertaken by regional malls management, such as visits from Santa Claus and the Easter Bunny, automobile shows, fashion shows, art and antique events, and the like. Expenses for these events are either paid by the developer or shared by the mall's tenants. The individual retailer gets the benefit of the resulting large crowds without having to foot the promotional bill alone.

Today, every major city boasts one or more regional malls. The new ones have vastly improved on the old, and the older malls are modernizing to remain profitable for their tenants. All across the country, mall face-lifts are commonplace, with new floors added for additional stores. Revitalization is necessary to serve the needs of the existing market, and land has become too scarce and costly to develop new malls on.

Although the United States is by far the leader in the regional mall game, other countries are now playing and, in some instances, outdistancing the United States with some of their entries. Canada, for example, boasts the world's largest mall in Edmonton. Not only does it house more than 800 stores selling a variety of merchandise but it features a giant pool complete with waves, rides and attractions, and a full-size ice-skating rink. Not to be outdone by any other country, the United States Mall of America is second largest, with a wealth of stores and attractions. A Mall of America spotlight follows.

Fashion Retailing Spotlights

MALL OF AMERICA

When Minnesota's professional baseball and football teams moved from Bloomington to downtown Minneapolis in the mid-1980s, 78 acres of land in Bloomington became available for other uses. Losing these two teams initially caused concern for the city of Bloomington, but when the Mall of America, the first American **megamall**, was built on those grounds it quickly allayed any fears the community had about losing revenues. The prime piece of real estate was only a mile and a half from the airport, with four major highways intersecting the property.

In 1987, Melvin Simon and Associates, America's largest developer of retail shopping centers, came on board as the developer and managing director of Mall of America. In 1989, ground was broken amid cries of skepticism from the local media. Despite the market research that showed its potential for tremendous success, with the possibility of drawing tourists from around the world, the naysayers were in full force.

At that point, the Twin Cities retail market was "under-retailed," in other words, its number of stores was well below the national average. Based on these figures, the developers went full speed ahead, and in August 1992, the Mall of America opened its doors. The mall was 71 percent leased with 330 brand-new stores, including Bloomingdale's, Nordstrom, and Sears, under one roof for the first time. In addition, it put more than 10,000 people to work.

Since its grand opening, more than 520 stores dot the mall's landscape. Twelve thousand people are employed, and more than 98 percent of the space is regularly leased. Visitor traffic runs between 35 to 42 million annually, and shoppers spend an average of three hours in the mall, which is three times the national average. It is one of the most visited destinations in the United States, attracting more visitors annually than Disney World, Graceland, and the Grand Canyon combined!

While shopping is the main attraction, consumers of all ages come from far away to enjoy features such as Camp Snoopy, Underwater Adventures, LEGO Imagination Center, Rainforest Café, Jillian's Hi-Life Lanes, America Live, and Cereal Adventure. Continuously changing special events such as "Duet with David Cassidy" and TLC's "Junkyard Wars" help to make this a must for tourists.

The success of this megamall annually has a $1.2 billion economic impact on the state of Minnesota.

Vertical Malls

As land became less available in the downtown central districts and the areas became more populated with household tenants, workers, and visitors, retailers found it impossible to find space in which to open their businesses. To accommodate many of these ventures and to make the prime locations better revenue producers, retailers began to think about high rise, or **vertical malls** to house scores of tenants in buildings that would otherwise be occupied by just one major company. Some buildings were erected from the ground up on the sites of old existing structures, and others were constructed by revamping vacant buildings. In Chicago, which has become the home of the vertical mall concept, one of the most profitable entries began as a new complex called Water Tower Place. Much like the sprawling suburban malls, it has two anchors, Marshall Field's and Lord & Taylor, and a host of upscale fashion specialty retailers. Its customer draw comes from a mix of people who work in the area, those who live close to the center, and tourists, many of whom stay in the Ritz Carlton Hotel that towers above the shopping center. Based on this success, two more vertical towers were erected close by. One houses Bloomingdale's and numerous fashion boutiques, and the other Saks Fifth Avenue and a wealth of fashion emporiums.

Mixed-Use Centers

One of the newest major shopping districts to be built is the **mixed-use center**. As the name implies, its composition is not strictly retail oriented, but incorporates office space, hotels, and entertainment outlets along with the stores. The concept provides a diverse market mix that consists of office workers, tourists, and entertainment seekers who not only utilize the

Lord & Taylor is an anchor store in Chicago's Water Tower Place, one of the nation's first vertical malls.
(Courtesy Ellen Diamond)

shopping facilities but the other attractions as well. These centers are built all over the country and are achieving enormous success. One of the first mixed-use centers that led to the current trend in shopping districts is the Fashion Centre at Pentagon City outside of Washington, D.C. Flanked by two existing upscale regional malls that housed the likes of Nordstrom, Neiman Marcus, and Saks Fifth Avenue, the developers believed that the massive Pentagon building, more than 4 million square feet and the site of thousands of workers and visitors, would provide a captive audience. In addition to such anchors as Macy's and Nordstrom, and fashion specialists such as Ann Taylor, Victoria's Secret, and Coach, the location includes a high-rise office building, a Ritz Carlton hotel, and a high-rise residential office building. Adding to the convenience of shopping there is the fact that the Fashion Centre is situated on the Metrorail, one stop away from the Pentagon, and a few stops from Washington, D.C.

Power Centers

Usually composed of twenty or more stores, the **power center** is a complex that utilizes high-volume, high-profile outlets to draw customers. Most of these centers have at their core **big box retailers** such as off-price merchants Best Buy, and fashion operations such as Marshalls and T.J. Maxx. The power centers occupy anywhere from 250,000 to 500,000 square feet and are located on major arteries or highways. Today, more and more discounters and off-pricers are dominating these centers.

Off-Price and Outlet Centers

Off-price fever has reached just about every corner of the United States. So successful is the concept that manufacturers and designers of fashion goods as well as the traditional fashion retailers are opening more outlets to dispose of their slow sellers and leftover merchandise. The vast majority of the items sold are fashion-oriented clothing and accessories for men, women, and children at every price point.

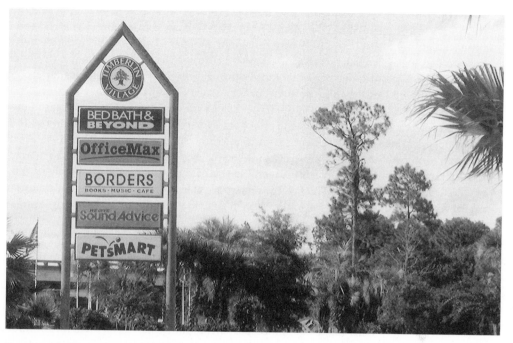

Power centers feature big box retailers.
(Courtesy Ellen Diamond)

One of the largest of these **outlet centers** is the Mills. Beginning with Potomac Mills in northern Virginia, the company has gone on to open these giant centers in locations throughout the United States such as Franklin Mills in Philadelphia; Opry Mills in Nashville, TN; Gurnee Mills outside of Chicago; and Sawgrass Mills, the largest of the group, in Fort Lauderdale. With more than 2 million square feet under one roof, Sawgrass Mills features enormous spaces for outlets of Saks Fifth Avenue; Last Call, the outlet of Neiman Marcus; and manufacturer and designer outlets of DKNY, Ralph Lauren, Calvin Klein, Barney's, and others. Along with the retail outlets that draw thousands of shoppers every day, prominent restaurants such as the Cheesecake Factory and a multitude of entertainment centers make this arena a regular destination for those who live in the regional market as well as tourists from all over the world.

Outdoor centers also continue to be successful ventures for the merchants who locate within them. They are found in every part of the country such as Freeport and Kittery, ME; Secaucus and Flemington, NJ; North Hampton, NH; Orlando, FL; Niagara Falls, NY; and Central Valley, NY. Marque labels such as Liz Claiborne, Calvin Klein, Burberry, Anne Klein, Patagonia, Jones New York and others dominate these centers.

The major players in the **off-price centers** and outlet centers are the Mills Corporation, Prime Outlets, Belz Factory Outlet World, and Tanger Outlet Centers. Collectively, they own hundreds of value centers throughout the United States. Tanger, one of the larger entries, is the subject of the following spotlight.

Fashion Retailing Spotlights

TANGER OUTLET CENTERS

Stanley Tanger, CEO of the company, developed the vision of factory outlet shopping centers by merging the concepts of customers searching for bargains and the manufacturers' needing to dispose of overstock. In 1981, his vision became reality with the opening of his first center off Interstate 85 in Burlington, NC. It was the first-of-a-kind **strip center** with factory outlet stores.

(continued)

Today, throughout twenty-one states, from coast to coast, more than 1,500 brand name manufacturer and designer outlets are available to satisfy bargain-hunting shoppers. Unlike other outlet centers, Tanger offers a unique policy called "Relax, It's Guaranteed," which offers customers a cash refund equal to the difference in price if the same product is found for less anywhere other than at Tanger. In this way, shoppers need not comparison shop to determine if the prices they paid were the lowest.

The merchandise mix found in the Tanger stores consists of first-quality, in-season merchandise as well as inventory overruns, slightly imperfects, and prior-season merchandise at substantial savings. In 2002, more than 68 million shoppers came to Tanger Outlet stores to purchase such fashion brands as Anne Klein, BCBG, Club Monaco, Escada, Hugo Boss, Nine West, Perry Ellis, and Versace. They also came to buy fashion merchandise from the outlets of such retailers as Limited Too, Eddie Bauer, The Gap, Casual Corner, Brooks Brothers, and Banana Republic.

Through the company's Web site, consumers are able to learn about sales and coupon offers, where the nearest Tanger locations are, and travel information in a number of different foreign languages.

Festival Marketplaces

When Faneuil Hall in Boston was "rediscovered" in the 1970s, a developer with foresight saw it and the immediate surrounding areas as an ideal location for a different type of shopping environment. Situated adjacent to Boston's waterfront—which was run down—a revitalization program was initiated that resulted in the now-famous Quincy Market, the subject of the next spotlight. It would soon become the prototype for other **festival marketplaces**.

It wasn't long before other downtrodden or underutilized facilities and locations would be transformed into centers that tourists and residents could enjoy. In New York City, the South Street Seaport was born in a place that formerly housed the wholesale Fulton Fish Market. Amid cobblestone streets and numerous restaurants, a wealth of merchants set up shop to make this an outstanding tourist attraction. The old St. Louis Union Station was refurbished as another festival marketplace, as was the waterfront of Baltimore, which became HarborPlace, and St. John's River waterfront in downtown Jacksonville, FL, which became the Landing.

Different from the traditional mall and downtown central district settings, the festival marketplaces are unique environments where shopping and entertainment coexist.

Fashion Retailing Spotlights

QUINCY MARKET

When James Rouse, the developer of Quincy Market, initiated the festival market concept, few had confidence that it would become a viable place for consumers to satisfy their shopping needs. As the doors to this retail arena were ready to open, the market was awash with unleased space. Complicating the problem even more was the fact that there weren't any parking facilities or anchor stores to guarantee its success. This was to be an open-air complex in which small merchants and high-end specialty food vendors would coexist in an antique building. Using pushcarts to give the impression that the center was a place where vendors were waiting for store space, the project launched. To the surprise of Rouse and his partners, 50,000 people were waiting for Quincy Market to open. During the course of that first day, more than 100,000 people circulated through the market.

The success continues today. Market research shows that 33 percent of its visitors are from foreign countries, with the rest American tourists and people who work in the areas that surround the center. Gone for the most part are the independent merchants who first tenanted the center. In their places are units of national chains. The result is a marketplace that is closer in tone to a regional mall except that it is much smaller and the environment is by no means traditional.

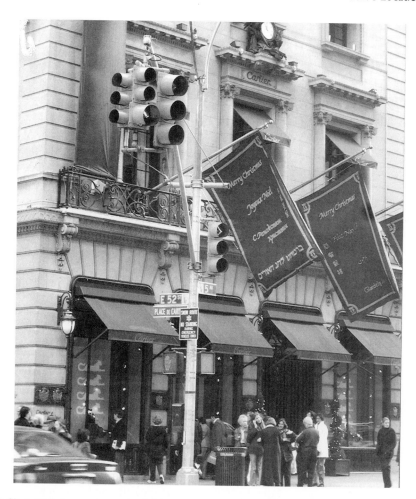

New York City's Fifth Avenue is a major fashion street that houses such companies as Cartier.
(Courtesy Ellen Diamond)

Fashion "Streets"

In affluent areas of the United States and abroad, fashion boutique flagships of renowned international designers are opening on specific streets. Rodeo Drive in Beverly Hills, CA; Fifth and Madison Avenue in New York City, NY; Worth Avenue in Palm Beach, FL; Rue de Antibes in Cannes, France; and Rue de Rivoli in Paris, France are home to such famous couturiers as Armani, Chanel, Yves Saint Laurent, Ferre, Gucci, and Givenchy as well as the designer collections of Ralph Lauren and Donna Karan.

While the vast majority of the population shops in malls and downtown central districts, those who desire and could afford the extravagances of these extraordinary creative geniuses prefer the lesser-congested environs of these shopping venues. Together with visitors from all over the globe, those who populate the prestigious areas that surround these **fashion streets** are the mainstays of the boutiques' clienteles.

Of course, the number of these locales is extremely limited, because their targeted customers are composed of the two segments of the upper class who have significant wealth.

Transportation Terminals

People who travel are finding that they often spend a significant amount of time in the airports and train terminals. With stopovers or plane changes becoming increasingly more prevalent because of weather delays, the waits can be anywhere from an hour to several hours. Check-in times have also gotten earlier because of time allowed for security screening, which

means that waiting an hour or two is the rule rather than the exception. Even long-distance train travel has become wrought with delays, leaving the traveler with time to spare.

These conditions have prompted retailers to take advantage of the situations by opening shops that appeal to the traveling masses. Airports, once the home to duty-free shops, restaurants, bars, and newsstands, have been joined by the likes of The Gap, Victoria's Secret, Wilson's Leather and other fashion-oriented stores. The trend for the development of these **transportation terminal centers** is increasing in the United States, but it pales by comparison to those found overseas. Heathrow Airport in London is a shopper's paradise. Companies such as the globally renowned Harrods have a branch inside the terminal, as do the boutiques of many upscale designers. In France's Nice Airport, Hermes, Chanel, and Versace offer an assortment of their products to the waiting travelers.

Trying to play catch-up, some of America's retailers have entered these locations in large numbers. Pittsburgh International Airport is the home to one of the largest collections of stores, offering a wide assortment of fashion apparel and accessories. With 60,000 daily passengers pouring through the terminal, sales continue to increase. Others include La-Guardia Airport in New York City, Ronald Reagan National Airport in Washington, D.C., and O'Hare Airport in Chicago. For train travelers, New York City's Grand Central Station, and Washington, D.C.'s Union Station offer a large number of shops that specialize in fashion merchandise.

Freestanding Stores

In today's retail landscape, a single store standing all by itself is a rare occurrence. Unless the retailer has significant clout and offers something that is unique, it is unlikely that a sufficient number of customers will come to patronize only it. There are, however, a small group of these merchants whose presence warrants such locations: the warehouse clubs such as Sam's, Costco, and BJ's. Their emphasis on value makes them destinations for masses of shoppers. While at first glimpse their merchandise assortment is comprised mostly of food items, products for the home, electronics, and pharmaceuticals, a wealth of fashion items such as Polo, Liz Claiborne, Perry Ellis, and Calvin Klein round out the product mix at prices that are far below what they cost at traditional retail outlets.

Costco's drawing power is so enormous that it warrants a freestanding location.
(Courtesy Ellen Diamond)

Unless the drawing power is sufficient to attract such crowds, setting up shop as **free-standing stores** isn't a good business decision.

Neighborhood Clusters

Rather than utilizing the controlled nature of such centers as malls, these locations are unplanned in every sense of the word. Merchants such as pharmacies, beauty salons, food stores, and butcher shops generally dominate these locations. In some cases, small boutiques and specialty stores are interspersed among these nonfashion operations. Occasionally, there are clusters that are predominantly fashion oriented and feature a host of women's shops, men's haberdasheries, shoe stores, jewelers, and accessories operations.

The success of the **neighborhood cluster** is that it offers small retailers that are unable to afford the enormous expense associated with downtown or mall locations an opportunity to serve a small trading area. Frequently the people who frequent the neighborhood clusters do so on a regular basis, often visiting daily.

Strip Centers

Akin to the composition of stores found in neighborhood clusters are those that are located in **strip centers**, configurations that usually feature a row of stores flanked by parking lots. Unlike the neighborhood clusters, where the buildings that house the stores are generally individually owned, the strip center is owned and managed by a single real estate developer. With this single ownership, the leasing of stores is more controlled, as in the case of malls, giving the lessees less competition. In the neighborhood cluster, with so many different landlords, there is the potential to have several similar shops in the one general location.

Flea Markets

These bargain arenas are primarily the destinations of value-hunting consumers. In parking lots of drive-in movies and racetracks and in abandoned indoor facilities, there are aisle after aisle of vendors selling everything from electronics to fashion items. The fashion merchandise are often leftovers from previous seasons, manufacturer overruns, or seconds. The majority of **flea markets** are part-time businesses open primarily on the weekends.

SITE SELECTION

Once the retailer has decided which shopping district is best suited to serve its needs, the next step is to select the specific site within it that will offer the best chance for success. Even within an enormous mall, one site might be more beneficial to a specific retailer's needs than any other. This decision also requires a good deal of research. Governmental agencies, trade associations, and primary research can provide information to help with the ultimate choice.

Competition

It is important to assess the competition when selecting a general trading area, and it is important to assess the competition when selecting a specific site. Setting up a business that is near others that are similar may lead to failure. If a new retailer offers a unique product mix, it will be possible to lure customers away from the stores they already patronize. In a proper mix of tenants, the new business has a chance for survival.

Neighboring Tenants

A location between two established stores is advantageous to the new retailer as long as they are not direct competitors.

Neighboring tenants with similar goods that are not direct competitors are advantageous to retailers.
(Courtesy Ellen Diamond)

In malls and downtown central districts, department stores attract the largest number of shoppers. If the new merchant can secure a location that is adjacent to such major retailers, the traffic that they generate could bring a wealth of shoppers to its premises.

Another advantageous location is near stores with complementary merchandise. If, for example, a new children's shop locates between a women's clothing store and a shoe store, the new venture will likely attract their shoppers.

Price points are another factor. It's not a good idea to open a fashion forward upscale shoe boutique next to a value-oriented operation such as a discounter or off-price store because each attracts a different type of market.

High-traffic areas such as food courts and movie theaters bring steady pedestrian traffic to retailers in those locations.

The ideal location is not always available. Choice sites in malls are generally taken. Similarly, downtown areas rarely have locations open near the major retailers. In these cases merchants should look to new centers that will provide them the opportunity of getting in on the ground floor so they can start on a positive note and refine their merchandising plans.

Transportation Accessibility

In downtown central shopping districts, parking space is often difficult to find so it is essential to assess the modes of transportation that bring the shoppers to the store. If subway lines and buses exist, merchants should check the proximity of their stops to the site they are considering. Being close to the subway station or bus stop will ensure a steady stream of people will pass by who might become customers.

If there are a sufficient number of parking facilities close to the considered site shoppers will be able to come to it. Locations near parking garages are also good, as more shoppers will see the store on their way to and from the garages.

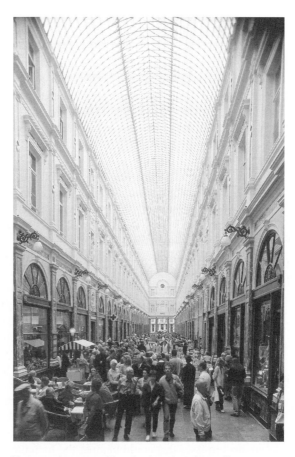

An abundance of foot traffic is an advantage of locating in a shopping mall.
(Demetrio Carrasco © Dorling Kindersley)

Pedestrian Traffic

A visit to any major city's central shopping districts such as those found in Chicago, New York City, or San Francisco immediately reveals the throngs of passersby. Whether they are residents of the area, commuters, or tourists, many are interested in shopping. The more pedestrians, the more the likelihood of reaching sales goals.

Even in the regional malls, where there is usually an abundance of pedestrian traffic all spaces are not equal. Most people frequent the main halls or arteries, with fewer passing through the secondary spurs. It is therefore essential to scout the potential site to make sure the location is in the path of passersby.

Entertainment and Dining Facilities

In major shopping centers, such as regional malls, there are increasing numbers of dining facilities and entertainment attractions. Retailers benefit from these attractions because they not only bring people to the malls but they also make the shopping experience last longer. People with small children, for example, will often use an amusement area to entertain the children and extend the shopping day. Food courts help to satisfy hungry patrons and keep them at the center for longer periods.

Megamalls such as Mall of America, for example, are excellent examples of the power of these facilities. Studies show that the time a shopper spends in such places is significantly longer than in those centers without entertainment and dining facilities.

OCCUPANCY CONSIDERATIONS

Once a retailer decides on a particular trading area, it is important to consider the arrangements necessary to secure a space. In major shopping centers such as malls or festival marketplaces, retailers must obtain leases. In a downtown central district or neighborhood cluster, retailers may be able to buy spaces.

If the retailer can choose an option, it is important to consider the pros and cons of both.

Leasing

The developers of the property have the ultimate say in the terms offered to the potential tenants. When the tenants are household names such as Macy's, Bloomingdale's, Marshall Field's, and Saks 5th Avenue and will be the mall's anchors, the developer is more apt to provide certain leasing advantages. These major retailers attract the crowds to the malls through their extensive advertising and name recognition, and without their presence, the success of the mall would be limited.

Leasing arrangements include the **fixed lease**, where the tenant pays a set amount for the space, and the **graduated lease,** where escalating rent clauses are built in, and the retailer's expense for the space increases over the life of the lease. Sometimes the cost of leasing space is based upon a set amount plus a percent of sales that the retailer generates.

The property developer also sets rules to which the tenant must agree. Hours of operation are generally spelled out in mall locations so that there are not different operating hours for different stores. There might be a periodic fee for general advertising, and each merchant must share in the expense of advertising the location. Occasionally, developers stipulate that merchants are required to pay maintenance fees to cover the costs of repairs.

The retailer should go over the total lease agreement before signing the lease so there are no surprises that could hamper the merchant's potential for success.

Ownership

Some retailers opt for ownership if it is possible. In particular, many of the major discounters such as Costco and Sam's Club purchase tracts of land where they set up shop. By owning a piece of property, the retailer is not at the mercy of the developer or landlord. Often times, when businesses are successful, as the lease is nearing the end of the term, the owner of the property will ask for exorbitant rental increases. The retailer faces the option of signing the new agreement or moving to another location. Sometimes the demands are so great that they cut into the merchant's profits and turn a success into a failure. Ownership avoids such penalties.

There are also no occupancy rules. When retailers own their premises, they decide the days and hours of operation and any other conditions that affect their business.

TRENDS IN STORE LOCATION

Brick-and-mortar retailers have a host of different types of locations available. The following location classifications are trends that may become more popular in the future.

Expansion and Refurbishment of Existing Malls

With primary locations becoming exceedingly scarce, many mall developers and management teams have opted to revitalize their existing facilities. Many single-story configurations have added second and third levels, and outdoor environments have become enclosed structures. With this expansion, the traditional two-anchor concept has given way to malls with as many as five or six anchors. Roosevelt Field, for example, has been a leader in this expansion movement, and it is now the fifth largest regional mall in the United States.

Transformation of Historical Buildings

Throughout the United States, there are architectural gems being transformed into exciting retail structures. One of the early leaders in this arena is Bloomingdale's, which took over the 1912 masterpiece Medina Temple and transformed it into a home furnishings showplace. Bloomingdale's is continuing the concept with a makeover of an historic 1860 cast-iron and stone building in SoHo in New York City.

Sharing of Expenses

Because of the significant expenses attributed to operating a shopping center, more developers are requiring tenants to offset the costs associated with promoting the premises. Each must pay a monthly fee to cover media exposure and special-events presentations. This is occurring not only in major retail shopping venues but also in smaller centers with as few as ten retailers.

Vertical Mall Development

With the shortage of space in downtown central districts, many cities are erecting vertical malls. In New York City, for example, a vertical mall that had fallen on bad times has been resurrected to feature exciting retail operations. Other cities are joining the vertical mall bandwagon to accommodate the number of retail businesses that can't find suitable ground-level space. The concept has been extremely popular in Chicago, where there are presently four vertical malls.

Specialization of Outlet Centers

Instead of the hodgepodge leasing of space to any retailers, outlet malls are becoming more specialized. Woodbury Commons in upstate New York and the Premium Outlet Mall in Orlando, FL, are examples of this type of specialization. Tenancy is limited to designer outlet shops such as Versace, Gucci, Barney's, Tod Shoes, Escada, and others in this upscale price point. By focusing on just one merchandising concept, these centers make it easier for consumers to assess whether the stores satisfy their fashion needs.

Revitalization of Downtown Shopping Districts

Starting in the 1950s, many families fled the cities for the suburbs, turning downtown areas into undesirable shopping destinations. Today, with a great resurgence in city living, the downtown areas are reinventing themselves to become the thriving shopping attractions they once were. Chicago's Loop has given itself a significant face-lift. Marshall Field's has spent millions of dollars to revitalize its flagship in the Loop, with others following suit.

Multiuse Centers

Instead of using all of the available space in a mall to house stores, the trend is for different types of facilities to be interspersed among the retail operations. For example, more shopping centers are incorporating multiplex movie theaters, restaurants, entertainment attractions, and even housing into their locations. This increases the likelihood of attracting people who might not initially come to shop but might do so once they are there.

SMALL STORE APPLICATIONS

The small fashion retailer is at a distinct disadvantage in terms of good available locations. While some entrepreneurs might have the determination and drive to open a fashion operation in a major mall, for example, it is more than likely that they will be preempted by a

more established retail organization for the choice of a particular site. The lifeblood of regional malls are the department store organizations and the vast number of specialty chains. The giants in the industry have the capital necessary for staying power. Too many small retailers are undercapitalized and cannot meet the costs of doing business in down periods. Mall developers therefore give the major retail organizations the first opportunities for prime locations.

All is not lost if small fashion retail businesses want to locate in malls and other shopping districts. Although the prime choices are quickly grabbed up by the giants, there are often less-desirable sites in spurs that the majors do not want, so they are available to smaller merchants.

Although the top locations in downtown shopping districts are also earmarked for the big companies, smaller stores can sometimes find sites on side streets. The locations might not be as desirable, but the rents are comparatively lower, which is an edge the entrepreneur often needs for survival. Smaller-city downtown districts or secondary central downtown areas often have spaces the small fashion merchants can afford because the giants are usually attracted to the top spots. Also, there are numerous mini-malls throughout the country, usually composed of boutiques and specialty shops that are perfect for small retailers. These locations often provide sufficient traffic in which the retailer can turn a profit.

Neighborhood clusters, small strip centers, and suburban main streets are usually good choices for the smaller fashion businesses because they attract a significant amount of local traffic and consumer interest. Since the retailer does not have to vie with the giants of the industry for these spaces, they are excellent choices for those who have been shut out of the prime retailing locations.

Even the smallest merchant should approach site selection carefully, much the same as the industry's leading counterparts do, analyzing the trading areas, available shopping districts, and factors associated with site selection before signing the lease.

Chapter Highlights

1. Initially, the trading area must be assessed before any plans to open a store can begin.
2. Population studies must be undertaken in terms of income levels, age groups, occupations, marital status, degree of stability, religious affiliation, and population shifts so that the merchant will know if the appropriate consumers are present to make the store a success.
3. Many areas have the benefits of unique attractions such as amusement centers that help to bring shoppers to them.
4. With so many different types of shopping districts available to retailers, they should perform careful analysis of each before making a final decision.
5. The downtown central districts are home to the major department store flagships, making them extremely desirable places for other retailers as well.
6. Regional malls have been the mainstays for suburban shopping since the 1950s and have continued to expand to meet the needs of the ever-growing populations in those areas.
7. In downtown areas where retail space is at a premium, vertical malls have been erected to provide additional selling space.
8. Off-price centers have developed in every part of the United States as places where bargain-hunting shoppers can satisfy their purchasing needs.
9. Festival marketplaces have been developed in areas that were once downtrodden, such as historical landmarks, city waterfronts, and old railroad terminals.
10. Fashion streets are important venues for designer flagships and include such locales as Madison Avenue in New York City, Worth Avenue in Palm Beach, and Rodeo Drive in Beverly Hills.
11. Freestanding stores can only be successful if the retailer is a high-profile operation that will draw consumers without the aid of other retailers.
12. Specific site selection is based upon such factors as neighboring tenants, competition, transportation accessibility, pedestrian traffic, and entertainment facilities.
13. There are two types of occupancy considerations: leasing and outright ownership.

Terms of the Trade

off the beaten path
trading area
destination location
population shifts
downtown central district
flagship stores
regional malls
controlled shopping center
mall anchors
mall walkers
megamalls
vertical malls
mixed-use centers
power center
outlet center
big box retailers
off-price center
festival marketplace
strip centers
fashion streets
transportation terminal centers
freestanding stores
neighborhood clusters
flea markets
neighboring tenants
fixed leases
graduated leases

For Discussion

1. What are the places to which stores expect to draw their shoppers called?
2. In addition to the size of the population, what other population characteristics should be considered before any location decision is made?
3. Should fashion merchants consider the occupations of those in the trading area before deciding upon a particular location? Why?
4. Can religious affiliation in any way help determine the retailer's choice of location?
5. Why are New York City, London, and Paris such excellent places for fashion retailers to open stores?
6. Who are the major tenants in a downtown central shopping district?
7. When did the regional mall concept first appear, and in what types of locations did they initially operate?
8. What is meant by the term "controlled" shopping center?
9. Why is it necessary for some downtown shopping districts to erect vertical malls?
10. What is a mixed-use center?
11. Who are the typical tenants of a power center?
12. How does a festival marketplace differ from the traditional mall?
13. Why have transportation terminals become viable places for retailers to open stores?
14. What is a fashion street?
15. How does a neighborhood cluster differ from a strip center?
16. Why is it beneficial for a retailer to open a store in a location that is flanked by two established stores?
17. Should a retailer consider opening a store that is next door to a competitor?
18. What are the two major types of leases that are available to retailers?

CASE PROBLEM 1

The Sophisticated Woman is a major fashion retailer with approximately 800 stores in the United States. Its success story is unparalleled in retailing in that it opened its first unit twenty years ago and has become one of the most profitable fashion retail specialty chains in the country. The proper merchandise mix and appropriate location choices have given the chain this enviable position. Whenever a prime location in a suburban or vertical mall has become available, the company has opened a unit.

Currently the Sophisticated Woman is facing a location dilemma. One of its most successful units is in a suburban fashion mall in southern Florida. The mall is anchored by two of Florida's leading department stores as well as department store branches of two that are based in New York City, which draw a considerable amount of traffic to themselves and the other specialty stores in that shopping district. So successful has business been that when the adjoining space became available, the Sophisticated Woman expanded its store and remodeled it into a very profitable shopping environment.

The Sophisticated Woman is always on the lookout for locations that would be as appropriate. Generally, the primary consideration is the distance of one unit to the other, with approximately four to five miles considered ideal. The problem that must be addressed concerns the projected development of a major mall that will be built just two blocks from the Florida mall in which the successful store is located. The new mall will be anchored by three major department stores and will be built as a multilevel structure that promises to be the most beautiful in the South.

Mr. Drummond, vice president in charge of site selection, believes that the company should close the existing store and move to the newer location. Ms. Connors, a senior executive in charge of merchandising, is of the opinion that the company should remain in the present location because of its profitability and forego the chance to open in the newer environment. Another route proposed by members of the senior management team is to maintain the old unit and open another in the new mall.

With space going quickly in the new facility, the Sophisticated Woman must come to a decision if it wants to open in the new mall.

Questions

1. If you were the person making the decision, which route would you take?
2. What factors did you consider in making your choice?

CASE PROBLEM 2

Fashion for Less is a small fashion retailer that specializes in off-price designer labels. The owners of the store, John and Caryn Gallop, opened their business three years ago and have become so successful that they are considering a second location.

With very little capital but good merchandising sense and connections to purchase overruns of many manufacturers at greatly reduced prices, they chose to enter business with the lowest possible overhead. They therefore chose a location off the beaten path and hoped for word of mouth to spread the news of their operation. Business was excellent. They turned a good profit after just six months.

As most other fashion merchants would do, the Gallops are looking to expand their business by opening another unit. They have been looking at new retail locations for the past three months and have yet to make a decision. Their choices are either another spot off the beaten path, a neighborhood cluster that presently houses fifteen stores, a power center, and an off-price shopping mall.

As the new season is approaching, the Gallops have yet to decide where the next unit of Fashions for Less should be opened.

Questions

1. Should the Gallops choose the same type of location in which they found their initial success or another type of location?
2. Discuss the factors they should consider before making the final location decision.
3. Which location would you choose and why?

EXERCISES AND PROJECTS

1. Either through in-person investigation or the Internet, research one off-price mall, power center, mixed-use center, or vertical mall. In an oral report, present why you believe the chosen facility lives up to its shopping center designation. In addition, describe any of the additional draws or attractions that make this area a viable shopping district.
2. Analyze the trading area of the largest city closest to where you live in terms of its demographics and characteristics. Prepare a written report highlighting those aspects of store location that make it appropriate as a trading area.

CHAPTER 8

Designing and Fixturing the Retail Environment

After reading this chapter, you should be able to discuss:

- ■ The various design concepts that fashion retailers are using in their stores.
- ■ The types of storefronts and window structures available to merchants.
- ■ Interior layout designs for single and multilevel stores.
- ■ Different fashion department classifications and designs.
- ■ Why major retailers in their flagships and branch stores are using in-house shops.
- ■ The layout of a store and why different departments are located in particular areas.
- ■ The different types of fixturing that fashion retailers are employing in their brick-and-mortar operations.
- ■ The walls and flooring surfaces used in today's retail environments.

Fashion retailers are increasingly changing the look of their stores from the traditional appearance that once was typical of brick-and-mortar design. The lack of originality in store design made stores look so much alike that consumers often couldn't identify which store they were in once they came inside.

In today's highly competitive fashion retail arena, unique interiors are the rule rather than the exception. Retailers are finally using the fervor in selecting their store designs that they employ in selecting their merchandise designs. They are realizing that their physical surroundings should differentiate them from their competitors the way their merchandise assortments do.

Ralph Lauren's flagship, on fashionable Madison Avenue in New York City, is housed in a former mansion instead of the typical brick-and-mortar structure. As shoppers enter the door, they are immediately surrounded by majestic antique fixtures, an elegant turn-of-the-century staircase, and paintings that help to make this setting more like a manor than a store. The Lauren collection is skillfully arranged in spaces that once served as the dining room, living room, and bedrooms so that the clothing takes on an aura of elegance. At the other extreme is the contemporary design in H & M stores, which cater to the young set around the globe. An abundance of glass and chrome make up this environment that is devoid of frills and perfectly sets the scene for the trendy merchandise it offers for sale.

Once fashion retailers come up with a design for their environments, it does not have to be set in stone. Occasionally, fashion merchants radically change their fashion concepts, and the new vision should be reflected in their environmental settings as well. A case in point is Banana Republic. Its store interiors and fixturing once were safari oriented, using a wealth of bamboo, raffia, netting, and other outback materials to enhance its khaki clothing. Today's Banana Republic stores are a far cry from that design concept. As it changed its merchandise

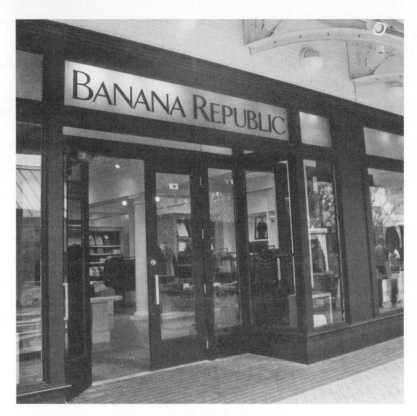

The transformation of Banana Republic's environment shifted its focus to a more contemporary setting.
(Courtesy Ellen Diamond)

focus to a more contemporary look with broader appeal, it also changed its store environments to a sleek contemporary interior replete with glass, beautiful woods, and leather accents.

The budgets for brick-and-mortar design and fixturing have exploded in recent years. No longer are run-of-the-mill architects the order of the day in store design. Retailers are willing to pay specialists who can translate an empty space into a store that not only truly enhances their merchandise but also stands out from the competition.

The vast number of environmental design specialists' Web sites highlight their diversity. The Internet has made it easier to locate and identify the wealth of different directions and alternatives in store design that retailers can pursue.

The top ten design firms with significant fashion retailing clients, as reported by *VM + SD Magazine,* are listed in Table 8.1.

TABLE 8.1 Top Ten Design Firms with Fashion Retail Clients[*]

Firm	Web Site	Major Fashion Retail Clients
Callison Architecture, Inc.	www.callison.com	Harrods (London), Nordstrom, Cole Haan
Pavlic Design Team	www.pavlicdesign.com	Lutte Ulsan (Seoul)
Gensler	www.gensler.com	Burberry
Design Forum	www.designforum.com	Marshalls
MCG Architecture	www.mcgarchitecture.com	Macy's, Ann Taylor
FAME	www.fameretail.com	Target, Marshall Field's
FRCH Design	www.frch.com	Timberland
MBH	www.mbharch.com	Express, Williams-Sonoma, Target
RSP Architects	www.rsparch.com	Target, Voice of America Center
RPA	www.rpaworldwide.com	Merrell Performance Footwear

[*]For 2002

Note: Excerpted from *VM + SD Magazine,* January 2003.

PLANNING THE CONCEPT

Before fashion retailers make any decisions concerning what shape the store's exterior and interior will take, they must first examine their objectives, image, and choice of location. If, for example, the operation is one that specializes in off-price fashion merchandise, uses the self-selection method of selling, and is located in an outlet power center, the design needs will be entirely different from those of the company that specializes in high-fashion, designer labels and emphasizes service as its forte. A look at Marshalls and Bergdorf Goodman immediately reveals that their needs are at the opposite ends of the design spectrum.

Whether retailers are small ventures or giant retail operations, they must establish a budget that includes how much they can spend on construction, fixturing, lighting, floor and wall decoration, heating and ventilation, and so forth before initiating their plans. Once they have finalized their financial considerations, it is time to begin on the brick-and-mortar design.

The best approach is to employ an architectural firm that specializes in fashion retailing store design. The Internet makes it easy to find a host of different firms. By studying their Web sites, retailers can determine which company will best serve their design needs. The Institute of Store Planners, a professional organization for retail planning and design is an excellent resource. Its Web site has a directory that lists a wealth of design firms in specific geographic areas. Another approach is to examine the pages of *VM + SD Magazine,* which has an annual listing of the top 50 design firms along with the clients they have served.

Although many of the world's leading fashion retailers have in-house store designers, the vast majority of them also utilize outside design groups. The collaborative efforts of the two make the ultimate design the one that best serves the store's needs.

Although small retailers are often limited in terms of their design-planning budgets, it is worth it to spend the money for expert advice so as to avoid costly mistakes.

Once retailers have selected a professional firm, they need to meet with the designers to discuss such areas as store image, target customers, merchandise mixes, services, and location so that the design will be appropriate for the store's operation. Some firms concentrate on design and leave the preliminary considerations to the retailer. Others totally involve themselves in the preplanning procedures and investigation as well as the actual design alternatives.

Callison Architecture, Inc., the world's leading design firm, bridges the gap between development and design.

Fashion Retailing Spotlights

CALLISON ARCHITECTURE, INC.

Callison Architecture's agility and creativity has taken it from a group of twelve architects that designed its first Nordstrom store in 1975 to the largest design firm in the United States. Today, the firm employees more than 400 people who engage in every aspect of environmental design from company headquarters in Seattle.

Not only do these designers provide the highest levels of interior and exterior design for their global clients but they also offer a wealth of services and new processes to meet their clients' demands. They conduct thorough market research, for example, to determine the ideal project size, physical layout, and tenant mix necessary for a successful venture. They synthesize and analyze pertinent market data that helps combine the optimal project concept with a realistic approach. Before any actual designs are developed, they assess land acquisition and ownership schemes, rent structures and projections, and construction phasing. Once these preliminary plans are finalized, they evaluate their design alternatives.

The facilities that Callison has designed for such fashion retailing clients as Nordstom, Gap, Harrods in London, Seibu in Japan, Wang Fujing department stores in China, and Marks & Spencer have gained it a record number of awards. Among them are those presented by *Chain Store Age Magazine,* the Institute of Store Planners, and *VM + SD Magazine.*

Some types of locations, as discussed in Chapter 7, "Store Location," may place limitations on certain aspects of the design such as store fronts, entrances, and window structures. In the major regional shopping centers, for example, the developers often establish a set of design rules to which the tenants must conform. Freestanding stores, however, are generally free from such restrictions other than those that might be imposed by governmental regulations.

DESIGNING THE EXTERIOR

The exterior of a store is important for a number of reasons. First, it gives passersby a quick impression of the store and the type of merchandise sold inside. Second, it allows window configurations that feature the items the merchant wishes to attract the shopper's attention. And finally, if it is part of a chain that uses a recognizable façade, it signals that this unit offers the chain's merchandise.

Today's retail exteriors run the gamut from the traditional types favored by department store flagships to the unique designs of trendy designers.

Store Fronts and Window Structures

A walk through any downtown central shopping district, regional mall, festival marketplace, or other shopping venue immediately reveals a host of different types of display windows and store entrances. Each is designed to match the allocated space the store's merchandising mix, and the retailer's concept of how to best attract shoppers.

Typically, these fronts feature parallel-to-sidewalk windows, windowless formats, arcades, and open windows, which are described in the following sections.

PARALLEL-TO-SIDEWALK WINDOWS

The ideal arrangement for making the greatest impact on the shopper is the **parallel-to-sidewalk** configuration. The design, traditional to the giant downtown central district's department store flagship, requires a large frontage. The main entrance to the store is flanked by as many as four large windows that are approximately twelve to fifteen feet wide and about eight or ten feet deep. They offer a stage setting concept in which the merchandiser may install spectacular displays such as the famous Christmas windows that draw shoppers to Lord & Taylor, Macy's, and Saks Fifth Avenue. These and other retail giants such as Marshall Field's, Bloomingdale's, and Nordstrom spend considerable sums throughout the year designing displays that bring their fashion images to the passersby.

Although this type of window structure can generate more excitement than any other, it is very expensive. Only those merchants that either own their own retail spaces, or have lifelong leases can avail themselves of this extravagant display space.

WINDOWLESS STORE FRONTS

In the major regional malls throughout the country, many fashion merchants subscribe to the **windowless storefront**, where display windows are replaced by large glass walls that separate the interior from the exterior. With space so costly and limited in these giant selling environments, the vast majority of it must be utilized for selling. The entrance is often a large glass front through which shoppers may see the entire store or a portion of it. Instead of using formal display installations, the store's merchandise on the selling floor serves as the display. In many malls, the trend is to eliminate stationary glass structures or windows entirely and install sliding glass panels that are pushed out of sight when the store is open for business. Although these stores relinquish the valuable formal display windows, they gain more accessibility from the mall's corridors.

ARCADE FRONTS

Stores that have little frontage but need formal window space to feature their merchandise sometimes build **arcade windows**. In this arrangement, the store's entrance is recessed ten

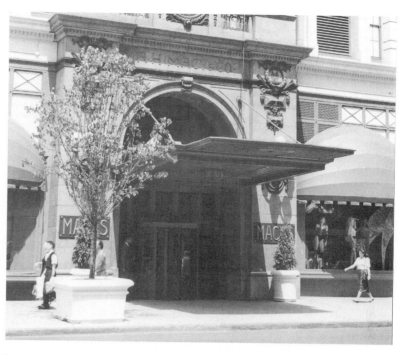

Downtown flagships, such as the Macy's at Herald Square in New York City use parallel-to-sidewalk windows to house their major visual presentations.
(Courtesy Ellen Diamond)

The windowless windows at Ross-Simons in Durham, NC, provide the shopper with a view of the store's interior.
(Courtesy JGA © Laszlo Regos Photography)

to fifteen feet from the building line and a large, rectangularly shaped window is constructed on either side of the entrance. This enables the merchant to feature merchandise that might tempt shoppers to come inside. One of the disadvantages of this arrangement is that it reduces the amount of selling space.

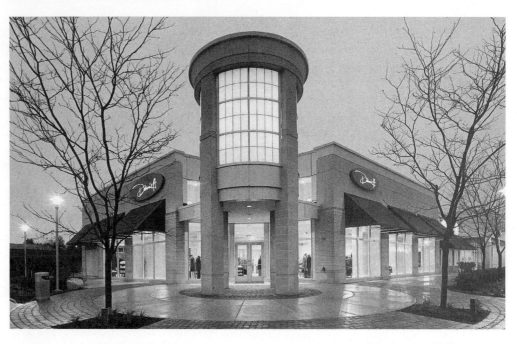

Unique storefronts and windows, such as this one in Daniels' in Grand Rapids, MI, sets the tone for the elegant merchandise inside the store.
(Courtesy JGA © Laszlo Regos Photography)

OPEN WINDOWS

Retailers that do not want to relinquish their space to arcades or parallel-to-sidewalk structures but still need to have some way to display merchandise opt for the **open window**. The open windows typically have panes of glass on either side of the store's entrance that feature small "stages" on which the merchandise is featured. With no backing to these stages, the passersby can see into the store. The only disadvantage of the open window is that the shoppers can handle the merchandise in the display and make it untidy.

MISCELLANEOUS WINDOWS AND FRONTS

While the aforementioned models serve the needs of most retailers, design uniqueness can give a retailer an edge in the pursuit of success. All sorts of outdoor props are used to entice the shopper to take a closer look. One exceptional entry is the eye-appealing Perfumania store in North Miami, FL.

Fashion Retailing Spotlights

PERFUMANIA

JGA, a major design firm, undertook a special assignment to make the Perfumania shop in the Aventura Mall in North Miami Beach, FL, different from the host of stores that line that facility. The atmosphere of whimsy and fantasy that it created has enticed customers of all ages to sample and purchase Perfumania's wide range of fragrances, signature cosmetic line, gift items related to bath and boudoir, and aromatherapy products. Instead of designing the typical retail facility, JGA's team took a different approach. In the limited space of approximately 1,000 square feet, designers utilized what they call an "over-the top" design.

An iconic metallic perfume bottle dominates the storefront and features a trapezoidal-shaped display case that shows a sampling of what is in the store. Drawing its cues from the forms and materials of fragrance bottles, the space is curvaceous, luxe, and dynamic, making shopping more fun than intimidating.

The design elements include a yellow terrazzo floor path, bottle shapes that emulate real perfume holders, ivory lacquer cases in bold colors, and circular fixtures of glass and metal in contrasting pale colors. The fixtures carry a Dali-esque feeling. Enhancing the environment is incandescent lighting that gives an upscale feel to the space.

Not only does the space appeal to shoppers during peak selling periods but also to those who merely enter the mall at off-times to spend some leisure time.

DESIGNING THE INTERIOR SPACE

Once the decision has been made for a particular store front and window structure, the remaining space must be apportioned for the store's operation. The largest and most important areas are those that sell the store's merchandise. Although as much as 90 percent of the space is allocated for customers to make their selections, there must be some set aside for nonselling functions such as receiving, storage, merchandise alterations, visual merchandising, promotion, buying, merchandising, and store management.

The way space is apportioned depends upon the status of the store. If it is a company flagship, more space is needed to perform the nonselling tasks. If the stores are units of a chain or branches of a department store, the space is apportioned primarily to sell merchandise because most of the nonselling operations are based in the flagships or central headquarters.

The following sections address the types of selling and nonselling departments.

Locating the Selling Departments

There are many factors to consider in where to locate the selling departments. Among them are the size of the store, the number of levels it occupies, the merchandise assortment, entrances, and the means for moving the shoppers from floor to floor.

SINGLE-LEVEL STORES

Most fashion-oriented stores that occupy one level are usually specialty stores or boutiques. Since the merchandise assortment and selling space are limited, the choice of how to arrange the departments is simpler than in the multilevel type. In fact, the merchandising classification is often so narrow that merchandise is freely placed throughout the selling floor with little attention as to its type. Stores such as Gap, for example, which restrict their assortment to casualwear such as jeans, shirts, sweaters, and other sportswear and are generally one-floor operations, do not separate their merchandise into departments. The newest items are usually placed near the store's entrance until the supply dwindles and they are replaced by the next new items. This alerts passersby and those who enter the store of the store's latest merchandise.

Stores such as Talbots, Ann Taylor, and The Limited, which stock more diverse assortments, have a greater task in merchandise location. These stores generally separate goods into distinct departments. They place a few pieces from each department at the store's entrance to show prospective customers the breadth of the store's offerings. These spaces are regularly updated to allow the most recent merchandise to hold center stage for a period of time. The remainder of the goods are arranged in such departments as casual dresses, evening wear, accessories, and shoes. The departments closest to the store's entrance are usually those that the store is expecting to generate the greatest sales volume.

The lower-volume departments are near the back of the store, and the selling locations farthest from the entrance are often reserved for the most expensive items.

There are no hard and fast rules in the location game; the company's management team decides what works best for each site.

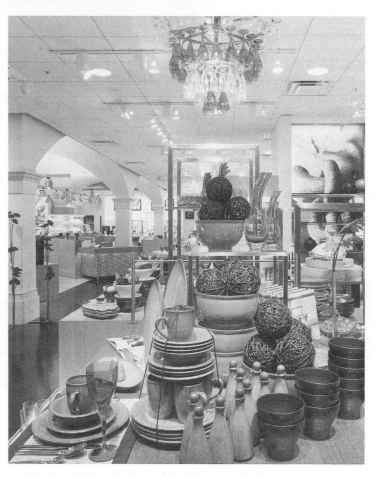

Mikasa in Schaumburg, IL, uses unusually high ceilings and arches to make the shopping environment a unique one for single-level selling.
(Courtesy JGA © Laszlo Regos Photography)

MULTILEVEL STORES

Some specialty chains such as Banana Republic and Ann Taylor have expanded their inventories and have opened larger units that occupy two or more levels. Banana Republic now features shoes and some home furnishings in these larger stores. Stores expand into **multilevel stores** because they have more extensive inventory but they also do so because in many locations, obtaining a large selling space on one floor has become too expensive to lease. Such is the case of Banana Republic on Chicago's North Michigan Avenue, where it has three floors to house its collection. In other Chicago North Michigan Avenue venues such as the vertical malls, specialty stores frequently occupy several levels. On Madison Avenue in New York City, where fashion retailers vie for space, the Limited occupies four floors.

Although the multilevel arrangement might be new to specialty store retailing, it is typical of department store flagships and branches. Not only do these stores have to grapple with as many as ten floors but they also have to deal with selling space allocation for a vast number of departments.

There are several "rules" that the retailers of multilevel operations tend to follow. The rules include the following:

1. The main, or first floor, is usually reserved for merchandise that is either bought on impulse, is at the store's lower price points, is high margin, or if it were placed anywhere else in the store, it would result in lower-than-expected sales. Cosmetics, a money-making fashion enhancement, occupy a wide area on most main floors. Many women purchase their cosmetics and fragrances without planning to buy them. When they pass through the main floor,

The North Face in New York City is a multilevel store that utilizes a grand staircase to attract shoppers to the upper level.
(Courtesy JGA © Laszlo Regos Photography)

women are often motivated by an attractive display, an exciting demonstration, or being sprayed with a fragrance by a company representative. Since the main floor is the most heavily traveled, it is the only place where cosmetics and fragrance sales are sure to be profitable. Similarly, fashion accessories are located on the main level because they too are often bought by customers attracted as they pass by. A traditional mainstay for the first floor has been men's wear. While women usually spend more time looking for clothes, men often demand that they find what they need with a minimum amount of effort in the least amount of time. When the men's department is on the main floor, men do not get caught up in crowds and do not have to wander through the store; they are more likely to patronize stores with this layout. This is starting to change, however. In today's retail environments, first floor space is sought by many of the fashion department's buyers and merchandisers, so the men's offerings are being placed on more than one floor. The main floor might feature only shirts, ties, shoes, and other haberdashery items, with suits, sportscoats, dress trousers, and the like relegated to another location usually one flight up. Of course, some department stores opt for other men's wear placement. Marshall Field's, for example, locates its men's collection on one of the top floors in the stores. Some multilevel operations feature **satellite departments** on the first floor, with the remainder of the items elsewhere in the store. In this way, more departments can get a share of the high-traffic space on the main floor.

2. The store's most profitable departments should be given location priority. They should be within the customers' view when they enter the selling floor and should be close to the store's elevators and escalators.

3. Higher-priced fashion merchandise such as designer collections are considered to be specialty goods, so shoppers are willing to seek them out in less traveled parts of the store. This is often the store's costliest merchandise too and is best kept away from the heavy traffic areas and out of the reach of would-be shoplifters.

4. Compatible departments should be next to each other. Fine shoe departments are often next to the store's better-apparel departments for both genders so that shoppers buying a dress or business suit can find a pair of coordinated shoes. Not only does this make the task of shopping easier for the customer but the store makes a larger sale when selling multiple items.

5. Since most department stores generate more business from fashion merchandise than hard goods, the former should always take location preference over the latter.

Some less traditional retailers break these rules. Saks Fifth Avenue and Lord & Taylor, in their New York City flagships, located their men's clothing departments on their top floors because they think that such a location, with easy access to elevators, makes shopping a quieter experience, away from the throngs that move through the main and lower selling floors.

Retailers should always bear in mind that customer comfort and convenience are most important and more shoppers have less time than ever before to spend in stores. Their needs should always be addressed when determining where to locate the selling departments. Otherwise, shoppers have more reasons to patronize off-site ventures.

Locating the Nonselling Departments

Administrative and sales-support departments should be located in places that are least desirable for selling. As a general rule, single-level stores place their **nonselling departments** at the store's rear, and multilevel units utilize the upper floors or rear portions of a few floors for these departments.

In present-day retailing, many fashion merchants are reducing the sizes of their inventories and are eliminating extra inventory and stockrooms. Many merchants are avoiding the deep **reserves of merchandise** and are replacing the sold goods with new styles. This allows a steady flow of fresh merchandise to make its way to the selling floor. Departments that sell shoes, however, still utilize stockrooms for their goods, and such space must be provided for in the store's layout. Stockrooms are usually located within the selling department to make the goods readily available to the sales staff.

Receiving and marking departments also tend to be smaller than those found in yesterday's operations. By having the merchandise pretagged by the vendors according to the retailer's instructions, or shipped to centralized warehouses where it can be checked and ticketed and then sent to the stores, a great deal of in-store space once used for such practices may be used as selling space. The receiving departments are usually confined to out-of-the-way areas that are less conducive to selling. Many major retailers once used significant portions of their basements for storage and receiving, but the practice has generally been eliminated since basement floors have become primary selling environments. Stores such as Macy's, with its famous Cellar, have led the way for other merchants to move the receiving area elsewhere.

Many stores are locating their administrative offices on the highest floors or in buildings that are adjacent to the store. Others use a separate floor to house their administrative staff. The Macy's New York flagship, for example, uses several floors high above the selling spaces for the offices of buyers, merchandisers, advertising and promotion executives, publicity personnel, human resource managers, computer experts, and other management people.

FASHION DEPARTMENT CLASSIFICATIONS AND DESIGNS

Once the general space allocations have been addressed and department sizes and places have been delineated, it is time to design the environment for each. In the case of the smaller fashion-oriented chain units, there is usually one design theme that follows throughout the store. The same holds true for individual specialty stores and boutiques. Only where specific

areas need further definition do selling areas have distinctive decors. In department stores, with their host of merchandise departments and different market segments, interior design distinction is a must. The department that caters to juniors will certainly be better served if it is different from the one that specializes in large-size apparel. Different price points, consumer markets, fashion directions, and so forth warrant individualized environments.

Traditionally, fashion retailers have segmented and classified their departments according to standard designations such as juniors, budget dresses, fashion accessories, and evening wear. While some merchants still departmentalize according to these conventional rules, today's major fashion operations use different approaches, creating exciting and distinctive names to describe their fashion departments and their more diverse merchandise mix. Some fashion merchants are offering the highest-priced designer fashion collections and are featuring separate areas for each of them. Still other fashion merchants are erecting in-house separate shops for specific marque label offerings. Whatever the approach, it is imperative that the design team understands the merchandising concept for each department and creates an environment that makes each one unique and conducive to shopping.

Traditional Fashion Departments

Within most stores, the traditional fashion departments generate a great percentage of the volume. Whether they are named "Moderate Sportswear," "Lingerie," "Hosiery," "Coats and Suits," or classified with more updated nomenclature such as the "Action Shop," "Junior Innovations," "After Five," and "The Contemporary Woman," they must be designed to reflect the image for which they were conceived. Merchandise in these departments is usually plentiful, racks and counters are often close to each other, and the environment generally follows the basic design concepts of the store. Fixturing is generally functional.

Daniels in Grand Rapids, MI, follows a traditional fashion setting where a multitude of racks and counters feature the merchandise.
(Courtesy JGA © Laszlo Regos Photography)

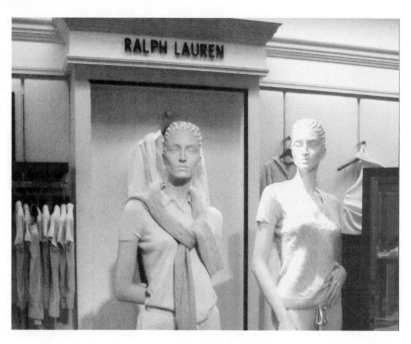

Ralph Lauren was one of the first designer salons to be featured in upscale retail operations.
(Courtesy Ellen Diamond)

Designer Salons

Most fashion-oriented department stores such as Saks Fifth Avenue, Marshall Field's, Bloomingdale's, Nordstrom, and Neiman Marcus differentiate their fashion couture and prêt-a-porter (ready-to-wear) collections from the standard fashion fare by installing separate departments for these offerings. Since the fashions comprise the store's highest price points, their merchandising requires a different approach than anything else the store has to offer. Individual **designer salons** are generally the choice so that each collection can receive the shopper's individual attention. Internationally renowned names grace these small salons, or boutiques, as they are often called, with each featuring the most elegant décor and appointments. Marshall Field's, in its Chicago flagship on State Street, has refurbished its fashion salon floor to make it one of the most exciting environments in fashion retailing. The salon areas are totally segregated from the store's other departments so that the couture customer is made to feel that she is shopping in each designer's own private shop.

Designers such as Donna Karan, Gianni Versace, Christian Lacroix, Chanel, and Yves Saint Laurent are marketed in this manner.

In-House Separate Shops

A trend has developed that separates specific collections of merchandise from everything else in the store by installing individual "stores" within the store's premises. In the designer salons, which are small and are not often totally separate from each other, the same sales associate may service customers in more than one salon. These **in-house separate shops**, however, often are enclosed environments where individual staffs, sometimes provided by the vendors, only service these areas. One of the reasons for this approach is the insistence of the manufacturer or designer. Ralph Lauren, for example, was an innovator in this area. He made it a rule for stores that carry his men's wear collection to build a separate facility specifically for the Lauren line. In Bloomingdale's New York City flagship, the Ralph Lauren men's collection is housed in such a setting. To make the shop different from the others in the store, the merchandise fixtures are often antiques or antique-inspired pieces that have become the hallmark for displaying Lauren merchandise.

Collection areas, such as this one that features "Context," enable the manufacturer to feature the designer's entire body of work.
(Courtesy Ellen Diamond)

Collection Areas

Somewhere between the salon approach and the separate shops are the **collection areas**. These are defined locations within specific merchandise classifications, such as better sportswear, which house a variety of sweaters, skirts, pants, and so forth, that set aside area segments for particular lines. Liz Claiborne, Jones New York, Tommy Bahama, and Anne Klein generally are found in these collection areas within larger departments. When merchandise is featured in this manner, the shopper is able to see the line's body of work and choose pieces that relate to each other. This plan often leads to larger purchases.

DECORATIVE AND FUNCTIONAL SURFACE MATERIALS

Having determined the location of the various departments and the different arrangements that the store will feature, the retailer must select the materials used in the design. Floors and walls must be decorative as well as functional. An attractive floor tile might have considerable eye appeal but might not be sufficiently durable to meet the challenges of heavy traffic. Similarly, an industrial carpet may be durable but its drab colors not complement the merchandise. The perfect marriage of the two must be assured to derive the maximum benefits.

When professional interior designers are contracted for this task, they already have the expertise to select the best materials for the installation. When inexperienced merchants are planning their first retail ventures and are working with a limited budget, they rarely have the background to make the best design decisions on their own. In these situations, merchants

must educate themselves regarding the availability of decorative and functional materials to avoid making poor choices. By carefully examining *VM & SD Magazine*'s annual buying guide, published every January, professionals and novices alike can explore the various offerings of manufacturers and distributors.

Flooring

There are many types of flooring materials used in retail environments. Supermarkets and hard-goods discount operations rely upon those that are relatively inexpensive, will handle the crowds, and can be easily cleaned on a daily basis. Fashion retailers, however, have different needs. Appearance and comfort, as well as durability and ease of care, are among the considerations they need to address.

Little else provides the feeling of luxury like carpet. Today's fashion merchants generally opt for commercial carpet that easily withstands a lot of traffic while at the same time provides the aesthetic appeal they are seeking to enhance their interior designs. In the past, the commercial varieties were often nondescript, leaving many merchants to take the chance with more attractive but less functional designs and replace them when they showed wear. Now, however, the choice of commercial carpet has significantly grown. Companies such as Karastan offer a wealth of patterns and fibers that will fit any fashion retailer's need for durable carpet. Coupled with the fact that it is comparatively simple and inexpensive to install over any type of subfloor, carpet is often the choice for any fashion salon.

The opposite end of the flooring spectrum includes hardwood. In addition to being attractive, wood is especially functional. Covered with laminates such as polyurethane, it can last for a long time. When it does begin to show signs of wear, it can be refinished and brought back to its original appearance. The artistry of competent installers guarantees a vast array of interesting patterns that range from the standard diagonal designs to herringbone and parquet motifs. Used either alone or in combination with rugs, wood has become the choice of many merchants. The variety of rugs available includes patterns in kilos, dhurries, Persians, and contemporaries that enhance any type of under-flooring and retail setting. Each has a personality of its own and immediately transforms a mundane floor into one that adds to the image and style of the retail environment. Like their wall-to-wall carpet counterparts, rugs can be cleaned and refurbished to make them practical choices for fashion retailers.

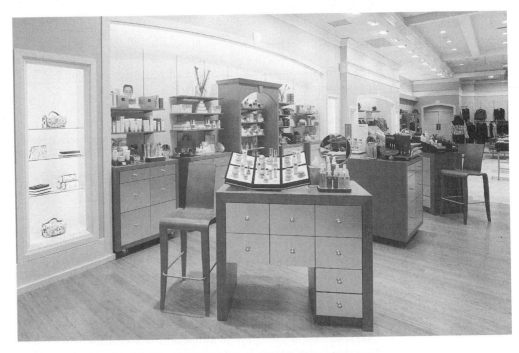

Hardwood flooring is both functional and attractive in sophisticated settings.
(Courtesy JGA © Laszlo Regos Photography)

When a retailer wants an impressive and elegant environment, designers often select marble. It comes in a variety of patterns and colorations. Aside from the sometime prohibitive costs of the product, it is also very expensive to install. However, many upscale fashion environments use marble for their floors, often in conjunction with other materials such as wall-to-wall carpet and wood, and it is often covered in areas by rugs. Marble is easy to clean, but when it is used without any rugs, it can be extremely hard on the feet of the sales associates who spend full days on the selling floor.

Ceramic tile is an excellent choice for a permanent floor installation and is extensively used in fashion environments. Ranging from traditional to contemporary patterns, it can serve any retailer's needs. In addition to those standard offerings, a new breed of tile is available on which designers can digitally master any pattern. In this way, a designer can perfectly augment the store's fixturing and come up with a unique pattern not seen in any other venues.

While the word *concrete* immediately signals a rather mundane, lackluster flooring, it has become the choice of many retailers. Once poured, it can be painted in a variety of patterns and finished to protect it from foot traffic. While it is a hard surface that will sometimes cause discomfort to the feet, it is relatively inexpensive to install and can serve the purpose of the retailer who wishes to minimize flooring expense.

Poured aggregate, or terrazzo emulates marble and provides a lasting floor for retail environments. It is less costly than marble but provides a look that many merchants opt for. Just like any other hard surface, rugs can cover some of its areas and provide a softness to the setting.

Rounding out the flooring choices are vinyl tiles in a variety of patterns, real brick or brick veneers, cork, rubber, laminates, and bamboo. In its prototype vendor shop in Macy's Herald Square, New York, Lacoste uses bamboo flooring to achieve the desired contempo-traditional look.

Walls

Among the wall coverings available are paint, wallpaper, fabric, wood, mirror, bamboo, foils, marble, plastic panels, leather, and metallics. Each offers the designer an opportunity to enhance other fixtures in the store, and provides a uniqueness to the fashion environment.

The most commonly used is paint. Available in an almost unlimited array of colors and textures, it can provide almost instantaneous results at a minimum expense. For those fashion settings that require more than basic paint, experienced painters specializing in **faux finishes** can accomplish a wealth of different patterns and dimensional surfaces. They can create motifs that rival real marble, for example. Of course, this is considerably more costly than the typical paint job. The major advantage to painting walls and the reason why many fashion retailers do so is that it is easy to quickly apply different paint to enhance a particular merchandise season or collection. In women's sportswear departments, for example, they have seasonal clothing, such as swimsuits, that they only feature at certain times. When the area is opened for the season, store designers can quickly transform the walls from their previous coloration, when the department featured skiwear, to a shade that compliments the swimwear offerings.

A look at the wallpaper from companies such as Schumacher and Waverly immediately reveals a wealth of different patterns that could provide the exact feeling needed for a particular fashion environment. Available in traditional to contemporary designs and in a host of textures, it is possible to install almost any environmental concept. In addition to the typical rolls of wallpaper there are numerous wallpaper murals that can quickly produce eye-appealing scenery that rivals hand-painted installations at comparatively less cost.

Foil is yet another choice for the designer. It is a paper-backed product that comes in a roll, similar to wallpaper, and is installed in the same manner. While more costly than most wallpapers, it provides a long-lasting metallic surface.

For the feeling of warmth and luxury, many designers opt for fabrics. An enormous variety of patterns and textures in moirés, brocades, velvets, velveteens, satins, denim, felt, damask, and shantungs can enhance any fashion environment. Each provides a distinct look that immediately transforms the bare walls into arenas of excitement.

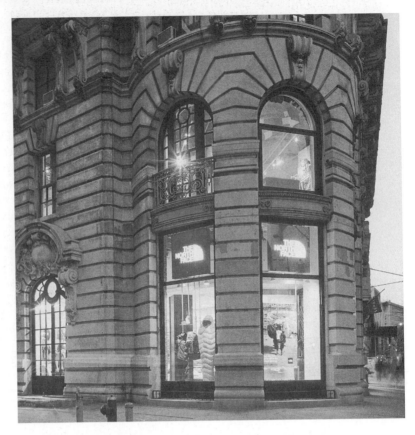

One-hundred-year-old brick gives this retail environment a uniqueness of its own.
(Courtesy JGA © Laszlo Regos Photography)

Designers creating more permanent space can use different types of wood planks and panels that range in style from the highly finished variety to the more rustic types that can be stained. Wood requires little maintenance and damaged walls can be covered to hide the blemishes. Even curved walls can be covered, with flexibly crafted varieties of wood.

Mirrors, both clear and veined, are used in more upscale fashion boutiques and specialty stores. Not only does this look elegant but mirrors help to create the illusion of greater space.

Glass covered with acrylic film is an exciting wall covering making its way into up-scale fashion emporiums. Tag Heuer's SoHo flagship features such walls in a vivid turquoise color that immediately draws attention. Glass panels with intricate detailing are being used to convey the feeling of opulence. C.D. Peacock features two seven-foot-by-three-foot glass panels etched with images of facing peacocks, artistically personalizing the company while giving the impression of old-word elegance.

The same marble and ceramic tile used as flooring may also be used on the walls. They lend an immediate aesthetic quality to the environment. Although the product costs and installations are comparatively expensive, they serve as excellent, long-lasting alternatives to the other available wall coverings.

Other wall coverings seen in fashion boutiques or departments of major retail emporiums are leather, bamboo, and other exotic materials, which can create a unique atmosphere when coupled with an exciting overall design.

FIXTURING

The image of the fashion environment is further enhanced by the choice of fixtures. There are three fixture categories: the first holds the merchandise, the second illuminates it, and the third displays the items used in visual presentations. The variety within each group is enor-

Multi-level shopping malls such as the St. Enoch Centre in Glasgow, Scotland, have become the major retail venue for fashion merchants. *(Stephen Whitehorn © Dorling Kindersley)*

All over the world, historical landmarks such as this 19th century arcade in Brussels, Belgium, have been transformed into unique shopping centers.
(Demetrio Carrasco © Dorling Kindersley)

Resort hotels, such as the Bellagio Resort Hotel and Casino in Las Vegas, Nevada, house couture shops for their guests.
(Alan Keohane © Dorling Kindersley)

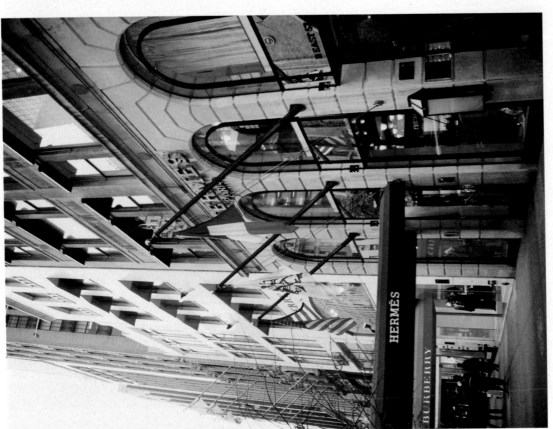

Fashion streets, such as those seen here on New York City's Fifth Avenue and East 57th Street, have become the global flagships for fashion's elite companies such as Burberry, Hermes, and Cartier.
(*Courtesy of Ellen Diamond*)

Outdoor malls are beginning to replace the traditional enclosed shopping centers in many parts of the United States.
(Courtesy of Ellen Diamond)

Kiosks that provide inexpensive retail space for merchants are found in the country's major shopping centers.
(Courtesy of Ellen Diamond)

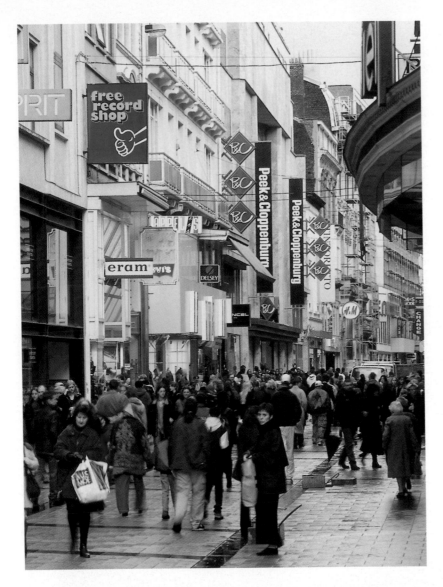

Bustling shopping streets all over the world, such as the Rue Neuve in Brussels, Belgium, are home to a wealth of fashion and other retailers.
(Demetrio Carrasco © Dorling Kindersley)

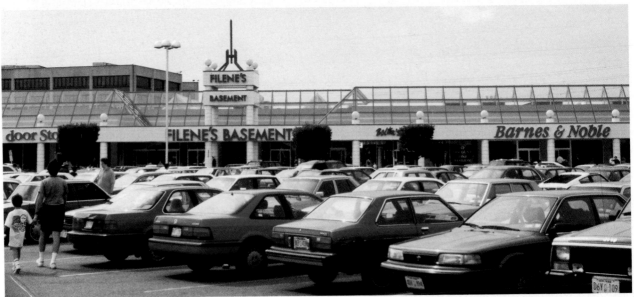

Power centers, such as the one housing Filene's Basement, are excellent locations for discounters and off-price merchants.
(Courtesy of Ellen Diamond)

Interior designers for the retail industry create environments that include everything from space allocation to fixturing.
(Courtesy of Ellen Diamond)

Designer presentations include storyboards and props that the retailer can evaluate before making the final fixturing decision.
(Courtesy of Ellen Diamond)

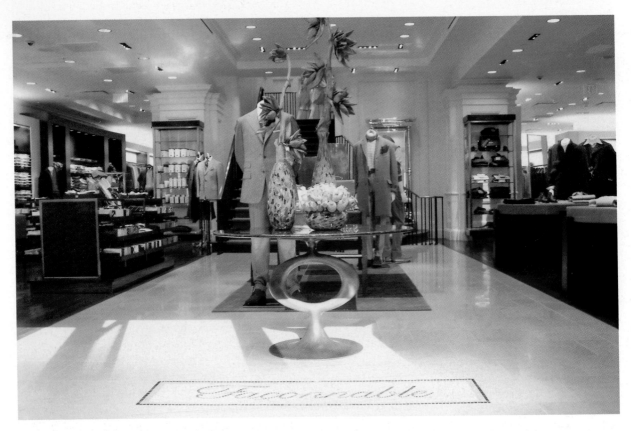

The use of the Façonnable "signature" lends a personal touch to the flagship store's interior.
(Courtesy of Façonnable USA)

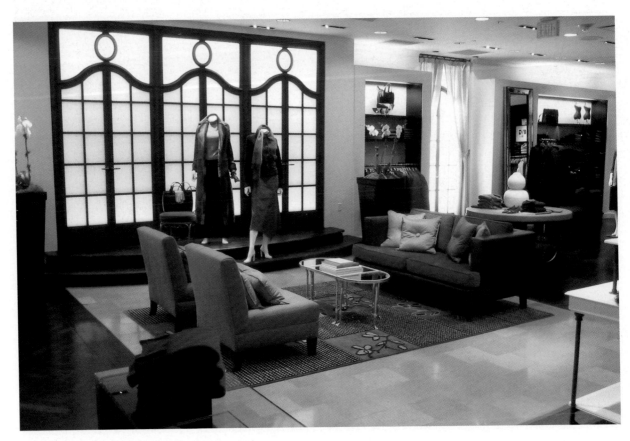

The use of elegant furnishings sets the tone for luxury shopping.
(Courtesy of Façonnable USA)

mous, and they must be selected with appearance and function in mind. A beautiful counter that does not hold a sufficient amount of merchandise will be as poor a choice as a lackluster display rack that features designer gowns.

This section explores the first two types of fixtures. The display fixtures will be examined in Chapter 17, "Visual Merchandising."

Merchandise Fixtures

The wealth of merchandise fixtures available today is quite a contrast to what was offered to fashion retailers in the past, when function was the main concern and style played a secondary role. Today designers may select from a variety of types that can help achieve a particular image without sacrificing function. First, though, it is important to consider the retailer's sales methods. Value merchants such as Target that sell a great deal of fashion merchandise emphasize **self-selection**, so open counters are a must. Fashion boutiques and salons show merchandise to customers, so they need closed counters to house the merchandise. This is extremely important when selling precious jewelry, where security is of paramount importance. Most fashion merchants use a combination of fixtures, since they often utilize both self-selection and personalized selling.

In addition to serving the retailer's selling techniques, merchandise fixtures play an important role in visually merchandising fashion collections. When shoppers enter a store or department within a store, their attention should be directed to the merchandise the retailer wants to feature. The appropriate counters, aisle tables, wall cases, and other fixtures help to show the merchandise to the best advantage. The Neiman Marcus store in Willow Bend, TX, in addition to the conventional fixturing, uses a TV table that features a four-by-four foot glass tabletop embedded with twelve video screens as a setting for home décor items. It immediately attracts the shopper's attention. In the Tommy Bahama stores, the fixturing instantly gives the shopper the feeling of an island setting and perfectly accents the merchandise.

The Ralph Lauren flagship on New York City's Madison Avenue uses the epitome of unique fixturing. Instead of the mundane cabinetry that often holds merchandise, antique armoires, unusual period tables, iron-encased racks, and other special fixtures contain the Lauren signature merchandise. The shopper is treated to an environment that at once makes the offerings more special.

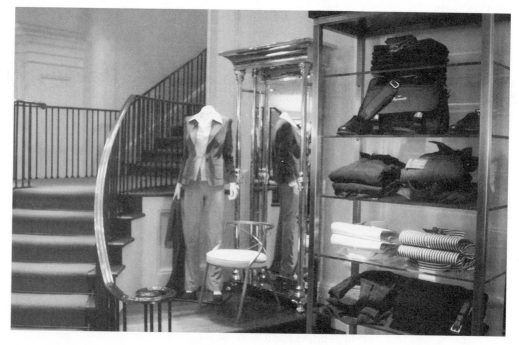

Glass and steel fixturing perfectly enhances upscale, contemporary merchandies.
(Courtesy Façonnable USA)

TABLE 8.2 Ten Fixture Design Companies and Their Specialties*

Company	Web Site	Specialization**
America's Finest Woodworking Team, Inc.	**www.afwt.com**	Custom high-quality wood and laminate fixtures
Architectural Systems, Inc.	**www.archsystems.com**	Unique building products for interiors
Creative Arts Unlimited	**www.creativeartsinc.com**	Concept shops
Dalco Concept, Inc.	**www.dalcoconcept.com**	Frameless glass showcases
Edron Fixture Corp.	**www.leggettsfg.com**	Up-market shop concepts
G.O. Concepts	Unavailable	Classic antique fixtures
MEG	**www.megfixtures.com**	Specialty wood and metal fixtures
Opto Intl, Inc.	**www.optosystem.com**	Modular systems
RCC Associates, Inc.	**www.rccassociates.com**	High-end fixtures
Studio Productions, Inc.	**www.studioproductionsinc.com**	Themed environments

*This represents a portion of the vendors in the industry.

**These are but a few of the specialties offered by the selected vendors.

Source: VM + SD Magazine, January 2003.

The fashion retailer should consider fixtures as carefully as the products placed in them. Whether they are the ready-made variety available at commercial vendors who specialize in store fixtures, or the more expensive customized cabinetry, there is a wealth of choices available to fit each store's needs.

There are many fixture suppliers that can meet the requirements of any retail environment. Fashion retailers should consult the pages of trade periodicals such as *VM + SD* or check the Internet to learn about the vendors and their specialization. Table 8.2 lists ten such suppliers.

Lighting Fixtures and Sources

One of the most exciting areas of store design is lighting. Once limited to the mundane choices of fluorescent lighting for overall illumination and incandescent lighting for emphasis, the lighting designer now has a host of different products from which to choose.

As in the case of other design decisions, lighting designers must consider store image, merchandise, and finances. While fluorescents are still the most economical light sources, they are not the appropriate choices for most fashion environments. Even the value retailers, such as Target, who deeply discount their fashion goods; the off-pricers such as SteinMart; and the designer closeout shops such as those operated by Ralph Lauren, DKNY, Calvin Klein, and Gianni Versace find that fluorescent lighting leaves much to be desired when showing the merchandise at its best. Today's technology has made **energy-efficient lighting** available to even the most cost-conscious merchant. By choosing carefully, it is possible to create a more attractively lit environment at considerably lower costs than in the past.

The choice of the right lighting and design company is essential. There are numerous products and companies that can improve any type of fashion retailing environment. One exciting lighting example is the one in Jil Sander's London flagship. Working with the elements of the historic building housing it, and not using any lighting that would interfere with the architecture, lighting designer Ross Muir recessed a multitude of lights in the existing ceiling beams to give the appearance of the original design. The *Visual Merchandising and Store Magazine*'s annual buyer's guide, lists such lighting companies as Ross MUIRreality, and retailers can consult it for help in making their choices and can then visit them or check their Web sites.

Creative designers sometimes use natural light to dramatically illuminate the retail setting in the form of skylights in the roof. As shoppers enter the store, the light from the skylight draws them to the space.

Table 8.3 features some of the major lighting companies.

Chandeliers not only provide illumination but also give the environment a more exciting look. *(Courtesy JGA © Laszlo Regos Photography)*

TABLE 8.3 Ten Lighting Design Companies and Their Specializations*

Company	Web Site	Specialization**
Amerlux Lighting Systems	**www.amerlux.com**	Energy-efficient lighting systems
Besa Lighting Co., Inc.	**www.besalighting.com**	Hand-blown European glass to produce high-end lighting fixtures
Birchwood Lighting, Inc.	**www.birchwoodlighting.com**	Low-voltage lighting
Bruck Lighting Systems	**www.brucklighting.com**	Innovative lighting systems
Color Kinetics, Inc.	**www.colorkinetics.com**	Pioneer of full-spectrum digital lighting
d'ac Lighting, Inc.	**www.daclighting.com**	Manufacturer of original-design contemporary decorative lighting systems
Hera Lighting LP	**www.heralighting.com**	Stylishly designed halogen and fluorescent lighting that features leading-edge technology
Jesco Lighting, Inc.	**www.jescolighting.com**	Track and recessed lighting
Lumenyte Intl. Corp.	**www.lumenyte.com**	Large core and stranded fiber optic lighting systems
Translite Sonoma	**www.translitesonoma.com**	Decorative and accent lighting

*This list represents a portion of the lighting industry companies.
**These are but a few of the products and services offered by the companies.
Source: VM + SD Magazine, January 2003.

There are numerous types of light sources that retailers use for overall illumination and highlighting. A complete discussion of them are featured in Chapter 17, "Visual Merchandising."

The largest fixture design company in the United States is Leggett & Platt, featured in the following spotlight.

Fashion Retailing Spotlights

LEGGETT & PLATT

What started out as a single step in 1993 has resulted in the creation of the largest manufacturer of store fixtures. Through an unparalleled degree of personal service, financial strength, and global resources, Leggett & Platt (L&P) has reached heights not seen before in the industry.

The company's designs serve the needs of retailers ranging from Macy's to Wal-Mart as well as others at home and abroad. For Macy's, for example, company designers took the challenge to design a home prototype store that would not only be unique to that merchandising segment but would also be completed in record time—three months to be exact. For the project in the Costa Mesa, CA, 213,700 square foot store, designers used almost 600 completely new, high-quality housewares fixtures that would complement crystal, silver, and other luxury items. Using glass showcases, nested display tables, and étagères, they designed an interior that would win the 2001 Grand Prize in the "New Specialty Store over 25,000 ft." category of the Association of Store Fixture Manufacturers Awards.

Paramount to Leggett & Platt's importance is the wealth of companies under its umbrella. Each serves a specific need and enables L & P to produce environmental designs and fixtures for every type of retail entry. Included in its group is Dann Dee Display Fixtures, Design Fabricators, Edron Fixture Corp., Geron Furniture, Slot-All, and Tarrant Interiors, all leaders in the design and fixturing industry.

L & P assigns small teams to meet with the client to understand its specific needs. The team leader assesses the client's needs, and pulls together products from the right outlet in L & P's group of companies to deliver custom fixturing, POP, or storage solutions in the specified time and budget.

BRICK-AND-MORTAR MAKEOVERS

Just as the malls and downtown districts are renovating their environments so are the traditional stores that inhabit their spaces. With competition stemming from a wealth of prime brick-and-mortar locations under lease or owned by retailers all across the country, many retailers acknowledged that their environments needed to reflect new trends in modern-day retailing. Although the stores were such household names as Macy's, Saks Fifth Avenue, and Tiffany's, their interiors still left much to be desired when measured against newer store designs.

One makeover is Marshall Field's flagship in Chicago's Loop. Retaining the magnificent Louis Comfort Tiffany pearlescent blue dome as its centerpiece, the store's designers brought elements of the glass mosaic tile down to the main floor's selling area. The result is a brighter environment that makes shopping more exciting.

Another is one of London's grande dames, Liberty. The Regent Street store dates back to 1875, and in recent years began to lose some of its luster. Utilizing its prime location, the company underwent a total facelift. Central to the design is a totally new Edwardian-style entrance that immediately motivates shoppers to enter the store. Inside they are greeted by a light sculpture that pulses with varying intensities of light. The drama of the entrance and the new reception area generates excitement for those about to set out to see the merchandise inside.

TRENDS IN RETAIL ENVIRONMENT DESIGN AND FIXTURING

Since the start of the new millennium, retailers have paid more attention to designing and fixturing their premises than ever before. Some of these new approaches have established trends that will probably continue to grow in the coming years.

More Illumination at Less Expense

With an abundance of new lighting technology available to retailers, more will adapt light systems that save energy and thus result in lower maintenance costs.

Changes in Window Structures

Because the cost of rental space has become more expensive, windows, except for those in the downtown flagship stores, will likely disappear. More attention will be focused on how to maximize the use of the space as interior selling floors. The window structures will more often take on the windowless look, where large panes of glass separate the exterior from the interior and the selling floor becomes the display space.

Minimalist Interior Design

Instead of the cluttered look of fixturing, many retailers will opt for the **minimalist interior design** approach that leaves more room for shoppers to make their way through the departments. Less obtrusive fixtures will give the premises a contemporary feeling.

Split Departments

In an effort to give prime space to as many departments as is possible, large department stores will utilize the **split-department** concept. For example, a selection of men's wear will be featured on the main floor, with the remainder elsewhere in the store.

In-Store Designer Salons

Upscale, fashion-forward retailers will continue to separate their couture lines into salons. In this way, they will offer those clients the comfort of individual designer boutiques and more personalized attention than that found in the remainder of the store.

Unique Departmental Nomenclature

Instead of labeling the departments with such traditional designations as juniors or extra sizes, unique new names will continue to surface. Many fashion emporiums such as Bloomingdale's and Nordstrom already subscribe to the concept, which will soon be followed by lower-price-point retailers.

Environment Surfacing

Both floors and walls will begin to take on new looks with products produced through technological advances. Acrylic patterned flooring, for example, will feature individual designs that are computer designed and reflect the store's image. Painted concrete will also be visible in patterns that add uniqueness to the store's floors at a comparatively low cost.

Versatile Fixturing

Instead of the permanent floor cases that have become commonplace in retail environments, many merchants will opt for a new breed of fixtures that can be adjusted, adapted, and transformed to fit many merchandising needs. Counters that are mobile will become part of the interior landscape so that selling floors can be used for other needs with a minimum of effort.

SMALL STORE APPLICATIONS

Many who open small fashion operations are more concerned with merchandise philosophies than they are with store design and fixturing. While merchandise considerations are paramount to the store's success, with the high cost of space, the proper use of it is imperative. Just as the giants of the fashion retail industry employ designers for their facilities, so should the smaller merchant.

The inexperienced retailer often considers professional design assistance too costly and decides to attack the problem alone. While designers are paid for their time and expertise, the costs certainly make up for the errors that can arise from inappropriate design. Often, the cost of the store designer is very little. It might be just a few hundred dollars for a consultation and a proposed design that would provide the essentials for the store's environment.

More detailed planning costs more, but the expense is often offset by the designer's ability to purchase fixtures and materials at lower prices then the retailer would have to pay. When architectural firms are used for store design, they generally have several companies bid for the job, thus making the cost of construction more competitive.

An alternative to using the already established design firm is to go to a university that offers an interior design program. Faculty are often willing to recommend graduate students about to enter the field. In such cases, these designers might be able to perform the task at minimal cost to gain the experience.

No matter how small, every fashion retailer should use some level of professional assistance for planning their environments.

Chapter Highlights

1. Environment designs should not be set in stone but should be changed when they become shopworn, or when the company embarks upon a new merchandising philosophy that the old design wouldn't suit.
2. It is important to familiarize onself with the latest trends when planning exterior and interior designs. Trade journals such as *VM + SD Magazine,* Internet Web sites of design firms, or the Web site of the Institute of Store Planners, which offers a wealth of design consulting firms are ways to gain information.
3. Exterior designs are important because they are the shopper's introduction to the store. Included in these designs are a number of storefronts and window structures.
4. More stores are leaving less of their overall footage space for windows and are using the windowless window concept instead of the more formal configurations.
5. In multilevel stores, the high-volume merchandise is placed on the main level, with impulse products such as cosmetics, shoes, jewelry, and accessories dominant.
6. Nonselling departments are located in out-of-the way places, leaving the prime locations for the selling departments.
7. Major fashion merchants are opting for designer salons and in-house separate shops for their marque labels to give shoppers a sense of being in smaller, individual private boutiques.
8. The materials that are used on the store's walls and floors are functional as well as decorative. A rash of new types allow environments to take on a more individual appearance.
9. Preparing to purchase merchandise and lighting fixtures is best achieved by looking at designer Web sites or by examining the pages of such trade periodicals as *VM + SD Magazine.*
10. More traditional fashion retailers are in the makeover mode to bring them into the era of modern-day retailing.

Terms of the Trade

parallel-to-sidewalk windows
windowless storefronts
arcade windows
open windows
multilevel store

satellite departments
nonselling departments
reserves of merchandise
designer salons
in-house separate shops
collection areas
faux finishes
self-selection fixtures
energy-efficient lighting
minimalist interior design

For Discussion

1. What is the best approach for brick-and-mortar retailers to use in the initial planning of their environments?
2. In addition to using the trade's periodicals to learn about different design firms, what other resource can the merchant use to gain this knowledge?
3. Why is it important for the store's façade to be carefully designed?
4. Which type of window structure is most typical of department store flagships?
5. Why don't most retailers use the parallel-to-sidewalk windows for their brick-and-mortar operations?
6. What is a windowless store front, and how does it help to attract the attention of the passersby?
7. In retail locations with little width, what type of window structure may the merchant employ that provides ample space to formally display merchandise?
8. In single-level stores, which merchandise is generally located in the rear?
9. Why do most major department stores locate their cosmetics, shoe, and fashion accessories departments near their main entrances?
10. How can retailers assign space to more departments on the main floor without forfeiting the potential for greater sales for each of the departments?
11. Where are the nonselling departments usually located on single-level and multilevel stores?
12. Instead of using only the traditional department approach, how are most major fashion operations defining their designer and couture departments?
13. In addition to providing an attractive impression of the store, what other consideration must the retailer address in the selection of wall and floor surfaces?
14. In what way is concrete being used as an attractive floor surface in brick-and-mortar operations?
15. Why is paint generally the choice for wall coverings?
16. How has Ralph Lauren's New York City flagship approached its choice of store fixtures to make a unique environment?
17. What resources can merchants investigate before making any decisions regarding their lighting projects?
18. What is meant by the term brick-and-mortar "makeover"?

CASE PROBLEM I

Jane Parker recently inherited a substantial amount of money and decided to invest it in a fashion boutique. For the past five years, she has worked as a fashion director at Cranston's, a department store with ten branches. Now that she has what she considers to be a sufficient amount of experience and an appropriate amount of money to use, she has decided that it is time to start her own company.

Jane has always been recognized for her excellent taste in fashion apparel and accessories. Her frequent trips to the wholesale markets with Cranston's fashion buyers and merchandisers helped her to develop an excellent understanding of the industry and merchandising techniques. She has already decided upon the approach she will take in the new store's merchandising philosophy and is now ready to tackle the problems associated with store design and fixturing.

To prepare herself, she has studied the layouts, fixtures, and materials used in many of her city's fashion stores. Although there are not many boutiques in her general trading area to study, she feels she can adapt the plans utilized by larger companies for her own venture. By combining a great deal of legwork with her practical experience, Jane believes she can develop a suitable store design and fixturing approach that will suit her needs. By eliminating the use of architects and designers, she feels that she can save a great deal of money.

Questions

1. Do you think Jane has the necessary competence to design her own store facility? Why?
2. What approach would you suggest she use to make certain that her plans are appropriate for the venture while at the same time not costing more than she could afford?

CASE PROBLEM 2

Collins and Sanders, a full-line department store with several branches, has decided to open another unit. Unlike the other branches, this one will confine its merchandise mix exclusively to fashion merchandise. The reason for the decision is that the company has realized a decrease in the store's hard goods sales. The new store will serve as a prototype for the company and will hopefully be the first of many fashion units to be developed.

As successful merchants for more than forty-five years, Collins and Sanders has been through many expansion programs. It has always used the same architectural firm for its stores and has been satisfied with the results. The architects and designers meet with top management for guidance in terms of space requirements for merchandise and to learn about any design preferences. Throughout the years, the company always subscribed to the traditional approaches for its fashion department layouts as well as for the rest of the store, and business generally flourished.

Before approaching the architects, Collins and Sanders held a meeting of its top management team and those responsible for visual merchandising. The meeting resulted in two different schools of thought for the new store's department designs. Top management believes that the traditional approach always worked for the company and the same approach should be taken. The visual merchandisers feel that the new store should utilize a more contemporary approach to interior design. They believe that with the new store's emphasis totally on fashion, the company would be better served with the establishment of several different department classifications and layouts.

Questions

1. With which group do you agree? Defend your answer with logical reasoning.
2. Discuss the concepts of traditional fashion departments and the newer approaches to fashion department classifications and layouts.

EXERCISES AND PROJECTS

1. Photograph the windows of a downtown department store or specialty store and those stores in a regional mall or neighborhood cluster. Mount the ten best on a foam board and describe the categories of window structures in which they fall to the class, or prepare a Power Point presentation to show each of them.
2. Visit a major fashion-oriented department store to learn about the names of ten of its departments and the merchandise offerings within each of them. Use the chart on the next page to record your observations.

STORE NAME: _____	
Department Name	*Merchandise Assortment*

3. Using any of the lighting design company Web sites featured in the chapter or any other that you select from the Internet, prepare a report on why you consider this one to be perfect for designing the lighting of a fashion retailer's premises. Include in your assessment the following:
 - History of the company.
 - Approaches to making the lighting decisions.
 - Types of lighting used by the company.
 - Awards received for its work.
 - List of clients.

SECTION THREE
Management and Control Functions

Human Resources Management

After reading this chapter, you should be able to discuss:

- ■ The various tasks performed by the human resources department.
- ■ The selection procedure used to assess a company's potential employees.
- ■ Why different sources are used to attract employees to the company.
- ■ The types of testing that merchants use in their hiring procedures.
- ■ The types of training techniques that are used by today's retail organizations.
- ■ Which methods of remuneration retailers are using for the different levels of employment.
- ■ The different types of services and benefits that are offered to employees, and their importance in attracting and retaining them.

The lifeblood of every retail organization is its staff. Without competent employees at every level, it is unlikely that the retailer will be able to function properly. Whether it is the decisionmakers at the organization's highest levels, the middle managers, the sales associates who directly interface with the shoppers, or those who provide the support services for the company, excellent employees are necessary to run a profitable company.

The task of attracting the best employees is no simple matter. People find many fields of business more attractive than retailing for a number of reasons. Except for the upper levels of management, retailing has an image of underpaying its workers. This, coupled with the potential for having to work long hours that extend into the evening as well as having to work weekends, often discourages many would-be employees from entering the field. Many of the country's most talented college graduates, when embarking on a career, opt for other means of employment. Confronted with such negatives, retail organizations must attract qualified people who are willing to take the challenges offered by a retailing career. Retailing does provide many pluses, however. Salaries at the middle-management level, for example, are comparable to those in other fields that require the same amount of formal education, fringe benefits rival those offered by other industries, and employee discounts enable workers to purchase a wealth of merchandise at well below the retail price.

The human resources (HR) department, still known as the personnel department in many retail organizations, has the initial responsibility of locating the best available people for the jobs. Once they are brought on board, the successful candidates must be trained to make sure they comprehend the company's mission and understand how to perform their various job tasks. This department also is responsible for making regular evaluations so that employees know how they need to improve their performance, and those who perform favorably can be earmarked for promotions to higher levels. The human resources team also makes recommendations on remuneration plans and employee services and benefits.

The HR department's place in the overall table of organization differs from company to company, as does its decision-making authority. In terms of hiring at the lower levels, such as sales associates, stock personnel, and maintenance people, most retailers leave the choices to the HR managers. When filling middle-management positions and those at the highest levels, however, those in human resources management play the role of advisors

rather than decisionmakers. Their primary task is to assess the various candidates with evaluation tools so they can recommend potential employees to the supervisors for further interviews. Thus, when an assistant buyer position in ladies shoes becomes available it is the shoe buyer who has the final say in the selection procedure and the human resources people who have narrowed down several applicants for the position.

Each retail operation must determine the parameters of the human resources department activities so that those in the department will be able to help staff the company with the best available employees and contribute to a working environment that will help maximize profits.

MAINTAINING EQUAL OPPORTUNITY

One of the problems that has plagued retailing (as well as other businesses) concerns equal employment opportunities for women and minorities. Whereas past business practices had shown favoritism in advancing white male Caucasians, the playing field has somewhat leveled in recent years. Once relegated to positions at the lower levels of employment even though they demonstrated the qualities necessary to move into upper management, employees who were formerly passed over are now making gains in reaching the upper levels.

Although the federal government has enacted such legislation as the **Equal Pay Act**, which guarantees men and women the same salary for the same job, and the **Civil Rights Act**, which protects people from discrimination, the biases and prejudices have not been completely eradicated from business practices. Companies of every type, including retailing, have made the headlines because employees have accused them of discriminatory practices.

Today, retailing, more than some other industries, has demonstrated that it has become aware of the problem and has promoted minority employees and women to positions of the highest level in the field, such as CEOs, general merchandise managers, divisional merchandise managers, buyers, store managers, advertising executives, publicists, and fashion directors. With each success story, the opportunity for advancement has become easier for others.

THE RECRUITMENT PROCESS

One of the most difficult tasks facing today's fashion retailers is to find prospects who have the potential to become productive employees. The difficulty becomes even greater when the economy is booming and there is more competition for workers. With fewer candidates available, human resources managers have to initiate new techniques in their quest for the best. When the economy falters and unemployment figures are at peak levels, however, the task is less formidable since there are more would-be employees to choose from.

There are many stages in the recruitment process. Organizations that have been in business for a number of years have well-established requirements for their jobs, but these companies may need to do some research into new requirements if they add new positions. Newly established retail operations should undergo job analysis research to determine the requirements and specifications of the jobs in the company's structure. Smaller companies, such as boutiques, that employ only a few people generally have a good idea of what their needs are to run a successful business, so job analysis is not warranted. The following discussion primarily pertains to the larger retail companies that do have human resources departments.

Job analysis is the study of a specific job to learn all about its duties and responsibilities. From this analysis, **job specifications** are spelled out listing the qualifications needed to perform the job. Finally, a **job description** is written, outlining the title of the job, the division in which it belongs, the specific department, the title of the immediate supervisor, and a brief description of the duties and responsibilities. Each job description is kept on a computerized file for easy access so that the recruiter can quickly examine the job description

DIVISION: Merchandising
TITLE: Fashion Director
SUPERVISOR: Vice President of Fashion Forecasting

DUTIES AND RESPONSIBILITIES:
Works closely with the vice president of fashion forecasting in carrying out the store's fashion policy in the flagship and branches. Specifically, the duties include:

1. Accessorizing the interior fashion visual presentations.
2. Assisting in the preparation of fashion shows.
3. Advising buyers and merchandisers on fashion market trends.
4. Preparing for store appearances by designers.
5. Writing commentary for fashion shows.
6. Visiting branch stores to evaluate fashion promotions and special events.
7. Visiting domestic and foreign fashion markets to evaluate new resources.
8. Accompanying visual merchandisers to trade shows.

APPEARANCE:
Fashion oriented in terms of hairstyle and attire.

Figure 9.1 Job description.

when placing a classified advertisement or preparing for an interview. When people apply for the jobs, the job descriptions assist the human resources team in determining if the candidates are qualified for the positions.

A typical job description for a fashion director is shown in Figure 9.1.

After developing the job description, the human resources manager should consult the roster of personnel sources that the HR department has created to use in the recruitment of employees.

Recruitment Sources

Basically, there are two separate areas to recruit candidates: the **internal sources**, which consist of people already employed by the company, and the **external sources**, which consist of people outside of the company.

INTERNAL SOURCES

One of the ways in which retailers may satisfy their human resources needs is by talking with people already employed by the company. These workers can help in two ways. First, if they are satisfied employees, they might be willing to recommend others for employment. Because they already understand the company's mission, the ways it operates, the benefits derived from being part of the organization, and the salary, potential for advancement, and so forth, they might want to tell friends and relatives about the position. Sometimes, staff is rewarded for making recommendations to the company.

The other way in which a retailer uses its internal resources is by **promotion from within**. New employees are frequently motivated to join an organization because they are told that they could move up to a more important position if they have good work records. In many retail organizations, human resources managers are instructed to first scour the present staff to seek candidates for higher positions before going outside of the company. This approach not only motivates staff members to perform at their highest levels but also provides a pool of candidates that already know the ins and outs of the company.

The disadvantage to using the promotion-from-within policy as the only means of filling upper-level positions is that it might result in stagnation and limited ideas. Outsiders often bring a breath of fresh air to a company. Combining those already on board with those from other sources generally provides a better employee mix.

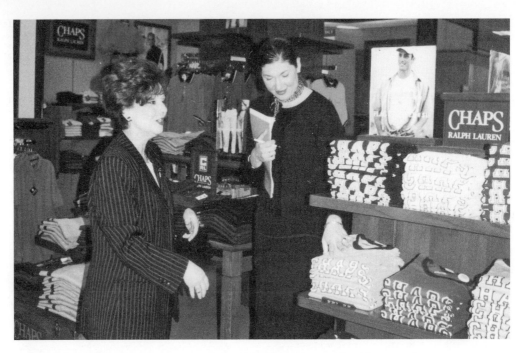

A salesperson, seen here speaking to the department buyer, could be considered for promotion.
(Courtesy Ellen Diamond)

EXTERNAL SOURCES

There is a wealth of outside sources that retailers use in their pursuit of excellent employees. Some have been used since retailing was in its infancy, such as classified ads and employment agencies. Newer ones include posting positions on the Internet, where merchants can also provide application forms for interested parties to complete.

Consumer Newspaper Classified Advertisements. The method most often used by retail human resources representatives is the newspaper classified ad. Typically, these ads are for lower-level positions such as sales associates, or middle-management positions such as department managers. Upper-level management positions are generally advertised in the newspaper's business section. On Sundays, for example, the *New York Times* features a separate section for executive positions, which includes retailing. Whichever section of the newspaper is used, the positions are posted as either **open ads** or **blind ads**. The former lists the name of the retailer in addition to any pertinent information about the job. The latter omits the company name, supplying only relevant information about the available position. Those who use the blind format often do so because it preserves the anonymity of the company and avoids unwanted telephone inquiries. However, sometimes blind ads discourage job seekers from applying because they fear they might be applying for their own position, thereby alerting their present employer that they are looking for another job.

Trade Periodical Classified Advertisements. When fashion retailers have positions they need filled, ads they post in trade publications often bring the greatest number of responses. *Women's Wear Daily,* for example, the largest of the fashion-oriented trade papers, features a section that lists a large number of mid-and upper-management retail positions. Since those with a lot of business experience generally read the *WWD* religiously, it is an excellent way to reach the best-most experienced group of potential employees.

Employment Agencies. Some retailers prefer to have job applicants prescreened before they consider them for an interview. By providing agencies with job descriptions, they can limit their time to interviewing those with the most potential. Agencies usually specialize in specific industries and particular levels of employment. Fashion retailers who utilize the services of an agency that specializes in their types of positions are more likely to have

PRE-APPLICATION QUESTIONNAIRE ⊙ **OASIS** STAFFING

DARKEN IN, WHERE APPLICABLE, YOUR RESPONSE TO EACH QUESTION. ●

Last
Name: _____ First
Name: _____ Middle
Name: _____ Social Security
Number: _____

Address: _____ City: _____ State: _____ Zip: _____

Telephone Number: _____ Answering Machine? ○ **Yes** ○ **No** E-mail: _____

Alternates: Work _____ Cell: _____ Pager: _____ Other: _____

1. Transportation accessibility? ○ Automobile ○ Bus ○ Other ○ None
2. How far are you willing to travel for work? _____
3. What position(s) are you applying for? _____
4. Minimum hourly pay rate you will accept? $_____
5. Are you eligible for work in the US? ○ Yes ○ No
6. Do you have your I-9 (work status) information with you? * ○ Yes ○ No
 * A U.S. Passport or drivers license and social security card are acceptable documents for the I-9 form. This is not an inclusive list.
7. Are you 18 years old or older? ○ Yes ○ No
8. Have you ever applied here before? ○ Yes ○ No If yes, when? _____
9. Have you ever worked here before? ○ Yes ○ No If yes, when? _____
10. Date available for work:

	Able to work:	Yes	Sometimes	Never
_____	Day (1st shift)	○	○	○
○ Short term temporary	Eve (2nd shift)	○	○	○
○ Long term temporary	Night (3rd shift)	○	○	○
○ Part time / direct hire	Weekend Days	○	○	○
○ Full time / direct hire	Weekend Nights	○	○	○

11. Circle days you are available for work:
 MO TU WE TH FR SA SU
12. Please indicate hours available for work:
 From: _____ To: _____
13. Can you accept same-day assignments? ○ Yes ○ No
14. Are you willing to take a drug screen for illegal drug use according to our policy? ○ Yes ○ No
15. If necessary, will you release your background information inclusive of criminal records and credit report? ○ Yes ○ No
16. Have you ever been convicted of, or pled guilty or no contest (nolo contendere) to, a felony in any jurisdiction. ** ○ Yes ○ No
17. Have you ever been sued in a civil action with regard to the death of, or personal injury or intentional damage to any person? **
 ○ Yes ○ No

 If "Yes" to #16 or #17, give details concerning the nature of the claims and defenses raised by the parties, the outcome of the
 action (e.g., settlement, jury verdict, or other disposition), and any other circumstances you deem relevant to a full understanding
 of what occurred: _____

*** Please Note – If you do not understand this question, you must ask Oasis Staffing for clarification. In responding to this question, you are
not required to disclose juvenile court records or convictions which have been sealed, expunged, annulled, pardoned, or otherwise shielded
from public scrutiny by the applicable jurisdiction. Answering "Yes" is not an automatic bar to employment. Factors such as age at the time
of the offense, seriousness and nature of the violation, relatedness to the job sought, and evidence of rehabilitation will be taken into
account. However, please be advised that a misstatement or omission in answering these questions may be grounds for disciplinary action,
including discharge.*

Signature of Applicant: _____ Date: _____

(STOP) **PLEASE SPEAK TO A STAFFING SERVICES COORDINATOR BEFORE PROCEEDING.**

S02 Employment Application rev 02/03

The pre-application questionnaire used by most employment agencies helps to screen the applicants before they are sent
to the retailer for further interviews.
(Courtesy Oasis Staffing)

better-qualified applicants recommended to them. They also might want to deal with differ-
ent agencies for their needs at different levels. One might serve their purposes for finding
entry-level prospects, another for mid-management personnel, and another for upper-
management positions. The latter agency is known as an **executive search firm**, or **head-
hunter**. It deals exclusively with people who have significant industry experience, and

agency staff are professionally experienced in attracting the most discriminating employees. Unlike the first two employment agencies, where candidates go to seek leads for future employment, the headhunter pursues the industry's best candidates and directs them to clients who have specific needs. When a company needs a general merchandise manager, it contacts the headhunter to find the right person to fill the position. Headhunters are paid on a commission basis that generally runs from 20 to 25 percent of the position's salary. Most major retailers find the headhunter route the best approach to attracting the most prized upper-level employees.

The Internet. Retailers at every level, from department stores such as Marshall Field's to value stores such as Target, are using their own Web sites to fill their human resources needs. On the same Web sites on which they self merchandise, retailers include special sections that can be accessed by people seeking employment. Job seekers can fill out application forms and send them immediately to the retailer. Those considered to be viable candidates are contacted via E-mail and asked for an interview. The Internet also features many career Web sites that offer a variety of jobs, retail included, such as **jobsonline.com**, **monster.com**, **hotjobs.com**, **headhunter.net**, **careerpath.com**, and **salary.com**. Typically, they provide resume services and post available jobs in a range of geographical areas.

Schools, Colleges, and Universities. Many educational institutions across America serve as excellent resources for retailers to find prospective employees. They sponsor career fairs, where merchants can meet students in a variety of formats. Merchants can make group presentations or hold one-on-one meetings to tell students about job opportunities within their companies. Companies set up booths that students visit, giving the students the chance to make quick comparisons among those companies in attendance and seek further information about those they may want to work for. Colleges and universities also implement internship programs that place graduating seniors in positions with various retail operations. In this way, employment managers get a first-hand knowledge of the student interns and can assess their progress to see if they should be considered for regular employment after the internships have been completed. More retailers are entering into these programs because they find there is no better way of learning about an employee's potential than by observing that person on the job. Fashion retailers participating in internship programs include Bloomingdale's, Macy's, SteinMart, Kmart, and Lord & Taylor. Some retailers participate in **shadowing programs** where students are invited to follow executives as they perform their daily routines. The participants are able to learn about a particular company in a brief period and determine whether or not they want to work there.

Walk-ins. One of the most successful means of staffing brick-and-mortar operations comes from people who apply directly at the store. Many retailers have excellent reputations and attract numbers of potential employees who wish to work for them. Most retailers agree that a substantial number of sales associates are found this way, and that they turn out to be among the most productive employees. In fact, many eventually work their way up the ladder to managerial positions. One of the reasons for the effectiveness of such sources comes from the applicants' self-motivation, evident in their willingness to go from store to store, looking for work. Some stores, such as Marshall Field's, utilize in-store kiosks with computer terminals in which those seeking jobs may complete applications for employment without the need to make an appointment with an employment manager. Evaluated almost instantaneously, the computerized applications provide human resources interviewers with a sufficient amount of information to determine if further screening is warranted. Sometimes, retailers seeking employees post signs alerting interested people of signing bonuses. These bonuses motivate **walk-ins** to seek further information about available positions and company benefits because the retailer is willing to pay them to accept a job with the company.

Industry Networking. Fashion retailers regularly interact with a host of different fashion-oriented businesses, such as the vendors from whom they purchase, resident buying offices, reporting services, and public relations firms. Each of these groups meets with

Some companies provide brochures to walk-ins regarding employment opportunities.
(Courtesy Marshall Field's)

retailers throughout the year and becomes familiar with their management employees. Fashion manufacturers and resident buying office representatives, for example, work closely with store buyers and merchandisers and are in the position to evaluate their abilities and expertise. Thus, when fashion merchants are looking to recruit a new buyer, they can use this informal **networking** route to learn the names of potential candidates for the position. Often times, assistant buyers achieve buying positions with other companies through these means.

Window and Exterior Signage. Small retailers often use signs in their windows to advertise positions. Often customers of the stores are willing to work there because they are familiar with the operations. Many of the giant retail operations strategically place help wanted signs in their stores that also list the benefits of working there. Since many who see the signs are customers, the lure of receiving merchandise discounts attracts some to apply. This is particularly true at Christmas time, when customers may be interested in earning a little extra money, coupled with the discounts, to do their own holiday shopping. The signs usually appeal to segments of the population who might be engaged in other full-time activities or think they are ineligible for this type of employment. The former group is generally made up of full-time moms or students, who are usually offered part-time hours that do not conflict with their regular responsibilities. The latter segment is often composed of senior citizens, who may believe they are ineligible for such employment or are anxious for a little extra money to supplement their retirement income. The companies that employ senior citizens range from giants such as Wal-Mart to small independently owned specialty stores.

Employment managers often keep records regarding the success of the various types of resources they use to obtain potential employees so that when they need to hire, they know which ones are the most effective. A retailer is most likely to contact a particular employment agency or headhunter that has brought them capable workers in the past before tapping any other resources.

The Hiring Procedure

Once people apply for a position, the human resources department must evaluate them to see if they meet the store's employment criteria. A company generally has rigorous rules to follow when making employment decisions but at times of employee shortages, the rules are sometimes compromised so that the company's needs may be satisfied.

Regardless of how urgently a retailer needs to hire, it is essential to carefully check each candidate's background. To do so, many retailers are utilizing outside agencies, which perform such services as public records checks, fraudulent use of social security numbers, criminal background checks, and drug testing. Table 9.1 lists selected investigative companies and the primary services they offer.

Hiring practices differ in terms of the position to be filled. A company seeking a divisional merchandise manager, for example, will use a different approach than when it is looking for a sales associate. The former position is at the top level of company management and requires significant decision-making ability and a substantial background in merchandising. A candidate for the latter position might merely need to be appropriately groomed and dressed and display a willingness to work. The procedure used to evaluate the candidates for the management position will be considerably more extensive than the one used to hire the salesperson.

TABLE 9.1 Selected Investigative Agencies*

Agency	*Services*
AccuCheck Investigations	Nationwide preemployment screening service
BackgroundChecks	Features OneSEARCH comprehensive database scan with results in seconds
Employee Assurance, Inc.	Preemployment criminal background checks
FYI Service	Preemployment background screening and evaluation
Know It All Background Research Services, Inc.	Preemployment public records checks
Landata research	Preemployment screening, background information, driving history, credit reports
Lang Investigations	Worker's compensation history and criminal records
Psychemedics Corporation	Drug testing using hair samples
US Investigations Services (USIS)	Employment screening, drug testing, and background investigations in North America
S.J. Bashen Corporation	Specialists in discrimination investigations and managing EEO claims

*For a more detailed analysis of these companies, access the Web site **www.dmoz.org/Business/Business_Services/Security/Investigation/Employment**.

Many retailers, as do other businesses, use the services of outside agencies; ACCU-TRAC is profiled in the following Spotlight.

Fashion Retailing Spotlights

ACCUTRAC

With the selection and promotion of employees becoming ever more difficult, many retail organizations are turning to outside agencies such as ACCUTRAC to help them.

The ACCUTRAC evaluation system for management and sales personnel analyzes as many as forty-four elements that are critical to success and performance. The system achieves 90 percent overall accuracy to help companies make more informed, objective, and cost-effective human resources decisions. The assessment tools are valid predictors of on-the-job-behavior, success potential, risks, and developmental needs.

Specifically they do the following:

- Predict managerial success from entry level to executive level management.
- Predict sales success potentials, closing strengths, sales poise, and achievement motivation.
- Determine a person's strengths and weaknesses.
- Evaluate decision making, planning, organizational, and leadership skills.
- Implement a targeted training and development program.

The system is administered to hourly, prospective, or current employees at every level of employment. It accurately identifies an applicant's potential for employee theft, early turnover, absenteeism, poor performance, and work compensation claims. All of the company's processing is done through the telephone, fax, or computer.

By logging onto ACCUTRAC's Web site at **www.accutrachr.com**, merchants can quickly learn more about its offerings and determine how the company can help solve their human resources problems.

Most retail operations adhere to similar stages in the selection procedure, although they may use them in different orders, the following sections discuss these stages.

RESUMES

Except when hiring for lower-level positions such as sales associates or stock handlers, the **resume**—such as that shown in Figure 9.2—is usually the initial step in the hiring process. However, some fashion merchants that cater to the middle- and upper-social classes will require resumes for their sales positions, since these jobs sometimes require more than just

Barbara Fitzgerald
1803 Colbie Street
Chicago, IL 60614
Telephone 773-168-1292 Email Bfitz@aol.com

EDUCATION: FORBES COMMUNITY COLLEGE Chicago, IL
 AAS-Fashion Merchandising, June 2004

SPECIAL EXPERIENCE: Participated in internship program at London's Polytechnic Institute to study
 fashion retailing and work as an intern at Harrod's.

HONORS: Dean's List, 4 semesters
 Magna cum laude

COLLEGE ACTIVITIES: Tutor, Textile laboratory
 Fashion Coordinator, Annual Fashion Show
 Senate Representative

WORK EXPERIENCE:
5/01-8/01 **The Gap:** Duties included checking inventory, making price changes, and
 rearranging merchandise on the selling floor.
 Location: Water Tower, Chicago, IL

5/02-8/02 **The Limited:** Duties included helping customers make selections, restocking
 inventory, assisting with visual presentation changes.
 Location: Water Tower, Chicago, IL

5/03-1/04 **Carson Pirie Scott:** Part-time sales in the Junior Sportswear Department.
 Location: State Street, Chicago, IL

2/04-5/04 **Marshall Field's:** Participated in college-sponsored internship program.
 Assistant to the Men's Wear department manager. Duties included selling,
 taking markdowns, changing department displays, and doing inventory.

INTERESTS: Art, music, theater, travel.

REFERENCES: Furnished upon request.

Figure 9.2 Résumé for recent college graduate seeking employment in fashion retailing.

meeting and greeting the shopper. In many upscale, fashion-forward retail operations such as Saks Fifth Avenue, Bergdorf Goodman, Neiman Marcus, and Nordstrom, where sales associates are expected to develop a customer base, resumes can show the level of customer relationships the sales associate has developed at other stores. This is important, because these sales specialists are often able to establish long-lasting relationships with customers that result in a steady flow of business, which is profitable to the retailer. Those seeking employment in management, merchandising, advertising and promotion, customer service, and store operations or control are expected to provide a resume that carefully spells out their educational, professional, and personal information.

The resume serves as a document that will help the reviewer to evaluate the candidate's ability to perform the duties and responsibilities of the available position and to fit in with the company's business environment.

APPLICATION FORMS

For those applying for lower-level positions, the first step is to fill out the application. For those who have submitted resumes and have been invited to provide more information, the second step is to complete the application. In any case, the application form is a basic instrument on which the candidate provides specific information that is necessary for the later stages of the employment assessment. Places to include personal history, educational achievement, professional experience, and references are usually part of the application

EMPLOYMENT APPLICATION

PREVIOUS EMPLOYMENT

OASIS STAFFING

Most recent employer name and address	Telephone	Dates Employed Mo./Yr. From: / To: /	Supervisor
Job Title / Duties Performed	Hourly Rate / Salary Starting: End:		Reason for leaving

Second most recent employer name and address	Telephone	Dates Employed Mo./Yr. From: / To: /	Supervisor
Job Title / Duties Performed	Hourly Rate / Salary Starting: End:		Reason for leaving

Third most recent employer name and address	Telephone	Dates Employed Mo./Yr. From: / To: /	Supervisor
Job Title / Duties Performed	Hourly Rate / Salary Starting: End:		Reason for leaving

ACCOUNT FOR YOUR TIME DURING ANY PERIODS OF UNEMPLOYMENT OTHER THAN THOSE WHEN YOU WERE ATTENDING SCHOOL.

FROM		TO		EXPLANATION	NAME AND ADDRESS OF PERSON WHO CAN BE CONTACTED
Month	Year	Month	Year		

Are you employed now? O Yes O No

Is your present employer aware of your plans to change employment? O Yes O No

May we contact your current and/or previous employers? O Yes O No

If no, please indicate which one(s) you do not wish us to contact: _____

Are you registered with any staffing services? O Yes O No Which one(s). _____

Education – Please circle the highest grade completed. 7 8 9 10 11 12 13 14 15 16 16+ GED

High School _____ O Yes O No _____
　　　　　　　　　　Name　　　　　　　　City/State　　　　　　　　　Graduate　　　　　　Degree

College: _____ O Yes O No _____
　　　　　　　　Name　　　　　　　　City/State　　　　　　　　　Graduate　　　　　　Degree

College: _____ O Yes O No _____
　　　　　　　　Name　　　　　　　　City/State　　　　　　　　　Graduate　　　　　　Degree

College: _____ O Yes O No _____
　　　　　　　　Name　　　　　　　　City/State　　　　　　　　　Graduate　　　　　　Degree

Other: _____ O Yes O No _____
　　　　　　　Name　　　　　　　　City/State　　　　　　　　　Graduate　　　　　　Degree

Continue To Next Page ➡

Some businesses are utilizing outside agencies to preview applications.
(Courtesy Oasis Staffing)

Selling floor application centers are commonly used for applicants seeking employment.
(Courtesy Ellen Diamond)

forms. Application forms can not ask for information pertaining to age, height, and weight, due to the enactment of the federal Civil Rights Act of 1964.

PRELIMINARY, OR RAIL INTERVIEWS

After candidates submit their applications, a member of the human resources team examines them to determine if these are any people applying for the positions who warrant further consideration. Those who do not meet the minimum requirements established by the company are dismissed at this stage, and those who seem like good prospects sometimes are contacted for a brief interview. These are known as **preliminary**, or **rail interviews** and give the employment manager an opportunity to meet the candidates and quickly assesses their personal appearance, because they should dress in a manner that fits the retailer's image, and their ability to communicate, because it is important that they can convey the retailer's fashion message and provide good customer service.

The interviewer also takes this opportunity to flesh out the candidate's answers on the application form to determine if they possess the minimal requirements for the position as outlined in the job description and job specifications. Those that pass this level of inquiry will be asked to move onto the next stage in the selection process.

REFERENCE CHECKS

Many HR departments spend considerable time checking candidates' references to verify that the information they provided is accurate. HR staff contact educational institutions to determine the accuracy of the dates of attendance the candidates state and any degrees they claim to have earned. HR staff may contact former employees to verify dates of employment and positions the candidates say they had with the company. They cannot ask about a candidate's performance, however, because this is considered an invasion of privacy.

To get a better picture of the candidate, many HR departments, as well as other businesses, are using the services of companies such as USSearch.com to learn more about potential employees than they are permitted to ask themselves.

TESTING

Many HR departments administer different types of tests as a means of evaluating the candidate. They include **aptitude tests**, which determine the applicant's capacity to work; intelligence tests, which determine how much the candidate has learned in the past; interest tests, which indicate whether or not the candidate has a sincere interest in the type of work; personality tests, which evaluate the candidate's characteristics and personality traits; and pen-and-pencil honesty tests, which help determine the candidate's honesty and integrity.

SRI Gallup has designed a video test that consists of short-skits portraying an employee dealing with customers in a variety of situations. After each scene, the video stops, and a narrator asks the viewer to select an answer from among the offered responses. The tape features about thirty incidents and allows fifteen seconds for each response. The HR department can evaluate each candidate's responses in terms of the retailer's needs. This type of visual test might enable recruiters to better evaluate those with potential who do not feel comfortable with written tests.

Drug testing is becoming a mainstay in most retailers' hiring process, because drug users are not generally reliable workers. There are numerous ways in which to test for drug use; for example, Psychemedics Corporation uses hair samples.

FINAL INTERVIEWS

Candidates who have satisfactorily passed through these preliminary stages usually go through at least one more intensive interview before they are offered the position.

These are lengthy and can take anywhere from a few hours to a full day, depending upon the level of the position. For upper-management jobs, more than one member of the staff conducts individual interviews or participates in a group session. These sessions are generally held in the office of the supervisor for whom the candidate will work, or when interview teams are used, in conference rooms. Occasionally, formal interviews are held in off-site venues such as restaurants so that the candidate may be evaluated in another setting.

THE FINAL DECISION

At lower levels of employment, such as sales associates positions in off-price fashion operations, the HR manager often makes the final decision instead of the new employee's supervisor, the department manager.

At the upper levels of employment, the decision is often a time-consuming one that involves careful review of all of the candidate's background materials, including test results, references, and the various interviews. The final decision generally rests with the immediate supervisor.

Candidates are usually required to undergo a physical examination. If the results of the exam are satisfactory, the person is offered the position.

TRAINING

Training is important to make certain that each employee knows how to complete the amount of work at a performance level that satisfies the company's needs and objectives.

Training takes place at different stages of employee development and is accomplished in different ways, depending on the employee's position and the size of the retailer. Small specialty shops and boutiques, for example, are less formal in their approach and often limit their instruction to on-the-job-training. Larger companies generally utilize a program that includes classroom instruction, on-line training, vestibule training, and on-the-job training.

The programs in the larger operations are usually developed by the human resources departments and carried out by experts on their staff and members of the company's supervisory team. Small stores generally rely upon owners or managers to familiarize their new

employees with the tasks of the operation; they are not cluttered with the variety of procedures and forms used by their large-retailer counterparts, thus eliminating the need for more than an orientation to the store and familiarity with the inventory. However, it is wise for small-store owners to learn about the essential elements of training so that they can better prepare their employees for satisfactory performances.

Both large and small merchants can benefit from learning about the latest training innovations from professionals in the field, such as Langevin Learning Services, the focus of the following Spotlight.

Fashion Retailing Spotlights

LANGEVIN LEARNING SERVICES

The world's largest train-the-trainer company, Langevin Learning Services has been in business since 1984. Its goal is to provide workshops for trainers who either freelance or work as members of in-house human resources programs. Langevin is headquartered in the United States in Ogdensburg, NY, and in Canada in Ottawa, Ontario. It also services clients globally in Europe, Asia, Australia, and New Zealand.

Langevin provides trainers with the skills, knowledge, and materials they need to competently train people at every level of employment. Its methodology consists of different workshops that include Web-based training, training needs analysis, advanced instructional techniques, e-learning strategy creation and training evaluation. The workshops require a high degree of participation, with students exploring issues and practicing skills during individual and group exercises. Within the workshops, trainers do the following.

- Focus on realistic, practical material that can be applied on the job.
- Survey the participants' interests before any session begins.
- Provide comprehensive course manuals for later use.
- Provide intensive single-subject analysis.
- Involve participants in regular exercises.

In addition to the standard workshops, Langevin also customizes programs for specific businesses and their individual training needs.

The company's effectiveness and recognition in the field can be measured by the fact that 82 percent of the Fortune 500 companies send their trainers to Langevin, more than 1,500 universities and colleges grant credits to attendees of its workshops, and it has been voted number 1 in the "Train-the-Trainer" category of *Training Magazine*'s First Annual Achieving Performance Excellence (APX) Awards for 2002.

New Employee Training

When people join a company, it is important to teach them as much as possible about the organization's philosophy, goals, and procedures. For fashion retailers, the challenges of training are even more complex and include teaching about its fashion image and direction. The level and scope of each position dictates the types and depth of training that must be provided before new staff members can tackle their jobs.

EXECUTIVES

The most important groups to be trained are those that will share in the management of the company, because its success, for the most part, is based upon management's ability to develop creative ideas and programs and to make certain that the rest of the staff carry them out satisfactorily. The upper level of every retail organization performs tasks involving merchandise analysis, forecasting, customer services, promotion, visual merchandising, and so forth to make the organization more profitable. Fashion retailers face even greater management challenges since they regularly must make decisions regarding the introduction of new styles, color selection, and fashion cycles, and purchasing from offshore vendors.

Even new employees who have excellent experience in other retail operations need to understand the specifics of their new company. Each organization has its own methodology as to how it will achieve its goals. Thus, training is an essential part of teaching new managers the complexities of the company.

Many of the marque fashion retailers spend a great deal of time and effort in the training of employees who come from colleges and universities to enter **executive training programs**. Some programs, such as the ones subscribed to by Macy's and Bloomingdale's, are so extensive that they are considered to be the Harvards of executive development. Graduates of these programs are regularly contacted by headhunters with offers to join other retail institutions seeking top-level managers.

MIDDLE MANAGERS

Department heads and assistant managers are not called upon to make policy decisions but are given the tasks of carrying out the decisions made by top management. They are trained to perform such duties as tallying the daily receipts, organizing meal breaks, determining employee schedules, handling customer complaints, and managing sales associates in their departments.

SALES ASSOCIATES

If a fashion retailer wants to make a profit, it must sufficiently train its sales associates in the role they play for the company. These associates assist shoppers by offering product knowledge, making suggestions, and making the sale. If salespeople are improperly trained, they could lose sales. People new to selling need more training in this area than those who come with previous experience. Both groups, however, must learn about company procedures, proper handling of credit cards, sending of merchandise, procurement of items from other units, and so forth.

NONSELLING PERSONNEL

Those responsible for receiving and marking merchandise, store security, customer service, accounting and control, stock keeping, and a variety of other nonselling tasks need training specific to their jobs. For example, merchandise receivers and sorters must understand how to use the computers so that they properly record the inventory. All employees in these support positions must learn the company's overall philosophy and procedures and apply them to their individual responsibilities.

Retraining Employees

Some people who are already on the company's payroll may need to be retrained because they are promoted or transferred, the company implements a new system they must use, or the company adds a new department that they will work in.

If an employee is transferred from one department to another, the new training might focus on familiarization with different merchandise. When an assistant buyer is transferred from men's wear to junior sportswear, for example, the company's buying procedures will be the same, but the merchandise knowledge and specifics of order replenishment will be different.

With promotions come additional responsibility. A group manager who executed merchandising plans for several departments might be promoted to buyer which includes different challenges and decision-making responsibilities. This person now requires training that includes development of a model stock, pricing, negotiation with vendors, open-to-buy calculations, and other skills.

The installation of new systems requires staff **retraining.** It might be a new point-of-purchase terminal that uses different types of scanning equipment or a new automated system for moving merchandise from the receiving room to the selling floor. Some new systems require the retraining of the entire staff, such as in the case of new computer software, or just that of one department, as in the case of a new conveyor system that replaces an older model.

Sometimes fashion retailers will expand their operations by adding new departments to their companies. For example, they might establish a boutique section that requires more personalized selling and better servicing of the more affluent customers expected to patronize these departments. Consequently, the sales associates who will work in these new areas will require additional sales and service training.

Training Methodology

Different positions and circumstances require different approaches in training, including such traditional methods as role-playing, vestibule training, classroom instruction, and on-the-job training. Today, many new techniques have been added and include the use of video presentations, on-line training, and CD-ROM instruction.

ROLE-PLAYING

Role-playing is one of the more effective methods of teaching sales techniques and methods. This learning tool involves two participants, one playing the consumer and the other the salesperson. The selling part is usually first demonstrated by a sales associate who has been with the company for a while. The newly hired salesperson is then asked to play this role and is assessed by people familiar with excellence in selling and using prepared forms. The results are then discussed by the trainer. Figure 9.3 is a typical form used in evaluating sales trainees during these exercises.

Evaluator's Name _____

Name of Sales Trainee _____

THE SALES PRESENTATION **SCORE**

APPROACH: Evidence of preapproach preparations, confidence, poise, friendliness, sincerity, achieved interest of prospect quickly . _____

SALES PERSONALITY: Proper appearance, tact, voice, grammar, attitude, absence of objectionable mannerisms . _____

BUYING MOTIVES: Skill in creating interest in product and arousing a desire to buy . . . _____

PRODUCT AND COMPANY: Knowledge of product and company necessary to convince prospect to buy . _____

SALES STORY: Well planned and executed, thorough, held prospect's interest, believably enthusiastic, illustrated how prospect could benefit from buying product _____

DEMONSTRATION: Imagination and appropriateness, encouraged prospect participation when suitable . _____

MEETING OBJECTIONS: Skill in overcoming barriers to completing the sale, application of proved techniques to handle objections . _____

TRIAL CLOSES: Ability to detect clues or buying signals, attempted closes when feasible . _____

CLOSE: Skill in application of closing techniques, order-filling proficiency, absence of idle chatter . _____

FUTURE BUSINESS: Encouraged return visit to store . _____

 TOTAL SCORE _____

As an individual judge, score the sales presentation on each of the areas listed by assigning points from 1 to 10. Total the points to get the score. A conscientious and unbiased rating helps the salesperson to learn how well he or she performed and to recognize strengths and weaknesses.

SCORING GUIDE: Excellent (10), Good (8), Fair (6), Poor (4)

Figure 9.3 Evaluation form used to rate participants in role-playing exercise.

Another area in which role-playing is used is in customer service. A trainer might act as a customer with a complaint about such things as defective merchandise or a bad experience with a sales associate, and the newly employed customer service representative responds. This demonstration is also analyzed and assessed.

VESTIBULE TRAINING

When teaching specific tasks such as using a point-of-sale terminal for recording sales, most retailers elect to simulate the conditions rather than train employees on the selling floor so they can learn to handle the equipment and perform the transactions without the fear of making costly mistakes. The trainer can provide the necessary information and allow the trainee as much time as necessary to comprehend the machine. This is called **vestibule training**, because it takes place away from the selling floor.

CLASSROOM INSTRUCTION

Most major retailers have instructional facilities that include a classroom. Such facilities are used for different purposes: orientation sessions to introduce new employees to company systems, retraining current employees, and instructing executive trainees. For example, since newly hired executive trainees generally rotate assignments, they must learn what each division of the company offers to the operation so they will be better prepared to handle any job. These trainees regularly meet in classrooms, where they are addressed by divisional heads of merchandising, management, promotion, and control as well as by human resources specialists who coordinate the training effort.

Many human resources instructors create PowerPoint presentations on their computers that clearly outline the key points of the lesson. They can also incorporate a wealth of drawings and photographs to help those in the classroom sessions comprehend the text.

Most classroom sessions include lectures followed by question-and-answer periods for teaching such tasks as servicing the customer, handling suspected shoplifters, and dealing with customer complaints.

ON-THE-JOB TRAINING

In most small stores, the only training that employees receive takes place **on the job**. The owner or manager usually familiarizes the new employee with store policy, such as return privileges, selling techniques, and anything else necessary to perform the job. Some larger stores also use on-the-job training in combination with vestibule, classroom, and other training practices.

VIDEO PRESENTATIONS

Many major retail operations are using individualized video instruction for their managers. For example, Dr. William G. Harris, of Stanton Corp., one of the earliest developers of video programs for instructional purposes, designed and created an instructional video for managers to use in honing their interviewing skills. One of the cassettes features a thirty-minute back-to-basics lesson that reinforces the importance of the initial interview and being prepared beforehand. It focuses on learning to ask the right questions and listen well. Although an instructor can provide such instruction in the typical classroom setting, this format enables users to examine the tape at their convenience and to review it as often as it takes to master the skills.

Video instruction is available that deals with a number of different retailing areas. Those who are concerned with mathematical concepts, that include open-to-buy and markup calculations for example can easily find videos that address such topics. Others concentrate on such areas as retail advertising and promotion, purchase planning, and visits to wholesale markets.

ON-LINE TRAINING

Many merchants are finding that the most efficient and affordable ways to train their staffs is through packaged or customized on-line training. It is especially good for companies with

a network of smaller branches and units in many geographical locations where classroom instruction might be impractical. Human resources departments can access specific programs that will help train their employees no matter where they are.

Among the well-known names in the field of on-line learning are Click2Learn, Plato, Socrates, NetG, Netop, and WebCT. Each offers a wealth of different instruction at different levels and different prices and includes tutorials, testing, and a host of other options that retailers can evaluate and determine which best suits their needs.

By perusing the numerous Web sites that offer instruction on-line, it is a relatively simple task to assess the benefits and pitfalls of each.

CD-ROMS

Many publishers of human resources testing materials provide CD-ROMs along with the written materials. These discs offer a variety of exam questions that can test the users on information they gained from reading the material and provide summaries of the key information from each lesson.

EVALUATING EMPLOYEES

Once the employees have been trained and assigned to specific jobs, they demonstrate their value to the company through their performance. Although each person may receive the same training and opportunity for advancement, not everyone is capable of the same results. Some may be outstanding in their assignments and merit future promotions, others might demonstrate the ability to perform but their current job does not sufficiently satisfy their own personal needs, and still others might show signs of incompetence or an unwillingness to succeed. Each of these situations will eventually need attention from management and result in such actions as promotion to positions of greater authority, transfers to areas that will better suit needs and abilities, and terminations.

To evaluate employee performance in a fair and equitable manner, the human resources departments in the larger retail organizations develop a plan for employee evaluation. Not only does it separate the talented from the unworthy but it also serves other purposes, such as the following:

- It helps the supervisor to evaluate the employee according to certain established criteria, thus ensuring fairness to everyone.
- Salary increases can be awarded based upon the employee's commitment to the company.
- When positions at higher levels become available, those best suited can be easily recognized.
- When employees are evaluated, their strengths and weaknesses can be addressed and productivity improved.
- When employees receive regular, positive feedback about their performances, they are motivated to perform better.
- It helps to determine if the employees present position is appropriate or if they might better serve somewhere else in the organization.

Characteristics of a Productive Evaluation Plan

Whether a company is a small venture with a few employees or one that ranks among the giants in the field, it needs to have a sound plan to evaluate employee performance. In small retail operations such as proprietary specialty stores or boutiques that have less formalized structures, evaluation procedures—if they are used at all—are often haphazardly administered. However, workers in the smallest stores will perform better if they know they are being evaluated. In these retail environments, the carefully developed rating forms and other materials used by the giants are unnecessary. The evaluation procedure should be spelled out at the time of the initial hiring and when it occurs, might include a brief written

evaluation followed by a discussion. If everyone is evaluated in the same manner, the manager will be able to address any problems, award the worthy with salary increases, and terminate those who have failed to perform according to the company's needs.

Larger organizations, because of their size and the many people charged with the evaluation process, must use formal employee evaluation systems. Not only is this a fair way to evaluate performance but in these times where disgruntled employees bring law suits, the company is better prepared to answer the charges.

The process should include the following ideas:

- Carefully structured evaluation forms should focus upon all of the major areas of importance to individual performance. There should also be space for a written summary outlining strengths and weaknesses.
- Evaluations should be taken at specific intervals, never greater than six months.
- The performance should be evaluated by the employee's immediate supervisor with a face-to-face discussion to make the employee aware of areas that need improvement. An effort should be made to discuss the person's positive characteristics as well as those that are negative. At the time of the discussion, the worker should be given time to respond to any negative comments in the report.
- If possible, rewards such as salary increases should be given to the better-performing employees.

METHODS OF COMPENSATION

The majority of people consider compensation as the most important factor when seeking employment. The human resources department is involved in determining which methods of remuneration are most appropriate for the various levels of employment and what the salary range should be for each job title.

There is a vast difference in the earnings potential for people in the lower-level jobs such as selling and those in top management. Not only are the dollar figures different but so are the ways in which they are paid.

Whatever the jobs, certain considerations must be studied before any decisions in terms of remuneration are made. Good plans should consider the following criteria:

- There should be a direct relationship between productivity and salary.
- Jobs that are similar to each other should offer similar salaries. This is not only important in terms of employee fairness but it is a requirement of the Equal Pay Act, which requires equal pay for equal work.
- Additional income potential and promotion are two motivational techniques that could be part of the plan.
- Employees should receive a constant minimum amount of money each week. While this is inherent in straight salary programs, straight commission plans could also be adapted to include regular income guarantees.
- Salaries should be based upon the prevailing wages of the retail industry and adjusted upward to attract the most qualified people.
- All employees should understand the plans. While straight salary arrangements are easy to understand, "quota bonuses" are more complicated and must be carefully described.

Straight Salary

Although some fashion retailers are now moving in different directions, many of their employees are paid a **straight salary**. This plan is simple to understand and guarantees the same salary each week, but it does not provide the necessary incentive to motivate employees to maximize their efforts. This lack of motivation is easy to recognize, especially in sales associates, by the minimum attention they pay to their customers.

Salary Plus Commission

One of the ways of combining a salary guarantee with productivity incentives is to use the **salary plus commission** method of remuneration. Employees receive a set amount based upon the number of hours they worked each week and an additional amount based upon how much merchandise they sold. In these plans, the commission usually ranges from 1 to 5 percent.

Straight Commission

The greatest amount of attention in fashion retailing compensation has focused on **straight commission**. Simply stated, this plan offers the employee the greatest earnings potential because remuneration is based solely on productivity.

The leader in this area has been Nordstrom. The company pays virtually all of its sales associates in this manner and reports that some associates have earnings that reach levels of $100,000 or more. In addition to providing members of its sales staff with the opportunity to earn as much as they are capable of, the company believes that its customers are serviced better than by any other retailer because of this payment plan.

Following the lead of Nordstrom are Bloomingdale's as well as other upscale fashion emporiums. In these stores, employees in the departments that sell the highest-ticket items are paid on the straight commission basis.

While straight commission motivates employees more than any other plan, it does not guarantee uniformity of earnings. That is, one week's commissions might come to $1,000 and the next, $500. To enable employees to budget themselves, most stores offer them a "draw" against future commissions. Employees are given a draw, or a loan, each week and, at the end of the month, the draw is compared with the actual earned commissions. In cases where the commissions are higher than the draw, the employees receive the compensation due them. Where the draw exceeds the commissions, the difference is subtracted from the next month's commissions. In cases where the draw is consistently greater than the actual earned commission, the draw might be adjusted or the ineffective employee might be terminated.

The inability to generate sales is not always the sales associate's fault. During economic downturns, for example, such as the recession that plagued the country during the beginning of the new millennium, retail sales were down. Those on straight commission received smaller paychecks as a result.

Quota Bonus

In the **quota bonus** system, the retailer determines a level of sales it expects from each salesperson. Those who surpass this amount are paid additional monies. Merchants that use this compensation method employ a variety of systems and amounts. Most report that it provides the necessary incentive to improve sales but it eliminates the uncertainties of many employees who are fearful of straight commission selling.

Typically, when the employee achieves the determined amount, one of two methods is used to reward the participants. One provides for a commission on sales that exceed the established quota. If the quota has been set at $2,000 for the week and sales in excess of that amount are commissioned at 5 percent, for example, and the salesperson sells $2,500 worth of merchandise, he or she gets $25 in addition to the preestablished salary. The other method merely awards a dollar amount for reaching the predetermined goal. The goals are set in stages of success. For example, after selling $2,000 worth of merchandise, the employee might be rewarded with $15 for every additional sale of $500. This amount is added to the base salary.

About 20 percent of the fashion retailers are now using quota bonus arrangements.

Salary Plus Bonus

Many retail operations offer bonuses to the management personnel who are responsible for their selling departments but they are not paid commissions or bonuses based upon what they individually sell. These bonuses are usually based upon overall sales in their respective departments. They are generally paid periodically, such as every three months, in addition to the salaries that they receive. The **salary plus bonus** incentive plan is used to reward the managers for their roles in motivating their sales associates to perform at their highest potential.

Other Methods of Compensation

Most of the previously described plans focus on compensation for the sales staff. To provide incentives to those paid on a straight salary arrangement, such as management employees, retailers frequently use a variety of plans, described in the following sections.

PROFIT SHARING

In many major retail operations, all of the management personnel, and in some cases, all of the company's employees, are given the opportunity to share in the company's profits. **Profit sharing** generally fosters company loyalty and discourages employee turnover.

STOCK OPTIONS

Retailers often offer their management teams the option of buying company stock at prices that are lower than those available on the open market. Some companies even provide stock to their managers without cost to them. In times of prosperity, these **stock options** have contributed to employee savings. There is no guarantee about the performance of the stock during recessions.

PRIZE MONEY

In cases where retailers want to encourage the sale of slow-moving merchandise, it is common practice, especially in the smaller specialty and boutique operations, to offer **prize money**, or **PMs** to sales associates. The PM might come in the form of a commission for each of the items sold or a preestablished dollar amount. Sometimes the rewards are in the form of free trips or other incentives instead of cash.

EMPLOYEE BENEFITS

Today, a significant number of job seekers are as concerned with employee benefits as they are with the salary potential of the positions they are applying for. Especially in retailing, where monetary compensation generally ranks below other fields, especially at the entry levels, benefits packages seem to be the answer to attracting qualified candidates for the jobs, and these packages continue to improve.

The human resources department has the responsibility for designing benefits and services packages that will not only compete with those in their own field but in other areas of employment as well.

Health Insurance

Obtaining health insurance is a major problem for most Americans. With the costs ever spiraling upward, more workers are looking for employment that offers some form of medical and dental program. In fact, some candidates take positions with companies solely because they offer such benefits.

Some companies offer numerous programs from which employees might select. The costs range anywhere from plans in which the employer pays all the premiums to those where the employee must pay a share of the premiums. Some cover only the worker, while others are available to the employee's family.

Discounts

Most merchants offer their employees merchandise discounts that range anywhere from 20 percent to 40 percent. In the large retail organizations, the typical discount is at the low end of the scale, small retailers often provide the larger discounts. Small fashion boutiques and specialty stores often encourage their employees to purchase and wear the merchandise that the store sells by offering it at cost. Customers often notice the clothes store employees wear and ask if they are available in the store. This helps to make selling easier and warrants the awarding of such a benefit to employees.

Dining and Recreational Facilities

Many of the giants in the retail industry provide spaces where their workers can relax during breaks and eating facilities that feature low-cost meals. Not only do these provide direct benefits to the employees but they enable the staff members to socialize and relate to each other away from the selling environment. Quite often friendships are established in these dining and recreation areas that help employees to work better with each other.

Pension Plans

One of the means by which companies can reduce the amount of employee turnover is by providing pension plans such as 401Ks. The knowledge that their company offers a pension plan often encourages them to stay with the company. Programs range anywhere from the employer making the entire contribution to those that require contributions from the employer and employee.

In the wake of the Enron and WorldCom scandals, when employees lost most or all of their pensions, most companies have entered into programs that make their pension plans relatively safe from mishandling by top management. Without this attention, employees are likely to seek employment elsewhere.

Tuition Reimbursement

As a means of encouraging their employees to improve their job performance, many merchants provide **tuition reimbursement**. Employees who take courses appropriate to their jobs, are able to do so without any out-of-pocket expense. Some organizations pay according to the grades their employees receive.

Child-Care Facilities

One of the more attractive benefits offered to employees are in-house child-care centers. While the expense is considerable, the centers attract people who would otherwise be unable to work and opens up a large pool of potential employees.

One of the more attractive retail benefits programs is offered by the Target Corporation, profiled in the following Spotlight.

LABOR RELATIONS

Although the human resources department is a part of the management team, it has the responsibility of acting as the liaison between company management and the employees and of working out any difficulties that may arise from disagreements between the two parties. If these problems are not resolved, staff performance could be severely hindered, which could lower company profits. The HR department also has to solve problems that range from minor everyday occurrences such as tardiness to more problematical concerns such as internal theft.

Fashion Retailing Spotlights

TARGET CORPORATION

The benefits package the Target Corporation offers to its employees is considered one of the most complete in the retailing industry.

The plan comprises a host of different aspects that help to attract the best available employees to the company, including the following:

- A 401K plan that includes a dollar-for-dollar match of the first 5 percent of the employee's salary. Stock options are also available that allow workers to own shares in the company.
- A prescription program that enables employees to receive pharmaceuticals at discounted prices.
- Merchandise discounts at all of the divisions of the Target Corporation, no matter which company the employee works for.
- Pretax salary set-aside to help pay for independent care.
- Child-care resource and referral information.
- Guaranteed time off for a sick dependent.
- Maternity leave.
- A variety of insurance programs for automobiles and homeowner policies at discounted rates.
- Discounts for airfare, car rental, hotels and other travel arrangements.

The HR department plays an important role in collective bargaining. Most retail operations have one or more unions representing the company's employees, and the senior vice president in charge of human resources has the responsibility of developing salary and benefits packages for union contracts. This vice president also establishes the means for dispute resolution. Fostering better relationships between management and labor is an extremely sensitive area and those with the best skills are likely to prevent job actions such as slowdowns or strikes.

EMPLOYEE TURNOVER AND PROFITABILITY

One of the more serious problems that plague retailers today is the alarming rate of employee turnover at every level. The rates increase when national unemployment numbers are down, especially at the entry-level positions, because retail salaries are generally less than those offered in other fields. Headhunters or retail recruitment firms are also constantly contacting upper-level employees and enticing them away from their current positions with offers of better salaries or benefits.

Company profitability is affected by the turnover problem, because it is very costly to constantly retrain employees. To adequately train new hirees, retailers need to maintain an in-house training staff or use the services of an off-site company.

Improper training could cause employees at all levels to make costly mistakes that might affect profitability. Sales associates, for example, unfamiliar with the different types of credit plans available for large purchases, could lose these important sales.

Turnover among those with extended company affiliation such as buyers and merchandisers, could result in the store having less negotiation power with vendors for better wholesale prices and terms.

Employee Retention Strategies

Those merchants that value their staffs and understand the importance of retaining them use different strategies to assure some degree of stabilization, such as the following:

- Developing remuneration programs that are competitive with other retail operations.
- Providing fringe benefits, such as health and dental care.
- Utilizing a promotion-from-within program that rewards the most productive employees.
- Recognizing outstanding performance with special luncheons.
- Maintaining day-care centers for parents with preschool children.
- Providing stock options for which the company contributes at least 50 percent of the cost.

TRENDS IN HUMAN RESOURCES MANAGEMENT

Human resources directors and their staffs have entered the new millennium with different approaches to their responsibilities. Included among them are the trends discussed in the following sections.

Posting Positions on the Internet

Many of the Web sites that major retailers use to sell their goods include separate career sections as a means of attracting potential employees. These sections list the available career opportunities along with applications for employment. As more people use the Internet, more job seekers take this route.

Increase in the Use of Part-Time Employees

The increased costs of such expenses as health insurance have paved the way for retailers to use more part-time employees. In particular, sales associates are hired to work on a part-time basis, because retailers are not required to offer them many of the fringe benefits they provide to their full-time staffs. This also gives retailers the opportunity to hire workers solely for the peak hour, and not for the slow periods.

Major Use of Preemployment Investigative Resources

Retailers in increasing numbers are prescreening their job applicants before interviewing them and are hiring investigative agencies to evaluate the backgrounds of potential candidates. Specialists in such areas as drug testing, criminal checks, and driving history, are providing the necessary information before retailers make any formal employment offers.

This can help minimize internal theft as well as the rate of employee turnover.

High-Tech Training Procedures

Instead of or in addition to the traditional employee-training methods, more merchants are using videos, CD-ROMs, and DVDs in their training programs. This can reduce the expenses associated with classroom instruction and other formal techniques. New employees can also reuse the training materials until they have mastered the company's methods.

Innovative Remuneration Methods

Instead of the straight salary approach that many retailers use, many are using motivational pay schemes to get their employees to sell more. This is especially true with sales associates

who are paid hourly rates. By changing to salary plus commission or straight commission formats, retailers have seen an increase in sales. The concept is also being offered to mid-managerial personnel in an effort to make their performances better.

SMALL STORE APPLICATIONS

For the most part, managing a small retail organization is much easier than managing its larger counterparts. In most small boutiques and specialty stores, the owner is usually involved in making decisions such as hiring and awarding salary increases. Owners are directly involved in the day-to-day operations of the business and can immediately learn who is and who is not making the contributions necessary for the company to turn a profit.

Owners of these small companies frequently fail to recognize the need for a system that deals with employee recruitment, training, evaluation, and complaints. The owner might very well be trained in one aspect of the business such as buying but lacks the skills associated with human resources management. To run a more profitable operation, attention to human resources is a must. While these merchants need not develop as formal a program as those found in the larger companies, they should have a plan that embraces all aspects of good human resources practices. Such established procedures help match the appropriate employees to the tasks for which they seem most suited and provide a framework for their future evaluation. Any plan, no matter how large or small, should provide workers with the company policy regarding such matters as discounts, paid vacations, sick day allowances, evaluation procedures, and frequency of salary increases.

Such human resources procedures and practices allow employees to know exactly what is expected of them and how they will be rewarded.

Chapter Highlights

1. Federal guidelines specify that companies must not discriminate in any manner in the hiring of employees and that men and women receive the same pay for the same job.
2. The recruitment process begins with job analysis, from which job specifications are determined and job descriptions are written.
3. Employers have two major sources for fulfilling positions: internal and external.
4. Promotion from within is an excellent concept that generally helps to motivate employees in their job performance.
5. One of the more efficient ways in which to attract new employees to a company is through its Web site.
6. The hiring procedure is more effective when retailers utilize the services of investigative agencies to check the backgrounds of new candidates before they are considered for employment.
7. Except in the recruitment of lower-level employees, most retailers prefer that candidates submit a resume before they call them in for an interview.
8. Employees are tested as part of the hiring process in such areas as personality, drug use, aptitude, and intelligence.
9. Training programs are used by retailers to introduce new employees to the company and to retrain those already in employment in new concepts. These training techniques include role-playing, vestibule training, classroom instruction, video presentations, and on-line training.
10. Periodic employee evaluation is extremely important to the success of the company and should be based upon carefully developed rating forms and other materials.
11. There are numerous methods of employee remuneration that retailers use in paying their staff. The methods that offer such incentives as commissions and bonuses generally motivate better performance.
12. Health insurance programs have become one of the more important aspects of employee benefits. In many cases, employees consider them to be more important than the salaries offered.
13. The human resources department has the responsibility of acting as liaison between management and labor so that difficulties can be effectively resolved without causing unrest between the two groups.

Terms of the Trade

Equal Pay Act
Civil Rights Act
job analysis
job specifications
job description
internal sources of recruitment
external sources of recruitment
promotion from within
open ads
blind ads
executive search firm
headhunter
shadowing programs
walk-ins
networking
resume
preliminary interview
rail interview
aptitude tests
final interview
executive training programs
retraining
role-playing
vestibule training
on-the-job training
on-line training
straight salary
salary plus commission
straight commission
quota bonuses
salary plus bonus
profit sharing
stock options
prize money (PM)
tuition reimbursement

For Discussion

1. What form of protection does the Civil Rights Act provide employees?
2. In new retail operations, what type of study is undertaken before any hiring plan is put in place?
3. Why are internal recruitment sources so important to the running of a retail operation?
4. If a retail operation utilizes a system of internal sources in its recruitment plans, why is it necessary to also use external sources?
5. Why is promotion from within such an important consideration in retailing?
6. What is the difference between a blind and an open ad?
7. How do headhunters assist merchants in their pursuit of excellent candidates for their jobs?
8. In what way has the Internet served retailers in their quest for new employees?
9. Why do walk-ins often become the most productive employees?
10. How does industry networking help retailers procure some of their best workers?
11. Why are investigative agencies becoming so important in the hiring procedure?
12. How does the rail interview differ from the final interview?
13. What types of testing are most retailers using in their hiring practices?
14. Why does on-the-job training sometimes become problematical for retailers?
15. In what way can role-playing help to improve the abilities of the newly hired employee?

16. What is vestibule training?
17. Why are more merchants using on-line training for new employees instead of the traditional methodologies?
18. Is it important for a retail operation to utilize a specified employee evaluation plan? Why?
19. Why do many retailers offer commissions in addition to guaranteed salaries to their employees?
20. What has become the most important employee benefit in most retail operations?

CASE PROBLEM 1

Until the last two years, Pendleton's, Inc., a high-fashion specialty department store, had little trouble in recruiting people to work for the company. Today, however, it is finding difficulty in attracting talented people to fill positions at most levels. It has remained competitive with the other companies in their trading areas in terms of salaries and benefits, but it seems to be suffering from retailing's image of long hours and low entry-level wages.

The human resources department has indicated to top management that one of the problems is related to higher salary scales in other industries, which have attracted potential managers as well as lower-level personnel. The better wages coupled with more compact work schedules offered by Pendleton's competitors has left the organization with personnel shortages in many areas. The obvious solution is to raise salaries to levels that would be competitive to other types of businesses. The company's chief financial officer, however, maintains that considerable monetary increases would cause serious harm to the company and would make it less profitable.

With their inability to offer higher wages, the next approach was to explore the company's current recruitment practices and employee benefits. The human resources department reported that it relied heavily on colleges and universities for its future managers and on a combination of classified ads and walk-ins for filling its lower-level positions. It also reviewed the fringe benefits the company offered, which included health insurance, reduced-cost meal plans, paid vacations, employee discounts, and recreation facilities, and assessed them to be comparable to other major retailers in the area.

At this time, Pendleton's still has not been able to correct its employment problem.

Questions

1. What other sources of human resources supply could the company use to recruit executive trainees and employees for lower-level positions?
2. Are there groups that the company might have considered to fill its needs?
3. What other benefits might help to attract greater numbers to the company?

CASE PROBLEM 2

Like most other fashion retailers, Calvert's, Inc. does more than 40 percent of the year's business during the Christmas selling period. Throughout the year, the company has well-trained sales associates who cater to the needs of its clientele. With an inventory steeped in upscale merchandise at very high price points, servicing the customer is of great importance.

Calvert's business—except for the Christmas rush, which begins the day after Thanksgiving and ends Christmas Eve—is unlike that of most traditional companies. The number of daily sales is not high, but the amount of each is significant. Companies such as Calvert's that stock such expensive merchandise have a small customer market from which to draw, but those who do patronize the company spend considerable sums.

To guarantee the best possible customer service, the human resources department spends considerable time and effort in training its sales associates. Before anyone is sent to the selling floor, he or she receives a great deal of attention. Training includes extensive classroom lectures as well as role-playing, where new employees participate in simulated sales presentations. Cou-

pling this training with high rates of commission has contributed to the company's ability to attract qualified employees.

The problem that Calvert's must deal with each year surfaces at Christmas time. During this period, the store is transformed into a different environment. Many more shoppers enter the store in search of Christmas gifts in addition to satisfing their own personal needs. To accommodate these large numbers, the store must recruit additional sales personnel. Those available are generally untrained and unfamiliar with the Calvert's customer service philosophy. With little time for traditional training, the company has not been able to staff the selling floor with competent people. With fewer and fewer people willing to work for such a brief period, Calvert's is finding it difficult to be selective. With such limitations, it has not been able to satisfactorily train the new employees to meet the needs of the company.

Questions

1. What training techniques might the company employ to deal with this group of sales associates?
2. Describe why such techniques are better for these circumstances than those traditionally used.

EXERCISES AND PROJECTS

1. Log on to the Web sites of five fashion-oriented retailers to learn about employment possibilities. Make a list of the available job titles, salaries (if provided), experience requirements, and instructions of how to apply for the position.
2. Prepare an application form that would meet the standards allowed by the government. These forms are available on Web sites.
3. Write a list of twenty questions that might be asked during a job interview for a particular retail position. As a role-playing technique performed in front of the class, select a partner and pretend that he or she is applying for this position, using all twenty questions.

CHAPTER 10

Merchandise Distribution and Loss Prevention

After reading this chapter, you should be able to discuss:

- The methods used by retailers to handle their merchandise.
- Some of the current technology used in merchandise handling between retailers of all classifications and their suppliers.
- Centralized and regional receiving installations.
- Quantity and quality checking systems.
- Marking and remarking merchandise procedures.
- Shoplifting and how it affects the retailer's bottom line.
- Deterrents to shoplifting.
- The problem of internal theft and how it can be minimized.
- How Internet theft is being addressed by the industry.

Merchandise acquisition is one of the most important parts of the retailer's operation, so it is vital that it is received, handled, and secured in an efficient manner. Buyers select their products and arrange for them to be shipped to the brick-and-mortar operations, catalog companies, and Internet merchants.

Retailers must have systems in place to handle the incoming merchandise that include a variety of receiving and marking procedures. Receiving records must be established, equipment must efficiently handle and disperse the goods, quantities must be checked to make certain that they are in line with the amounts indicated on the purchase orders and invoices, quality assurance must be addressed, and merchandise must be marked to indicate prices, sizes, and any other pertinent information that will be needed for inventory tracking and future purchase planning.

Today's retailers have a significant edge over their predecessors because they have a wealth of technology that enables them to perform their merchandise handling responsibilities more quickly and efficiently. Such programs as electronic data interchange (EDI), quick response (QR), and vendor managed inventory (VMI), have made the routines associated with inventory handling faster and more accurate than ever before.

Once the merchandise arrives at its retail destination, whether it is on the selling floor, a centralized or regional warehouse being readied for shipment to these selling floors, or in an off-site merchant's facility such as those utilized by catalog companies and E-tailers, it must be properly secured to reduce the losses due to shoplifting and employee theft. Shoplifting resulted in losses of more than $26 billion in 2002 and employee theft at more than $15 billion for the same period, so retailers face a significant task in safeguarding their inventories from those who work for them as well as from those who pose as shoppers. These two groups, coupled with vendors that cheat their retail customers, as well as theft by those that ship the merchandise to the retailers account for significant losses that seriously affect the retailers' bottom lines.

In an attempt to offset these staggering losses, merchants continuously focus on new loss prevention technology. The use of shoplifting deterrents, such as video surveillance

Inventory shortages are often due to theft at the vendor's premises.
(Courtesy Ellen Diamond)

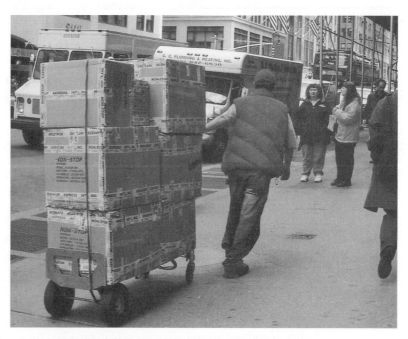

Shippers have been responsible for theft of merchandise in significant amounts.
(Courtesy Ellen Diamond)

systems, electronic surveillance systems (EAS), careful applicant screening, and a host of other methodologies help to reduce the problem. There are still, however, a great deal of losses that lead to reduced profits. Few customers realize that they are actually paying for some of the losses caused by dishonest shoppers because retailers adjust their prices upward to regain the lost profits due to shoplifting and other types of internal theft.

The proper handling of merchandising and its security is thus a prime responsibility of company management. While it is unlikely that the entire problem will disappear, attention to the latest innovations will more than likely help to reduce it.

MERCHANDISE DISTRIBUTION

Brick-and-mortar operations, regardless of size; catalogers; E-tailers, and home shopping outlets must all establish a system that assures they will receive merchandise as stated on the invoice and that will be delivered to their warehouses and selling floors in a timely manner.

Retailers must determine the way their incoming merchandise is handled, the manner in which the goods are scrutinized, how they are marked, and the ways in which they are moved to their final destinations before they can sell a single item.

By investing enormous sums in new technology, merchants are not only guaranteeing their merchandise's safe arrival at their destination points—the selling floors of brick-and-mortar operations and the warehouse of the off-site operations—but they are also benefiting from the potential for greater company profits.

In-House Receiving

The methodology and techniques used for **merchandise distribution** from the vendors to the retailer's premises generally depends upon the size of the retailer. Small operations with few outlets, such as boutiques and independently owned specialty stores, generally have new orders sent directly to the units; this is called **in-house receiving**. Some major retailers also subscribe to this arrangement, such as OshKosh B'Gosh. They believe that by using such a receiving system, the merchandise gets to the selling floor faster than it does if it made an intermediary stop at a centralized warehouse. By using a barcode system that is affixed to the outside of the delivered cartons, the units in the chain are able to determine the contents and learn if it is the same as what was listed on the purchase orders.

CENTRALIZED RECEIVING

Many of the larger department stores and specialty organizations, catalog operations, E-tailing ventures, and home shopping outlets receive their goods at a centralized location in which all of the products go through a receiving procedure before they are sent to their final destinations. Often times, in the cases of the off-site retail operations, the receiving department is within the headquarters of the company, and the goods remain there until they are ordered by the customers.

There are several reasons why **centralized receiving** is the choice of the vast majority of large retail organizations. These include the following:

• *More space for merchandise on the selling floor.* In brick-and-mortar operations specifically, space has become so prohibitively expensive that the more that can be used for selling, the more likely the store will have larger profits. While each of the units in a large organization must still set room aside for receiving incoming goods, fewer units are involved in marking the merchandise. Space in warehouse facilities used in the receiving process is also costly, but it is considerably less expensive than store-leasing costs.

• *Better control of goods.* Retailers using centralized locations are more likely to spend on the latest technology to track their incoming merchandise. By using a variety of programs such as electronic data interchange and vendor managed inventory, the goods are carefully tracked and recorded before they make their way to the selling arenas. In contrast with store managers, who are often in charge of single-store receiving and have other duties and responsibilities to perform, those in charge of centralized receiving facilities only have to concentrate on this one role. The end result is usually a more efficient way in which to carefully handle the goods from the receiving platform to their final destinations.

• *Cost reduction.* The monies needed to invest in the latest receiving technology is extremely high so it is often impossible to install them in each of the chain organization's numerous outlets. By using the centralized approach, large retailers can put in place the latest and most efficient systems that will not only better serve the needs of the entire organization but also do it more economically.

REGIONAL RECEIVING

When a brick-and-mortar operation has a large number of units dispersed throughout a range of geographical locations, most opt for **regional receiving** departments. Instead of having a centralized facility to handle the goods for every store in the chain, regional offices cover one region. The advantage of this system is that merchandise reaches the selling floors in less time than if it came from centralized points. A company with units throughout the United States, for example, that subscribes to this decentralized arrangement will more than likely get the goods to the stores in the different regions more quickly than if they were all shipped from a centralized location that was far away from many of the regions.

The receipt of goods in a timely manner is particularly important to the fashion retailer. With fashion cycles playing such a significant role in its merchandising endeavors, every day that is saved in shipping gives the retailer more time to sell the items.

INDIVIDUAL STORE RECEIVING

In the case of individual proprietorships, where just one or a few units are involved in the receiving procedure, there is little choice but to have each unit process its own incoming merchandise.

Goods are usually delivered to the front door of the store, then opened, checked, tagged, and made ready for the selling floor directly within the selling space. In some stores, small back rooms are available to handle the incoming merchandise. The latter choice is a better one, since it does not interfere with the activities taking place on the selling floor.

Since the people responsible for the unpacking, sorting, and making merchandise ready for inclusion onto the racks and counters are responsible for other chores, the cartons are often left unattended until they have time to attend to them.

Merchandise Distribution Technology

Unlike the retailers of the past, who manually handled the tasks associated with the receiving and marking of merchandise from vendors, today's merchants have the benefit of technological advances to perform these steps. In fact, the vast majority of major retailers utilize technology to interface with their suppliers. Most important among the retailer-vendor innovations are **electronic data interchange (EDI)**, and **vendor managed inventory (VMI)**.

EDI is a computer-to-computer exchange of data organized in a format specified by retailers and vendors. There isn't any human involvement at either end of the transactions. Inherent in the benefits of the system are better inventory management, reduced expenses, improved accuracy, better business relationships, increased sales, and a minimization of paperwork.

Retailers of all classifications use the EDI system. It is especially attractive to fashion retailers, because the increased speed of transactions can extend the life of the product on the selling floor, in catalogs, in E-tail outlets, and on home shopping operations. Where time is of the essence in retail transactions, no other system can place a company in a better market position. Thus, the tasks of placing purchase orders, preparing invoices, and shipping are performed at record speed, saving time and money for the merchant.

VMI involves the use of scanners at the retail operations, by which suppliers are able to gather information about the sale of their products and replenish inventories with a time lag. It places the onus on the vendors to make certain that their retail customers' inventories are stocked as needed.

These technologies, collectively known as **quick response inventory systems (QR)**, are the keys to better merchandise management controls, resulting in more profitable situations for their users.

Nonprofit Supply Chain Involvement

Several nonprofit groups have been organized to improve the retail industry's merchandise supply chain: the Collaborative Planning, Forecasting, and Replenishment Committee (CPFR), and the Voluntary Interindustry Commerce Standards Association (VICS). Each of-

fers recommendations and guidelines for retailers and vendors to follow so that their merchandise delivery will be most efficient.

VICS is the focus of the following Spotlight.

Fashion Retailing Spotlights

VICS

The Voluntary Interindustry Commerce Standards Association was formed in 1986 to take a leadership role in the identification, development, and implementation of industry standards, protocols, and guidelines that simplify the flow of merchandise and information for retailers and vendors.

The organization is composed of senior executives who have shown in their own companies that the timely and accurate flow of product and information has improved their competitive situation. They provide the contacts necessary to implement quick response partnerships in technologies such as EDI. VICS publishes a newsletter that addresses the current problems associated with product flow.

There are two types of memberships: sponsoring members and associate members. In the former group are such fashion merchants as Dillard's; Donna Karan International; Gap, Inc.; JCPenney Co., Inc.; Liz Claiborne, Inc.; Neiman Marcus; Saks, Inc.; and Target Corporation. Associate members include such technology giants as Dell Computer Corp.; consulting groups such as Supply Chain Consultants, Inc., and Kurt Salmon Associates; and companies that supply retailers with loss prevention systems such as Sensormatic Electronics Corp. Also members are trade associations that are either retail oriented or that interface with retailers, including the National Retail Federation, the International Mass Retailers Association, and the American Apparel and Footwear Association.

Sponsoring members pay a one-time fee of $5,000 and annual dues of $2,000, and associate members pay $10,000 plus $2,000 annual dues. Trade associations pay an initial fee of $1,000, plus $2,000 in annual dues.

Receiving Equipment

After the merchandise has been delivered to the receiving platform or loading dock and has been checked to make certain that the shipment includes all of the cartons or racks indicated on the receiving invoice, it is transferred to the marking area.

In most major retail operations, outside sources such as shipping companies or the vendors from whom the retailers purchase their goods mark the merchandise. The merchandise tags are prepared by the retailers or by the outside sources that use the information provided by the retailer. When manufacturers do the actual tagging, they often also place the garments on hangars, which saves time once the goods reach the retailer's premises.

Whether the merchandise has been tagged or not, discrepancies sometimes occur at this point. Vendors may make unintentional errors when preparing their shipping records that, if undetected, will result in the retailer paying for merchandise that was not received. A great deal of pilferage takes place during the shipping procedure, and unsuspecting merchants may fall victim to such crimes. In any case, retailers need to detect the discrepancies at this point to correct the flawed invoices.

Once the receiving process has been completed, the merchandise moves from the platform to places where closed cartons are opened, unmarked merchandise may be ticketed, and any other product handling procedures can be completed.

The equipment that is used in the movement of the goods includes packaged merchandise transporters, stationary tables, and conveyors.

PACKAGED MERCHANDISE TRANSPORTERS

There are several types of **packaged merchandise transporters** that move merchandise through the receiving process. Some are open, in which the goods can be seen, and others are closed, for maximum security merchandise such as precious jewelry. They all move on swiveling casters that maneuver easily around the selling floor aisles and narrow lanes of distribution centers. One of the larger manufacturers of such transporters is Jesse J. Heap and Son, Inc.; its Web site, **www.jesseheap.com,** provides more information.

STATIONARY TABLES

In many retail organization's **stationary tables** are used for all of the receiving operations. The cartons are opened on the tables, checked to see if the merchandise quantities agree with those shown on the packing slips, quality assessed to make certain that they meet the company's standards, and marked if they haven't been done so at an outside source.

CONVEYOR SYSTEMS

Most larger retailers have installed **conveyor systems** that move incoming goods from one handling stage to another and ultimately take them to a place in the warehouse or on the selling floor. The systems that fashion merchants use are either roller conveyors that move cartons containing flat packed items or trolley conveyors that move merchandise on hangers. In central operations, once the goods have been processed and are ready for shipment to the brick-and-mortar operations, they are placed in the merchandise transporters and taken to their final destinations.

Merchandise Checking Procedures

The actual checking of the incoming merchandise is both quantitative and qualitative. Merchants must carefully verify that the number of items they are being charged for is the exact number inscribed on the packing slip or invoice. Quality is also an important part of the process since vendors sometimes substitute lesser-quality goods for the ones they featured in the samples the retailers used to order by. It is commonplace for a manufacturer to substitute different fabrics or less-desirable trimmings.

QUANTITY CHECKING

When checking incoming merchandise it is important to do more than count the number of cartons, because there is the possibility that the contents will not match the invoice. Thus, there are different **quantity-checking** systems, such as the following:

- *Direct checks.* In this check, which is most commonly used by retailers, the checker uses the invoice or packing slip to verify amounts and compares the actual contents to the size, color, and price specifications entered on the purchase orders. Checkers physically count merchandise, and make any adjustments at this point. **Direct checking** is the fastest technique but it also has one distinct disadvantage: dishonest employees might verify the contents without actually making the physical count. Once checkers have signed off on the invoice, the company has no recourse if shortages are later discovered.

- *Blind checks.* This method is the opposite of the direct check. Merchandise checkers must prepare a list of the items that are in the packages without utilizing any invoices that accompany the packages. With the **blind check method**, the checker must account for each item. While the system is somewhat slower than the direct check, it eliminates the potential for cheating.

- *Semiblind checks.* The **semiblind check method** combines the best features of the other two. Checkers are provided with a list of the items without the quantities. Thus, they must count the items to verify the actual contents against those indicated on the invoice.

QUALITY CHECKING

More retailers are using quality controllers to inspect incoming goods and to make certain that they are exactly what has been ordered. Too often, vendors use **substitution shipping**; instead of shipping exactly what has been ordered, they substitute other products, colors, and sizes. Sometimes manufacturers run out of particular products and ship replacements in the hope that their inclusion will go undiscovered. Vendors might include items of different colors because the color on the purchase order was out of stock. Different sizes are substituted because those selected by the buyer are unavailable.

In small fashion-retailing operations, buyers are generally present to evaluate the quality of the incoming merchandise, and they do the examination. No one knows better than the

buyer what the actual samples looked like at the time of the purchase or is more capable of comparing the items received against what was ordered. If the new goods aren't carefully scrutinized, retailers could end up with merchandise that is less than desirable, and therefore is difficult to sell.

After the goods have been inspected and any discrepancies are noted, they are sent to the marking area unless they have been marked by an outside source.

Marking Merchandise

Individual items must be marked for a number of reasons, such as the following:

- Some states require that all merchandise be individually marked with tags that feature the price to eliminate the possibility of charging different prices for different customers.
- Merchandise tags that feature such pertinent information as price and size are particularly beneficial to retailers such as Target and Wal-Mart, and off-pricers such as T.J. Maxx and Burlington Coat Factory that rely upon customers to make their own choices without the assistance of sales associates.
- Shoppers are able to quickly assess the prices and determine if the merchandise is in their price range.
- By placing information such as vendor name (usually in some coded form), style number, color, merchandise classification, size, and price on the tags, the retailer has enough data to evaluate the customer's response to the merchandise in a variety of ways. This is especially important to fashion merchants who must continuously analyze their inventories so as to make future purchases that will maintain customer satisfaction.
- The proper information on the tags allows merchants to use EDI and VMI systems to automatically adjust inventory levels of the items in stock.
- The tags allow merchants to evaluate stock turnover, open-to-buy, and other merchandise inventory requirements, each of which will be discussed fully in Chapter 14, "Inventory Pricing."

Merchandise tags provide a variety of information for the shopper as well as the retailer, who uses it for inventory purposes.
(Courtesy Checkpoint Systems, Inc.)

Computer-generated tags help merchants keep track of inventory information.
(Courtesy Checkpoint Systems, Inc.)

MARKING PROCEDURES

Fashion retailers use different systems to mark their goods, ranging from hand tagging, which is used in small stores such as boutiques, to the automated systems used in chain organizations, department stores, catalog companies, E-tailers, and home-shopping organizations.

* *Hand marking.* Although the vast majority of retailers around the world use some automated or handheld device to mark their merchandise, some small merchants still **hand mark** information on the price tags. It cannot be computer read, so if the retailer uses an inventory system to track sold items, someone must update by hand the information on the tags.

* *Handheld equipment.* A variety of handheld equipment is available that allows such information as price, color, size, merchandise classification, vendor name, and a host of inventory control information to be scanned into the company's computers. Each company can tailor its tagging requirements to the needs of its inventory system.

* *Computerized tags.* Many companies use **computer-generated tags** that have **bar codes**, which encode data that can be optically read and produce machine-readable symbols that can be converted to computer-compatible digital data. There are about 225 different bar code languages, each with its own capabilities, but only a handful are in current use. The encoding ranges from 128 to 256 characters. The use of bar codes dates back to the early 1950s and has accelerated the flow of merchandise and information throughout the retail community.

Paxar, an international leader in labeling systems, is the focus of the following Spotlight.

Fashion Retailing Spotlights

PAXAR

Since 1928, Paxar has been designing, building, and implementing labeling systems for major retailers that include JC Penney, Kohl's, Target, Eddie Bauer, and Victoria's Secret. Its technology enables it to track merchandise that retailers have manufactured for themselves from the production point to the consumption point. With a globally based operation, it is able to deliver labels to any location worldwide. The company employs 6,000 workers in over 75 countries.

One of its subsidiaries is Monarch Marking Systems, which has been in business since 1890, supplying marking systems for such fashion retailers as Brooks Brothers, Talbots, Gap, Nordstrom, and Saks Fifth Avenue. Monarch customizes its tags in a manner that offers 100 percent scannability, thus eliminating the time needed for rescanning

and relabeling. A staff of chemists, with over 120 years of combined experience, carefully selects the perfect combination of adhesives, paper, and ribbon to meet the most demanding retail applications. Unlike most label manufacturers, the company does not outsource its service to third parties.

Paxar's in-store printing systems are the answer to many retailers' needs. They include bar code printers that can be quickly adjusted to reflect price changes and help move the ticketed merchandise through the checkout counters as quickly and accurately as possible. The bar code printers can be taken to the sales floor, thus eliminating the need to remove merchandise to stockrooms to be remarked. It can then be available to be sold.

The wealth of labeling and tagging products that Paxar offers to the retail industry is described on its Web site, **www.paxar.com**.

REMARKING MERCHANDISE

In today's competitive fashion retail environment, there are a number of reasons that merchants must reduce prices for in-stock merchandise. These include the following:

- Styles are out of season.
- Only a few pieces in a particular style remain in the inventory.
- Buyers purchased merchandise that didn't sell as well as had been anticipated.
- Colors were selected that customers didn't like.
- Only a few sizes remain of certain styles.

To dispose of this unwanted merchandise and make room for new items, merchants take markdowns and indicate them on the price tags by handmarking the new price directly on the tag in a different color from the original price or using handheld machines to enter the new price.

LOSS PREVENTION

Retailers all over the globe are victim to losses attributed to shoplifting, internal theft, vendor theft, and Internet fraud. No matter how carefully they try to protect their inventories, the **shrinkage** numbers continue to climb. Retailers are combining older systems with new technology to attempt to reduce their losses.

Because they are so vulnerable to theft, fashion merchants implement measures ranging from stationing uniformed guards at store entrances to installing vast security measures that include electronic article surveillance systems. It is not only shoplifters but company employees who regularly help themselves to goods without paying for them. Whether they are on the selling floor or working somewhere in the supply chain such as warehouses, employees are often in positions to take merchandise. Vendors, to a lesser degree, are also culprits in the shortage scheme, accounting for about 1 percent of the shortages. The increased use of the Internet as a selling tool has also resulted in fraud that costs retailers.

The following sections address each of these groups in terms of the losses they account for and the ways in which the retail industry is acting to control their theft.

Shoplifting

Simply stated, shoplifters are people who enter brick-and-mortar establishments for the purpose of stealing merchandise rather than paying for it. While many think it is easy to recognize potential shoplifters, this is far from the truth. People from all walks of life have been apprehended, including members of the clergy, those in the upper socioeconomic groups, celebrities such as movie stars, drug addicts, and those with mental problems. Their dress and demeanor are generally indistinguishable from that of the legitimate shopper, making them harder to detect.

The average **shoplifting** loss in the United States in 2002 was $207.18 per incident, a significant increase over the previous year's average of $195.73 per incident. European retailers are also plagued by shoplifting; the Centre for Retail Research in its European Retail Theft Barometer indicated losses in 2002 of 3.2 billion Euros.

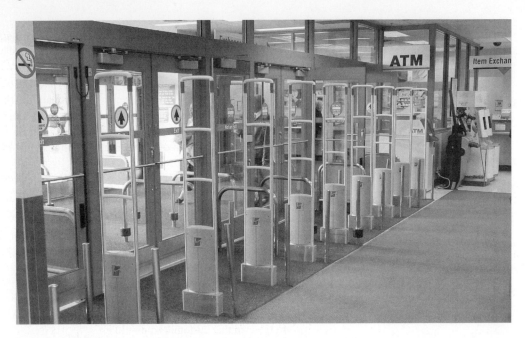

Shoplifting is generally reduced when alarm systems are used at store entrances.
(Courtesy Checkpoint Systems, Inc.)

The costs of illegally taken merchandise continue to affect retailers' **bottom line**. To meet the challenges of these thefts, merchants spend enormous sums to protect their inventories, resulting in higher prices for the honest customers who pay for the products they want. Thus, if a retailer's shoplifting losses are 3 percent of sales, prices are often adjusted upward to regain the 3 percent loss.

One of the reasons for this problem is that many merchants have reduced the number of people on the selling floor. While the likes of Nordstrom and Saks Fifth Avenue and other service-oriented merchants have maintained their level of sales associates, the value organizations such as discounters Target and Wal-Mart and off-pricers such as Marshall's have just a skeleton staff in their stores to assist shoppers. The former group has numerous "eyes" to watch the goods and report potential problems, but the latter group hasn't the in-store people power to do the same. However, no matter how many employees are on duty, the experienced shoplifter has the know-how to steal.

DETERRENTS AND CONTROLS

Retailers employ a wealth of deterrents and controls to address the problems of shoplifting. These include the following:

Electronic Article Surveillance Systems (EAS). With shoplifting in America accounting for almost half of their retail shrinkage, the vast majority of large retail enterprises utilize one of the many EAS systems. Any one system automatically protects the merchandise from theft. Commonly referred to as the **tag-and-alarm systems**, industry experts say that they are the most effective antishoplifting tools available today. EAS identifies merchandise as it passes through a gated area at the store's entrances. Each piece of merchandise is tagged with a hard reusable tag or a paper tag that is not used again. Sales associates deactivate the item by swiping it over a pad or scanning device. If a tagged item has not been deactivated and a customer attempts to take the item through these portals, an alarm sounds, alerting the store personnel.

The most widely used EAS systems are the **radio frequency (RF) systems**. In this system, a label that is basically a miniature disposable electronic unit and antenna is attached to a product and responds to a specific frequency emitted by the transmitter antenna. The response from the label is then picked up by an adjacent receiver antenna in one of the gates at

If shoppers pass through store portals with tagged items that have not been deactivated, the EAS system sounds an alarm.
(Courtesy Checkpoint Systems, Inc.)

the store's exit. This processes the label response signal and will trigger an alarm when it matches specific criteria. When a package that meets this criteria moves through the gates, the alarm rings, indicating that there is an illegal removal of goods from the store's premises.

Electromagnetic (EM) Systems. Many retail chains throughout Europe use the **EM system.** This technology uses magnetic, iron-containing strips with adhesive layers that are attached to the merchandise. Unlike the tags in the EAS system, which are removed once the customer pays for the merchandise, the strip is not removed at the checkout counter but is deactivated by a scanner. An advantage of this system is that the strip can be reactivated if the merchandise is returned.

Acousto-Magnetic System. This is the newest entry in antishoplifting systems. Stores that use RF systems require the labeled transmitters in the items and the receivers in the gates to be about eight feet apart. Retailers with wide entrances prefer the **acousto-magnetic system.** The tags and labels used in the acousto-magnetic system are detected in wide areas, so this doesn't require stores to have narrow-gated entrances. The acousto-magnetic system also responds extremely well with metal shopping carts, unlike other systems that don't work with metal objects.

One of the world's largest producers of antishoplifting devices is Sensormatic, the subject of the following Spotlight.

Video Surveillance Systems (CCTV). Closed circuit television systems enable security personnel to monitor store activity as it is taking place. In the newest, more sophisticated systems, retailers are able to monitor several stores in their organization, as well as distribution centers, from a single location. These remote **video surveillance systems** allow retailers to transmit full-frame image streams over high-speed phone lines to a variety of locations and to electronically store digital video images for review or evidence. Although the video cameras were once easily visible, today's offerings are harder to spot. They can be mounted in smoke detectors, sprinkler heads, thermostats, and clocks, making them virtually invisible to the shoplifter who might attempt to stay out of their view.

Fashion Retailing Spotlights

SENSORMATIC

Sensormatic's electronic surveillance systems are in use in stores all across the globe. A division of Tyco Fire and Security, the company designs and manufacturers the most advanced lines of fully integrated EAS systems. Its customers include a majority of the top one hundred retailers around the world.

Because deterring shoplifting is a top priority for retailers, Sensormatic continuously finds ways to meet industry requirements and expectations. Beginning with the introduction of the EAS systems, the company has regularly provided a variety of innovative devices to meet the needs of its customers, including the reusable hard, plastic tags, known as **alligators**, that are attached to most apparel with a locking mechanism that requires a special detacher for their removal, and fluid tags, also known as **inktags**. If removed without using the proper tool, these ingenious tags are designed to break, releasing indelible inks that will ruin the garment. Even if the item has been successfully removed from the store's premises, the tag affixed to it is impossible to detach at home without causing irreparable damage.

In keeping up with its innovative designs, in 2002 Sensormatic introduced the **Alarming Supertag**. Unlike systems that sound an alarm at store exits, this invention emits a loud beeping sound whenever a shoplifter tries to remove the tag from the merchandise while still in the store, immediately alerting personnel to the attempted theft. Even in hard-to-see places, such as behind large displays or in changing rooms, the special alarm sounds. Additionally, the new system can be easily connected to the store's video surveillance cameras, enabling visual confirmation and recording for evidence when an alarm is triggered.

Besides providing large retail organizations with antitheft systems, Sensormatic has produced antishoplifting solutions for smaller retailers. The AssetPro system consists of antitheft tag detector pedestals placed at retail entryways that work with a variety of Sensormatic-brand hard tags and labels at a cost more affordable for smaller merchants.

Merchandise Anchoring. Locking things up is one way to secure expensive merchandise. High-ticket items such as leather apparel are secured by means of cables and wire products. These locking devices will more than likely prevent shoplifting, but they will also make it difficult for customers to try on the garments. Because clerks must open the locks, **merchandise anchoring** is a time-consuming process that may discourage shoppers in a hurry from availing themselves of the merchandise.

Magnifying Mirrors. Many smaller merchants without the budgets necessary to install sophisticated surveillance systems turn to **magnifying mirrors** to alert them to would-be shoplifters. By strategically placing these mirrors, clerks can spot the shoplifters in action. Although the system might not enable store personnel to see all of the shoplifting attempts, their existence sometimes deters shoppers from attempting to steal.

Try-on Room Control. A number of different controls are put in place to deter shoplifting in the fitting rooms. One method posts an employee at the try-on room entrances to count the items and give shoppers a number to coincide with number of items they taken into the room. When shoppers exit, the employee counts the number of items they have to make certain that they have the same number and have not concealed any on their bodies. Of course, experienced shoplifters often exchange one of the items they brought to the fitting room with one that they wore into the store. Another system requires that each try-on room be locked and not opened until the clerk counts the number of items the shopper has taken inside. Again, it is difficult to prevent the shoplifter from exchanging a new item for one worn into the room. Companies such as Banana Republic use this control access system in their stores.

Employee Programs. There are numerous programs that motivate the retailer's staff to assist in the reduction of shoplifting. These include incentive awards that reward employees with special merchandise discounts if they alert security officers of potential crimes, workshops that alert sales associates and floor managers of the magnitude of the problem and their roles in assisting the security staff in apprehending the perpetrators, and bulletin board announcements of congratulatory notes to employees who have assisted in foiling shoplifting attempts.

Internal Theft

The problem of employees stealing from their companies is often greater than that of shoplifting. **Internal theft** is running rampant in the United States and abroad. Although security devices have deterred the illegal removal of merchandise from the store by shoppers, the same devices are less successful in stopping those employed by the company for a variety of reasons including employee awareness of the systems in place, employee relationships with security guards, unsupervised spaces such as workrooms where employees are often left alone, and the company's lax prosecution of offenders.

There are many ways employees steal from their companies. Not only do they take merchandise from the store but they also engage in ticket-switching, ringing up sales at lower prices for their acquaintances, not charging for all the items in a purchase, and extending greater discounts than allowed.

Internal theft is not limited to brick-and-mortar facilities. Catalog retailers are facing problems with the loss of merchandise in their warehouse, in which significant amounts of goods are stocked and made ready to be shipped to online mail, and telephone order customers. These premises are often not as carefully scrutinized as are the store operations, because shoppers do not have access to them. Unless retailers establish stringent rules and precautionary measures, merchandise losses can run extremely high.

Each of these unethical practices affects the retailer's bottom line. While total elimination of internal theft is unlikely, there are numerous ways in which it can be curtailed, as discussed in the following sections.

DETERRENTS

Merchants use a variety of tools, such as the screening of applicant's reference checks, drug testing, testing, rewards programs' and the timely prosecution of offenders (see Chapter 9, "Human Resources Management").

Screening of Applicants. The best time to weed out potential risks is when a candidate completes an application for employment. Whether the person completed the form in a company's human resources department, at an in-store computerized kiosk, or on-line, it is essential that every word be carefully scrutinized to alert the employment manager of possible areas of concern. Especially at peak selling periods such as the Christmas holiday seasons, when a host of part-time sales associates are brought on board for short periods of time, management is often more concerned with getting the necessary number of bodies on the selling floor than with examining the information on the form. Details such as a large number of positions held in a short time frame or the listing of companies that are no longer in business should serve as red flags for human resources personnel.

Many retailers are using the services of outside agencies to assist them with applicant screening. Companies such as **www.efindoutthetruth.com** run background checks for as little as $19.95 for local searches to $49.95 for nationwide investigations. In twenty-four hours or less, the merchant is able to determine whether or not job applicants are worthy of further consideration.

Many potential job candidates, especially those seeking mid-management to upper-management positions, offer resumes of their educational and professional backgrounds. These too must be diligently checked to eliminate those people without the proper credentials from further consideration. This screening process is essential, since further evaluation of the candidates is time consuming and costly.

Checking References. The value of references depends upon the candidate's previous employers' willingness to cooperate. Some only verify employment histories in terms of dates employed. Other companies might be willing to offer a more complete evaluation of the former employee's work ethic and performance. Where references provide little information, especially about honesty, some retailers use outside research firms, such as USSearch.com. For a nominal fee, the companies provide a background check with information that might be helpful in early evaluation.

Testing for Drugs. More merchants are requiring the use of drug tests for new candidates. In fact, some randomly test people already in their employ to determine drug use. The reason for the increased attention to drug screening is that there seems to be a direct correlation between drug abusers and internal theft; for example, employees who need to have extra money to feed their habits often steal from their company. Search engines such as **www.askjeeves.com** or **www.google.com** can provide names of a host of drug-testing agencies.

Psychological Testing. The use of psychological and honesty tests are increasingly part of the screening process. By administering a variety of tests, either in-house or at outside agencies, employers, regardless of size, can get yet another look at candidates before offering them positions. Some of the better-known tests are Wonderlic and Stanford Binet; to examine others, search the keywords *psychological testing* on the Internet.

Merchandise Control. Small items, such as a pair of sunglasses, hosiery, or scarves are easy to conceal, especially in large handbags that managers and sales associates carry with them to the selling floor. To prevent the theft of such items, many retailers require employees to store personal handbags in lockers, and to take only small see-through plastic purses on the selling floor. In this way, it is difficult to conceal stolen goods.

"Shopping" the Sales Associates. Many retail establishments have traditionally used **mystery shoppers** to test sales associate honesty. Posing as customers, they pretend to be making a purchase, and carefully watch the transaction to see if it is done in an honest manner. They note if the clerk rings up the wrong amount or fails to put the cash in the register, and immediately report it to management. Often, if management suspects that particular employees are involved in illegal practices, the shoppers are told to shop in their department and carefully scrutinize their actions.

Recognition Programs. To encourage employees to report those engaged in internal theft, some companies have instituted programs that reward the honest employees with monetary rewards or extra merchandise discounts. Of course, employees must be assured that their assistance will remain anonymous; otherwise, they are unlikely to participate.

Offender Prosecution. The key to the success of apprehending those engaged in internal theft is quick prosecution. Immediate termination and repayment of cash or items stolen are necessary components of any determent system. Companies that have the reputation of looking the other way or taking a lax position on these criminal actions will send a weak message to employees, and, internal theft will more than likely continue.

Internet Theft

Internet business for retail operations continues to increase every year. While this has proven to be an excellent outlet for selling fashion merchandise as well as other products, its success doesn't come without problems, particularly the losses due to fraudulent activities of many Internet shoppers using stolen credit card numbers. So severe is the problem that industry professionals estimate the losses to be greater than those of shoplifting and internal theft combined. Because retailers are responsible for their own losses, they are addressing the problem, as are the credit card companies that approve the sales. Customers whose numbers were stolen are protected from Internet fraud because any disputes usually result in chargebacks to the merchants. Not only does this create monetary losses for the retailer, but it can compromise the customer's faith in the company.

FORMS OF FRAUD

Research studies from organizations such as APACS reveal that those who steal credit cards or their numbers are most often responsible for theft of merchandise on the Internet. The card's details may be taken from the following sources:

- Discarded cards or lost receipts.
- Card numbers that aren't carefully concealed by their owners and written down for later use.
- On-line programs that generate account numbers.

Many retailers are taking out insurance policies to cover their losses, although the expense of such policies is considerable and affects their bottom lines.

FRAUD PREVENTION

A host of companies offers numerous ways in which merchants may eliminate **Internet theft** or at least reduce it. Advice for merchants offered by the Web site **www.protx.com** includes the following:

- Be wary of purchasers who do not complete forms or provide full contract details, or who offer Post Office box or drop box addresses.
- Beware of orders from remote addresses.
- Be wary of orders that are shipped outside of your own country.
- Be wary of orders that are outside the norm such as those that exceed the value of your average orders.
- Beware of purchases made in the middle of the night.

Merchants can learn more about the prevention of Internet theft by searching the Internet.

Vendor Theft

The manufacturers and wholesalers that fashion retailers purchase goods from are occasionally the sources for merchandise and monetary losses. Some of the errors are accidental, but others are deliberate attempts to defraud their accounts.

Improper billing, while usually an occasional occurrence, does take place. Invoices may not be carefully tallied or may be deliberately misstated. Retailers should take the time to check the charges.

Similarly, merchandise shortages can be either deliberate or the result of improper order fulfillment. Those merchants that have systems in place to check quantities, as discussed earlier in this chapter, will not be the victims of such shortages. When checkers physically count the merchandise, they will discover whether or not the invoice truly reflects the number of pieces in the package. If there are discrepancies, the merchant must immediately notify the vendor of the problem.

In-Transit Theft

Once the shipment leaves the vendor's premises and the invoices have been accurately prepared to reflect the contents, there is no guarantee that the entire order will reach the retailer's destination. The items might be shipped on racks that leave them open for theft. In the case of closed containers, the cartons may not be carefully sealed, leaving room for the nimblest of fingers to remove some of the items. In either situation, the shipment, if not adequately checked, will result in losses for the retailer.

TRENDS IN MERCHANDISE DISTRIBUTION AND LOSS PREVENTION

Changes are occuring in merchandise distribution and loss prevention that will add to the efficiency of retail operations. Discussion of these trends follow.

- *Expanded use of technology.* Just about every day, retailers are refitting their distribution centers with new technology that brings the goods from the vendor to the selling floors in a more efficient manner.
- *Increased use of computerized tags.* Many merchants are using computerized tags for their products so that pertinent information can be fed directly into their systems, making inventory analysis faster than ever before.

Open racks often are the cause of in-transit theft, as is the case when fabrics are being sent to retailers' product developers.
(Courtesy Ellen Diamond)

- *Updating of EAS systems.* While electronic article surveillance systems have been used for many years, newer models are being installed that provide better coverage, such as the acousto-magnetic system, which improves upon the older models.

- *Applicant screening.* With the amount of internal theft increasing, retailers are turning to outside services that check potential employees' backgrounds before the companies hire them. Most retailers are using outside Internet services that, for minimal fees, check the candidates in twenty-four hours or less.

- *Fraud prevention.* Fraudulent transactions are increasing at an alarming rate in retailing. To overcome these problems, retailers are implementing prevention systems. Web sites such as **www.protx.com** provide retailers with a great deal of advice about the problems and how to properly handle them.

SMALL STORE APPLICATIONS

Even the smallest retail operation must develop a system for merchandise distribution and handling. To determine the accuracy of the shipments coming from the vendors, retailers must pay attention to every package received. Some manufacturers are notorious for substituting unordered merchandise if the products indicated on the purchase orders weren't available at the time of shipment. Without diligent checking, this unwanted merchandise may make its way onto the selling floor, jeopardizing the buyer's model stock.

While the techniques small retail operations employ need not be as sophisticated as those used by their larger counterparts, they should address all of the problems associated with merchandise handling. Something as simple as a manual counting system will easily turn up any shortages and lead to more accurate recordkeeping, and the merchant will only be charged for merchandise ordered and received.

Shoplifting losses plague the small merchants much like they do the larger retail operations. The only advantage that the smaller merchant has is the fact that the store's premises is relatively small and is regularly staffed by the owner, manager, and sales associates. These close quarters make it more difficult for shoplifters to steal. Of course, personal attention to customers from the store's sales staff contributes to safety of the merchandise. By accompanying customers to try-on rooms, for example, where much of the shoplifting is accomplished, staff can prevent losses. If the store has considerable traffic, as do the off-price and discounter merchants, the owner should install systems similar to those used by major retailers. The savings in stolen merchandise will more than offset the initial expenses involved.

Internal theft at these smaller operations is far less prevalent than in larger retail companies. The presence of the owner generally discourages employees from stealing. In times of the owner's absence, such as on buying trips to the wholesale market, the person left in charge could be a serious culprit. Left to oversee such details as the handling of incoming merchandise and inventory management, this person is responsible for controlling the inventory. Unless there is a computerized inventory-control system, the likelihood of internal theft arises. The computerized systems are readily available at modest cost.

Whatever the size of the operation, any amount of shortages will affect the company's profits. Owners must take care to prevent the losses.

Chapter Highlights

1. With the use of such programs as EDI, RR, and VMI, retailers can handle their merchandise distribution operations more quickly and efficiently.
2. The methodology and techniques used to move new merchandise from the vendor to the retailer's premises generally depends upon the size of the retailer.
3. A centralized receiving location is generally preferred by larger department stores, specialty organizations, catalog operations, E-tailing ventures, and home shopping outlets.
4. Some major chains that have units spread throughout the United States prefer to use regional receiving facilities so that the merchandise will be closer to the stores they serve.
5. The industry's supply chain has been vastly improved due to the efforts of several nonprofit groups such as CPFR and VICS.
6. Fashion merchandise is generally moved around the retailer's location by packaged merchandise transporters, stationary tables, and conveyors.
7. Quantity checking is essential to ensure proper recordkeeping and is accomplished through direct checks, blind checks, or semiblind checks.
8. When merchandise is properly marked, it will include such details as price, style number, color, merchandise classification, and size, and each detail is pertinent to accurate merchandise inventory recordkeeping.
9. Shrinkage numbers continue to climb in the United States, requiring retailers to install the latest systems that will help to alleviate the problems.
10. Shoplifting accounts for approximately $207.18 per incident, causing considerable adverse affects on the merchant's bottom line.
11. Control of shoplifting is accomplished through the use of electronic article surveillance systems, electromagnetic systems, acousto-magnetic systems, video surveillance systems, merchandise anchoring, magnifying mirrors, and try-on room control.
12. Internal theft is running rampant in the United States and abroad. To deter the losses, many employers carefully screen job candidates, check applicants' references, test for drugs, administer psychological exams, control employee access to merchandise, use mystery shopping services, and offer recognition programs for honest employees.
13. Internet theft is at a level that causes losses greater than shoplifting and internal theft combined.
14. Vendor theft can come from either improper billing or shortages in shipped merchandise.
15. After the goods leave the vendor's facility, theft is often attributed to the shipping industry.

Terms of the Trade

merchandise distribution
in-house receiving
centralized receiving
regional receiving
electronic data interchange (EDI)
vendor managed inventory (VMI)
quick response inventory systems (QR)
packaged merchandise transporters
stationary tables
conveyor systems
quantity checking
direct checking
blind check method
semiblind check method
quality checking
substitution shipping
hand marking
computer-generated tags
bar codes
loss prevention
shrinkage
shoplifting
bottom line
electronic article surveillance systems (EAS)
tag-and-alarm systems
radio frequency (RF) systems
electromagnetic systems (EM)
acousto-magnetic systems
video surveillance systems (CCTV)
alligator tags
inktags
Alarming Supertag
merchandise anchoring
magnifying mirrors
internal theft
mystery shoppers
Internet theft
in-transit theft

For Discussion

1. Why is it necessary for fashion retailers to invest in the latest innovations for merchandise distribution?
2. Why do some chains opt for in-house receiving at individual units instead of using centralized receiving facilities?
3. What are the advantages to the major retailer in using centralized receiving facilities?
4. Instead of using the centralized receiving plan, why do some major chain organizations prefer to use regional receiving centers?
5. What are the two major merchandise distribution technologies that are important to retailers and vendors?
6. Why have nonprofit groups been established for supply chains?
7. What common feature do all packaged merchandise transporters have that helps in the quick movement of goods from the receiving room to the selling floor?
8. In what way does the direct method of quantity checking differ from the blind method?
9. Does the practice of substitution shipping affect the retailer's merchandising plans? How?

10. Why are computerized tags so vital to the retailer's inventory procedures?
11. Is there a particular profile for shoplifters? If not, who are the culprits?
12. What is the common name used to describe electronic article surveillance systems?
13. In what way can a video surveillance system help a retailer with their loss prevention programs?
14. How do try-on room control systems work?
15. What is the best initial step to take in the reduction of internal theft?
16. How can merchants check the backgrounds of candidates for positions without doing the "legwork" themselves?
17. Why is drug testing so important as a means of preventing internal theft?
18. What are some of the forms of fraud that Internet companies face?
19. What are the two main areas of theft as they relate to vendors?
20. What is meant by the term "in-transit theft"?

CASE PROBLEM I

When Claudette Fashions opened its first store twenty years ago, it was a small operation that employed three salespeople. The buying and other decision-making responsibilities were handled by the company's partners, Jackie Andrews and Carrie Michaels. As the shipments arrived at the store, the boxes were opened on the selling floor, where the merchandise was examined by either of the partners. They checked for quality and to make certain that the invoices reflected what was ordered and that the quantities were properly charged on the invoices. The sales associates would tag the merchandise according to the partners' orders and prepare it for inclusion in the inventory. The system for handling incoming merchandise was simple and satisfactory for the store's needs.

Every few years, the company reinvested its profits and opened additional units. Today, it operates six stores that are all within a fifty-mile radius. Each store receives merchandise directly from the vendors, and handling procedures are dealt with by the individual stores. At the present time, Claudette Fashions is considering an expansion that would bring its store total to ten and expand its trading area to a radius of 120 miles. Along with the plans for expansion has come a need to examine its past practices, particularly merchandise handling and distribution. Both partners agree that individual shipments to each unit are inappropriate, now that the company has expanded. In fact, discussions with vendors have indicated that a centralized approach to receiving would significantly reduce shipping expenses. With all of the merchandise delivered to a central warehouse, merchandise handling costs could be minimized.

Although Jackie and Carrie are ready to acquire a distribution center for merchandise receiving, checking, and marking, they have not yet been convinced that the new arrangement would be as good as the one they have used in the past. Their concerns involve the accuracy of the shipments received in terms of quantity and quality checking and the costs involved in the operation of the new facility.

Questions

1. Will the new facility reduce or increase the overall personnel expenses attributed to merchandise handling? Why?
2. Which system of quantity checking will be best to guarantee proper attention to the shipments? Why?
3. How can quality checking be successfully achieved if the buyers are not in attendance at the warehouse?

CASE PROBLEM 2

The combination of exquisite merchandise and sophisticated shoppers has made Boulevard one of southern Florida's most prestigious fashion empires. With three shops in the region's most exclusive shopping environments, Boulevard is the place to buy the latest in fashion-forward

merchandise and for customers to receive the most personal attention. Discerning customers come from distant places to satisfy their fashion needs.

Along with the success has come the problem of shoplifting. While some of the highest-priced fashions are stored in stockrooms and brought out to be shown to customers, other items are featured on the selling floor with easy shopper accessibility. Such garments as leather apparel are displayed unattended and have fallen victim to shoplifters. One such theft each day could cause profits to erode considerably.

Boulevard's management recognizes the need to alleviate the problem but has not been able to determine how to minimize shoplifting. Such deterrents as chaining the merchandise to the racks or the use of uniformed guards are out of the question because of the image it would project to the customers.

Faced with an ever-increasing problem, the store is still trying to address the situation. Management does not want to change the store's image with the use of unsightly, offensive deterrents and controls.

Question

1. What suggestions would you make to Boulevard, keeping in mind the company's image?

EXERCISES AND PROJECTS

1. Choose a company that specializes in receiving equipment for fashion retailers and request information and brochures on its computerized merchandise distribution systems. Through the use of a search engine such as **www.aol.com** or **www.google.com**, you can find a host of companies specializing in such equipment. Make contact in writing, by telephone, or through the E-mail addresses that the companies' Web sites generally offer. You can also read such trade publications as *Chain Store Age, Stores Magazine,* and *Visual Merchandising and Store Design* to get names, or check the yellow pages of your area's phone book.

 Prepare an oral report describing the systems available and how they are used by fashion retailers. Include brochures and photographs to provide the class with a better understanding of the equipment.

2. Visit a major fashion retailer to investigate some of the techniques and methods it employs to deter and control shoplifting. Complete the following chart and use it in an oral presentation before the class. Visit five different departments in the store.

STORE OBSERVATION REPORT		
Retailer Visited: _____		
Department	*Shoplifting Deterrents*	*Merchandise Assortment*

SECTION FOUR
Merchandising Fashion Products

Planning and Executing the Purchase

After reading this chapter, you should be able to discuss:

- ■ The duties and responsibilities of fashion buyers.
- ■ The methodology used in the planning of each season's purchases.
- ■ Several of the external support systems that are used by fashion buyers to help them with their purchase plans.
- ■ How model stocks are planned.
- ■ The qualitative and quantitative considerations for purchasing.
- ■ How buyers select their merchandise resources.
- ■ The concept of open-to-buy, and how it affects purchases.

The merchandise that has been chosen for inclusion in the company's inventory is, of course, the basis of any retail operation. Those responsible for the task are generally the company's in-house buyers, or to a lesser extent, resident buyers who act as purchasing agents for retail operations. In any case, these people face the challenge of providing merchandise that will appeal to their clienteles. Whether the company is a brick-and-mortar operation, a catalog company, an Internet organization, or a multichannel business that uses a variety of means of selling to the consumer, the buying responsibilities are the same.

Purchasing any product classification requires a wealth of knowledge on the buyer's part, but no classification provides the challenges of fashion merchandise. Electronics and appliances, for example, are inherently staple items that have staying power. They do not go in and out of favor in short periods and generally remain constants in their company's inventories. There are changes in design, but the volatility associated with fashion merchandise is absent. Those responsible for purchasing apparel, shoes, handbags, and the like are constantly aware that changes will take place every season and sometimes within seasons in areas such as colors, silhouette preferences, and fabric choices. Even with considerable purchase planning for each season, a buyer's best-laid plans often go awry. A wrong color selection could result in markdowns that will impact on the company's profits. With little room for error, the fashion buyer's position in a company is extremely vulnerable. Those making more than the allowable number of purchasing errors often find themselves in search of new careers. However, the most successful of the group generally move into positions of greater authority such as divisional merchandise managers; the most productive might even find themselves in the highest merchandising slot, general merchandise manager.

Buyers either work directly for retail operations or are outside consultants who work for market specialists such as resident buying offices. The former's duties and responsibilities are significantly greater than the latter's because they are the ultimate decisionmakers for their companies. Resident buyers, while sometimes asked to make purchases, generally work in an advisory capacity, most often assisting retail buyers with product selection.

This chapter's material focuses on retail buyers and how they plan the purchase. Chapter 12, "Purchasing in the Domestic and Off-Shore Markets," will explore the resident buying office's assistance when the retail buyer visits the wholesale market.

FASHION BUYERS' DUTIES AND RESPONSIBILITIES

The realm of tasks required of fashion buyers primarily depends first upon the size of the company and then upon the retail classification in which it falls. In small stores, for example, the buyers do everything from purchasing the merchandise to selling to customers. Often the owner fulfills the buying responsibility as well as a host of other management duties. In the larger companies buyers are mainly responsible for purchasing; they also interact with other management personnel such as advertising managers and department managers.

The other major consideration is the company's retail classification. Brick-and-mortar operations tend to expect the buyer to have some in-store participation such as making store visits to learn about the needs of their shoppers. Department store buyers generally have more in-store responsibility than do their specialty chain counterparts, who generally work from centralized headquarters and are often too far from the stores to makes visits viable. Off-site retailers such as catalog companies and Internet organizations use their buyers exclusively to purchase merchandise. As most of the larger merchants now practice multichannel retailing, the buyer's duties and responsibilities are not as clear-cut. Some of these companies have separate buyers for each of their channels, while others make the buyer responsible for in-store and off-site purchasing. Each company proceeds in a manner that it believes is best suited toward the success of its operation.

Some of the typical duties and responsibilities of buyers are discussed in the following sections.

Purchasing

Without question, this is the most important role performed by all buyers. Those in the fashion industry are concerned with choosing the best possible resources from which to purchase; previewing collections and selecting those items that seem to have the potential for widespread acceptance; determining assortments that will fit the needs of the company's model stock; working out arrangements that include discounts, promotional allowances, and delivery dates; and timing the purchases so that they will be ready to sell when customers want them most.

A buyer works on model stock to determine her needs for the coming season.
(Courtesy Ellen Diamond)

Pricing

To bring a profit to the company, buyers frequently determine at what prices the goods should be marked. Some retail operations subscribe to uniform **markups**. That is, each item carries the identical markup as the others. For example, **keystone markups**, which involve doubling the cost to arrive at the selling or retail price, is the choice of many retailers. In this case, the buyer need not be concerned with pricing. In most retail operations, however, buyers determine the retail price based upon such factors as competition, inventory protection, the average time it takes for the item to sell (known as the turnover rate), probable perishability, and the buyer's judgment of the value of the individual items.

In-Store Visual Presentation

The buyers' responsibility for visual presentation is not the same as that of the professional in-house visual merchandising team, which trims windows and arranges the interior displays. The buyers' involvement in visual presentation is limited to the placement of the merchandise within the department. Where fashion products are placed and shown often affect their sales potential (Figure 11.1). For example, when a **"hot" number** is featured at the department's entrance, everyone entering the area will probably see it. A dress that has been touted by the fashion press, when properly accessorized by the buyer, has an even greater chance to be a big seller.

Those buyers who are far removed from the stores, such as those who work for chain organizations and are centrally located at corporate headquarters, usually have little opportunity to directly place the merchandise in the departments. Some use faxes and E-mails to direct store managers about where to place specific fashion products in the most visible locations.

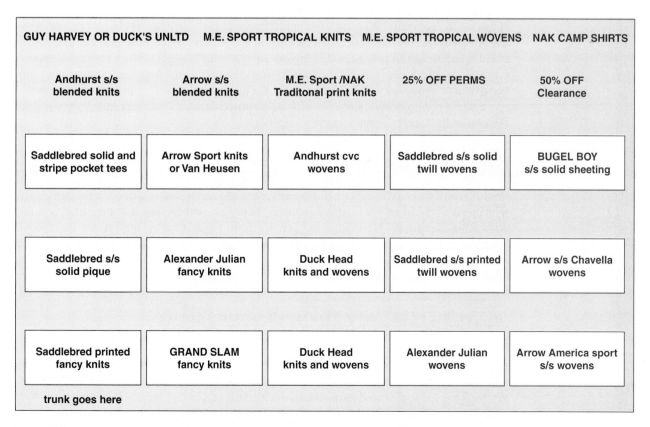

Figure 11.1 Many buyers use a flowchart to indicate where products are to be placed in the department.

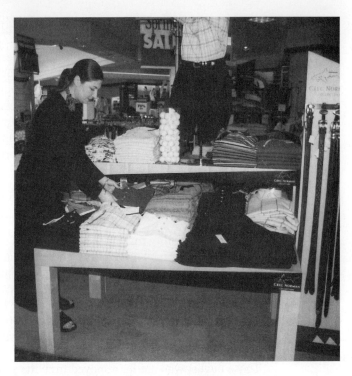

Evaluation of selling space and merchandise placement is the responsibility of the buyer in many retail operations. *(Courtesy Ellen Diamond)*

Selecting Merchandise for Advertising and Promotions

No one is more knowledgeable than the buyers when it comes to the merchandise they purchase for the company. With significant promotional budgets, retailers of all classifications use advertising, special events such as fashion shows, and window displays to capture the attention of the consumer. Although buyers are not usually adept at the technical aspects of promotion—these are left to the advertising, visual merchandising, and promotional departments—they are expected to choose the products that will appear in these formats. Even when the promotions are for **off-site ventures** such as catalogs and Web sites, the buyer usually makes the merchandise selections.

Managing a Department

When buyers focus primarily on purchasing, they are rarely still responsible for department management. Some of the midsize retailers, however, still require that buyers play a role within the department they purchase for. In those organizations, buyers are involved in scheduling, handling customer complaints, and selling during peak periods. In the smaller retail operations, such as boutiques and specialty stores, the buyer is generally one of the company's principals and performs a host of management duties.

Interacting with Other Midmanagement Personnel

The goal of any retail operation is to turn a profit, and in attempting to maximize the effort, managers in every division interact with each other. Buyers in brick-and-mortar operations and off-site ventures regularly meet with advertising managers to make certain that their products are being featured in the best possible manner; visual merchandising managers to assure that their items are being displayed in the best light; and distribution managers to ensure the receipt of merchandise from the warehouse in a timely fashion.

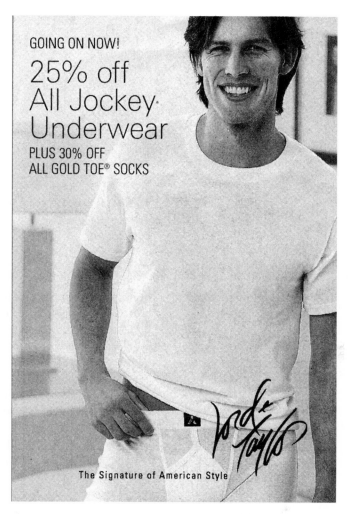

GOING ON NOW!
25% off All Jockey Underwear
PLUS 30% OFF
ALL GOLD TOE® SOCKS

The Signature of American Style

The selection of merchandise to be advertised is the buyer's responsibility.
(Courtesy Lord & Taylor)

PLANNING FASHION MERCHANDISE PURCHASES

With changes in fashion coming at a rapid pace, the buyers must always be prepared to assess their merchandise needs, using internal sources as well as those that are external to the company.

It has long been argued whether fashion merchandise selection is an art or a science. Proponents of each theory present viable reasons for their positions, but in the end, the result is usually a combination of both. On the one hand, the buyer who plans purchases based only upon last season's data is often missing the artistic element that enables some fashion buyers to select creative and unused collections for their companies. On the other hand, those who base their purchasing decisions solely on whim often make impractical decisions that turn into costly mistakes.

Buyers usually begin with an analysis of the sales figures from a variety of internal reports, and combine them with the wealth of information culled from external sources.

Internal Preparation

By investigating past sales records, the buyer of any fashion retail operation is able to analyze the success or failure of each vendor, style, color, price point, size allocation, and other information.

After the merchandise has been distributed to the brick-and-mortar units, or warehouses, as in the case of catalog and on-line operations, it is unpacked, sorted, tagged, and entered into a merchandise recordkeeping system. When an item is sold, the different factors such as price, color, classification, and size that appear on the merchandise tag are updated in the system and retained for use in a variety of merchandise reports. Although the information is available to the buyer anytime, it typically is presented in weekly, biweekly, or monthly presentations. By being able to go back a few months, or even a few years, buyers can make inventory adjustments based upon this data. Without question, past sales records are the backbone for any future purchase planning.

Retailers use other sources to assist with their merchandise acquisition decision making. Many subscribe to various survey methods, as addressed in Chapter 5, "Classifications and Methodology of Retail Research," to assist in the development of purchase plans. By determining customer fashion preferences through fashion counts or direct questioning via the personal interview or questionnaire technique, or through focus groups, the buyer is able to incorporate customer wants and needs into the buying plans.

Employee input is yet another internal source that seasoned buyers employ in the decision-making process. Staff personnel, such as fashion directors, are the experts in the field of fashion and can offer invaluable information regarding the state of the fashion market. The specialists, generally on the staffs of major fashion operations, often are at the vice-president level, which indicates their importance to the company in terms of fashion information. They often travel to the wholesale marketplaces in advance of the buyer's visits so that they can obtain early information on what the trends are going to be. They also meet with members of the fashion editorial press to get their opinions on fashion innovation and design and gain significant information that they bring to the buyers.

Sales associates in brick-and-mortar units also provide invaluable information to the buyer, because they are intimately acquainted with customer likes and dislikes. Buyers able to get to the selling floor themselves can also obtain this.

Department managers at the brick-and-mortar units are also excellent sources of information. Many routinely meet with their staffs to elicit ideas about how to improve sales and satisfy customer needs and can share that information with the buyer.

External Assistance

Once the buyer has carefully studied past sales records and has met with those inside the organization that could provide information regarding purchase planning, the next step is to make use of the many available external sources. A large number of fashion merchants employ the services of a resident buying office, fashion forecaster, or reporting service; join trade associations; or subscribe to trade publications for information regarding the new season and its offerings and consumer periodicals to learn about what fashions these magazines are presenting to the public.

RESIDENT BUYING OFFICES

The fashion industry's most important external source of market news is the **resident buying offices**. They are located within the wholesale markets, making it easy for buyers to meet with their company's representatives whenever they are visiting vendors.

The headquarters of these offices are located in New York City's Garment Center, the largest of the domestic fashion wholesale markets. Leading the pack is The Doneger Group, a company that specializes in accessories and apparel for the family and in home furnishings. Although the bulk of its business is related to the traditional resident office buying functions, its diversity has made it a one-stop place for clients throughout the world who rely upon research, analysis, and evaluation of every segment of the fashion industry's products. The following Spotlight focuses on the company and its diverse offerings.

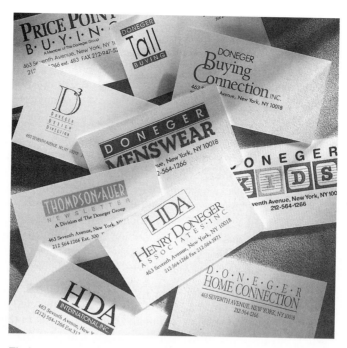

The largest of the resident buying offices, The Doneger Group is comprised of many different merchandise and concept divisions.
(Courtesy The Doneger Group)

Fashion Retailing Spotlights

THE DONEGER GROUP

Since its inception in 1946, spearheaded by its founder, Henry Doneger, the company has helped fashion retailers generate greater sales, increase profits, gain market share, and realize their full potential. Initially a small resident buying office, this independent operation has strengthened its position through a number of mergers and acquisitions. Its ability to stay at the top of the field has been unmatched, and its staying power is even more remarkable, since the industry has gone through a shakeout that witnessed the demise of such legendary resident buying offices as Felix Lilienthal & Company and Mutual Buying Syndicate.

One of the key ingredients in the company's success is its highly specialized divisions. In addition to the typical resident buying office segments such as better sportswear, juniors, and men's wear, The Doneger Group includes Carol Hoffman, which represents women's specialty retailers in the contemporary bridge, designer, and couture markets; Doneger Buying Connection, which has been instrumental in the development and dramatic growth of the women's plus-size business; HAD International, which provides information, sourcing, and product-development opportunities to international retailers from a range of U.S.-based manufacturers and importers; Doneger Creative Services, the color, fabric, silhouette, and trend forecasting and analysis division of the company; Price Point Buying, a leader in uncovering off-price deals in women's sportswear and men's wear; and Doneger Marketplace, an on-line facility that retailers and manufacturers use to communicate and conduct business.

The Doneger Marketplace, launched in 1999, has become a leader in on-line presentation of manufacturers' styles to retailers. It maintains extensive Web sites that enable clients to learn about the latest trends in the fashion industry. Specifically, its family of sites is **www.doneger.com**, which brings the company's features to potential and current users; **www.donegermarketplace.com**, which shows the latest styles in the market; and **www. donegerconsulting.com**, which offers special services for clients. The advent of these Internet Web sites has made it possible for clients throughout the world to immediately feel the pulse of the market without having to leave their offices.

Although The Doneger group has become significantly involved in on-line presentations, its forte is still personal service for its membership. Whether it is accompanying retail buyers to vendor showrooms, assisting merchants in the analysis of their individual needs, or making reservations with manufacturers for buyer visits during Market Week, the company is ready to do anything it can to help its retail clients improve their business.

Other resident offices include Brazilay Goldberg Buying Group, Jane Dragonas, Dianne Cohan Associates, Equatoriale S.r.1, Magenta, and Marshall Kline Buying Service. A complete list of these and other buying offices can be accessed at **www.apparelsearch. com/buying_groups.htm**.

Most resident buying offices primarily either assist with or directly purchase merchandise for their members. Some provide a host of other services that include the following:

• *Locating new resources.* Buyers of every fashion retail classification, be they brick-and-mortar operations or off-site ventures, constantly look for new lines of merchandise. Since the vast majority of a retailer's in-house buyers are often faced with numerous duties and responsibilities, they don't often have the opportunity to visit the wholesale markets other than during market week, when the new season's offering are shown for the first time. In their place, resident buyers, who have the advantage of being located in the wholesale markets, are able to visit new resources and evaluate their collections. The clout that these offices have makes them a constant target for vendors to contact, especially those that are new to the fashion industry. The recommendations that resident buyers make to retail buyers can help make the buying decision easier and potentially more successful.

• *Previewing collections.* When **retail buyers** come to market to shop for the new season, their time is often limited. **Resident buyers** save the retail representatives time and effort by previewing the collections and analyzing their merits in terms of their client's needs. Then, when buyers come to Market Week, they can pass over the lines that the resident team hasn't recommended and spend more time with the vendors that are recommended. Having several years of a close retailer–resident buying office affiliation makes it easier for the resident buyers to assess the retailer's purchasing preferences and needs.

• *Following up orders.* Although retailers place purchase requisitions, merchandise frequently does not arrive according to the instructions on the order form. It is the responsibility of the resident buyer or assistant to visit the vendors and try to determine if a problem exists. Some resident buying offices employ follow-up interns for these chores.

• *Communicating with retail buyers.* The more communication there is between the merchant and the resident buying team, the more likely it is that the retailer's inventories will be up-to-date and include the latest fashion offerings. Resident buyers contact their clients by calling, faxing, E-mailing, and mailing the latest brochures and pamphlets that feature fashion information. Resident buying offices with Web sites can post updates there for their clients to access as well.

Communication between the retail and resident buyers generally makes purchasing more reliable.
(Courtesy The Doneger Group)

- *Purchasing.* Although it is the retail buyer who is most often responsible for the bulk of the company's merchandise acquisitions, some buyers pass the responsibility on to the resident buying office. Generally, however, the resident buyer's purchasing duty is limited to placing special orders, processing reorders, or buying new merchandise that the retailer has asked the office to scout. Resident buyers are asked to place reorders because they have clout with the vendors and are usually able to obtain the hot items that are in limited supply. When resident buyers place these orders, it is liklier that they will be accommodated sooner than when the retailer places them.

- *Market week preparation.* Several weeks before the buyers come to town for **Market Week**, the resident buyers are at their busiest to make sure the retail buyer's trip is a success. They are busy previewing the new season's collections, obtaining sample merchandise to show the retail buyer, participating in the planning of in-house fashion shows, preparing written materials that include suggestions for the coming sales period, and taking care of all the other details that would be beneficial to their clients. In Chapter 12, "Purchasing in the Domestic and Off-shore Markets," the role of the resident buying office during the merchant's visit to the market is extensively examined.

- *Arranging adjustments.* No matter how much attention the retail buyer pays to purchasing, there can be problems with the merchandise once it arrives at the retailer's outlet. For example, the fit might be imperfect, the construction could be shoddy, the fabrics might not be exactly as promised by the samples, or the customers just aren't buying it. Under such circumstances, the retailer sometimes tries to return the goods to the vendor. If these attempts are futile, the retailer often calls upon the buying office representative to act as mediator; the significant amount of business they refer to the vendors often gives them the connections to work out a deal. The resident buyer might arrange for the goods to be returned or to have the vendor offer **chargebacks**, discounts for slow-selling goods.

- *Analysis of market conditions.* Buying and suggesting purchases are not the only services resident buying offices provide. In fact, many of them have shed this traditional name and have substituted the title **market consultants**. These organizations are familiar with the state of the market because of their continuous involvement with designers, manufacturers, fashion forecasters, reporting services, trade publications, and trade associations. Through these contacts, they are able to assess the conditions of the market and apprise their member retailers of any changes or trends that might affect their businesses. This assistance allows the merchants to be better able to adjust their future purchasing plans.

The resident buyer and her assistant evaluate the market's offering in preparation for meetings with retail buyers. *(Courtesy Ellen Diamond)*

• *Promotional planning.* The success of the retail operation is essential for the resident buying office to be successful. Although many of the large retailers have in-house promotional divisions that develop special events, create unique advertising campaigns, and design exciting visual presentations, some of the smaller companies do not enjoy this advantage. Some of the full-service resident buying offices maintain promotional staffs to help these retailers prepare advertising layouts and develop promotional concepts, and present their fashion offerings in exciting ways.

• *Pooling orders.* Some vendors have minimum order requirements that the smaller retail operations cannot meet. Many of the resident offices arrange for these merchants to **pool orders** with other merchants so that they can purchase from these vendors.

• *Inventory management.* While all of the large and midsize retail operations have in-house staffs that develop computer programs for inventory management purposes, their smaller counterparts do not. With inventory management at every level of retailing essential to maximizing profits, some market consulting companies help these smaller retailers design the systems that could satisfy their needs and assist in training the people who will be using the programs.

FASHION FORECASTERS

Fashion forecasters scout markets all over the world before buyers are ready to begin the purchasing process. They visit textile mills, trimmings manufacturers, design studios, and trade associations so that they can determine what fashion trends in fabrication, color, and style will probably reach the marketplace. Some of these internationally based firms, such as Promostyl, are able to supply their clients with information pertinent to buying plans about a year in advance of the season. Promostyl offers **trend books** for textiles, women's wear, accessories, men's clothing, and children's fashions that contain a host of photographs and forecasting predictions, and the buyers find these publications valuable sources of merchandise information.

Global markets are scouted by fashion forecasters to assure that the retail clients get a complete picture of what are the latest trends in fashion merchandise.
(Courtesy The Doneger Group)

COLORS ■ ■ ■ HOLIDAY/EARLY SPRING 2003/04

OASIS

Escape to a safe haven, a protective place designed to revive and rejuvenate... a relaxing sanctuary where the worries of the world evaporate and all is peacefully protected. Retreat to a secluded spot enveloped in breezy blues and tile greens, fresh flower pinks and lilac, sunshine yellow and sunset orange.

Lively shades for resort in cottons and silks, solid or iridescent taffeta and satin, yarndyes, jacquards and tapestry patterns, as well as playful prints.

Trends that include fabrics, colors, silhouettes, and yarns are just some of the information provided by fashion forecasters to their retail clients.
(Courtesy The Doneger Group)

Doneger Creative Services, a division of The Doneger Group, one of America's leading fashion-forecasting companies, is featured in the following Spotlight.

Fashion Retailing Spotlights

DONEGER CREATIVE SERVICES

Doneger Creative Services is an important division of the Doneger Group. This division offers **trend forecasting** and color forecasting and analysis to buyers and merchandisers as well as a broad range of products that enable merchants to better understand the direction of the fashion industry. The creative directors provide information on apparel, accessories, and lifestyle markets in the women's, men's, and children's categories through printed publications, on-line content, and live presentations.

The analysis Doneger provides buyers and other fashion executives includes the following:

- **Color forecasts.** These predictions comprise the season's range of palettes accompanied by inspirational color collages that convey the message of each palette. Colors are shown in actual yarn samples. The forecasts are delivered four times a year.

- **Clipboard Report.** Augmented by European contributors, the **Clipboard Reports** are presented on-line to give clients the information they need to keep current and stay ahead of the competition. The topics include runway, street, and merchandising trends. The on-line reports are updated regularly, with printed copies delivered monthly.

- **Design elements.** This is particularly important for those buyers involved in product development for their companies' private-label collections. Fabrics, trims, details, shape, and proportion information is presented twice a year.

- **TFS forecast.** Presented fourteen months in advance of a season, these presentations provide an in-depth analysis of the styles that will develop in coming seasons. Collage storyboards replete with design details and fabric swatches are

(continued)

offered to buyers to help them predict what will be popular and make future buying plans. They are sent to the buyers twice a year.

- **Live presentations.** Throughout the year, live presentations are offered that review the up-and-coming fashions for each season.

When buyers want to augment their purchase plans that were primarily based on past sales, the vast majority of the American fashion industry relies on Doneger Consulting, a division of The Doneger Group.

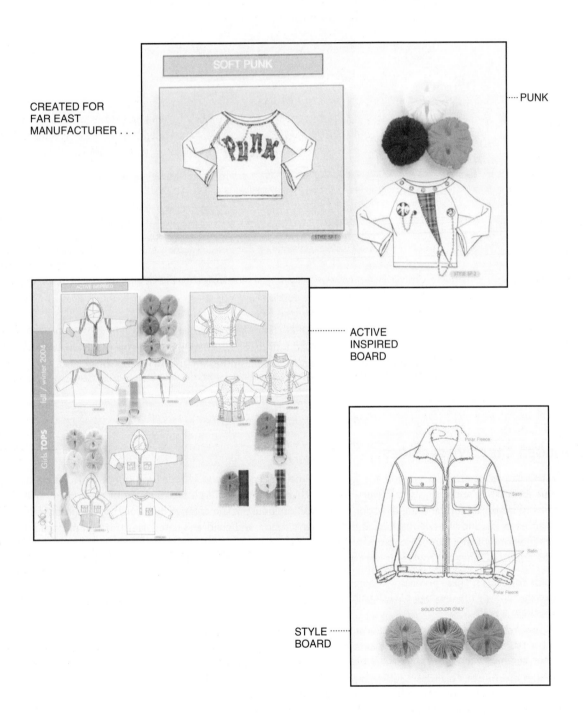

Doneger Consulting recommends items based on color, fabric, and trim.
(Courtesy The Doneger Group)

REPORTING SERVICES

Most major fashion retailers subscribe to **reporting services** that provide them with up-to-the-minute information on a weekly basis. Through the distribution of brochures and pamphlets that feature such information as the current hot sellers, which retailers are successfully selling what particular fashions, the names of the resources where the headliners in the fashion industry are available, what items are being reordered, and suggestions for inventory replenishment, fashion retailers are able to quickly adjust their inventories to reflect what is making news in fashion. One of the major fashion industry reporting services is Retail Reporting Bureau, based in New York City. It offers a number of weekly informational reports to its clients that address such areas as the market's hottest items and includes editorial overviews. Seasonal supplements explore merchandising themes for the upcoming seasons, complete with style, fabric, and color stories, and the names of resources where the latest designs can be ordered.

TRADE PUBLICATIONS

Each segment of the fashion industry has at least one trade periodical that explores a particular fashion merchandise classification. The leading publisher for the industry is Fairchild Publications, which produces a wealth of globally acclaimed papers. The Spotlight that follows discusses the Fairchild organization and the trade publications it produces.

Fashion Retailing Spotlights

FAIRCHILD PUBLICATIONS

Founded in 1892 by Louis Fairchild in Chicago, IL, the company was the first to be at the center of fashion and report industry news to the professionals in the world of fashion. Its publications appealed to every segment of the fashion industry and were especially accepted by retailers that concentrated on fashion merchandise. At the turn of the twentieth century, Fairchild moved to New York City, the capitol of the domestic fashion industry. In 1999, the company, owned by the Disney Organization, was acquired by Advance Publications.

Today, as it has been for most of its years of operation, Fairchild's flagship publication is *Women's Wear Daily (WWD)*, which covers the women's apparel and accessories industries. It has often been called the **"Bible of fashion"** and serves as the global newswire of change in fashion, beauty, and retail industries. In this periodical as well as its others Fairchild's purpose is to produce first-rate publications that deliver the latest innovations and news regarding the retail and fashion industries. Fairchild also publishes the following periodicals:

- *Details.* Earmarked for a new generation of men, *Details* is written for men of intelligence. Its targeted audience is the 25–35 age group of affluent professionals with the income and desire to reach the next level of success. Produced by an editorial staff that fits the same demographics as its audience, the result is a mixture of smart service, modern photography, and provocative journalism. Its advertisers include the latest innovative fashion purveyors that appeal to that set.
- *DNR.* The counterpart to *WWD, DNR* covers the men's wear industry and appeals to merchants of all fashion classifications. Replete with industry insights and the latest in innovative fashions, it has been the mainstay of men's wear buyers and merchandisers all around the world.
- *Beauty Biz.* With the beauty industry's sales soaring each year, this publication has become a must for its professionals. Tracking the almost daily charges, it include trends, brand information, the retailers that merchandise cosmetics and fragrances, and the personalities that drive the business. Although *WWD* covers this market, *Beauty Biz* goes to greater depths.
- *Footwear News.* This is the leading publication for the global footwear industry. A weekly magazine, it covers fashion, retailing, manufacturing, and the financial aspects of the business. It spotlights the hottest new designers, newsmakers, and business leaders and also reports on the industry's groundbreaking fashion trends.
- *InFurniture.* Once considered a staple-oriented business, today's furniture industry has become significantly fashion oriented. This periodical completely covers the fashion trends, provides in-depth analysis of the trade, offers personality interviews, and is illustrated with a wealth a graphics and photographs.
- *Children's Business.* Beginning with its first issue in 1985, it has become the leading publication dedicated to the children's wear market. It covers everything from apparel to accessories for the newborn to age twelve categories.

In addition to its national publications, Fairchild also has regional editions that cover such markets as Los Angeles, Atlanta, Dallas, and Chicago.

TRADE ASSOCIATIONS

Every industry has a trade association that provides its membership with vital information necessary to properly conduct its business. Retailing is no exception. In addition to many small trade organizations, many of which are regional in nature, the **National Retail Federation (NRF)** is an association with members throughout the world. It conducts it major meeting every January in New York City, and merchants congregate from every part of the world to learn about everything that is current in the industry. In addition, NRF sponsors a wealth of specialty regional shows in the United States and abroad.

By belonging to these groups, buyers, merchandisers, and others in the retailing business learn about the problems facing their industry counterparts, trends, changes in consumer shopping patterns, and so forth.

CONSUMER PERIODICALS

There are numerous consumer publications that provide buyers with insights into the world of fashion. Most notable are *Elle, Vogue, Harper's Bazaar, Esquire,* and *Seventeen.* Even newspapers, such as the *New York Times,* have columns that address the trends in the fashion world. By reading these papers and magazines, buyers become aware of the fashion information their potential customers read. Since many consumers are motivated to buy what their favorite publication's editorial staffs are touting, buyers need to keep this information in mind when they are planning their new purchases.

MISCELLANEOUS SOURCES

Other external sources that are valuable to buyers are the television shows watched by their targeted markets so that they can see what clothing the characters are wearing. Viewers frequently follow the design direction of their favorite personalities.

Street fashion also provides buyers with insight into the styles that consumers are wearing now and what they may wear later.

Movies and theatrical events can also influence what the public will wear, and buyers need to be aware of these potential style setters when planning their purchases.

Buyers need to be alert to every fashion barometer that indicates what will be hot and what will not.

Model Stock Development

A **model stock** is an inventory that includes an appropriate assortment of merchandise in terms of price points, styles, size ranges, color, and fabrics. Fashion buyers have a much more complicated task in developing a model stock than their buying counterparts who purchase hard goods and staple items. Fashion items are always seasonal in nature, so the model stock is constantly changing, but nonseasonal or nonfashion goods are stable, and the model stock can have a longer selling period without becoming obsolete.

The scope of the model stock is determined by those who decide which merchandise classifications will be included and how much money will be expended. In small fashion operations, this decision is made by the company owner with perhaps a manager's input. In larger organizations where formalized organization models are in place, such as those discussed in Chapter 3, "Organizational Structures," the amount spent on the model stock is determined by the upper levels of the merchandising divisions. The general merchandise manager apportions the budget among the various selling divisions. The head of each of these divisions, the divisional merchandise manager, then determines how much each buyer is to receive for product purchases. Each buyer, with these figures in hand, then sets out to develop a model stock that must stay within the budgetary limitations and address the department's merchandising needs.

The model stock of a **bridge department**, which are collections that fall between departments, such as couture and better sportswear, for example, must reflect which designers will be featured, the depth and breadth of each merchandise category, the number of tops

needed for the number of bottoms, the concentration on particular sizes, the price points that must be emphasized, and so forth. The buyers' initial plans are generally preliminary programs that could easily change once they visit the marketplace and examine the vendors.

Elements of Fashion Buying

To construct a realistic model stock, the buyer must address specific areas known as the **elements of buying**: the qualitative and quantitative considerations, the fashion merchandise resources, and the timing of the purchase.

QUALITATIVE CONSIDERATIONS.

Internal and external sources give the buyer an indication of the nature of the fashion products that customers will want. The scope of fashion merchandise is so broad that it is available at every price point and quality, in styles that range from conservative to extremely fashion forward.

Each fashion operation has developed a character and image that the buyer must consider before completing even the simplest task. These are the qualitative considerations of the model stock. Buyers charged with the responsibility of merchandising a conservative model stock will immediately know the types of styles preferred by the customers, because these customers tend to buy fashions that do not change much in style or design from year to year. They know whether their customers like man-made or natural fibers, the length of the skirt that most would wear, the preference of basic colors over new colors and the ratio in which the bottoms should be divided between pants and skirts.

It can be much more difficult for buyers who purchase extreme fashions. While size allocations and price points are generally simple to ascertain for this fashion audience, it is harder to predict style and color preferences. If the fashion editors of *WWD* are championing the micro-miniskirts, is it a safe bet to invest large sums in inventory in these items if last season's styles centered around the midi look? If wide, billowy pants are being heralded as the potential winners of the next season, should the buyer cram the inventory with such fashion designs or go with a safer streamlined look popular now? Should an investment be made in a new designer's collection over those designers who have been steady winners in the past? The answers to these questions are not simple to address, and they are not the only types of decisions that a buyer must make before placing any orders. Even the most seasoned buyer is sometimes doubtful about making fashion decisions, particularly when the new season's offerings are a departure from what the customer accepted in the past.

QUANTITATIVE CONSIDERATIONS

One of the most important planning aspects is how much money the buyer has to spend at any given time for new merchandise. The established limits that have been approved by the divisional merchandise manager are based upon sales forecasts for each department. The forecasts take into account past sales, economic conditions, and the company's assessment of each merchandise classification's relative worth to the entire organization.

When a department is given a dollar amount for merchandise it will need to meet the projected sales figures, this is not solely for new purchases for the coming season but must include the size of the present inventory. Since sales are constantly being made, new merchandise is arriving, and customer returns are placed back in the inventory, the budget ceiling must be constantly examined to make certain that it has not exceeded its limits. If a retail buyer were able to dispose of every piece of merchandise from the previous season and start fresh for the next, the job would be much easier. Since this is an impossible task it is necessary to determine the total worth of the inventory at any given time. It is standard practice for buyers to use a formula called **open-to-buy** to make these determinations. Although today's merchants have the advantage of computer programs that instantly provide them with the open-to-buy figures, it is beneficial to those using the formula to understand its different components. The following example depicts the numerous figures considered in the open-to-buy calculation.

PROBLEM

On June 1, the handbag buyer wanted to know how much she still had in her present budget to purchase additional merchandise for the period ending June 30. On this day, the following figures reflected her department's situation:

Merchandise on hand	$72,000
Merchandise on order	18,000
Inventory planned for end of month	90,000
Planned sales	36,000
Planned markdowns	3,000

What was the handbag buyer's open-to-buy on June 1?

SOLUTION

The formula for open-to-buy is:

Merchandise needed − Merchandise available = Open-to-buy

To find merchandise needed for June

Planned end-of-month inventory	$90,000
Planned sales	36,000
Planned markdowns	3,000
Merchandise needed	$129,000

To find merchandise available for June 1

Merchandise on hand	$72,000
Merchandise on order	18,000
Merchandise available	90,000

Open-to-buy ($ 129,000 − 90,000) = 39,000

With the use of a few additional figures such as actual sales and actual markdowns, the buyer can determine open-to-buy at any time.

RESOURCE SELECTION

Buyers of fashion merchandise have a host of domestic and foreign resources to buy from, the major locations of which are be focused upon in Chapter 12, "Purchasing in the Domestic and Off-Shore Markets." Unlike the other merchants who buy from wholesalers as well as manufacturers, those involved in the area of fashion generally restrict their purchasing to the producers. The principal reason for this approach is that fashion items have short lives and must reach the retailers as quickly as possible. The nature of wholesaling is to have goods warehoused until they are needed. Products such as appliances are purchased from wholesalers that store them until they are needed. Since such goods have long lives and are not subject to the **fashion perishability** factor, there is little chance for them to become obsolete before they are sold.

Although most retailers buy from manufacturers, there are a small number of fashion merchandise wholesalers in business. They serve the needs of some very small merchants that are unable to buy directly from the producer because of certain imposed restrictions such as minimum order requirements and stringent credit requirements. Fashion wholesalers also play a role in enabling some retailers to acquire imports. To make foreign purchases, a retailer usually has to take on large commitments, visit offshore markets, commit to purchasing many months before the traditional buying period, or rely upon **commissionaires**, who are foreign resident buyers acting in behalf of American retail buyers. These

and other factors might be too restrictive for those with limited financial ability or whose merchandise needs do not warrant the risks involved, so they buy foreign goods from the wholesaler.

With the seemingly limitless number of available resources for every classification of fashion merchandise, the buyer must evaluate those companies from which purchases were made in the past and investigate the possibility of eliminating some of them and adding other vendors to the company's roster of suppliers.

To evaluate the retailer's current resources, the buyer must carefully inspect the retailer's past sales records. Computer-generated reports such as brand analysis details give the buyer an idea of how successful each vendor's products were. It is imperative for retailers of every size to examine each supplier in terms of **maintained markup** (how much profit the company was able to achieve over the cost of the merchandise), the number of customer returns, **stock turnover** (the average time it took to sell the items), reliability of shipments (whether the orders were received on time and in the same quality as the samples), fit, and anything else that might make the vendor a valuable one or a risk for another season.

Buyers should always pay attention to the external sources of information where they might discover new resources. Often a new designer is on the horizon or a new line might become hot in the industry, and their offerings could result in new, exciting merchandise. The trade papers, resident buying offices, fashion forecasters, and reporting services are in business to discover and recommend the industry's latest winner's and buyer's should consider their choices.

Buyers must not only address the domestic marketplace in selecting their merchandise resources but must also scan the globe to find vendors that can supply the most suitable items for their customers. With overseas design and production ever growing, buyers must be aware of where these fashion markets are and the types of fashion merchandise they make available for export.

Chapter 12, "Purchasing in the Domestic and Off-Shore Markets," explores the decision about whether or not to pursue global fashion resources.

TRENDS IN PURCHASE PLANNING

While most professional retail buyers have internal and external sources to help with purchase planning, there are trends in purchasing that they should be aware of, including the following.

• *Studying international publications.* With fashion merchandise available from every corner of the globe, more buyers are subscribing to foreign trade and consumer publications. *Elle,* for example, produces a French version of its popular American magazine that features the designs that are popular in France and other European markets. Since fashion often flows from France to the United States, the buyers reading these publications can get a better picture of what will be expected and can plan for these imported ideas without having to wait for the domestic periodicals to bring them the news.

• *Becoming familiar with global trade expositions.* The markets for foreign-made fashion merchandise continue to proliferate. Buyers for the larger retail operations most often purchase off-shore merchandise, and by learning where the hot spots are, can plan their visits to them. As Chapter 12, "Purchasing in the Domestic and Off-Shore Markets," describes a wealth of these markets all over the world. By planning how to attend them, buyers are able to more efficently cover these expositions in less time.

• *Planning for a greater proportion of private-label merchandise.* With the major fashion collections of such designers as Ralph Lauren, Liz Claiborne, and Calvin Klein in just about every major retail operation, buyers are carefully studying the proportion of marque brands to their own exclusive offerings. In many operations, both brick-and-mortar and off-site ventures, the trend has been to tip the scale toward carrying more of these private brands to give the retailer a unique merchandise mix and the potential for greater profitability.

SMALL STORE APPLICATIONS

It is as essential for the small merchant to carefully plan purchases as it is for its large retail counterparts. Buying without any preplanning, which is sometimes the case in small boutiques and specialty stores, often leads to purchasing more or less merchandise than is actually needed.

Buyers for small retail operations, who are most often the owners, can use systems that are similar to those used by the major retailers to make certain that they effectively plan their purchases. A wealth of software is readily available from computer specialty stores or on-line that offer simple-to-use programs dealing with inventory analysis, recordkeeping, and so forth. By using these systems, buyers can access information such as past sales, open-to-buy, and the like to plan future purchases.

Because so many vendors require retailers to make minimum orders, many small entrepreneurs cannot buy from certain fashion vendors. There are two ways to address the problem. One is to form a buying syndicate composed of noncompeting small merchants to pool orders so that they can reach the minimums. Another is to join a resident buying office, which forms these pools for their clients.

Since overseas buying visits are most often out of the question for small fashion merchants, those who wish to avail themselves of such merchandise may do so by attending import expositions in the United States. Trade papers such as *WWD* and *DNR* list the dates and locations of these fairs.

Chapter Highlights

1. Company size is a major factor when it comes to the buyer's duties and responsibilities.
2. Off-site retailers exclusively use their buyers to purchase merchandise.
3. In most retail operations, the buyers determine the markup percent for the merchandise in their department, unless the company employs standardized markups.
4. Buyers who purchase for the large department stores are often called upon to assist in the planning of in-store visual presentations.
5. To make a retail operation as profitable as possible, buyers are called upon to interact with managers in other company divisions.
6. Without question, past sales records are the primary indicators that buyers use in determining their fashion purchases for the next season.
7. Merchants use a variety of research tools to assess consumer wants and needs.
8. The major external source of information used by fashion retailers is the resident buying office.
9. Among the activities that resident buyers engage in to properly advise their retail members are locating new resources, previewing collections, following up orders, arranging adjustments, and preparing for Market Week.
10. Small merchants that are unable to meet minimum purchase requirements often have their orders pooled with other small merchants through the assistance of the resident buying office.
11. Fashion forecasters are specialists who do preliminary field work so that they can bring the pulse of the fashion wholesale market to the retail buyer.
12. Trade publications, reporting services, consumer periodicals, and trade associations are invaluable resources for buyers to research before they make their actual purchasing commitments.
13. A model stock is an inventory that includes an appropriate assortment of merchandise to meet the retail customer's needs.
14. Both qualitative and quantitative considerations must be undertaken by the buyer before making any purchases.
15. Open-to-buy is a concept that indicates how much money a department can spend for new purchases at any time of the month.

Terms of the Trade

keystone markups
markups
"hot" numbers
off-site ventures

resident buying office
retail buyer
resident buyer
Market Week
chargebacks
market consultants
fashion forecaster
pool orders
trend books
trend forecasting
Clipboard Reports
reporting service
"Bible of Fashion"
National Retail Federation (NRF)
street fashion
model stock
bridge department
elements of buying
open-to-buy
fashion perishability
commissionaire
maintained markup
stock turnover

For Discussion

1. Why is it more difficult to purchase fashion merchandise than staple merchandise?
2. Buyers in the largest retail operations were once responsible for in-store management; why has this responsibility been taken from them?
3. Although most medium-sized and large retail brick-and-mortar operations have in-house visual merchandising staffs, why does the buyer play a role in visual presentation?
4. Why is it necessary for retail buyers to interact with their management counterparts in retailing's other divisions?
5. What is generally the first step that buyers take in the planning of future purchases?
6. What purpose does it serve the buyer to have such information as vendor name, style, and color listed on the merchandise tags?
7. Is there any distinct advantage to computer recordkeeping for merchandising purposes?
8. How important is the role played by the resident buying office in fashion merchandising?
9. Where are the major New York City resident buying offices located, and why are they located there?
10. Why is it important for resident buyers to preview fashion collections before the retail buyers see them if it is the buyers who make the ultimate purchasing decisions?
11. What does the term "following up orders" mean, and why is this an important role played by the resident buying office?
12. Is it sometimes important for the resident buyer to intervene with vendors on behalf of the retail buyers when there are disputes?
13. Why do some merchants need to pool their orders?
14. How are some of the larger resident buying offices providing their members with up-to-the-minute fashion information and visuals?
15. In what way does a reporting service differ from a resident buying office?
16. Do consumer fashion publications play an important role for retail purchase planning?
17. What is a model stock, and why is it important to determine in fashion merchandising?
18. What is the difference between qualitative and quantitative considerations in purchase planning?
19. How important is it for buyers to determine their open-to-buy?
20. What is a commissionaire?

CASE PROBLEM 1

Ellen Sherman has been employed in fashion retailing for the past thirteen years. After majoring in college in fashion buying and merchandising and successfully completing an internship with Conway, Inc., a full-line department store, she accepted a position with that company after graduation.

For approximately nine months, she participated in Conway's executive development program, rotating throughout the store in a number of merchandising and management roles. She was involved in a combination of formal classroom instruction and on-the-job training. After nine months, the company decided Ellen was ready for her first full-time assignment, assistant buyer for men's furnishings.

After about five years, showing considerable strength as an assistant buyer, Ellen was promoted to become a buyer of moderately priced men's sportswear. She met the challenge of the job admirably and enthusiastically carried out a successful career for another seven years.

A few months ago, Ellen was approached by an executive search firm that specialized in fashion retailing and offered to arrange an interview for her with a major upscale fashion retail organization. Although she was satisfied with Conway's, the temptation of working for such an important fashion leader motivated her to go through the interview process and ultimately accept the new position.

Ellen Sherman became the buyer for men's designer collections at John Steven's, the midwest's most highly regarded fashion retail empire. The merchandise for which she was now responsible was at the highest price points and was the most fashion forward. Although she was a seasoned buyer, this new venture was totally different from her previous experience.

At the time of her employment with John Steven's, the company was preparing its purchasing plans for the fall season. With approximately six weeks before the industry's collection openings, Ellen has to develop a model stock for her department and address the elements of fashion buying. Since the new position was completely different from the last in terms of merchandise classification and customer base, she had a considerable challenge ahead of her.

Questions

1. Which information source should Ellen first investigate in initiating her buying plan? Discuss the various aspects of the source with which she should become familiar.
2. In trying to quickly familiarize herself with the merchandise classification, which external sources of information should she utilize?
3. From which people on the store's staff could she seek advice and counsel to develop a sensible buying plan?

CASE PROBLEM 2

As the proprietor of a small fashion boutique, Maggie MacNamara performs just about every task in the store. She buys, sells, schedules her small staff, arranges for such promotions as fashion shows, and changes the window displays. The business, which began as a lark for Maggie after her children were grown, has taken off and developed into a successful operation. In just three years, her space doubled, as did her sales volume. Today her annual sales are approximately $900,000.

The merchandise mix offered in the store includes designer ready-to-wear, bridge collections, custom-made clothing, and accessories. Her merchandise resources include designers from the United States and abroad. She buys at manufacturer's showrooms during market weeks, at trade shows, and occasionally from sales representatives who visit her store. Her only advice on buying has been from her sales staff and from paying attention to trade publications such as WWD and consumer periodicals. She has no resident buying office affiliation or any connection with fashion forecasters.

Prompted by many of her customers to open a men's shop in the vacant building that is adjacent to her store, Maggie has signed a lease for that purpose. It seemed to her that with her loyal women's clientele, their spouses would favorably embrace the new shop. The only problem is with the merchandise. Maggie has no experience in men's wear, although she has impeccable taste. She is unfamiliar with the market and would need some assistance in merchandise procurement. She would like to have overall responsibility for the purchase of the new merchandise classification and would be willing to delegate her other responsibilities to people presently employed in the women's boutique.

Currently, she is listening to a host of ideas generated by her staff and industry professionals to find a solution to the new purchasing problem.

Questions

1. Now that Maggie has committed herself to the new operation, do you believe she is capable of purchasing the needed merchandise? Defend your answer with sound reasoning.
2. What types of assistance should she employ to help her with the purchase of men's wear?

EXERCISES AND PROJECTS

1. Log onto the Web site of Fairchild Publications to learn about the many different periodicals the company publishes. After selecting the one that seems most interesting to you, contact the publication to obtain a few issues and examine it for articles that would help buyers who were planning for the next season's purchases. In an oral presentation, discuss each article in terms of how it will help buyers with their plans.
2. Make arrangements to interview a store's fashion buyer to determine how he or she develops a model stock. It may be difficult to get an interview in the buyer's office; if this is the case, arrange a phone interview or one via E-mail. Prepare your questions in advance of the interview so that you will be fully prepared; and ask particularly about the various elements that go into fashion buying. Once you have gained the necessary information, prepare a report that describes the particular buyer's approach to model stock development. In addition to the written material, include photographs or drawings (often available in newspapers) that are typical of the buyer's merchandise.
3. Using any search engine to obtain a list of resident buying offices, or going directly to a resident buying office's Web site such as **www.doneger.com**, study the services they offer to their clients. Prepare a report that highlights these services, and anything else that would help prospective members evaluate them.

Purchasing in the Domestic and Off-Shore Markets

After reading this chapter, you should be able to:

- Discuss the advantages of purchasing in the domestic marketplace.
- Name the major domestic fashion marketplaces in which retail buyers make their purchases.
- Supply the vital statistics associated with New York City's Garment Center.
- Name the leading regional fashion markets in the United States and some of the important resources located within them.
- Prepare a list of the important permanent domestic fashion marts.
- Discuss the importance of visiting resident buying offices before calling on any vendors.
- Tell how overseas fashion consultants may help buyers maximize their profit potential.
- Name and discuss the most important off-shore fashion capitols.
- Discuss why off-shore purchases are beneficial to American retailers.
- Provide the reasons for the need to perfectly time the purchase.
- Prepare a list of fashion trade shows and the merchandise they feature.
- Discuss the areas of negotiation that need to be addressed before any purchase order is written.

Once buyers carefully plan their purchases for the next season by consulting various internal sources necessary to determine facts and figures and exploring external information sources, and develop a model stock that serves the needs of their retail organization, there is still much to be done before they are ready to put their signature on the bottom of any purchase order.

Buyers have three major areas of concern regarding their order placement. The first is the geographical locations of the vendors they are considering purchasing from. It is easier to procure products from domestic resources than from the foreign producers, but off-shore fashion merchandise providers are still important players.

The second concern is how to determine the most appropriate time to have the new merchandise arrive on the selling floor or be ready for inclusion in catalog offerings or on Web sites.

The third concern is whether or not it is best to make personal market trips to evaluate the latest fashion innovations, use Internet resources for product procurement, or rely upon the seemingly unending parade of road representatives who bring their collections to the retailers' premises.

This chapter describes the domestic and off-share marketplaces and discusses the various aspects of purchasing in each arena.

THE DOMESTIC MARKETPLACE

Most buyers purchase the majority of their model stocks in one of the major U.S. wholesale markets. They flock to these sales facilities during the market weeks as well as other times depending upon the size of their companies and their proximity to the markets.

However, the off shore marketplace increasingly attracts U.S. fashion retail buyers. Many leading fashion merchants such as Bloomingdale's, Saks Fifth Avenue, Bergdorf Goodman, and Neiman Marcus regularly go overseas to attend the fashion premiers of the world's leading couturiers, such as Armani, Dolce & Gabbana, Ferre, Chanel, and others. Companies at the other end of the fashion spectrum such as Wal-Mart and Target, also go to off-shore markets to purchase their value-priced items. And fashion apparel bearing the names of Liz Claiborne, Ralph Lauren, Tommy Bahama, and Calvin Klein, for example, are actually made in China, Hong Kong, Korea, Peru, and other distant shores where labor is generally cheaper than in the United States. In spite of this rising foreign competition, the domestic scene is still significantly important to fashion retailers for the following reasons:

- *Delivery reliability.* It is more likely that orders placed with American manufacturers will arrive in the retail operations in a timely fashion. Although delivery problems can result no matter where the merchandise is procured, the closer proximity of the domestic vendors generally results in fewer problems.

- *Price guarantee.* When a purchase order is finalized domestically, the prices inherent in the orders are in American dollars. Products purchased overseas are listed in the country's own monetary system. For example, the Euro, now the official currency of most European nations, fluctuates against the dollar every moment of every day. At the time of purchase, buyers might consider the wholesale price to be appropriate for their purchase plans, but the actual cost might not be the same as it was at the time of the order placement. The **landed cost,** which is the actual cost at the time the merchandise arrives in the United States, might be greater than the buyer anticipated, often making it too pricey to maintain the markup the buyer initially counted on for a profitable season. This concept will be fully explored later in the chapter.

- *Chargeback adjustments.* A buyer's best-laid purchase plans do not always result in the procurement of products that shoppers will buy. Price adjustments have become commonplace in the fashion industry. Buyers usually negotiate discounts from the vendors for the merchandise that didn't sell. Although this is a growing problem for fashion manufacturers, they often acquiesce so that retailers will continue to patronize them. Negotiating the **chargeback** adjustments is a relatively simple procedure if the vendor is in a domestic market. Buyers and manufacturers are able to directly communicate with each other because of their similar business culture, common language, and their close proximity. It is more difficult to settle the details of such demands with foreign vendors for the opposite reasons.

- *Economic advantage.* For the past several years, the unfavorable balance of trade with overseas markets has caused considerable concern for Americans. Importing more than exporting, has a negative effect on the U.S. economy. Purchasing in the domestic marketplace keeps the dollars in the United States and strengthens the domestic economy.

- *Reliability of "fit."* Although there are no standards when it comes to size uniformity, products that are purchased in the United States generally fall within a specific set of size standards. Although one manufacturer's size 6 isn't exactly the same as another vendor's, there is some degree of standardization. Purchasing overseas doesn't usually offer the same fit guarantees. Each country has its own set of measurements that are best suited to its own population, but they do not necessarily coincide with the figures of overseas consumers. Merchandise made in the United States is less likely to have these fitting problems, thus reducing the number of merchandise returns for this reason.

Major Domestic Wholesale Fashion Markets

Buyers who represent American fashion retail operations travel to a host of different fashion markets to preview the new collections and place orders. These markets are in many major American cities, and New York City is the leader.

New York City's Fashion Center kiosk helps buyers find their resources.
(Courtesy of Ellen Diamond)

NEW YORK CITY

The **Garment Center**, as it is generally referred to, is in New York City. It is home to the largest number of fashion manufacturers in the United States. Other cities traditionally have centralized apparel marts and merchandise marts that feature a host of vendors under one roof; the Garment Center is spread out among several streets, the most notable being Seventh Avenue and Broadway. Along with these main fashion arteries are the side streets from 34th Street to 41st Street. Even that doesn't perfectly describe New York City's Garment Center. With a multitude of new resources opening every year, new fashion manufacturers have opened headquarters in New York City's Soho district, Chinatown, Greenwich Village, the Upper East Side and West Side, and lower Manhattan. A *WWD* supplement, *The Fashion Center,* reported that the Garment Center was approximately 34 million square feet and included 5,100 showrooms and 4,500 factories.

Although the majority of the collections displayed at these manufacturers' premises are no longer produced in New York, the bulk of their sales are transacted in New York City's showrooms. That is where the designers still create their collections and the buyers come to preview them. Marque collections such as Liz Claiborne, Calvin Klein, DKNY, and Ralph Lauren are headquartered there, as are lesser-known fashion lines that hope to achieve the success of their better-known counterparts.

Buyers from all over the world come to this location, especially during each season's market weeks, when each new season's collections are introduced for the first time. Buyers visit the numerous vendor showrooms that feature everything from couture to lower-priced collections, trade shows that bring together a wealth of collections under one roof, and fashion presentations by such groups as the Council of Fashion Designers of America, (CDFA), where **"7th on Sixth"** runway shows highlight the latest exciting collections. Buyers keep their notepads in hand to remind them of what they saw at each venue that had merit for inclusion in their model stocks and to keep records to help them with their purchasing decisions.

The tents at "7th on Sixth" are the perfect arenas for buyers to preview the season's new fashion offerings in women's wear.
(Courtesy of Ellen Diamond)

AMERICAN REGIONAL MARKETS

Other American cities have centers of their own that make them important to retailers. Some major fashion designers, such as Bob Mackie, are headquartered in Los Angeles, as are the more modest collections of Carole Little and Karan Kane, making it the second most important wholesale market after New York City. San Francisco is not far behind, with Jessica McClintock and Levi Strauss, two of its better-known fashion brands.

In these wholesale regional markets, companies either are headquartered there or companies based in New York City or other locales have branches there. Buyers come to place orders during their market weeks or any time of the year they need to order. They may patronize these markets rather than those based in New York City because they are close to the buyers' retail operations or because they want to visit more than one market in pursuit of the best merchandise they can add to their model stocks.

While New York City and the two California markets make up the lion's share of regional markets, there are others notable in the industry. Most regional markets operate primarily from marts or centers. Table 12.1 lists some of the important domestic fashion marts.

TABLE 12.1 Selected Permanent Domestic Fashion Marts

Mart	Location	Specialization
Chicago Apparel Center	Chicago, IL	Apparel and accessories for men, women, and children
The Merchandise Mart	Chicago, IL	Home furnishings and giftware
California Market Center	Los Angeles, CA	Fashion merchandise and textiles
Dallas Market Center	Dallas, TX	Home furnishings, giftware, apparel, and accessories
Miami Merchandise Mart	Miami, FL	Fashion merchandise
The New Mart	Los Angeles, CA	Contemporary fashion
Concourse Exhibition Center	San Francisco, CA	Fashion apparel
Bedford Mart	Bedford, MA	Giftware
Denver Merchandise Mart	Denver, CO	Apparel, accessories, gifts
L.A. Mart	Los Angeles, CA	Fashion merchandise

OFF-SHORE FASHION MARKETS

With every passing season, more fashion merchants are sending their buying teams to distant shores in pursuit of merchandise that is either unique or better priced than that found at home. The competition demands of retailing are such that the **"me-too" lines** merchandised in so many domestic companies will not satisfy consumers who want products atypical of what U.S. manufacturers provide. Whether they are looking at couture-level merchandise, trendy fashion items that provide style as well as value, or something in between, buyers seem to be spending more time abroad than ever before.

To make certain that their visits to the off-shore markets are merited, many American companies are members of reporting services that cover the foreign fashion markets. By using these resources while planning their purchases and visiting them once they are in the foreign markets, buyers are able to get a better feel of what's new in the marketplace.

The following Spotlight focuses on Carole and Nathalie, a fashion reporting service that covers the European fashion arena.

Fashion Retailing Spotlights

CAROLE AND NATHALIE FASHION REPORTING SERVICE

Formed by Carole Ledesman and Nathalie Jonqua, who were coworkers in a fashionable boutique on Boulevard St. Germain in Paris, their fashion reporting service has become an important resource for industry professionals in the United States.

With its motto, "Your Eyes in Europe," the company continues to serve the needs of buyers who come to the various European markets in search of unique merchandise for their retail clienteles. Buyers often come by Carole and Nathalie's headquarters as their first stop before converging on the numerous European collections to predetermine what's hot and what's not.

In preparation for the buyers' visits, the company provides a wealth of materials that include monthly photo portfolios featuring at least one hundred pictures of the previous month's fashion trends and CD-ROMs of photo reports.

Members of the service staff also shop and research the markets with their clients so that they can provide advisory assistance and learn about the various retailers' particular fashion needs. The latter service is extremely important for buyers who cannot regularly visit the European fashion capitals. By learning its clients' needs first hand, the company can make purchases on their behalf in their absence.

Carole and Nathalie Fashion Reporting Service covers such reigning fashion markets as those found in London, Paris, Amsterdam, St. Tropez, Paris, Berlin, and Milan, thereby helping its retail buyer clients to maximize their potential for success.

Just as the domestic marketplace offers certain advantages to buyers, so do the **off-shore production** locales for the following reasons:

• *Fashion-forward design.* Although many American designers present lines with a definite "look" to them, a season's cutting-edge fashions often appear first on the runways of Paris, London, and Milan. The creations shown in these venues typically give buyers a glimpse of what is on the fashion horizon for all price points.

• *Prestige.* Many foreign designers attract a segment of the fashion consumer market. Clothing by names such as Prada and Louis Vuitton, for example, immediately give the wearer a feeling of status. It is obvious that neither the unique construction nor the materials of these items account for their cost; people are willing to pay for the gratification that comes from someone recognizing the names or logos emblazoned on them. Prestige and status are extremely important aspects of upscale, fashion-forward merchandise, and buyers and merchandisers responsible for purchasing the most noteworthy of these items often find them in the world's overseas fashion markets.

- *Value.* Not every foreign resource produces prestigious apparel. Buyers who purchase merchandise for the brick-and-mortar operations, catalogs, and retail Web sites are more often concerned with getting a price advantage. The cost of producing goods in America is far greater than it is in many overseas manufacturing arenas except for those designed and produced in the couture capitals of the world. Eastern European countries, Mexico, China, and the Caribbean Basin countries, for example, are able to manufacture items that are similar to those made in the United States but at significantly lower prices. One need only glance at the labels of the value-oriented merchandise found in Target and Wal-Mart to see the large percentage of items produced overseas.

- *Exclusivity.* More major retailers are in pursuit of items that are not found in their competitors' model stocks, because inventory duplication invariably affects their bottom line. When retailers need to meet last year's sales figures during a slow selling period, they might mark down certain lines. If these lines are the same that a competitor is also reducing, a price war may develop. To avoid these complications and to also provide unique styles, many buyers scour the overseas markets for products that the retailer can have to itself. Often times, a manufacturer will produce a collection that bears the company's own label, thus making it an exclusive line. In other cases, a buyer searching for out-of-the-way resources might turn up products that the competition might not know about. When retailers place large orders from these off-shore producers, they generally negotiate exclusivity agreements, enabling them to merchandise the line as they see fit, which usually results in higher-than-average markups.

- *Product quality.* Just as foreign automobiles are enticing to many Americans because of their high quality, so are fashion items from certain overseas countries. Places such as Belgium are noted for the fine workmanship on linen garments, Japan for silk products of distinction, and Spain for quality leather apparel. Professional purchasers for prestigious American fashion retail outlets are in constant pursuit of collections that feature unusual quality and they frequently include merchandise labeled from these countries to satisfy their customers.

These advantages make off-shore purchasing tempting, but as was mentioned previously in the discussion on domestic markets, the quoted prices are often in foreign monetary designations such as the Euro. The daily fluctuation of the Euro against the dollar makes it difficult to predict exactly what the cost of the merchandise will be when it is invoiced to American retailers. When the dollar weakens, the merchandise may actually cost more than anticipated to the point of being outside the merchant's price point structure. To this unknown are costs that are added to the initial price of the items such as packing, commissionaires' fees, tariffs, and shipping. Buyers must carefully determine the latter extras to derive the actual cost, or the landed cost, of the merchandise when it reaches their American retail operation.

Major Off-Shore Fashion Markets

The four corners of the world are dotted with fashion markets that produce every conceivable classification of apparel, accessories, and home furnishings that have appeal to the American consumer. These markets are in the traditional fashion capitals of Europe, in Asian countries, Canada, and Mexico as well as in obscure locations such as the Caribbean Basin countries. Each serves as a unique environment for buyers to explore and find products that best meet the needs of their clienteles.

PARIS, FRANCE

Ever since the designs of Paul Poiret, Madame Paquin, and Jeanne Lanvin made headlines at the turn of the twentieth century, and Vionnet, Patou, Chanel, and Schiaparelli followed, Paris became the standard for couture fashion. Today, with **couturiers** such as Lagerfeld carrying the torch, it is still Paris that commands the respect of professional buyers, fashion editors, and those who just love to read about the world of fashion.

The seriousness of fashion as a business in Paris is addressed in a Spotlight of **Chambre Syndicale De La Couture**.

Paris still remains an important overseas fashion venue where American buyers flock to see the new collections and study the styles featured in the couture shops.
(Courtesy of Ellen Diamond)

Fashion Retailing Spotlights

CHAMBRE SYNDICALE DE LA COUTURE

As the regulating commission that determines which fashion design houses are eligible to be true haute couture houses, Chambre Syndicale plays a major role in the promotion of fashion in Paris. Unlike the fashion industry in the United States, for which there is no regulatory control, the Chambre deals with piracy of styles, foreign relations and organization, and the coordination of the fashion collection timetables. It is this last function that is vitally important to buyers from every part of the globe so that they can best manage their time constraints and be able to view the collections.

Only the crème de la crème are eligible for membership in Chambre Syndicale. Those successful in gaining membership must produce fifty new and original designs of day and evening wear for each collection, must show two collections each year, and must employ a minimum of twenty full-time people. Because of the strict regulations, only a few design houses can achieve this status. This, of course, makes those collections the ones that the buyers want to see.

Buyers of couture merchandise for companies such as Bergdorf Goodman, Saks Fifth Avenue, and Neiman Marcus regularly contact the Chambre to make certain that their schedules dovetail with the collections' openings. They also communicate with the Chambre to ascertain the roster of designers that are members of the association and to learn about newly admitted couture houses. By doing so, the buyers are able to guarantee which couturier collections will be on view during the hectic season openings.

Attendance at the collections comes at a price. Unlike their fashion counterparts in the United States, where collection viewing is free, couture houses in Paris charge a **caution fee**, or an attendance fee, to view the lines. The fee is scaled according to the buyers' purposes. Some buyers go only to get an idea of the styles that will eventually be produced for public consumption, others for the purpose of buying and selling certain models, and still others for the rights to purchase *linen toiles,* with detailed sketches that their retailers can use as the basis of their own private lines.

Today there are only twelve couture houses that enjoy the status of being recognized as an "official" couture house in Paris. The large number of buyers that continue to flock to the collections' openings verify the importance of Chambre Syndicale as a fashion influence.

Buyers come from every part of the globe to catch the heralded openings of each season's fashion couture collections. They come there not only to buy the couture designs for their most affluent customers but also to get ideas about the trends that will eventually emerge from these designer creations. Also important to many fashion buyers are the prêt-a-porter, or ready-to-wear, collections offered at significantly lower price points. For the most part, it is these more affordable collections that eventually make their way into the American retail operations.

MILAN, ITALY

Where Paris once stood alone as the preeminent fashion capitol of the world, Milan has joined her as a fashion center of global importance. With Armani, Ferre, Missoni, and Krizia heading the list of fashion **couturiers**, buyers responsible for couture price points or as well as those who just want to learn about fashion's cutting edge gather there to view the collections.

LONDON, ENGLAND

Rounding out the trio of European fashion leaders is London. Its popularity as a fashion center is based upon the acceptance of such notable designers as Vivienne Westwood, Zandra Rhodes, Maxfield Parrish, and Betty Jackson, and it features a variety of designs ranging from the avant-garde to the more traditional.

SPAIN

When American buyers are in the market for leather apparel and footwear, few countries offer them more variety than Spain. Recently however, this country has made its way onto the list of buyers seeking to purchase women's and children's fashions. Most companies are centered in Madrid or Barcelona and feature the designs of Adolfo Dominguez, Antonio Alvarez, Marguerita Nuez, and others who have gained considerable recognition in the United States.

GERMANY

Another rising star in the international fashion scene is Germany, with its ever-growing list of fashion designers headed by Hog Boss and Jil Sander. So successful have their creations been with American consumers that these designers have opened flagship stores in the United States.

JAPAN

For upscale, fashion-forward design, Japan is one of the leading forces in Asia. In addition to being a leader in partnering with many American companies to produce their collections for consumption in Japan and other Asian countries, Japan also has a wealth of designers who have gained a great deal of attention from the American fashion industry; Issey Miyake and Rei Kawakubo being just two.

As in Paris and the other international fashion centers, specific dates and times that collections will preview their new lines are scheduled months in advance so that the buyers will have ample time to view as many collections as possible. As most buyers have only a short time to be away from their headquarters, they must plan their trips months ahead to maximize their time spent in these fashion capitols.

HONG KONG

Although it has made recent strides in producing original fashion collections through the efforts of such companies as Toppy and Episode, Hong Kong's importance to the industry is based upon its ability to produce fashion merchandise at comparatively low prices. Buyers flock there on a regular basis to discover designs that they can use in their companies' private label collections.

Hong Kong is an excellent overseas market where buyers flock to assess merchandise that they can amend for their company's private label collections.
(Courtesy of Ellen Diamond)

CANADA

With the passage of the North American Free Trade Agreement (NAFTA) in 1994, Canada has started to emerge as a fashion resource for merchandise that ranges from expensive to modest, and in stylings that include sophisticated as well as more serviceable products. Although its product range includes women's and children's wear, men's wear is Canada's forte.

MEXICO

Also a beneficiary of the NAFTA pact, Mexico continues to increase in importance as a supplier of fashion merchandise for American retailers. Its extremely low cost of production makes it especially appealing for merchants to have their private label collections produced there.

TIMING THE PURCHASE

As discussed in the previous chapter, buyers must make quantitative and qualitative decisions as well as resource evaluation, known as the elements of buying, before they actually make their purchases. Rounding out the details of this fundamental plan is the actual timing of the purchase so that the merchandise can reach the selling floors, catalogs, and Web sites in time to make the greatest impact on the consumer.

There are traditional purchase periods in the fashion market when the buyer begins to make selections for the next season. The time when the major companies send their buyers to the fashion industry to visit the resources is called **Market Week**. The number of such markets varies according to the particular merchandise classifications and the places where the markets are held. During Market Week, the buyers face a whirlwind challenge that requires their attendance at a host of collection openings.

Not every fashion retailer heads for the market during these times; most buyers attending then are the major players in the field who must get a jump on the competition in discovering what the latest offerings will be. Smaller retailers or those who are concerned with opportunistic buying, such as the off-price merchants, usually wait a little longer before they begin the process of evaluating the new season's offerings. The timing decisions are individually geared to the needs of the particular retailer, and different timing strategies have different implications.

Early Decision Making

Among the many advantages afforded the fashion buyer who participates in the earliest timing of purchases include the following:

• *Seeing the line in its entirety.* A vendor showing its collection for the first time includes every design it has created. The buyers at this showing have the opportunity to see the entire line and choose what is most appropriate for their model stocks. It is commonplace in the fashion industry for lines to be **edited** soon after Market Week, making fewer items available for the buyers to purchase later on. The editing is often based upon buyer acceptance, and if buyers don't place a sufficient number of orders for certain items those pieces often fall by the wayside. Thus, if buyers wait until a later time to view the collections, they do not have a role in selecting what items a vendor will stock, causing some pieces to be eliminated.

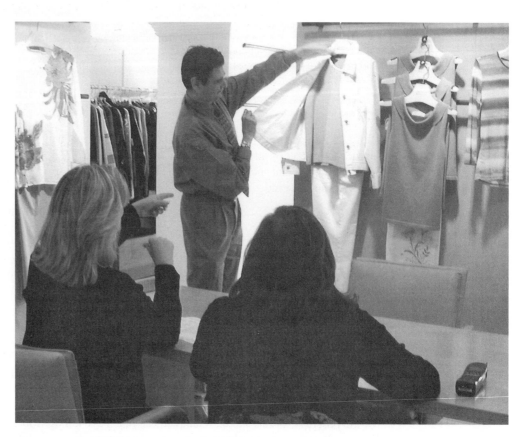

Buyers who visit the showrooms during "Market Week" see the entire line before it is "edited".
(Courtesy of Ellen Diamond)

- *Guarantee of early delivery.* In the fashion game, merchandise always must be delivered on time. This, however, does not imply that every merchant requires the same delivery dates. Fashion-first retailers such as Saks Fifth Avenue, Neiman Marcus, Bloomingdale's, and Macy's require the merchandise to be in stock as soon as it comes from the manufacturers' plants. For them, early delivery is essential so that they can have their model stocks ready to meet the needs of the customers who shop early each season.

- *Exclusivity agreements.* Almost every major player carries some of the identical lines, which can lead to significant problems with their competitors. When shoppers enter the selling floors of Neiman Marcus, Bloomingdale's, or Saks Fifth Avenue, for example, they see sections devoted to Ellen Tracy, Liz Claiborne, Ralph Lauren, or Dana Buchman in each one. While each store would prefer to avoid the potential problems associated with carrying the same labels, these marque brands are the leaders in their fields, and customers want to buy them. Retailers can gain a degree of exclusivity even with these collections through early decision making. Often, designers and manufacturers of such lines are willing to confine specific groups within the collections to retailers within a specific trading area. In this way, the designer label is represented in each store, but some of the merchandise is exclusively distributed to certain retail operations. Buyers who purchase early often work out these exclusivity agreements.

- *Obtaining seasonal discounts.* Early purchasing is sometimes a way to get the merchandise at discounted prices, because manufacturers love to get a jump on the season and will offer inducements to buyers who purchase early. In the swimsuit industry, for example, many producers reward their retailers with seasonal discounts if they purchase ahead of the traditional purchasing time frame. Not only is this a price advantage for these buyers but it gives them a head start on the competition and enables them to test the items with smaller quantities early in the season before the major selling period arrives. They can then eliminate the slow sellers and invest in the better styles.

Just as there are advantages to making early decisions in terms of purchase timing, there also disadvantages for some retailers. Among them are the following:

- *Purchasing "edited" items.* All fashion designers or manufacturers produce a line that they hope will appeal to the buyers. In reality, however, this is rarely the case. Some items do not sell well enough to be considered for production. Vendors have minimum order requirements known as **cutting tickets** that go into effect before they begin manufacturing a style. Buyers who order very early in the season may choose one of the eliminated items, only to be notified later that it is cut from the line. They must reexamine the collections to replace the discontinued models and make certain that their inventories are appropriately adjusted. Buying a little later in the season eliminates this occurrence.

- *The "winners" are yet to be determined.* While buying early affords buyers with the opportunity of being fashion first, it also makes the selection process more difficult. Early decision making also gives the buyer the opportunity to make more mistakes. Once the lines have been seen by the buyers who attend market weeks and purchase early, the vendor's sales reps know which pieces will be edited out and which will be the season's potential winners. Buyers who sometimes rely upon the vendor sales reps to give them advice now have the opportunity to gain from the reps' insights in terms of what is going to be a hot item.

Lead Time Requirements

One of the primary considerations in the proper timing of the purchase is **lead time**—the amount of time it takes to receive the order once it has been placed. Unlike much of the hard goods, such as major appliances, that line the floors of the wholesalers' premises and can be shipped within a day or two of an order, fashion merchandise is a different story. Vendors usually do not start manufacturing fashion items until they have processed a sufficient number of orders. Typically, fashion merchandise produced in the United States takes as long as six months after it is ordered before it is delivered. Buyers need to place their orders for goods produced offshore even earlier to make certain they will receive their orders on time.

Seasoned buyers are fully aware of the problems associated with receiving merchandise when they want it and must place their orders sufficiently early. It is vital that the inventory is in place to coincide with catalog presentations and advertising and promotional plans.

PURCHASING IN THE MARKETPLACE

Buyers have a wealth of both domestic and off-shore markets in which they may make their purchases. Buyers for major merchants, who have the luxury of visiting any of the global arenas, have a considerable advantage over those whose market visitations are more restricted. They can feel the pulse of the marketplace at the earliest possible time, enjoy the privileges of the earliest possible delivery dates, gain insight from the market representatives based within the wholesale markets, and trade information with the noncompeting merchants they meet at the trade expositions and manufacturers' showrooms.

Resident Buying Office Visits

Chapter 11, "Planning the Purchase," fully explored the relationship between the market specialists, also known as resident buyers, and the companies they represent. One of the most important services they provide is to assist the retail buyers when they come to market during Market Week by locating new resources, prescreening the fashion collections, analyzing market conditions, and so forth.

Most buyers stop at their resident buyers' office when they first arrive at the fashion markets. The resident buyers help their retail buyers clients make the best use of their limited time in the market. They perform a variety of duties such as presenting an overview of what the buyers are about to see in the vendors' showrooms or at the trade shows, providing buyers with a list of scheduled appointments made for them at these purchasing venues, alerting buyers to new resources that have the potential for success with their companies, answering any questions buyers might have regarding market conditions, and making themselves available to accompany the buyers to the market if the need arises.

Once the resident office representative provides the buyers with all of the information they need for a successful visit, they head for the showrooms or trade shows to preview the lines in which they are interested.

SHOWROOM VISITS

In the major wholesale venues such as New York City, the vast majority of fashion manufacturers and designers maintain permanent showrooms. Buyers visit these showrooms to see a season's entire collection and meet with the sales reps who regularly service their account. In some of the more important showrooms, especially during Market Week, the premises are transformed into show facilities that feature runways on which the models parade the latest offerings. In smaller showrooms, the different styles might be informally modeled so that the buyers can get a better idea of how the garments will look when they are worn. Other wholesale arenas such as the Apparel Marts in Chicago and Dallas also feature permanent showrooms for the buyers in those trading areas to visit and place their orders.

TRADE SHOWS

Trade shows, held throughout the world, specialize in a particular fashion segment and only last a short time. Table 12.2 lists some of the trade shows, their fashion segments, and their locales.

The value of trade shows is that buyers can see a great number of collections under one roof, saving them the time of going from one showroom to another and enabling them to compare the different lines more easily. Trade shows include the collections of smaller companies that aren't able to afford the luxury of their own sales arenas, so buyers can also see their offerings as well.

A visit to a trade show enables the buyer to evaluate many different collections under one roof.
(*Courtesy of Ellen Diamond*)

The salesman shows the buyers the details and the fabrics used in the garment under consideration for purchase.
(Courtesy of Ellen Diamond)

The manufacturer's merchandising executive explains the concept of the collection.
(Courtesy of Ellen Diamond)

Stay on top of:

- **Key Items**
- **New Resources**
- **Overseas Influences**
- **Fashion News**

Buyers who wish to make certain they are abreast of the information that affects their purchases often log onto such resources as Doneger Online, the Web site of a resident buying office.

(Courtesy of The Doneger Group)

casuals

palm isle
left to right

Vest 1422928 p & w, Tank 1422075 p & w,
Pant 1422876 p & w

Shirt 1422602 p & w, Tank 1422075 p & w

T-Shirt 1422076 p & w (coral and peach),
Skirt 1422725 p & w

Sweater 1422300, Skirt 1422724

Fundamental Sweater 1422302 p & w

Shirt 1422615 p & w, Tank 1422075 p & w,
Fundamental Pant 1422885 p & w

island girl
left to right

Jacket 1422923, Tank 1422021

Tank 1422021

Fundamental Sweater 1422302
Pant 1422884

T-Shirt 1422094, Pant 1422883

Shirt 1422608, Pant 1422883

Shirt 1422606, Pant 1422883

Shirt 1422607, Pant 1422883

boheme
left to right

Jacket 1422929 p & w, Tank 1422081
Skirt 1422737 p & w

Shirt 1422698 p & w (white and celery)

Sweater 1422310 p, Pant 1422804 p & w

Fundamental Sweater 1422302 p & w
Pant 1422879 p & w

T-Shirt 1422095 p & w

Vest 1422920 p & w, Tank 1422081 p & w
Skirt 1422736

Shirt 1422612 w, Tank 1422081
Fundamental Pant 1422885 p & w

mosaic
left to right

Tank 1422082, Skirt 1422730

Tank 1422082, Fundamental Pant 1422885

Fundamental Sweater 1422302
Skirt 1422732

T-Shirt 1422007

T-Shirt 1422084

T-Shirt 1422007

Fundamental Sweater 1422302
Skirt 1422731

Tank 1422082, Fundamental Pant 1422885

T-Shirt 1422084, Skirt 1422729

After visiting a manufacturer's showroom and still undecided on the merchandise to be purchased, many buyers use product photographs as reminders.
(Courtesy of Susan Bristol, Inc.)

When ideas are needed for product development of a retailer's own label, Hong Kong is often the destination.
(*Courtesy of Ellen Diamond*)

Visits to off-shore markets such as Paris help buyers learn about the trends in couture and upscale fashion merchandise.
(*Courtesy of Ellen Diamond*)

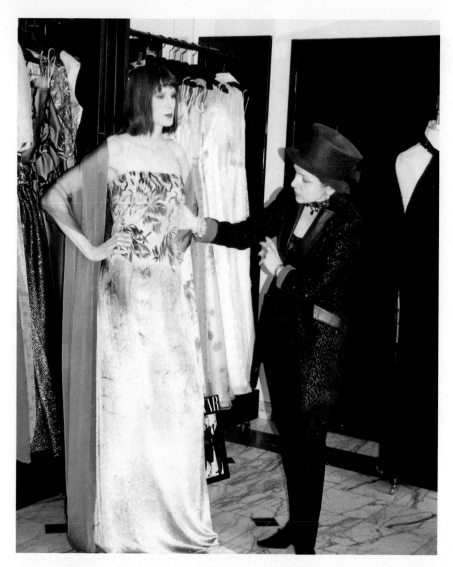

At the couture level, a designer, shown here adjusting a model's gown, maintains a large fabric collection for possible use in this design and others.
(Courtesy of Ellen Diamond)

Fine fabrics are a necessity in the creation of a couture design.
(Courtesy of Ellen Diamond)

Using computer-aided design to perfect the silhouette.
(Courtesy of Ellen Diamond)

The workrooms, many of which have moved off-shore, manufacture the products.
(Courtesy of Ellen Diamond)

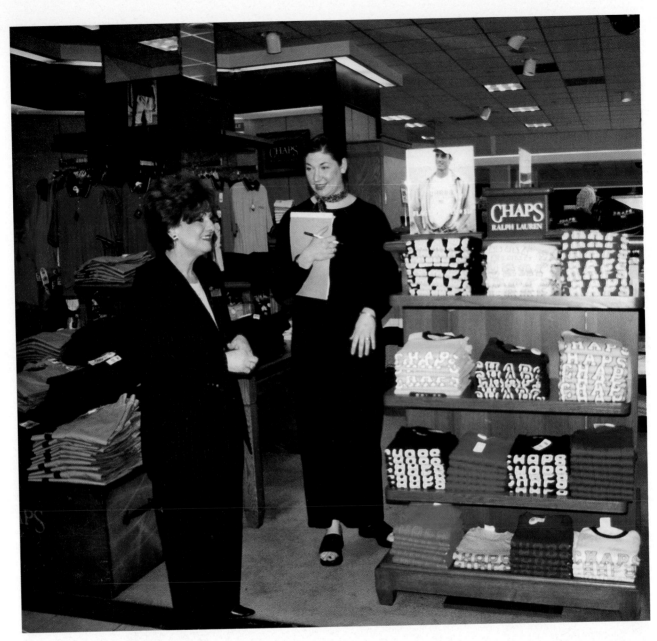

A buyer checks newly arrived merchandise.
(Courtesy of Ellen Diamond)

Showroom visits enable the buyers to see the entire collection.
(Courtesy of Ellen Diamond)

TABLE 12.2 Selected Trade Shows

Trade Show	Specialization	Location
Moda Prima	Knitwear	Milan
Fashion Shoe	Footwear	Bologna
Pitti Uomo	Men's Wear	Florence
Pitti Bimbo	Children's Wear	Florence
Premium Sportswear	Men's and Women's Wear	Berlin
Copenhagen International Fashion Fair	Women's, Men's, and Children's Wear	Copenhagen
Jewelry World Expo	Jewelry	Toronto
MODA Moscow	Women's and Children's Wear	Moscow
MAGIC	Women's and Men's Wear	Las Vegas
NAMSB	Men's Wear	New York City
Pret-a-Porter Paris	Women's Ready to Wear	Paris
International Boutique Show	Women's Apparel and Accessories	New York City
Kids Fashion Brussels	Children's Wear	Brussels
International Kids' Show	Children's Wear	New York City
Paris Haute Couture Collections	Couture Women's Wear	Paris

ALTERNATIVES TO WHOLESALE MARKET VISITS

Many smaller fashion retailers have neither the time nor the financial resources necessary to visit the wholesale markets to make their purchases. Those that can, however, usually must restrict their number of market visits to Market Week openings. To assess the fashion producers' merchandise on a year-round basis and review any additions to various lines made since the season began, buyers are able to arrange for alternative purchasing opportunities.

Trade shows enable buyers to cover the wholesale market more quickly.
(Courtesy of Ellen Diamond)

Fashion Representative Visits

Most major fashion manufacturers maintain a staff of road representatives that visit different retailers. The sales reps are responsible for certain regional territories, and they travel from retailer to retailer to show what is new to their line. Although this is an excellent way for merchants to see a vendor's line without leaving their premises, the reps are not able to carry the entire collection and frequently only bring what the vendor considers to be its highlights.

Business-to-Business Web Sites

Many fashion manufacturers and designers maintain Web sites to show their collections to the retail buyers. They regularly update the sites to feature the highlights of their lines and to edit them as the need arises. By logging onto these Web sites even buyers from the smallest operations can feel the pulse of the fashion industry without leaving their businesses.

Buyers who practice opportunistic buying for off-price ventures use numerous Web sites that feature fashion closeouts of fashion items at distressed prices. Merchandise from well-known labels including Liz Claiborne, Nike, and Ralph Lauren are regularly offered at closeout prices.

The beauty of **business-to-business Web sites** for fashion merchandise is that buyers can search them any time of the day or night without interfering with their other duties.

WRITING THE ORDER

Seasoned buyers rarely commit themselves to specific merchandise the first time they see the lines. They generally take notes on what they have seen at each showing so that they can compare and evaluate each item against what they have seen at all of the resources. Once they have examined everything, they choose those fashions that best fit their model stocks.

Before they write any order, buyers must negotiate the various terms of the agreement. A purchase order is a formal contract and must be entered into with care. The negotiation involves price, a host of discounts, allowances for advertising, delivery dates, terms of the shipment, and chargebacks. Each of these areas are described in the following sections.

On this business-to-business Web site retail buyers are led to the latest fashion offerings without having to leave their premises. *(Courtesy of The Doneger Group)*

Susan Bristol

Casuals, Spring 2004

SB ORDER NO._____ ACCOUNT NO._____ SUSAN BRISTOL · SPRING '04/FORM 1/25
STORE NO._____ DEPT NO._____ P.O. NO._____
CUSTOMER NAME_____
BILL TO_____ ADDRESS_____
SHIP TO_____ ADDRESS_____
UNITS_____ DOLLARS_____ SPECIAL INSTRUCTIONS_____
ORDER DATE_____ START DATE **12/15** COMPLETE DATE **1/30**

Garden Grown

SWEATERS

STYLE 1412302 — $44.00
L/S Colorblock Crewneck with Embroidery and Beads.
100% Cotton.

Color	S	M	L	XL	Units	Total
04-Multi						

STYLE 1412305 — $60.00
Long Sleeve Zip Front Cardigan with Embroidery and
Coverstitching Detail. Cotton Blend.

Color	S	M	L	XL	Units	Total
61-Aquamrn						

FRENCH TERRY TOPS

STYLE 1412400 — $39.50
French Terry Hooded Zip Front Jacket with Solid Canvas Fabric as
Pocket Detail. 80% Cotton 20% Polyester.

Color	S	M	L	XL	Units	Total
51-Kelp						

STYLE 1412497 — $39.50
French Terry Open Neck Raglan Sweatshirt with Multi Embroidery and
Contrast Stitching Detail. 80% Cotton 20% Polyester.

Color	S	M	L	XL	Units	Total
42-Coral						
51-Kelp						

STYLE

Color	S	M	L	XL	Units	Total

SHIRTS

STYLE 1412689 — $39.50
Long Sleeve Button Front Floral Printed Blouse with Lace
Insert Detail. 100% Cotton Lawn.

Color	S	M	L	XL	Units	Total
05-Multi						

KNIT TOPS

STYLE 1412028 — $24.50
Long Sleeve Split Neck 1x1 Rib Tee with Lace Applique Detail.
100% Cotton.

Color	S	M	L	XL	Units	Total
20-Natural						
44-Coral						
62-Aquamrn						

STYLE 1412045 — $29.50
Long Sleeve "V" Neck 1x1 Rib Tee with Floral Printed Fabric Trim.
100% Cotton.

Color	S	M	L	XL	Units	Total
20-Natural						

STYLE 1412058 — $19.50
Scoop Neck Lustreknit Tank.
55% Cotton 45% Polyester.

Color	S	M	L	XL	Units	Total
43-Coral						
57-Kelp						
65-Aquamrn						

SKIRTS

STYLE 1412700 — $34.50
Long Drawstring Stretch Skirt with Side Welt Pockets and Seaming
Detail. 36" Length. 98% Cotton 2% Spandex.

Color	4	6	8	10	12	14	16	Units	Total
52-Kelp									

STYLE 1412701 — $44.00
Short No-Waist A-Line Skirt with Lace Insert Detail and Invisible
Side Zip Entry. Lined. 25" Length. 100% Cotton Lawn.

Color	4	6	8	10	12	14	16	Units	Total
05-Multi									

PANTS

STYLE 1412833 — $49.00
Jacquard Cargo Pant with Contrast Stitch Detail and Embroidery.
31" Inseam. 100% Cotton.

Color	4	6	8	10	12	14	16	Units	Total
21-Stone									

STYLE 1412834 — $34.50
Drawstring Stretch Pant with Side Welt Pockets and Seaming
Detail. 31" Inseam. 98% Cotton 2% Spandex.

Color	4	6	8	10	12	14	16	Units	Total
52-Kelp									

STYLE 1412846 — $34.50
French Terry Pull-On Drawstring Pant with Pieced Solid Canvas Fabric
and Multi Embroidery Detail. 31" Inseam. 80% Cotton 20% Polyester.

Color	S	M	L	XL	Units	Total
51-Kelp						

STYLE 1412862 — $29.50
French Terry Cropped Drawstring Pant with Contrast Stitching Detail.
25" Inseam. 80% Cotton 20% Polyester.

Color	S	M	L	XL	Units	Total
42-Coral						
51-Kelp						

STYLE

Color	4	6	8	10	12	14	16	Units	Total

signature_____ date_____

Some fashion manufacturers provide an order sheet for their customers that features the designs as well as the wholesale prices. *(Courtesy of Susan Bristol, Inc.)*

Pricing Considerations

In most cases, fashion merchandise pricing is fixed, with the same costs applicable to both large and small merchants. Even those who purchase in small quantities are often bound by the constraints of the **Robinson-Patman Act**. This piece of legislation was enacted to limit price discrimination and help the small retailers compete with large ones so they could stay in business. The conditions of the law are carefully spelled out and indicate that every purchaser must pay the same price except under certain circumstances. These exceptions are as follows:

- The merchandise is a job lot or closeout in which assortments are limited and reorders are unavailable.
- The manufacturer needs to meet the competition's prices.
- The savings that come from producing merchandise for specific clients may be passed on to the clients.

DISCOUNTS

Although the base prices are generally fixed, there are conditions under which a better price may be negotiated, as follows:

- *Cash discounts.* The vast majority of fashion manufacturers and designers offer small **cash discounts** to encourage prompt payment of the invoices. This usually involves a thirty-

day time frame in which the bills may be discounted at rates that vary from a typical high of 8 percent to a low of 2 percent.

- *Anticipation discounts.* To motivate retailers to pay their bills even earlier than they would to receive a cash discount, many manufacturers offer an extra discount known as an **anticipation discount**. Merchants who opt to pay their invoices at this predetermined time are rewarded with additional discounts of 1 to 2 percent. Suppliers who might have a cash flow problem and need the money as soon as possible to pay for the costs of production frequently offer those discounts.

- *Quantity discounts.* Although the Robinson-Patman Act generally disallows discounts based solely on the size of the order, some **quantity discounts** are allowed if the production of the large quantity results in lower manufacturing costs.

- *Seasonal discounts.* In some fashion merchandise classifications such as swimwear and outerwear, retailers taking early deliveries sometimes receive extra price reductions. For example, coat buyers, whose season typically begins in early September, willing to take the goods as early as June, can often negotiate an additional discount. There are advantages to both the buyer and seller of this merchandise. Early delivery enables retailers to test the waters and determine what the hot sellers will be, giving them an indication of what should be reordered and what should not. Vendors enjoy the advantage of getting paid earlier and do not need to allow space for long-time storage of the items, a costly part of their marketing.

Advertising Allowances

Retailers, large and small, use advertising as a means of promoting their companies and merchandise to regular and potential customers. The costs of these endeavors are comparatively high, and any assistance to defray their costs can help improve the retailers' profit margins. At the time of negotiating the terms of the purchase, buyers are often able to get monies from the vendors to help with their advertising budgets. Through the use of **cooperative advertising**, vendors contribute to costs of the retailers' advertisements as long as their companies' name and merchandise appears in the ads. Chapter 15, "Advertising and Promotion," provides a more detailed discussion of cooperative advertising.

Delivery Dates

Although the timing of the merchandise delivery is important to every product classification, prompt delivery is especially important for fashion merchandise. The nature of this type of merchandise, with its relatively short seasonal life, makes on-time arrivals imperative. Buyers must make certain that the goods are promptly delivered according to the dates stipulated on the order for a number of reasons: to reap the benefits of planned advertisements, to have goods in stock early enough for peak selling periods, and to allow for special promotions of the goods.

The buyer must carefully note the delivery dates on the purchase order and include starting dates and **completion dates**. If deliveries are not made within these time frames, buyers must make certain that the orders are subject to cancellation. In either case, the early or late deliveries interfere with the predetermined model stocks. Merchandise received too early may result in too much merchandise for a particular selling period; Merchandise received too late may cause the inventory to be incomplete.

Shipping Terms

The cost of shipping merchandise continues to escalate. To make certain that the manufacturer chooses the most cost-effective methods for the deliveries, the buyer must indicate on the purchase order the name of the preferred shipping company and the terms of the shipment. Typically, shipping costs are the responsibility of the retailer, but in special cases where the orders are significantly large, buyers may be able to negotiate a deal where such expenses might be passed on to the vendor or shared by both parties.

The order must have such terms as **FOB shipping point** or **FOB destination** clearly spelled out to avoid any problems. The former requires that the retailer pay for the shipping charges, and the latter charges the vendor.

Chargebacks

When merchandise doesn't sell as well as anticipated, many major retailers want the vendor to share in the problem. Although the manufacturers and designers do not want to partake in such discounts, they are inclined to do so if the purchaser represents a major retail operation. Given the competition in fashion merchandise, there is little that vendors can do to avoid the problem of chargebacks. Without these considerations, buyers are likely to find other resources that will acquiesce to these demands. The professional buyer must negotiate these terms when the order is written. Failure to do so may result in the vendor's refusal to grant these discounts.

When all of the terms and conditions of the orders have been agreed upon by both parties, the order is submitted and processed for future delivery.

TRENDS IN DOMESTIC AND OFF-SHORE PURCHASING

The different domestic and off-shore fashion wholesale markets continue to provide venues in which buyers may make their purchases. Among the trends that are in the forefront of such purchasing are the following:

• *Purchasing in atypical arenas.* While buyers continue to visit the major fashion capitals around the world for their primary resources, more are visiting remote areas of the globe to obtain merchandise at the lowest possible costs. Most of these purchases are based upon the retailers' own designs for private labels, and they use these foreign resources to manufacture them.

• *Purchasing domestically produced products.* Although overseas markets are becoming increasingly more important to retailers, and the labels verify that a wealth of products are produced off-shore, many American retailers are opting for domestic production because of such advantages as quality control, more reliable delivery dates, and the promotional value of stocking "Made in America" merchandise.

• *Using intermediary buying services.* Especially for the smaller retailer that doesn't have the resources to check overseas markets on a regular basis, if at all, the use of off-shore buying offices and fashion services continues to increase. These market specialists allow such merchants to avail themselves of the latest fashion innovations without leaving their premises.

SMALL STORE APPLICATIONS

The smaller merchant is at a disadvantage when it comes to covering all of the global fashion markets. Although being able to assess the different domestic and off-shore marketplaces is vital to their success, most have neither the financial resources nor the time to cover them.

By limiting their visits to seasonal openings in wholesale markets that are close to their operations and augmenting these visits with appointments with road representatives, small retailers can offer their customers the latest in fashion merchandise. With at least one regional market in the United States within reach of most fashion merchants, attendance at the season's openings in these markets can be cost effective. There are also numerous traveling trade shows that come to the major cities that are likely to be within reach of even the smallest merchant.

As a backup to these visits, membership in a resident buying office or fashion consulting firm assures small retail buyers of advice on the trends in fashion merchandise and assistance with making purchases.

Chapter Highlights

1. The vast majority of the products found in most major traditional retail operations are purchased in one or more of the domestic markets.
2. Purchasing in the domestic markets affords the retailer greater delivery reliability, price guarantees, reliability of fit, and economic advantages.
3. For fashion apparel and accessories, the major domestic wholesale market is in New York City.
4. Regional markets in the United States are found in many parts of the country, with the leaders in Los Angeles, San Francisco, Chicago, Dallas, and Miami; local manufacturers show their wares and those of companies from other parts of the country.
5. Purchasing off-shore is attractive to fashion buyers because of such advantages as fashion-forward design, prestige, value, exclusivity, and product quality.
6. Paris remains the world's leading couture fashion market due in part to the efforts of its regulatory agency, Chambre Syndicale.
7. Other countries such as Italy, England, Spain, Germany, and Japan offer the collections of world-famous designers.
8. Purchase timing is essential to the success of every fashion operation.
9. Buying in the wholesale markets, especially during Market Week, affords the retailer the guarantee of early delivery, potential exclusivity agreements, the chance to see the line in its entirety before it has been edited, and the possibility of seasonal discounts.
10. When buyers go to the fashion markets, those with resident buying office affiliation head to these market consulting firms before they make any vendor visits to receive advice on what they are about to see.
11. Buyers can visit individual manufacturer and designer showrooms or go to trade shows, where a wealth of different lines are shown under one roof.
12. Retail buyers who are unable to regularly make personal visits to the marketplace may place orders with traveling sales reps or through business-to-business Web sites.
13. Writing the order involves such aspects as pricing considerations, negotiating a variety of discounts, and obtaining advertising allowances.

Terms of the Trade

landed cost
chargebacks
Garment Center
7th on Sixth
me-too lines
off-shore production
couturiers
Chambre Syndicale De La Couture
caution fee
Market Week
edited lines
cutting tickets
lead time
trade shows
business-to-business Web sites
Robinson-Patman Act
cash discounts
anticipation discounts
quantity discounts
cooperative advertising
completion dates
FOB shipping point
FOB destination

For Discussion

1. Why do the ever-growing list of off-shore fashion merchandisers continue to play such an important role for American retailers?
2. What are some of the advantages of buying in domestic marketplaces?
3. Define the term "chargeback" and explain why so many major retailers demand this consideration before placing their orders.
4. Which is the major fashion wholesale market in the United States, and what are some of the regional markets of importance?
5. With all of the potential problems involved in off-shore purchasing, why do so many American fashion retailers still choose to purchase overseas?
6. What is the meaning of the term "landed cost," and what impact may it have on purchases?
7. Who is the regulating body for couture fashion in Paris, and how does it serve retailers who have plans to attend the collection openings?
8. Why have Mexico and Canada become more important off-shore producers for American retailers?
9. What advantages do early decision making in terms of purchasing afford the retail buyer?
10. Is it important for buyers with resident buying office affiliation to visit their market representatives before visiting the vendors? Why?
11. In what way does a visit to a trade show benefit the buyer more than visits to different manufacturers' showrooms?
12. If buyers are unable to regularly come to the wholesale market to purchase, what alternatives allow them to view the vendors' lines?
13. What is the purpose of the Robinson-Patman Act?
14. How does a regular cash discount differ from an anticipation discount?
15. What arrangements for advertising compensation do buyers often make with their vendors?
16. What is the difference between FOB shipping point and FOB destination?

CASE PROBLEM I

Abby and Amanda Ltd. is a very chic, upscale retail fashion operation. Its clientele is composed of women who are primarily in the lower upper classes. Wives of entertainers and successful businessmen, as well as being major executives in their own right, these women are extremely careful about acquiring the most fashion-forward merchandise available. Price is not a factor, only the uniqueness of the apparel and accessories.

Unlike the majority of retailers that merchandise collections at these price points, Abby and Amanda Ltd. is a comparatively small company. Since it began ten years ago in a small space that measured 1,200 square feet, it has continuously expanded its store to its present location that occupies approximately 15,000 square feet. Its merchandise assortment is primarily composed of price points that begin at the bridge level and go upward to the couture level. Its appeal to its clientele is based upon the fact that it does not carry the "me-too" lines of other merchants but deals exclusively with marque couturier collections and prêt-a-porter lines that do not regularly have a great deal of recognition in the United States.

The need for Abby and Amanda Ltd. to maintain its level of exclusivity requires that the company's partners, Abby and Amanda, who are also the buyers, visit the overseas fashion markets to make their selections. They always go together to make certain they agree on their purchases. While it has been their practice to attend the major French collection openings twice a year, their time constraints haven't allowed them to look past these lines. The five days in Paris is barely enough time to see the major offerings. Being aware of other European fashion capitols as potential resources, Abby and Amanda would like to expand their purchasing horizons and buy the exciting lines available there. In particular, they would like to learn more about the fashion collections in London and Milan for possible inclusion in their inventories. But with their limited time to spend overseas, they haven't been able to adequately assess these fashion capitol offerings.

With more of their customers inquiring about the couture collections of other countries, the partners are in a quandary as to how to evaluate these fashion offerings and how to attend the openings in London and Milan without spending more time abroad.

Questions

1. Is there any way in which the partners can gain sufficient information on the European fashion market without spending time abroad?
2. How might the partners devise a plan to cover the European collections without spending more time abroad?

CASE PROBLEM 2

Fashions for Less is a small off-price retail chain that specializes in a wide assortment of fashion apparel and accessories. Its price points begin at the moderate level and continue up to the bridge collections. Liz Claiborne, Jones, Anne Klein, and other recognizable labels are regularly found in its inventories.

It began with one small unit and now operates a chain of eight, all of which are within a 200-mile trading area. Its customers are astute fashion shoppers who have an excellent sense of the latest innovations in the fashion industry. The major reason for its customer appeal is the price advantage it offers. Typically, the merchandise it carries is priced at least 25 percent below what the traditional fashion retailer charges.

With its considerable success, the chain is always in the market for new merchandise. Of course, it buys opportunistically to be able to offer the bargains to its clientele. Being in New York City's Garment Center at least three days a week gives its buyers ample time to cover the closeouts that the vendors are offering. However, with their close proximity to New York City, this is the only market they are able to regularly attend. With such domestic fashion capitols as Los Angeles and San Francisco producing fantastic fashion lines, the buyers would like to cover them with the same vigor and regularity that they do in New York City.

At the present time, the company has three buyers, with each covering a specific price point. While it might eventually be practical to hire a fourth person to cover the other markets, the company believes it should move slowly in that direction and use alternate means of product acquisition before it adds another buyer.

Opportunistic buying is different than traditional buying because purchases must often be made as soon as the value merchandise becomes available.

Question

1. What would you suggest that the company do before hiring another buyer and at the same time be able to cover the other domestic wholesale markets?

EXERCISES AND PROJECTS

1. Log onto a search engine such as **www.google.com** to locate the Web sites for international fashion associations such as Chambre Syndicale De La Couture. Each fashion capitol has associations that provide a great deal of involvement in its respective industries. Select one of these organizations and write a report that includes the following:
 a. The name of the group
 b. Its purpose
 c. Requirements for inclusion
 d. Costs of membership
 e. Roster of members
2. Using the domestic fashion marts listed in the chapter, select two and either write to them for information regarding their purpose or log on to their Web sites to gain this information. Prepare an oral report on the two marts that includes their locations, the retail markets they serve, their product specialization, and so forth.

CHAPTER 13

The Retailing and Development of Private Labels and Brands

After reading this chapter, you should be able to:

- Contrast the merchandising advantages of private labeling and branding with those of the national brands and labels.

- Enumerate the different approaches used by retail operations in their pursuit of private label and brand involvement.

- Discuss the differences between *partnering* and the other private brand routes merchants take.

- List many of the major retailers involved in private branding and labeling and their approaches to this merchandising concept.

- What the term "The Store Is the Brand" means, and why some of the country's largest retailers have embraced this plan.

- The different merchandise acquisition methods retailers use in their pursuit of private labels.

- How small retailers have entered this merchandising market without the resources necessary for their own production facilities.

Fashion retailing is a very competitive business, and the effort to keep customers from shopping elsewhere often seriously affects a company's profitability. Because so many retailers carry inventories that look like clones of each other, there is often little difference between their model stock. Walking through most department stores, for example, or looking at the offerings featured off-site in catalogs and on Web sites, one immediately recognizes that they all carry the same lines by fashion leaders such as Liz Claiborne, Ralph Lauren, and DKNY. Because so many outlets have the same stock, there is as little variety in fashion offerings as there is in the appliances that are stocked in the large home-improvement stores. Although most consumers don't mind if the appliances they buy are not unique, they do want variety in their selection of fashion apparel and accessories. Fashion enthusiasts want a degree of exclusivity. Most do not want to walk into a room and find several people clad in the same ensembles.

This lack of individuality is not the only problem that results from merchants stocking almost identical inventories. With so many retailers carrying the same lines, they must frequently cut prices. Faced with a slow selling period, the overstocked merchant might slash prices, which could force its competitors to do the same, resulting in a loss instead of a profit for them all.

More merchants are turning to creating private labels and brands to differentiate their model stocks from the rest of the field. They are either using them as a percentage of the total merchandise mix or exclusively stocking their shelves with a single signature brand. The development of these labels and brands gives retailers a degree of exclusivity and makes them less likely to be affected by the problems associated with carrying the same brands as their competitors.

This steady move toward private labeling was prompted by industry research pertaining to fashion merchandise, particularly the results of a study conducted by the market research firm NPD Fashionworld, based in Port Washington, NY. It revealed that designer apparel accounts for 7 percent of the business, private label 35 percent, national brands 52 percent, and others 6 percent.

Major fashion retailers such as Bloomingdale's, Macy's, Marshall Field's, and Saks Fifth Avenue have embraced this concept by developing a host of these brands that they include alongside the marque labels that many of their customers still desire. Others, such as Gap and Banana Republic, have taken exclusive branding to an even greater stage and feature only their own products in their inventories. This concept has become known as "the Store Is the Brand," and has freed the businesses that subscribe to it from the need to continuously check the competition to learn if their prices are in line with them.

By choosing this approach to inventory development, fashion retailers have taken on a new responsibility. Where merchandise selection was once determined by assessing the industry's offerings and selecting the best collections for their clienteles, retailers are now in the business of creating lines that bear their own signatures, producing them, promoting them, and hoping that they have the appeal to motivate their customers to purchase them.

NATIONAL BRANDS

Throughout the United States and abroad, the brick-and-mortar operations as well as the off-site ventures feature a host of **national brands** and labels that are immediately familiar to the consumer, such as Ralph Lauren, Calvin Klein, Liz Claiborne, DKNY and Anne Klein. These are the brands that have been promoted through both the print and broadcast media and have maintained a loyal following among shoppers around the world. They are generally available in a variety of retailers' model stocks and do not feature any degree of exclusivity.

In spite of their universal appeal, these brands cause a number of different problems for the merchants that stock them. First and foremost is price cutting. Retailers have no protection from competitors that find the need to reduce their prices of these identical lines. They also are at the mercy of the off-price merchants, whose opportunistic purchases give them

The "story board" is used to create private brands for retail clients.
(Courtesy of Ellen Diamond)

the advantage of buying for less and selling for less, than the traditional merchants. There is no longer any **fair-trade pricing,** which once protected retailers from untimely markdowns. The availability of these designer brands in so many on-site and off-site ventures in turn often makes them less desirable to those customers looking for some degree of exclusivity, and they shop elsewhere in their search for unique fashions.

In spite of all of these drawbacks there is still a market for these collections, and as indicated by the racks upon racks of these nationally prominent lines in most stores, retailers are not about to relinquish their rights to stock them.

Advantages of National Brands

While there are certainly disadvantages inherent in carrying national brands, there are also a wealth of reasons for retailers to feature them in their inventory, including the following:

• The amount that manufacturers spend on advertising and promoting them is significant. Whether it is in the seemingly limitless numbers of ads run in fashion magazines and newspapers, retailer direct marketing efforts, or broadcast commercials, the message about these brands is always somewhere the public will hear or see it. This cost is included as part of these brands' promotional budget.

SHEER BEAUTY

Bobbi Brown. New creamy color lip gloss. $18.00.
At State Street, Woodfield and Mayfair.

Marshall Field's
fields.com®

Bobbi Brown, featured in this Marshall Field's ad, is typical of the value of merchandising national brands. *(Courtesy of Marshall Field's)*

National brands receive a great deal of attention through visual presentations.
(Courtesy of Marshall Field's)

• Visual presentations, both in retailers' windows and interiors, continue to bring these labels to the consumer's attention. A walk through a major merchant's different departments is enough to see that large sections of selling space have been set aside to feature extensive collections of these labels. Liz Claiborne, for example, enjoys the luxury of several sections in major department stores such as Macy's, Marshall Field's, and Bloomingdale's. Each showcases a different division of the Claiborne empire that utilizes a slightly different name for the merchandise.

• While shoppers are sometimes suspicious about the quality and fit of the fashion merchandise they purchase from off-site means such as catalogs or the Internet, they are generally assured of getting what they expect when they purchase one of these **marque labels**. Manufacturers with national reputations are extremely careful about quality assurance and deliver exactly what they have promised in terms of fabrications, wearability, and care. They have gained the public's trust by making certain that their products meet the highest industry standards.

• Continuity of production is an extremely important requirement for retailers who discover "winners" in their inventories. These items are the backbones of their inventory and account for their potential to maximize profits. The nationally prominent manufacturers have the capability of continuing to deliver these winners in a timely manner, thereby developing positive relationships with their retail clients.

• The prestige provided by many of the national manufacturers' labels is of significant importance to fashion merchants. A considerable number of fashion enthusiasts are motivated to buy "names," such as the products offered by Prada. Handbags priced upwards of seven hundred dollars soon sell off the shelves of the fashion leaders. It certainly is neither the fabrics nor the construction that distinguish these accessories, although they are of the highest quality, but rather the little nameplate that adorns the outside of the product. It is debatable if they would sell in the same quantities if the labels were on the inside. Prestige is something that gives the wearers of such merchandise a feeling of exclusivity, which is often the most important factor in determining whether they will purchase the product or not.

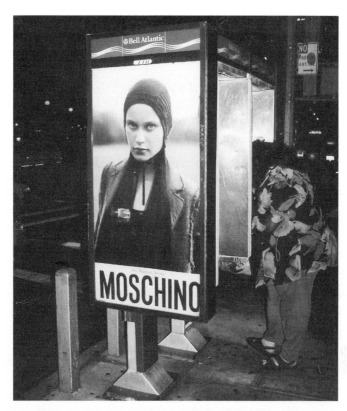

The prestige provided by the Moschino label makes it more appealing to fashion enthusiasts.
(Courtesy of Ellen Diamond)

PRIVATE LABELS AND BRANDS

No matter the venue, whether the retailers are brick-and-mortar operations, catalogs, or Internet Web sites, they carry a host of brands and labels that they exclusively market. Some outlets feature labels that they have developed and that account for a specific percentage of their overall model stocks, while others subscribe to the retailing strategy, "the Store Is the Brand." In both cases, it is the exclusivity factor that plays an important role in the marketing of these labels and brands.

In department stores that subscribe to **private label** and **private brand** retailing, they frequently carry more than one collection of these exclusive names. At Marshall Field's, for example, Field Gear and Pink Ribbon Separates are private labels and can only be found in their stores, catalogs, and Web sites. At Federated stores, the degree of exclusivity is not limited to just one of the Federated units but may be found in several—I.N.C., a private label, is found in the Macy's and Bloomingdale's divisions.

Private labeling and branding doesn't only rely upon the exclusivity factor but also on the premise that the products that bear these names are equal in quality and styling to their nationally prominent counterparts.

Once a private brand is established and accepted by consumers, it often is confused with the national brands. Shoppers who are satisfied with a store's private label offerings sometimes seek these collections at other retail outlets, not realizing that they may only be found in the companies that successfully developed them. For example, shoppers frequently enter a Lord & Taylor store looking for an Alfani label, only to find that it is sold at Macy's and other Federated outlets. Some successful labels even rival the offerings of nationally prominent manufacturers. In Federated, the world's largest department store group, with divisions such as Bloomingdale's, Macy's, Rich's, Burdines, and Lazarus, their own labels are often as visible as those of the marque manufacturers.

When a company embarks upon a private brand program, it is a major undertaking. Aside from the significant financial investment necessary to get into this type of merchandising,

a number of other factors must be addressed to make the product a successful rival to the national brands. These factors that contribute to the success of these exclusive offerings are discussed throughout this chapter.

Advantages of Private Labels and Brands

Merchants that stock their own brands as part of their merchandise mix or use them as the only label they market are afforded certain advantages, such as the following:

• **Price cutting**, a problem that is pervasive in the world of fashion retailing, is eliminated. When merchants are overstocked and economic conditions warrant markdowns, they often reduce the prices of the national brands. Merchants try to get an edge on the competition and show their customers that their prices can't be beaten, resulting in a lowering of profits. With the exclusive nature of private labels, this cannot happen. Retailers can control the prices, and shoppers cannot comparison shop at other venues, seeking bargain prices for these collections.

• In the case of national brands, the items are produced to have the broadest appeal to their retail clients. Except in the most extreme cases, there are no changes to the mass-produced lines of merchandise. Since retailers that deal in private branding and labeling have complete control over the design of their products, they can make their merchandise to their specifications. For example, once a line has been created, a long-sleeve model can be changed to a 3/4-sleeve offering if the retailer believes it will sell better in that style. These and other product specifications, such as trimmings, can be adjusted until the retailer thinks it is a potential best seller.

• Because there is less competition there is the potential for greater profitability. National brands are heavily promoted, adding extra costs to the products. With private branding, this, and other extra costs, such as the salaries of high-profile designers, are eliminated. The retailer that produces a private brand without these expenses can often achieve a higher markup and in return realize greater profitability.

• The need to adhere to some manufacturer's purchasing requirements is eliminated. For example, many of the better-known brands are prepacked according to the dictates of the producer. That means that buyers are unable to tailor the size distribution to fit their specific needs. This can lead to an abundance of slow-selling sizes and a shortage of the sizes that sell best. Ultimately the leftovers head for the markdown racks and minimize profits.

• When a private brand or label is well received by the retailer's customers, it has the potential to create brand loyalty. Satisfied shoppers often return again to purchase the same lines of goods or buy them from the company's catalog or Web site and repeat business is the key to success for any retail establishment.

• Vendor demands in terms of advertising requirements are eliminated. Many of the better-known manufacturers, as a condition of purchasing, set minimum amounts that retailers must spend to promote their products. This contract term adds costs to the marketing of the products, often making them less profitable for the company.

Merchandising Approaches

There are numerous ways in which retailers approach private branding. As previously mentioned, some carry a certain proportion of private labels and national brands, others subscribe to the "Store Is the Brand" approach, some utilize licensed arrangements with well-known names to bring exclusivity to their inventories, and a few engage in the latest innovation known as partnering.

THE PROPORTIONAL PHILOSOPHY

To have a model stock that will appeal to the widest range of customer desires generally requires retailers to mix name brands and private brands and labels. By proportioning their merchandise, these merchants recognize that some customers prefer established household

Department stores like Marshall Field's carry both national brands and private labels throughout their departments. *(Courtesy of Marshall Field's)*

names, some like private labels, and still others want to choose from a combination of both. Department stores tend to subscribe to this **proportional philosophy**.

Because department stores are organized to provide a wealth of different products and brands to the consumer it can prove damaging to their bottom line to carry only private brands or only national brands. A case in point is Sears. For most of its years in business, the company prided itself on its own brands and labels. While this approach made Sears one of the more important players in retailing history, its popularity slowly eroded when customers began demanding it carry more of the nationally advertised brands. In response, in the early 1990s, Sears abandoned its private brand identity and started stocking highly visible labels. Today, it promotes numerous famous brands alongside its own, including Levis, French Toast, New Balance, Reebok, and Timberland, among others.

Two other brands, Lands' End and Structure, are now part of Sears' private labels because Sears bought the two companies. Sears acquired Lands' End for $1.9 billion. As it is an established brand with an enormous customer base, including Lands' End products in the Sears merchandising mix is expected to generate a tremendous increase in sales. Sears bought Structure, the men's division of Limited Brands, Inc., for $10 million and plans to initially introduce it as a product for the twenty- to thirty-five-year-old male, with the possibility of adding other merchandise classifications to the label.

The proportion of private to national brands that a retailer stocks depends upon how much customers accept each type. Past sales records are excellent indicators of the popularity of each classification. By examining these sales figures in predetermined time periods, retailers are able to determine the relative success of the two merchandise offerings and make adjustments as dictated by customer purchases. For example, if each period in a five-year study indicates a 1 percent increase of private brand sales, the inventory plans should be adjusted to reflect this trend. If private label products are decreasing in popularity, the retailer should carry a great proportion of manufacturer brands.

When a retailer first embarks upon a private label program, it will have no past sales records to help determine the proportions. Through various types of marketing research, which might include questionnaires, the merchant "guesstimates" its initial private label needs and adjusts them once the label is better established and has begun to generate sales records.

Table 13.1 lists some major retailers and their private brands.

TABLE 13.1 Fashion Retailers with Private Brands

Company	Private Brands	Merchandising Approach
Federated	I.N.C., Alfani, Charter Club, Christopher Hayes	Fully owned private brands
Marshall Field's	Thomas Pink, French Connection	Partnering**
Lord & Taylor	Kate Hill, Identity	Fully owned private brands
Costco*	Kirkland	Fully owned private brand
Kmart	Martha Stewart, Jaclyn Smith	Licenses
Dillard's	Preston & York	Fully owned private brand
Target	Isaac Mizrahi, Todd Oldham	License
Tiffany	Tiffany	Fully owned private brand
Sears	Lands' End, Structure	Partnering**
Saks Fifth Avenue	SFA Folio	Fully owned private brand

*Costco also uses the same private brand for its food items.

**A concept in which a separate retail operation establishes a department within another retailer's premises.

THE "STORE IS THE BRAND" PHILOSOPHY

When shoppers enter a Gap location, a Banana Republic store, or an Old Navy unit, they are limited to buying the products that bear each store's name. Although Gap once carried lines such as Levi Strauss, today it only features its own brand. This philosophy centers upon the concept that the store and the brand are one and the same. If the stores are successful in motivating customers to return to their brick-and-mortar units or Web sites to purchase their branded products, they have achieved the ultimate in exclusivity.

The Gap organization has more units than any other company that follows "**the Store Is the Brand**" concept. Catching up to it is Chico's, one of the fastest growing fashion operations in the United States that features its own private label merchandise. It began as a small store on Sanibel Island, FL, and it now has more than 510 stores nationwide. Its success is based upon three components: the unique designs created by Chico's own in-house staff; the best personalized service in specialty store retailing, in which sales associates are trained to coordinate the mix-and-match pieces in Chico's collection and perfectly accessorize them; and its focused marketing by way of database that includes over four million names as of 2004. Over 90 percent of Chico's sales comes from its Passport (loyalty program) members. Unlike other retailers in its category, Chico's features new styles in its stores every week.

One of the fastest expanding "store is the brand" retailers is Chico's, which develops its own styles.
(Courtesy of Chico's Retail Service, Inc.)

Other major retailers that successfully utilize the "Store Is the Brand" philosophy include Limited Brands, with divisions such as the Limited, Express, and Limited Too under its umbrella; Abercrombie & Fitch; American Eagle; and Eddie Bauer, the subject of the following Spotlight.

Fashion Retailing Spotlights

EDDIE BAUER

Eddie Bauer, Inc., is a leading international retail brand that specializes in lifestyle apparel and accessories for the family as well as a wealth of products for the home. First established in Seattle in 1920, it has gone on to attract a significant segment of shoppers through its stores, catalogs, and Web sites.

Key to Eddie Bauer's success has been its own brands that it markets both on-site and off-site. The continued patronage from customers around the world makes it an excellent example of how successful "Store Is the Brand" merchandising has become. Today, it has more than 600 stores worldwide, 12 annual catalogs that feature both personal and home products, and on-line Web sites, primarily **www.eddiebauer.com**, which features apparel along with links to its other Web sites. Most of the units it operates are fully owned by the company, but the divisions that service Germany and Japan are joint partnerships.

From its meager beginning in 1920 as Eddie Bauer's Sport Shop, it has steadily grown. Throughout its history, it has designed products that were firsts in the clothing and accessories industry. In 1936, it manufactured the first quilted down-insulated garment, the Skyliner jacket; in 1970, it shifted its focus from making expedition gear to casual lifestyle apparel; and in 1987, it launched its *All Week Long* catalog that featured classically styled fashions for professional and special occasions. Spiegel purchased the company in 1988.

Prompted by the success of its apparel offerings, the company launched its *Eddie Bauer Home* collection that now has stores of its own, catalogs, and a Web site.

The company continues to expand its offerings and play an important role in community relations, a factor that has increased its consumer visibility around the globe. Specifically, it has won numerous awards, such as the Hispanic College Fund Corporation Award of the Year in 2001, and the NAACP, Washington, DC, Urban League award. Company associates and customers raised nearly $1 million for the victims of 9/11.

The most recent addition to its corporate family that also exclusively features its brands is Eddie Bauer Kids, with stores, catalogs, and a Web site.

LICENSED PRIVATE BRANDING

Recognizing the power of certain signatures and relationships, some retailers subscribe to a form of private branding and labeling that involves licensing, called **brand licenses** and **brand signatures**. By contracting with well-known personalities, businesses such as Kmart and Target have reaped significant benefits.

One of the earliest licensing agreements in fashions for the home has been Kmart's association with Martha Stewart, the guru of good taste. Spearheaded by her visibility on television and in her own magazine, she has earned the respect of millions of followers who want to add her touch to their homes. Thanks to her instant name recognition, her line of bedding and linens that are sold in Kmart stores are the dominant collection in that merchandise classification. Although Martha Stewart has been convicted of criminal action, Kmart continues to feature the brand. Kmart also added an apparel collection designed by Jaclyn Smith of *Charlie's Angels* fame, and it has proven to be yet another winner in the private label arena.

In 2003, Kmart took another step in the direction of private branding with the addition of the Thalia line. Licensed with Latino pop star, Thalia Sodi, Kmart hopes the line will have significant appeal with one of the country's fastest growing markets, Latinos, which make up 17 percent of Kmart' sales. The collection is the most comprehensive brand launch Kmart has ever undertaken and features everything from shoes and stockings to apparel. Unlike its other merchandise, Kmart is presenting the line as a "shop-in-shop" department that is located in the front of the regular apparel department.

Another example of private labeling via the licensing route is the line designed exclusively for Target by Isaac Mizrahi, the world-renowned fashion creator. What makes this a unique undertaking is that Mizrahi has long been known for his couture-level creations that sell for thousands of dollars each; his Target collection will sell at extremely low price points, such as $35 for a blazer. Target is expected to reap enormous benefits from having a high-profile designer associated with its private collections.

Target has also joined forces with Liz Claiborne to introduce yet another celebrity to its apparel names with the Niki Taylor line. It has been successfully launched to capitalize on the name of the model who served as the "face" of the Claiborne company in both print ads and outdoor advertising since 1996. The collection will offer moderately priced business, casual, and weekend wear.

Not to be outdone by these recent deals, JC Penney has joined the fray by contracting with Bisou Bisou, a contemporary line previously sold only at better department and specialty stores such as Bloomingdale's and Nordstrom.

PARTNERING BRANDS

The most recent innovation in privatization of brands and labels is known as **partnering**. Instead of developing their own brands and labels or becoming involved in the typical licensing agreements, a few major retailers are taking an approach that is similar to the concept of **leased departments**. In leasing arrangements, outside merchants occupy a portion of the store and use it to sell their own products. Often times these vendors, many of whom sell precious jewelry or furs, maintain their own departments in the retail operations but do not identify themselves as the merchants, so they appear to be the same as any others in the store. Practitioners of this type of retailing may operate a number of these departments in several stores on a nonexclusive basis. In partnering arrangements, the outside vendor has an exclusive relationship with the retailer it occupies.

This relatively new retail format involves a formal relationship with a well-known retailer that operates its own units, catalogs, or Web sites and sells directly to the consumer. In an attempt to bolster sales for both partners, the two retailers join forces in a manner that enables each to continue its mode of doing business.

The following Spotlight focuses on Marshall Field's partnering direction.

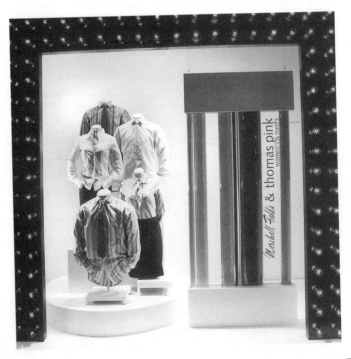

Partnering is a concept that Marshall Field's uses to gain exclusivity to certain brands such as Thomas Pink. *(Courtesy of Marshall Field's)*

Fashion Retailing Spotlights

MARSHALL FIELD'S

When it first opened what was to become its flagship store in Chicago's loop, few knew that Marshall Field's would become one of the country's premier department stores. From the beginning, it earned a reputation for excellence in merchandising and customer service. Among its firsts were establishing a European buying office, opening a dining room restaurant, and creating a bridal registry.

In 1990, Marshall Field's was acquired by the department store division of the Dayton Hudson Corporation, now the Target Corporation. The power of the Marshall Field's name led the company to change the names of all of the Dayton Hudson outlets to Marshall Field's making it a sixty-four-unit department store organization. These were not the only changes that would take place. In 2004, Marshall Field's was acquired by The May Department Stores Company.

As the trade papers continue to report, traditional department store operations are losing the luster they once enjoyed. Profitability has been down in most of the companies that have been serving shoppers since the late 1890s. To make certain that its stores continue to be dominant players in the communities they serve and to return to its original prominence, Field's has embarked on a new approach to department store retailing: partnering.

Already involved with numerous distinctive private label collections, the company has moved in an uncharted direction. On September 18, 2003, the company unveiled the "new" Marshall Field's to considerable fanfare. With models strutting down the exterior of the store's façade, appearances by famous names in fashion such as Kenneth Cole and Estee Lauder and supermodel Carolyn Murphy, live bands, and the Hubbard Street Dance Company, Field's was set to see if its new plan would capture the attention and pocketbooks of the consumer. The centerpieces of the new partnering concept would be housed in this completely refurbished Chicago flagship.

Through a multitude of contractual arrangements, Marshall Field's became the first major department store to have branches of world-famous merchant's stores within its premises on an exclusive basis. Thomas Pink, the world-renowned "master of dress shirts," opened a boutique; Smashbox Cosmetics, developed by the grandsons of makeup legend Max Factor, opened another; Tricia Guild presented the first boutique in the country to offer a line of contemporary furniture, bed linens, and accessories; iittala opened its first boutique for innovative entertaining products; and French Connection served up its first in-store boutique of contemporary merchandise for men and women.

This new approach transcended the traditional format in which company buyers were responsible for all of the store's offerings; partnering placed the responsibility for merchandising these new boutiques in the hands of the individual companies with whom it had exclusive arrangements. It blended the ever-popular specialty store with department store merchandising.

This is just one more example of why Marshall Field's has remained a premier retail operation.

PRIVATE LABEL AND BRAND ACQUISITION

Retailers that purchase manufacturers' brands have to buy either directly from them or from manufacturer representatives or wholesalers. Retailers that participate in developing their own brands and labels, however, have several choices for merchandise acquisition. They can have the goods manufactured in their wholly owned facilities; purchase them from outside contractors that specialize in tailoring private label products for specific users; buy from national manufacturers that, in addition to producing their own "name" collections also produce special lines for retailers under their own labels; participate in private label programs that have been designed and distributed by retail marketing specialists such as resident buying offices; or form noncompeting retailer groups.

The following sections describe these different choices.

Wholly Owned Subsidiaries

The main way that the giants in fashion retailing obtain their private label merchandise is by owning their own production companies. "The Store Is the Brand" retailers in particular are merchants as well as manufacturers. These support businesses that manufacture the products for the retail outlets are called **wholly owned subsidiaries**.

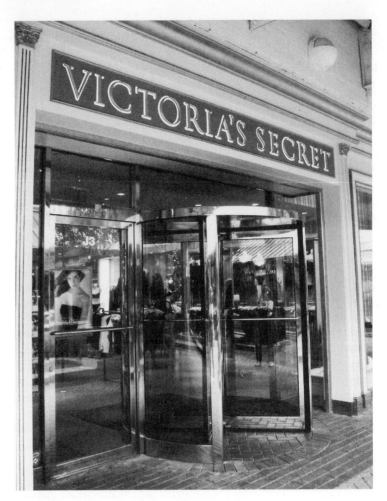

Victoria's Secret is a major retailer that provides its private label merchandise through a wholly owned subsidiary.
(Courtesy of Ellen Diamond)

The following Spotlight focuses on Limited Brands and its approach to private branding and labeling.

Fashion Retailing Spotlights

LIMITED BRANDS

Founded in 1963 in Columbus, OH, by Leslie Wexner, the first Limited Brands retail outlet opened in Kingsdale Mall. Little did Wexner know that his venture would turn into a retail empire that today boasts more than 4,000 stores and 7 retail brands.

Throughout the years, Wexner acquired several chains, such as Lane Bryant, Bath & Body Works, and Victoria's Secret, and opened others, such as Structure and Limited Too. Never one to rest on his laurels, Wexner directed numerous changes that included the sale of some divisions, such as Structure to Sears and Lane Bryant to Charming Shoppes, and continued to redevelop some of his divisions such as Express to include mens' wear along with women's apparel and accessories.

Because private branding and labeling is the key to the company's success, Limited Brands, then known as Limited, Inc., acquired Mast Industries, Inc., one of the world's largest contract manufacturers, to produce its collections.

Mast owns and maintains manufacturing facilities in places such as Sri Lanka, Jakarta, and Shanghai. Recognizing that growth is better achieved through **joint ventures**, the Mast division entered into agreements in many countries and now partners with Intimark, Mexico; Fielding Group, United Kingdom; and Intimate Fashions, India; and domestically with the Lilli Group. It operates more than fifty manufacturing facilities through these joint ventures that employ

approximately 20,000 workers. Acquiring Mast gives Limited Brands the advantage of having merchandise produced in factories all over the globe at times and places that provide it with the best potential for maximizing profits.

Any of the Limited Brands stores contain a merchandise mix that is up to the minute, visually merchandised in a striking manner, and priced to meet the needs of the majority of Americans.

Unique to this type of retailing, Limited Brands only operates stores within the United States.

Purchasing from Outside Contractors

While company-owned production facilities affords the retailer total control in terms of product design, a guarantee of exclusivity, the best possible production time frame to maximize sales, and so forth, some merchants have neither the financial resources to have their own factories nor the expertise needed for such undertakings. Instead, they choose a method that involves relationships with companies that supply everything from design assistance to the actual production of the merchandise.

Throughout the United States and abroad, there are many manufacturers of fashion merchandise that are in business to help merchants create their own private label collections to sell at all price points in brick-and-mortar operations, catalogs, Web sites, and even through home shopping outlets. The latter channel of distribution, in fact, is an enormous client of private label developers—the vast majority of the merchandise offered for sale are not standard manufacturers' brands but items only available from the home shopping programs.

In many instances, a retailer brings styles that have been successfully marketed by prominent designers and manufacturers to a contractor to have the styles adapted to its needs. The contractor then modifies the original designs by substituting fabrics, adding or deleting trimmings, or making minor modifications such as sleeve lengths, thereby creating a "new" model and producing it for the retailer to sell under a private label.

Using National Manufacturer Production Facilities

Although their primary concern is to design and market their own brands and labels, some of these manufacturers contract with retailers to produce lines that bear the retailers' own signatures. The practice was first popularized by Sears, when its Kenmore brand of appliances was produced by prominent manufacturers and marketed as Sears' private brand.

In many cases, the retailer purchases the nationally known collections that bear the producer's label but also contracts to have a separate line made that is identified as its private label. Manufacturers of these established labels engage in this activity for a number of reasons: it helps to maintain a sound working relationship with a major retailer that regularly purchases the national brand; keeps factory operations running during slow periods, thus avoiding layoffs of employees; and achieves an additional profit that it would otherwise forego.

The retailer's advantages from these relationships include the guarantee of receiving merchandise with the same qualities as those from the manufacturer's own brands and maintaining servicing of its accounts because of its commitments to the national brands.

Participating in Resident Buying Office Programs

In addition to the typical benefits that they receive from resident buying offices and other fashion consulting groups, many retailers use these resources as a means of procuring private label collections for their own companies. By choosing this route, they avoid the vast expenditures associated with maintaining factories or engaging in long-term contracts with outside contractors.

The larger resident buying offices, such as The Doneger Group, have their own private label brands, such as Greg Adams, Sportworks, Repertoire, Spectacle, Complements, and Lauren Matthews, that they offer to their clients. The lines are developed by them and produced by contractors. The retailer need only select the models from the private label

In addition to producing their own brands, some manufacturers create private collections for retailers by presenting them with layouts that include drawings and fabric swatches.
(Courtesy of Ellen Diamond)

Doneger Consulting individualization

An outside resource to supplement inside talent. Individualized projects are customized to the needs of style-related businesses from apparel to interiors to consumer products. Doneger Consulting provides a tailored solution for creative planning and brand development.

Customized Seasonal Analysis
Individualized evaluation of merchandise trends, color stories and delivery flow; presentation of relevant cultural influences and consumer preferences.

Product Line Development
Creation of seasonal color palettes, materials and style direction; identification of essential items and product opportunities; product design and development, including key fabrications and finishing details.

Lifestyle Analysis
Identification of lifestyle trends across categories of business; influences in store environment and consumer experience; insight into related style industries.

Through special product development programs, such as Doneger Consulting individualization, retailers are able to satisfy their private label needs.
(Courtesy of The Doneger Group)

collections in the same manner it would choose styles marketed by the national manufacturers. The only difference between a "true" private label program and this one is that these items are not for the exclusive use of one particular retailer, although The Doneger Group limits their acquisition to noncompeting retail operations, so that they are not carried by other merchants in their own trading areas.

Those merchants that are either too small to establish their own labels or are not properly versed in production matters often use this route as a means of entering the private label arena.

Forming Noncompeting Buying Groups

Because of the potential for better profits from private label programs, a growing number of small retailers are pooling their resources and professional expertise and are entering the private label market as groups, thereby avoiding the significant expense of going it alone. The concept of **buying groups** is not new; they have been in existence for many years. Originally their primary purpose was to combine orders so that they could buy from designers and national manufacturers who maintained minimum order requirements that were too extensive for their individual needs.

The process generally involves interfacing with freelance designers who create models that would serve the member's merchandising needs, and making arrangements with contractors for the production of the lines. Before any items are produced, the line is evaluated by the members of the group, and edited to make any necessary changes.

The degree of exclusivity that is important to private branding and labeling is sufficient to the needs of the group's participants. Since the member merchants are not in direct competition with each other, they are able to control pricing, invest in joint advertising and promotion of the label, and make any changes that suit the needs of the membership.

PROMOTING AWARENESS OF PRIVATE BRANDS AND LABELS

The advantage of having nationally prominent brands and labels in the retailer's inventory is that they are generally in the public's eye. With the vast sums invested by prominent designers and manufacturers on special promotions and ad campaigns, and the coverage of such collections by the fashion industry's editorial press, the individual retailer's clienteles are generally aware of their offerings. Companies like Ralph Lauren, Liz Claiborne, Calvin Klein and other marque labels have either their own in-house public relations staffs to get their messages across or use the services of outside publicity resources to make the public aware of its latest fashion introductions.

Those engaged in private label programs do not enjoy the luxury of having someone else promote their exclusive lines, but must engage in a variety of endeavors to guarantee consumer recognition. Ways to achieve this recognition include advertising campaigns, special events, development of special departments, visual presentations, and staff familiarization. The following sections describe those different methods.

Advertising Campaigns

When major retailers embark upon a new private label, they budget a significant sum to make their own customers and others aware of the new merchandise. Some retailers have in-house teams that develop ad campaigns involving both print and broadcast media.

Retailers can easily alert their regular customer base to the new line via direct marketing. Armed with mailing lists of their credit card customers, they generally send separate mailers announcing the private label or enclose ads in each customer's monthly billing statements. Supplementing the direct mail endeavor is generally a multimedia campaign that combines newspaper, magazine, television, and radio advertising. In this technological age, the Internet has become an extremely important tool for reaching the consumer. On retailers' own Web sites, they post complete spreads featuring the newly arrived brand that tell shoppers about the private label and how it can benefit them. Sometimes, retailers pay to generate "**popups**" on search engines that announce the new line and lead users directly to the retailers' Web site where they can further explore the products.

One-time ads are insufficient in marketing new private collections, so retailers must create a variety of advertising campaigns that regularly remind shoppers of the private labels in their merchandise mix.

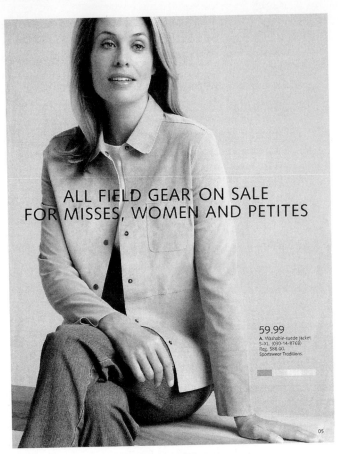

ALL FIELD GEAR ON SALE
FOR MISSES, WOMEN AND PETITES

59.99
A. Washable-suede jacket
S–XL. (030-14-8768)
Reg. $88.00.
Sportswear Traditions.

Marshall Field's promotes its private label collection "Field Gear" in its direct mail catalogs.
(Courtesy of Marshall Field's)

Special Events

The introduction of a new fashion private label requires a substantial investment in special events. These happenings include runway shows that take place either within the department in which the new line will be housed or in a special events center that most major retailers have in their stores. Often, these fashion shows are dovetailed with charitable events that provide contributions for the charities while highlighting the merchant's newest merchandising endeavor.

Celebrities are often used to promote a new label. When shoppers visit the store to see them, they are also made aware of the new private label. Personality appearances are not limited to brick-and-mortar outlets; celebrities are often on the home shopping cable shows to endorse particular lines, all of which are private brands that either include the celebrity signature on the label or use the personality to give the line or product a little extra clout.

Creation of Special Departments

Today's retail environments are no longer the large arenas with what seem to be never-ending departments featuring a host of different lines. More retailers are utilizing individual shops within their stores that delineate these collections. Fashion retailers that subscribe to the **store within the store** concept include Bloomingdale's, Saks Fifth Avenue, Marshall Field's, Bergdorf Goodman, and Neiman Marcus. To underscore the importance of their own private labels, many retailers have designed departments that separate the products from the others in the store in settings that exemplify fashion exclusivity. Federated stores uses this approach with several of the company's in-house labels such as I.N.C. and Charter Club.

Visual Presentations

Exterior and interior visual merchandising are excellent means of highlighting new private labels. Whether potential purchasers of the private brand have been motivated by advertising to come to the store or have merely walked past the premises by chance they can be attracted to the merchandise by window displays that prominently feature the items. Inside the store, strategic placement of the goods, eye-catching displays, and other tools of the visual trade can make shoppers even more curious about the new line.

Customer Giveaways

Some retailers have developed promotional plans that help keep shoppers aware of the new private label even after they have left the store. By distributing shopping bags emblazoned with the name of the new label, small items such as pens engraved with the brand's logo or signature, or reusable totes that feature the private label's name, the retailer makes it more likely shoppers will remember the label and look for it when buying in the store, on-line, or through catalogs.

Employee Training

It is important to train employees at all levels so they are prepared to answer shoppers' questions concerning the collection. The training may be accomplished in the following ways:

- *Special classes.* In these face-to-face sessions, product developers and others responsible for creating the new line present the salient points about the merchandise, such as pricing comparisons to similar nationally marketed lines and ease in care for the product.
- *Closed circuit TV.* In large department stores and specialty chains operating a great number of units in different regions, management often utilizes closed circuit programming to offer product presentations. This technique allow staff that are far from the company's headquarters or flagship stores to ask questions of the upper management personnel who give the presentations.
- *Video and DVDs.* Professionally produced **videos** and **DVDs** carefully outline all of the planning that went into the creation of the new line, the final products that will reach the selling floor, and the benefits that will be passed on to the customers who purchase them. Employees can view these programs as often as necessary to solidify their knowledge of the private label.

DEVELOPING A LABEL THAT COUNTS

While the major concern for those involved in private label and brands programs is the development of the line, it is also essential that they come up with an appropriate name for the collection. For companies that are "Store Is the Brand" retailers, the task is quite simple. Because their goal is to establish the company and product line as one, they use the name of the company on the label. Retail operations such as Banana Republic, Gap, and Limited Too follow this labeling practice.

In situations where outside organizations such as the resident buying offices create their own private label collections, the retailer does not need to "name" the line because the group that offers these private label collections has already chosen the name for each garment.

Label development is the responsibility of retail organizations that create their own products. Marshall Field's; Federated Department stores, which include Macy's, Bloomingdale's, and Burdines; Saks Fifth Avenue; and others are in this group.

There are several approaches used to name a private label. Some companies follow the path of establishing a person's name with their products. With so much attention paid to designers all across the globe, these merchants emulate the designer label with names that give the impression that a designer created the label. Macy's, for example, has successfully

followed this approach with names such as Jennifer Moore and Christopher Hayes. Many consumers who have become devotees of these lines believe they are buying designer labels.

Another approach is to incorporate the company's name in the label. At Marshall Field's, its rugged wear collection is called Field Gear. This brings attention to the Field's name but expands upon it to give a description of the product line.

Still others create private label names that imply the clothes were designed in a country that is a leader in fashion. Macy's Alfani label has been a steady entry in its mens' wear merchandise mix. The name implies Italian, but close inspection reveals that the goods come from many countries around the world other than Italy.

In the private label programs that involve licensing agreements with celebrities, their name is on the label. The whole purpose of the business association is to bring that famous name into the company. Martha Stewart for Kmart, and Isaac Mizrahi and Todd Oldham for Target are just a few celebrity endorsers of private labels.

TRENDS IN PRIVATE LABELS AND BRANDS

Many retailers are using private brands and labels to give a degree of exclusivity to their product assortments and to remove the competitive nature inherent in fashion merchandising of national brands.

Some of the trends in this retail segment include the following:

- *An increase in the proportion of private labels in the merchandise mix.* Most every major department store is increasing its proportion of private label merchandise to the national brands. With private label business now at an all-time high of 35 percent, it's obvious that this trend is likely to continue.

- *Licensing agreements on the rise.* With the success of such names as Martha Stewart in Kmart, others are joining the bandwagon in record numbers. Isaac Mizrahi, for example, a marque designer of international fame, has created a line of moderately priced women's apparel for Target, and Todd Oldham has done the same for Target's home furnishings.

- *Partnering is becoming a factor in private retailer relationships.* With the department store's continuing decline in importance in fashion retailing, some of the major companies are entering into agreements with other retail operations to compete with specialty stores. Marshall Field's has taken the lead in partnering with retail boutiques such as Thomas Pink.

- *Expansion of established "store is the brand" concepts.* Many of the successful practitioners of this type of private branding are expanding their operations to capture other segments of the fashion market. Eddie Bauer has entered the multichannel game with stores that sell home furnishings and others that specialize in baby apparel and home products. The Gap has also spread its wings and now has opened operations that concentrate on fitness apparel.

- *Resident buying office expansion in private label offerings.* With many of those in retailing either too small to engage in their private label programs or not sufficiently experienced to compete with others in the field, many of the fashion marketing specialists are either adding private labels to their offerings or expanding those programs that are already in place to handle the increasing needs of their clients.

SMALL STORE APPLICATIONS

At first glance, the whole notion of private labeling and branding seems suitable only for retailing's major players. Although full participation on their own is unlikely, there are ways in which even the smallest boutiques may incorporate private labels within their model stocks.

The two acquisition routes that are used by these small entrepreneurs are to become members of resident buying offices or to participate as partners in noncompeting buying

groups. The former is the easiest way to become involved in this exclusivity venture. By joining a resident buying office that features its own labels, any client can purchase brands that these companies produce and market. Since the production is exclusively for the buying office's membership, and the members are noncompeting operations, private label programs are easy to come by.

The other is a little more involved in terms of time and monetary commitments. Each of the participants in a buying group must spend time with other merchants in developing such labels, determining the methods by which they will be produced, advertising approaches, and so forth. The participants must also be willing to invest financially in the creation of these labels and lend their expertise to their development.

Chapter Highlights

1. The use of private labels in major department stores and chains is continuing to increase and now stands at 35 percent of the overall inventories.
2. While national brands still dominate the fashion retailing industry, every year their importance erodes in most retail operations.
3. Advantages of private branding and labeling to retailers include a lessening of price-cutting, the ability to tailor garments to specific retailer needs, minimizing competition, the potential for establishing brand loyalty, and the elimination of the need to adhere to specific manufacturer purchasing requirements.
4. The most important approach to private labeling is known as the proportional method, where retailers set aside one proportion of their model stock for private labels and the rest for manufacturer-produced brands.
5. Retailers following the "Store Is the Brand" philosophy require that the only brand they carry is the one that bears their name.
6. Partnering is a recent approach to developing merchandise exclusivity in which a major retailer forms formal partnerships with other retail companies that occupy specific shops within the store.
7. Licensed arrangements with celebrities are very important to retailers that believe their clout will help to sell the products.
8. Retailers may acquire private labels and brands through wholly owned subsidiaries, joint ventures, purchases from outside contractors and/or national manufacturers, membership in resident buying offices, participation in buying groups, and partnering.
9. To ensure that their private labels and brands become important products, retailers must significantly advertise and promote them, feature them in special events, show them in special departments, create successfull visual presentations, and train their employees to completely understand them.
10. Retailers must carefully consider and design the name of the private label with the same commitment and expertise they use in the creation of the products themselves.

Terms of the Trade

national brands
fair-trade pricing
marque labels
private label
private brand
price cutting
proportional philosophy
Store Is the Brand
brand licenses
brand signatures
partnering
leased departments
wholly owned subsidiary

joint venture
buying groups
Internet popups
store within the store
DVD training
video training

For Discussion

1. Why do the majority of fashion retailers carry nationally advertised brands in their inventories?
2. Does prestige ever play a part in motivating some consumers to purchase specific fashion merchandise? Why?
3. Is it possible that prestige adds a significant amount to the retail price of a garment or accessory? Why?
4. Why have more fashion retailers opted to include private label merchandise in their model stocks?
5. What philosophy does the typical fashion-oriented department store use in its private label involvement?
6. In what way does the proportional private label concept differ from the Store Is the Brand philosophy?
7. Why are many retail operations stocking their fashion inventories with merchandise acquired through celebrity-licensed agreements?
8. How does partnering differ from department leasing?
9. If retailers aren't able to participate in private label acquisition through wholly owned subsidiaries or joint ventures, by what other means can they acquire private label fashion products?
10. How can small retailers purchase private label merchandise when the amount of merchandise they need is often too small to produce it themselves and still guarantee a degree of exclusivity?
11. Why do some nationally prominent manufacturers that produce their own collections enter into the private label arena?
12. What types of special events do retailers of private labels conduct to promote their own brands?
13. Why is it beneficial for major retailers to create special departments for their private label collections instead of mixing the items into other departments?
14. By what means are retail employees trained to fully understand the advantages of their company's private brands?
15. Is the need to "name" a private label a routine matter for retailers? Why?

CASE PROBLEM I

Since the late 1800s, when it first made its debut as a fashion retailer, the Carnegie Company has maintained a position in the marketing of fashion merchandise that is rivaled by few in the industry. After the success of the first store, the proprietors opened several branches, and in 1922 operated and managed the original brick-and-mortar unit, its flagship, and five other units. Business kept improving, with each year's sales and profits exceeding those of the previous year.

The Carnegie brothers, eventually replaced by their offspring, continued to successfully operate the company as a private entity. They employed a management team that aided them in their decision making and left the buying and merchandising responsibilities to buyers and merchandisers who had gained experience from their roles in other department store operations.

In 1965, Carnegie, now the operators of sixteen units, entered into direct marketing with a Christmas catalog. The response was more than it expected, and soon it added numerous catalogs throughout the year to give its off-site venture more visibility. This decision was also positive, and sales continued to increase.

In 1982, the company sold its holdings to another fashion retail giant, Walker & Peck; because the Carnegie name was considered to be prestigious, the new owners kept it. The new owners continued on the expansion program. By 1997, there were thirty-two units and twelve individual catalogs were produced each year.

Always ready to address any means of increasing sales, Carnegie entered the world of the Internet and established its own Web site. It was now a true multichannel retailer. While on-line sales weren't as spectacular as those in the brick-and-mortar operations and catalogs, the Web site showed the potential of being accepted by consumers.

At the turn of the twenty-first century, for the first time in its history, the company was feeling the negative effects that department stores faced across the country. As a result of the "me-too" merchandising that was pervasive in the industry, Carnegie customers began to opt for specialty stores where the merchandise assortments were often more exciting. Even though its private label programs, first introduced in 1982, were successful, the company had a need to look for more individuality.

The company's CEO held several meetings to try to rectify the falling sales and profits. Suggestions included turning the company into a Store Is the Brand operation, disbanding the Web site operation since sales only increased slightly each year, and changing the name of the company to Walker & Peck. At this time a decision has yet to be rendered to improve the company's profit picture.

Questions

1. Do any of the suggestions make sense in terms of improving Carnegie's position? Defend your answer with sound reasoning.
2. What alternate solution might help the company achieve a new direction and ultimately increase sales and profitability?

CASE PROBLEM 2

Wertheimer's is a major specialized department store operation that has been in business since 1938. It began as a one-unit organization and currently operates fifteen branches, a catalog division, and a Web site. Its forte has always been high-fashion apparel and accessories for women that it markets to the most affluent members in its trading areas. The collections it is noted for include original couture from such European designers as Giorgio Armani, Gianfranco Ferre, Karl Lagerfeld, and their American counterparts Ralph Lauren and Donna Karan. Bridge collections include DKNY, Ellen Tracey, and Garfield & Marks.

Unlike many of the other full-line and specialized department stores that carry some of their own labels, Wertheimer's has remained an unusual fashion merchant and has regularly dismissed the need to enter the private label market. It always believed its customers preferred the globally recognized fashion labels and that anything else would adversely affect the image of the company.

This past year, the company's CEO retired and was replaced by someone from Hogan Astor, another upscale fashion emporium. It too specialized in the "names" but augmented its merchandise assortments with a few private labels. These products helped to not only increase sales but also to distinguish the company from all of the others that carried the same collections. With fashion retailing becoming a "me-too" industry, Carrie Gable, the new CEO, believed the way of the future was in private labels to bring a degree of exclusivity to the company.

After much discussion with her management team, they decided that a trial offering of a private label was worth the effort. If the company's clientele didn't accept it, it would be eliminated from its merchandise mix.

With sufficient capital, the company decided to establish a manufacturing division that would produce the garments from the designs delivered to it. With a newly hired head designer and two assistants, the plan was ready to go forth. The only remaining problem was to create a name for the private collection.

Questions

1. How important is the name in private label merchandising?
2. What plans would you devise to select the name?

EXERCISES AND PROJECTS

1. Visit a department store or specialty store and evaluate its private label collections. Through your own observation, and with the help of a department manager, gather enough information to complete the list below.

Name of Company: _____

Department Name	Private Labels	Merchandising Approach*

*The designation should be fully owned private label, license, partnering.

2. Visit any value retailer such as Target, Wal-Mart, or Kmart to assess its collections of private brands. You might ask to meet with the store manager or write to the company before your visit to learn the names of these products. Ask questions concerning the number and names of any licensing arrangements the retailer has made, the names of brands that it has developed using names it has decided upon, the importance of these brands to its overall merchandising direction, and anything else of interest concerning this type of merchandising. With the acquired information, prepare a brief report on your findings and present it to the class.

Inventory Pricing

After reading this chapter, you should be able to:

- Discuss the various factors that fashion retailers consider in pricing their merchandise.
- Evaluate the importance of competition to retailers in determining their prices.
- Explain the concept of markup and perform its calculation.
- Identify the different markup philosophies that retailers use in pricing their inventories.
- List several reasons for markdowns and how they are calculated.
- Discuss the nature of automatic markdown systems.

After retailers have established their **merchandise mix** through purchasing national brands and creating private labels and brands, the buyer, in the case of purchases from outside manufacturers, and merchandise managers or upper management teams, in the case of private labels, must determine the individual price that will be charged for each item. Whether retailers are exclusively brick-and-mortar operations, catalogs, or Web sites, or engage in a multichannel approach to reach their targeted market, they all develop pricing philosophies and guidelines that they hope will bring a profit to their companies.

Retailers must consider many factors before formulating such policies, including the composition of their consumer market, the image that they wish to project, the amount of competition they face, and other elements that relate to specific merchandise. Retailers who have their own private labels and brands, have additional concerns to address. Unlike merchandise that has designated specific wholesale costs, such as national brands, brands that have been designed and produced specifically for and by the retailer involve costs associated with design origination, fabric selections, construction techniques and the like that the retailer must consider before assigning any retail price.

The buyers and merchandise managers must then apply their markups (the amount added to the cost to arrive at the retail price) based upon the guidelines established by the company's CEO and upper level management team, which depend upon the type of retail outlet and the inventory it carries. These guidelines range from the relatively simple policy of uniform markups to the more complex concept of individual markups.

Although retailers invest a significant amount of expense and time into planning its model stock, even the best plans will need some adjustments. Some merchandise will be on target and warrant reordering, and others will fall short of expected sales and might require markdowns. When to reduce the prices of slow sellers and how much of a reduction should be applied to these items are just two of the problems that buyers and merchandise managers must handle.

All retailers face a number of hurdles in merchandise pricing, but it is the fashion merchants that usually have the greatest challenges to confront. Fashion goods are more difficult to merchandise than any other inventory classification because retailers must contend with customer acceptance of designer whims as well as seasonal cycling of merchandise, which creates a short selling period.

PRICING CONSIDERATIONS

Before they decide on the appropriate price of each piece of merchandise fashion merchants focus their attention on such areas as the amount of competition they face, the life expectancy of the item, riskiness in terms of customer acceptance of a trendy style, overhead, the type of promotional endeavors they need to conduct to bring attention to the product, the image of the company they wish to project, the type of customer patronage they seek, special requirements needed in the sale of the merchandise, and its vulnerability to pilferage. These areas are described in the following sections.

Competition

Fashion retailers today face greater pricing challenges than they experienced in the past. In addition to the traditional competition from the conventional brick-and-mortar retail community, there is a growing number of merchants that sell fashion for less. The off-pricers such as Burlington Coat Factory, Marshall's, and Symms carry many of the well-known fashion collections but at greatly reduced prices. Retailers also face **on-line competition.** Web sites of all kinds offer a wealth of the same sought-after labels such as Calvin Klein, DKNY, and Ralph Lauren. By logging onto such Web sites as **www.smartbargains.com**, shoppers can get a great assortment of the Ralph Lauren label at highly discounted prices, and at **www.bluefly.com**, the cream of the fashion crop, such as Fendi and Prada, is available at discounts of up to 70 percent. The big Internet giant eBay now offers fashion merchandise that customers do not bid for, at prices that are well below the traditional.

Faced with all of this value pricing, many department stores are meeting the competition by presenting several promotions throughout the year. Bloomingdale's, in particular, regularly sends discount mailers to its customers with coupons they can redeem in stores or through the catalogs.

One of the major competitive forces is the continued expansion of the outlet malls such as those operated by the Mills Organization. They are replete with entertainment centers and eating facilities that are above the standard. Sawgrass Mills in a suburb of Fort

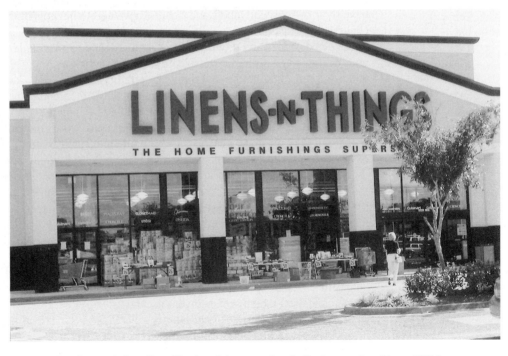

Traditional retailers are being affected by the pricing strategies of off-pricers such as Linens-N-Things.
(Courtesy of Ellen Diamond)

Lauderdale, FL, for example, offers dining establishments such as the Cheesecake Factory to make the shopping experience a pleasant one that offers bargains at the same time.

With the growth of these retailing empires, the traditionalists have been geared to study their competition's pricing and make price adjustments to their merchandise accordingly.

Merchandise Characteristics

To a large extent, fashion merchandise has a limited life expectancy, or **perishability**. Not only do seasonal changes affect the salability of goods but fashions that are considered to be trendy or fadlike often decline in desirability soon after they reach the selling floor, catalog pages or company Web sites. In these cases, their prices must be high enough to cover the losses attributed to their sudden demise.

Some items are delicate or fragile and subject to damage. White or pastel garments often require markdowns when they become soiled after careless handling, and sheer, chiffon-like materials might be damaged after they are tried on by many customers. These perishable characteristics necessitate higher than typical markups to offset the losses caused when they are damaged.

Swimsuits and furs, because of their seasonal nature, are generally marked up more than other items to make certain that those that do sell early in the season bring sufficient profit to cover the losses of those that do not.

Small fashion items such as jewelry must be stored in cases and therefore necessitate additional sales personnel to show them. This tends to increase overhead expenses, thus warranting an additional markup.

Company Image

Many fashion retailers enjoy prestigious images that enable them to price their merchandise higher than what is typical for their industry. A markup of just a few percentage points is safe since it will rarely discourage customers from purchasing. Companies such as Bergdorf Goodman, Neiman Marcus, Saks Fifth Avenue, and Henri Bendel are typical of those that

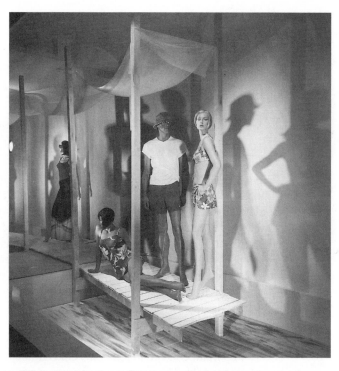

Swimsuits, because of their seasonal nature, often command higher than average markups.
(Courtesy of Lord & Taylor)

High-image companies such as Bergdorf Goodman sometimes charge higher than the traditional prices.
(Courtesy of Ellen Diamond)

charge higher prices for their merchandise. Although value shopping is becoming increasingly important to the vast majority of consumers, price is not a factor for every customer. Many get sufficient pleasure from patronizing these companies and are willing to pay a little extra for the "privilege."

Customer Profile

Chapter 4, "The Fashion Consumer: Identification and Analysis," focused a great deal of attention on different types of consumers and how their fashion needs are satisfied. All retailers should recognize the composition of their markets and understand how price affects their purchases. Some classes of people are cost conscious and only shop in stores or patronize off-site ventures that feature the price advantage, while others such as those in the upper-upper and lower-upper classes are more concerned with service and quality and pay little attention to price. Factors such as income, lifestyle, and psychographics indicate to what degree price is an object; merchants need to take these into consideration before establishing a pricing philosophy.

Stock Turnover

A very important concern to retailers is the number of times a year most items in an average inventory are sold. The more often an inventory turns over, the less need there is for a high markup. Conversely, the lower the number of **stock turnovers,** the higher the markup to make a profit.

Off-price retailers and discounters are able to turn profits with lower markups because they expect greater turnover rates. Traditional fashion retailers that charge higher prices than the off-pricers and discounters expect fewer stockturns. In men's wear, for example, the stock does not turnover as much because men do not purchase as many items, so men's items are often marked higher than women's wear, because women buy more items and thus turnover the stock more frequently.

Promotional Endeavors

Fashion retailers participate in a variety of promotional activities to attract shoppers. The promotional involvement depends upon the size of the organization, its method of operation, its budget, and its target market. Promotional dollars spent on advertising, special events such as fashion shows, and visual merchandising contribute to the retailer's overhead expenses, which in turn necessitate higher prices. The use of special events such as Macy's annual Flower Show and Thanksgiving Day Parades, and the extravagant Christmas windows featured by Lord & Taylor, Marshall Field's, and Saks Fifth Avenue, are explored respectively in Chapters 15 and 16, "Advertising and Promotion," and "Visual Merchandising."

Services

Unlike their off-price counterparts, which subscribe to a bare-bones service philosophy, many of America's better-known fashion emporiums offer a host of services to their clienteles. These include **personalized shopping**, where customers receive individualized attention for all of their shopping needs, such as the "At Your Service" program at Bloomingdale's; foreign language assistance for non-English speaking shoppers, such as the interpreters program at Macy's; corporate gift service; and bridal registries. While there are no extra costs charged to the customers for these services, the expenses incurred by offering them are taken into consideration when merchandise is being priced.

Vulnerability to Shrinkage

The attention retailers pay to shoplifting and internal theft, as described in Chapter 10, "Merchandise Distribution and Loss Prevention," underscores the severity of the problem and the losses fashion retailers sustain. Some companies are plagued by the problem more than others and must address its seriousness when determining price. These **shrinkage** losses are felt not only in the brick-and-mortar units, but also on Web sites, where shrewd thievery is taking place. The cost of losses must be considered, as must the cost attributed to the protection of the merchandise and the fraudulent order placement.

In fur departments, for example, where retailers must install sophisticated surveillance systems to protect the merchandise and include additional sales associates on the selling floor, the cost of doing business increases. Departments that are located near store entrances provide shoplifters with greater accessibility to the merchandise and ease of getaway and thus might warrant higher prices than other departments that are less prone to thievery.

While highly sophisticated systems are in place in most retail environments to curtail shoplifting and in most warehouses to deter internal theft, enough merchandise is stolen to necessitate higher prices.

Buyer Knowledge

Typically buyers apply the same markup to all of the items they have purchased from manufacturers. Occasionally, however, they may price some styles higher or lower. Collections that are likely to be carried by competitors are not going to be priced higher or lower than usual. But a particular business suit that has been obtained on an exclusive basis from a relatively unknown resource, may allow for a higher markup. A few extra dollars added to the retail price of this merchandise could result in a better profit for the company. Conversely,

another suit might seem too expensive when the traditional markup is applied and the buyer will mark it lower to have broader customer appeal.

It is imperative that the buyer completely evaluate each item that is to become part of the department's model stock and make certain that the retail price applied will make it a potentially successful and profitable seller.

Exclusive Merchandise Resources

Some fashion retailers are able to charge prices that are higher for some styles because of their exclusive rights to the merchandise in their trading area. For merchants involved in multichannel retailing that extensively market their products via catalogs and the Internet, these trading areas are far beyond those of their brick-and-mortar operations, so they are usually unable to charge higher prices, except for privately held brands and labels.

As described in the preceding chapter, "The Retailing and Development of Private Labels and Brands," companies that create and produce their own products are not affected by the competition associated with the selling of nationally known labels and brands. Exclusivity of this merchandise enables them to gain additional markups since they have eliminated the competitive factor from the pricing equation.

Sometimes a retailer will stock manufacturer brands and labels that are rare in its trading area, giving it a degree of exclusivity. In such cases, the retailer may charge higher prices.

If a retailer is willing to purchase merchandise from a manufacturer in extremely large quantities, it may benefit from controlling the limited distribution of the items in its area. In such situations, the retailer will likely charge more than it normally would if the products were mass distributed to several competing retailers.

MATHEMATICAL CONCEPTS OF PRICING

Once a retailer's top management has analyzed all of the factors that make up the cost of its operation, it must determine the **markup**—how much must be added to the cost of the merchandise to arrive at a selling price that will bring a profit. While this is the beginning point

Exclusivity of merchandise, such as the private labels that are developed for retailer use, enables the traditional merchant to charge higher than typical prices.
(Courtesy of Ellen Diamond)

in price determination, not every item sells at the original marked price, and it might have to be reduced to motivate purchasing. The amount of the reduction is known as the **markdown.** The following section addresses the reasons for these price reductions as well as the mathematical computation involved in determing the markup and markdown.

Markups

Markups are derived from a mathematical formula. Computer programs can also automatically determine the markups once the wholesale price (cost) and selling price (retail) have been considered. The basic formula is as follows:

$$\text{Retail} - \text{Cost} = \text{Markup}$$

For example, if a pair of men's trousers costs $80 and it is priced to retail at $150, the markup is $70.

$$\$150 \text{ (R)} - \$80 \text{ (C)} = \$70 \text{ (MU)}$$

In this case, the buyer purchased the pair of trousers from a resource for $80, and priced it to sell at $150, and achieved a profit of $70. This situation is the best possible one for the retailer, but in reality, not every item sells at the original, or **initial markup.** Using the above illustration, assume that the trousers did not sell and were marked down to $120 and then sold. The actual markup, or the maintained markup, achieved by the retailer was $40.

$$\$120 \text{ (price after markdown)} - \$80 \text{ (C)} = \$40$$

One of the factors that retailers often build into their initial prices is an estimate of how great the eventual markdowns will have to be before the goods are sold.

While dollar markup gives the actual dollars achieved by the retailer once the product has been sold, markups are usually expressed in percentages. Although the markup percents may be expressed on cost price or retail price, fashion retailers generally use the method of markup percent based on retail price.

Before the markup percent can be determined, it is necessary to first find the dollar markup. To determine the markup percent based on retail price the dollar markup price is divided by the retail price. For example, if a sweater costs $40 and it retails for $80, the markup percent on retail is 50 percent.

$$\text{Retail} - \text{Cost} = \text{Markup}$$
$$\$80 - \$40 = \$40$$
$$\frac{\text{Markup}}{\text{Retail}} = \text{Markup percent based on retail}$$
$$\frac{\$40}{\$80} = 50\%$$

Markdowns

No matter how carefully a buyer determines costs and applies markups, the retailer will likely have to mark down merchandise. There are numerous reasons why prices must be adjusted. Some are attributable to retailer error and others to uncontrollable outside forces. The following sections explore the reasons for marking down the merchandise as well as the size of the reduction and when markdowns should be taken.

REASONS FOR MARKDOWNS

The circumstances that prompt retailers to reduce the price of merchandise include errors committed by the buyer, management errors, sales force inattention and situations the retailer cannot control.

Buying Errors. Fashion buyers are more prone to errors than any of their purchasing counterparts because of the unpredictable nature of the industry; consequently, they must take the markdown route to right their wrongs. For example, they might misjudge the popularity

of a potential fashion trend and find that shoppers do not like the new styles. They might overbuy a particular silhouette or choose the wrong color palette, incorrectly determine the proportion of private label goods to designer brands, inaccurately time the arrival of the merchandise, and place too much emphasis on an unheralded designer. All these miscalculations may require markdowns to entice customers to turn over the stock.

Management Errors. Although buyers are given the purchasing responsibility, they are guided by the decisions made by management, particularly the DMM and the GMM. They determine the markup percent, for example, on which the buyer figures the retail price. Some retail operations follow the **"markup by classification"** philosophy, which mandates a specific markup percent for each department. If the buyer lacks the flexibility to adjust the prescribed price, an item might have too high of a selling price to motivate purchasing and may eventually be marked down.

Inadequate Sales Staff. Most shoppers have been discouraged from making a purchase by sales staff, even when calling catalog divisions seeking assistance before placing orders or using Web sites where individualized help is supposedly available. Many retailers are negligent when it comes to training their sales personnel. A few days of rigorous training by in-person, classroom instruction; video presentations; or on-line teaching can supply the direction the sales associates need to improve their efforts.

Retailers such as Nordstrom, Bloomingdale's, Neiman Marcus, and Saks Fifth Avenue have taken the initiative to motivate their on-site sales associates by offering commission incentives. Instead of taking the traditional straight salary route, which provides no direct correlation between sales and employee income, these companies have instituted remuneration programs that require 100 percent attention to selling and servicing the customer. The result has been increased sales, fewer markdowns, and better profits.

High Initial Prices. Sometimes buyers misjudge the price their customers are willing to pay for specific items. Occasionally they will price them higher than they should be, and if the competition charges less for the same item, not only won't the item sell, but the "overcharging" could result in a bad reputation for the company.

External Factors. Even the very best merchandise mix that is carefully advertised, promoted, visually merchandised, and presented to the shopper by enthusiastic, knowledgeable salespeople does not always provide the company with the sales results and profits it envisioned in its planning mode. Adverse weather conditions can be neither predicted nor avoided. An unusually warm September in traditionally cold climates might discourage shoppers from buying snowsuits for their children or other cold weather fashions such as coats, gloves, and scarves. A rainy, cool summer will not provide the necessary stimulation for purchasing swimsuits. Since the merchandise affected by these unforeseen conditions is seasonal in nature, each day of the inclemency provides less opportunity for selling. Markdowns are often necessary to induce stock turnover.

A poor or declining economy, such as was prevalent in early 2002, also plays a significant role in the poor sale of fashion merchandise. While food items and other essentials are not as seriously affected, consumers generally pay less attention to fashion-oriented items during those times.

National disasters are often the causes of poor sales. One of the best examples is the tragedy of September 11, 2001. Only time would eventually help the country's social and economical life return to normal.

Because it is impossible for anyone to control these external factors, it is the responsibility of everyone on staff to reduce errors in their own jurisdictions.

WHEN TO TAKE MARKDOWNS

The seasonal nature of fashion and its unpredictability in terms of customer acceptance make it a merchandise classification that is more complicated to manage than any other. Although many factors necessitate price reductions to turn the inventory, timing the markdown is critical to providing ample time to sell the merchandise.

Given that the goods must be sold sometime during the season, retailers take different approaches to timing their markdowns. In the recent past, the vast majority of fashion merchants subscribed to the semiannual markdown philosophy. Typically the periods following Christmas and July 4th were traditional for marking down unsold merchandise.

Today more fashion retailers are opting for more frequent markdown periods for the following reasons:

* Fashion items that are held too long lose their market.
* Merchandise held too long will require more significant markdowns.
* By quickly disposing of less desirable goods, the retailer's turnover rate will improve and enable the buyers to purchase fresher fashion items.
* There will be less room on the brick-and-mortar selling floor to display the new season's offerings that can be sold at full markup.

Although most fashion merchants abide by these principles, some still play by the old rules of following **traditional sales periods**. They argue that:

* Too many "sale" periods put customers on notice to wait for the price reductions.
* Sometimes a hasty decision to lower prices is unnecessary and waiting a few more weeks will bring a better profit to the company.
* During periods of markdowns, more people crowd the store, resulting in a reduction of customer service.

Filene's of Boston, the subject of the following Spotlight, originated a markdown system that practically guaranteed the sale of all its slow-moving merchandise within thirty days.

Fashion Retailing Spotlights

FILENE'S BASEMENT

Filene's is a well-known traditional department store based in Boston. Like most other full-line department stores, Filene's expanded its operation with the opening of branch stores. Today the stores are known as Filene's/Kauffmann, the result of a merger by its present-day parent organization, the May Company. It now operates more than one hundred stores that feature a fine selection of hard goods and soft goods and offer a great deal of customer service. It has, because of its Basement operation, become a Boston institution. Unlike its department store counterparts throughout the country, Filene's initiated a merchandising philosophy that brought large profits to the company.

In 1909, Edward Filene announced that he was going to transform the lower level of the flagship store into a bargain basement. While bargain basements were not unusual to department stores, this venture was unique. It did not merely house the store's lowest-priced goods, as was the case in most operations, but it also served as a clearing center that would guarantee the disposal of merchandise within thirty days through an **automatic markdown system**.

Every piece of merchandise is tagged with different dates and prices that indicate when and what it will sell for. The reductions amount to 25 percent the first week, 50 percent the second, and 75 percent the third. After the thirty-five days, any merchandise remaining in the inventory is given away to charity.

Originally intended to quickly dispose of the company's slowest sellers, the concept was expanded to help manufacturers sell their unsold fashions. Filene did not believe that this would be profitable but felt it would serve to save some of his store's resources from going out of business. Not only did it enormously help those suppliers in distress but it also added to the company's overall profit. Buying merchandise from resources at bargain prices enabled Filene's to offer low prices to its consumers

A third aspect of the operation, in terms of merchandise acquisition, involves purchasing end-of-season inventories from well-known merchants. Dramatically announcing the acquisition of high-fashion merchandise from a prestigious retailer, Filene's sent a twelve-truck caravan across the country proclaiming in large, bold letters: "Neiman Marcus to Filene's Basement."

Today, the basement operation is no longer a division of Filene's/Kauffmann but is a separate organization. It has branches throughout the United States, but it only operates its automatic markdown system in Boston.

DECIDING THE SIZE OF THE MARKDOWN

To make goods sell faster, the markdown must demonstrate a significant savings for the potential customer. Few shoppers would be motivated to buy a dress that originally retailed for $120 that is now being offered for $110.

The size of the markdown percent is usually dependent upon when it is offered in the selling season. When a buyer wants to motivate coat shoppers in early October, the discount could be much smaller than the discount offered in the middle of January, when the season has virtually ended. The early markdown decision not only affords the buyer a lower markdown percent, so the retailer loses less profit on the discount, but also allows for a higher markdown later in the season, when the retailer just wants to move the inventory.

Early markdowns usually reflect a savings of at least 20 percent, with end-of-the-season sales often producing markdowns of 50 percent or more. Markdowns of less than 20 percent rarely entice the shopper to buy.

Arithmetically, the retailers calculate markdowns as percentages of the new selling price. For example, a dress originally priced at $100 has been marked down $30 to retail for $70. To determine the markdown percent, the following formula is used.

$$\frac{\text{Markdown}}{\text{New retail}} = \text{Markdown percent}$$

$$\frac{\$30}{\$70} = 37.5\%$$

PRICING POLICIES

Fashion merchants subscribe to three major pricing policies in terms of how they apply their markups: uniform company markup, markup by classification, and markup by individual item. The following sections describe these policies.

Uniform Company Markup

Very few retailers apply a universal markup to each item in their inventory, except for off-pricers or discounters. In these organizations, the inventory as a whole is often marked up at a specific percent without any attention being paid to the factors discussed in the section on pricing considerations. The retailer determines the cost of running the operation and applies a markup that covers these expenses with enough left over for profit.

The **uniform company markup** is the simplest approach to pricing the merchandise but doesn't account for the variables that necessitate different markups for different product classifications and items.

Markup by Classification

Department store and chain organizations generally employ a system that involves different markups for each of their merchandise classifications and carry them throughout their on-site and off-site divisions. Since each category requires different attention and costs in bringing the goods to the customers, their separate markups reflect these costs. For example, precious jewelry and furs necessitate better security systems, and furniture requires more costly warehousing. Fashion merchandise is often short lived and must bring higher prices to make up for the lower markups of highly competitive electronics. If retailers that carried a full complement of hard goods and soft goods, as most department store organizations do, used the uniform companywide markup philosophy, some items would be profitable and others would represent losses to the organization.

For such retailers to turn a profit, they must first assess the overall markup needed to be profitable. Once all of the pricing factors have been considered, a specific markup is as-

TABLE 14.1 Department Store Markups

Markup Classification	Markup Percent
Jewelry	70%
Women's Apparel	65%
Fashion Accessories	65%
Children's Clothing	50%
Electronics	35%
Women's Shoes	65%
Men's Wear	55%
Men's Shoes	55%
Home Furnishings	55%

signed to each merchandise classification. Averaging these markup percents should result in the appropriate overall markup needed by the company.

Traditionally, a department store's fashion merchandise is marked up higher than most of the company's other offerings. Table 14.1 represents typical multichannel department store markups by classification.

In many retail operations, where traditional markup percents are uniformly applied according to classification, **keystone markup**, which refers to the doubling of the wholesale cost to arrive at the retail price, is commonplace. An extension of this concept is known as **keystone markup plus** where, in addition to doubling the cost to arrive at the selling price, an extra amount is added.

Markup by Item

More fashion buyers are given the opportunity to apply individual markups to their inventories. They must, however, consider the markup percent mandated by their merchandise managers. By using this pricing approach, buyers are able to price certain lines, such as private labels and those that they have arranged for exclusive distribution within their trading areas, higher than they normally would and price more competitive styles, such as national brands carried by their competitors, lower. As in the case of markup by classification, where averaging is a factor, this system also requires averaging. The only difference is that the average markup is achieved within the department.

For example, consider a junior sportswear department that features a large variety of items such as sweaters, dress pants, jeans, skirts, and sweats. Some of these items are more competitive than others and might require lower markups. To offset the lower prices, other items within the department will carry greater markups. The data in Table 14.2 is indicative of how the buyer must mark the goods in this department to generate the greatest sales volume and achieve the predetermined markup established by the divisional and general merchandise managers.

In Table 14.2, the buyer is confronted with competition generated by "Store Is the Brand" retailers such as The Gap that specialize in jeans and sweats and often price them lower than the traditional department store organization does. To be able to feature such items and still make a profit, the department store's junior department must use the averaging technique, by which the less competitive items not carried by its lower-pricing rivals are priced higher, resulting in the overall desired markup percent.

TABLE 14.2 Traditional Markups

Junior Sportswear	Markup Percent
Sweaters	60%
Dress pants	65%
Jeans	50%
Skirts	60%
Sweats	50%

PRICE POINTS

No one retailer is able to feature fashion merchandise at every conceivable price. With couture designs at the top of the price scale and value items at the bottom, there is an enormous range of merchandise available that different types of retailers can offer. Retailers select particular price ranges, or **price points**, for their inventories for a number of reasons, including the following:

- Brick-and-mortar units are too small to feature every price point.
- Higher-priced fashions are merchandised differently from their lower-priced counterparts.
- Different levels of customer service must be delivered for every price range. For example, those engaged in high-end fashion are more likely to offer individualized customer attention than those that sell value-priced items.
- Different price points denote different company images.
- Fashion merchandise is available in similar styles at many prices, and featuring too many price points could confuse the customer.
- Too many price points would reduce the overall assortment.

Today, more than ever before, retailers are becoming more restrictive in their merchandise price ranges. Macy's, for example, once carried a broad variety of prices ranging from upscale to budget. In the early 1980s, it began to trade up and narrow the price points. By doing so, it was able to project a more defined image of its company and tailor the services needed to satisfy its customers. Retailers that offer a narrower range of price points are also beneficial to consumers, enabling them to immediately determine if a particular retailer meets their price requirements.

Pricing is no simple matter and retailers must carefully address it so that their profits will be maximized.

TRENDS IN INVENTORY PRICING

As retailers entered the new millennium, they were faced with greater competition than ever before due to the expansion of the brick-and-mortar units, the wealth of new catalogs that have joined the fray, and the continued importance of the Internet for fashion purchases. Also, the cost of doing business has continued to upwardly spiral, causing some new tends in the pricing of merchandise, described in the following sections.

- *Greater markups.* As alluded to in the opening of this section, retailers in every level of fashion merchandising are experiencing higher costs of operation. To cover these rising expenses, many are increasing their markup percents. Where keystone markups were once considered standard practice, this approach is fast becoming a dinosaur in fashion retailing.

Retailers are also using the larger initial markups in anticipation of the markdowns that will eventually take place.

- *Private brands and labels.* With fashion merchants introducing more of this exclusive merchandise, the prices they are able to charge for them are on the increase. Without the fear of competition for their own products, many continue to use these brands and labels as a means of bringing greater profits to their companies.

- *Shrinkage.* One of the major concerns of retailers is the amount lost to shoplifting, internal theft, and Internet fraud. These losses have caused many merchants to increase their prices. The greater markups do not bring extra profits to the company, but merely cover the losses.

- *Timing of markdowns.* Rather than wait for traditionally established periods in which to take markdowns, the vast majority of fashion retailers are reacting quickly to shoppers rejection of certain styles and are reducing their prices as deemed necessary by the merchandising team.

• *Decrease in uniform companywide markups.* Where some fashion operations once used a uniform approach to marking up their goods, the practice has become less prevalent. Competition among different product classifications has led buyers and merchandising managers to a system that addresses each item more carefully and are assigning prices that meet the competition.

SMALL STORE APPLICATIONS

Many small fashion retailers are finding that the competition generated by the major department stores, specialty chains, catalogs, and on-line ventures is often overwhelming. Few can feature the breadth of services offered by the giants in the field or are able to be as price competitive. The large retailers often have the pricing edge because of their buying potential. Manufacturers are quick to offer deep discounts to the major on-site and off-site fashion operations, enabling them to feature lower prices. How could the small fashion merchant compete in such an environment?

Some attack the pricing problem by cutting their expenses, which enables them to sell for less. A less costly store location or the elimination of charge accounts and other services might be the answer. Another approach is to maintain their markup strategies and appeal to the customers on a different basis. They might become more service oriented, warranting the higher markup. For example, offering custom alterations free of charge might induce fashion-conscious women to patronize a smaller store, because the costs of garment alterations at the most exclusive major retail operations often carry additional charges that significantly increase the price of the purchase. This free service could attract "hard-to-fit" shoppers to the store. Although such a service will incur to the store owner an additional cost of doing business, the merchant can offset it by achieving higher markups. Fashion boutiques all across the country are finding this approach helps them compete with the industry giants, especially for higher-priced merchandise.

Small fashion merchants must be creative to meet the competitive challenges of the giants. For example, they could contact charitable organizations to sponsor fashion shows and contribute a small percentage of the profits to the charity. Many people have favorite charities and would like to patronize a store that participates in such events. Or small boutiques could offer appointments to customers that guarantee them uninterrupted attention at a desirable time. This might appeal to shoppers with time limitations.

Whatever the approach, small merchants must implement a plan to make certain that the prices they charge will not deter people from shopping in their stores and will result in a profit for them.

Chapter Highlights

1. Before fashion retailers can make any pricing decisions, they must consider many factors.
2. Retailers must explore such pricing considerations as the level of competition they face, the image they are trying to portray, the services they deem necessary to maintain customer satisfaction, and their vulnerability to shoplifting and internal theft.
3. Today's traditional merchant is facing a great deal of competition from Web sites that deal exclusively with highly discounted merchandise.
4. Many major fashion merchants are facing the competitive nature of the game by creating their own brands and labels.
5. Sometimes retailers' ability to negotiate exclusive agreements within their trading areas gives them the advantage of maintaining their pricing structures.
6. After costs of running the operation have been determined, the fashion retailer decides upon the appropriate markup to cover expenses and bring a profit.
7. Markup is the difference between the retail price and the wholesale cost.
8. Fashion merchandise is marked up higher than most other product classifications due to its perishability.
9. Even the greatest amount of purchase planning doesn't guarantee that shoppers will like every product. Some items must be marked down to improve their sales potential.

10. Markdowns may be needed because of errors attributed to the buyer, sellers, or management, or for reasons such as adverse weather conditions or economic slowdowns.
11. There are three major markup philosophies utilized by retailers in regard to their pricing policies: uniform company markups, markup by classification, and markup by individual item.
12. Retailers must establish which price points they will carry so that they will be able to properly project their image, offer the appropriate services for that price point, and feature the largest selection of products in that price range in the brick-and-mortar operations.

Terms of the Trade

merchandise mix
on-line competition
perishability
customer profile
stock turnover
personalized shopping
shrinkage
exclusive resources
markup
markdown
initial markup
markup by classification
traditional sales periods
automatic markdown system
uniform company markup
keystone markup
keystone markup plus
price point

For Discussion

1. Why is it more difficult to merchandise fashion items than any other classification of consumer products?
2. Briefly describe two types of nontraditional fashion retail operations that pose considerable competition for the conventional retailer.
3. Explain the effect having a prestigious image makes on pricing.
4. What is meant by the concept of stock turnover?
5. While it is obvious that knowledgeable buying often improves the retailer's merchandising mix, does it in any way affect the prices the retailer charges?
6. List three factors that constitute exclusive merchandise resourcing.
7. If a dress costs the retailer $65 and it is retailed for $125, what is the dollar markup?
8. What is the difference between initial and maintained markup?
9. What is the markup percent on retail for a sweater that costs $30 and retails for $50?
10. Discuss some of the errors attributed to management that might cause merchandise markdowns.
11. Why are an increasing number of fashion retailers opting for earlier markdowns?
12. Describe the concept of automatic markdowns.
13. If a coat that was initially priced to retail for $225 was marked down to $210, would it generally sell at a faster pace?
14. Differentiate between the uniform markup philosophy and markup by classification.
15. Why do most department stores use the classification approach when pricing their merchandise?

CASE PROBLEM I

Langham's is a traditional full-service department store that has been in business for sixty years. In its downtown flagship and twelve branches, it features a wide assortment of hard goods and

soft goods. It has always offered many services to its customers who, for the most part, are considered loyal to the company, even though company loyalty is considered by many industry professionals to be a thing of the past. For all of its years of operation, Langham's has been the primary source for family needs in all of its locations.

Unlike most of Langham's department store counterparts throughout the United States, which have abandoned some of their hard goods lines, the company continues to feature major appliances, television and stereo equipment, and electronics. It is company policy that it provides one-stop shopping for the markets the branches serve. While this policy has afforded customer convenience, it has adversely affected the company's profit picture.

For the last three years, the sales volume in the appliance department has declined. The problem seems directly related to the opening of a discount appliance center in the Langham's flagship trading area and others in or near the areas of some of its branches. To combat profit decline, members of the management team have made several suggestions. Among them are:

1. Eliminate the appliances department and expand the company's fashion areas.
2. Restructure the company as a specialized department store, closing all of its hard goods departments.
3. Retain its hard goods and soft goods philosophy but adjust its pricing policies. It should be noted that Langham's has always subscribed to the uniform markup policy.

Questions

1. Which management suggestion is most appropriate to solve Langham's problem?
2. Using your answer to question 1, how would you specifically make the company a more viable retail institution?

CASE PROBLEM 2

When Kensington Fashions opened its doors five years ago, it never anticipated the success it would soon achieve. Located in a fashionable suburban strip center, it features such designer labels as Liz Claiborne, Anne Klein, Calvin Klein, Ralph Lauren, and DKNY.

The store's reputation is not due solely to its merchandise assortment but to the various services and conveniences it affords its customers. In addition to custom alterations, personal shopping, and wardrobe consultation, it enjoys a reputation that defies competition. Including in its premises a downstairs hair salon and cosmetics counter as well as a small dining facility where lunch is served and informal fashion shows of the store's fashions are held has made Kensington more than just another retail operation.

To offer such unusual surroundings and services, Kensington marks up its merchandise at a rate that is higher than that typically found in specialty stores. Its success indicates that customers are willing to pay a little extra for the pleasures they derive from the company.

The impending opening of a branch of an off-price fashion outlet has caused great concern for Kensington. Exeter, Inc., has six units, each featuring many of the same labels as Kensington. Although most of the Exeter goods are parts of closeouts or job lots, they do bear similarity to Kensington's merchandise assortment. With the bare essential services it offers, and the opportunistic prices it pays for its goods, Exeter is able to sell its goods below that of any traditional retailer. With such competition, it is difficult for full-price operations to compete favorably.

Questions

1. Should Kensington abandon its method of operation and compete with Exeter on price?
2. What suggestions would you make to Kensington so that it can successfully continue its business?

EXERCISES AND PROJECTS

1. Visit two different types of fashion retailers, one a traditional department store and the other an off-pricer, and compare the various considerations they address when determining prices. Through your own observations, examine such factors as each store's promotional endeavors, image, security, services offered to the customers, or other areas that affect pricing. Use a form similar to the one featured below to record your observations.

	Department Store	Off-Pricer
Image	_____	_____
	_____	_____
	_____	_____
	_____	_____
Store Design	_____	_____
	_____	_____
	_____	_____
	_____	_____
Services	_____	_____
	_____	_____
	_____	_____
	_____	_____
	_____	_____

2. Write to a company such as Filene's Basement or Symms, or visit their Web sites, to learn about their automatic markdown systems. Write a report on the company you choose emphasizing its merchandise assortment and the specifics of the markdown system.

SECTION FIVE

Communicating With and Servicing the Fashion Clientele

CHAPTER 15

Advertising and Promotion

After reading this chapter, you should be able to:

- ■ Define the term "advertising."
- ■ Classify the types of fashion retailing advertisements.
- ■ Evaluate the advertising media in terms of their importance to fashion retailing organizations.
- ■ Discuss online advertising and how it differs from print and broadcast media.
- ■ Discuss the concept of cooperative advertising and how it aids the fashion retailer.
- ■ Describe the various special events undertaken by retailers to promote fashion merchandise.
- ■ Explain the different types of fashion shows utilized by the retail industry.
- ■ Identify and discuss several techniques that fashion merchants employ to promote their companies and merchandise.
- ■ Discuss how the small fashion retailer with limited financial resources can still implement advertising and promotion efforts.

Once a retail organization's management team has made the decisions concerning store location and design, human resources selection, and merchandise procurement, it needs to decide how to make its potential and regular customers aware of its existence and its merchandise assortment. The primary manner in which to achieve such recognition is through advertising. Today, with the fashion retailing community expanding its operations through the use of Internet Web sites, the challenge of reaching a broader customer base is another task that these advertisments must meet. The wealth of advertising directed toward the fashion consumer is immediately obvious in newspapers, magazines, catalogs, direct marketing pieces, and on television, radio, and fashion retail Web sites.

In the highly competitive fashion retailing market, it is imperative that merchants establish specific images and alert shoppers about their companies so consumers will think of them when they want to satisfy their fashion needs. Advertising is the best way to spread the word.

In addition to different advertising options, retailers can use numerous types of special promotions and events.

THE FASHION RETAILER'S SALES PROMOTION DIVISION

To promote their companies and the merchandise they carry, retailers, both large and small, set aside sums that are earmarked for advertising and promotion. The larger retail operations usually have in-house promotional divisions. For special major events, these retailers may call in outside organizations to help their own staff face the challenges of such undertakings. Small retailers usually employ agencies to carry out their promotional programs.

Once a company has determined its promotional goals, it needs to ensure it can achieve them.

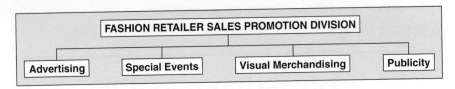

Figure 15.1 Typical sales promotion division.

While advertising accounts for the largest percent of the promotional expenditures, it is not the only avenue fashion retailers take to reach their target markets. Fashion shows, demonstrations, in-house video programming, special campaigns and celebrations, personal appearances by designers and celebrities, and institutional events such as charity functions are also successful means of getting a merchant's fashion message to its consumers.

Along with their advertising and promotional involvement, fashion retailers use visual merchandising in their brick-and-mortar operations. The magnitude of this attention-getting medium is discussed in Chapter 16, "Visual Merchandising."

The structure of a typical sales promotion division for major fashion retailers is shown in Figure 15.1.

Although the individual departments comprising the promotional division are all on the same level in terms of organizational planning, the advertising department generally commands the lion's share of the promotional dollar.

Management of the Advertising and Promotion Functions

The size of the organization and scope of its advertising and promotional activities determine what department or entity is responsible for managing the functions. Most major fashion retailers, whether they are department stores, specialty operations, catalogers, on-line companies, or multichannel businesses, employ internal staffs to manage and develop their advertising and promotional campaigns. Smaller businesses rely upon outside companies or freelancers to create and direct their advertising and promotional involvement because their needs are minimal and they cannot afford to maintain in-house staffs. Regardless of its size, advertising and promotion is imperative to the success of any fashion venture.

Management is responsible for the initial publicity planning in terms of direction, budget allocation, and media selection. In major fashion retail enterprises, the buyers interface with a promotional division that carries out the technical tasks of placing ads and creating promotions such as special events. In small brick-and-mortar outlets, the proprietor makes the publicity decisions and passes the responsibility for carrying out the function to one or more of the outside creative forces.

As noted in Chapter 3, "Organizational Structures," the larger retail organizations have separate promotional divisions generally called Sales Promotion Division, Publicity Division, or Division of Advertising and Promotion. Whatever the names, their roles are the same. They are in charge of advertising, special events, promotional campaigns, visual merchandising, and publicity.

Each of the departments within the division is responsible for a specific aspect of the company's sales promotion programs to help the company realize the greatest sales potential from its promotional investments.

ADVERTISING

As defined by the American Marketing Association, **advertising** is "a paid-for form of non-personal presentation of the facts about goods, services, or ideas to a group." These "facts" are illustrated with the use of **copy** (the written message) and/or **artwork** that includes photographs and drawings. It is impersonal in nature because it is directed to a group rather than to a specific person, as is the case in personal selling.

The advertising programs are either internally structured, utilizing a host of in-house specialists to carry out the various aspects of anything from single ads to complete campaigns, or externally based, outside sources that encompass numerous different approaches to developing advertising plans and carrying them out.

The Internal Structure

In-house advertising departments based in the major fashion retail operations are organized in a few different ways. The majority are similar to the one depicted in Figure 15.2.

In the organizations shown in Table 15.2, there are three individual subdepartments that carry out the company's programs. The Copy area develops the written messages; the Production section carries out the technical aspects inherent in ad reproduction, proofreading, and placement; and the Art section produces the photographs or drawings that will be used in the ads.

In fashion retailing's giant operations, which use extensive advertising, the advertising department is larger and resembles the one featured in Figure 15.3.

The difference between the two types of ad departments is that the former groups all of the media in one general area, and the latter divides responsibility into separate areas for each of the media.

External Advertising Resources

As noted earlier, few, if any, smaller fashion retailers such as small chain organizations or sole proprietorships enjoy the luxury of having in-house professionals to carry out their advertising programs. Instead they rely upon one or more outside sources. The large retailers also use outside sources to supplement their in-house staffs.

In each of these external organizations, specialists guide the retailer clients through their quests to become better known to the consumer or to make the public better aware of their merchandise offerings. The following sections describe various types of external advertising resources.

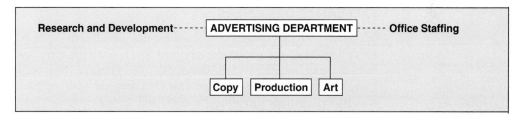

Figure 15.2 In-house advertising department.

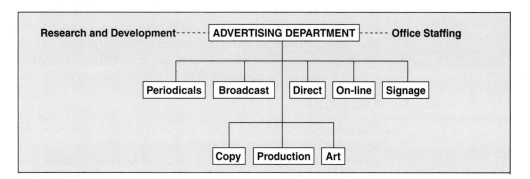

Figure 15.3 Major retailer's in-house advertising department.

Except for the giant retail operations, advertisements are created by professionals in external organizations. *(Courtesy of Ellen Diamond)*

ADVERTISING AGENCIES

Whether a client needs a complete campaign to announce the opening of a new branch, an individual advertisement to recognize the accomplishments of a charitable organization in the community or anything in between, **advertising agencies** offer a full range of creative services. The agency is paid based upon a commission by the medium in which the ad is featured; the standard rate is 15 percent. For example, if an agency places an ad in a newspaper that costs $10,000, the paper will return $1,500 to the agency. It is similar to the arrangement travel agencies have; the client doesn't pay to have the agency to book a cruise; the cruise line pays the agency a commission for sending the business its way.

FREELANCE DESIGNERS

Sometimes a retailer wishing to feature a unique advertising or promotional campaign employs the services of an outside specialist. Even when the merchant has its own staff, an outside designer might assist in developing the concept. Not only do **freelancers** provide creative ideas to be used in the program but they can oversee the entire advertising process, which might include providing the copy and artwork.

MERCHANDISE RESOURCES

Some fashion merchandise manufacturers prepare a variety of aids to help stimulate sales of the lines they provide to their retail customers. Some prepare direct-mail flyers that feature specific items and offer them to their retail accounts at cost. Retailers then include the flyers with their customers' monthly charge account statements. Other manufacturers prepare complete ads that the retailers can use as designed or as guides for their own ads. Most of the major fashion designers and manufacturers participate in cooperative advertising programs in which they pay for a share of the advertisements, a concept that is explored later in the chapter.

THE MEDIA

Fashion retailers advertise in a variety of print and broadcast **media** to whet the appetites of their customers. To assist their retail clients with their advertising needs, media organizations generally have staff that supplies a variety of services for advertising preparation. These specialists will help create the entire advertisement including writing the copy, preparing the layout, and providing information on demographics and direction in terms of where the ads

might be most effectively placed. These are free services, and clients pay only for the space that their ads will occupy.

MARKET CONSULTING FIRMS

In Section IV, "Merchandising Fashion Products," Chapters 11 through 14 discussed the services performed by market consultants, particularly resident buying offices. In addition to all of their preplanning assistance and the help they give buyers during their market visits, the major consulting groups offer advice on advertising. Many have in-house specialists that provide everything from suggestions to complete ad campaigns to generate business for the upcoming season.

Classifications of Fashion Advertisements

Fashion merchants must carefully assess the various types of advertisements that alert customers to their existence or sell specific merchandise. Within a retailer's promotional budget, the funds it sets aside for advertising are often divided in some way, not always equally, to cover promotional, institutional, and combination advertisements. Institutional ads receive the least amount of funding, and promotional ads realize the most of the overall budget.

Markdowns are used as promotional devices to bring the items to the shopper's attention.
(Courtesy of Marsha Field's)

PROMOTIONAL ADVERTISING

When a retailer wishes to sell a specific item or alert shoppers to a style that has been marked down, it uses **promotional advertising**. These ads are employed to provide immediate sales results for the merchant. For example, if a retailer advertises a hot item, the ad's effectiveness should be measured in the sales volume that item generated immediately after the ad ran.

INSTITUTIONAL ADVERTISING

Rather than promoting a particular style, an announcement of a clearance sale, or anything else that is directly related to the selling of merchandise, some fashion retailers, particularly those that are traditionally organized, such as the department stores, spend a portion of their advertising budget to promote their image. The concept is known as **institutional advertising** and is used as a means of letting the consumer know that the retailer is connected to its community as well as trying to sell merchandise.

Ads of this nature concentrate on a number of areas. After the September 11, 2001 attacks, for example, just about every major retailer quickly showed its support and allegiance to the country and its concern for the victims' families with the use of institutional ads. Not only did retailers not run the vast majority of their promotional ads during this period, but they changed the allocation of their promotional budgets to finance institutional ads.

At other times, retailers use institutional ads to promote their recognition of charitable organizations in their trading areas, ecological and environmental concerns of their customers and staff, their commitment to ethical practices, social responsibility, and other areas that show them as concerned businesses.

While the effectiveness of these ads cannot be measured in terms of immediate sales, as they can be with promotional ads, they do generate long-term results. This type of advertising is designed to gain long-term customer confidence and receive customer loyalty.

The American flag was used as a symbol to show many retailers' recognition of 9/11.
(Courtesy of Ellen Diamond)

This announcement of "Fashion Week" featuring a particular fashion item and the designers that will be represented is an example of combination advertising.
(Courtesy of Marshall Field's)

COMBINATION ADVERTISING

The best of both worlds is the advertisement that features promotional and institutional elements. In **combination advertising**, the retailer might choose to alert customers to the company's dedication to fashion and the community and at the same time feature a particular fashion item. For example, New York City's high-fashion retailers announce the Metropolitan Opera's opening night with ads that feature ball gowns that might be worn for the occasion.

Cooperative Advertising

Few fashion retailers have unlimited funds for advertising. Often they have a greater need to inform their regular and potential customers of newly arrived merchandise, personal appearances of designers and celebrities, or special promotions than their budgets allow. Although industry experts usually agree that advertising is worth the expenditure, because it has the potential to increase sales, retailers often reduce their promotional budgets when the economy is faltering and sales have declined. The shortfall is often made up with a commitment from vendors to participate in **cooperative advertising**.

The concept involves a joint effort between the merchant and the vendor and the expense of the advertisement is shared by both parties. The ads feature the names of both the supplier of the merchandise and the retail operation, making them valuable to each

The use of a particular designer in a retailer's ad constitutes cooperative advertising.
(Courtesy of Lord & Taylor)

participant. The ad is designed by the retailer, but the merchandise resource has the right to examine its contents and layout before the ad goes into production to make certain that it meets its requirements.

Under the rules of the Robinson-Patman Act, manufacturers must offer cooperative advertising allowances to all retail customers. Companies that offer such monetary compensation must do so by using a formula that is fair and equitable to both its largest and smallest accounts. Typically such arrangements are predicated on the amount of the retailer's purchases, with a percentage of sales usually used as the basis of the allowance. The following example demonstrates how the cooperative arrangement may be applied.

Beaumont Fashions purchases $300,000 worth of coats from Coleridge, Inc. The manufacturer offers an allowance of 5 percent of purchases for all its customers to use in cooperative advertising and pays up to 50 percent of the cost of the ad.

$$\$300,000 \times .05 = \$15,000$$

If Beaumont chooses to run an advertisement for $30,000, Coleridge will pay $15,000, or 50 percent of the cost of the ad (the amount earned on the basis of the $300,000 purchase).

The Exeter Boutique also purchases coats from Coleridge, Inc., but the amount of the sale is only $5,000. Using the same arrangement it provides to all of its retail accounts, Coleridge allows Exeter a total of $250.

$$\$5,000 \times .05 = \$250$$

Exeter might now be able to run an ad for $500, with each party paying $250 toward its cost. If Exeter chooses to run an ad that costs $1,000, Coleridge is only responsible for $250, the amount earned through the cooperative advertising arrangement. Thus, Exeter is responsible for $750 even though it is more than half of the cost.

Although the amounts of money contributed by Coleridge, Inc., to each customer is different, it used the same percentage allocation in the determination, a concept mandated under the provisions of the Robinson-Patman Act.

The Media

The fashion retailer's advertising needs are best served by the **print media**, whether it is newspapers, magazines, direct mail catalogs, or shopping publications.

PRINT MEDIA

Newspapers. Throughout the United States, readers of such newspapers as the *New York Times, Washington Post, Chicago Tribune, Miami Herald,* and the *Los Angeles Times* are exposed to ads for their favorite retail operations' merchandise offerings. Smaller localized papers are also good outlets for fashion merchants.

Newspaper advertising is timely and is used for a variety of themes ranging from promotional to institutional concepts.
(Courtesy of Marshall Field's)

Most full-line and fashion-specialized department stores spend the greatest proportion of their budgets on newspaper advertising. The reasons for such unparalleled use include the following:

1. The timeliness of the newspaper is important to the fashion retailer. Its seven-day schedule allows advertisers to quickly reach their audiences with the latest style and fashion innovations.

2. Unlike monthly magazines, which require a significant amount of **lead time** for advertisement placement, newspaper ads can be inserted almost up to press time.

3. A newspaper's appeal is not limited to one family member, as are some magazines. Columns and features are directed to every person in the family, giving the advertiser exposure to more than just one segment of the population.

4. The newspaper reaches large numbers of households via subscriptions, guaranteeing the retail community a large number of daily readers.

5. When compared with other media, most notably magazines and television, the newspaper affords the advertiser lower cost per prospective customer.

6. A newspaper's **advertisement "life,"** while not as long as that of a magazine, is much greater than radio or television. The Sunday paper, which contains significant advertising, often has a life expectancy that lasts until the next week's edition is delivered. Families often read its numerous parts throughout the week, making it an excellent investment for the advertiser.

7. The major newspapers usually incorporate full-color advertising supplements in their Sunday editions. These sections are printed on high-quality **stock**, which provides the fashion retailer the opportunity to feature merchandise in a more exciting format. Some readers retain such supplements after discarding the rest of the newspaper, giving the advertiser the advantage of extended periods of customer awareness.

8. Retailers can reach specific markets, since each newspaper targets a different consumer segment. Through assistance provided by advertising agencies and the media themselves, retailers are able to assess which newspaper is most appropriate for their merchandise assortments.

9. Since most newspapers concentrate on narrow geographic areas, it is easier to confine advertising to those within reach of the company's brick-and-mortar operations. Many newspapers have regional editions that narrow the population even more strictly, giving retailers a more exact exposure. Some even publish special sections earmarked for particular communities in the trading area.

Magazines. A trip to the newsstand immediately reveals that the fashion magazine has reached new heights in publishing. From both domestic and global publishers, a wealth of publications such as *Vogue, Elle, Harper's Bazaar, Glamour, L'Officiel-USA, Italian Vogue, Town and Country, Seventeen, Mirabella,* and *Linea Italiana* are reaching the American fashion consumer.

While the advertising in these periodicals mainly focuses on designers and manufacturers, more fashion retailers, national and regional, are using magazines to deliver their advertising messages. Because of the broad trading areas retailers serve, magazines' regional editions allow retailers to restrict their ads to people in predetermined trading areas. Because of the nature of multichannel retailing, which includes the use of Web sites, it makes sense for retailers with limited brick-and-mortar outlets to address customers around the country, because they can include their Web site address in their ads. Magazines do have the disadvantages of a longer lead time necessary for ad placement and comparatively prohibitive costs.

Advantages of magazine advertising include the following:

1. The quality of the stock enables the fashion retailers to put its best foot forward. Excellent paper coupled with the high-quality color reproduction allows every item to get the best possible exposure.

2. Magazines, unlike newspapers, have extremely long lives. Many subscribers keep copies for extended periods and often pass them on to others. In this way, the advertisement has the potential to be seen over and over.

Magazine advertising is very important to fashion retailers who appeal to large consumer markets.
(Courtesy of Ellen Diamond)

3. Many fashion retailers operate branch stores throughout the country, as is the case with Saks Fifth Avenue, Lord & Taylor, Federated stores such as Bloomingdale's and Macy's, the Limited, and Gap, making each able to reach a very wide audience. Many also have on-line divisions so that, when their Web site addresses are noted in the magazine ads, their potential for even broader markets is raised.

4. Since people hold on to magazines for awhile, some fashion merchants use institutional ads to keep their names in the minds of their audiences without having to worry about the perishability factor that is a problem in promotional advertising.

5. With the women in most households now part of the workforce, magazine ads that feature telephone, mail order, and Web site addresses also become appropriate vehicles for showing customers how to place orders.

6. Regional editions make it easy to market the magazine to specific groups and geographical areas.

Unlike the typical fashion magazines that feature scores of advertisements among various articles and regular columns, some fashion retailers have produced magazines that bear their own names. Three of these entries come from Bergdorf Goodman, Neiman Marcus, and Saks Fifth Avenue, the most recent entry, with editions that carry fashion newsworthy events in addition to photographs of the retailer's merchandise. The Saks magazine is called *5* and is expected to build the company as a fashion authority. While the magazine will concentrate on Saks' fashions, it will not feature an order form. The concept is based on the number 5. In the first issue, for example, "5 Women That Matter," is featured, as are five places to vacation. The intention is for the periodical to announce promotional events while having an editorial slant.

The latest to enter this media arena is Bloomingdale's with the introduction of "B," the subject of the following Spotlight.

Fashion Retailing Spotlights

B

As most fashion devotees know, Bloomingdale's is one of the leaders in upscale merchandise for the family, due to its focus on stocking fashion-firsts and merchandise with unique styling. In addition to the attention it pays to merchandising its collections and providing a wealth of promotional ideas to its clientele, Bloomingdale's has embarked upon yet another way in which to publicize its name and the products it sells. The project is known simply as *B*.

In October 2003, Bloomingdale's created a quarterly magazine called *B* in conjunction with John Brown Publishing and mailed it to almost 300,000 customers. The first edition was given away to these prized clients in the hope that they would spend $3.95 for future editions at Bloomingdale's stores or eventually become subscribers. Bloomingdale's would like newsstands across the United States to sell the magazine alongside the likes of *Elle*, *Harper's Bazaar*, *Vogue*, and other fashion "bibles."

B concentrates on everything that has made Bloomingdale's a success and a household brand. Much of the merchandise is featured in "lifestyle" formats. Actress Kim Cattrall appeared on the cover of the first issue, and was pictured inside wearing the fashions of such marque designers as Ralph Lauren and Giorgio Armani. Celebrities in other editions have donned the clothing that Bloomingdale's features. Like Cattrall, they are the focus of articles, making *B* more than just a catalog featuring the company's latest fashions.

The magazine features Q & A segments by Bloomingdale's executives, such as Kal Ruttenstein, senior vice-president for fashion direction, and notable designers are featured, as well as travel stories, gossipy pieces, and other items of interest that make it more than just another fashion magazine.

At *B*'s launch, the executive vice president of advertising and marketing, Tony Spring, stated, "It will be a full-fledged magazine." He also said that Bloomingdale's has "a good idea of what our customers are looking for, so we tried to pull together a terrific representation of her interests. . . . fashion, home, beauty, travel, pop culture, hot new restaurants, new books, music. It's about what we think insiders want to know."

The magazine also features a wealth of advertising from companies such as Mercedes and Boru Vodka interspersed among the editorial articles.

According to the publisher, *B*'s target customer is a female in her late thirties to early forties, affluent, well traveled, well read, and very focused on shopping as a hobby, not a chore.

Always ready to make headlines in fashion, Bloomingdale's hopes that this is yet another venture that will bring them greater sales.

Direct Mail. Most people's overstuffed mailboxes are indications of the amount of **direct mail** pieces coming into American households. The vast majority of these mailings are fashion oriented with catalogs, brochures, pamphlets, and other formats, offering products ranging from apparel and accessories for the entire family to home furnishings.

Because their shopping time is often limited, more consumers are looking at these advertising pieces. Department stores are using direct mail in ever increasing numbers, as evidenced by the fact that they are treating these publications as separate entities from their brick-mortar-operations. Some companies, such as Macy's, have management teams that are apart from their brick-and-mortar operations to better serve consumers who prefer to buy off-site, ordering from information included in the direct mail pieces.

Names and addresses of direct mail recipients come from a variety of places. Many are the retailer's own credit card customers, with others culled from lists the retailer purchases from marketing research firms. These can be tailored to the retailer's demographic needs in terms of age, family size, income, and profession, and the retailer's preferred psychographic segmentation as discussed in Chapter 4, "The Fashion Consumer: Identification and Analysis."

Some of the reasons for direct mail's success include the following:

1. Retailers can target specific groups that appear to have the right characteristics for the company's merchandise assortment.
2. Retailers can insert small direct mail pieces in end-of-the-month statements, thus avoiding the additional expense of separate mailings.

Direct mail catalogs significantly augment brick-and-mortar sales.
(Courtesy of Chico's Retail Services, Inc.)

3. Since people read each advertisement individually, it gets their attention. Ads in newspapers must vie for the reader's attention, because newspapers are full of advertisements.

4. People can examine the mailings at their leisure and order when they have time.

One of the drawbacks for some direct-mail pieces is that people may perceive them as junk mail and not open them. However, if people are interested enough to open them, they frequently are motivated to purchase what the piece is advertising, proving that these are important sources of business for retailers.

BROADCAST MEDIA

Once considered impractical for most fashion retailers, radio and television have become important advertising outlets for some merchants with significantly large trading areas and the budgetary resources necessary to use **broadcast media** in addition to print media. The pros and cons of radio and TV are described in the following sections.

Radio. Of the two broadcast communications outlets, retailers use radio less frequently than television. Although the costs involved in radio are significantly less than those required for television advertising, radio's appeal is limited, because people understand fashion merchandise best when they can see it. Verbal descriptions leave much to be desired. The radio-listening market is also somewhat restricted to a narrow segment, often the teenage or young adult population, and they tend to turn the dial when commercials are aired. Those consumers who listen to the radio do so primarily in either their automobiles or on headsets, thereby reducing the time they listen to commercials to when they are commuting to and from their jobs, or are exercising. People do not spend much time listening to the radio at home.

In spite of these negatives, some fashion retailers find that the radio is a good tool for announcing sales or promotional events.

Television. The old saying "A picture is worth a thousand words" is true, especially when it comes to promoting fashion merchandise. Consumers are able to see the items presented in a variety of interesting ways that might motivate them to visit the retailer's brick-and-mortar operation, log on to its Web site, or call in an order.

The costs associated with such presentations, however, are often considerable. Rarely do fashion merchants sponsor or cosponsor television programming, unless they are giants in the industry such as Sears, with outlets across the country. Even they rarely sponsor programs.

Instead, retailers pay for **spot commercials**, in which their message is delivered during the programs. Often, local merchants, seeking to reach a narrower market, use the spots to reach an identified audience during the time that a program is interrupted for commercial messages or station-identification breaks. This way, a chain in the South can pay to have its ads on programs aired in that region, while another in the West can target its commercials to viewers in that area.

With the costs of airing television commercials generally lower on cable outlets, more retailers are opting for this exposure than using the networks. There too they can focus on regional audiences.

Although television commercials provide a great number of advantages for the retailers that run them, the advent of systems such as TiVo, which enable viewers to bypass the commercial messages whenever they choose is beginning to diminish the value of such advertising.

WEB SITES

Retailers are increasingly using off-site channels to sell merchandise. Major companies that engage in multichannel retailing are reporting more sales every year. The vast majority of retailers have developed Web sites to attract yet another segment of the market that is either too busy to visit the brick-and-mortar operations or too unmotivated to buy through catalogs.

Both multichannel retailers and Web site-only merchants are generating on-line sales. Giants such as Amazon.com and eBay are involved in record-breaking sales every day.

Amazon, once primarily the marketer of goods such as CDs and books, has entered the fashion business in a big way. When people log onto the Amazon Web site, they see a number of different product categories they can access. Fashion classifications include jewelry, apparel, and accessories, and links to the retailers with whom Amazon has made contractual arrangements immediately appear on the screen when users choose a category. These links then lead users to companies such as Nordstrom, Old Navy, and Marshall Field's so that they can see the featured merchandise. Both partners in the arrangement benefit from the association. Amazon gets its fee from the companies for providing them with enormous numbers of consumers who might otherwise not log onto their Web sites, and the retailers gain by making sales.

eBay, the leader in on-line auctions, has successfully moved into fashion merchandising as well. Shoppers do not need to bid on products that range from the most sought-after labels such as Prada, to lesser-known brands. Instead, eBay offers bargain prices for each item. The results have been exceptional, with sales reaching new heights every day.

OUTDOOR MEDIA

Though not as important as the other media, some local fashion merchants use billboards, backlit transparencies, and posters to promote themselves.

- *Billboards.* Along interstate routes and on heavily traveled streets, retailers use large photographs or hand-rendered paintings to inform potential shoppers of their operations. Billboards can be dedicated to a particular merchant or advertise a shopping mall that houses a variety of different retail establishments.

- *Backlit transparencies.* **Backlit transparencies** are illuminated signs displayed in places such as bus stops and inside malls. They can be stationary, where one image is affixed to the screen, or moving, where a few different transparencies are interchanged about every ten seconds to

Shopping bags are both functional and promotional in that they "carry" merchandise and the store's message outside of the shopping environment.
(Courtesy of Genpak)

Backlit transparencies are illuminated advertisements that bring the message to the shopper twenty-four hours a day.
(Courtesy of Genpak)

provide additional images to the passersby. The illumination feature makes the presentation visible twenty-four a day.

- *Posters.* These are generally smaller versions of billboards displayed on the outside of buses. They reach a large number of pedestrians who may see them as they walk to their destinations as well as people in cars who pass the buses or are next to them at traffic lights.

Collectively, outdoor advertising is modestly priced, which makes it affordable even for small merchants.

Overall Costs of Advertising

Retailers must first develop a budget for advertising endeavors so that they can determine which approaches best serve their needs. Retailers can compare the costs of the different media by consulting the **Standard Rate & Data Service (SRDS)**. Retailers generally establish their promotional budgets through one of the methods described in the following sections.

PERCENTAGE OF SALES METHOD

Most retailers who have been in business for a number of years choose this technique to determine how much they will invest in advertising. They first analyze past sales so that they can try to determine what the sales figures might be for the next period. Once they have determined these figures, retailers assess other expenses, such as their plans for expansion in terms of additional brick-and-mortar units, and whether they should broaden the use of their catalog operation, if they have one, and their Web site programs, if they are part of their selling tools. Changes in merchandising policies and practices and the state of the economy are also factored into the equation and carefully assessed.

After addressing these areas, retailers then apply a percent of their anticipated sales to arrive at what they will budget for advertising costs.

OBJECTIVE AND TASK METHOD

In this more sophisticated approach, the company analyzes its objectives and the tasks it must perform to achieve these goals. Today, this method is particularly appropriate for large fashion retailers that are expanding their operations from primarily operating brick-and-mortar units to creating multichannel ventures that use off-site approaches to increase their sales potential; their advertising needs tend to grow accordingly. Other factors that often require retailers to have additional advertising expenses include introducing private brands and labels and expanding customer services. Retailers then analyze these situations to determine how much they need to spend on advertising to reach these objectives.

UNIT OF SALES METHOD

In addition to being concerned with dollar volume, most retailers keep records on the number of units their different sales channels sell. In the unit of sales method technique for advertisement budgeting, the retailer tries to assess how much it must spend on advertising to sell each unit. In large retail organizations with numerous merchandise classifications and departments, each product type requires a different advertising investment. For example, furs will certainly necessitate greater per-unit expenditures than shoes because of the differences in prices and units sold. The retailer must then examine just how much advertising might cost for each merchandise category. Once this has been estimated, the retailer multiplies the numbers of units that are expected to sell by the factor that has been assigned to them.

Advertising Cost Differentials

There are certain costs inherent in each media classification that account for the actual charges. In newspaper, magazine, and broadcast advertising, additional charges are routinely applied if the retailer requests specific placement for its ads.

NEWSPAPERS AND MAGAZINES

When placing an ad in a newspaper or magazine, the retailer has no guarantee it will generate sales. However, placing an advertisement in a specific part of the publication will sometimes bring better results in terms of sales. It can help the retailer to know the various technical placement terminology, described in the following section, when considering the various options.

- *Run of press.* This is the basic cost of advertising in a periodical's space. Being the least expensive rate, it does not guarantee a specific location in the publication. Placement is left to the discretion of the publisher. If a retailer chooses **run of press (ROP),** its ad might be printed in a location it considers undesirable.
- *Preferred position.* To guarantee that their ad is put in a particular place, or **preferred position,** many merchants pay a premium rate. Fashion retailers who want to get maximum exposure are often willing to pay extra for an ad to be placed near a fashion column or as close to the first page as possible, where most readers are likely to see it.
- *Regular position.* Some merchants subscribe to the theory that if their advertisements always occupy the same position (i.e., a **regular position**) in a publication, their customers will be able to find them quickly. Retailers, and other advertisers, sign long-term contracts for this right and pay additional charges for ads to occupy the same position each time.

Evaluation of the Advertisement

The purpose of advertising is to increase sales and profits. To make certain that the advertising is fulfilling its purpose and warrants the expense involved, retailers need to evaluate its effectiveness.

Small fashion retailers, because of their involvement with customers, often hear from their customers that they saw the ad in a particular location. Though this does provide anecdotal evidence of the ad's effectiveness, it is certainly not a scientific approach to advertising evaluation.

Larger retail operations that invest heavily in advertising must know if their costs were worth the investment. Most of the major companies with in-house research departments measure sales prior to the advertisement and immediately after it has run. If there was an increase in sales for the advertised merchandise, it can be assumed that the ad brought in the additional revenues. In addition to the increase in sales, some retailers determine if the additional sales brought enough business to the company to cover the cost of the ad and deliver a profit.

Some of the research tools discussed in Chapter 5, "Classifications and Methodology of Retail Research," are used to evaluate advertising's effectiveness.

PROMOTIONAL PROGRAMS

Whether it is to attract new customers to their on-site and off-site outlets, make the consumers aware of their image, promote the collections of established as well as new designers, herald the arrival of a new season, or call attention to company-sponsored charities, fashion merchants are constantly developing promotional programs. While the flashier and more ambitious endeavors take place in retailing's major organizations, their small-company counterparts use numerous devises and tools with considerable success. It is not always the extravaganzas paid for by the seemingly limitless budgets that attracts the customers' attention to the retailer but rather the creative promotions that are accomplished with small monetary investments.

Special events and regular promotional programs are planned by specialists in the major retail organizations. Under the direction of a divisional manager, the promotional efforts are usually part and parcel of a plan that includes advertising and visual merchandising, making it a multimedia collaboration. With proper coordination, the advertising captures the consumers' attention and brings them to either the company's brick-and-mortar units or its catalogs and Web sites, and the visual presentations in the stores enhance the promotions.

The smaller operations usually rely upon the talents of their owners or managers to develop the fashion formats and tools that will draw customers to their shops.

Jeffrey Kalinsky's involvement in raising funds for charities is the focus of the Spotlight about his upscale fashion emporiums.

Fashion Retailing Spotlights

JEFFREY

When Jeffrey Kalinsky opened his first Jeffrey store in Atlanta in the early 1990s, few expected it to become one of America's premier fashion emporiums. It has been called "the combination of a small boutique and the graciousness of an old department store." With the great success Kalinsky achieved in the Atlanta unit, and his two other entries in the upscale Phipps Plaza, Bob Ellis Shoes and Jil Sander, he was on his way to entering the highly competitive New York City fashion arena.

Instead of beginning the new venture on one of Manhattan's better-known venues such as Fifth Avenue and Madison Avenue, or one that would coexist with other fashion operations in Soho, he opted to open his shop in the Meatpacking District, a location that is well described by its name. Amid the wholesalers that slaughtered meat for a living, Kalinsky developed the "essential destination for the fashion obsessed." His choice was on target and made him a major player in the New York City arena.

In addition to filling his operation with merchandise from Yves Saint Laurent, Gucci, Giorgio Armani, Michael Kors, and Jil Sander, he turned his attention to raising funds for his favorite charities.

In Atlanta, for example, Kalinsky holds an annual fund-raiser for Project Open Hand and the Susan G. Komen Breast Cancer Foundation. Since the fund-raiser began in 1992 as a small in-store event in his Atlanta store, it has gone on to become one of the most visible charitable events in the fashion industry. At a function known as Fashion Cares, the 2003 installment held in Atlanta's Woodruff Arts Center raised more than $200,000. Internationally renowned models such as Patchin paraded down the runway in wares from each of the Jeffrey Phipps Plaza boutiques and wowed the crowd that included more than 500 people, many of whom were devotees of Jeffrey and wore clothing from his shops. Local radio and TV personalities worked up the crowd for the silent auction that included the top bid of the evening—$10,000—for a four-night stay for up to twelve people at the Highland House on Montego Bay, Jamaica. Auction merchandise was also donated by Tiffany, Christian Dior, Cynthia Rowley, and others.

The evening, typical of his numerous fund-raisers, was perhaps best summed up by a fellow retailer, who said, "Jeffrey introduces the best of fashion to Atlanta and has always been known for that. His charitable contributions speak for themselves."

Not only does he gain recognition for his charitable efforts but his company receives a wealth of publicity in such consumer newspapers as the *Atlanta Journal-Constitution* and the trade paper *WWD*.

Fashion Shows

What better way is there for retailers to dramatically present the latest styles to their customers than with a fashion show? While other devices may bring excitement to the retail arena, few incorporate the company's merchandise in the presentation as well as fashion shows. Ranging from formal events that demand the attention afforded professional theater and require significant budgets to the fashion "parades" that merely employ simple runways and recorded music, fashion shows may be produced for every retailer's budget and audience.

FORMAL PRODUCTIONS

Complete with themes, live music, and commentary, formal shows are the most costly. The settings are usually in theaters that have been leased for the occasion or ballrooms that have been transformed to stage the events. Professional models wearing the clothing dance, march, frolic, or even skate through the various scenes of these shows. Sometimes the backgrounds and props rival the fashions that are being displayed.

Major fashion retailers such as Bloomingdale's and Neiman Marcus subscribe to these extravaganzas and often present them in conjunction with fund-raisers for charitable organiza-

Fashion shows run the gamut from formal productions to runway parades.
(Courtesy of Ellen Diamond)

tions. They sell tickets for these special events with the proceeds going to the charities. The retailers involved often get free publicity from the media's editorial press that covers such events, such as *Women's Wear Daily* and *DNR,* recognition from the public for their participation in worthy causes, and ultimately business from the sale of the fashions featured in the production.

RUNWAY PARADES

The more typical fashion show is presented runway style, generally in the store. The staging area might be a department that has been cleared of its merchandise for the event and refitted with chairs that are placed on either side of the runway, an in-store restaurant where the patrons may watch the show after finishing a meal, in community and special events rooms, or in shopping center malls.

Easy to organize and modest in cost, such **runway parades** concentrate on specific collections or merchandise departments. They might introduce resort wear or be organized around a **trunk show** that features a designer's collection brought in so clients can preview it and place special orders. Trunk shows are very popular with many high-fashion merchants and are equally favored by their clienteles. The designer or company representative delivers the commentary and answers questions at the show's end.

Where the magnitude of the formal show requires considerable participation from professionals and salaries that are commensurate with their talents, retailers can offer the less-structured fashion parades without incurring as many costs. College students, charity workers, or store employees could be used in place of the professional models and observers enjoy watching these amateurs walking the runway. Instead of paying a professional band or pianist, retailers can contact a school's music department about using student musicians and make a small donation to the educational institution in return. Prerecorded music is also an inexpensive option.

INFORMAL MODELING

Some merchants use the least formal fashion show concept, **informal modeling.** This approach involves dressing models in specific styles and having them move throughout the store's different departments. Furs are often shown this way as are other unique collections

that the retailer is trying to promote. The models carry identifying merchandise cards that list the name of the designer, price, location where the collection may be seen, and other information. This method requires little planning other than to choose the styles the models will wear and to delineate the routes that they will take throughout the store to show the clothing.

Whatever the retailer's size or budget, it can present fashion shows that will bring both publicity and profits.

Unique in the retail industry is the annual fashion extravaganza presented by Victoria's Secret, the topic of the following Spotlight.

Fashion Retailing Spotlights

VICTORIA'S SECRET

No other retailer has made the marriage between its fashion shows and television like Victoria's Secret has done. Stocking cutting-edge lingerie, the chain, with more than 1,000 outlets, has revolutionized the innerwear industry. Of course, the televised fashion show extravaganza has helped the company achieve its goal as the best-known purveyor of scanty undergarments in the world.

The show is presented as an entertainment vehicle similar to a Broadway musical, with live performances by well-known entertainers. The 2003 entry featured Sting, Mary L. Blige, and Eve, performing on stage, but the audience comprising such celebrities as P. Diddy, Denzel Washington, Damon Dash, Chris Noth, Ahmad Rashad, and Tommy Lee gave them a great deal of competition. Of course, the models who strutted down the aisle featured such marque names as Tyra Banks and Naomi Campbell, and they sported whimsical items that had Generations X and Y appeal.

At a cost of more than $6 million, the Victoria's Secret's event is the most expensive fashion show to be put on by a retail organization. It also has the distinction of being the only fashion brand to have its own network television special. Originally an Internet phenomenon, its popularity in that venue paved the way for its television appearance during the "sweeps" period, a time when TV audiences are measured and programmers are wooing large viewing groups.

While the return on its investment is a company secret, the organization does say there is a direct correlation between the show and immediate sales, and overall annual sales are boosted by about $10 million dollars.

With plans for the annual Victoria's Secret Show underway for many years to come, it is obvious that the company feels the benefits are worth the cost.

Special Campaigns and Celebrations

The major fashion-oriented department stores are proponents of special campaigns and celebrations to attract customer attention. Companies such as Neiman Marcus, Bloomingdale's, and Marshall Field's in the United States, and Harrod's in London periodically organize these types of promotions.

Harrod's, for example, kicks off its annual storewide sales with a parade that is replete with celebrities from around the world arriving at the store in horse-drawn carriages. The crowds that gather to watch them go by are much like those that witness the traditional Thanksgiving Day parades sponsored by American retailers such as Macy's.

In 2003, Marshall Field's State Street flagship in Chicago introduced its new retail concept of partnering with boutique retailers from around the world by employing a number of models to scale the walls of the store's exterior dressed in the fashions that would be sold in these partnered venues. This occasion drew large throngs of curious onlookers.

Other retailers adopt international themes and transform their stores into showplaces that feature clothing and accessories from other countries.

Institutional Events

Some retailers draw attention to themselves by featuring events that are not specifically merchandise oriented but are intended to bring people to their stores, where they will be moti-

vated to shop once they are inside. These promotions run the gamut from physical fitness-related programs to flower shows.

The annual Macy's New York flower show literally transforms the main floor of the flagship store into a botanical garden overflowing with flowers. The show heralds the arrival of spring and has been a well-received promotion since 1975. The windows feature merchandise abundantly surrounded with flowers, the streetside awnings are changed to incorporate the theme, and the interior displays incorporate flowers throughout the selling departments. The success of the show is measured by the huge crowds attending and the increase in sales during that time.

Designer and Celebrity Appearances

When a store announces that Calvin Klein is going to appear to discuss his latest collection or that Elizabeth Taylor will be there to promote her perfume line, it is a guarantee that enormous crowds of shoppers will be on hand to see them. The arrival of soap opera stars, who have little to do with design or fashion generally results in crowds that are often too large for the store to handle.

When Tommy Hilfiger showed up to promote his fragrance at a Belk branch in Jacksonville, FL, the crowds were so enormous that security had trouble controlling them. Sales, of course, skyrocketed.

Often, the celebrities do nothing more than show up at a store but if they have star power, they are more than likely to attract their followers and fill the store with potential shoppers.

Celebrity appearances often bring a great number of shoppers to a retailer's environment.
(Courtesy of Ellen Diamond)

Holiday Parades

Also institutional in nature but not held within the confines of the stores, are the numerous holiday parades that draw throngs of potential shoppers to the retailers' vicinity. The most prominent of these is the annual Macy's Thanksgiving Day Parade in New York City, which is coproduced with NBC. Crowds stand twenty feet deep and line the streets of the parade route that winds from uptown to the Macy's Herald Square flagship. Floats filled with celebrities from theater, film, sports, and television; soaring helium-filled balloons that rise up into the sky; marching bands that have competed for the right to be in the parade; and the last float carrying Santa Claus finish their participation at the entrance to the Macy's flagship. There, the television cameras are stationed to capture the numerous extravagant musical performances that have been specially staged for the event and the show-stopping scenes from Broadway plays—with Macy's in the background. Macy's parade, with its multimillion dollar budget and the year it takes to plan, has brought it more attention than anything else it does to promote itself.

In-House Video

Many of today's leading fashion designers produce **in-house videos** of their collections to be shown in the retail operations that they sell to. These productions run the gamut from those aimed at the teen market that have models dancing to rock music white wearing the latest trendy styles to those aimed at affluent adults that show sophisticated runway presentations featuring couture collections.

Retailers install video screens in the departments that feature this merchandise, and, if the videos are well produced, they capture the attention of passing shoppers.

Demonstrations

On any major fashion retailer's main floor are the cosmeticians who are there to show the transformative powers of their products. Stores such as Henri Bendel on Fifth Avenue in New York City always has a wealth of such "artists" on hand to demonstrate their products. Women regularly line up for the chance to have makeovers with these cosmetics. Not only do participants purchase the cosmetics but frequently those who watch the demonstrations do so as well.

Sampling

Another promotion technique dominated by the cosmetic industry is **sampling**. Every major manufacturer has followed the lead of Estee Lauder, who first offered a free sample of her product to passersby. Today, especially around Christmas time, the cosmetics counters at every major department store are filled with sample packages of products that are beautifully gift-wrapped and modestly priced to promote their companies' lines.

Free samples are intended to introduce the products and motivate customers to purchase the items once the samples have run out.

PUBLICITY

Every major fashion retailer has a public relations (PR) or publicity department that works to gain as much favorable **publicity** for the merchant as possible.

Sometimes referred to as **free publicity,** it comes as a result of the retailer's involvment in an activity that is considered newsworthy and is technically free because the store does not pay for it. Of course, the Macy's Flower Show and Thanksgiving Day Parade cost millions of dollars to produce, but the press coverage Macy's receives as a result comes at no direct cost.

Retailer PR departments prepare press kits and releases of their promotions and send them to a variety of media in the hopes that they will find the promotional activities sufficiently appealing to mention in print and on the air.

Because of the competitive nature of fashion retailing, every bit of positive publicity that a merchant can garner will serve to attract shoppers to its retail outlet.

TRENDS IN ADVERTISING AND PROMOTION

The methods that fashion merchants use to promote their companies and the products they sell have, in some ways, remained the same as the ones merchants used in the past decades, but there are some new practices gaining popularity, described in the following sections.

- *Increase in direct mail usage.* Although fashion merchants have made significant use of catalogs to reach their clienteles in the past, today's publications are becoming bigger and are read more frequently by those in the retail industry. It is not uncommon for people to receive a different catalog every day of the week.

- *Fashion catalogs as information resources.* Unlike the typical direct mail catalogs extensively used by retailers, a new breed has surfaced that combines product advertisements with news information. One of the earliest proponents of this type of direct marketing, Patagonia, augmented its product offerings with articles on environmental concerns; it is now joined by other retailers that use this avenue to promote their companies and products. Bloomingdale's, for example, produces a magazine called *B* that not only features its upscale merchandise but also includes articles on the fashion scene.

- *Decrease in storewide promotions.* Although in-store promotions are still very important to fashion retailers, the storewide events, such as the Neiman Marcus Fortnights and Bloomingdale's foreign country fashion promotions, have all but disappeared from the fashion-retailing scene. The dollars they expend for such extravagant programs have not provided the companies a worthwhile return.

- *Decrease in institutional advertising.* What was once considered a mainstay for fashion retailers has now become a rarity in the industry. In place of institutional advertisements, the success of which is difficult to measure, retailers are turning more to the promotional types that, if successful, immediately translate into sales.

- *Cooperative advertising advances.* As the costs of advertising continue to upwardly spiral, fashion merchants are demanding that their merchandise resources share expenses before they place their orders. To compete in the highly competitive fashion arena, where retailers are reducing their advertising budgets, the sharing of these expenses is the only way many can continue their promotional campaigns.

- *Decrease in major fashion show presentations.* While fashion shows continue to play an important role in the retailer's promotional endeavors, the use of the extravaganza has significantly decreased. Instead of spending large sums for these events, more fashion merchants are implementing runway parades and informal in-store modeling.

- *Increases in demonstrations.* Especially in the cosmetics classification, in-store demonstrations have become more and more visible. In most every fashion department store, each vendor supplies make-up artists to demonstrate its products. Retailers like this promotional activity because the expenses are borne by the cosmetics companies themselves.

SMALL STORE APPLICATIONS

Small retailers often believe that the expenses attributed to advertising and promotion are simply too high for them to participate in these endeavors. Those that do not advertise their companies are likely to be less profitable than those that do.

Promoting a business through advertisements and promotional devices need not be costly if the retailer tries certain approaches to the problem.

One way in which to stretch the budget is to consider cooperative advertising. By sharing expenses with the merchandise resource and using inexpensive local print media, such as the weekly newspapers, even the smallest merchant can participate.

Fashion boutiques and other small operations attract attention by producing fashion shows. As was discussed in this chapter, retailers can use students and customers instead of paid models, meeting rooms of charities into stages for the event (and make donations to the charity to offset the cost of rental space), have store owners write the commentary if deemed necessary, and play recorded music.

Chapter Highlights

1. Those responsible for the management of the advertising and promotion functions in large fashion retailing operations are specialists who limit their duties to the companies' promotional plans. In small operations, this responsibility is in the hands of the owner, who also performs a host of other duties.

2. Retailers, both large and small, employ the services of advertising agencies that plan everything from layouts to ad placement. Even the largest companies that have their own in-house staffs use the agencies either to assist them with their own presentations or to help them with major events.

3. Retailers sometimes employ freelancers who provide everything from the design concepts to the ad placement; and the media themselves employ staff to assist merchants with their advertising needs.

4. Some fashion designers and manufacturers are willing to share the expense of advertising and enter into cooperative arrangements with their retailer customers. By dividing the cost, the retailer can make better use of its budget, and the vendor can make certain that the retailer is featuring its line.

5. The most important advertising medium for fashion retailing is the newspaper. It requires little lead time for publication, can reach a defined market, and is relatively inexpensive in terms of the numbers of potential customers reached.

6. Television is used sparingly by the fashion retailer. Aside from its cost, it generally appeals to too wide an audience, unless the advertisement is shown only on a local affiliate that reaches the retailer's targeted audience. TV ads usually announce sales.

7. The fashion show is one of the more important promotional devices used by the industry. The events are usually parades that feature models on runways or informal modeling in which the action takes place in the aisles of the stores.

8. To get their names in print and on the air, the larger fashion retailers have public relations departments that send press releases and kits to area media describing their activities and events.

Terms of the Trade

advertising
copy
artwork
advertising agencies
freelancers
media
promotional advertising
institutional advertising
combination advertising
cooperative advertising
print media
lead time
advertisement "life"
stock
direct mail
broadcast media
spot commercials
backlit transparencies

Standard Rate & Data Service (SRDS)
run of press (ROP)
preferred position
regular position
runway parades
trunk show
informal modeling
in-house video
sampling
publicity
free publicity

For Discussion

1. Which departments are part of a major fashion retailer's promotion division?
2. How does the typical in-house advertising department differ from the one used by many giants in the industry?
3. In addition to the advertising agencies, what other external sources are available to retailers to promote their organizations?
4. How does a promotional advertisement differ from one that is institutionally oriented?
5. What is meant by the term "combination advertisement?"
6. Is it possible for a retailer to place ads that cost double the amount allocated in the budget? How?
7. Why is the newspaper the most important advertising medium for the vast majority of major department store operations?
8. What are some of the advantages of magazine advertising for retailers?
9. How can fashion retailers without national prominence make use of television advertising?
10. In what way does the fashion retailer benefit from becoming a participant in the Web sites of giants such as Amazon.com?
11. What advantage does the backlit transparency have over the traditional forms of outdoor signage?
12. How does SRDS serve the retailer?
13. How does the *percentage of sales method* differ from the *objective and task method* in determining budgetary allowances for advertising?
14. In what way is the formal fashion show different from the fashion parade?
15. What is a trunk show?
16. Why do some retailers use institutional events as part of their promotional programs?
17. Why are designers often willing to take time from their busy schedules to make in-store appearances?
18. Why has in-store video usage become an important part of the fashion retailer's promotional plan?
19. Who began the concept of sampling in the cosmetics industry, and what purpose does it serve?
20. Discuss the concept of publicity and how it differs from advertising.

CASE PROBLEM 1

The Kensington Kloset is a modest-sized boutique that specializes in upscale fashion for the discriminating woman. The majority of the merchandise is custom designed by its owner, Jim Sanders. Using talents that were honed by attending a well-known fashion school and working as an apprentice for a clothing designer, Jim has achieved moderate success in his own shop.

To round out his merchandise mix, Jim purchases bridge apparel and some couture products.

The shop is located off the beaten path and out of sight of a potentially large market. He chose this location because those situated in better places cost more than he can afford. The only way he has earned a customer following is through client recommendations.

He believes that he hasn't reached his sales potential, but with little money to spend on advertising and promotion, his outlook for increased business is bleak. Some of his friends who work for major organizations have suggested that he use the cooperative advertising route to

augment his own promotional budget. Since most of the merchandise he features is his own, this approach doesn't seem to be viable. Even with some cooperative money, major newspaper ads are out of the question because of their costs. Magazine and broadcast advertising are similarly too expensive to consider.

At this point, he would like to begin to promote his store and collection, but he hasn't been able to come up with any ideas that would fit his budget.

Questions

1. Should Jim be satisfied with his modest success and forget about promotion?
2. What promotional devices would you suggest that would be within his reach?

CASE PROBLEM 2

Langham and Dover is a traditional department store organization that has been in business for fifty-two years. Since its inception, it has regularly examined its merchandising philosophy and made changes where necessary. In the beginning, it featured an equal assortment of hard goods and soft goods but has gradually shifted away from furniture and appliances to concentrate on its fashion apparel and accessories classifications. While the merchandise mix has drastically changed, the company's approach to advertising has not.

Members of the upper-level management team in the promotion division have been with the company for many years, some as much as forty years. While they are technically trained specialists who have served the company well, their creativity has stagnated. They still employ traditional approaches to advertising, with little excitement visible in their campaigns. With the company ready to expand its store operations by adding more catalogs and pursuing off-site shoppers via a newly created Web site, the old advertising methodology doesn't seem to fit its present-day needs to remain competitive.

The company's CEO and his management team have considered replacing those responsible for the advertising program, but their longevity and dedication to the company make this choice impossible.

With its present expansion plans, the company doesn't believe it is equipped to handle the changes and make its presence better known.

Questions

1. Would you alter the internal staff in any way?
2. What other suggestions might you make that would help solve the company's problem?

EXERCISES AND PROJECTS

1. Collect ten retail fashion advertisements from newspapers and magazines and categorize each according to type: promotional, institutional, and combination. Mount each ad on a fomecore board and explain to the class why it fits into the specific category.
2. Using the Standard Rate & Data Service, available at most libraries or on-line, look up the advertising rates for three newspapers in the same general trading area. Prepare a chart that shows the rates for ROP, preferred position, and regular position placement for each publication, and the circulation for each.
3. For an end-of-the-semester activity, develop as a class a runway fashion show to raise money for a charity. Many retailers will gladly provide the clothing for such a purpose if they receive the proper publicity. Divide the class into groups with each handling a different aspect of the production, such as development of the concept, model selection, acquisition of props, writing commentary, publicity, retailer liaison, and so forth.

 The production should take place on the campus or the retailer's premises. Sell tickets with the proceeds going to the charitable organization.

CHAPTER 16

Visual Merchandising

After reading this chapter, you should be able to:

■ Define the term *visual merchandising* and how it differs from the term *display*.

■ Discuss three major means by which fashion retailers carry out their visual merchandising plans.

■ Compare the approaches used to display merchandise in windows and on the selling floor.

■ List and describe the importance of the different elements that make up a retailer's visual presentations.

■ Identify the different principles of design that go into the creation of visual presentations.

■ Discuss the ways in which the retailer's "trimmers" help to maximize the visual program's success.

When passersby stop and look into the windows of such fashion retail giants as Lord & Taylor, Macy's, Marshall Field's, Nordstrom, Saks Fifth Avenue, and Neiman Marcus, they are immediately treated to visual presentations that often motivate them to come into the store. Especially in these retailers' downtown flagships, where the window structures are replete with mini-stages, visual merchandisers design displays that are so visually attractive that even those with limited time stop to admire the offerings.

Of course, **visual merchandising** is not limited to the major fashion retailers and their windows but is used by every type of retail entry that offers apparel, accessories, or home fashions, both outside and inside their retail environments.

Those who have walked through the selling floors of companies such as Crate & Barrel are immediately treated to presentations of glassware, dinnerware, tableware, and decorative accessories that often prompt them to make unplanned purchases. It's not the uniqueness of the merchandise at Crate & Barrel that makes people want to buy it but the settings in which the items appear. Williams-Sonoma, one of the leading purveyors of cooking equipment and food presentation items, is another example of a store that uses exciting visual presentations to transform even the most mundane products into settings that often stimulate shoppers to make unplanned purchases.

With the competitive climate that every retail operation faces today and the "me-too" aspect of the fashion industry, it is often the creative hands of a company's visual team that set its environments and merchandise presentations apart from the rest with creative displays that will help the store sell its merchandise.

In the past, the term "display department" generally described the company's division responsible for installing windows and formal interior presentations. Today, this nomenclature is all but gone replaced by "visual merchandising department," since visual presentation tasks have been expanded to include the placement of merchandise on the selling floors, the development of signage, and assistance with the design of environments. Those who head these divisions generally carry the title of vice president, showing that they have the same importance to the company as other members of the upper management team.

A store's visual presentations are not always developed and installed by in-house teams but can be done by others who either work as freelancers, if the store is part of a chain, or are

The excitement of this Marshall Field's window presentation often motivates shoppers to enter the store. *(Courtesy of Marshall Field's)*

in the chain's central headquarters. Regardless of the arrangement, the visual elements that the visual merchandisers deal with and the design principles they follow are the same.

RESPONSIBILITY FOR THE VISUAL MERCHANDISING FUNCTION

Ideally, it is best to have an in-house staff to provide the creative and developmental concepts of visual merchandising and to carry them out at a moments notice, if necessary. In reality, however, this luxury is limited to those giant fashion merchants with department stores encompassing enormous square footage in their flagships and branches and the budgets necessary to make them visually appealing.

Other companies, such as chain operations that often have more than 2,000 individual selling units, generally have little need for in-house visual specialists since the space the units occupy doesn't warrant such hands-on attention. These organizations generally subscribe to a centralized management approach to the visual function, where the actual presentations are left to each unit's manager or assistant, who is guided by the directions of the company's central visual team. Small, independent retailers generally opt to use freelancers to install their displays and offer assistance regarding the proper positioning of merchandise on the selling floor. The following sections describe these three approaches.

In-House Staffing: The Department Store Approach

The major department stores have full-time staffs that develop and execute their visual programs. A visit to any of these stores immediately reveals the scope of their involvement. With the advent of a new season or the beginning of a special holiday selling period, these visual teams transform their environments almost overnight from one theme to another.

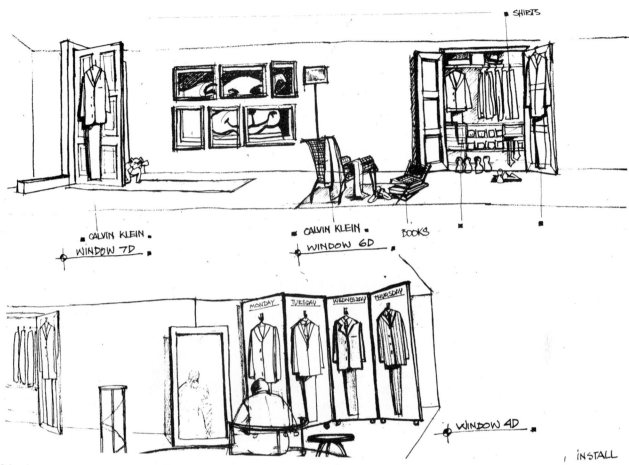

Major department stores create their own visual presentations beginning with rough sketches.
(Courtesy of Lord & Taylor)

When major displays are warranted, many retail giants use outside resources to produce the required props.
(Courtesy of Ellen Diamond)

As sales traditionally wane after the introduction of fall fashions, retailers are ready to get their premises revitalized for their biggest selling season of the year, Christmas. Each year, usually beginning in early November, the major merchants across the country go all out to provide the most unique visual presentations that their staffs can design. The monies spent during this period are significantly greater than at any other time.

Headed by a visual merchandising director or vice president, **in-house staffs** prepare for their assignments with the same dedication as fashion apparel designers who are preparing for their latest collections. Teams of prop builders, signmakers, painters, carpenters, photographers, and trimmers work diligently to make each year's presentation equal to or better than the one that preceded it.

Many of the retail fashion giants use their own teams to actually present their themes but also contract with outside display designers to construct the props that best enhance the themes. The leader in animated design, especially for use at Christmas time, is Spaeth Design, whose creations are featured in store windows all across the United States. A Spotlight of the company follows.

Fashion Retailing Spotlights

SPAETH DESIGN

When fashion retailers such as Lord & Taylor, Saks Fifth Avenue, Marshall Field's, and Macy's want to make an impact on the public with imaginative window displays, they immediately call in Spaeth Design. In business since 1945, this family company has long been considered one of the top firms in the creation of exciting visual décor for America's leading fashion retailers. One look at the moving mechanical figures dressed in period costumes reflecting fashion from other eras is enough to see why Spaeth commands such attention. These are not the typical installations regularly turned out by visual teams but works of art that have been developed by in-store teams and built by Spaeth. The attention these works of art achieve can best be explained by the crowds that line the streets in front of the stores that feature them. In New York City, these store windows receive as much attention as the magnificently decorated Christmas tree that stands in Rockefeller Center and the spectacular annual Radio City Music Hall show

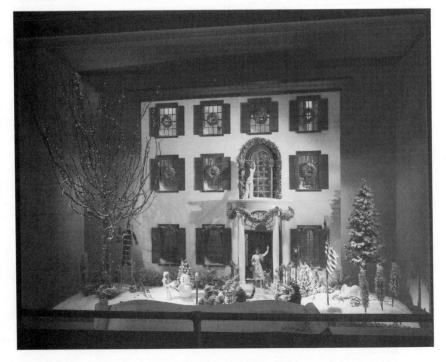

Spaeth Design's forte is the creation of Christmas window displays.
(Courtesy of Lord & Taylor)

featuring the world famous Rockettes. With a staff of the most creative and innovative designers, artisans, crafts people, and carpenters, Spaeth regularly executes visual presentations of distinction. These creative teams look like they are building permanent structures rather than short-lived window displays.

The founders of Spaeth Design, Walter and Dorothy Spaeth, had the design ability and foresight to enter into this segment of the visual industry. Still a private company, Spaeth Design is spearheaded by their son David, who is CEO. Although it specializes in animated displays for year-round projects and engages in store planning, the company's forte is the Christmas period.

Not long after the remains of winter and the preceding Christmas have faded, it is time to begin again for the next Christmas season. With about 90 percent of its business realized from Christmas promotions, Spaeth is ready to greet the retail industry's major visual merchandising proponents in the early spring so that the retailers' plans can be incorporated into new themes that will be ready for installation just before Thanksgiving.

Around the beginning of July, after continuous planning sessions between the Spaeth designers and the retailers' visual planners, the ideas are usually finalized. The themes run the gamut from the traditional to the high-tech, with the dominant feature usually being miniature mechanical figures. Since the development and creation of the various displays are the combined efforts of each store's visual team and Spaeth, the results are totally different for each retail operation. The actual installation requires the hands-on efforts of the merchant and Spaeth.

By November, about thirty carpenters, painters, and welders are working diligently to meet their deadlines. At the very last moment, Spaeth employs many part-time workers to put the finishes of glitter and other coverings on the displays. Just before Thanksgiving, when all the retailers want to unveil their new Christmas windows, teams of Spaeth designers depart for Chicago, Kansas City, San Francisco, and wherever else the orders came from to install their creations. Spaeth also closes up shop to make the rounds of the local stores close to home, such as Lord & Taylor and Macy's, to check their work.

The crowds that look forward each year to these spectacular displays are always on hand along the sidewalks in front of the stores to greet and marvel at the new masterpieces. One look at their magnificent presentations is enough to see how creative Spaeth Design is. The continuous increase in its business indicates the company's success.

Centralized Visual Merchandising: The Chain Organization Approach

The size of a chain organization, by definition, ranges from a company with as few as 2 units to the giants in the industry with 2,000 or more. While those with fewer stores do not generally utilize a centralized approach to visual merchandising, those with more units are generally proponents of this concept.

The smaller chain operations often utilize one or two people who go from store to store installing window displays and making interior merchandise changes in counters, showcases, vitrenes (glass display cases used for small, formal presentations), and other fixtures. Their efforts generally center upon changing the merchandise displays rather than drastically transforming the store to depict different seasons.

Larger chain organizations often subscribe to the practice of **centralized visual merchandising**, which involves a small professional visual team that operates from a company's central headquarters. A staff headed by a visual merchandising director plans each window and interior presentation. After the designs have been executed in "sample" windows and typical interior spaces, they are photographed. The photos, either in the hard copy format or on computer disk, accompanied by some props, signage, materials, and instructions, are then forwarded to the individual units of the chain. So carefully executed are these visual merchandising plans that the store manager or assistant can easily install them.

This route is utilized for a number of reasons. First, it saves the company considerable expense by eliminating the necessity for professional **trimmers**. Second, the practice guarantees the uniformity of visual presentation throughout the organization. Third, it allows the central office to quickly make changes throughout the company without sending trained professionals to each store. Organizations such as Gap, Banana Republic, and Williams-Sonoma rely upon centralized visual merchandising for their stores.

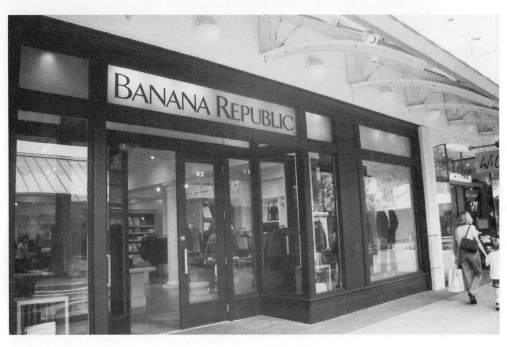

Banana Republic is a proponent of centralized visual merchandising.
(Courtesy of Ellen Diamond)

Freelancing: The Small Store Approach

Small fashion merchants, such as those who operate upscale boutiques or specialty stores, neither have the need for in-store trimmers nor the budgets to afford the expense associated with such practices. They do, however, understand the need for creative, timely visual presentations in their windows and interiors, and many chose **freelancers** to carry out these responsibilities.

These professional trimmers provide all of the elements necessary to create interesting displays. They either sell the necessary seasonal props, background materials, individualized signage, and other elements to the stores to use at other times or rent these fixtures. Together with the merchant's own mannequins and merchandise, these design elements create visual presentations that will tempt shoppers to enter the store's premises.

For their services, freelancers are paid on a fee basis and usually contract for a period of one year.

Between these professional periodic installations, many small fashion entrepreneurs make their own merchandise changes in their display windows. Sometimes they do so because a customer wants a particular item in the window that is in short supply in the store, or because they want to show new items that weren't available at the time of the installation.

Many of these merchants are fashion savvy and hone their display skills through classroom instruction. They master such simple techniques as mannequin dressing or pinning and draping in these courses. By altering the original installations, they are able to make their own changes before the next professional display is installed.

Whatever approach retailers use to achieve visual displays, they need to understand that a windows timeliness and perfection often motivates shoppers to enter the store to take a closer look at what is offered.

THE ENVIRONMENTS OF VISUAL PRESENTATION

Visual merchandisers work on two separate store environments: the windows and the interiors. They design displays in each to capture the attention of shoppers and motivate them to purchase merchandise. The presentations in each area are changed regularly so that the retailer can display new fashion merchandise that corresponds to different seasons, holidays,

or other selling events. The following sections describe how visual merchandisers work in these two store environments.

Windows

As was discussed in Chapter 8, "Designing and Fixturing the Retail Environment," retailers have a variety of window structures to display their merchandise. The function of each is the same: to tempt passersby to enter the store and purchase merchandise.

The smaller retail operations have one or two window spaces to display their featured merchandise; the larger fashion merchants, especially in their downtown flagships, have as many as one hundred, or even more. Regardless of the number of windows a store has, it is imperative that the retailer plan the use of the display space to have a successful visual program.

In the major retail operations, visual merchandisers work closely with the buyers to determine which fashions will be featured and how they can be best presented to the shoppers. Using this information, they then prepare window schedules for six-month periods that indicate the dates of each presentation, the merchandise classification or institutional theme to be featured, the nature of the background materials and props, the length of time each installation will remain, and the exact location of each window or display case. Fashion buyers then work with these schedules when they contract with the vendors to make sure that the merchandise that is to be featured in the displays arrives in time to coincide with its allocated window time.

Institutional window presentations, such as those displayed from Thanksgiving to Christmas that do not feature merchandise, are planned by the visual merchandising director or vice president.

The most extravagant window displays are those that adorn the major fashion department store flagships in busy downtown areas where pedestrians continuously pass the windows. Most of the fashion giants such as Nordstrom, Lord & Taylor, Saks Fifth Avenue, Marshall Field's, and Neiman Marcus spare little expense when they are designing their major window presentations. Usually changed weekly, these displays feature different merchandise classifications, specific designer collections, seasonal themes, or institutional endeavors that concentrate on the store's image, and the planning that goes into them is as painstaking as that of many theatrical productions.

Little expense is spared by major retailers at Christmas time.
(Courtesy of Lord & Taylor)

Stores in malls usually have less formal window designs. The windows are smaller and sometimes are just enormous glass partitions that separate the people walking by from the store's interior. The square-footage cost of the selling space is often so costly that there is not much space left for the formal visual merchandising presentations. Therefore, retailers devote less expense and attention into this type of window display. They might just use a few mannequins at their entrances, and change the clothes on them, or incorporate some props that are indicative of a theme or season. Some merchants feature small glass-encased shadow boxes in addition to the mannequin presentations.

Interiors

For many years, retailers allocated more funds for windows than for interior installations because they felt the windows had more drawing power as **silent sellers**. Today, however, few retailers other than the downtown flagships of major department stores allocate space for formal window structures. Retail space in malls is costly, and many shoppers come directly from the parking lots into stores that are devoid of showcase windows.

Interior visual merchandising is more than a few mannequins dressed in the store's clothes. A great deal of attention is focused on effectivly presenting the merchandise so that it beckons the customer.

Gap and Banana Republic have transformed themselves from moderately successful to significantly profitable operations, in part, because of their visual merchandising approach. Abundant quantities of merchandise is carefully folded on self-selection counters in color-coordinated stacks. It is regularly rotated, with new styles replacing the older ones. Crate & Barrel employs the same philosophy to displaying its household fashions. Color-coordinated stacks of glassware, serving pieces, vases, and other items are featured at the front of the stores' entrances, enticing shoppers to closely inspect, handle, and often purchase the displayed items. The Crate & Barrel merchandisers concentrate on one or two color schemes that make even the most mundane items more appealing.

Another direction for interior visual merchandising is the **environmental visual concept**. Initially started by Banana Republic, which featured bamboo and rattan interior props

This simple yet elegant interior display often motivates the shopper to take a closer look at the merchandise. *(Courtesy of Façonnable USA)*

Crate & Barrel uses the merchandise, instead of seasonal props, as the display's focal point. *(Courtesy of Ellen Diamond)*

and fixturing to enhance its then safarilike merchandise (this has now been changed to suit its newer contemporary clothing lines), others have followed suit. Tommy Bahama stores, for example, feature permanent reed and raffia Bahamalike fixturing to enhance its island-type merchandise. This eliminates the need to make seasonal or thematic changes throughout the year.

Most retailers, however, make seasonal interior changes. Each spring, summer, fall, and winter, the selling floors are transformed into new, exciting environments designed to notify shoppers that new merchandise has arrived and is available for sale. Similarly, holiday periods call for elaborate interior displays, and visual merchandisers trim the selling space accordingly to stimulate shopping during these times. Besides Christmas, when the bulk of retail sales are made, Valentine's Day and Mother's Day are periods when retailers highlight women's fashions; Easter is when retailers feature fashions for the entire family; President's Week is the time when retailers have remarkable sales to dispose of the previous season's offerings.

No matter which approach to visual presentation the store features, the creativity of the visual team transforms bare environments into settings that will stimulate shopping. Without their expertise, retailers' sales arenas take on a mundane atmosphere and look like any other store. In these competitive times, retailers cannot afford to let this happen.

ELEMENTS OF THE VISUAL PRESENTATION

Whether they are designing formal window displays, creating interior environments for a major fashion promotion, or featuring a specific style on a mannequin in a department, visual merchandisers have to properly coordinate many elements, such as merchandise, materials and props, lighting, color, signage, and graphics, to maximize the visual effects. These elements are discussed in the following sections. Unless otherwise stated, the visual presentations described are not institutional installations, which have different goals that their displays are designed to meet.

First and foremost, it is the merchandise that takes center stage in most visual presentations. *(Courtesy of Façonnable USA)*

The Merchandise

First and foremost in any visual presentation, is the merchandise the retailer wants to sell. Too often those responsible for display forget that their goal is to present the merchandise in the best possible way, and they proceed to develop concepts and themes that overpower the fashions. The retailer is trying to sell merchandise, not props and background materials.

The visual planner should first meet with the buyer, or in the case of the small operation, the freelancer should visit the store and speak to the owner, to examine the specific items that are to be included in the display and decide on the proper vehicle for their promotion. If the shopper cannot immediately determine what merchandise the display is selling, the display is ineffective.

Most of the major fashion retailers have forms that the buyers complete when they send merchandise to the visual merchandising department. These forms include such information about the items as material, construction, price, or other details that might play a part in the window or interior presentation. If the actual merchandise isn't available, as is often the case when preseason planning is essential, the buyers can send photographs, drawings, and descriptions as substitutes.

Materials and Props

Once the particular items have been selected and examined, it is time for the visual team to determine how best to show them to shoppers. Some teams have large budgets that allow them to purchase sophisticated and costly **props**. While these display pieces are often elaborate and functional, they are not always the ones that generate the most excitement. Household objects such as ladders and tables, antiques, and even items pulled from the junk pile can effectively enhance the merchandise. Knowledgeable and creative visual merchandisers know what is best suited for a particular display.

The trade periodical *Visual Merchandising & Store Design* is an excellent up-to-the-minute reference guide for materials and props.

Mannequins

One need only look into the windows of the world's fashion emporiums to see the diversity of **mannequins** that wear their clothing. Just as apparel designers and merchants take different fashion directions, so do mannequin designers. Figures that feature men's, women's

Mannequins are the single most important element in a fashion display when merchandise is featured in a realistic setting.
(Courtesy of Adel Rootstein Company)

and children's fashions run the gamut from the highly sophisticated models that cost as much as $1,000, to those that are created by the store's visual team.

The traditional models are still the most popular, but stylized versions are readily available to fit the most unique requirement. Table 16.1 features some of the major mannequin resources.

Those responsible for purchasing mannequins often approach their task with the same enthusiasm and care exercised by the merchandise buyers. They must work within the framework of a budget; consider the image of the company they represent; examine the offerings of the marketplace; evaluate what is available in terms of quality, durability, and flexibility; and make certain that final choices meet the merchant's needs. For example,

TABLE 16.1 Resources for mannequins

Company	Specialty	Web Site
Patina-V	Abstract and realistic mannequins	**www.patinav.com**
Goldsmith	Manufacturers of men's and women's mannequins of all types	**www.goldsmith-inc.com**
Rootstein	High-end mannequins	**www.rootstein.com**
Mannequin Service Co./ Lania D'Agostino Studios	New and used unique mannequins	**www.mannequinservice.com**
Look	Mannequin alternatives	**www.lookonhudson.com**
Alternatives Plus Mfg., Ltd.	Manufacturer of mannequins in all materials including fiberglass, soft sculpture, cloth	**www.altplusmfg.com**
ALMAX S.P.A.	Stylized mannequins	**www.almaxspa.com**
New John Nissen Mannequins	Realistic mannequins	**www.new-john-nissen.com**
Silvestri California	Traditional and customized mannequins	**www.Silvestricalifornia.com**
Frank Glover Productions, Inc.	Reconditioned mannequins	**www.frankgloverproductions.com**

Source: VM&SD magazine, June 2004.

while athletically built male models might be quite fashionable, putting them in the window or on the selling floor of a conservative men's store would not foster the store's image or properly feature its merchandise.

The best way to purchase mannequins is by making market visits; perusing the pages of such publications as *Visual Merchandising & Store Design;* logging onto such Web sites as **www.visualstore.com** and **www.storeexpo.com**; or attending trade shows such as GlobalShop. Although catalogs showing a manufacturer's offerings provide some indication of the mannequin's appearance, they do not provide enough to make meaningful selections. It is important to make a careful physical examination of a form to determine if it has the moveable parts that are necessary to facilitate merchandise changes, its weight, the quality of its cosmetic applications and wigs, and other details.

The leading upscale mannequin manufacturer, Rootstein, with showrooms around the world, is the subject of the following Spotlight.

Fashion Retailing Spotlights

ROOTSTEIN

In the early 1960s, London was beginning to influence fashion with such innovative designers as Mary Quant and Jean Muir, who were providing an alternative to the Parisian designers. The major drawback to the presentation of these fashion-forward designs were the mannequins on which they were displayed. Rigid and lifeless, they looked like "dummies," a name used to describe mannequins, and they couldn't do justice to the new styles they "wore."

With extensive experience in window design, Adel Rootstein knew there was a void to be filled in mannequin design; the old forms used in display windows around the world were inadequate for displaying the fresh new fashion designs. She formed the Adel Rootstein Company, giving birth to a new generation of mannequins that had a unique look that would eventually catapult her to world fame.

She initially based her creations on the faces and figures of celebrities such as Twiggy, Joan Collins, Marie Helvin, Karen Mulder, and Ute Lemper. The process, which took several weeks to complete, began with a plaster cast of the chosen models, and the end result captivated visual merchandisers all over the world. Besides understanding the perfect attributes of each form, Adel also knew that it was necessary to find the right face and figure eighteen months ahead of the fashion trends. Her success is an indication that she was generally on target.

The drama of the mannequin wearing a spectacular costume immediately impacts the shopper's attention. *(Courtesy of Adel Rootstein Company)*

With an instinct for the right facial expressions and body movements, she created mannequins that captured the attention of such global fashion emporiums as Saks Fifth Avenue, Bloomingdale's, Printemps, Harrods's, and Neiman Marcus. In showrooms all over the world, Rootstein unveils a new collection of mannequins every six months. The figures are magnificently featured in grand settings and clothed in apparel that is especially designed to enhance them, created with the same pains designers put into designing apparel destined for the human model.

These "studios" reveal environments that spell *theater* to the observer.

Today, the company's continuing success is due to the strong creative team that has taken up where Adel Rootstein left off. From Oxford Street in London to Fifth Avenue in New York City, and all around the globe where fashion reigns, the Rootstein mannequins, created by company sculptors, make-up artists, and hair designers, are always uniquely different from all the others in the field.

Lighting

The narrow intensive beam of light that settles on a fashionably dressed mannequin accentuates and dramatizes it as nothing else can. The tiny, sparkling bulbs that grace the majestic Christmas trees at holiday time in store windows and interiors transform the most mundane displays into enchanting presentations. The exciting dimension attained with the use of artistically crafted neon designs turn interior spaces into lively sales arenas. With comparatively little expense, lighting has been successfully used by visual merchandisers to enhance otherwise unexciting displays.

Before fashion merchants select the lighting that will become part of their windows and interior environments, they must first assess what they want the lighting to do by focusing on the following goals:

- *Attract attention.* The merchandise featured in the windows and interiors must be sufficiently illuminated so that shoppers will notice it over the merchandise offered by the competition. Whether in downtown central districts, where the flagships reign; in the shopping malls; or on the fashion streets that dot the major cities, effective lighting can make the passersby stop and take notice of what the merchants are offering.

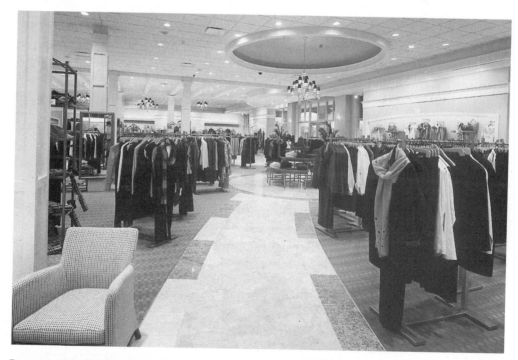

Recessed ceiling lighting creates the necessary mood for upscale shopping.
(Courtesy of JGA © Laszlo Regos Photography)

- *Create a mood.* Store windows or interior spaces that are properly illuminated create an ambience that provides a positive mood for shopping.
- *Enhance the store's image.* It is obvious that upscale, high-fashion brick-and-mortar units, and discount or off-price chains have different approaches to their visual merchandising. In terms of lighting, each must approach its goal differently. The former use subtle lighting with pinpoint spotlights to enhance their premises and create a low-key environment and the latter rely upon bright, overall illumination to light up the entire premises.
- *Provide flexibility.* Most of today's fashion retailing environments require different lighting for different purposes. Retailers need illumination systems that can adapt to these changes. For example, track lighting is flexible enough to enhance any type of display.

Once retailers have established their goals, the store designers, in consultation with the visual merchandising experts, choose from the many available lighting sources and systems to install the types that best suit their needs.

The plans should include general lighting designed for overall illumination and accent lighting that highlights specific targets, such as mannequins. Different light sources make the lighting both functional and mood setting. These include **fluorescent lighting**, the narrow cylindrical tubes that offer a great deal of light at little expense; **incandescents**, which are available as both spotlights that pinpoint specific targets and floodlights that provide general, overall illumination; **fiber optics**, which offer cool light such as those needed to show diamonds and other gems; energy savers such as **high-intensity discharge bulbs**, which produce more light per watt than any of the other forms of lighting; **neon**, a flexible offering that sculptors can use to create unusual designs; and **halogen lamps**, which is ideal for dramatic, intense lighting.

The systems that can deliver these light sources include track lighting, which offers a great deal of flexibility; recessed fixtures, which house both spotlights and floodlights; and many types of decorative fixtures, such as chandeliers, that help to set a mood or create an impression.

Color

Putting a single red dress in the midst of an all-white window will generate excitement and help focus the viewer's attention on the colored merchandise. The striking contrasts of reds and greens will intensify both colors in a manner that cannot easily be achieved by any other means. The feeling of warmth imparted by a color scheme that utilizes amber creates a comfortable mood for shoppers looking for swimsuits.

These are but a few examples of how visual merchandisers can properly use color to quickly and inexpensively create moods and capture shoppers' attention with windows and interiors that are attractive and distinguishable from the competition.

The visual merchandiser's cue for color selection must first come from the merchandise selected for the display. Clothing that features prints or patterns can inspire the trimmer to select a particular scheme as can seasonal colors, and the fashions worn during certain times of the year. An autumn display would naturally include the rusts, oranges, and yellows of the turning leaves, and many fall styles come in these colors. For a summer display, the colors of the American flag could inspire the tints to use in a nautical setting. Sometimes, proper color selection is not so obvious, and visual merchandisers need to refer to technical theories to help them choose attractive and correct schemes.

The theory of color and its appropriate selection is based upon a number of different methods. The most widely used involves the **color wheel**. When the wheel's three **primary colors**, yellow, red, and blue, and the **secondary colors**, orange, violet, and green, or variations of them are used in particular arrangements known as schemes, the results are pleasing to the eye. Most seasoned visual merchandisers are so familiar with the standard approaches that the wheel has to offer that they automatically make their color selections without referring to it. The novice, however, can learn a lot about creating color harmonies of distinction by using the wheel and understanding the color guidelines.

Experienced visual planners often break the rules, however, and create color schemes that are eye stoppers.

THE "RULES" OF COLOR

There are a host of color schemes or arrangements that are simple to extract from the color wheel. Each scheme is based upon a specific color or set of colors and their placement on the wheel.

The simplest arrangement, which utilizes only one hue, or color, is a **monochromatic color scheme**. While at first this scheme doesn't seem very stimulating, when used properly, it has the potential for real visual elegance. By using variations of the single hue and accenting it with neutrals such as black and white, visual trimmers can produce a showstopper. They can provide extra interest in the monochromatic arrangement by using a variety of textures and patterns that stay within the single color range.

Analogous colors are those that are adjacent to each other on the wheel. Using this scheme enables the trimmer to develop a presentation that has more than one color. Because fashion designers often use analogous arrangements in their fabric designs, it is easy for the visual professional to pick it up from the featured merchandise and carry out the color story in an exciting setting. As with monochromatic harmonies or schemes, adding variations of the colors along with the neutrals can create interest.

The use of two colors that are directly opposite each other on the wheel results in a **complementary color scheme**. When reds and greens are placed next to each other in a setting, as is the case in many Christmas displays, the colors intensify. When trimmers want intensity, no other scheme can accomplish this.

Other color arrangements include **split complementaries**, which use one basic color with two other colors on either side of the color's complement; **double complementaries**, which use two sets of colors, or four basic colors, that are opposite each other on the wheel; and **triads**, which use three colors on the wheel that are equidistant from each other.

Trimmers can use neutral ingredients such as black, white, gray, or tan to go with any color harmony and achieve more flexibility for their presentation.

The rule to follow when applying color to a window or interior presentation is that the merchandise is the most important element, and color should be used in background materials and props only as enhancements. Any other application could distract viewers from the merchandise.

Signage and Graphics

In the vast majority of brick-and-mortar establishments, **signage** and **graphics** are becoming increasingly important. Oversized graphics in particular are one of the most important tools merchants can use to attract immediate attention. Chains such as Gap and Abercrombie & Fitch use graphics in both their windows and interiors. With a minimum of expense, they quickly get their fashion messages across to passersby and shoppers. Retailers that must restrict their visual budgets have found that graphics have made a big difference, and they are reporting that graphics are as effective as many of the traditional, more costly props.

Retailers can easily acquire both signs and graphics in a number of ways. Those that want to minimize their expenses and require immediate acquisition, choose **stock houses**. These companies maintain thousands of images that cover every conceivable format. By going directly to the libraries that house the images or viewing them on-line, visual merchandisers can quickly select the one that is best suited for their operation. Just as advertising agencies assist retailers with their promotional needs, **stock agencies** offer sources from which the merchants can choose their images.

Retailers that want to avoid a "me-too" look choose original photography. Photographers that work for the fashion retail giants or freelancers that accommodate smaller businesses offer custom artwork on an exclusive basis.

There is a wealth of different types of signage and graphics available to the retail community. These include **backlit transparencies**, which use photographs in light boxes to provide exciting illumination; **digital images**, which offer enormous visuals that often measure one hundred feet wide and twenty-five feet high and are used outdoors to announce the

The use of oversized graphics and signage on buses is an important way to make pedestrians aware of retail operations such as Gap.
(Courtesy of Ellen Diamond)

opening of a new retail outlet; **prismatic displays**, which simulate a venetian blind and automatically rotate the graphics to feature different messages; and **motion displays**, which are full-screen programmable visual offerings that can be easily changed to fit the user's needs.

Even the smallest retailers can use signage and graphics. Computerized offerings are available in every part of the country and can inexpensively be created to satisfy their needs.

By continually investigating the resources that provide the latest in materials and props, mannequins, lighting fixtures and formats, graphics, and other state-of-the art components, visual merchandisers can not only make their presentations fresh and exciting but can also create displays that will satisfactorily stand up to the competition. Table 16.2 features a sampling of the vendors that supply the visual merchandisers with their tools and includes their Web site addresses.

TABLE 16.2 Visual Merchandising Resources

Resource	Product Classification	Web Site
ABET LAMINATI	High-pressure laminates	**www.abetlaminati.com**
Adstock Photos	Stock photography for graphics	**www.adstockphotos.com**
Altera Lighting	Design and production of superior fluorescent luminaires	**www.alteralighting.com**
Banner Creations, Inc.	Full-service banner company that produces digital printing, dye sublimation, screenprinting, etc.	**www.bannercreations.com**
Bowman Displays Digital Imaging, Inc.	Modular lightboxes, vehicle graphics, photography	**www.bowmandisplays.com**
Coastal Woodworks & Display	Quality wood displays	**www.coastalwoodworks.com**
Consolidated Display Co., Inc.	Seasonal décor, Christmas displays, animations	**www.letitsnow.com**
Goldsmith	Mannequins	**www.goldsmith-inc.com**
Gemini Display, Inc.	Dimensional sign letters	**www.signletters.com**
HERA LIGHTING LP	Stylish halogen and fluorescent lighting	**www.heralighting.com**
ILLUMA DISPLAY INC.	Curved and frameless backlit displays	**www.illumadisplay.com**
Laser Magic	Holographic projection	**www.laser-magic.com**
LED LABS, Inc.	Low-voltage lighting	**www.ledlabs.com**
Regal Display	P-O-P displays	**www.regaldisplay.com**
Spectralite	Architectural signage	**www.spectralite.com**

THE PRINCIPLES OF DESIGN

Once the visual term has selected the functional fixtures, mannequins, and other materials that will put the chosen merchandise in the best setting, or in the case of an institutional theme, will enhance the retailer's image, the visual team is ready to install the presentation. To achieve the best effects, the trimmers must follow the principles of design and incorporate them in ways that will maximize the display's effectiveness.

The design principles that visual merchandisers adhere to are the same ones followed by interior and apparel designers: they strive to achieve balance, emphasis, proportion, rhythm, and harmony. When coupled with imagination and the creative use of props and merchandise, they result in presentations of distinction. The following sections discuss these design principles.

Balance

The concept of **balance** gives the impression of the equal distribution of weight. For example, a scale is balanced if both sides are at the same level and each is supporting a similar object.

Visual merchandisers are less concerned with absolute balance, which scientifically assigns exact weight to each side; they are more concerned with the impression of equal distribution on either side of a central imaginary line. Balance is accomplished either formally, or symmetrically, or informally, or asymmetrically.

SYMMETRICAL BALANCE

Perfect, formal, or **symmetrical balance** involves the placement of identical items on both sides of a central, imaginary line. For example, placing a mannequin on one side of the window and another of the same dimensions on the other side provides symmetrical balance. While this is a safe approach to guaranteeing a balanced presentation, the results are usually monotonous. Beginning visual designers sometimes fall into this trap, because they want to make sure their display is balanced and they do not have the confidence to select less obvious symmetrical elements.

It's possible to achieve an interesting, symmetrically balanced display if the merchandise is unusually appealing, the colors are exciting, and the items on either side of the imaginary line are similar in weight but are not identical.

ASYMMETRICAL BALANCE

Informal, or **asymmetrical balance** is more relaxed, and trimmers can use it to show off their design talents. While the imaginary center line still exists in this type of balance, and there is still a concentration on weight distribution, the objects on either side of it are different. Two small items on one side might be balanced with one large one on the other.

Emphasis

Every installation requires an area of interest that draws the shopper's eye. Keeping in mind that the fashion merchant is first and foremost in business to sell merchandise, the professional visual merchandiser must make certain that this area of emphasis, or the **focal point**, is the item for sale, or as in the case of institutional window displays, it motivates the shopper to enter the store. While some props are excellent attention getters, they should never steal the thunder of the products being promoted.

Emphasis can be achieved with a variety of techniques including the following:

- *Size.* Oversized graphics, which many retailers use, draw the eye immediately. When these larger-than-life images are contrasted with traditionally scaled merchandise, it achieves a positive effect.

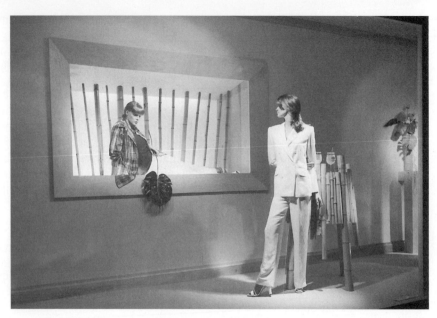

Asymmetrical balance provides an appropriate placement of items without the formality of symmetrical balance. *(Courtesy of Lord & Taylor)*

- *Repetition.* Whether it is color, shape, pattern, or texture that is repeated, the eye quickly focuses on the repetitive aspect. This approach emphasizes the important element to the shopper. When a monochromatic color pattern is the repetitive element, the shopper quickly realizes that this is the dominant color of the season.

- *Contrast.* Using light and dark colors, or arranging certain shapes, such as cones, that contrast with the merchandise forms, accomplishes a visually pleasing effect.

- *Unique placement.* Placing an element in an unexpected position in a display can capture the shopper's attention. Suspending a mannequin from an overhead position immediately draws the eye to examine the clothing the mannequin is wearing.

Proportion

The principle involves the comparative relationship of the different design elements to each other. It is particularly important that these elements are properly scaled to their space. For example, an oversized mannequin in a low-ceiling window will make the presentation look awkward. Similarly, small jewelry pieces should never be placed in oversized spaces.

To assure appropriate proportionality, trimmers must consider the size of the window, showcase, floor case, counter, or vitrene before selecting the merchandise. Similarly, they must make certain that the proportions of the mannequins and other props enhance the merchandise featured on or near them.

Rhythm

To make the eye travel from one part of a display to another, trimmers try to achieve movement, or **rhythm**. This is an extremely important design principle since it guarantees that the shopper will look at the entire presentation. Trimmers can achieve it by using the same shapes in a row; using borders or moldings that will flow in a continuous line; using the gradation of line, shape, size, or color; radiating from a central point; or alternating patterns such as awning stripes.

Harmony

If the visual team executes all of the design principles, the visual offering will achieve a harmonious effect. The merchandise-oriented display that incorporates balance, emphasis, proportion, and rhythm and is augmented with appropriate lighting, fixturing, signage, and other

visual elements presents a compelling whole that motivates the passersby to stop and take a closer look.

It is not difficult to master the design elements and employ them in visual settings, but the professional visual merchandisers can break the rules and achieve exciting and creative effects that will attract attention and shoppers into the store to buy the merchandise so imaginatively displayed.

MAXIMIZING THE VISUAL PROGRAM'S SUCCESS

It seems logical that when retailers budget large sums of money for visual merchandising and significant planning has preceded the use of the funds, the end result would be distinctive installations. This is not always the case. If the visual merchandising vice president or director in the largest company, or the entrepreneur in the smallest boutique do not pay strict attention to details, their visual programs will not deliver what they are capable of doing.

For a program to achieve maximum success, the visual team needs to develop a checklist outlining basic visual rules and regulations and religiously adhere to it. The areas of concern in the following sections include some that are most often mishandled or ignored.

Maintenance of the Display's Component Parts

A chipped mannequin, burned-out spotlight, unkempt wig, or other unsightly display element can cause a distraction and minimize the effectiveness of the entire presentation. Before installing any display, trimmers need to repair and refresh the fixtures and props, check lighting to make certain that it is functioning properly, carefully press merchandise, and clean every part of the display. After installing the elements, it is necessary to have a final inspection to remove stray pins from the floor, to conceal those pins that have been used on mannequins to alter the apparel, and to carefully check if any loose threads have been left on the merchandise. These seemingly trivial details can diminish an installation.

It is sinful and wasteful and bad business to present the latest fashions in settings that don't do them justice—and won't sell them.

Prompt Removal of Displays

Visual presentations must be timely to maximize the retailer's profits. Retailers that have a store window the day after Mother's Day that still features fashions for that event or interiors that still have the Christmas look long after the holiday has passed do a disservice to their visual program.

Fashion retailers are always moving from one season to the next and must use every day to alert their customers to new merchandise. While the days leading up to marque events are big volume periods for retailers, once the events are over, displays featuring those items are not important and waste valuable promotional space.

Visual merchandisers should remove signage and graphics used for brief promotions once the event has passed. When a store offers a three-day sale and reduces prices 25 percent, it could cause problems to leave up signage that publicizes the promotion. Telling shoppers, "the sale is over" if they ask for the discount is a poor way to cement customer relations and the retailer might have to sell the merchandise at the lower prices past the sale period.

The Daily Walkthrough

With the increased concentration on in-store displays, more visual merchandisers are using mannequin groupings at selling department entrances, on free-standing islands, and on open counters. While these presentations invite shoppers to inspect them and often motivate shoppers to purchase the displayed items, passersby might also handle them.

To make sure these point-of-purchase displays appear as fresh as the day they were first installed, they must be regularly checked. Most major merchants develop **walkthrough**

The visual merchandising manager straightens a display as part of his "walkthrough" procedure.
(Courtesy of Ellen Diamond)

schedules during which trimmers refresh them and restore their original, attractive appearance if necessary. If no one does this every day, the featured merchandise will no longer be appealing, and the store will take on a poor visual image.

Maintenance of Self-Selection Merchandise

When shoppers enter fashion retailers such as Gap, Banana Republic, and Crate & Barrel, they immediately see merchandise offerings that invite handling. The self-selection method is very successful in these retail environments and not only tempts passersby to stop and touch, but also considerably reduces the expense attributed to personal sales assistance.

Store designers and planners are creating self-selection fixtures in more quantities and styles than ever before. Although this type of merchandising generates significant sales volume, it also gives the counters and other selling units a sloppy appearance. At Gap, for example, the tidiness of the stacks of color-coordinated sweaters, that are merchandised in this fashion is imperative to attracting shopper attention. To keep the sweaters as appealing as when they were first placed on these risers, sales associates must constantly refold and realign them according to color.

If the self-selected merchandise is not strictly maintained, the stores will become a jumble of merchandise and the visual effect of the display will be lost.

Rotation of Merchandise

It is very important that every piece of merchandise is within reach and view of passing customers. Since some locations in the department are more accessible and visible than others, it is important to rotate the inventory so that each item can have a turn in the best location. For example, placing the new arrivals at the entrance to the department puts them within easy customer accessibility. Displaying a complete outfit, fully accessorized, at the head of the display rack might motivate shoppers to find their size in all the items and head for the try-on room.

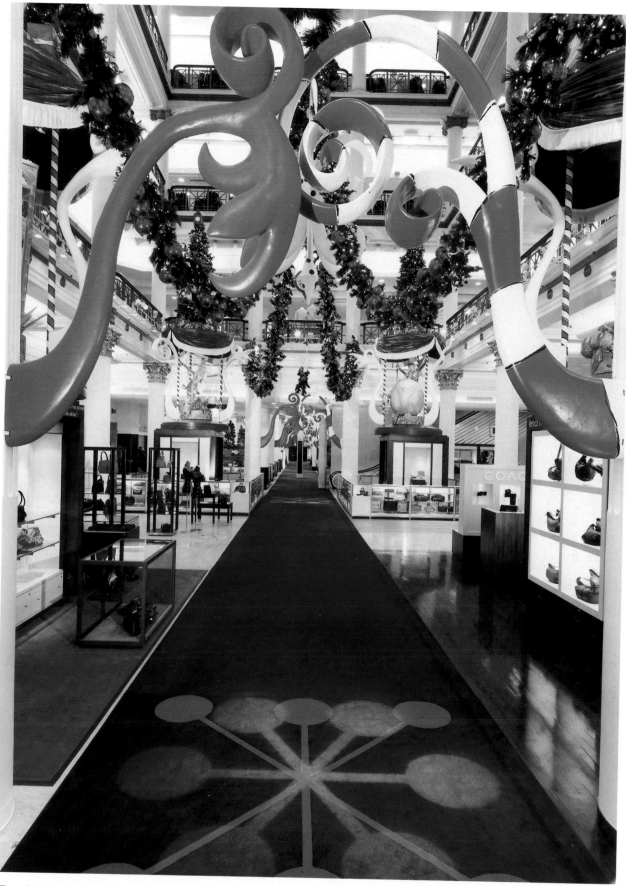

There is no better time than during the Christmas season for retailers to put their best feet forward to transform their premises into an exciting place to shop.
(Courtesy of Marshall Field's)

the definition of

modern style

NEW FROM CALVIN KLEIN

Lord & Taylor

The Signature of American Style

Cap-sleeve tee, $65. Drawstring skirt, $125. At Fifth Avenue and selected Lord & Taylor stores. Red Rose Personal Shopping Service, Red_Rose@lordandtaylor.com or 1-800-348-6940.

Magazine advertising is an excellent tool that is used by major multichannel fashion retailers.
(Courtesy of Lord & Taylor)

The process used in the preparation of direct mail pieces used by the multi-channel fashion retailers, as seen here, requires careful attention by experts.
(Courtesy of Ellen Diamond)

Careful attention must be focused on the printing equipment before the direct mail pieces are run.
(Courtesy of Ellen Diamond)

Personal appearances, such as this one by Nicole Kidman to promote Bloomingdale's opening of their Moulin Rouge shop, bring enormous crowds to the retailer.

(Courtesy of Ellen Diamond)

The preparation of unique props for a major visual presentation requires the artistry of talented craftspeople.
(Courtesy of Ellen Diamond)

Artists are employed to create backdrop signage for use in special displays where mass-produced elements are inappropriate.
(Courtesy of Ellen Diamond)

Ethnic mannequins are especially important to fashion retailers that appeal to diverse consumer markets.
(Courtesy of Rootstein)

Realistic mannequins are the mainstays of visual merchandisers since they can represent every type of fashion merchandise classification.
(Courtesy of Rootstein)

Retailers such as Marshall Field's use storybook characters regularly for special events.
(Courtesy of Marshall Field's)

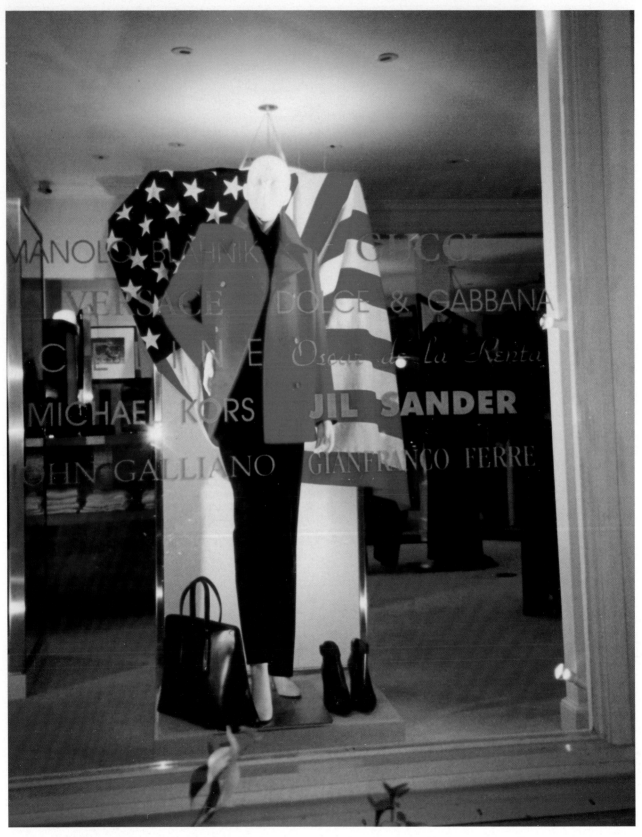

When fashion retailers wish to emphasize designer labels along with a patriotic theme, they often use the American flag as their main prop.
(Courtesy of Ellen Diamond)

If the merchandise is rotated on a weekly basis, shoppers can see and consider each collection within the department. It also indicates to the shopper that new merchandise is arriving every week and that the retailer has the latest in fashion.

Attention to such details makes one visual team more effective than another and one store's premises and merchandise more appealing then another's.

TRENDS IN VISUAL MERCHANDISING

The concepts of visual merchandising have gone through considerable changes in the first few years of the twenty-first century, as described in the following sections.

• *Decrease in the use of formal window presentations.* Except for the downtown flagships, where the parallel-to-sidewalk window configurations still are prominent, the new retail structures leave much less formal window space. Except for perhaps a few exterior shadow boxes, the displays are found inside the store. The reason for this trend is the cost of retail space. Merchants lease total square footage and leave as much as possible for their selling departments.

• *Greater attention to interior visual merchandising.* Instead of just relying on formal interior displays to attract attention, more merchants are paying close attention to the way in which the merchandise is featured on racks and counters. At the end of the apparel racks, they are featuring the merchandise the rack holds and are fully accessorizing the clothing to give shoppers a better idea of how an outfit will look on them.

Also, in and around store entrances, escalator landings, and elevator stops, displays are used to quickly show the shoppers what is awaiting them in the adjacent sales departments. These are changed regularly to feature the store's latest styles.

• *Return to traditional mannequins.* While abstract and stylized forms have been successful in recent years and still are used in some retail operations, the traditional mannequins are returning to windows and interiors of the vast majority of upscale fashion emporiums. The offerings of such vendors as Rootstein are regaining the popularity they once enjoyed.

• *Increased use of low-voltage lighting.* Without having to sacrifice true colors, **low-voltage lighting** has become the ever-increasing choice of visual merchandisers because they give off less heat and result in energy/maintenance savings. In particular, the heat produced by conventional lamps often fades the illuminated products so they cannot be sold or returned to the selling floor. With operating costs continually increasing, using low-voltage lighting is one way the retailer can minimize expenses without losing the benefits of traditional light sources.

• *Significant use of graphics.* With their minimal costs and ease in production, retailers are turning to a variety of graphics for their visual programs. Available in most every size, including the larger-than-life types, companies such as Gap, Abercrombie & Fitch, and Eddie Bauer use them in place of the more costly props. Many major retail construction sites use these oversized graphics to announce the impending store opening since they are weatherproof, and can be seen from great distances.

Retailers are also using more backlit transparencies to give the graphics the benefit of twenty-four-hour lighting and to make them seem more lifelike.

• *Point-of-purchase fixturing.* The selling departments in most major fashion retail operations are becoming increasingly popular as venues for point-of-purchase displays. Replete with interactive video, gondolas, closed-circuit video, and countertop cases, these displays bring all types of fashion merchandise to the shopper's attention. Of particular importance are displays of small products such as cosmetics and hosiery that people buy impulsively or without-preplanning.

• *Vendor participation in retail visual merchandising.* Many designers and manufacturers are giving retailers special fixtures and display materials to distinguish their collections from the others in the store. This way, they can control the visual merchandising of their own lines. Merchants are receptive to this arrangement since it reduces their own expenses.

SMALL STORE APPLICATIONS

While the lavish displays and distinctive interiors are commonplace in the major fashion retailers' premises, the enormous budgetary requirements needed for these programs are generally out of the reach of the small specialty stores and boutiques. However, this should not prevent entrepreneurs from energizing their environments and maximizing visual excitement at a minimal expense.

There are numerous ways in which these merchants can significantly improve their visual merchandise. Color, for example, is a free visual element. The proper use of color in formal window displays or in interior presentations, can easily motivate shoppers without any additional expense, to stop and take a closer look. When buyers make their purchase plans and concentrate on specific color schemes for their merchandise, it is easy to plan a color-oriented presentation technique to display the items.

Lighting is another way to highlight merchandise, though it does require a minimal investment. With the advent of low-cost lighting, even the smallest merchants can provide their premises with the dramatic emphasis needed to spotlight distinctive fashions. Light fixturing systems such as track lighting emphasizes specific areas without needing additional fixtures.

Although props can be costly, there are alternatives to the traditional props that the smaller merchants can use to present the merchandise in a unique manner. Armoires, writing desks, and other pieces of furniture can be borrowed from other retailers in exchange for offering them "loaner credit" and used to display merchandise. Old ladders and picture frames, with a little refurbishing, can become integral parts of displays.

Although fine mannequins are generally necessary to display apparel, they can be too expensive for the average small merchant to afford. Many small retailers are opting to use mannequin alternatives that they create on their own from hangers, wooden dowels, and "heads" of Styrofoam that they trim with decorative adornments that give them a degree of individuality.

Signage purchased from professional companies can be too expensive. By using computer programs such as Adobe or Print Shop, even the smallest entrepreneur can create signs of distinction that announce sales, special events, or other promotions.

By faithfully reading such periodicals as *Visual Merchandising & Store Design,* or logging onto Web sites such as **www.visualstore.com**, small store owners can learn about up-to-the-minute visual trends, props, lighting, and other elements of visual merchandising and familiarize themselves on the most recent visual innovations.

It is as important for retailers to keep abreast of visual merchandising techniques as it is to plan their merchandise purchases so they can display their merchandise in a manner that will increase shoppers' curiosity and perhaps motivate them to buy.

Chapter Highlights

1. Department stores have their own in-house visual teams to create and install both window and interior displays. The principals in these departments are generally located in the company flagships, with a few people assigned to the branches to carry out the visual director's plans.
2. Chain organizations usually employ a visual program that involves developing concepts in their headquarters that are photographed and sent to the individual units to recreate.
3. Small fashion merchants either use freelancers to install their displays or create them themselves.
4. Windows are the main arenas for major visual presentations. To successfully carry out window installations, calendars are prepared six months in advance so that the visual team and the buyers responsible for ordering the merchandise can have sufficient time to plan for the presentations.
5. Interior display has become an important part of the retailer's visual environment because the traditional large-scale windows, except for those found in the downtown flagships, are not as prevalent as they once were.

6. Without question, in merchandise displays, it is the merchandise that is the most important element in the visual presentation.

7. To enhance the featured merchandise, trimmers use a host of mannequins, props, proper lighting, signage, and graphics.

8. By paying attention to the principles of design such as balance, emphasis, proportion, rhythm, and harmony, visual merchandisers can create effective window and interior displays.

9. A visual program can maximize its success by maintaining the display's component parts, promptly removing out-of-date displays, conducting daily walkthroughs, maintaining self-selection merchandise, and rotating the items.

Terms of the Trade

visual merchandising
in-house staffs
centralized visual merchandising
trimmers
freelancers
silent sellers
environmental visual concept
props
mannequins
fluorescent lighting
incandescents
fiber optics
high-intensity discharge bulbs
neon
halogen lamps
color wheel
primary colors
secondary colors
rules of color
monochromatic color scheme
analogous colors
complementary color scheme
split complementaries
double complementaries
triadic color scheme
signage
graphics
stock houses
stock agencies
backlit transparencies
digital images
prismatic displays
motion displays
balance
symmetrical balance
asymmetrical balance
focal point
proportion
rhythm
harmony
walkthrough
low-voltage lighting

For Discussion

1. How have display specialists of the past broadened their responsibilities in today's retail environment?
2. What type of fashion merchant uses in-house staffing for its visual merchandising function?
3. What are some of the areas of responsibility performed by the in-house team?
4. Define the term "central visual merchandising," and describe how it is employed by fashion retailers.
5. If the smaller fashion retailer wants to utilize professional visual merchandising but is unable to afford someone to work exclusively for the store, what approach should it take?
6. Why has there been a decrease in the use of window displays by department stores and other retail operations that have units in regional malls?
7. Describe the environmental concept that some fashion merchants have subscribed to, and name two companies that have used this approach.
8. List all of the elements of a visual presentation and briefly discuss the importance of each to a presentation's overall success.
9. Identify the most important element in a display and explain its importance.
10. Why has the use of graphics become so prevalent in fashion retailing?
11. In addition to the traditional fluorescent and incandescent bulbs, what other types of lighting are being extensively used to illuminate visual presentations?
12. In what way can visual merchandisers and fashion retailers get an overview of the visual market and satisfy their needs without leaving the store?
13. Briefly discuss the rules of color.
14. What device do many visual merchandisers use to make certain that their color schemes are technically correct?
15. What is meant by the term "backlit transparency?"
16. List the display's component parts and tell how they must be maintained to be effective.
17. Describe a store's trimmer walkthrough and its purpose.
18. How can small fashion retailers energize their stores without significantly increasing their visual budget?

CASE PROBLEM I

Oxford and Pembroke is a large fashion specialty chain that has 450 units throughout the United States. It has been in business for fifty-eight years, specializing in moderate to better-priced missy and junior sportswear. Most of its stores are in major regional malls.

The company's success has been due in part to the fashion-forward merchandise mix it provides for its customers and the manner it is featured in store windows and interiors. Most of the stores in the organization are built to "formula"—each is a clone of the others with approximately the same general square footage and window configuration. The oldest stores in the company have been refurbished to bring them up to date with the newer units.

O & P, as it is often referred to, has been a family enterprise since it opened its first unit. General management of the company has recently been assumed by one of the founder's sons, Jonathan Pembroke. With Don Oxford and the senior Mr. Pembroke now retired, the company's future is in Jonathan's hands.

Although the company has maintained a healthy profit for all of its years, the new CEO believes that some changes could be made to improve the organization's profit picture. He thinks that savings could be realized in visual merchandising. Up to this point, the company has employed a number of regional visual teams to install window and interior displays. Each team of two is responsible for ten stores that it visits every week to make the necessary changes. There are ninety people on the visual staff. While they perform satisfactorily, they are costly to the company. Expense is not the only problem. The company provides no direction in terms of

visual approach, and each team is left to its own judgment and expertise in deciding how to visually merchandise the stores it visits.

Jonathan would like to see the company adopt a more uniform approach that would also provide a savings.

Questions

1. Should management tamper with O & P's success by changing its approach to visual merchandising?
2. If a new method is instituted, what direction should it take? Bear in mind that uniformity and budgetary savings are essential ingredients of the plan.
3. Are there advantages to keeping the present policy?

CASE PROBLEM 2

Amanda Norfolk has decided to open a fashion boutique with the money she has just inherited. She is well versed in the fashion field in areas such as buying and merchandising, having spent eight years as a buyer with Dover Fashions, a small specialty chain.

Her previous experience, coupled with her formal education as a fashion major in a community college, has prepared her for most of the tasks she will have to personally perform. Her one weakness is in the area of visual presentation. As she never took a course in visual merchandising or participated in her previous employer's display program, she is not sure how to approach the situation.

Amanda has decided to hire a freelancer to perform the typical window installations, believing that professionalism is necessary to bring the best results. She also wants to make certain that the fixturing, props, lighting, and other visual elements reflect her own personal tastes, and does not want the freelancer to purchase these items.

With all of the details of opening her store yet to be worked out, such as staffing, buying, and so forth, she has little time to properly scan every corner of the market for her visual merchandising needs. She has agreed to let the contracted visual merchandiser assist her with the selections, but neither has sufficient free time to do a good job of choosing mannequins, forms, and other elements.

Questions

1. How might Amanda quickly assess the market and satisfy her needs?
2. If the freelancer cannot accommodate her, should she pursue the effort alone?

EXERCISES AND PROJECTS

1. Visit a downtown shopping area or regional mall to photograph fashion-oriented window displays. Select five of the most interesting visual presentations, take pictures, and mount them on a piece of foam board. Alongside each one, write an evaluation of its elements.
2. In groups of three or four, visit small local fashion merchants to discuss with them an offer to trim a window or install an interior display. In exchange for the project, encourage the merchant to provide discounts.
3. Go on-line to find resources that provide visual merchandising elements such as mannequins, props, and lighting. Prepare a chart that lists ten vendors, their product specializations, Web sites, telephone numbers, faxes, and E-mail addresses.

Servicing the Customers in On-Site and Off-Site Ventures

After reading this chapter, you should be able to:

■ Discuss the role of the fashion sales associate in brick-and-mortar operations.

■ Describe the sales associate's role as intermediary between the company-buyers and the customers.

■ Differentiate between on-site and off-site selling.

■ List the essentials of successful fashion retailing selling techniques.

■ Name and discuss the nature of rewards programs offered by fashion retailers.

■ Describe the different types of customer services offered by retailers, and why many go to such extents to offer them.

■ Explain the different types of credit arrangements that retailers offer to their clienteles.

As has been continuously noted throughout this book, competition in the retailing industry continues to significantly increase. Fashion merchants, in particular, are facing challenges never before realized in the history of retailing. They must be concerned with the problems associated with merchandise distinction from other retailers and the best location and design of their brick-and-mortar operations. Competent staffing is especially important for retailers—both the long-term maintenance of employees from the upper-management levels to those who interface with shoppers, either in person, or through catalog or on-line inquiries but especially in ensuring that these front-line employees properly service their customers.

The key to the success of any retail operation, no matter how large or small, is the development of positive relationships with customers so that they will return to shop in their stores, catalogs, and Web sites and ultimately to become loyal patrons of the organization. Achieving this regular patronage depends a lot upon the product mix that the company offers; but the manner in which the company services its customers is equally as important.

Are customers greeted properly when they enter the brick-and-mortar selling departments? Does the merchant provide sufficient services to make the customer's shopping experience a pleasant one? Is the catalog order taker helpful in answering questions? Are the sales associates knowledgeable about the merchandise they sell? Is the Web site equipped to allow customer service representatives to interact with shoppers? Merchants that provide these types of services are able to expand their customer bases, increase sales, and maximize profits.

Upper-management executives are more likely to spend time developing their company's image, directing merchandise acquisitions, developing standards, and attending to other operational details than dealing with actual shoppers. They leave this crucial task to sales staff, who are at the lower levels of the company organizational structure. Often, those at the top spend little time studying the problems associated with customer satisfaction, and those at the bottom of the ladder are often inadequately trained to make the customer's experience a pleasant one and satisfactorily close sales—which is what ultimately brings profits to the company.

Focusing attention on providing better services to customers in all aspects of the multichannel shopping experience will enable these retailers to compete more favorably. This chapter addresses personal selling and describes different types of services that companies can use to distinguish themselves from their competitors and gain customer satisfaction and loyalty.

PERSONAL SELLING

In this age of multichannel retailing, personal selling goes far beyond the confines of the brick-and-mortar operations. Many Web sites have links that directly connect the shopper with a responsive salesperson. Catalog users calling in their selections are greeted by company representatives who are not only there to take orders but also to answer questions and perhaps make "suggestions" for additional merchandise to expand the purchase.

While there are some sales techniques that salespeople can use in each of the multichannel divisions, others are unique to only one or two types. The sections that follow address each retail category separately to show the most effective sales techniques for that channel.

Brick-and-Mortar Operations

Except for those organizations that are strictly Web site–or catalog-based, retailers generate the bulk of their sales in their stores. Advertising and promotion and previous successful experiences, attract significant numbers of shoppers to their premises. Once shoppers are inside the store, the sales associates are expected to provide all of the assistance necessary to transform them into satisfied customers. However, in an ever-growing number of retail outlets, especially those that offer value pricing, there has been a decrease in the number of salespeople on the selling floor, and in some cases, a complete absence of them. Fashion merchants that base their operations on traditional pricing rely upon their sales force to make shopping a pleasant experience and achieve the sales figures they need to turn a profit.

Fashion emporiums such as Nordstrom, Neiman Marcus, Bloomingdale's, Saks Fifth Avenue, and Marshall Field's are proponents of excellent customer service and make certain that those on the selling floor are not only properly trained to sell but also to provide any other assistance that will make the shopper's experience a comfortable one. When salespeople at Neiman Marcus, for example, successfully complete a sale, they often follow it up with a personal note showing their appreciation for the sale. A sales associate who offers refreshments to the shopper who needs time to come to a decision is providing the quintessence of professional selling.

All too often, however, shoppers are totally ignored when entering a store or are merely greeted with the typical, routine question, "May I help you?" If the customer's response to the question is negative, the associate has little chance to recapture the customer's attention and make the sale.

The retailer's indifference to satisfying customer needs is a problem that plagues a large number of retail organizations. Except for the up-scale fashion operations, providing service to the customer has become a rarity. Today, when many people work full-time and have little time to shop, it is essential that sales staff receive proper training to help customers in their stores make their selections quickly. Except at holiday shopping periods, most stores do not experience the hustle and bustle of the crowds, because many shoppers opt to use off-site outlets for their personal needs and only come to the stores when they can't be satisfied by these other means.

THE ROLE OF THE FASHION SALESPERSON

When salespeople deal with shoppers, they must make every effort to not only sell the products but also to provide customer service, promote the company's image, and act as the intermediary between the shoppers and the company's buyers.

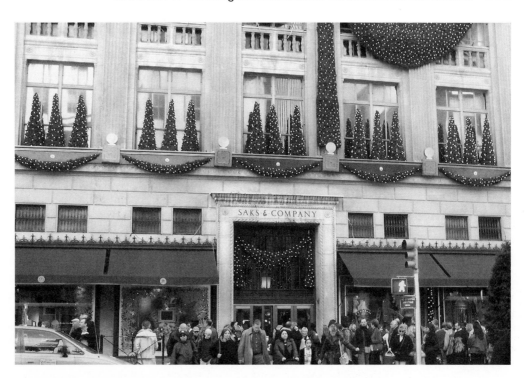

Upscale fashion retailers like Saks offer excellent personalized selling to their clientele.
(Courtesy of Ellen Diamond)

Selling the Product. What is the difference between a sales clerk and a professional retail sales associate? The former simply assists shoppers with selections by directing them to the try-on room, retrieving unwanted merchandise and replacing it on the racks and shelves, and performing cashiering and wrapping services for goods that the customer has chosen. The latter is a different player in the game. Sales associates try to determine the customer's needs through specific questioning techniques, suggest merchandise that might meet the customer's requirements, solve problems when the need arises, and coordinate and accessorize outfits to show how they might be enhanced while at the same time increasing the size of the purchase and cementing a relationship that will bring future business to the store. For example, those in fashion retailing shoe departments who have been professionally trained rarely bring only the style that the customer asks for but also return with a number of different styles in case the requested one doesn't fit the bill. Similarly, the service-oriented men's wear seller brings a shirt and tie that would complete the suit that the customer has selected.

This is professional selling of the highest order, and it not only helps the store achieve its sales figures but also has the potential to build a private clientele for the sales associate.

Providing the Service "Extras". Those who sell are more likely to be successful if they offer more than just their sales assistance. Simple courtesies such as providing a chair for a husband to use while his wife is trying on clothing, taking a shopper's coat and storing it until the shopper is ready to leave, tending to small children when their parent is in the try-on room, ringing up merchandise from other departments so that the shopper doesn't have to make numerous trips to different register stations, and assisting customers to their car if their packages are too cumbersome to handle are all actions that make customers feel special. Not one of these services is difficult to offer, and each could result in customer satisfaction and loyalty to the store.

Promoting the Store's Image. People frequently say, "I dislike that store; I'll never shop there again." It is usually not the store they mean but the salespeople they encountered there. Many retailers try very hard to project a positive image by assembling an appropriate merchandise mix, developing creative advertisements and promotions, and constructing visual displays that present their stores in an exciting manner. All of these expensive

enhancements can mean little if sales associates are inattentive and careless. Why should people bother to shop in a store where those working on the selling floor are improperly dressed and groomed, discourtesy is a routine event, and tactless outbursts are prevalent? When people have so many other places to shop, retailers need to avoid these obstacles.

Acting as Intermediaries Between the Customer and the Buyer. Chapter 11, "Planning and Executing the Purchase," and Chapter 12, "Purchasing in the Domestic and Off-Shore Markets," described how a company's fashion merchandising team researches the market, develops a buying plan, and purchases the goods that seem most appropriate for its clienteles. While the buyer receives scores of informational reports to get direction on future purchasing and also engages many external sources such as resident buying offices, fashion forecasters, and reporting services for additional input, only one source interfaces regularly with the shopper—the salesperson.

Computers can report which styles sold best, which colors outdistanced all of the rest, which price points brought the greatest profits, which sizes remained for markdowns, and which silhouettes were preferred. They cannot provide information on what the customer requested that the store did not stock and why sales were lost. The salespeople are the intermediaries between the shopper and the buyer. They hear about customers' likes and dislikes, their merchandise wants and needs, and anything else on their minds.

Savvy buyers understand the vital role sales personnel play in terms of merchandising, and they regularly approach these associates to learn information about the customers that other sources cannot provide.

CHARACTERISTICS OF THE SUCCESSFUL PROFESSIONAL FASHION SALES ASSOCIATE

Specific qualities and characteristics separate the average salesperson from the outstanding performer. The best of the lot could have natural ability and be born salespeople, but others can learn to refine their craft by investing time and effort to acquire the characteristics that are obvious in the most successful sellers. The following sections describe the attributes that enable successful professional sales associates to produce revenue for the company.

Appropriate Appearance. Most retailers have established dress codes that mandate a certain appearance for their staff. These codes are not formulated to force all sales associates to look alike but to make certain that sales staff favorably enhance the company's image.

Appropriate appearance on the selling floor is imperative to making a good impression with shoppers. *(Courtesy of Ellen Diamond)*

The first impression that salespeople make is not with motivational greetings or through the display of product knowledge but by their clothing and grooming. If customers find their appearance offensive, they might not want to shop in the store.

Fashion retailers in particular are very concerned with the way their staff dresses. Since fashion is the essence of their business, they must insist that their staff have proper wardrobes and grooming that will enhance their merchandise offerings and make their customers feel comfortable. Although there are certain standards for acceptable dress in fashion-oriented stores, there are variations on the theme. A conservative men's retailer such as Brooks Brothers might be more rigid in terms of ensemble design and hair style, whereas an upscale, avant-garde organization such as Barney's will allow a more contemporary look. Because beards and longer-length hair are more popular in general, many traditional merchants have adjusted their once conservative philosophies on appearance and begun to permit these once-taboo styles.

Some fashion merchants encourage their sales associates to wear their merchandise by allowing them a significant discount. Ralph Lauren, in his flagship store on New York City's fashionable Madison Avenue, goes one step further to motivate the staff to purchase and wear Lauren-designed apparel and accessories in the store. All employees are given a monthly dollar allowance toward the purchase of anything that they can wear to work. Not only does having staff wear the company's clothing ensure proper appearance but it promotes the Lauren image and at the same time shows the prospective purchaser how the merchandise looks when it is worn. Shoppers will often ask the salespeople where they bought their outfit. If it is in stock, the salesperson is likely to make a sale.

Communication Excellence. Salespeople who can clearly articulate their selling points have a distinct advantage over those who can't. Of course, it is possible to learn good communications skills that will better assist shoppers with their purchases.

There are many ways sales staff can improve these skills. Colleges offer various courses in their regular degree programs as well as in their continuing-education offerings that cover everything from correct language usage to proper pronunciation. For those who have little time for formal course work, there are a wealth of audio tapes, videotapes, CDs, and DVDs that they may use at their convenience that address every aspect of proper voice and speech.

In his Madison Avenue flagship, Ralph Lauren requires that the sales associates dress in Lauren clothing. *(Courtesy of Ellen Diamond)*

Since selling requires effective communication, it is essential that sales staff refine their language skills.

Product, Company, and Consumer Knowledge. Salespeople must have the proper appearance and communication abilities to successfully approach the shopper. Salespeople must also possess sufficient knowledge about the product classification they are selling, the company, and the customer to make selling easier and, if they are working on a commission basis, financially rewarding. Armed with such information, sales associates can immediately answer questions, handle potential customer objections, and successfully close the sale.

It is important for sales staff to understand consumer behavior so they can assess the shopper's needs and be prepared to motivate the shopper to buy. Chapter 4, "The Fashion Consumer: Identification and Analysis," describes what motivates people to buy and how retailers can use this knowledge to appeal to more consumers.

Salespeople need to know the company's philosophies in terms of fashion direction, pricing, and services so they know how to handle special orders, delivery, credit, merchandise returns, alterations, prices, and special customer services, and finalize the sale. Having this information at their fingertips makes a positive impression and helps to gain the customer's confidence. Retailers can provide their sales staff with new-employee orientations, handbooks and manuals, and video presentations to teach them their philosophy.

At the core of any sale is product knowledge. While articulate and well-groomed salespeople can talk to shoppers to encourage purchasing, if they don't have the right merchandise information, they may fail to close the sale. Bluffing to cover up lack of knowledge and misrepresentating the merchandise might convince the customer to buy it, but these lapses might also result in merchandise returns and loss of customer loyalty when the customer realizes the item is not what the salesperson said it was.

Sales staff can acquire product information by consulting a variety of sources. Designers of fashion merchandise sometimes provide retailers with videotapes and DVDs that feature their latest collections in fashion parades.

Some manufacturers provide press kits concerning their latest collections. Oftentimes, these not only address the latest in fashion innovation and collection highlights but also include photographs of models wearing the garments. Some manufacturers also generate brochures, pamphlets, and other literature that carefully spells out which styles are best suited to which body types. The swimsuit industry often provides such information.

Some colleges offer product information courses that provide technical insights of such fashion classifications as shoes, apparel, gloves, jewelry, and other accessories. Not only do these courses address style but they also discuss the manufacturing methods and the key benefits of each to the consumer. On a less formal basis, the company's fashion director can conduct seminars to bring the latest in fashion news to the store.

One of the simplest ways sales staff can gain insight into various fashion product classifications is to examine both consumer and trade publications. Such magazines as *Elle, Vogue,* and *Harper's Bazaar* regularly feature the latest and hottest trends along with commentaries by their editorial staffs. Since these publications are aimed at consumers, salespeople can learn what they are being tempted to buy and can be prepared with this information. Trade publications such as *WWD* and *DNR* include news on men's and women's fashions from the industry's point of view. Such information as color trends, fabric innovation, and texturing are regular features of these journals.

Salespeople who can discuss why one shoe manufacturing process is better than another, which fabrics will perform better, how garments should be cared for, why 14-Karat gold is more costly than gold plate, and which product will provide more comfort will find it is easier to make sales and help the shopper to gain more confidence in them.

Company Loyalty. All too often, sales associates lack the integrity for success in such a career. They jump from one company to another to gain small salary increases or better hours. While salary and time commitments are important, the better way to succeed in any company is to become a loyal member of the "family." Sales staff who move around not only do disservice to themselves by not being on board long enough to make a positive impression but also cause problems for the company itself.

Staff people who establish longevity with a merchant and capably spread the message of the company's image will benefit in two ways. One is the likelihood of a promotion, and the other is having the personal experience of becoming an important part of the organization. Companies that promote from within generally seek those employees who have demonstrated staying power.

THE SALES PRESENTATION

In stores that depend on personal attention to be profitable, sales associates play an important part. Those who are prepared to sell and follow specific stages that are fundamental to any selling endeavor will more than likely make the register ring. These stages are used by all successful sellers, and once learned, they become second nature.

The sequence of events inherent in most selling situations are described in the following sections.

Approaching the Customer. The timeworn opening question, "May I help you," frequently brings a negative response, leaving the seller little room for additional conversation. More successful are approaches that begin with, "Good morning, sir", or "What a lovely day it is." These are just pleasantries that could be the beginning of a meaningful dialogue.

Determining Needs. If shoppers ask for a specific item, the salesperson knows exactly what they want. There are times, however, when salespeople need to ask questions to uncover the customer's wants. Asking brief questions or making statements might produce results. For example, if the department is one that features designer labels, the seller might bring up the focal points of the best-known designer collections, which could elicit a response from the shopper that could be used to carry on the conversation. Another question might ask the shopper about the purpose of the proposed purchase: "Will you need something for a particular occasion, or is it just to add excitement to your wardrobe?" This type of questioning usually generates an answer. After spending a great deal of time on the selling floor, experienced sales associates individualize their needs assessment techniques to particular types of shoppers and use questions or other methods that become second nature to them.

Presenting the Merchandise. When showing particular styles and models to prospective customers, salespeople need to discuss their features and selling points. This might include talking about the newest fashion trends and how this item is at the center of the concept, or focusing attention on the item's color and how it is being featured in fashion magazines such as *Elle* and *Harper's Bazaar.* If the shopper is purchasing something for travel, the salesperson could stress an item's ease in care and wrinkle resistance. If the price has been reduced, the associate should call attention to the value of the garment.

The associate should try to convince the shopper to try on the merchandise if that is appropriate. Once the shopper is in the fitting room, the associate could bring other styles that might motivate purchasing. In such circumstances, professional sellers are often able to **suggestion sell**, which could result in a larger sale.

It is important to involve the shopper wherever possible. "Feel the quality of this fabric. Doesn't it feel like silk?" This is another way to bring the sale closer to completion.

Overcoming Objections. After spending considerable time with a salesperson, looking at the merchandise and asking questions, many people are simply not ready to commit themselves to a purchase for real reasons, such as the price being higher that they are willing to spend, or for other reasons that could be explained away. Whatever the situation, the seller must attempt to **overcome the objections** and satisfy those that are real.

There are several methods a salesperson can use to bring the sale closer to a conclusion when the customer has raised objections. The **yes, but method** involves agreeing with the customer's objection but offering alternatives that might turn the objection into a selling point. If the price seems higher than the shopper expected to pay, the seller might say, "Yes, it is a little higher priced than you might have anticipated, but the quality and versatility of the garment will serve you in many different ways. You could wear the dress to the office and, when properly accessorized, you could use it for social occasions."

Other comments using this type of objection intervention include:

1. You are right, the style is very basic, but jewelry and scarves could enhance it.
2. The cost of the gown might be more than you intended to spend, but you could alter this type of style for street wear, giving it longer life.
3. You may have to wait longer for the delivery date of the color you want, but it will be smashing in that color.

Some salespeople prefer to handle objections by asking questions about the objection, such as, "Why isn't the color right for the party?" "Which types of fabrics do you prefer to the ones I've shown you?" and "What price would you consider your limit for a pair of shoes?"

Occasionally there is no basis for the shopper's objection. In such cases, the seller can deny the objection, although only when the seller knows with absolute certainty the shopper is incorrect. For example, "No, we do not charge more for the same items that are carried by Petite Woman," or "No, the dress will not need pressing; it is constructed with a wrinkle-resistant fabric."

The seller should handle objections in a positive manner and not one that is offensive to the customer. Some objections simply cannot be overcome, and the seller should always leave the door open for future business.

Closing the Sale. After going through the natural progression of the different stages, the seller should attempt to make the sale. Closes that are attempted before the right time are known as **trial closes**. Sometimes the attempt is successful, other times the seller has to do more selling. Some shoppers close the sales themselves, but this is not always the case.

All during the selling process, the salesperson should listen for signals that indicate the shopper is willing to buy, such as

1. May I leave a deposit on the shoes and pick them up at another time?
2. Can it be ordered in my size?
3. Can you locate it in my size in one of your other stores?
4. Will there be a charge for delivery?
5. Can this be changed for another item?
6. Can I get a refund if I change my mind?

Many times the closing signals are not so obvious. In such cases, the professional seller uses an assortment of questions or statements, such as the following, to determine if the shopper is ready:

1. Would you like to pay cash or have it put on your credit card?
2. Could I give you a card to enclose with the gift?
3. How much time do we have to dye the shoes to match your dress?
4. Would you like the black or navy blue skirt?
5. This new ivory shade would be perfect with the ensemble.

Even when the seller has made many closing attempts, the sale might never come to fruition. Sometimes the shopper simply cannot be satisfied. Other times, the approach could be to involve someone else in the store who has higher standing. In a boutique, it might be the buyer, or in a department or specialty store, it might be the department manager. When a store representative who has more authority, becomes involved in the transaction customers might feel that they are receiving special attention and may be ready to buy as a result.

The most experienced sales associates know that not every sale can be completed no matter how many selling techniques they employ. If this is the case, they handle the shopper in a courteous manner to encourage future business.

ESSENTIALS OF A SUCCESSFUL SALES PROGRAM

To attract the most talented people to join its sales staff and to motivate company loyalty, the retailer should consider the essentials for running a successful program.

Incentives are often the key to success. At Nordstrom, which pays its sales staff a straight commission, sales associates try their best to make the sale: only completed sales provide them with their income. Promotion from within is another means of reward for satisfactory service. Recognition seminars, prizes for the highest weekly sales, and extra staff discounts on purchase when they have achieved certain sales goals might motivate sales staff to try harder.

Proper staff training, as discussed in Chapter 9, "Human Resources Management," is another essential in a sound selling program. It gives the seller the feeling of self-confidence that can translate into bigger sales.

Periodic evaluations are also a necessity to help sales associates learn about their positive as well as negative characteristics. A good evaluation program can help build morale and foster employee longevity.

Finally, an occasional pat on the back may go a long way in motivating the seller to try harder.

Selling on the Internet

Although the amount of consumer sales transactions accomplished over the Internet pales by comparison with those accomplished in the stores, Web site selling is increasing every year. More people are turning to this channel not only for books and CDs, as they did in the early stages of this medium, but also for a variety of fashion merchandise ranging from value-priced items to the likes of Prada, Ralph Lauren, and Calvin Klein.

While a great deal of the purchasing on the Internet does not require selling techniques, some merchants have recognized that some selling effort might be required to complete the sale. Pictures or descriptions of items aren't always sufficient to close the sale.

Many of the reasons people use the Internet as a shopping channel are discussed in Chapter 2, "The Emergence of Off-Site Fashion Retailing." This section examines the role of the seller in that channel.

Personal selling comes about in two ways. One involves interaction by telephone between the on-line selling agent and the customers and the other by **chatting on-line** or interactive relationships.

One of the major merchants to use Web site interactivity is Lands' End, the subject of the following Spotlight.

Fashion Retailing Spotlights

LANDS' END

In 1963, in a basement along the river in Chicago's old tannery district, Lands' End was born. Initially, the company principals consisted of sailors who were interested in selling and making racing sailboat equipment, duffle bags, rainsuits, sweaters, and other clothing. After some unexpected growth, the business began to spread its wings and eventually moved to Dodgeville, WI. Today, the company is one of the largest in the United States to produce and sell a variety of the same products in its initial offerings as well as many others.

Although the company has been purchased by Sears, which features some of its product in Sears stores, Lands' End still considers itself to be a direct merchant, eliminating the markups of middlemen. Its customers purchase directly from their home or office through catalogs or via its Web site; Lands' End does have a few outlet stores that dispose of imperfect merchandise or overstocked goods.

Unique to its Web site is the Lands' End Live innovation. This feature enables shoppers with questions to directly interact with company representatives, or sellers, either through direct telephone communication that is accessed on the Web site, or through typing in questions that customer reps answer. Both techniques enable Lands' End staff to answer questions that range from simple queries about color or size to detailed concerns about durability, warranties, or other more personal needs.

A service called "My Personal Shopper" "suggests" items and outfits that best suit the user's unique taste, style, and preferences, based on information the user enters in the area called "My Virtual Model." Shoppers complete a questionnaire that addresses such factors as body type, waist size, height, and weight, and facial features such

(continued)

as eyes, nose, and lips. The computer program then generates a detailed figure of the shopper, and stores it so that each time a shopper wants to consult with a personal shopper, the representative can access it and make suggestions on the proper apparel for any occasion.

Other unique innovations on the Lands' End Web site that help sellers assess needs are the "Shop with a Friend" program, which allows two shoppers to browse the site together and communicate with each other and with the company representative, and "Lands' End Custom" which asks the shopper a few questions about measurements and body type, allows the shopper to discuss them with a rep, and sends the information to the proper manufacturing department so that the shopper's garments are tailored to fit perfectly.

Lands' End has recognized that the Internet is here to stay as a selling tool, has incorporated a high degree of personalized "selling", and has expanded its Web site to serve the United Kingdom, Japan, Germany, France, Ireland, and Italy.

Catalog Selling

Chapter 2, "The Emergence of Off-Site Fashion Retailing," discussed how catalog purchasing is alive and well and is big business for many of today's fashion merchants. Catalogs provide users with significant benefits in terms of convenience and retailers significant benefits in terms of profits.

Shoppers buy from catalogs in two ways. They either complete order forms included in the catalogs and mail them in to the merchant, or call the company and place their order with a knowledgeable **order taker**. The latter method of contact gives companies an opportunity to offer selling assistance.

Catalog retailers supply their telephone divisions with all the different catalogs they offer, which are identical to the ones consumers receive. When callers know exactly what they want to purchase, no "selling" is required. When callers have questions before they decide to purchase, the representative must be fully versed on such matters as additional color availability, size variation, delivery dates, shipping costs, and return procedures. It is then that the reps may need to do some selling to close the sale.

There are major differences in the sales presentation that sellers use in the brick-and-mortar operations and in catalog operations. Unlike the former, which requires the sales associate to dress appropriately and have skills in customer approach, the latter requires neither. These shoppers never see the "seller" nor do they need a special approach. Catalog users initiate the transaction by making the telephone call. The goods are not physically presented; they consist of catalog photographs and descriptions. The seller does not even have to assess the caller's needs except when the caller wants some additional information about such factors as product durability and care.

The similarities between personal and distant selling come at the overcoming objection and closing the sale stages. Here, the order takers assume the role of sellers. They must be able to overcome any objections that callers might raise and attempt to close the sale whenever the objections have been overcome. They might also, as do on-site sellers, suggest additional products to increase the size of the sale.

L.L. Bean, the subject of the following Spotlight, uses catalog selling as its main means of customer contact and makes the experience as close to personalized on-site shopping as possible.

Fashion Retailing Spotlight

L.L. BEAN

Although L.L. Bean operates four stores, including its flagship in Freeport, ME, its catalog generates the wealth of the company's business. With an abundance of personal apparel for the entire family, L.L. Bean has been able to satisfy their customers' needs since 1912.

At the heart of the organization is customer service. Just as the flagship store is open 24 hours a day, 365 days a year, so is the catalog operation. Recognizing that different shoppers have different time constraints, order takers are available at any time.

The catalogs make it extremely easy for users to have their needs satisfied. For those who prefer to mail their orders to the company, forms are available in each catalog that addresses such areas of customer concern as shipping procedures and costs, delivery expectancy, special packaging such as gift boxes, product guarantees, methods of payment, and even guidelines to assure proper fit. The latter feature of the catalog's order form is especially essential in that it significantly reduces the rate of return for merchandise that was ordered in the wrong size.

Even with all of these features, it is sometimes necessary for a direct contact between a "live" company representative and the consumer. The "L. L. Bean Live Help" service connects the two parties so that reps can address any questions. This is where personal selling augments the routine ordering of catalog items. The reps are completely ready to discuss the caller's problems or concerns and make the necessary recommendations to finalize the sale.

The catalog also lists each of the company's on-site locations and its Web site, showing that it is a true multi-channel retailer.

With more than twelve million customer calls, L.L. Bean has achieved the right approach and attitude necessary to make catalog selling a viable alternative to store visitations.

CUSTOMER SERVICE

When Henri Bendel, founder of the famous fashion institution that bears his name, personally greeted customers at the door and directed each one to a sales specialist who would satisfy their needs, he displayed the epitome of customer service. Today, Wal-Mart, the epitome of value shopping, continues that concept with the use of **store greeters** at the stores' entrances to provide the same personal attention. While these two companies are at the complete opposite ends of the retailing spectrum, they each, nonetheless, have recognized the value of customer service. They, along with just about every fashion merchant, offer a host of services that they believe assists them in gaining their fair share of the marketplace and gives the shopper a reason to shop in their stores for reasons other than merchandise procurement.

This text has made many references to the highly competitive nature of fashion retailing and the sameness of the merchandise carried throughout the industry. It has focused attention upon some of the ways in which retailers attempt to separate themselves from the rest of the pack, including the design of elegant surroundings for their brick-and-mortar operations, innovative and imaginative visual merchandising, creative advertising, special events, the development of private brands and labels, and professional and dedicated sales associates.

Being able to have a personal shopper preselect merchandise that is appropriate for any occasion, have garments altered in a minimum of time, make gift selections without having to go to the store, and enjoy the assistance of a sales associate who can converse in a language other than English are all things that make shopping more pleasurable and appealing. Retailers that offer these services, and many others, are able to count on customers as loyal followers who regularly return to their different retailing channels whenever the need arises.

The first part of this chapter addressed what many consider to be the most important of the customer services: personal selling. This alone, however, is not where service ends. Customer service encompasses a whole host of offerings that help motivate **customer loyalty**.

Many of the services retailers feature in their stores, catalogs, or on their Web sites are fairly traditional to the industry, while some merchants customize services to better fit their own clientele's needs. The multichannel phenomenon has caused merchants to offer a variety of services in all of their distribution outlets, and they attempt to tailor the type of services to accommodate the shoppers using those different channels.

On-Site Services

Merchants provide the greatest number of customer services in their brick-and-mortar units. The following sections discuss several traditional services offered by many retailers.

REWARDS PROGRAMS

Just as the airlines try to gain consumer loyalty by providing frequent flier miles that regular passengers can put toward free flights, companies such as Saks Fifth Avenue, Neiman Marcus, and Marshall Field's have established incentive programs that reward shoppers every time they purchase from them. These programs also benefit those who purchase from the companies' catalogs or Web sites, but shoppers earn the bulk of these points in the brick-and-mortar outlets.

The *InCircle Rewards* program at Neiman Marcus gives shoppers one point for each dollar charged to their credit card. Those who accumulate 3,000 points are recognized with a distinctive charge card, giving them extra shopping status. Participants can redeem the points for merchandise as well as for use in such frequent flyer programs as American Airlines and United Airlines.

SaksFirst, the **rewards program** Saks Fifth Avenue offers, is similar to that of Neiman Marcus. It too requires a minimum of 3,000 base points before it awards membership. Those enrolled in the Saks program also benefit from double and triple point events, exclusive promotions and giveaways, complimentary companion ticket offers from British Airways, and special offers from the Ritz Carlton hotel chain and Cunard Cruises.

At Marshall Field's, the *Regards* program offers such exclusive services as complimentary signature gift wrap, complimentary coffee or tea, event privileges and special offers, members-only mailings, and a guest service toll-free line. Each time customers accumulate $400 or more in their Rewards account, they receive a special discount card that they may use on any day they select.

Retailers that offer these and similar programs attempt to create customer loyalty and motivate people to shop at their stores before they shop elsewhere.

REGISTRIES

Just about every fashion retailer offers bridal and other gift **registries**. Couples making wedding plans or expecting the birth of a child visit a store and preselect items that they would like to receive as gifts. The registries provide selection assistance from specialists who accompany the registrants throughout the store to help with their decision making. Once the registrants have chosen what gifts they would like to receive, they fill out forms listing their choices that people wanting to buy them presents can consult. This helps the registrants avoid

Rewards programs for shopping in a particular retail operation, as seen in a Hong Kong department store, often motivate shoppers to return again and again.
(Courtesy of Ellen Diamond)

receiving duplicate gifts and ensures the retailer offering the registry that it will receive a lot of business from people who are buying gifts for the registrants.

CORPORATE SERVICES

Most major fashion merchants provide corporate services for businesses. Business representatives can choose from gifts of every price point and type. In addition, the retailers offer corporate discounts, engraving services for more personalized giving, and signature packaging featuring their logo. This service is especially appealing during the Christmas selling season, when businesses can select gifts for their clients and staff without any additional expense.

PERSONAL SHOPPERS

With less time to spend shopping, many consumers are turning to *personal shoppers* to quickly and efficiently choose fashion products to fit their needs. A customer contacts a merchant and gives the personal shopper pertinent information such as style and color preferences, price points, size, and the event to which the garment will be worn. The personal shopper then combs the store's premises for items that fit the customer's request.

Next, the personal shopper schedules a convient time when the customer visits the store and tries on the selected items, and a fitter is also present to make alterations if necessary.

Some customers prefer to have a personal shopper accompany them to the various merchandise departments and help them find things or make suggestions.

Macy's was one of the earliest proponents of **personal shopping**. Its MBA, or Macy's By Appointment program, was the one other fashion retailers emulated when they developed their own programs.

INTERPRETERS

Some fashion retailers have the advantage of being located in areas that are regularly visited by tourists. In London, Harrods provides interpreters who speak just about any language. The Macy's Herald Square store in New York City, has a similar program in place.

At no additional charge, store employees who are fluent in many languages will accompany shoppers throughout the stores. They arrange for immediate alterations, provide currency exchange information, and offer any other translation assistance that shoppers require to make their visit to the store successful and enjoyable.

VISITOR SERVICES

Out-of-town visitors patronizing certain fashion retail operations receive a host of different services. At Marshall Field's, for example, the store provides free coffee or tea and a 10 percent shopping discount for the day's purchases. At Macy's New York City flagship, the visitor is treated to a free tote bag, reservation assistance for local attractions, and city maps and directions.

Many retailers also provide concierge services for these visiting guests that enable them to spend their time more productively.

MERCHANDISE ALTERATIONS

Often, the fact that a retailer supplies an alteration expert is enough to convince some customers to patronize it. Many shoppers with little time to spend seeking alterations opt for in-store help so they can quickly and easily get their finished product.

Small specialty stores and boutiques, in particular, find that this service enables them to compete with their larger fashion-retailing counterparts. The personalization of such a service often brings customers back again and again, contributing significantly to their customer loyalty.

EXCLUSIVE SHOPPING HOURS

Some of the high-fashion retailers, such as Henri Bendel in New York City, set aside specific shopping hours for the exclusive use of particular segments of the market. For example, they

feature "Girls' Nites" that offer workshops on beauty, wedding planning, shopping, and other fashion-oriented topics to women only.

Others set time aside for "men only" hours at peak holiday times in which this population segment receives individual attention, times for the disabled who cannot easily move through crowded aisles during regular shopping hours, and special shopping periods for disadvantaged children so they can spend time in the store without parental supervision.

CREDIT CARDS

Although almost all merchants accept credit cards as means of payment, the cards are still technically considered to be part of their service package. Most retailers offer a host of different plans for their customers to use including those cards that they offer, bankcards, travel and entertainment cards, and cash rewards cards. These cards are described in the following sections.

Company Cards. All major fashion merchants offer one or more of their own cards. The most widely used is the **revolving credit card**, which allows shoppers to purchase up to preset spending limits. Shoppers can pay the bill in full at the end of the billing cycle, for which there is no extra interest charge, or can spread their payments out over a period of time. Those who opt for the latter option are charged interest on the unpaid balance. This arrangement enables shoppers to make additional purchases whenever necessary, as long as they haven't reached their credit limits. **Charge accounts** are offered to those customers who agree to pay their bills at the end of thirty days. These accounts also have credit limitations that are preestablished by the company but do not carry any interest charges. Most retailers that sell large-ticket items offer **installment credit.** Each of these purchases are treated as individual sales, and the retailer sets monthly payments that shoppers make until they have paid off the entire bill in a certain amount of time.

Credit cards are offered to make shopping easier for the customer.
(Courtesy of Checkpoint Systems, Inc.)

Bank Cards. MasterCard and Visa are typical of these cards. They are issued by banks that set credit limits for card holders that are based upon their ability to pay. Users are expected to pay at least a minimum amount of the outstanding balance once a month, for which there is an interest charge, or they can pay off the total, and no interest is charged. Basically, **bank cards** are revolving credit cards.

Travel and Entertainment. American Express is the major issuer of this type of credit card. While it was once primarily used for travel, entertainment, and dining, now it is one of the major cards used for retail purchases. No interest charges accrue on these cards, but users must pay the entire month's charges in full at the end of the billing cycle.

Cash Rewards Cards. The major **cash rewards card** is the Discover Card. The difference between this and the typical bank card is that the user is rewarded with a cash rebate at the end of the year. The American Express Company has an exclusive arrangement with Costco, which features a special platinum card that, like the Discover Card, provides a cash rebate feature.

MISCELLANEOUS SERVICES

Other services retailers offer include dining facilities that range from restaurants to snack bars; **leased departments,** such as travel agencies; gift wrap facilities; child care centers that provide baby sitting services for shoppers in their stores; and kiosks that feature products that are unavailable in the store but are obtainable from company catalogs.

Off-Site Services

Many of the services offered by brick-and-mortar stores are also featured in catalogs and on retailer Web sites, such as credit purchases, gift boxing, limited alterations such as pants hemming featured by L.L. Bean and Lands' End, and gift registries. Many Web sites make interactive communication available between the shopper and the retailer for personal shopping services, such as L.L. Beans' "Live Help" program.

More Web sites provide a feature that creates and constructs **virtual models** of the shoppers using the information they supply. With this feature, companies such as Lands' End, with "My Virtual Model," can offer personal shopping assistance.

Recognizing that shoppers will continue to use off-site shopping sites, making them valuable revenue-producing channels, retailers that have these outlets are continuously refocusing their efforts on customer service to stay ahead of the competition.

TRENDS IN SERVICING THE CUSTOMER

Whether it is in the brick-and-mortar operations or in the off-site channels, retailers are offering as many services as possible to maintain solid customer relations and promote customer loyalty.

Some of the trends in this area include the following:

• *Noninterest installment purchase.* While fashion apparel retailers are not yet offering this option, several home furnishings giants are selling their goods on the installment plan without charging the traditional interest expense. Following the lead of retailer Rooms to Go, merchants are allowing consumers to avail themselves of the merchandise and to pay it off over a certain time without paying any accrued interest. In fact, some of these companies are allowing customers to make **installment purchases** that require neither interest nor any cash outlay for as long as two years.

• *Personal shopping service.* The number of personal shoppers, both on- and off-site, are increasing. Recognizing the fact that time limitations are often the cause of decreased customer patronage, more merchants are increasing the size of their personal shopping staffs. Some, such as Bergdorf Goodman in New York City, have designed individual rooms where

personal shoppers can serve clients refreshments while they examine merchandise selected especially for them. More fashion retailers are providing interactive service on their Web sites to offer this personalized shopping experience to off-site shoppers.

• *Expansion of dining facilities.* Retailers are installing different types of eating establishments, ranging from the quick-snack variety to the full-service restaurant, so that customers do not have to leave the store's premises to satisfy their hunger. Those who do not offer dining run the risk of customers not returning to the store after they leave it to eat and consequently making fewer purchases.

• *Concierge service.* Fashion retailers such as Nordstrom, are being joined by others in making the shopping experience a more pleasurable one by offering such services as obtaining taxis and cars, assisting shoppers by carrying heavy packages to their cars, and arranging for theater tickets or dinner reservations.

• *Corporate buying programs.* With many large companies in the market to purchase gifts for their staffs and clients, many retailers have established special **corporate buying programs** that address their needs. This has increased sales in such items as perfume, small leather accessories and engravable items during peak holiday periods. Some retailers even offer discounts to their corporate accounts.

SMALL STORE APPLICATIONS

The reason why many small fashion merchants gain customer loyalty is because they offer individualized personal attention to their customers. Boutiques and small specialty shops aren't often able to compete with the industry's giants otherwise.

One approach some use is to develop a customer file that lists the customer's size, style preferences, and price point considerations, and then to telephone the customer when they receive merchandise they think the customer will like. This special approach makes the customer feel special, and the call usually brings them to the store and leads to a purchase.

Custom alteration, whereby a shop can make adjustments on clothing for "hard-to-fit" figures or provide delivery of altered garments in a relatively short period of time, contributes to the shop's success.

Some small fashion merchants offer special, noninterest accruing charge accounts for their special clients. This service gives the customer the feeling of receiving special treatment, though it costs the merchant the additional expense of accepting bank and other credit cards. Of course, most small retailers do accept these third-party credit cards in addition to their own.

Sometimes, small fashion merchants address their customers' needs by bringing clothing to their homes or even their places of business when limited time prevents in-store visits.

Chapter Highlights

1. The role of professional fashion salespeople is not only to sell the product but also to provide service "extras" to help differentiate their store from the rest.
2. Sales associates are the intermediaries between the customers and the company's buyers, so they can pass on any information to the buyer that might make the company's merchandise mix better.
3. Professional sales personnel in brick-and-mortar operations must be properly dressed and groomed since they are the ones that make the company's first impression with the shopper.
4. A salesperson's knowledge of the merchandise, company, and the consumer will lead to more sales and also has the potential of developing customer loyalty.
5. Since not all shoppers who enter a store know exactly what they want to purchase, it is up to the sales associate to assess needs and present merchandise that has the potential to suit those needs; by doing so, this motivates shoppers to become purchasers.
6. Closing the sale is one of the most difficult steps in a sales presentation. Those with the most selling experience use a host of means to determine when it is the right time.

7. Off-site selling is more than order taking. Some major fashion retailers have made provisions for interactivity between shoppers and their reps so that the reps can do some actual selling while talking to the shoppers.

8. Customer service involves more than personal selling and includes such areas as rewards programs, personal shopping, gift registries, corporate buying programs, interpreter programs, and merchandise alterations.

9. Retailers accept credit cards in many different formats including company cards, bank cards, travel and entertainment cards, and cash rewards cards.

10. To make on-line shopping more successful, some retailers have used such customized approaches as virtual models and live help programs.

Terms of the Trade

suggestion selling
customer loyalty
overcoming objections
yes, but method
trial closes
chatting on-line
order taker
store greeters
customer loyalty
rewards programs
registries
personal shopping
revolving credit card
charge accounts
bank cards
cash rewards cards
leased departments
virtual model
installment purchases
corporate buying programs

For Discussion

1. What is meant by the term "suggestion selling?"
2. What are some of the service extras that the sales associate can provide to increase the potential for making the sale?
3. When shoppers say, "I don't like that store," what are they actually referring to?
4. How can a fashion sales associate assist the company buyer?
5. Why is appropriate appearance so essential for the sales associate in a fashion retailing operation?
6. Which three knowledge areas are generally essential to making the sale?
7. From which sources may a sales associate acquire product knowledge?
8. What is the first stage in a sales presentation, and how should it be addressed?
9. List and describe two techniques that are used to overcome customer objections.
10. When is it appropriate for a seller to try to close the sale?
11. What are some of the closing techniques used in sales closes?
12. Is there any actual personal selling on Web sites, and if so, how is it accomplished?
13. Does catalog usage ever afford a shopper the opportunity to do anything more than place an order?
14. Why have rewards programs become important service features in major fashion retailing operations?
15. What special service is afforded by most fashion retailers' personal shoppers?
16. Why are visitor services for out-of-town shoppers offered by major retailers?
17. Differentiate between charge cards and bankcards.
18. What is meant by the term "revolving" credit?

CASE PROBLEM 1

Caroline Fredericks owns a small fashion boutique of that same name that specializes in apparel for "that special occasion." Brides, members of the bridal party, and invited guests to such affairs comprise the major portion of the store's market. Many of the garments are especially designed and created on the premises, while others are offerings from prestigious designer collections.

The success of the store has been based upon the uniqueness of the merchandise, excellent individual attention to the customer, and fine service. Since the store is located off the beaten path, business is generated through word of mouth. Satisfied customers send their friends and relatives whenever the occasion of a wedding or other formal event arises. Business has been brisk since the store opened five years ago, but Caroline believes it could improve if she took steps to promote the store.

She believes that a catalog and perhaps a Web site that feature some of her merchandise could be used to sell to those who might not have the time to shop in person. She is prepared to call upon a marketing specialist to prepare such an approach to increasing sales volume.

Questions

1. Does Caroline's operation lend itself to off-site marketing? Defend your answer with logical reasoning.
2. What tool might she use to reach people in their homes?

CASE PROBLEM 2

The Carriage Trade is a fashionable men's and ladies' specialty store on Chicago's most fashionable street. It enjoys a clientele that is among the most affluent and influential. Its customers are primarily business executives, bankers, entertainers, lawyers, doctors, and other professionals. The market served is downtown Chicago and all of the surrounding suburban areas.

The bulk of the Carriage Trade business is from credit card transactions. It operates its own credit department and currently utilizes only two types of proprietary instruments, the regular charge plate and the revolving credit card. Customers are evaluated in terms of their finances and are assigned lines of credit that indicate how much they can charge during any given period.

While business has always been profitable, the recently hired CFO believes that Carriage Trade is making a credit error. He believes that third-party credit cards such as American Express as well as the bank cards will bring additional revenue to the company. For example, out-of-towners happening into the store might want to shop there. Since they are visitors to Chicago, it is unlikely that they will have the company's credit cards and would need to use a third-party card to make a purchase. Opening a special store account wouldn't make sense for these shoppers.

The company's principals, however, are reluctant to alter their traditional approach. They feel that the proprietary customer is loyal and likes the prestige of the store's own cards, and that more business is generated because of this condition. The CFO argues that the acceptance of multiuse cards will generate additional business.

Questions

1. With whom do you agree? Why?
2. How might the acceptance of additional cards improve the business?

EXERCISES AND PROJECTS

1. Choose any fashion merchant that is involved in multichannel retailing. Using its Web site, assess five different customer services offered in its stores, catalogs, and Web sites. With the information gathered, complete the following chart, writing yes or no for each channel's service offering.

Company Name: _____			
Service	*In Store*	*Catalog*	*Web Site*

2. Visit three different fashion brick-and-mortar operations and evaluate their approaches to greeting the customers. For each store, in the space provided below, indicate the method used. After you have collected the information and recorded it, select the best of the three, and, in the "comments" section, tell why you think its approach is advantageous over the others.

Greetings	*Store A*	*Store B*	*Store C*

Careers in Fashion Retailing

Few careers offer as much excitement and reward as those in the fashion retailing environment. And because of the global nature of the field, there are opportunities in many parts of the world.

Recent years have also witnessed considerable growth in the field due, in part, to the fact that almost every major fashion merchant in the United States is a multichannel retailer, as are many foreign venues as well.

The idea of owning an exclusive boutique or other small outlet is appealing, and those with significant experience, determination, and resources can succeed as a self-employed entrepreneur. The larger organizations, with their potential for both profits and problems, employ most people interested in the industry, and there are many opportunities for those who are creative and hard working to succeed in these companies. Companion industries that service fashion retailers, such as marketing consulting firms, resident buying offices, fashion forecaster companies, and reporting agencies, also offer interesting and rewarding jobs.

Before deciding upon a starting place or a particular job, it is best to explore positions in all of the levels of fashion retailing.

SMALL STORE OPPORTUNITY

Small stores offer the chance to learn about the field by working closely with the owner, but such an environment generally provides little opportunity for advancement. In the vast majority of these operations, owners are combination buyers, merchandisers, managers, and promotion planners. They are jacks of all trades and make most of the decisions. The employees in these places are usually salespeople. Often, to make matters worse, when and if the owner feels it's time to relinquish the reins, a member of the family is waiting in the wings to take over. In other cases, when owners are ready to retire and have no family members to run the business, they place the store on the market. Of course, a staff person could purchase the business, but most people lack the necessary capital requirements.

ENTREPRENEURSHIP

Many people dream of the time when they can be masters of their own companies. While the thought of opening a small specialty store or boutique is exciting, it can be difficult to succeed. The capital requirements associated with ownership, along with the experience needed to deal with competition, often turn the most ambitious venture into a failure. Many small retailers do survive and flourish, but this is the exception rather than the rule. Of course, those with the desire of ownership should follow their dreams, but they should carefully plan ahead and prepare themselves for the challenges they will face.

Today's entrepreneur requires considerable sums of money to establish a business. The cost of fixtures, visual props, construction materials, design plans, advertising and promotion, and other initial investments is considerable. In addition to these expenses, a

good location is often difficult to find. The better sites in downtown locations near flagships are very expensive to lease, as are places on busy city streets or in other high-foot traffic neighborhoods. Rarely, if ever, would a mall developer accept an independent as a tenant if a chain operator wanted the same location. Most small stores must locate in less-expensive, less-traveled strip malls or side streets.

Although the outlook for fashion retailing entrepreneurs looks bleak, there are opportunities for those willing to take the risk.

Franchises and licenses are an option, though they offer little room for creativity. These stores are clones that have been established by retailers who have had some success in business and wish to expand by offering specific units to people who pay for the right to their name and their merchandise mix. Company philosophy, merchandising practices, image, methods of operation, and other details are decided upon by the franchiser or licenser. The unit owners merely follow predetermined rules and regulations and keep whatever profits their stores make. Those with the desire to start a business from the bottom up would not be satisfied with the restrictiveness mandated by such retail operations.

Occasionally, small shop owners find the right formula for entrepreneurial success. It might be because they have the ability to design and create unique fashions, they provide custom tailoring for hard-to-fit figures that larger fashion operations don't offer, or they develop a merchandise mix or approach that is in short supply and meets the needs of a percentage of the population that can't be easily satisfied elsewhere. For example, a fashion-savvy personal shopper scouts the wholesale markets for unique merchandise, calls upon busy business executives who don't have the time to shop in stores or dislike the impersonal nature of catalog and Web-site shopping and shows them these products. The personal shopper establishes a clientele, accumulates client data such as size, style, and color preferences, and develops a solid business relationship based on attentive personal service and strong customer loyalty. It would be a natural step for this personal shopper to become a small boutique owner.

LARGE COMPANY MULTICHANNEL OPPORTUNITY

Without question, the greatest potential for career advancement is in those companies that are important names in fashion retailing. Department stores and chain organizations, most of which have entered the multichannel arena by developing catalog and Web site divisions, are where the astute, properly trained person can achieve success. The size and scope of these operations, and the number of specialists needed to perform their functions, make them ideal places for anyone with the desire for fashion retailing careers. Large-scale off-site ventures are increasingly popular with shoppers, and they too offer rewarding career possibilities.

Whether it is a multichannel retailer, a catalog-only operation, or a pure fashion Web site organization, many of the job titles within each are similar. Buyers, for example, whether their realm is a store or a catalog, have the same or similar responsibilities. All are involved in merchandise sourcing, development of model stocks, market visits, and interfacing with external sources of information. Of course, some jobs, such as selling, are primarily a brick-and-mortar function, although order takers do a degree of selling in Web site operations and catalogs as well.

FASHION RETAILING JOB CLASSIFICATIONS

The manner in which jobs are classified in fashion retailing generally follows several specialized categories. Those that dominate are classified as merchandising, management, operations, promotion, and finance. Within each of these categories, which often form the basis of the larger company's organizational structure, are the specific positions necessary to successfully proceed with the business at hand. In small operations, there is little need for such specialization since owners and perhaps managers fulfill several of these different positions.

Merchandising

The lifeblood of any fashion retailing organization is the merchandise it sells. The following positions are typical of those in merchandising.

GENERAL MERCHANDISE MANAGER (GMM)

The merchandising division is headed by the GMM, who oversees and makes decisions concerning the company's merchandising philosophy and future plans. The GMM is responsible for determining the company's merchandise mix, pricing strategies, fashion focus, and other details. This position is just one part of the organization's management team, and major policy decisions come from the joint efforts of that team.

The GMM is the top position in the company's merchandising division, and since there is only one in an organization, competition for it is keen. Those who ascend to GMM positions either come from the ranks of the divisional merchandise managers or from the rosters of other companies.

DIVISIONAL MERCHANDISE MANAGER (DMM)

In the larger fashion retail operations such as the department stores and specialty chains, the organizational structure generally divides merchandising responsibilities at the level below that of the GMM according to product classifications. For example, the major full-line department store will generally have divisional heads for such merchandise categories as men's wear, women's apparel, wearable accessories, home fashion, and children's wear. Each division is headed by a DMM, who has the responsibility to divide the division's merchandise budget among the buyers in the area, coordinate the activities of the buyers, make trips to the marketplace along with the buyer when major purchasing decisions need attention, and advise on markup and markdown goals. The DMM reports to the GMM and is responsible for the buyers in the division. Although there are several divisional merchandise managers in a company, it can be difficult to reach this level.

BUYER

The buyer is responsible for all of the department's purchasing decisions, which include development of a model stock, resource evaluation, market visits, merchandise acquisition, pricing, and in some companies, assistance in the development of private label products. Because larger companies offer so many different product classifications, they need many buyers to accomplish the purchasing task. This level of employment is within reach of those working on the selling floors who display ability and ambition and have been employed in the fashion retail industry for about five years. It is the next step for assistant buyers.

ASSISTANT BUYER

This entry-level position in the merchandising division is often filled by those who have successfully completed a company's formal executive training program or by sales associates who show dedication and ambition.

FASHION DIRECTOR

This position is more advisory in nature than decision making. Fashion directors often scout the market before buyers visit them so that they make the buyers aware of market conditions, new resources, potentially hot items, current styles, color and fabric directions, and the like. They also coordinate the merchant's fashion image, prepare and direct fashion shows, and sometimes accessorize apparel featured in the store's interior visual presentations.

Management

Throughout every fashion retailing segment, there are numerous areas of management. Some of the more typical positions are explored in the following sections.

STORE MANAGER

Major retail organizations such as department stores and chain stores employ managers who have the responsibility to oversee all of the activities in their particular units. The size of the specific operation determines the extent of the manager's activities. In the department store flagships and branch stores, responsibilities include management of human resources, selling departments, customer services, traffic, security, and maintenance as well as seeing to it that the company's procedures and policies are satisfactorily carried out. In a chain organization's individual units, which are typically smaller than those found in department store branches, managers perform some additional activities, such as hiring assistant managers and sales personnel, scheduling employee hours, handling customer complaints, changing visual presentations, preparing inventory reports, tallying sales receipts, and doing anything else of a management nature.

DEPARTMENT MANAGER

In both on-site and off-site retail ventures, individual managers run specific departments. In the brick-and-mortar operations, where they are responsible for particular merchandise departments, they schedule employee hours, arrange merchandise on the selling floor, assist sales associates with customer complaints, make visual presentation changes within the department, and sell during peak periods. In some large department stores, group managers supervise a number of departments.

The nature of management in the off-site ventures, such as the catalog and Web site divisions, is different than what is expected in the stores. These managers are primarily responsible for making certain that their inventories are up to the levels needed for selling and that those under their jurisdiction are carrying out their responsibilities.

ASSISTANT DEPARTMENT MANAGER

Before becoming a manager, a person must be an assistant. As the name implies, these employees assist managers with each of their responsibilities, and in their absence, take charge of the operation. In store units, a great deal of the assistant manager's job is spent on the selling floor.

HUMAN RESOURCES MANAGER

The human resources manager or director is primarily responsible for providing the company with competent employees. In smaller companies, they are jacks of all trades, handling such tasks as interviewing, training, settling disputes, planning remuneration changes, recommending promotions, and anything else of a labor-relations nature. In larger retail organizations, they are called upon to oversee a number of specialists who perform human resources tasks. It is important for these employees to have a background in retailing and psychology, coupled with courses in industrial labor relations.

Promotion

Those in the promotion divisions of retail organizations are responsible for advertising, special events, visual merchandising, and publicity.

DIRECTOR OF PROMOTION

The director is expected to coordinate all of the activities of the departments within the promotional divisions. Directors of promotion prepare the budgets for the promotional expenditures, apportion them to the managers within the division, and coordinate the efforts of each manager they direct so that advertising, visual presentations, and special events have a cohesive look.

ADVERTISING MANAGER

Most major retailers spend considerable sums on advertising to attract potential shoppers. At the helm of this division is the advertising manager. In ads that are directed to consumers who shop in the brick-and-mortar operations, in catalogs, or on Web sites, the advertising manager generally sets the tone of the advertising, oversees campaigns, develops new print and/or broadcast concepts, and manages the staff who write copy, prepare artwork, and create layouts. Ad managers usually interact with advertising agency personnel when agencies help develop their programs. Advertising managers have not necessarily studied retailing but have majored in advertising.

VISUAL MERCHANDISING DIRECTOR

One of the most important ways to motivate shoppers to enter stores and buy merchandise is by providing exciting window displays and tempting interior presentations. The head of the department that performs these tasks is the visual merchandising director, or vice president of visual merchandising. The visual merchandising director's responsibilities include the planning of all windows and interior displays and overseeing their installations, and hiring artists, carpenters, painters, trimmers, and others who install the presentations. The job demands a great deal of creativity as well as an understanding of consumer motivation. The people generally suited for such positions are those whose background combine both retailing comprehension and a knowledge of art.

SPECIAL EVENTS MANAGER

This person creates the various concepts for the merchant's special events programs such as holiday parades, fashion shows, celebrity appearances, charitable functions, and other events that provide publicity for the company.

PUBLICITY MANAGER

The publicity manager creates press kits and press releases about store events, news, and community involvement and sends them to newspapers or magazines and broadcast media so that they will give press or air coverage to the store. This free publicity attracts customer attention without the store having to spend money on associate advertising, special events, and visual merchandising.

Operations

The operations division is primarily responsible for making certain that the company's facilities are well taken care of and that the premises is properly secured to minimize shoplifting and internal theft. There are several managers in this division.

OPERATIONS MANAGER (OM)

The OM heads this division and has the overall responsibility for managing the employees in charge of property maintenance, receipt of merchandise, security, equipment and supplies purchases, and workrooms.

SECURITY CHIEF

The security chief has had formal security education and participates in one or more aspects of securing the company's premises. Responsibilities include developing the appropriate programs to alleviate the potential for shoplifting and employee theft, assessing the most recent tools for loss prevention, and managing the security team. While off-site retail ventures do not deal with shoplifting, security chiefs in these venues concentrate on preventing employee theft in off-site warehouses, which sometimes results in more losses than those realized in stores.

RECEIVING MANAGER

In the centralized receiving facilities that service most chain organizations and some department stores, the premises in which catalogers and Web site companies receive their goods, and the individual receiving areas that are used to bring the merchandise to the selling floors, product handling and record-keeping are important functions. The receiving manager is responsible for the overall operation of these departments and manages the people who work in them, develops receiving procedures that include checking and marking, and verifies invoices.

MAINTENANCE MANAGER

The maintenance manager maintains a company's physical premises whether it is a brick-and-mortar operation or an off-site facility. These managers are responsible for the cleanliness of the facility, physical facilities alterations, heating and ventilation, mechanical equipment maintenance and replacement, and assessing the latest innovations in equipment and supplies used in the company's environments.

PURCHASING MANAGER

Unlike the buyer, who purchases merchandise for resale, this department head is responsible for the purchase of equipment and supplies necessary to run the operation, such as office supplies, computers, electronic equipment used in workrooms, lighting fixtures and bulbs, and paper bags and boxes.

WORKROOM MANAGER

Workroom managers are responsible for the workrooms and the employees who do clothing alterations and merchandise repairs.

Finance

A company's success is based upon its ability to maximize profits. While each division in a retail operation contributes to the gaining or losing of profits, it is the finance, or control, division that closely oversees the functions that can make the company more profitable. Areas such as accounting, credit, payroll, and inventory management comprise this division.

CREDIT MANAGER

In a time when fewer consumers are using cash, the role of the credit manager is increasingly important. This person manages every aspect of credit, oversees credit policies and credit authorization, and makes recommendations to the upper-level management team regarding new instruments for credit use. The job has become extremely significant with the increased use of the Internet as a shopping tool. Because many consumers are reluctant to place orders for fear of identity theft and other problems of fraud, the credit manager works with the companies that provide technology that eliminates such fraud.

ACCOUNTING MANAGER

The accounting manager is responsible for the development of the different programs and procedures that are required for the company's own needs and those mandated by the government, as well as the recruitment and training of the department's subordinates.

PAYROLL MANAGER

Today's retailing environment requires several different types of remuneration plans for company employees. Those in sales, for example, are paid on straight salary, salary plus commission, straight commission, bonus plans, or other plans. The payroll manager oversees careful record keeping to ensure the employee is paid the appropriate amounts. The payroll manager also hires department staff.

INVENTORY CONTROL MANAGER

Regular internal inventories are mandated by the government for tax purposes and by management for assessing profits and losses. The manager of this department develops the procedures and methods used for inventory taking.

Miscellaneous Careers

In addition to those already discussed, there are others that are important to the successful retail operation.

SALES ASSOCIATE

Sometimes, those that begin in sales positions hope to reach other levels within a company. However, in some companies, selling is a major responsibility, and many opt to stay in these positions for their entire careers. A case in point is Nordstrom, where sales associates often realize earnings in the six-figure range.

PERSONAL SHOPPER

Personal shoppers are merchandise specialists who consult with customers to select items before they come to the store, scout the company's premises for suitable merchandise, help coordinate complete outfits, and provide any other personalized attention necessary to making shopping easier. Their services are generally commission based and remuneration is often in the six-figure range.

Other fashion-orientated positions include comparison shopper and fashion coordinator.

ANCILLARY CAREERS

Those who initially set out to work in one of the fashion retailing segments often choose careers in businesses that service that industry instead of working directly in it. The vast majority are employed by market specialist companies that are external to the fashion retailers. The positions included in these organizations, the majority of which are in resident buying offices, are merchandise managers, resident buyers and their assistants, product developers, fashion forecasters, and reporting service scouts.

Resident Buying Offices

Most fashion merchants, large and small, use these agencies to learn about the wholesale markets, and the trends that are developing, and to assist them with their purchasing needs.

MERCHANDISE MANAGER

This position parallels the same title in retail establishments. These managers oversee a specific merchandise classification such as women's bridge apparel, cover the wholesale markets to learn about trends and other important information that they pass on to their retail clients, and manage the individual buyers in their merchandise division.

BUYER

Unlike retail buyers, these buyers have more of an advisory than a decision-making role. They scout the market to assess the collections, locate new resources, suggest hot items to their retail clients, accompany retail buyers into the market, prepare materials and plans for market weeks, and other functions.

ASSISTANT BUYER

Assistant buyers accompany the buyer to market prior to Market Week, follow up orders placed by the retail organizations, handle retailer complaints, and perform other support tasks.

PRODUCT DEVELOPER

With the continued importance of private label merchandise in retail operations, the product developer is extremely important in the fashion industry. Product developers design new styles and select fabrics and colors that are best suited for those styles. They work directly for the retailer and create models best suited for their client's needs.

FASHION FORECASTER

Forecasters predict the direction of a particular segment of the fashion industry as far as eighteen months in advance of the season. The work involves visiting foreign shores to study fashion trends, visiting mills to assess textile production, predicting color trends, and performing other long-range advisory tasks.

REPORTING SERVICE SCOUT

Scouts work for a reporting service that alerts retail clients to hot items in the marketplace, studies of market trends, advertisements of major fashion retailers, and any other information that will make their clients more competitive.

THE PLANNING STRATEGY FOR A SUCCESSFUL CAREER

To successfully gain entry into the fashion retailing arena and any of its ancillary segments, it is necessary to set a path that leads to the appropriate company and eventual position. Those who follow a plan are more likely to find success than those who use a hit-and-miss approach.

Preplanning: Pursuing a College Degree

It helps to complete an educational program that provides a better understanding of the requirements for success in fashion retailing, the development of decision-making ideas, and the acquiring of technical information.

FOUR-YEAR COLLEGES AND UNIVERSITIES

Those with goals of reaching the highest levels of employment in fashion retail organizations are best equipped by completing four-year college programs. These courses offer more than just introductory information but help train students in decision-making and assessment skills. To achieve the highest levels of employment, one must be able to critically assess the nature of the industry and offer suggestions to increase productivity that are based upon a sound understanding of the problems inherent in everyday practices and future planning.

COMMUNITY COLLEGES

The associate degrees offered at community colleges provide a wealth of specific courses in fashion and retailing that successfully prepare graduates with the knowledge needed to obtain a midmanagement position or to enter into retailer's training programs that often lead to careers as buyers and chain store managers. Courses cover product information, merchandising, buying procedures, advertising and promotion, computer utilization, and management.

Community colleges, as well as the higher institutions of learning, often offer internships as part of their curriculums. In their last semester, students are placed in retail operations to provide them with first-hand experience. Often, these temporary positions become permanent ones.

PROPRIETARY SCHOOLS

Throughout the country, proprietary institutions offer two-year programs or certificates that are specifically geared toward fashion retailing. Those with a flair for fashion and a desire to work in such ancillary organizations as resident buying offices and reporting service companies as fashion forecasters, resident buyers, and reporting service managers may find the right type of education in these schools.

Preparing a Professional Resume

The resume is probably the most important thing a person needs to obtain an interview. Generally, those responsible for hiring have little time to spend interviewing every applicant for the job. Human resources people examine the resumes to determine which applicant seems qualified and is worth inviting to the store to provide further information through a personal meeting. Therefore, job candidates must carefully develop and prepare their resumes.

Competency in resume writing may not be within every person's realm of capability. Those with the skills to write their own should check with sources that offer practical advice. There are numerous books on resume writing as well as literally hundreds of Web sites from different companies that specialize in this area. Each has a different emphasis or focus as well as price. Some of the sites worth logging onto include **www.employment911.com**, which features a spoken message along with resumes; costs begin around $115; **www.hotjobs.com**, a resume service that also offers links to many significant articles on the importance of resumes; and **www.provenresumes.com**, a company that features sixty free resume job search workshops.

Writing a Cover Letter

Candidates for jobs should prepare a simple and brief letter to accompany their resume. It is not necessary for the letter to list the candidate's particular strengths, since that will be obvious in the accompanying resume. The letter should be typed on the same paper as that used for the resume to present an attractive package to the company representative.

The previously mentioned Web sites also provide cover letter suggestions, as do many other sources.

Gaining an Interview

With the professionally developed resume and cover letter in hand, the candidate's next step is to gain an interview with the company or companies that whet their appetite. Networking is a good way to discover companies and positions. Most people have some connection with those in the industry of their choice and should contact them to help arrange an interview. The network might include friends, relatives, acquaintances, educators, or anyone else that might have some familiarity with the field, and talking to them might result in job leads. Using someone's name often opens the door for an interview.

Other means of discovering job openings include classified ads in the consumer newspapers and trade papers such as *Women's Wear Daily,* and *Daily News Record.*

Most retailers feature sections on their Web sites with available jobs. By logging onto the ones that seem interesting, the job seeker can learn about the company, and in most cases can download an application and transmit it back to the company.

Interview Preparation

After candidates receive an invitation to interview, it is important for them to prepare themselves. First, they should thoroughly study the company so that they will be able to talk knowledgeably about it during the interview. This gives the interviewer a favorable impression and shows the candidate's interest and initiative. Candidates can obtain information by writing to the company, researching articles, or accessing its Web sites. Many trade journals, such as *Chain Store Age* and *Visual Merchandising and Store Design,* regularly feature the most important retailers in the industry.

Candidates can also prepare themselves for the actual interview by visiting the company and seeing how its employees dress or reading a book that offers all of the dos and don'ts of proper appearance.

Finally, candidates can ask friends to help them prepare by role-playing. Chapter 9, "Human Resources Management," discusses role-playing.

The Follow-Up Letter

Immediately after the interview, the candidate should send a letter of appreciation to the interviewer. Not only does this show courtesy but it also serves as a reminder that the candidate is interested in the job.

Index